Astrophotography for the Amateur
Second edition

This is a much expanded and fully updated edition of the best-selling handbook *Astrophotography for the Amateur*. It provides a complete guide to taking pictures of the stars, galaxies, the moon, the sun, comets, meteors, and eclipses, using equipment and materials readily available to the hobbyist.

In this new edition, the book has been completely revised and now includes new chapters on computer image processing and CCD imaging, greatly expanded advice on choosing cameras and telescopes, completely updated information about films, a much larger bibliography, and many new photographs (including 43 new colour plates and more than 140 new black and white images) by some of the world's best amateurs, demonstrating the latest equipment and techniques.

Astrophotography for the Amateur has become the standard handbook for all amateur astronomers. This expanded and updated edition provides an ideal introduction for beginners and a complete handbook for advanced amateurs. It will also appeal to photography enthusiasts who can discover how to take spectacular images with only modest equipment.

An avid amateur astronomer since the age of 12, Michael Covington has linguistics degrees from Cambridge and Yale. Currently, he is engaged in research at the University of Georgia's Artificial Intelligence Center, where his work won first prize in the IBM Supercomputing Competition in 1990. His current research and consulting areas include logic programming, computational linguistics, and computer security. His other pursuits include amateur radio (his call sign is N4TMI), electronics, computers, ancient languages and literatures, philosophy, theology, and church work. He is the author of several books and over 200 magazine articles, mainly about computers. He lives in Athens, Georgia, USA, with his wife Melody and daughters Cathy and Sharon, and can be visited on the Web at http://www.ai.uga.edu/~mc.

Astrophotography for the Amateur

Second edition

MICHAEL A. COVINGTON

PUBLISHED BY THE PRESS SYNDICATE OF THE UNIVERSITY OF CAMBRIDGE
The Pitt Building, Trumpington Street, Cambridge, United Kingdom

CAMBRIDGE UNIVERSITY PRESS
The Edinburgh Buidling, Cambridge CB2 2RU, UK
40 West 20th Street, New York, NY 10011-4211, USA
10 Stamford Road, Oakleigh, VIC 3166, Australia
Ruiz de Alarcón 13, 28014 Madrid, Spain
Dock House, The Waterfront, Cape Town 8001, South Africa

http://www.cambridge.org

First published 1999
Reprinted (with corrections) 2000

Printed in the United Kingdom at the University Press, Cambridge

Typeset in Akzidenz Grotesk 9/12 in Advent 3B2 [KW]

A catalogue record for this book is available from the British Library

Library of Congress Cataloguing in Publication data

Covington, Michael A., 1957–
Astrophotography for the amateur / Michael A. Covington. – 2nd ed.
 p. cm.
Includes bibliographical references.
ISBN 0 521 64133 0. – ISBN 0 521 62740 0 (pbk.)
1. Astronomical photography – Amateurs' manuals. I. Title.
QB121.C68 1999
522'.63–dc21 98-20464 CIP

ISBN 0 521 64133 0 hardback
ISBN 0 521 62740 0 paperback

SOLI DEO GLORIA

Contents

Preface xi
Notes to the reader xiii
Symbols used in formulae xiv

I SIMPLE TECHNIQUES **1**

1 Welcome to astrophotography **3**
 1.1 The challenge of astrophotography 3
 1.2 Choosing equipment 3
 1.3 Sharing your work with others 5
 1.4 Maintaining balance and enjoyment 7

2 Photographing stars without a telescope **8**
 2.1 Stars and trails 8
 2.2 BASIC TECHNIQUE 1: Photographing stars
 without a telescope 10
 2.3 How long can you expose? 10
 2.4 PRACTICAL NOTE: How to approach
 formulae 12
 2.5 Choice of camera and lens 12
 2.6 Slides versus prints 14
 2.7 PRACTICAL NOTE: Getting good color prints 14
 2.8 Getting the most out of your film 15
 2.9 Keeping records 16
 2.10 PRACTICAL NOTE: Film and false economy 18
 2.11 Interpreting your pictures scientifically 19

3 Comets, meteors, aurorae, and space dust **21**
 3.1 Comets 21
 3.2 BASIC TECHNIQUE 2: Photographing a bright
 comet 25
 3.3 Meteors 25
 3.4 BASIC TECHNIQUE 3: Photographing a meteor
 shower 26
 3.5 Aurorae 28
 3.6 BASIC TECHNIQUE 4: Photographing the
 aurora borealis 28

 3.7 Zodiacal light, Gegenschein, and
 lunar libration clouds 28
 3.8 All-sky cameras 33

4 The moon **35**
 4.1 Lenses and image size 35
 4.2 Using a telephoto lens 35
 4.3 BASIC TECHNIQUE 5: Photographing the
 moon through a telephoto lens 37
 4.4 Determining exposures 38
 4.5 PRACTICAL NOTE: What is a "stop"? 39
 4.6 Afocal coupling to telescopes and
 binoculars 40
 4.7 BASIC TECHNIQUE 6: Photographing the
 moon (afocal method) 43
 4.8 Films and processing 44

5 Eclipses **46**
 5.1 Lunar eclipses 46
 5.2 Lunar eclipse dates and times 47
 5.3 Lunar eclipse photography 48
 5.4 Videotaping a lunar eclipse 50
 5.5 BASIC TECHNIQUE 7: Photographing an
 eclipse of the moon 52
 5.6 Solar eclipses – partial and annular 52
 5.7 Eclipse safety 54
 5.8 PRACTICAL NOTE: How eclipse eye injuries
 happen 55
 5.9 BASIC TECHNIQUE 8: Viewing a solar eclipse
 by projection 55
 5.10 Safe solar filters 56
 5.11 Photographing partial solar eclipses 60
 5.12 BASIC TECHNIQUE 9: Photographing a
 partial solar eclipse 60
 5.13 Solar eclipses – total 60
 5.14 Shadow bands and other phenomena 62
 5.15 BASIC TECHNIQUE 10: Photographing a
 total solar eclipse 63
 5.16 Session planning 63
 5.17 Videotaping solar eclipses 63
 5.18 The 1999 total eclipse in Europe 65

II ADVANCED TECHNIQUES 67

6 Coupling cameras to telescopes 69
 6.1 Prime-focus astrophotography 69
 6.2 Telescope types and optical limitations 70
 6.3 Image size and field of view 73
 6.4 Afocal coupling 75
 6.5 Positive projection 77
 6.6 PRACTICAL NOTE: Measuring s_2 for eyepiece projection 79
 6.7 Negative projection 80
 6.8 Compression (focal reducers) 82
 6.9 Combinations of projection setups 83
 6.10 Diffraction-limited resolution 84
 6.11 The subtle art of focusing 85
 6.12 Camera viewfinders 86
 6.13 PRACTICAL NOTE: Does your SLR focus accurately? 88
 6.14 Aerial-image and crosshair focusing 89
 6.15 Knife edge focusing 89
 6.16 How accurately must we focus? 90
 6.17 Focusing Schmidt–Cassegrains and Maksutovs 91

7 The solar system 93
 7.1 Film or CCD? 93
 7.2 The challenge of high resolution 93
 7.3. Tracking 94
 7.4 Vibration 96
 7.5 Unsteady air 97
 7.6 Dew 98
 7.7 The sun 100
 7.8 The moon 103
 7.9 Planetary photography 106
 7.10 The individual planets 107
 7.11 BASIC TECHNIQUE 11: Photographing a planet (afocal method) 111
 7.12 BASIC TECHNIQUE 12: Photographing a planet (by projection) 112

8 Deep-sky photography 113
 8.1 Piggy-backing 114
 8.2 BASIC TECHNIQUE 13: Piggy-back deep-sky photography 114
 8.3 BASIC TECHNIQUE 14: Polar alignment procedure 118
 8.4 Barn-door trackers 120
 8.5 Lenses for deep-sky work 121
 8.6 Scale enlargement and edge-of-field fall-off 124
 8.7 Magnitude limits and surface brightness 126
 8.8 Guiding 130
 8.9 PRACTICAL NOTE: What do you mean by 12 volts? 132
 8.10 Polar alignment accuracy 133
 8.11 Periodic gear error, PEC, and autoguiding 134
 8.12 Choice of film 135
 8.13 Light pollution and nebula filters 137
 8.14 PRACTICAL NOTE: The campaign against light pollution 139
 8.15 Deep-sky photography through the telescope 142
 8.16 BASIC TECHNIQUE 15: Deep-sky photography with an off-axis guider 144
 8.17 Keeping warm while observing 145
 8.18 Safety and etiquette at the observing site 145
 8.19 Mosquitoes and other vermin 146

III PHOTOGRAPHIC TECHNOLOGY 149

9 Cameras, lenses, and telescopes 151
 9.1 The 35-mm SLR 151
 9.2 Choosing an SLR 152
 9.3 Olympus SLRs 154
 9.4 Nikon SLRs 155
 9.5 Other SLR makers 156
 9.6 Buying used cameras 157

9.7	Camera maintenance and repair	158
9.8	Some miscellaneous SLR hints	159
9.9	Other types of cameras	160
9.10	Special astrocameras	161
9.11	Lenses	162
9.12	Lens quality and performance	164
9.13	Lens mounts	165
9.14	Buying lenses	166
9.15	BASIC TECHNIQUE 16: Testing lenses	167
9.16	Lens repair	169
9.17	Choosing a telescope	169
9.18	PRACTICAL NOTE: Does a lower f-ratio give a brighter image?	170
9.19	Telescope quality and performance	171
9.20	BASIC TECHNIQUE 17: Star-testing a telescope	171
9.21	How to clean optics	172

10 Film **174**
10.1	How film works	174
10.2	Spectral sensitivity	175
10.3	The characteristic curve	177
10.4	Film speed	179
10.5	Reciprocity failure: theory	180
10.6	Reciprocity failure: measurement	181
10.7	PRACTICAL NOTE: Does film "give up" after a certain amount of time?	184
10.8	Hypersensitization	184
10.9	Graininess and resolution	186
10.10	Some specific films	187
10.11	PRACTICAL NOTE: Film: What's in a name?	192
10.12	PRACTICAL NOTE: Is "professional" film better?	192
10.13	Bulk loading	193

11 Developing, printing, and photographic enhancement **195**
11.1	The darkroom	195
11.2	Developing black-and-white film	196
11.3	Black-and-white printing	201

11.4	PRACTICAL NOTE: Color negatives on black-and-white paper?	203
11.5	Making high-contrast prints	204
11.6	Unsharp masking	205
11.7	Processing color film	206
11.8	PRACTICAL NOTE: Help! The film is scratched!	207
11.9	Slide duplication	207
11.10	Rephotography	210

IV DIGITAL IMAGING **213**

12 Computer image enhancement **215**
12.1	How computers represent images	216
12.2	Resolution and image size	218
12.3	PRACTICAL NOTE: How images get resized	220
12.4	File compression	220
12.5	File formats	222
12.6	Getting images into the computer	222
12.7	Scanner artifacts	223
12.8	PRACTICAL NOTE: Taking pictures that scan well	224
12.9	The ethics of retouching	224
12.10	Manipulating the characteristic curve	225
12.11	Working with histograms	229
12.12	Manipulating color	229
12.13	Enhancing detail	230
12.14	PRACTICAL NOTE: An example of digital enhancement	231
12.15	Combining images	231
12.16	Printing out the results	231
12.17	Image enhancement theory: spatial frequency	232
12.18	PRACTICAL NOTE: Signal and noise	233
12.19	Convolutions, 1: smoothing	233
12.20	PRACTICAL NOTE: Median filters	236
12.21	Convolutions, 2: sharpening	237
12.22	The Laplacian operator	238

12.23 PRACTICAL NOTE: Convolution or
 deconvolution? 239
12.24 Maximum-entropy deconvolution 239

13 CCD imaging 241
13.1 How CCDs work 242
13.2 Video and digital cameras 243
13.3 Astronomical CCD cameras 244
13.4 Field of view 244
13.5 Aiming and focusing 246
13.6 Exposure 247
13.7 Optimal focal length 248
13.8 BASIC TECHNIQUE 18: Imaging the moon
 or a planet 249
13.9 Flat-fielding 250
13.10 Calibration frames 251
13.11 Deep-sky work 253
13.12 Choosing a CCD camera 253

APPENDICES 257

A Exposure tables
A.1 How exposures are calculated 259
A.2 Obtaining B from photometric
 brightness 259
A.3 Other systems for calculating exposure 260
A.4 PRACTICAL NOTE: Why don't my results
 agree with the tables? 260
A.5 Moon and lunar eclipses 261
A.6 Sun and solar eclipses 266
A.7 Planets 269
A.8 Faint objects 273

**B Mathematical analysis of polar-axis
 misalignment 276**
B.1 Summary of the most important results 276

B.2 Declination drift 276
B.3 Field rotation 279
B.4 Computer algorithms 281

C Plans for an electronic drive corrector 283
C.1 How it works 283
C.2 Circuits and parts list 286
C.3 Adaptation to 240 V, 50 Hz 287
C.4 Drive rates 288
C.5 Line power supply 288
C.6 Other designs 289

D Film data 290
D.1 Kodak Technical Pan film (TP) 291
D.2 Kodak Professional Ektachrome Film
 E200 298
D.3 Kodak Professional Ektapress Films 306

E Photographic filters 307
E.1 High-efficiency yellow, oranges, and
 reds 307
E.2 Other sharp-cutoff filters 308
E.3 Color balancing filters 309
E.4 Other filters 310

F Organizations and resources 311
F.1 Organizations 311
F.2 Internet resources 312
F.3 Magazines 312
F.4 Manufacturers 313
F.5 Dealers 315
F.6 Camera repairs and modifications 317

Bibliography 318
Index 325
Colour plates facing p. 114

Preface

The purpose of this book is to tell you how to photograph the sky with simple techniques and affordable equipment.

Astrophotography is easier today than when I wrote the first edition of this book fifteen years ago. Telescopes are better built, and films have far less reciprocity failure. Many off-the-shelf consumer films are better than the Kodak Spectroscopic emulsions used by astronomers in the past.

Most cameras, however, have become less suitable for astrophotography and harder to use. Many of the newest cameras can't make time exposures without running down their batteries, and the beginning astrophotographer needs more advice about choosing a good camera. This has accordingly been added to Chapter 9.

Meanwhile, digital imaging has come on the scene, and two chapters have been added to cover it. I've had to be careful because digital technology is still changing rapidly. Nonetheless, digital image processing is our most promising new technique, and even if you don't have a computer, you can make digitally enhanced prints at a workstation at the local camera store. With digital technology, I've concentrated on underlying principles rather than specific equipment.

In this digital age, why do we still use film at all? Because it is still the most cost-effective way to acquire and store images. A color slide or negative is equivalent to at least 6 million pixels, considerably larger than presently affordable CCDs. Further, film can store up light in time exposures; non-astronomical CCDs generally cannot do this because of dark currents. Film images can be digitized and processed by the computer exactly as if they had come from CCDs.

I want to thank all the astrophotographers who allowed me to use their pictures – as well as many more who offered pictures that I wasn't able to use. Because this is an introductory handbook, not a gallery of fine astrophotography, many of the best astrophotographers are not represented here. In fact, I had to turn down a number of pictures because they were too good! Most of the pictures in this book were chosen to represent what any amateur can accomplish with a moderate investment of time and equipment.

Several people deserve special thanks. Douglas Downing provided early encouragement. Bob Lucas helped me punch the chassis for the electronic drive corrector in Appendix C. Eric Pederson did lots of careful E-6 processing in his minilab. Dennis Milon and Dennis Di Cicco, of *Sky & Telescope,* and the staff of *Astronomy* helped me locate contributors. Kodak answered seemingly endless technical questions. Simon Mitton, Adam Black, and their colleagues at Cambridge University Press have provided continuing help through three editions (first, revised first, and second).

In this new edition, special thanks are due to the astrophotographers on the Internet. Chuck Vaughn, Jerry Lodriguss, Robert Reeves, John Hermanson, Joe Marietta, Emery Hildebrand, Wil Milan, Gregory Terrance, and dozens of others have reacted to my ideas, answered questions, and suggested numerous improvements to this edition. I thank Kodak, Fuji, and Ilford for film samples and Meade Instruments, Tektronix, B&K Products, Cyanogen Productions, and Rigel Systems for lending me equipment and software.

My wife Melody drew nearly all of the diagrams and line drawings for the first edition; she is my "in-house art department." Our daughters Cathy and Sharon, themselves avid photographers, provided encouragement and assistance and took some of the photographs for this edition.

I also want to thank the many people who, at various times and places, helped me learn about astronomy and shared with me their appreciation for the sky, though they did not contribute anything specific to this book. I owe much to the amateur astronomical communities of Valdosta, Georgia, where I grew up; Albuquerque, New Mexico, where I spent an enjoyable summer in 1980; and the newly reactivated University of Georgia Observatory.

Perhaps the biggest difference between this and the earlier editions is the impact of the Internet. I wrote and revised the first edition in relative isolation, relying on published literature, my own experiments, and some correspondence with a few fellow amateurs. Thanks to the Internet, I've been able to write this edition amid constant discussion with dozens of experienced astrophotographers as well as numerous beginners. That has given me a much surer sense of where people's interests lie, what questions they are likely to have in mind, and what points are difficult or prone to misunderstanding.

Preparing the second edition was more work than writing the original. My employer, the University of Georgia, supported the effort even though it had little to do with my job. Although it was a backhanded kind of good fortune, I suppose I should also thank the numerous students who did not sign up for CS 857 in the fall of 1997, thus giving me time to work on the book.

I enjoy hearing from astrophotography enthusiasts on all levels. Readers with questions, comments, or suggestions for revision are welcome to write to me in care of the publisher, with the understanding that I cannot return photographs or other material unless postage is provided. I can answer letters in German, French, Spanish, and Italian if you are content with a relatively short reply.

Michael Covington
Athens, Georgia

Notes to the reader

Bibliography: References to books and articles are given in full on pages 318–324. Within the text, most references are cited either by author and title (e.g., Tirion's *Sky Atlas 2000.0*) or by author and date (e.g., Dragesco 1995).

Metric units: SI (metric) units are used throughout the book except for industry standards still defined in inches. Apertures of telescopes are always given in centimeters, focal lengths in millimeters, even when large; thus a 20-cm telescope is 20 cm in diameter but a 200-mm lens is 200 mm in focal length.

Symbols used in formulae

These symbols are used consistently throughout the book. As in calculus, Δ before a symbol indicates a change in its value; for example, δ is declination and $\Delta\delta$ is apparent shift in declination.

When the units in a formula are not specified, all quantities should be given in the same units. For example, if the focal length of a telescope is given in millimeters, the image size will also be in millimeters.

γ	Contrast of film or paper (gamma)
δ	Declination (like latitude in the sky)
$\Delta\delta$	Shift in declination (due to guiding problems)
$\Delta\rho$	Image rotation (due to guiding problems)
θ	Apparent size of celestial object (as an angle)
λ	Wavelength of light (in nanometers)
B	Subject brightness in arbitrary linear units
b	Diameter of blur circle (defocused point image)
D	Density (light absorption), logarithmic scale
d	Diameter of lens
F	Focal length of lens, telescope, or complete system
F_1	Focal length of telescope alone, ignoring projection lenses
F_2	Focal length of projection or compression lens
F_E	Focal length of eyepiece
f	f-ratio (F/d)
f_1	f-ratio of telescope alone, ignoring projection lenses
M	Magnification
m	Magnitude (total apparent brightness of celestial object)
m''	Magnitude per square arc-second (apparent surface brightness)
p	Schwarzschild exponent (a measure of reciprocity failure of film)
S	Film speed in ASA or ISO arithmetic-scale units
s_1	Distance from lens to subject
s_2	Distance from lens to image (focal distance)
Δs_2	Focusing error (error in s_2)
t	Exposure time (in seconds)
w	Width of image (on film) or width of film

Simple techniques

Part I

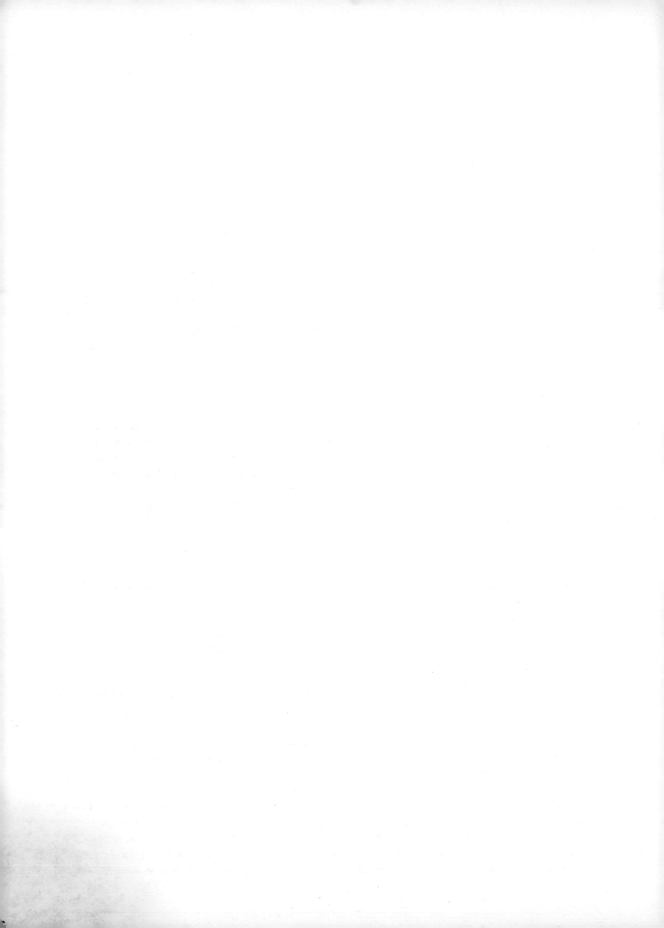

Welcome to astrophotography 1

Welcome to astrophotography! This book is for people who want to take pictures of the stars and planets, and, perhaps more importantly, who want to understand how astrophotography works. The earlier chapters contain instructions for beginners, and the later chapters are more like a reference book.

My goal is to show you how to do astrophotography at modest cost, with the equipment and materials an amateur can easily obtain and use. I haven't covered everything. I've concentrated on 35-mm cameras and relatively inexpensive telescopes, 20-cm (8-inch) and smaller. Techniques that require unusual skill or expenditure are mentioned only briefly with references to other sources of information.

1.1 The challenge of astrophotography

Why photograph the sky? Because of the great natural beauty of celestial objects, because your pictures can have scientific value, and, perhaps most importantly, because you enjoy the technical challenge. Astrophotography will never be a matter of just taking snapshots, and Kodak's old slogan, "You press the button, we do the rest," certainly doesn't apply. Astrophotographers push the limits of their equipment and materials, and a good astrophotographer has to know optics and film the way a race-car driver knows engines. There are three main technical challenges:

- Most celestial objects require magnification; that's one reason we use telescopes. (Not all objects require magnification; star fields, meteors, and bright comets can be photographed with your camera's normal lens.)
- Many celestial objects are faint, requiring long exposures to accumulate light on the film. In fact, astronomical discoveries have been made this

way; the Horsehead Nebula and Barnard's Loop are too faint to see with any telescope, but are not too hard to photograph.
- Whenever high magnification or long exposures are involved, the rotation of the earth gets in the way by making the sky seem to move continuously. To compensate for this motion, telescopes have equatorial mounts and drive motors. Sometimes the camera rides "piggy-back" on the telescope while taking a picture through its own lens (Fig. 1.2).

Almost everything in this book deals with how to overcome one, two, or all three of these challenges in a particular situation. It's not always easy; some kinds of astrophotography are much harder than others, and I present the easier techniques first.

Fortunately, you don't have to master the hardest techniques in order to get impressive pictures. Piggy-backing and moon photography are particularly rewarding even though they require only modest effort and simple equipment. Photographing galaxies is especially hard; so is high-resolution photography of the planets.

1.2 Choosing equipment

Never buy a telescope or camera unless you understand exactly what it will do for you and how it will do it. Always educate yourself first, because the equipment doesn't take the pictures; you do. Chapter 9 gives detailed advice on choosing cameras and telescopes, but your knowledge should always run ahead of your equipment.

Learn the sky before buying a telescope. It goes without saying that if you can't point your finger at M31 or the Orion Nebula, you won't be able to point a telescope at them either. I usually tell young amateur astronomers that they're not ready for a telescope until they can identify at least five constellations and three

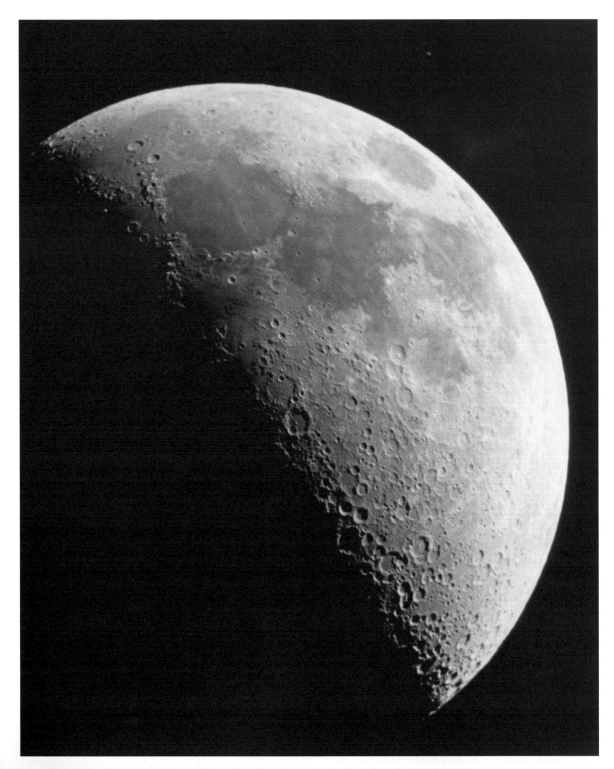

Figure 1.1 **The moon photographed at the prime focus of a 12.5-cm (5-inch) *f*/10 Schmidt–Cassegrain telescope. A half-second exposure on Kodak Technical Pan Film developed in Technidol LC; clock drive running. (By the author)**

Figure 1.2 **The author gets ready to photograph star fields with a camera and 180-mm lens mounted "piggy-back" on a 20-cm (8-inch) Schmidt–Cassegrain telescope. (Melody Covington)**

interesting objects (planets, star clusters, or the like) without a map. Don't be seduced by computer-controlled telescopes; they save time if you have a busy observing program, but you can't use them effectively unless you already know the sky.

Full advice for beginning stargazers is beyond the scope of this book, but any of the major magazines (*Sky & Telescope*, *Astronomy*, or *Astronomy Now*) will quickly lead you to all the other sources of information.

The publishers' addresses are in Appendix F, along with addresses of useful astronomy sites on the World Wide Web.

Useful books for beginners include Patrick Moore's *The Amateur Astronomer* and Liller and Mayer's *Cambridge Astronomy Guide*; the latter emphasizes using a camera rather than a telescope, so its point of departure resembles Chapter 2 of this book. More advanced observers should not miss Martinez' two-volume *Observer's Guide* and Burnham's *Celestial Handbook*. As a handbook of astronomical science, including astrophysics, I particularly like *Fundamental Astronomy*, by Karttunen *et al.*, because it doesn't leave out the mathematics; you can skip the mathematical portions if you like, then go back reread them if you feel the need.

1.3 Sharing your work with others

Once you have some good astronomical photographs, what do you do with them? You could join the legions of amateurs who send their pictures to major astronomy magazines. Unfortunately, your chances of getting a picture published that way are slim; none of mine ever have been! With hundreds of excellent pictures coming in every month, astronomy magazines can print only a few that are truly exceptional.

Instead, look for other ways to share your pictures with your friends and the public. Enter them in local photography contests. Assist the local newspaper with pictures of eclipses and comets. Give slide shows for school children and science clubs. Decorate your home and office with enlargements. Sell prints at art shows. Make Christmas cards. Do anything any other photographer would do, remembering that unlike most people's, your photographs probe the limits of the universe.

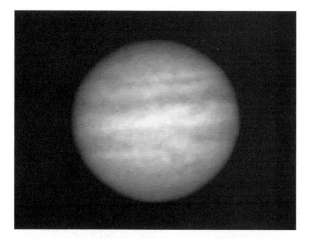

Figure 1.3 **CCD image of Jupiter, taken with 20-cm (8-inch) *f*/10 Schmidt–Cassegrain telescope and ×2 Barlow lens. Exposure 100 milliseconds with Meade Pictor 216XT camera. The image was processed by unsharp masking to bring out detail. (By the author)**

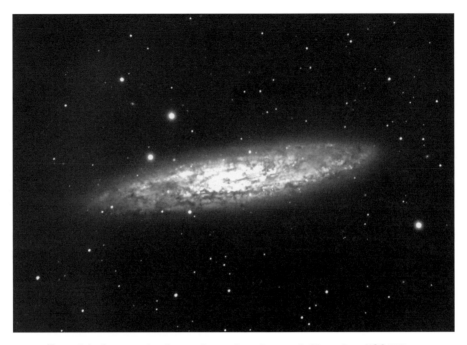

Figure 1.4 **An example of very advanced amateur work. The galaxy NGC 253; a 60-minute exposure on hypersensitized Kodak Technical Pan Film with a 14-inch *f*/7 telescope. (Chuck Vaughn)**

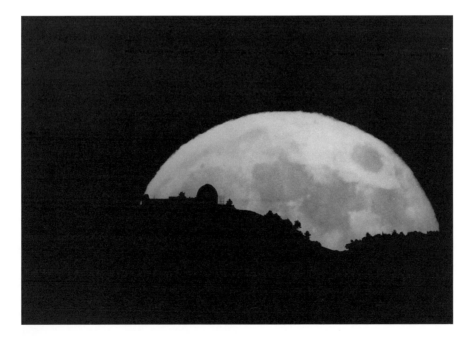

Figure 1.5 **A picture well worth sharing: the moon rising over Lick Observatory. Richard A. Milewski carefully calculated the position of moonrise to take this picture.**

1.4 Maintaining balance and enjoyment

Let me end with an exhortation: remember that we do this because we enjoy it. Like most amateur astronomers, I am in the middle of a thriving career in something else (computational linguistics in my case) and have neither an unlimited budget nor a perfect observing site. But that's part of the challenge – to make intelligent and creative use of limited resources. Astrophotography is not a competitive sport, the beauty of a picture is not proportional to the difficulty of taking it, and your pictures don't have to be the best in the world in order to be satisfying. As G. K. Chesterton put it, "Anything worth doing is worth doing badly" – that is, worth doing even when you're not an expert.

Photographing stars without a telescope

2

By making time exposures with an ordinary camera, you can photograph more stars than your unaided eye can see, and your photographs will show the colors of the stars vividly. This chapter will tell you how to photograph the starry sky with minimal equipment, how to maximize picture quality, and how to put your pictures to practical use.

2.1 Stars and trails

To get started in astrophotography, all you really need is a camera that can make time exposures, a tripod or other steady support on which to mount it, and a cable release that will allow you to open the shutter and latch it open without vibrating the camera. Load your camera with color slide film rated at ISO (ASA) 200 or faster, go out on a starry, moonless night, aim the camera at a group of bright stars, open the lens to its widest f-stop, and make two time exposures – 20 seconds and 5 minutes (Fig. 2.1).

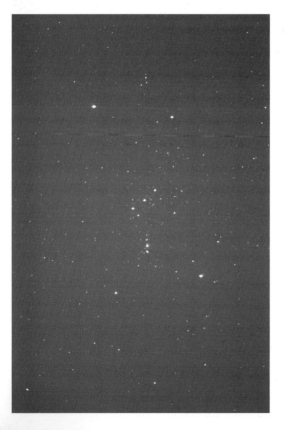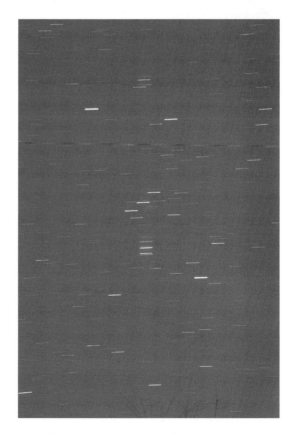

Figure 2.1 **Twenty-second and five-minute fixed-tripod exposures of Orion. Fuji Sensia 400 film, Minolta 50-mm *f*/1.7 lens wide open. (By the author)**

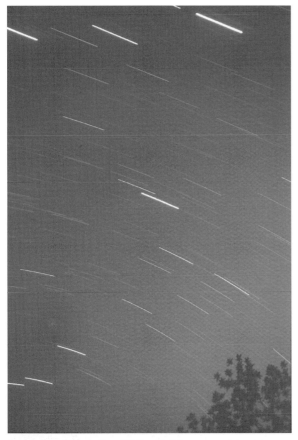

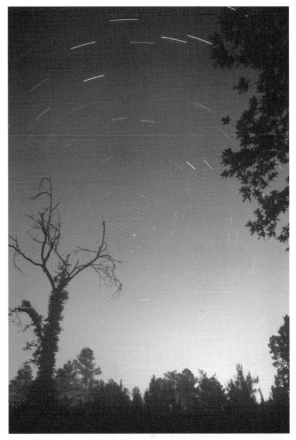

Figure 2.2 **Star trails – this is what happens when you expose much longer than 20 seconds. A 30-minute fixed-tripod exposure of the constellation Bootes taken in 1982 on Ektachrome 200 Professional with a 24-mm wide-angle lens at *f*/4.**

Figure 2.3 **Star trails centered on Polaris – but mostly the lights of a nearby town. A 30-minute fixed-tripod exposure taken in 1982 on Ektachrome 200 Professional, 24-mm lens at *f*/4. Compare this with Plate 2.1, which was taken in the country.**

When you get your film developed, look at the results. The 20-second exposure should show the stars much as they actually looked in the sky – but if you look carefully, you'll see that the film caught some stars that were too faint for you to see. In the 5-minute exposure, though, the stars won't look like stars. The star images will be short lines or curves instead of points – and if you exposed longer, the lines or curves would be longer. It's as if the stars had been moving.

In reality, of course, it's the earth that moves; the earth's rotation is fast enough to create star trails instead of point images even on exposures as short as a minute or two. Stars directly above the earth's equator appear to move in straight lines; those in the northern or southern sky appear to trace circles around whichever of the two celestial poles is nearer. To see a dramatic

demonstration of this effect, aim your camera at Polaris and expose for perhaps two hours at *f*/8 – or look at Figs. 2.2 and 2.3 and Plate 2.1.

Another difference between the 2-minute and 10-minute exposures involves *sky fog* – the sky background looks much lighter in the longer exposure. The reason is that the night sky isn't perfectly black (it's often deep blue or green), and the film picks up background haze that is too faint for your eye to see. The longer the exposure, the more sky fog the film records. Sky fog is a constant nemesis of astrophotographers; we'll consider it more fully in Chapter 8. In the meantime, Basic Technique 1 sums up the procedure for making a short exposure of a star field.

2.2 BASIC TECHNIQUE 1:
Photographing stars without a telescope

Equipment: Camera capable of time exposures, fast 50-mm lens, tripod, latching cable release.

Film: Color slide film, 200 to 1600 speed. Print film can be used if you can obtain custom prints; automatic machine prints are likely to be disappointing.

Sky conditions: Clear moonless night. Some city light is tolerable as long as stars are clearly visible. No lights should shine directly on the observing site.

Procedure: Place the camera on the tripod and aim it at a bright group of stars in the sky. Set the lens opening to $f/1.8$ or $f/2$ and focus on infinity. Expose for 20 seconds.

Variations: Near the northern or southern celestial pole, you can expose a good bit longer than 20 seconds. Elsewhere in the sky, longer exposures will render the stars as streaks instead of points.

Wide-angle lenses permit longer exposures; telephoto lenses require shorter exposures if you don't want streaks.

2.3 How long can you expose?

As long as you're using a fixed tripod and want to get images that look like stars rather than trails, the motion of the earth limits how long you can expose. The practical limit for a particular picture depends on two things, the focal length of the lens and the position of the stars in the sky.

The focal length matters because longer lenses make everything look bigger, including the motion; hence the same amount of motion will be more visible when you use a telephoto lens. Thus telephoto lenses require shorter exposures. Wide-angle lenses make everything look smaller, including the motion, so they let you expose longer.

The position of the stars also makes a difference because the nearer a star is to the celestial equator, the faster it appears to move. The distance from the equator to a star is called the star's *declination* and is expressed as an angle, like latitude on earth; stars with higher declinations move more slowly and allow longer exposures. You can probably get away with a 45-second exposure of the Big Dipper (Plough) because of its high declination (about $+60°$).

To be precise, the length of the streaks depends on the cosine of the declination. Thus, if 20-second exposures look acceptable when taken with a 50-mm lens aimed at the celestial equator, the longest acceptable exposure, t, at any declination, with any lens, will be:

$$t \text{ (in seconds)} = 1000/(F \cos \delta)$$

where F is the focal length of the lens, in millimeters, and δ is the declination of the star. Where did we get 1000? It's simply 50 (the original focal length) times 20 (the original number of seconds). Table 2.1 gives some values computed with this formula.

If you want perfectly crisp, round star images, the exposure has to be shorter. Use this formula instead:

$$t \text{ (in seconds, for sharp stars)} = 343/(F \cos \delta)$$

This formula ensures that the trails are less than 1/40 mm long, short enough to be hidden by the limited resolution of the lens and film.

Those formulae apply to 35-mm cameras and other formats that are essentially the same size, such as APS and 126. If you're using 120 film, which is about twice as wide, you can probably expose twice as long because the streaks won't be enlarged as much when you make the print. But your normal lens will be 80 to 100 mm rather than 50 mm, so your normal exposure near the celestial equator will still be 20 seconds.

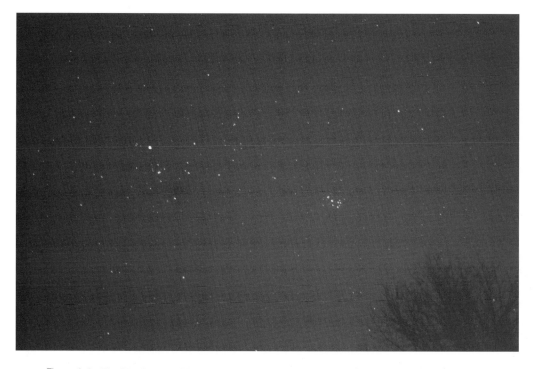

Figure 2.4 **The Hyades and Pleiades, two prominent star clusters in Taurus. A 20-second fixed-tripod exposure on Fuji Sensia 400 film, Minolta 50-mm *f*/1.7 lens wide open. (By the author)**

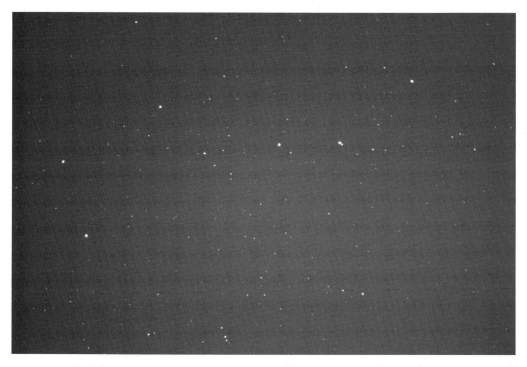

Figure 2.5 **The familiar Big Dipper or Plough (Ursa Major). A 30-second fixed-tripod exposure, 50-mm *f*/1.8 lens wide open, Ektachrome P1600 film. (By the author)**

If you don't know the declination of the stars you're photographing, you can assume that $\cos \delta$ is typically about 0.9, or less if the star is in the far northern or southern sky. But rather than trying to work out the mathematics more precisely, just experiment. Try several exposures and see how they look. Table 2.1 is just an approximation.

Table 2.1 *Maximum fixed-tripod exposure, in seconds – assuming 20 seconds is the limit with a 50-mm lens aimed at the celestial equator. For perfectly sharp star images, expose for only 1/3 as long*

Lens focal length (mm)	Declination of center of star field				
	$0°$	$\pm30°$ or unknown	$\pm45°$	$\pm60°$	±75
18	55	65	80	110	220
24	40	50	60	85	160
28	35	40	50	75	140
35	30	33	40	60	110
50	20	23	28	40	75
100	10	12	14	20	40
135	7.5	8.5	11	15	30
200	5.0	5.5	7	10	20
300	3.3	3.8	4.7	6.5	13
400	2.5	3.0	3.5	5.0	10

2.4 PRACTICAL NOTE:
How to approach formulae

You've just encountered the first of many mathematical formulae in this book. It's important to understand from the outset that a formula is not just a procedure for calculating numbers; it's a description of *how something works*. Here are three things to ask yourself every time you encounter a formula:

- Which variables are under your control? In this formula, $t = 1000/F \cos \delta$, you get to choose F and δ.

- What happens when you increase or decrease those variables? In this case, greater F leads to smaller t; greater δ (positive or negative) leads to greater t.

- Does the formula contain anything nonlinear, such as \sqrt{x}, x^2, e^x, $\sin x$, $\cos x$, or even $1/x$? If so, expect the changes to be bigger at one end of the scale than at the other. Sure enough, going from $\delta = 75°$ to $85°$ is a much bigger change than going from $5°$ to $15°$. (Work it out and see!)

2.5 Choice of camera and lens

Why did I say to start with your 50-mm normal lens? Because with 35-mm cameras, the 50-mm $f/1.8$ or $f/2$ lens turns out to be better for this job than any other, for several reasons.

Table 2.1 shows that short-focal-length, wide-angle lenses allow the longest exposures; if exposure time were the only relevant factor, the shortest lenses would be the best. However, a lens should also be fast, and you might expect an $f/2$ normal lens to outperform an $f/2.8$ wide-angle – which it does.

But that's not the whole story. For reasons we'll go into in Chapter 8, the ability of a lens to photograph stars depends, not on its speed expressed as an f-number, but on its actual diameter – and long telephoto lenses are the largest in diameter, if not the fastest. So you might expect telephoto lenses to photograph the most stars. They do – with equal exposure times. But because they magnify the earth's motion, they only permit short exposures.

Figure 2.6 **One of the author's first fixed-tripod star photographs, taken in 1975. The constellation Lyra, 10 seconds on Ilford HP4 film (400 speed) with a Mamiya/Sekor 55-mm $f/1.8$ lens wide open. The negative was treated with chromium intensifier and printed on high-contrast paper.**

Yet another factor is that short lenses pack the star images together more densely on the film, resulting in a richer-looking picture.

And as if that weren't complicated enough, the film speed isn't constant. Because of a phenomenon called *reciprocity failure*, most kinds of film become progressively less sensitive to light in longer exposures, and the extent of this speed loss varies from film to film. Kodak Tri-X Pan, a 400-speed black-and-white film,

loses half its speed in a 20-second exposure; Kodak Ektachrome Professional E200 loses almost none. Reciprocity failure depends somewhat on temperature and humidity, and a complete mathematical analysis is therefore futile.

But you can see where all this is leading – the best lenses are neither the longest nor the shortest, but somewhere in between. My experience has been that 50-mm lenses are usually best. Not only are they the

fastest lenses, they are also, usually, the sharpest. Fast $f/1.2$ and $f/1.4$ lenses aren't sharp enough wide open, though; they benefit from being stopped down to $f/2$. Moderate wide-angle and moderate telephoto lenses do have their uses; you can get good star pictures with a 35-mm wide-angle lens or a 90- or 100-mm medium telephoto. Experiment with all the lenses you have access to, and try exposures both longer and shorter than those given in the table.

2.6 Slides versus prints

I suggested using color slide film so you won't be at the mercy of whoever makes the print. All the processor has to do is develop your film, cut it apart, and mount it; then you can see exactly what your camera recorded. The only thing that can go wrong is that your slides may be cut apart incorrectly – the black background of most astronomical photographs makes it very hard to tell where one picture ends and the next begins. You can circumvent this by asking the processors to return your film uncut, and putting it in slide mounts yourself. This is especially easy with Pakon plastic mounts. Or you can mix astronomical with terrestrial photographs on the same roll so it will be obvious where to make the cuts.

With print film, the situation is different. The person or machine making the print has to decide how light or dark the picture should be, what adjustments to the color balance are needed, and whether the contrast is right. This adjustment isn't optional. Inherently, photographic paper covers a smaller range of brightness than film does, and the printmaker has to decide how to fit the brightness range of each negative onto that of the paper.

As you might expect, few photofinishers are good at printing astronomical negatives, which look like nothing they've ever seen before. Often they make them far too light (with a mid-gray sky) or far too dark (with a pitch-black sky in which faint stars are lost). If you can make the prints yourself, or communicate with the people who make them, there's hope – but even then, it will be hard for you to separate the effect of different exposures from the effect of different printing adjustments. That's why it's usually safest to start with slides, from which, of course, you can get prints made whenever you need them.

2.7 PRACTICAL NOTE: Getting good color prints

A well-made print of a star-field picture is neither too dark nor too light, and it has higher than normal contrast. Color balance is not critical. By far the best way to print a star-field negative or slide is to digitize it and adjust the brightness and contrast by computer. Some camera stores have workstations where you can do this yourself. The price seems high, largely because you have to buy an 8×10 enlargement whenever you use the machine, but you don't have to print every negative.

Second best is to educate the people who make your prints. Show them some of the pictures in this book, and tell them that the sky background should be about a quarter of the way from black to mid-gray – light enough that you can see all the stars, but not light enough to look unnatural. They'll be relieved that you're not picky about color balance, which is their usual bugbear.

If you find you can't work with the technicians at one minilab, try another. Minilabs in camera stores are generally better than those in pharmacies or department stores. Look for someone who regularly deals with professional photographers rather than just casual snapshooters.

Getting prints made from slides is easier; often it's sufficient to tell the lab to make the print look like the slide, with a background that is dark but not black.

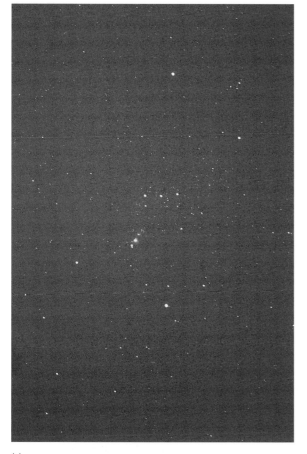 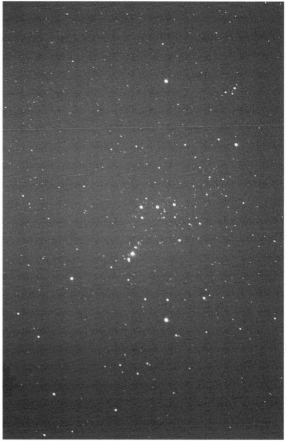

(a) (b)

Figure 2.7 **A 20-second fixed-camera exposure of Orion through a 50-mm *f*/1.8 lens on Ektachrome 400 film, pushed one stop. (a) Original slide; (b) after duplication by Kodak.**

2.8 Getting the most out of your film

Stars are faint; fixed-tripod star-field pictures are invariably underexposed, and any technique that increases either the speed of the film or the contrast of the image will improve the picture.

You can increase the effective speed and contrast of any film by "push-processing" it – that is, by extending the development time. Many labs will do this for you for a small extra charge. Its main disadvantage is that it increases film grain; trying to increase the speed by a factor of more than two to four can make the film so grainy that star images begin to disappear. Also, some films "push" better than others. Kodak Ektachrome Professional E200 "pushes" to 640 speed especially well.

Contrast matters more than speed. Color slides often benefit from being duplicated, since duplication almost always increases contrast (Fig. 2.7). One of the best slide-duplicating services is that offered by Kodak through local photofinishers worldwide. Kodak duplicates are consistently good – though duplication by Kodak no longer gives as much of a contrast increase as it did in the 1960s. From the ordinary photographer's viewpoint, this is of course an improvement; most people don't want increased contrast.

Or you can do your own slide duplicating; see Chapter 11 for information. With fixed-camera star photographs, there is usually very little sky fog, and you'll want to make the duplicate lighter than the original in order to bring out detail. Try a wide variety

of exposures, starting with what your exposure meter indicates, and then increasing it by one or two stops.

If you're using black-and-white film and don't have pictorial photographs on the same roll, give the film extended development in a high-energy developer. For example, develop black-and-white film for twelve minutes in Kodak HC-110 (dilution B) or four minutes in Kodak D-19 at 20 °C. The result will be higher contrast and increased visibility of faint stars, which can be improved even further by treating the negatives with an intensifier (a chemical that darkens the developed image). Then make the prints on No. 4 or No. 5 (Extra Hard or Ultra Hard) paper, making sure not to make the background so dark that faint stars disappear into it.

Normally, the sky background is visible, at least faintly, on the slide or negative. If you're taking short exposures with a long lens, your star pictures will have a pitch-black background (clear on the negative). In this case, you can increase the film's response to faint light in either of two ways. You can *preflash* the film – that is, expose it to a small amount of light in advance of the main exposure, just enough to produce a barely detectable amount of fog. Then it will respond more efficiently to the additional light that it receives from the stars. Preflashing can be done by making a double exposure in the camera; first photograph a blank white surface of some kind, deliberately underexposing a couple of stops, and then photograph the stars. Or you can *hypersensitize* the film with hydrogen gas (see Chapter 8). Hypersensitized film is available commercially from Lumicon (p. 315), Astrofilms (p. 315), and other suppliers. For more information on push-processing, preflashing, and other techniques, see Chapter 11 and Stensvold, *Increasing Film Speed*.[1]

If you don't have access to a darkroom, you may want to send your black-and-white or color negative film to a custom lab or a lab that caters to amateur astronomers (check the ads in astronomy magazines). Another approach is to have your negatives developed locally and returned to you unprinted; you can then put them in slide mounts and view them as slides (Fig. 2.8). Professional astronomers often view negatives instead of positives in order to be sure of seeing everything present on the original film; there is no reason why amateurs shouldn't do the same.

2.9 Keeping records

In a sense, every astronomical photograph is a scientific experiment. It's impossible to say in advance how well a particular technique will work or in what ways it can be improved. This makes it vitally important to keep records of all the astronomical photographs you take. Otherwise, when you get good results you won't know how you did it, and when things don't turn out well, you won't be in a position to make modifications intelligently.

After experimenting with many ways of organizing records, I've concluded that strict chronological order is the best; whenever I've tried to divide my notes up by subject, something has gotten lost.

I give each photograph a unique serial number consisting of the date in numeric form (year, month, day) followed by an identifying number for that date; for example, 98.03.24.06 would be the sixth exposure made on 1998 March 24. (If midnight comes and the date changes in the middle of a session, I ignore it so that a single session will have a single numbering sequence.)

In general, your records should include the following:

1 The object being photographed.

[1] Full references for these and other books start on page 318.

Figure 2.8 **A negative image of Sagittarius, showing star clouds. A
20-second exposure on T-Max P3200 film, 50-mm lens at $f/2$. (By the author)**

Figure 2.9 **Part of the author's record-keeping system.**

2 The condition of the air (clear or hazy, steady or unsteady, etc.).

3 The details of the equipment used (remember to note the f-stop and include filters, if any). You'll probably want to devise standard abbreviations for commonly used setups.

4 The type of film, including notes on processing.

5 The date and time of the exposure. (From experience I've learned that these should be recorded in terms of *local* time; conversions to UT or the like should be done later. I once almost missed a lunar eclipse because in converting the time to UT on the spot, I forgot to convert the date.)

6 The length of the exposure, in seconds.

7 Space for comments to be added later, when you get the film developed and evaluate the results.

2.10 PRACTICAL NOTE:
Film and false economy

The trouble with 35-mm film is that it takes too long to finish a roll. Back in the old days, pioneer photographers would expose a plate and immediately develop it. Nowadays we have to take 35 more pictures before we get to see how the first one came out.

Over the years I've wasted untold amounts of time trying to use the whole roll effectively. In my youth, my first roll of film, admittedly not astronomical, lasted me over two years. That meant that for two years I learned next to nothing about how to take pictures.

Fast turnaround is essential to learning – and in astrophotography we never stop learning. Often you'll need to muster your courage, rewind the film, and have it developed right away, even though (gasp!) the roll isn't finished.

You may finish the roll sooner than you think. I make it a rule to *take every astronomical picture at least twice* if time permits. That way, I have no irreplaceable slides or negatives. Murphy's Law entails that if you have only one good image of something, it will get scratched.

There's also something to be said for *skipping a frame between pictures*. As explained on p. 91, this makes the film lie flatter in the camera. It also protects gas-hypersensitized film from humidity – you're always using film that has been completely inside the cartridge until the last moment.

Finally, remember that you can *change films in mid-roll*. To do this, rewind the film, leaving the leader hanging out of the cartridge, and note the number of frames used. (If you accidentally rewind the leader into the cartridge, pull it out with a gadget called a film-leader retriever.) When you want to use the rest of the roll, put it back into the camera and shoot the requisite number of blank frames with the lenscap on – plus two more, to allow for inaccuracy. If you're using slide film, notify the processing lab that the spacing of frames will be uneven.

Some astrophotographers just take the camera into the darkroom, cut off the exposed film, and develop it, leaving the rest of the roll in place. (One early SLR, the Exakta VXIIa, had a knife built into it for this purpose.) Remember that the film on the takeup spool is wound backward and may be hard to load onto a developing reel.

2.11 Interpreting your pictures scientifically

Now that you've taken a good picture – what, exactly, did you photograph, and what can you learn from it? To find out, you'll need to compare your picture to a star atlas, either a printed one such as *Sky Atlas 2000.0*, *Uranometria 2000.0*, or the *Millennium Star Atlas*, or a computerized star atlas such as *Epoch 2000sk or The Sky* (distributed by Meade and Celestron respectively).

The first thing to determine is the *magnitude limit* of your picture – that is, how faint are the faintest stars that you caught? The brightness of stars is measured in *magnitudes*, a system that originated in ancient Greek times. Originally, stars were classified into "first class" (brightest), "second class," and so on down to "sixth class" (the faintest stars visible to the naked eye). In modern times the system has been made precise, but the faintest stars you can see without optical aid are still about magnitude 6 and the brightest are about magnitude 1. A few are brighter; Vega is 0.0, Sirius is −1.4, the planet Venus is −4, the moon is −12, and the sun is −27. Going in the other direction, with an 8-inch telescope you can see stars down to about magnitude 14.

Fixed-tripod star-field photos typically reach magnitude 7 or 8, occasionally 9. That is, their magnitude limit is comparable to that of *Sky Atlas 2000.0*, although you may occasionally need to turn to *Uranometria 2000.0* to check a particularly successful photograph. We'll explore magnitude limits more fully in Chapter 8, but in the meantime, note that if you increase the limit by one magnitude, you triple the number of stars in the picture.

Don't panic if you see stars in the picture that aren't in the atlas. All star atlases are incomplete; some have remarkable omissions. Uncharted stars can also turn out to be planets, asteroids, variable stars that have brightened, distant satellites, aircraft, or even flaws in the film. All the same, they're worth watching. You can use fixed-tripod photographs to monitor a variable star by comparing it with other stars in the field. You can also demonstrate the orbital motion of a planet or bright asteroid by photographing it amid the stars on successive dates.

Color slides often show the colors of stars vividly. Kodak Elite Chrome 200 is especially good for this; it often produces a harvest of blood-red and sky-blue star

images. Bear in mind that these colors aren't realistic; bright red stars such as Antares are actually about the temperature of the filament in an ordinary light bulb, yellowish, but not far from white-hot. They seem red only in contrast to their hotter neighbors. To learn more about star colors and ways of photographing them, see Malin's *A View of the Universe* (1993).

Computerized star atlases give you the magnitude and other properties of a star when you click on "object description" or the like. With a conventional printed atlas, you have to identify the star by its coordinates and look it up in *Sky Catalogue 2000.0* or a similar catalogue.

Among the stars, your pictures will also show some "deep-sky objects" such as star clusters, nebulae, and galaxies. Again, star atlases are very helpful in identifying these. The Orion Nebula (M42), Andromeda Galaxy (M31), and numerous clusters and nebulae in Sagittarius are easily within reach of fixed-tripod photography. Color film responds well to emission nebulae; most black-and-white films do not.

Finally, if you're using fast film and a fast lens, you've almost certainly noticed *sky fog* from city lights. Sky fog is a pest, but it's a pest worth studying. By taking identical fixed-tripod exposures on the same film from different locations, you can compare the sky fog at different sites. Thus, your camera and tripod could even be used as a site selection instrument for planning an astronomical observatory.

You can also track the development of sky fog at a single site as years go by and cities grow. For this purpose, use a type of film that will still be available, unchanged, years hence. Kodak T-Max 100 black-and-white film is probably a good choice. Color films are not suitable for long-term comparisons because the manufacturers modify them frequently.

Comets, meteors, aurorae, and space dust

3

Perhaps a bright comet, a meteor shower, or a display of the Northern Lights stimulated your interest in astrophotography. This chapter will tell you how to photograph all those things, as well as some little-known phenomena caused by dust in the Solar System.

3.1 Comets

Any comet visible to the unaided eye can be photographed with a camera on a fixed tripod, using the techniques described in Chapter 2; the exposure can

be as long as two or three minutes if necessary, since even a trailed picture is undeniably better than no picture at all, and comets are rather fuzzy objects to begin with (Fig. 3.1, Plate 3.1).

There's usually no way to predict when a bright comet will appear; most are discovered only a few weeks or months before they reach maximum brightness. Indeed, Comet Halley, with its 76-year period, is the only naked-eye comet that returns predictably. Even Comet Hale–Bopp (1996–97), discovered two years before its perihelion passage, was exceptional; more commonly we get much shorter

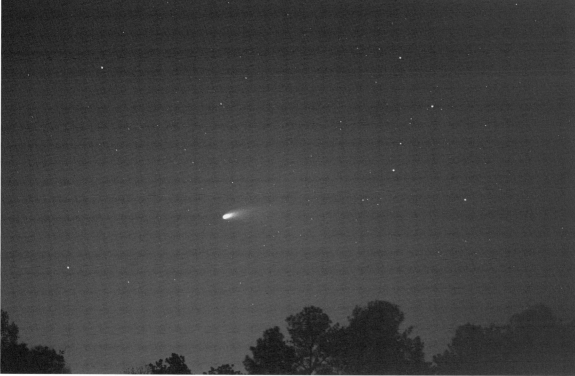

Figure 3.1 **Comet Hale–Bopp and the constellation Cassiopeia. A 20-second fixed-tripod exposure with a 50-mm *f*/1.8 lens on Kodak Ektachrome Elite II 100 pushed 1 stop, against a rather bright town sky. (By the author)**

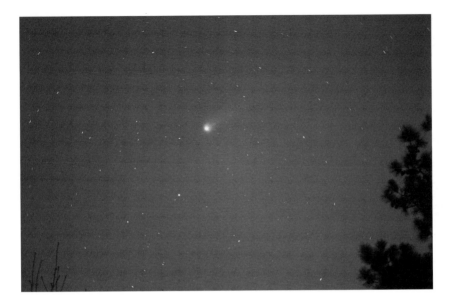

Figure 3.2 **Comet Hyakutake on 27 March 1996 at declination +85°, close enough to the pole to permit a 3-minute fixed-tripod exposure with a 90-mm *f*/2.8 lens on Fuji Sensia 100 film. Note how the stars seem to circle Polaris. (By the author)**

notice. Comet West (1976) came and went so quickly that many astronomers missed it. The brightness is hard to predict, too; Comet West was unexpectedly bright, but the news media ignored it, having been disappointed by Comet Kohoutek a year and a half earlier.

If you're interested in comets, then, you'll need to keep up with fast-breaking news. The information in magazines is two months old by the time it reaches you; the Internet is faster. One good source of information is the weekly news bulletin published by *Sky & Telescope* at http://www.skypub.com. Other astronomical web pages can be located through Cambridge University, http://www.ast.cam.ac.uk.

Comets are brightest when they are closest to the sun, and that means they usually appear low in the western sky after sunset or the eastern sky before sunrise. There are exceptions; Comet Hyakutake (1995)[1] appeared high in the midnight sky, then passed so close to the north celestial pole that long fixed-tripod exposures were possible (Fig. 3.2).

Unlike comets in cartoons, those in real life do not streak rapidly across the sky; their motion against the stars is apparent only over a period of hours or days. In fact, the tail of a comet is not a trail left behind by its movement; the tail consists of matter driven off the comet by solar heating, and it always points away from

the sun, regardless of which way the comet is moving. Indeed, the tail often splits into two parts, an ion tail (blue) and a dust tail (white or cream-colored) (Plates 3.1, 3.3).

The position of a comet is given as right ascension and declination (for plotting on your star atlas), and its expected brightness, expressed in terms of *magnitude*. We introduced star magnitudes on page 19, but the magnitude of a fuzzy object, such as a comet, is somewhat problematic. A 4th-magnitude comet is a good bit harder to see than a 4th-magnitude star because its light is spread out over a larger area. But you can photograph comets down to the fifth or sixth magnitude against a dark sky by using fixed-tripod exposures of a minute or less with a fast camera lens and fast film. Give the film as much push-processing as possible, and do what you can to increase contrast. Fainter comets, and better pictures of bright ones, require an equatorially mounted telescope or a barn-door tracker; the techniques are those described in Chapter 8, except that ideally, you should guide on the comet, which may be moving as fast as half a degree per hour relative to the stars.

Bright comets are always close to the sun, and you will often find yourself having to take pictures against a sky background that isn't completely dark. (Table 3.2, later in this chapter, gives the duration of

[1] In case you're still wondering, the *y* in *Hyakutake* is a consonant. The name is pronounced *yah-koo-tah-keh* with an additional *h* sound at the beginning.

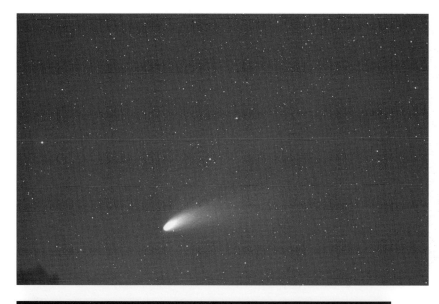

Figure 3.3 **A 2-minute exposure of Comet Hale–Bopp using a barn-door tracker. Olympus OM-1 camera, 100-mm *f*/2.8 lens wide open, Kodak Ektachrome Elite II 100 film pushed 1 stop. (By the author, assisted by Gary and Aaron Paul)**

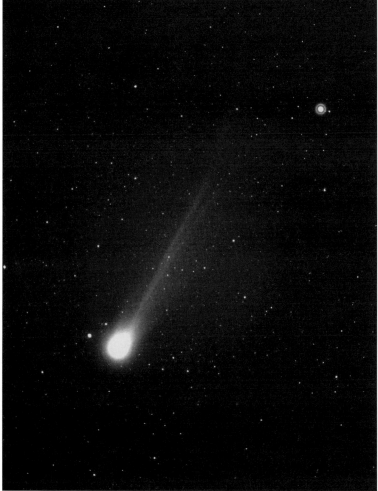

Figure 3.4 **Comet Hyakutake. A 6-minute exposure with 180-mm *f*/2.8 lens piggy-backed on a telescope, using Kodak T-Max 100 film pushed 1 stop in HC-110 developer. The halation ring around the bright star is caused by reflections within the film. (By the author)**

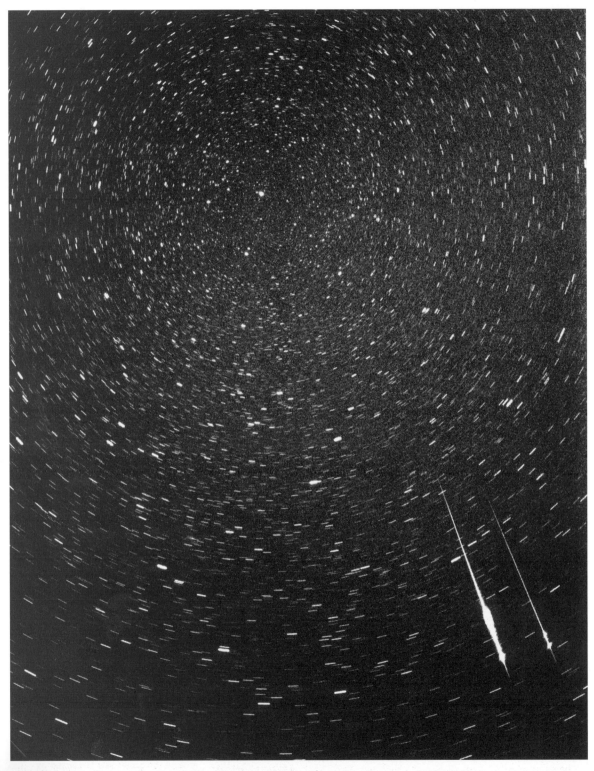

Figure 3.5 **Polar star trails and Perseid meteors. A lucky $4\frac{1}{2}$-minute exposure on Kodak T-Max P3200 film with a 28-mm lens at f/2.8. (Len Nelson)**

twilight.) Moonlight may also interfere. A pale yellow filter can reduce twilight, moonlight, and sky fog, but it will weaken the blue ion tail of the comet. Comets emit a lot of light between 490 and 520 nanometers in wavelength, and an interference filter that passes just this band is available from Lumicon (p. 315). Blue-green (cyan) filters are also useful in difficult cases. It may be helpful to use a film with a short-toed characteristic curve, such as Agfapan 400 or Kodak Plus-X Pan. Try a wide variety of exposures, including some that you think will be too short, and use contrast-increasing duplication techniques on the ones that turn out best.

print film. If the sky is dark, color slide film may give more satisfying pictures because of its higher contrast.

3.3 Meteors

The way to photograph a meteor is to make a long exposure of a star field, with or without guiding, and hope that a meteor passes through the field while the shutter is open.

Naturally, your chances of success will be greater if you make your attempt on a night when meteors are more common than usual – that is, during a *meteor shower*. "Shower" is a relative term, of course; meteors never fall like hailstones, and a respectable shower is doing well to yield a visible meteor every two minutes. When there is no shower going on, the meteor rate is more like one every twenty or thirty minutes.

Meteor showers occur when the earth crosses paths with a swarm of meteoric particles that are circling the sun in a regular orbit; each meteor shower thus occurs at a particular point in the earth's orbit, and hence at a fixed time of year, and the meteors all appear to come from the same direction (the *radiant*, identified by the star or constellation for which the shower is named). Radiants are usually low in the eastern sky because that's the direction toward which the earth is moving.

Table 3.1 lists the most important meteor showers; the name usually tells you the star or constellation where the radiant is located. The hourly rate listed in the table is what you get when the radiant is high in the sky; it will be markedly lower if the radiant is near the horizon. Because the meteoric particles are not evenly distributed in space, there is always some variation from year to year. In the case of one shower, the Leonids (whose radiant is in the constellation Leo), this variation takes the form of a 33-

3.2 BASIC TECHNIQUE 2:
Photographing a bright comet

Equipment: Camera capable of time exposures, fast 50-mm to 135-mm lens, tripod, latching cable release.

Film: Color print film, 200 to 800 speed. You will need custom prints; automatic machine prints may be disappointing. See page 14.

Sky conditions: Clear moonless night. Depending on when the comet is visible, some twilight or moonlight may be unavoidable.

Procedure: Place the camera on the tripod and aim it at the comet. Set the lens to its lowest f-stop (but no lower than $f/1.7$) and focus on infinity. Make exposures of 5, 10, and 20 seconds.

Variations: If the comet is near the northern or southern celestial pole, you can expose a good bit longer. If substantial moonlight or twilight is present, exposures will have to be shorter, possibly as short as 2 seconds.

Color print film is recommended because it tolerates overexposure; moonlight or twilight can be subtracted, to some extent, by making the print darker. The same is true of black-and-white

Table 3.1 *Major annual meteor showers*

Date (every year)	Name	Typical max. (hourly rate)	Remarks
Jan. 1–5	Quadrantids	40	Brief maximum on Jan. 3 or 4 Radiant near θ Boötis
April 21–23	Lyrids	15	Brief, variable shower
May 1–8	Eta Aquarids	20	Maximum around May 5
July 15–Aug. 15	Delta Aquarids	20	Maximum July 27/28
July 25–Aug. 18	Perseids	40–100	Reliable; occurs every year Maximum August 12
Oct. 16–26	Orionids	25	Maximum October 21
Nov. 15–19	Leonids	Varies	Maximum November 18 Recurs in 33-year cycle
Dec. 11–17	Geminids	75	Maximum December 14 Usually a fine shower

year periodicity: there was a dramatic Leonid shower in 1901, a respectable one in 1932, and a spectacular "meteor storm" in 1966 in which the rate reached 40 meteors per *second* – but virtually nothing in most of the "off" years. (Be prepared for the Leonids of 1999; no one knows what to expect.) There are always more meteors after midnight than before, since after midnight you are on the forward side of the earth relative to its orbital motion.

In photographing meteors, use a normal or wide-angle lens, not only in order to cover a wide expanse of sky, but also because the small image scale helps to slow down the rapid motion of the meteors. To improve your chances, consider using several cameras at once.

For meteor photography, you want a film that responds better to brief flashes of light than to faint, continuous glows – that is, a film with a high degree of reciprocity failure – so that you can catch as many meteors as possible without being bothered by sky fog. (This is the opposite of normal astrophotography, in which you need film that responds well to very long exposures.) The film of choice is therefore Kodak Recording Film 2475, T-Max P3200, or Tri-X Pan. Develop for high contrast. Be forewarned that Kodak Recording Film 2475 is very grainy.

Exposure is tricky: the longer you expose, the more meteors you'll catch, but if sky fog blots out faint meteor trails, you lose what you've gained. To reduce

sky fog, add a yellow or orange filter rather than stopping down the lens – it's better to reduce light selectively rather than indiscriminately. And, of course, if you see a bright meteor go through the field you're photographing, end the exposure immediately – once you've caught a meteor, you don't need to accumulate any more sky fog.

For more on meteor observing see Edberg and Levy (1994) and Kronk (1988).

3.4 BASIC TECHNIQUE 3:
Photographing a meteor shower

Equipment: Camera capable of time exposures, fast 50-mm or wide-angle lens, tripod, latching cable release.

Film: Any film rated at 200 speed or faster, preferably print film so that sky fog can be counteracted when making the print. Older-technology films with greater reciprocity failure, such as Kodak Tri-X Pan, have an advantage.

Sky conditions: Clear moonless night.

Procedure: Place the camera on the tripod and aim it at or above the expected radiant. Set the lens to its lowest f-stop (but no lower than $f/1.7$) and focus on infinity. Expose for several minutes or until a bright meteor passes through the field.

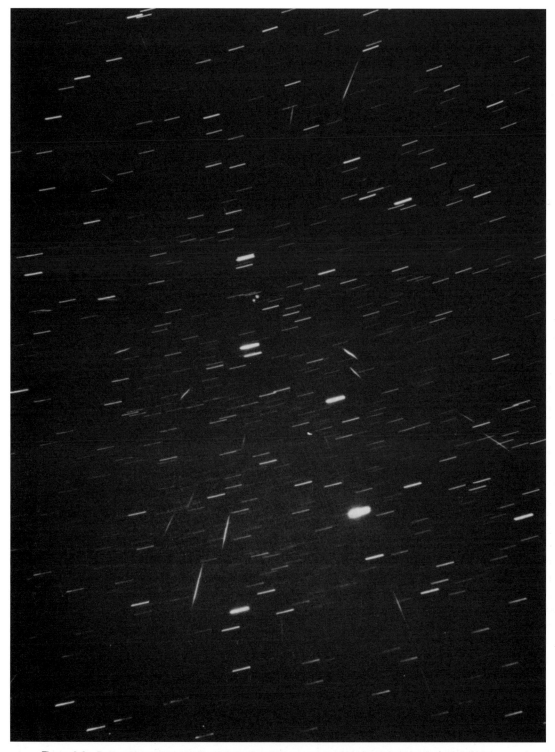

Figure 3.6 **During the 1966 Leonid shower, the meteor rate briefly reached 40 per** *second*. **The two spots in the middle are meteors that burned up while heading straight toward the camera. A fixed-tripod exposure on 120-format Kodak Tri-X Pan Film developed in D-19, with a 105-mm lens at** *f*/3.5. **(Dennis Milon)**

Plan to make a lot of exposures in order to catch a few meteors. Previous experience at the same site will tell you how long you can expose without excessive sky fog.

Variations: The camera can track the stars if you mount it on a barn-door tracker or clock-driven telescope (Chapter 8). This produces a more pleasing picture but does not affect the images of the meteors themselves.

3.5 Aurorae

If you're fortunate enough to see a display of the *aurora borealis* (the Northern Lights), by all means photograph it. Use a normal or wide-angle lens, put the camera on a fixed tripod (the aurora does not share the stars' apparent motion), and expose from 10 seconds to a minute on fast film, with the lens wide open. Photographs often show color that was not visible to the unaided eye, since the eye does not perceive color in dim light; if you do see color visually, the color in your photograph may not match it, since the light emitted by the aurora is confined to a few specific wavelengths, and one of these may fall on a particularly high or low point on the film's spectral response curve.

The visibility of the aurora borealis varies greatly from place to place; it depends roughly, but not exactly, on proximity to the north magnetic pole. Northern Alaska, Greenland, and Iceland see aurorae over 100 nights per year, twilight conditions permitting. The rate is more like 10 nights per year at Vancouver, Chicago, New York, or Manchester and drops to an average of one night a year in Arizona, Texas, Florida, or France. North America is much better placed for auroras than Europe – in Rome the aurora is visible, on average, only once in ten years. (There is also a southern hemisphere

aurora, the *aurora australis*, but none of the inhabited continents are well placed to see it.)

Since aurorae are caused by electrically charged particles emitted by the sun, they are most frequent when solar activity (of which sunspots are the most visible sign) is at a maximum. Solar activity varies in an 11-year cycle and reached a minimum in 1997. The next maximum is predicted for 2001, give or take a year or so, followed by another minimum in 2008. The rise leading up to a maximum is quicker than the fall after one; conditions for observing aurorae remain good for two or three years after each peak.

3.6 BASIC TECHNIQUE 4: Photographing the aurora borealis

Equipment: Camera capable of time exposures, fast lens (normal, medium telephoto, or wide-angle), tripod, latching cable release.

Film: Any film rated at 200 speed or faster, preferably color print film so brightness can be adjusted when making the print. Slide films also work well.

Sky conditions: Any sky in which the aurora is visible, generally a clear moonless sky.

Procedure: Place the camera on the tripod and aim it at the aurora. Make several exposures ranging from 2 to 60 seconds with the lens wide open (but no wider than $f/1.7$).

3.7 Zodiacal light, Gegenschein, and lunar libration clouds

Among the promising but neglected targets for amateur astrophotographers are various glows in the sky caused by clouds of small particles of matter in interplanetary space. The easiest of these to observe is the *zodiacal*

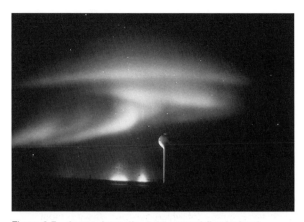

Figure 3.7 **Aurora borealis. A 20-second fixed-tripod exposure with 50-mm _f_/1.8 lens on High Speed Ektachrome (ASA 160) more than twenty years ago. (Sherman Schultz)**

Figure 3.8 **Unlike twilight, the zodiacal light is visible when the sun is more than 18° below the horizon.**

light, a glow that extends to the east and west of the sun along the ecliptic (the line in the sky that corresponds to the plane of the earth's orbit) and is visible after sunset and before sunrise (Fig. 3.8). Near the sun, the zodiacal light is slightly brighter than the Milky Way; it is caused by dust particles orbiting the sun, though the outermost parts of the sun's corona may also be involved. You can only see it from places that have a clear dark sky all the way down to the horizon.

The best way to confirm that what you're looking at is the zodiacal light, and not the last vestige of twilight or the first sign of dawn, is to observe at a time when there is no twilight or dawn to be seen. The duration of astronomical twilight – that is, the length of time to wait after sunset in order to get a completely dark sky, or the length of time before sunrise that the sky begins to lighten – depends on your latitude and the time of year; Table 3.2 gives

Table 3.2 _Length of astronomical twilight after sunset or before sunrise, rounded to nearest 5 minutes. Asterisks mark places where the sky never gets completely dark_

Date		Latitude (north or south)				
(northern hemi-sphere)	(southern hemi-sphere)	20°	30°	40°	50°	56°
Jan. 1	July 1	80	90	100	120	140
Feb. 1	Aug. 1	75	80	90	115	130
Mar. 1	Sept. 1	75	80	90	110	125
Apr. 1	Oct. 1	75	80	95	115	140
May 1	Nov.1	75	85	105	140	*
June 1	Dec. 1	85	95	115	*	*
July 1	Jan. 1	85	95	120	*	*
Aug. 1	Feb. 1	80	90	110	150	*
Sept. 1	Mar. 1	75	85	95	120	145
Oct. 1	Apr. 1	75	80	90	110	125
Nov. 1	May 1	75	80	95	110	125
Dec. 1	June 1	80	85	95	115	140

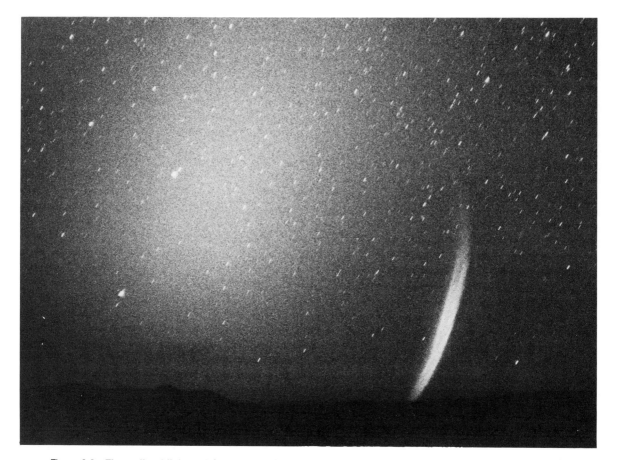

Figure 3.9 **The zodiacal light and Comet Ikeya-Seki were visible to the naked eye on the morning of 26 October 1965. A 25-second fixed-tripod exposure on Tri-X Pan film with a 50-mm $f/2$ lens, taken 2100 meters above sea level in the Catalina Mountains of Arizona. (Dennis Milon)**

approximate values, and more extensive information can be obtained from the *Astronomical Almanac*. (The best way to determine the time of sunrise or sunset is by direct observation; the times given in newspapers are not always accurate, and the times given in the *Astronomical Almanac* have to be corrected for the difference between local mean time and standard time.) Volcanic dust in the air prolongs twilight, as demonstrated by Malin (1993, p. 35); unusually clear air can shorten it.

The zodiacal light is easiest to see when the ecliptic is most nearly perpendicular to the horizon. For observers in temperate latitudes, the best viewing occurs in the spring evening sky and the autumn morning sky. (Phrased this way, this statement holds true for both the northern and southern hemispheres, though the calendar months involved are different.)

The zodiacal light should show up on a 20-second to 2-minute exposure at $f/2$ on ISO 400 film, provided the air is clear right down to the horizon (a situation most often achieved at sea, on remote mountaintops, or in extremely cold weather). Use a normal or wide-angle lens, push-process the film, and print on high-contrast paper or increase the contrast by slide duplication or digital image processing.

Once you've caught the zodiacal light on film, turn your attention to the *Gegenschein* (German for "counterglow"), a faint patch visible in the night sky in the direction exactly opposite the sun, caused by interplanetary dust particles that reflect sunlight back in the direction from which it came. Although fainter than the Milky Way, the Gegenschein is visible to the naked eye under clear, dark skies and is much brighter than some of the nebulae that amateurs routinely photograph.

Table 3.3 *Where to look for the Gegenschein. For dates in between those listed, add one degree of ecliptic longitude per day*

Date	Ecliptic longitude of sun	Ecliptic longitude of Gegenschein	Constellation in which Gegenschein appears
Jan. 1	280°	100°	Gemini
Feb. 1	312°	132°	Cancer
Mar. 1	340°	160°	Leo
Apr. 1	11°	191°	Virgo
May 1	40°	220°	Libra
June 1	70°	250°	Ophiuchus*
July 1	99°	279°	Sagittarius*
Aug. 1	128°	308°	Capricornus
Sept. 1	158°	338°	Aquarius
Oct. 1	187°	7°	Pisces
Nov. 1	217°	37°	Aries
Dec. 1	248°	68°	Taurus*

* In June, July, and December, the Gegenschein coincides with the Milky Way and cannot be seen.

You will also discover that the zodiacal light actually extends all the way around the ecliptic, connecting the sun to the Gegenschein – it's just that most of it is almost always too dim to see.

To locate the Gegenschein, refer to Table 3.3 and any good star atlas. The Gegenschein is always centered on the ecliptic; the table gives its position in terms of ecliptic longitude (the numbers marked on the ecliptic in star atlases). To photograph it, make as long an exposure as your technique permits – either a three- to five-minute fixed-camera star trail, or a clock-driven exposure of twenty to thirty minutes or as long as sky fog will allow. Use a normal lens, and develop for high speed and contrast. To ensure that you are not led astray by reflections or lens flare, make two exposures with the camera aimed a bit differently for each; the Gegenschein should stay in the same place relative to the stars. Don't put the Gegenschein in the exact center of the field, since many lenses render the center of the field noticeably brighter than the edges whether it really is or not.

Figure 3.10 shows a successful photograph of the Gegenschein – successful, that is, after the negative was processed digitally to make an extremely high-contrast print. (On the original print the Gegenschein was barely visible, although the nebulae

and clusters were beautiful.) The Gegenschein is the bright area above the meteor trail at the right; you can see the zodiacal light extending downward from it. The Pleiades appear as a bright spot at the lower right, and the Double Cluster is the bright spot on the left, halfway up. The notch in the top edge of the picture is M31, the Andromeda Galaxy. Digital processing has also brought out some extremely faint scratches on the film that would be completely invisible on an ordinary print.

If you succeed in photographing the Gegenschein, you may want to undertake a hunt for the *lunar libration clouds* or *Kordylewski clouds*, which have the distinction of being the only objects in the sky that are regularly visible to the unaided eye but whose existence went unnoticed until the twentieth century.

Back in 1772, the mathematician G. L. Lagrange calculated that, because of gravitational effects, small objects should accumulate at specific places in the orbits of larger objects. These points are called *libration points* because objects in them tend to wobble back and forth. ("Libration" means "wobble" and in this context has nothing to do with libration of the visible face of the moon.) For example, there are groups of asteroids at the libration points of Jupiter's orbit around the sun.

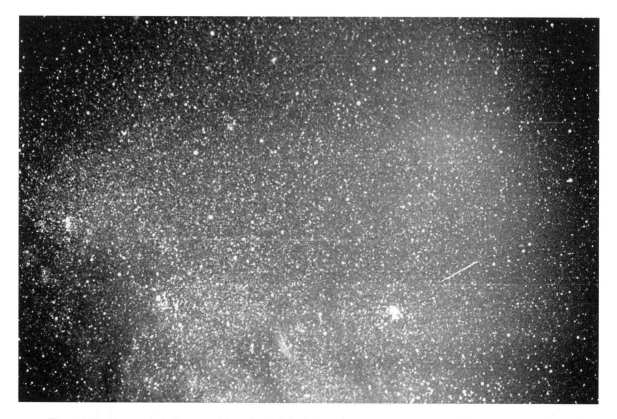

Figure 3.10 **Gegenschein (upper right), zodiacal light (below it), and winter Milky Way (lower left), photographed by Tom Krajci on Kodak Pro Professional 400 (PPF) color negative film from an extremely dark site. A 30-minute guided exposure, 28-mm lens at f/4. Digitally processed image; see text.**

In the 1950s the Polish astronomer K. Kordylewski began searching for objects at the libration points of the moon's orbit around the earth. What he found was a pair of faint dust clouds that are comparable in brightness to the Gegenschein and are visible to the unaided eye under very dark, clear skies (most observations of them have been made from mountains, deserts, or ships at sea). The existence of Kordylewski's clouds was disputed until they were observed from outer space by the OSO-6 satellite in 1969 and 1970.

The Kordylewski clouds are 60° away from the moon in either direction along the ecliptic (Fig. 3.11). But it is not unusual for them to be as much as 6 to 10 degrees off their predicted positions, in any direction. Each Kordylewski cloud is brightest when it is directly opposite the sun, near the Gegenschein. This means that the best times to look for the two clouds are 4 to 6 days before or after full moon respectively. The moon

Figure 3.11 **The lunar libration clouds (Kordylewski clouds) are swarms of dust particles that accumulate at the Lagrange points L_4 and L_5, 60° ahead of and behind the moon in its orbit.**

itself must not be in the sky at the time. The
Kordylewski clouds are best observed when the ecliptic
is high in the sky (in the winter or spring for evening
observers), but if a Kordylewski cloud falls on the Milky
Way you will not be able to see it.

Very few photographs of the Kordylewski clouds
have ever been taken, and any that you are able to
obtain will be of considerable scientific interest.
Simpson (1967) succeeded in capturing the
Kordylewski clouds in 8-minute exposures on highly
push-processed Plus-X Pan film, but the clouds were
only barely visible on the negatives, and densitometer
tracings were needed to confirm their presence.
Nonetheless, several interesting facts emerged; the
clouds wandered around quite a bit relative to their
predicted positions, and the L_5 cloud turned out to be
(at the time, at least) double.

With modern films and image enhancement
techniques, there is no reason why amateurs should not
expect equal or better results. The procedure is the
same as for photographing the Gegenschein: go to a
site well away from city lights, and make an exposure,
preferably clock-driven, that is long enough to show an
appreciable amount of sky fog. Then increase the
contrast of the picture by printing on extra-hard paper
or by repeated slide duplication, and look for
irregularities or bright spots in the sky fog. As with the
Gegenschein, pictures should be made in pairs in order
to distinguish glows in the sky from reflections in the
lens or flaws in the film.

3.8 All-sky cameras

An interesting way to photograph the whole sky at
once, capturing the zodiacal light, Milky Way, and other
faint glows in their respective places, is to aim the
camera downward at a shiny spherical surface
(Fig. 3.12) – one of the wide-angle mirrors used in
supermarkets would be ideal, and old, round automobile
hubcaps have been used with success. The camera is,

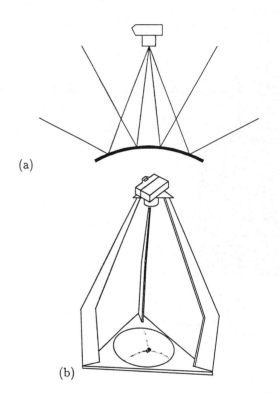

Figure 3.12 **All-sky cameras. (a) The principle: the camera
photographs the sky reflected in a sphere. (b) Diagram of
the all-sky camera built by Chris Schur and used to take
Fig. 3.13.**

of course, reflected in the middle of the picture, as is
the tripod or other structure that supports it, but if the
camera is several feet from the reflector, its reflection is
tiny. Rather than being focused on infinity, the camera is
focused on the virtual image in the mirror, and the lens
is set to its widest f-stop. The overall effective focal
length is short – on the order of ten millimeters at the
center of the field – with the result that exposures as
long as two or three minutes show little trailing. The
overall f-ratio is the same as that of the camera lens
alone. Figure 3.13 shows what can be achieved with
this technique.

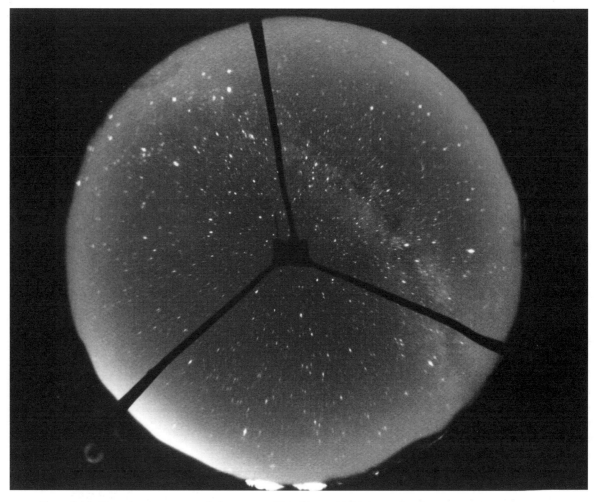

Figure 3.13 **Ten-minute exposure of the summer Milky Way on Tri-X Pan, using the apparatus shown in Fig. 3.12, mounted on a telescope for guiding. The Great Rift is visible at the right. (Chris Schur)**

The moon

In many ways the moon is the easiest celestial object to photograph. Its surface shows such a wealth of detail that you can get pleasing, dramatic pictures of it with many different kinds of equipment. Photographs of the moon almost always look impressive, even when they fall far short of the theoretical capabilities of the equipment and materials.

This chapter will tell you how to photograph the moon with simple equipment. We'll deal with more advanced lunar work in Chapter 7.

4.1 Lenses and image size

To photograph the moon you need a long telephoto lens or a telescope of some kind; your camera's normal lens by itself won't give a large enough image to show any detail (Fig. 4.1, Plate 4.1). The size of the image of the moon on the film depends on the focal length of the lens, as expressed by the formula:

$$\text{Image size (on film)} = \text{focal length} \div 110$$

with the focal length expressed in the same units as the image size (normally millimeters). As an approximation, just remember that the moon image size is a bit less than 1/100 of the focal length.

Table 4.1 shows the image size you'll get with lenses of various focal lengths, both on the film and on a ×15 enlargement (the biggest enlargement that is practical with most films and lenses – about the equivalent of a 16 × 20-inch print from a 35-mm negative, if you were to enlarge the entire picture area).

Let's suppose you're working with a 35-mm camera. If you use a 50-mm lens, the image of the moon on the film will be about half a millimeter in diameter, and even with maximum enlargement, you'll only get an image about a quarter of an inch across on the print – far too tiny to show any detail. So you switch to your longest telephoto lens, a 400-mm. This gives you a 3.6-millimeter moon image that you can enlarge to about an inch and a half – big enough to show the

lunar maria ("seas") and the face of the man in the moon, but probably not big enough to show craters (Figs. 4.2, 4.3).

If you then add a ×2 teleconverter, the effective focal length will be 800 mm, which is well within the useful range for photographing lunar detail; you can get a four-inch enlarged image, and, if your lenses are sharp enough and your tripod is steady enough, you may begin to see craters and mountains. A lens whose focal length is 600 mm or more by itself, without a converter, is of course even better.

4.2 Using a telephoto lens

Here are some important points to remember in photographing the moon through a telephoto lens:

Table 4.1 *Size of moon image with various focal lengths*

Focal length (mm)	Size of image on film (mm)	Approximate size on ×15 enlargement	
		(mm)	(inches)
28	0.25	3.8	1/8
50	0.45	6.8	1/4
100	0.91	14	1/2
200	1.8	27	1
300	2.7	41	1.6
400	3.6	54	2.1
500	4.5	68	2.6
600	5.4	81	3.1
750	6.8	100	4
1000	9.1	135	5.4
1250	11	170	6.7
1600	14.5	220	8.6
2000	18	270	10.7

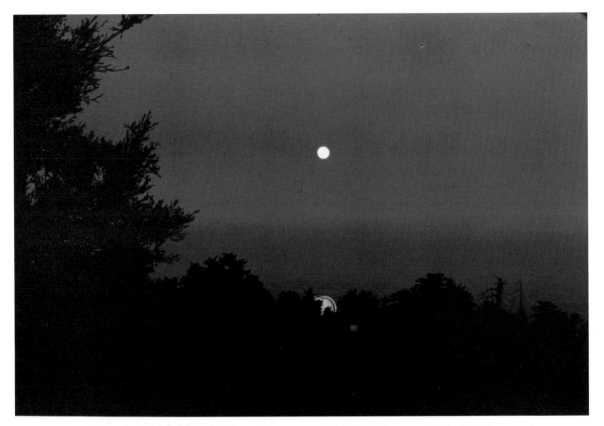

Figure 4.1 **The moon over Mt. Wilson Observatory, photographed with a 50-mm lens. Note that the moon fills only a tiny part of the picture. (Jim Baumgardt)**

Figure 4.2 **The moon through a 400-mm ƒ/6.3 telephoto lens. A 1/500-second exposure at ƒ/8 on Ilford FP4 film with a Wratten G filter. (By the author)**

Figure 4.3 **As Fig. 4.2, but with a ×2 teleconverter added, 1/125 second. (By the author)**

1 Always use a tripod. You need as sharp an image as your camera can give, and you won't get maximum sharpness unless your camera is mounted on a *very steady* tripod. Use a cable release or self-timer to keep from vibrating the camera when you click the shutter. Even with short exposures, hand-held photography of the moon isn't practical.

2 Set the lens at about $f/5.6$ or $f/8$ if possible, particularly if you are using a teleconverter. Most lenses are sharpest in this range.

3 If possible, use a yellow filter to improve sharpness by reducing the effect of chromatic aberration.

4 Focus carefully. Don't just set the lens to infinity and snap away; the lens may not actually be at infinity focus. The infinity stop on the lens probably includes some allowance for thermal expansion and other sources of error. The teleconverter, if present, introduces some errors of its own and magnifies any that are already present.

5 Remember that teleconverters multiply the f-ratio as well as the focal length. For example, a 100-mm lens set at $f/8$ becomes 200 mm at $f/16$ with a ×2 converter, or 300 mm at $f/24$ with a ×3. Take this into account when calculating the exposure.

6 Remember also that teleconverters can't magnify detail that isn't there. You may do just as well, if not better, by using the lens by itself with finer-grained film.

7 It's very hard to see or photograph craters on the full moon because the light is striking it so flatly. To capture the roughness of the moon's surface, photograph it when it is lit from the side, particularly at crescent or quarter phases.

8 If your lens gives only a small image of the moon, the way to get photographs of aesthetic value is to include other objects in the picture. For example, photograph the crescent moon shortly after sunset, while there is still enough light to show trees or buildings silhouetted against the horizon; if Venus or Jupiter is nearby, so much the better (Plates 4.1, 4.2). This type of picture usually requires a much longer exposure than a picture of the moon by itself; bracket widely.

4.3 BASIC TECHNIQUE 5:
Photographing the moon through a telephoto lens

Equipment: Camera, telephoto lens, sturdy tripod, cable release.

Film: Color print film, 50 to 400 speed. Most photo labs make reasonably good prints of the moon, even if they can't handle other astronomical pictures, but don't hesitate to have a picture reprinted lighter or darker if it needs it.

Sky conditions: Clear night with moon visible. Sky need not be completely dark.

Procedure: Place the camera on the tripod, aim it at the moon, and focus carefully through the viewfinder. Use the plain matte area of the focusing screen rather than the central microprism or split-image device.

Exposure: As in Table 4.2 or tables in Appendix A. If the sky is hazy or the moon is near the horizon, increase the exposure ×2 or more. If possible, work with the lens set to $f/5.6$ or $f/8$ for sharpness.

Variations: Print film is recommended because it covers a wide range of brightness; when the moon is illuminated from the side, some parts of its visible surface are much brighter than others. Since the moon is nearly colorless, black-and-white film is suitable, but color print film gives less visible grain. If you use slide film, try exposures shorter and longer than that recommended in the tables.

Figure 4.4 **Auto-exposure astrophotography. The moon at the prime focus of a 20-cm *f*/10 telescope (focal length 2000 mm), auto exposed on Fuji Sensia 100 film with an Olympus OM-4T camera. (By the author)**

Table 4.2 *Moon exposure table for 400-speed film. Times are given in seconds; see Appendix A for other film speeds and f-ratios*

f/	Thin crescent	Wider crescent	Quarter	Gibbous	Full
2.8	1/250	1/500	1/1000	1/2000	1/8000
4	1/125	1/250	1/500	1/1000	1/4000
5.6	1/60	1/125	1/250	1/500	1/2000
8	1/30	1/60	1/125	1/250	1/500
11	1/15	1/30	1/60	1/125	1/250
16	1/8	1/15	1/30	1/60	1/125
22	1/4	1/8	1/15	1/30	1/60
32	1/2	1/4	1/8	1/15	1/30

bit of lunar photography with Olympus OM-2S and OM-4T cameras, coupled to telescopes giving a focal length of 1250 to 6000 mm (Fig. 4.4, Plate 4.2).

Ordinarily, though, you have to determine exposures from tables or by calculation. The basic formula for calculating any exposure is:

$$t \text{ (in seconds)} = \frac{f^2}{SB}$$

where t is the exposure time, f is the f-ratio, S is the film speed expressed in ISO (ASA) units, and B is a constant that indicates the brightness of the object being photographed: 7 for a thin crescent moon, 16 for a wider crescent, 32 for a half moon, 70 for a gibbous moon, or 180 for a full moon.[1]

For example, if you're photographing the full moon at $f/16$ on ISO 400 film, plug the values into the formula as follows:

$$
\begin{aligned}
t &= \frac{f^2}{SB} \\
&= \frac{16^2}{400 \times 180} \\
&= 0.036 \text{ second} \\
&= 1/281 \text{ second.}
\end{aligned}
$$

Naturally, your camera doesn't have a 1/281-second setting; use the closest one that it does have, probably 1/250. Table 4.2 summarizes the exposure times for

4.4 Determining exposures

You can sometimes use an exposure meter or even an auto-exposure camera when you photograph the moon. This is possible when the camera has through-the-lens metering (virtually all SLRs do) and the moon fills most of the picture or is viewed against a bright twilight sky. If you have a small moon in the middle of a large black area, the meter will average the bright moon with the pitch-black background and give you an overexposure. With color print film, the overexposure may not be fatal; such films tolerate overexposure well. I've done quite a

[1] The alert reader will note that in the first edition, these numbers were 10, 20, 40, 80, and 200 respectively. You can still use the old numbers if you'd like; they're easier to remember. The newer values are based on more careful examination of actual photographs and photometric data.

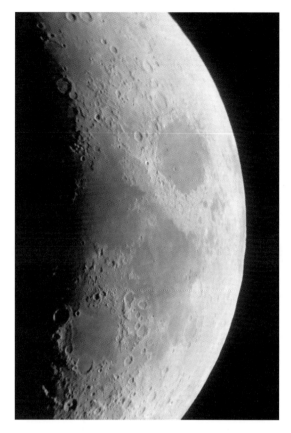

Figure 4.5 **Same film, camera, technique, and telescope as Fig. 4.4, but with a ×3 teleconverter added, giving a focal length of 6000 mm. (By the author)**

Table 4.3 *Longest exposure that will give sharp images without a clock drive. These times apply to any celestial object*

Focal Length (mm)	Exposure (seconds)	
	For critical work	Where some blur is tolerable
90–180	2	8
180–350	1	4
350–700	1/2	2
700–1500	1/4	1
1500–3000	1/8	1/2
3000–6000	1/15	1/4
6000–12000	1/30	1/8

where F is the focal length in millimeters. The moon's declination doesn't have to be taken into account because it doesn't vary enough to have a significant effect. Table 4.3 summarizes the results.

lunar photography on 400-speed film; a more complete set of exposure tables is given in Appendix A. The calculated exposures are only approximations; variations in the transparency of the air and other factors can throw them off, so always bracket your exposures.

There's one other thing to take into account: the earth is rotating, and if your camera or telescope doesn't have a clock drive to counteract its motion, there is a limit to how long an exposure you can make. The situation is the same as with fixed-camera star photography, except that now we want to eliminate trailing completely, not just keep it down to a moderate level. The formula to use is:

Longest practical exposure (in seconds) $= 250 \div F$

4.5 PRACTICAL NOTE:
What is a "stop"?

Photographers often talk about increasing or decreasing an exposure "one stop." What does that mean?

The answer: A one-stop change is a ×2 change. To increase an exposure or a film speed by one stop means to double it. To decrease it by one stop means to cut it in half.

This can be done repeatedly. To increase an exposure by three stops, multiply it by 8 (because $8 = 2 \times 2 \times 2$).

Shutters are calibrated with speeds that are one stop apart; that is, the exposure doubles as you move from one setting to the next: 1/2000, 1/1000, 1/500, 1/250, 1/125, . . . There is some rounding, so that instead of 1/62.5 you get 1/60, and so forth, but the intent is to change by a factor of two in each step.

The f-stops are arranged this way too, although you may not realize it. The standard f-stops on a lens are 2, 2.8, 4, 5.6, 8, 11, and 16.

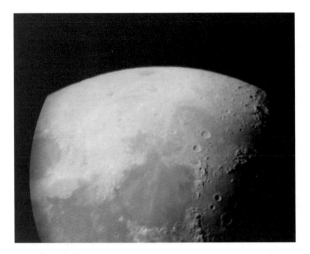

Figure 4.6 **Just hold your camera up to the eyepiece of a telescope and you *may* get something. A Ricoh AF-5 point-and-shoot camera and a a 20-cm (8-inch) telescope at ×120, focused by eye. The exposure latitude of color print film helped ensure a printable picture. (Sharon Covington)**

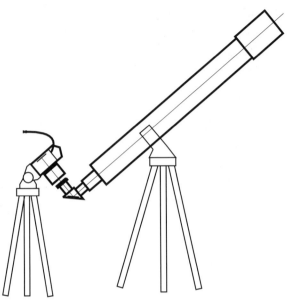

Figure 4.7 **Afocal coupling means the camera looks into the eyepiece of a telescope.**

Remember that in the exposure formula, the f-ratio is *squared*. Well, if you square the standard f-numbers, here's what you get:

$$1.4^2 = 2$$
$$2^2 = 4$$
$$2.8^2 = 8$$
$$4^2 = 16$$
$$5.6^2 = 32$$
$$8^2 = 64$$
$$11.3^2 = 128$$
$$16^2 = 256$$

You can see what's happening – the f-numbers correspond to factor-of-two differences in actual exposure. On the lens, each f-number is rounded to two digits, which is why the lens says $f/11$ rather than $f/11.3$.

4.6 Afocal coupling to telescopes and binoculars

Even the best telephoto lens is no match for an astronomical telescope. Some telescopes, particularly Schmidt–Cassegrains and Maksutovs, simply fit onto the camera body in place of a lens; this is known as *prime focus* photography. For example, a 20-cm (8-inch) $f/10$ Schmidt–Cassegrain operates as a 2000-mm $f/10$ telephoto lens, and everything in the previous section applies to it. But in this section I'm going to concentrate on *afocal coupling*, a technique for linking almost any camera to almost any telescope. For other ways of coupling telescopes to cameras, see Chapter 6.

In the afocal method, the camera takes the place of your eye at the eyepiece of the telescope; that is, you simply aim the camera (with its lens in place) into the eyepiece. No special adapter is needed; in fact, the best way to arrange the equipment is to put the camera and the telescope on separate tripods so that neither can transmit vibration to the other (Fig. 4.7). The camera should be equipped with a normal or medium telephoto lens, set to its widest opening. Take care to get the camera lens as close to the eyepiece and as well centered as possible.

If your camera is a single-lens reflex, you'll have no trouble focusing. Start with the telescope focused for normal viewing and the camera lens set in the middle of its focusing range; look in the viewfinder and focus, using the telescope's focusing knob first and then making fine adjustments by focusing the camera lens. If you happen to have a twin-lens reflex, focus with the viewing lens in front of the eyepiece, then move the

Figure 4.8 **Camera and telescope can stand on separate tripods to keep from transmitting vibration. This technique looks clumsy but works well.**

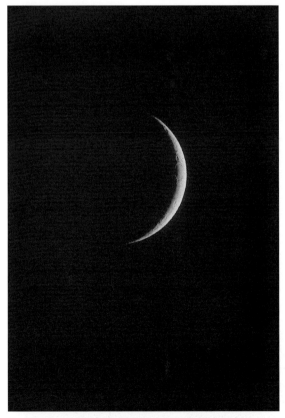

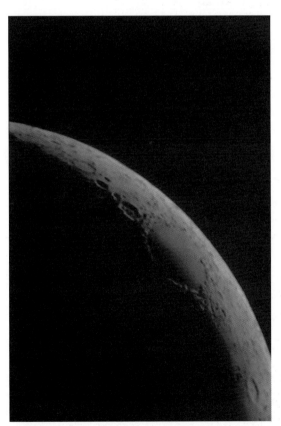

Figure 4.9 **A thin crescent moon photographed at the prime focus of a 12.5-cm (5-inch) Schmidt–Cassegrain telescope (1250 mm focal length, $f/10$). A 1/15-second exposure on Ektachrome 400. (Taken in 1981 by the author)**

Figure 4.10 **Taken a few minutes after Fig. 4.9 with the same telescope and film, but using the afocal method with an 18-mm eyepiece on the telescope and a 100-mm telephoto lens on the camera, giving an effective focal length of 7000 mm ($f/56$). One second, with clock drive running. (By the author)**

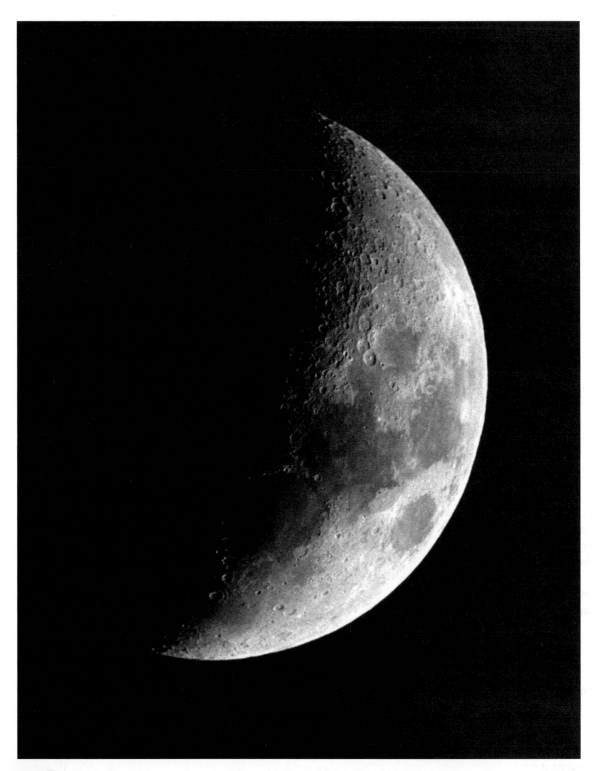

Figure 4.11 **Even a cheap camera can take good afocal pictures. Russian Lubitel twin-lens reflex aimed into the eyepiece of a 12.5-cm Schmidt–Cassegrain telescope working at ×40. Ilford HP5 Plus film, 1/30 second. The picture is a mirror image of the moon because the telescope included a star diagonal. (By the author)**

camera so as to take the picture through the picture-taking lens. Figure 4.11 was taken this way, with very satisfying results.

If your camera doesn't have through-the-lens viewing, you can still focus accurately – but it's a bit more complicated. In addition to the camera and main telescope, you'll need a small hand-held telescope of about 5 to 10 power; your main telescope's finder, or one side of a pair of binoculars, will do fine. First aim the hand-held telescope at the moon or some other very distant object, and focus it so that what you see is sharp. Next, aim the small telescope into the eyepiece of the main telescope and focus the main telescope so that you again see a sharp image. Then set your camera to infinity focus (the long-distance end of the focusing scale, usually marked ∞), put the camera in place, and make the exposure.

The hand-held telescope is necessary to reduce the amount of variation that the focusing muscle of your eye can introduce. When you focus your telescope for normal viewing, there is quite a range of settings that will give an image that appears equally sharp; you can put the image at any virtual (optical) distance from about two feet to infinity. The hand-held telescope ensures that you are placing the virtual image at infinity, so that a camera focused at infinity will be focused on it.

The effective focal length of an afocal setup is simply the focal length of the camera times the magnification of the telescope:

$$F = \text{focal length of camera lens} \times \text{magnification of telescope}$$

The system f-ratio is the effective focal length divided by the diameter of the telescope objective:

$$f = F \div \text{diameter of telescope}$$

Throughout this book, capital F stands for focal length and small f stands for f-ratio. Be sure not to confuse the two.

Here's an example. Suppose you're using a 6-cm (60-mm, 2.4-inch) telescope at $\times 30$, and a 50-mm lens on your camera. Then:

$$F = 50 \text{ mm} \times 30 = 1500 \text{ mm}$$

(which is just right for photographing the moon on 35-mm film), and:

$$f = 1500 \text{ mm} \div 60 \text{ mm} = 25$$

That is, the system operates at $f/25$, so you'll want to use relatively fast film. Generally, to photograph the whole face of the moon, you'll use telescope magnifications from 10 to 50, about the same as what you'd use to observe the moon visually. At higher magnifications, only part of the moon fits into the picture, but you get enlarged images of craters and other features.

The afocal method works well with even the smallest telescopes, spotting scopes, and binoculars. If you put a camera with a 50-mm lens behind one of the eyepieces of a pair of 7 × 35 binoculars, you get an effective focal length of 350 mm at $f/10$ – and you can use the other eyepiece as a finderscope. The moon image with such a setup is a bit small for photographing lunar detail, but fine for eclipses, as well as for taking pictures of birds, distant scenery, and the like. There are commercially available brackets for coupling cameras to binoculars, and you can also make your own.

4.7 BASIC TECHNIQUE 6:
 Photographing the moon (afocal method)

Equipment: Telescope (almost any telescope will do), camera with normal or moderate telephoto lens (up to 135 mm), cable release, tripod for camera.
Film: Color print film, 400 speed, is probably the best choice for beginners; almost any kind of film can be used.

Sky conditions: Clear night with moon visible. Sky need not be completely dark, but glare will be a problem if you try to use this technique in the daytime.

Procedure: Aim the telescope at the moon. If the camera is an SLR, simply aim the camera (on its tripod) into the eyepiece and center it as well as possible. Focus on the SLR viewing screen, using the plain matte area rather than the microprism or split image. If the camera is not an SLR, focus as described on p. 43.

Then take the picture using the cable release to avoid vibrating the camera or telescope.

Exposure: The camera lens must always be wide open; you cannot adjust it to change the exposure.

See p. 43 to calculate system f-ratio and focal length; then determine exposure from Table 4.2 or the tables in Appendix A. If the sky is hazy or the moon is near the horizon, increase the exposure ×2 or more.

If the moon fills the picture, you can use your camera's through-the-lens exposure meter or auto-exposure capability. Do not use auto-exposure systems that do not measure through the camera lens.

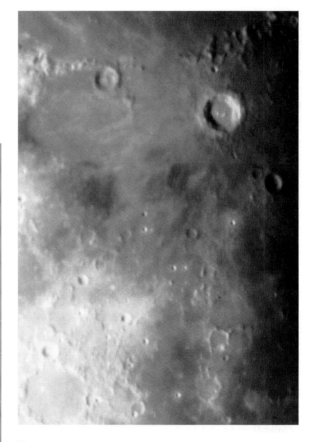

Figure 4.12 **A "close-up" of the crater Copernicus, using a 12.5-cm (5-inch) Schmidt–Cassegrain telescope at ×140 coupled afocally to camera with a 100-mm lens. One-second exposure (with clock drive running) on Panatomic-X film push-processed for high contrast. Like the previous figure, this picture is mirror-imaged. (Taken in 1982 by the author; digitally retouched to remove dust and scratches.)**

4.8 Films and processing

The moon is a relatively undemanding photographic subject; you can get pleasing pictures of it with practically any film. For this very reason, it makes a good object to experiment on – you can try a variety of films and processing techniques and observe the different results while knowing that you'll probably get something usable no matter what happens. So this is as good a time as any to start getting acquainted with the factors that influence the choice of film for lunar and planetary photography.

The main technical challenge in photographing the moon is that, except when full, it spans a tremendous brightness range. Craters are most visible in the dimly lit areas near the terminator, but it's almost impossible to expose such areas correctly without grossly overexposing the brighter areas. This means that you need a film with excellent exposure latitude and ability to hold shadow detail. At the same time, you need good contrast, particularly in the brighter areas, which are rather flatly illuminated – so the usual strategy of increasing the exposure latitude by reducing the contrast won't work very well.

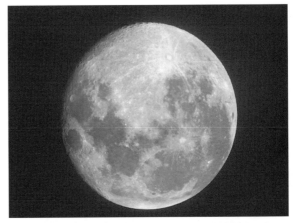

Figure 4.14 **After full moon, the lunar landscape is lit from the opposite direction than before. Note the angle of the light on the craters visible here. Prime focus of a 20-cm (8-inch) *f*/10 telescope, 1/250 second on Ektachrome 200. (By the author)**

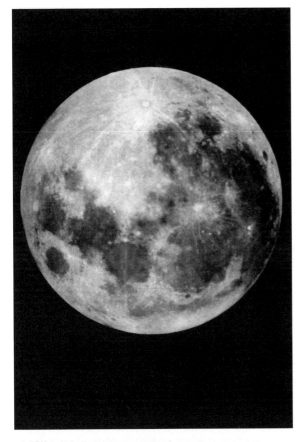

Figure 4.13 **The full moon requires high-contrast development and printing. Taken with a 15-cm (6-inch) *f*/8 Newtonian reflector and a 32-mm eyepiece, coupled afocally to a camera with a 45-mm lens. An exposure of 1/125 second on Tri-X Pan film developed in D-19 and printed on Kodabromide No. 5 paper. The moon is about to go into eclipse, as evidenced by a slight darkening at the lower right. (Taken in 1970 by the author)**

What you need, in fact, is a film whose contrast increases with exposure, so that well-exposed areas show good contrast but the film's response to less-well-exposed areas tapers off gradually, with gradually diminishing contrast. A film of this type is known as "long-toed" because the curved "toe" portion of its characteristic curve extends well up into the working range. Among 35-mm films, Kodak T-Max 100 has a longer toe than most of its competitors; so does Kodak Technical Pan developed in Technidol. Both of these films also have unusually fine grain. (In the old days we used Kodak Panatomic-X, which was similar to T-Max 100 but slower.) In general, you should develop the film to about the same level of contrast as for terrestrial

photography, then print on contrasty paper (about No. 4) and do a fair bit of dodging and burning-in. T-Max films developed in Kodak T-Max developer may have excessively dense highlights; when in doubt, err on the side of underdevelopment.

Another approach is to use the film with the greatest exposure latitude, then adjust the overall density when printing. Kodak T400 CN film and Ilford XP2 are especially good for this; they are black-and-white films that are developed in color chemistry so that the image is composed of dye clouds rather than silver granules. As a result, they have fine grain and a remarkable tolerance for overexposure.

For the same reason, there's a lot to be said for using color print film, even though the moon is colorless. Color print films are designed to span a wide brightness range and to tolerate over- and underexposure. You can get prints made cheaply at a minilab.

With the full moon, the situation is completely different. The full moon is a low-contrast subject because of the flat lighting. It requires a high-contrast film such as Kodak Technical Pan (developed in HC-110 or D-19) or, for color slides, Kodak Elite Chrome 100; both of these are fine-grained. If you decide to increase the contrast of regular film by overdeveloping, remember that overdevelopment increases grain; you can often get better results by developing the film normally and printing on high-contrast paper.

Eclipses

Eclipses of the sun and moon are both easy and interesting to photograph. This chapter will tell you briefly how to do so. For fuller information about eclipse photography see also Pasachoff and Covington, *The Cambridge Eclipse Photography Guide* (1993), and the eclipse handbooks published by NASA (Espenak 1987 and 1989, Espenak and Anderson 1997, and others).

Details of the solar and lunar eclipses for any given year are in the *Astronomical Almanac*, published jointly by the British and American governments. Note that most libraries classify the *Astronomical Almanac* and the NASA books under government publications rather than astronomy. Detailed information about eclipses is also available on the World Wide Web at http://umbra.nascom.nasa.gov and, of course, in magazines such as *Sky & Telescope*.

5.1 Lunar eclipses

Eclipses of the moon are the kind of eclipse that people get to see most often, since they are visible from wide areas of the earth at once. An eclipse of the moon is caused by the moon's passing into the earth's shadow, which blocks the sunlight that normally illuminates it; since the darkening takes place on the moon, not the earth, it is visible from everywhere that the moon is visible.

Figure 5.2 shows that the shadow of the earth, like any shadow from a light source of appreciable size, consists of two parts: an inner, uniformly dark part called the *umbra*, and an outer, fuzzy, gray part called the *penumbra* that gradually gets lighter toward the edges. (The same is true of the shadow that your hand casts in sunlight or the light of a single light bulb; try it.) Figure 5.3 shows the moon's passage through the earth's shadow as seen from earth; the moon enters first the penumbra, which causes it to dim somewhat, and then the umbra, which plunges it into almost complete darkness.

If the only light reaching the moon were direct sunlight, the moon would be completely black and invisible while in the umbra, but in fact a certain amount of light gets around the earth, through the atmosphere, and bathes the moon in a dim, coppery glow (see Plate 5.1). The brightness of this glow is unpredictable, since it depends on the distribution of clouds and dust in the earth's atmosphere.

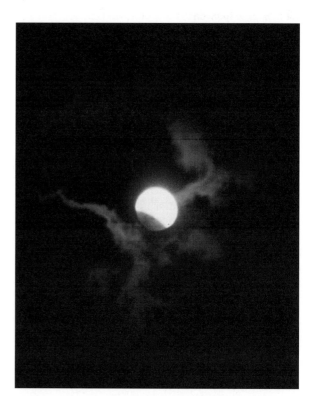

Figure 5.1 **An eclipse of the moon photographed under adverse conditions (17 July 1981). A 100-mm f/2.8 telephoto lens and a ×3 teleconverter; a 1-second exposure on Fujichrome 100 through a momentary break in the clouds. (By the author)**

(a) As usually shown in textbooks:

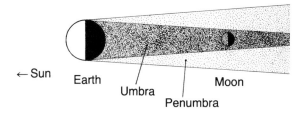

← Sun Earth Umbra Moon Penumbra

(b) A more accurate picture:

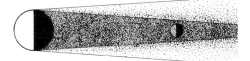

Figure 5.2 **A lunar eclipse.**

5.2 Lunar eclipse dates and times

Table 5.1 lists forthcoming lunar eclipses through the year 2005. Most of these are *total* eclipses; that is, at some point during the eclipse the moon is completely within the umbra. The rest are *partial*: the moon grazes the umbra but is never more than partly immersed in it. There are also frequent *penumbral* eclipses, in which the moon passes through some part of the penumbra without touching the umbra at all; these are not listed in the chart because the dimming is almost imperceptible.

To find out whether you can see a particular eclipse from your location, you need to know the time at which the eclipse takes place and whether the moon will be in the sky at your location at that time. The times in Table 5.1 are expressed in Universal Time (UT – also known as Greenwich Mean Time, GMT). To convert this to your local zone time, you'll have to add or subtract a fixed number of hours; Table 5.2 lists the conversions for the United States, Canada, and most of Europe. *Remember to convert the date* – 01:00 UT is 8 p.m. EST on the preceding day. To double-check your conversion, you can get the current time of day in UT by listening to any shortwave radio station or by looking at the display on a GPS (Global Positioning System) receiver. Eclipse calculations sometimes use Ephemeris Time (ET), which is within about 1 second of GMT but is not corrected for variations in the earth's rotation.

Table 5.1 *Umbral lunar eclipses, 1999–2005. Times given are for umbral first and last contact; penumbral phases start earlier and end later*

Date (UT)	Partial or total?	First contact (UT)	Last contact (UT)	Visible in USA?	Visible in UK?
1999 Jul. 28	40%	10:22	12:45	Partly	No
2000 Jan. 21	Total	03:01	06:26	Yes	Yes
2000 Jul. 16	Total	11:57	15:54	Partly	No
2001 Jan. 9	Total	18:42	21:59	Partly	Yes
2001 Jul. 5	50%	13:35	16:15	No	No
2003 May 16	Total	02:03	05:18	Yes	Yes
2003 Nov. 8–9	Total	23:32	03:05	Yes	Yes
2005 Oct. 17	7%	11:34	12:32	Partly	No

Data from Espenak (1989).

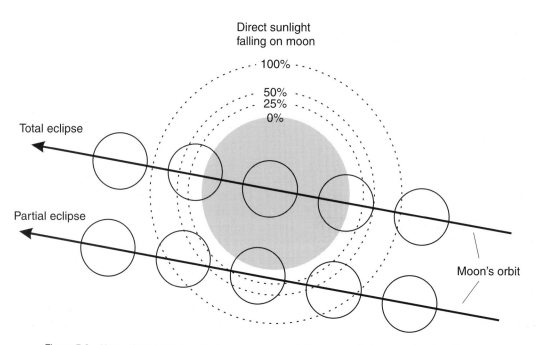

Figure 5.3 **How a lunar eclipse looks, seen from earth. The moon darkens gradually in the penumbra, then abruptly in the umbra (shaded).**

Table 5.2 *To convert UT to local zone time, add or subtract the specified number of hours. Dates of Daylight Saving Time vary, and some localities do not observe it*

Time zone	Local zone time =	
	Winter (standard time)	Summer (daylight saving time)
Great Britain	UT	UT+1
Western Europe	UT+1	UT+2
South Africa	UT+2	not used
Australia (west coast)	UT+8	UT+9
Australia (east coast)	UT+10	UT+11
New Zealand	UT+12	UT+13
North America:		
Atlantic Time Zone	UT−4	UT−3
Eastern Time Zone	UT−5	UT−4
Central Time Zone	UT−6	UT−5
Mountain Time Zone	UT−7	UT−6
Pacific Time Zone	UT−8	UT−7
Alaska	UT−9	UT−8
Hawaii	UT−10	not used

Will the moon be in the sky at the time of the eclipse? Yes, if the sun isn't. The totally eclipsed moon is directly opposite the sun in the sky, so the moon rises when the sun sets, and vice versa. So if you know the local times of sunrise and sunset, you can figure out whether the eclipse is observable at your site.

Let's put all this together with a concrete example. Suppose you want to observe the eclipse of July 16, 2000, and you live in California. Daylight saving time will be in effect on that date, so your conversion formula will be:

$$\text{Local zone time} = \text{UT} - 7 \text{ hours}$$

The eclipse lasts from 11:57 to 15:54 UT, and using the formula we find that this corresponds to 4:57 to 8:54 a.m. Pacific Daylight Time. But the sun will rise and the moon will set around 6 a.m., depending on your location, so you'll only get to watch part of the eclipse.

5.3 Lunar eclipse photography

Once you've chosen an eclipse to observe, you'll have no trouble photographing it; the equipment needed to photograph lunar eclipses is the same as for

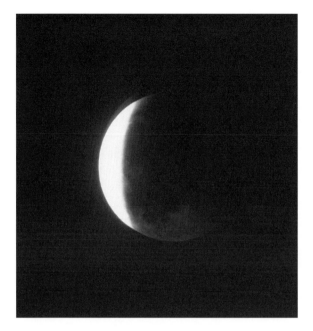

Figure 5.4 **The lunar eclipse of 24 May 1975. Part of the umbra is visible along with the greatly overexposed penumbra. Prime focus of a 15-cm (6-inch) $f/8$ Newtonian, 3 seconds on Fujichrome 100. (Douglas Downing)**

photographing the moon generally, and, if anything, the requirements for sharpness are less stringent, since surface detail is of less interest. You'll almost certainly want to photograph in color, in case the umbra turns out to be a striking copper hue.

The main problem is how to determine the correct exposure. During the partial phases of the eclipse, you can do either of two things: expose for the bright area outside the umbra, making the umbra itself look pitch-black, or try to get both the bright and the dark parts of the moon into the sensitivity range of the

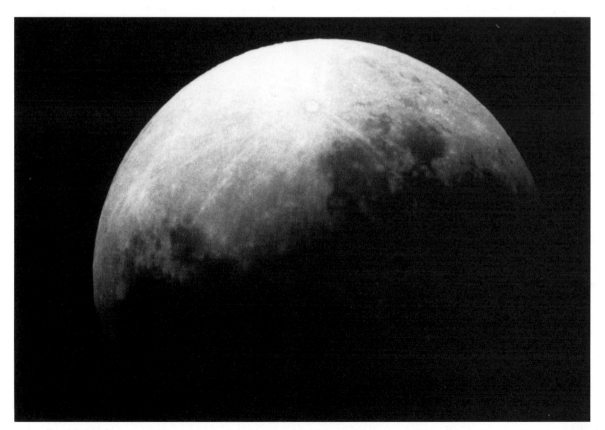

Figure 5.5 **The lunar eclipse of 17 August 1970 (note Leibniz Mountains on limb). A 15-cm (6-inch) $f/8$ Newtonian reflector with a 32-mm eyepiece coupled afocally to a camera with a 45-mm lens and focused by the hand-telescope method. Tri-X Pan developed in D-19 for high contrast. (By the author, who was not quite 13 years old at the time.)**

film. Appendix A gives exposure tables for both of these approaches; the second is considerably more difficult, since the umbra and penumbra differ in brightness by a factor of about ten thousand. Chances of success are best when the moon is almost completely inside the umbra and only a small sliver of penumbra remains. Naturally, it helps if the film has good exposure latitude.

Correct exposures for the totally eclipsed moon are unpredictable because the amount of light reaching the moon through the earth's atmosphere cannot be predicted in advance; some lunar eclipses are relatively bright, with the moon continuing to glow light orange even when eclipsed, while at other times the eclipsed moon is so dark as to be invisible even in a telescope. The tables in Appendix A give suggested exposures for relatively light and relatively dark eclipses, but these are only approximations; to be on the safe side, vary your exposure several stops on either side of the suggested values.

One thing you'll notice from the tables is that exposures for photographing the totally eclipsed moon can be quite long − as much as several minutes at $f/8$, even on relatively fast film. This means that if you are using a slow lens, you'll need to mount your camera on a telescope equipped with a clock drive to follow the earth's motion; otherwise, the limits in Table 4.3 still apply (though they can be stretched a bit if critical sharpness is not necessary). With exposures of a couple of minutes or more, the difference between solar and lunar drive rates can even become significant; the telescope will need to be driven slightly slower than its usual star-tracking rate because the moon is moving continuously in its orbit (see Chapter 7 and Appendix C).

The dimness of the totally eclipsed moon does have one advantage: it makes it possible to take a picture of a star field with the moon in it, a feat that is normally impossible because the moon is too bright. Use a medium telephoto lens, mount the camera on a clock-driven telescope, and expose for two to five minutes; or use the fixed-camera techniques described in Chapter 2.

If your camera can make multiple exposures, you can take a striking picture of the progress of the eclipse by placing the camera on a fixed tripod and exposing once every five minutes or so as the moon moves through the field (Fig. 5.6). Since the moon images will not overlap, each of them should be exposed normally. As an alternative, mount the camera on a clock-driven telescope, guide on a star (against which the earth's shadow is relatively stationary), and expose about once every 45 minutes; you'll get a photographic version of Fig. 5.3.

5.4 Videotaping a lunar eclipse

Lunar eclipses lend themselves very well to time-lapse videotaping. I have only done this once, but the result was very satisfying; the camcorder was mounted piggy-back on a clock-driven telescope, which, moving at solar rate, tracked the earth's shadow rather than the moon. The whole eclipse was compressed into about one minute of time, during which the moon moved across the field into and out of the earth's shadow, looking like Fig. 5.3, animated.

The camcorder was a JVC unit with its lens zoomed out to maximum focal length (50 mm); this gave a moon image of reasonable size. The focus was locked on infinity. Exposure was the biggest challenge. Since the moon occupied only part of an otherwise pitch-black field, the camcorder wanted to overexpose. To counteract this, I locked the camera on maximum exposure and adjusted the exposure with a variable neutral density filter made of two polarizers. At totality, this filter was removed. On the whole, the images, though inferior to conventional photographs, were satisfactory; Fig. 5.7 is an example.

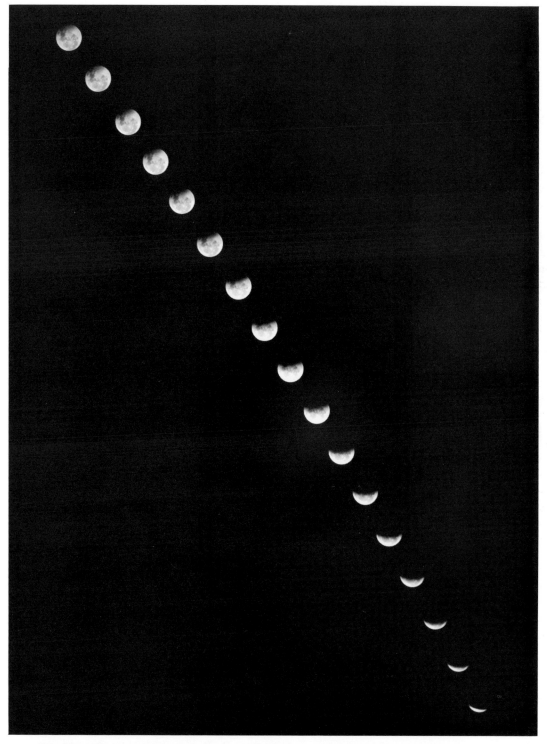

Figure 5.6 **The moon rising and coming out of eclipse on 20 December 1982. Exposures at 5-minute intervals on Ektachrome 64 using a homebuilt 4×5-inch sheet-film camera and a 400-mm lens, on a fixed tripod. Exposures ranged from 1/2 second at $f/5.6$ for a thin crescent to 1/125 at $f/11$ for the nearly full moon. (Akira Fujii)**

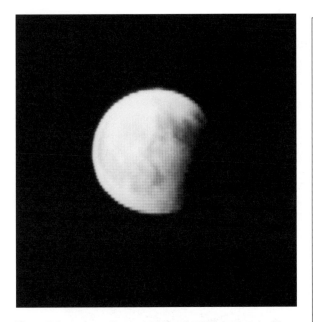

Figure 5.7 **Lunar eclipse of 23 March 1997, captured with a video camera (×20 zoom lens), using crossed polarizers as a neutral density filter. The picture was made by photographing the monitor screen.**

5.5 BASIC TECHNIQUE 7:
Photographing an eclipse of the moon

Equipment: Camera with long telephoto lens (300 to 1500 mm for a 35-mm camera), or camera with normal lens aimed into eyepiece of telescope or monocular. See pp. 35–37 and 40–44 for more information about equipment.

A sturdy tripod and cable release are necessary. If exposure exceeds 1 second, a clock-driven equatorial mount is probably needed.
Film: Color print film, 400 speed. Many other films can be used. Print film is preferable because of its wide brightness range and tolerance for incorrect exposure.
Procedure: As described on pp. 37 and 43–44 respectively, depending on setup. The entire procedure can be tried on the uneclipsed moon a few days before the eclipse.
Exposure: See tables in Appendix A. Through-the-lens auto exposure usually works well if the image of the moon is reasonably large. Exposures for the totally eclipsed moon can be quite long; the most dramatic pictures are usually obtained when the moon is about 95% eclipsed and a small sliver is still bright (Plate 5.1).

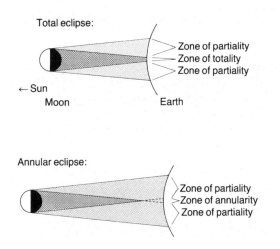

Figure 5.8 **Solar eclipse configurations in space. An eclipse is annular if the moon is too far from the earth for its umbral shadow to reach the ground.**

5.6 Solar eclipses – partial and annular

Solar eclipses happen when the moon passes in front of the sun – that is, when the moon's shadow falls on the earth – and what you see depends on where you are located relative to the shadow. The sun is totally eclipsed only in a a small region – the *zone of totality* – which is a few miles or a few dozen miles in diameter and moves rapidly along a track several thousand miles long (Figs. 5.8, 5.9). Surrounding it is the *zone of partiality*, a couple of thousand miles in diameter, within which the eclipse is seen as partial.

What this means is that *even a total eclipse is actually partial* most of the time and in most places. If you are situated on the path of totality, you see a long, ever-deepening partial eclipse as the zone of partiality envelopes you. Then the zone of totality reaches your location and takes one to eight minutes to traverse it; during that time the bright disk of the sun is completely

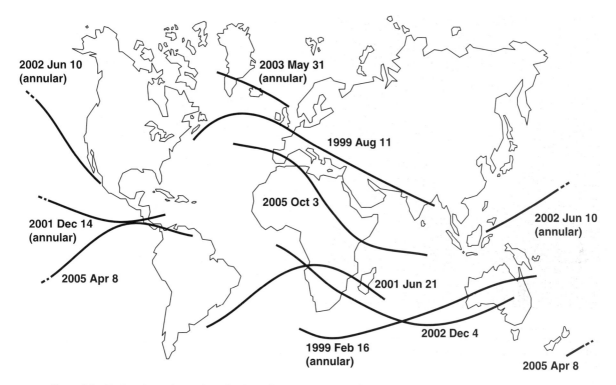

Figure 5.9 **Paths of annular and total solar eclipses, 1999–2005. Each eclipse is partial for many hundreds of miles either side of the path. There is also an annular eclipse in Antarctica on November 23, 2003.**

hidden from view and you see the corona. Suddenly the bright surface of the sun breaks through again; totality is past, and you are again watching a partial eclipse. If you had been a few miles away, totality would have missed you altogether and you would have seen only a partial eclipse.

All this is possible because the moon can cover the whole sun as seen from earth. The moon is in fact only barely big enough to do this. What's more, its distance from the earth varies, and when it is farther away than average (and therefore looks smaller) it can indeed fail to cover the whole sun. What happens then is that there is no zone of totality; an observer in the exact center of the moon's shadow sees the moon centered on the sun but not quite big enough to cover it, so that a ring-like area of the sun's surface remains visible (Fig. 5.10). This is called an *annular eclipse* (from Latin *annulus* 'ring'); there was a spectacular annular eclipse in the United States on May 10, 1994.

Total eclipse

Annular eclipse

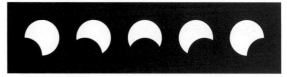

Any eclipse seen from outside the central path

Figure 5.10 **How solar eclipses look from earth. Any eclipse is partial if you are outside the path of totality or annularity.**

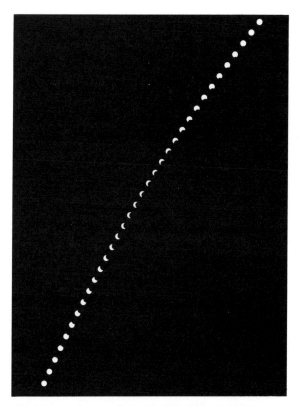

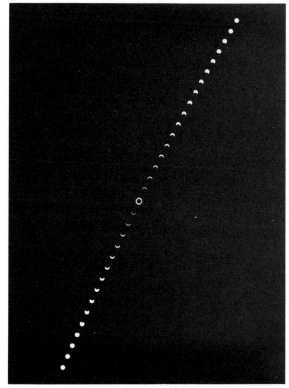

Figure 5.11 **Solar eclipse of 31 July 1981. Multiple exposures at 5-minute intervals with a Mamiya C330 camera (6×6-cm film format) on a fixed tripod with a 100-mm lens at f/16 and a filter of logarithmic density 4.0. Each exposure was 1/60 second on Ektachrome 64. (Akira Fujii)**

Figure 5.12 **The total solar eclipse of 16 February 1980, photographed from India. The setup and exposure were as for Fig. 5.11 except that totality was exposed for 1 second with no filter. (Akira Fujii)**

5.6 Eclipse safety

The bright surface of the sun, the *photosphere*, is bright enough to damage your eyes if you look at it directly or through a telescope. Only the *corona* – which is visible only during totality – can be safely viewed without a protective filter. Failure to take proper precautions can result in temporary or permanent blindness, and safety shouldn't be a matter of guesswork.

> NEVER *look at the sun through* ANY *optical instrument unless you are* SURE *it is equipped with filters that make it safe.*

Obeying this warning is a matter of know-how, not just common sense, for two reasons. First, *this type of eye injury is often painless*; you may not know at the time that you have suffered any permanent damage. What usually happens is that the injured person experiences a sensation of "dazzle" exactly like the normal (and harmless) afterimage from a photographer's flash, except that instead of disappearing after a few minutes, it gets worse and within a few days develops into a permanent blind spot. Even if you recover normal vision, how do you know your night vision is as good as it would otherwise have been? For obvious reasons, very few astronomers are willing to sacrifice any visual acuity at all.

Second, and perhaps more importantly, *the fact that the sun looks comfortably dim does not prove that a filter is safe.* You can't judge a filter by looking at it, because eye damage can be caused not only by visible light, but also by ultraviolet and infrared wavelengths just outside the visible spectrum. *Ordinary photographic filters, colored glass, colored plastic, and smoked glass transmit far too much infrared.* Filters are safe only if instrumental tests have shown that they cut infrared and ultraviolet radiation to a safe level.

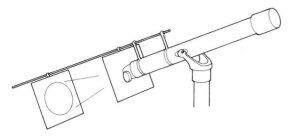

Figure 5.13 **Projecting the image of the sun with a refracting telescope. The first card, around the telescope, casts a shadow so the image on the second card is easy to see. *Do not use a reflecting or catadioptric telescope* – the secondary can overheat.**

This harsh warning needs to be tempered by a few words about keeping things in perspective. People sometimes say that "the only safe way to watch an eclipse is on television." This is simply not true; it is like saying that the only safe way to see the Grand Canyon is on a picture postcard because you might fall in if you visit it in person. Well-meaning authorities have sometimes frightened the public with exaggerated warnings, which become even more exaggerated in the minds of the hearers. Soon the children and even the dogs and cats are herded indoors, the windows are shut, and no one dares look at the sky.

The trouble with exaggerated warnings is that they aren't true, and they lead to dangerous incredulity. Optometrist B. Ralph Chou, an authority on eclipse safety, puts it this way (Chou 1997: 20–21):

> A student who heeds warnings from teachers and other authorities not to view the eclipse because of the danger to vision, and learns later that other students did see it safely, may feel cheated out of the experience. Having now learned that the authority figure was wrong ... how is this student going to react when other health-related advice about drugs, alcohol, AIDS, or smoking is given?

This point has also been made by Jay Pasachoff and other experts. Like most things, eclipse watching can be done dangerously or safely; with an eclipse, as with the Grand Canyon, it would be unfortunate to miss a spectacle of nature because of unrealistic fears.

5.8 PRACTICAL NOTE:
How eclipse eye injuries happen

Eye injuries from eclipse viewing are now uncommon, but a few still occur. Most victims are people whose reflexes are dulled by alcohol, sedatives, or pain medication, or people who are deliberately defiant ("I'm going to do it because they told me not to" – always a risk with large, poorly supervised groups of young people).

Injuries from improper filters are apparently rare; the word has gotten out, and if people use a filter at all, they generally use a safe one. Accidents with equipment, such as filters falling off, are always a possibility against which one should take careful precautions.

The August 1999 total eclipse will reach an unprecedentedly large population in countries whose news media have not dealt with eclipse safety before. Careful public education is in order. As Chou (1996) points out, information given to the public by the mass media is often inaccurate. The media often confuse totality with partial phases, and they sometimes say the eclipse *causes* the sun to emit some unusual kind of radiation. Astronomers giving interviews should insist that their viewing instructions be quoted complete and unaltered.

See also *Sky & Telescope*, April 1985, p. 315, and, for medical details, Chou and Krailo (1981) and Istock (1985).

5.9 BASIC TECHNIQUE 8:
Viewing a solar eclipse by projection

To view an eclipse of the sun, you don't have to look *at* the sun at all. There are two ways to project an image onto a piece of paper for indirect viewing. There is then no danger to the eyes, and many people can view the projected image at once.

One method is to use a telescope aimed at the sun (Fig. 5.13). Rack the eyepiece a little farther out than normal, and you'll get a sharply focused image on a card a few inches away. You'll probably see sunspots and faculae clearly.

Figure 5.14 **Shadow of the author holding a piece of paper with a 6-mm (1/4-inch) hole in it during a partial solar eclipse. The image of the hole takes on the shape of the partially eclipsed sun. (Melody Covington)**

Table 5.3 *Three ways of measuring the light transmission of a filter*

Percent transmission	Filter factor	Logarithmic density (D)
50%	× 2	0.3
25%	× 4	0.6
10%	× 10	1.0
1%	× 100	2.0
0.1%	× 1000	3.0
0.001%	× 100 000	5.0
0.0001%	× 1 000 000	6.0

Use extreme caution because the beam of light coming out of the eyepiece is extremely strong. If you hold a piece of paper in it, it will catch fire; I've heard of a British astronomer who lights his pipe this way. Do not use a reflecting or catadioptric telescope at all; the secondary mirror is likely to get warm, possibly coming loose from the mount to which it is cemented. *Cover the finderscope* so the crosshairs don't get burnt up.

The other method is simpler. Just punch a hole in a card, anywhere from pinhole sized up to perhaps a quarter of an inch (6 mm). Let sunlight shine through the hole and fall on a white surface some distance away – the distance should be something like 100 to 200 times the diameter of the hole. You'll see a bright spot that is the same shape as the visible part of the sun (Fig. 5.14). People are often surprised by the simplicity and effectiveness of this technique. (*Caution*: When told to punch a hole in a card, many people, including some newspaper reporters, immediately assume the next step will be to gaze at the sun through the hole, which of course is dangerous. Be sure no one falls victim to that misunderstanding.)

You can even do without the card. Just make a small opening with your finger and thumb, and let sunlight shine through it onto light-colored pavement or sand. You then have a safe, zero-cost, completely portable eclipse observing apparatus.

5.10 Safe solar filters

One of the most important characteristics of a sun filter is, of course, the extent to which it reduces the intensity of the light, and, as Table 5.3 shows, there are three ways of measuring this: as a percentage transmission, as a filter factor, and as a logarithmic density. These are related by the formulae:

$$\text{Filter factor} = 100 \div \text{percent transmission}$$

$$\text{Logarithmic density} = D = \log_{10}(\text{filter factor})$$

When two filters are combined, the filter factors multiply, but the logarithmic densities add; this is the main reason for using logarithmic densities. For example, a ×2 neutral density filter and a ×10 filter used together have a combined filter factor of 20 (= 2 × 10); expressing the same thing logarithmically, filters with densities of 1.0 and 0.3, used together, have a combined density of 1.3. Be sure not to confuse filter factors with logarithmic densities; a ×4 neutral density filter is a medium gray, while one with a density of 4.0 is so dark that nothing except the sun or a very bright light can be seen through it.

The surface of the sun is about 300 000 times as bright as an ordinary sunlit scene on earth; this means that in order to reduce its brightness to a comfortable level, you need a filter whose logarithmic density is about 5.5 (= \log_{10} 300 000). In practice, densities of about 4.0 to 6.0 are used (the lower densities on high-magnification telescopes and slow lenses that give an intrinsically dimmer image). The important thing is not so much the visual density as the density in the infrared and ultraviolet, which you can't see. A thorough set of sun filter safety tests has been conducted by Dr. B. Ralph

Table 5.4 *Safe and unsafe sun filters*

Safe	Metallic film filters designed for solar viewing and used as directed (best)
	Two or three layers of fully exposed and developed conventional black-and-white film
	No. 14 welder's glass
Unsafe	Photographic neutral density filters of any density
	All other combinations of photographic filters, including crossed polarizers
	Filters made of color film
	Filters made of chromogenic (silverless) black-and-white film, such as Kodak T400 CN, Ilford XP2, or Agfapan Vario-XL
	Smoked glass
	Any filter through which you can see things other the sun and bright electric lights
	Any filter located at the eyepiece end of the telescope, unless used with an unsilvered mirror or Herschel wedge
	Any filter not *known* to be safe

Chou of the University of Waterloo (Ontario) Optometry School (Chou 1981a, 1981b, 1998). Table 5.4 summarizes his results.

In particular, note that photographic neutral density filters (Wratten No. 96 or the like) are *not* safe to look through. This is a pity, since they come in a wide range of accurately regulated densities; they are perfectly satisfactory for solar photography, of course, provided you can find some way of aiming and focusing your camera without looking at the sun through it.

The cheapest way to get a safe sun filter is to take a roll of conventional black-and-white film, unroll it in daylight or full room light so that it is fully exposed, then develop and fix it in the normal manner and use two or three layers of the resulting black film as a sun filter. A 120 roll of Kodak Verichrome Pan or T-Max 100 makes a piece of black film about 6×75 cm ($2\frac{1}{4} \times 30$ inches). Other conventional black-and-white films are also suitable. You can develop the film in full room light, since it's fully exposed anyhow, or you can have it developed commercially. However, do not use color film or chromogenic black-and-white film.

The trouble with filters made of exposed film is that they aren't very good optically; they don't give sharp images with lenses longer than about 200 mm in focal length. The same is true of welder's glass. But excellent optical quality combined with first-rate eye protection can be obtained by using a filter that consists of thin coatings of metal on glass or plastic. Thousand Oaks filters are good; so are "Solar-Skreen" filters. The latter consists of two layers of Mylar plastic each of which has an aluminum coating on both sides, and it mounts in front of the telescope. Its only disadvantage is that it makes the sun look a peculiar electric blue color, but this is no real loss since the sun is a rather colorless object; for more realistic-looking color photographs, a No. 12 or 15 yellow filter can be added. Wrinkles in a Mylar filter do no harm; the filter should be somewhat loose in its mount and should be inspected before each use. A holder for a Mylar filter can be made out of a wooden needlepoint ring.

The importance of placing the sun filter in front of the telescope cannot be overstated. *A sun filter placed at or near the eyepiece is not safe*; the concentrated heat of the sun can crack or melt it, with disastrous results. This is true even if the telescope is quite small, since virtually all of the light that does not go into your eye has to be converted to heat within the filter. (Even giving the filter a shiny, reflective surface – as was commonly done a century ago – does not reduce heat absorption to a safe level.) The only safe way to use an eyepiece-mounted sun filter is to reflect the light off an unsilvered glass surface (a Herschel wedge) first – and even then, you have to deal with image degradation resulting from heat waves in the air inside the telescope. It's better to keep full sunlight out of the telescope altogether by using a front-mounted filter.

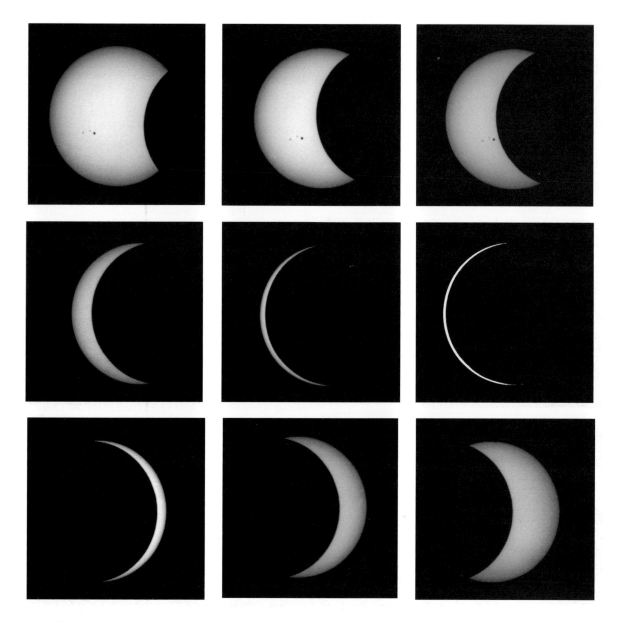

Figure 5.15 **The deep annular eclipse of 30 May 1984 photographed from Pendergrass, Georgia, with a 12.5-cm (5-inch) *f*/10 Schmidt–Cassegrain telescope and full-aperture Solar-Skreen filter. Each exposure is 1/30 second on Kodak Technical Pan film developed 6 minutes in HC-110 (D) at 20 °C. At mid-eclipse, almost all of the photosphere was covered, and shadow bands were seen on the ground. (By the author)**

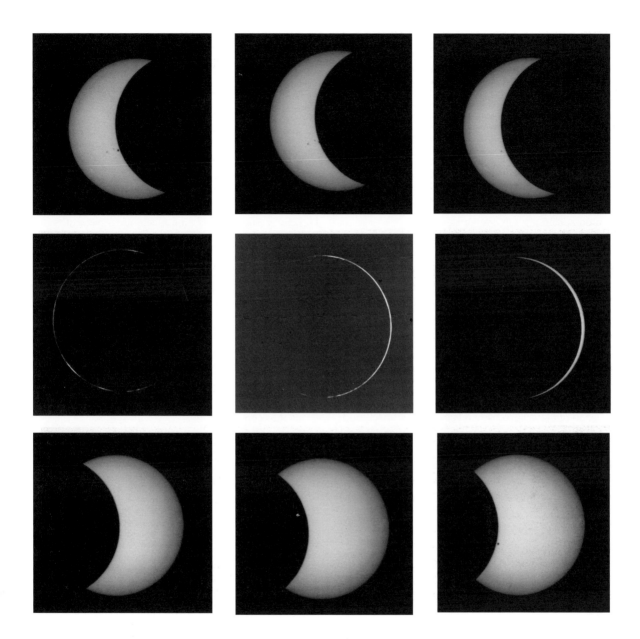

Figure 5.15 (cont.)

5.11 Photographing partial solar eclipses

Apart from filtration, the optical requirements for photographing the sun are the same as for photographing the moon – in fact, your eclipse-photography setup, minus the filter, can be tested on the full moon two weeks before the eclipse. The image sizes for the sun and the moon are exactly the same, and the exposure-time limits in Table 4.3 are equally applicable – though with the sun it is easy to keep exposures short by choosing filters of appropriate density.

Partial solar eclipses can be photographed on practically any kind of film. The exposure needed depends on the filtration used and can be determined in advance of the eclipse by practicing on the uneclipsed sun. In past years it was customary to take advantage of the sun's brightness and use extremely slow film for solar photography, but this strikes me as a bad idea – if your filtration is so light that you can photograph the sun on films significantly slower than what you would use without a filter for photographing the moon, then it probably isn't safe to look into the eyepiece.

There is one additional precaution that may not occur to you in advance, since the need for it arises only in the daytime: if you're using an afocal setup to photograph the sun, stray light has to be kept out of the space between the eyepiece and the camera lens. A convenient way to do this is to drape a piece of black cloth loosely around the camera and telescope after positioning them.

5.12 BASIC TECHNIQUE 9:
Photographing a partial solar eclipse

Equipment: SLR camera with long telephoto lens (300–1500 mm) or camera coupled to telescope, on steady tripod with cable release.

A reliable sun filter (Thousand Oaks, Solar-Skreen, or equivalent) must be mounted in front of the lens or telescope. *Do not use photographic neutral density filters;* in a pinch, use a piece of fully exposed and processed black-and-white film as described on p. 57. Cover the finderscope, if any.

Film: Almost any film will work, black-and-white or color. Because there is plenty of light, medium-speed films are usually used.

Procedure: Aim the telescope or camera at the sun and focus normally, then take the picture. (With a safe solar filter in place, you can look through the viewfinder in the normal manner.) Repeat every few minutes to show the progress of the eclipse.

Exposure: See tables in Appendix A, or determine exposures by experimenting on the uneclipsed sun. Exposures for the sun with a filter of density 6.0 are comparable to exposures for the full moon with no filter.

5.13 Solar eclipses – total

The totally eclipsed sun is at once an easy and a difficult photographic target – easy, in that many different equipment configurations, films, and exposures can give pleasing results, but difficult, in that no photograph can record all the coronal structure and color visible to the eye. The reason for this is that the corona is much brighter near the center than at the extremities. Your eye adjusts to this brightness variation automatically, but photographic film does not; if you expose for the outer corona, you overexpose the inner regions, whereas if you expose for the inner corona, you lose the outer parts completely (Plate 5.7). This makes it difficult to photograph more than a small amount of the

streamer-like structure that is so striking visually; but at the same time it ensures that any exposure within quite a wide range will be right for *some* part of the corona.

To photograph the corona you need a field of view somewhat wider, and hence a focal length somewhat shorter, than what you needed for the partial phases of the eclipse. The useful effective focal lengths with 35-mm film range from about 1500 mm, which covers about twice the diameter of the solar disk, down to 200 mm or so; even a 50-mm "normal" lens can be useful in recording the outermost parts of the corona. Suggested exposures are given in Appendix A. It goes without saying that no filters are needed for viewing or photographing the sun during totality, since the bright photosphere is completely hidden.

The best way to get a good picture of the corona is to use color negative film, then digitize the picture and perform unsharp masking by computer. That way, you can preserve detail in coronal streamers over a tremendous brightness range. Using conventional photographic technology, you can make, or get a custom lab to make, a dodged print in which the relative density of the inner and outer parts of the picture is adjusted by hand. It is possible to construct a special dodging mask to get the right amount of correction more or less automatically; for two ways of doing so, see *Sky & Telescope*, May, 1973, pp. 322–326. The same article describes a way to use an occulting disk inside the camera to establish a density gradient with much the same effect. The unsharp masking technique described in Chapter 11 may also be helpful.

Modern color negative films are all excellent and cover a wide brightness range; films in the 200 to 400 speed range are probably most suitable. Color slide films, though not quite as suitable, can also give good results; choose a relatively fast film with good exposure latitude, such as Kodak Ektachrome Professional E200 or Fuji Astia, and stay away from high-contrast materials. Nowadays almost no one photographs the corona in black and white, but if you choose to do so,

develop the film to slightly lower than normal contrast and plan on doing some dodging when you make the print.

The light of the corona is partly polarized, and it is interesting to take several pictures through a polarizing filter, changing the orientation of the polarizer for each exposure. Another peculiarity of coronal light is the region of reddish color that sometimes appears at about twice the diameter of the photosphere; its existence was disputed until Charles W. Wyckoff and Peter R. Leavitt photographed it on a special ultra-wide-range emulsion originally developed for the Apollo astronauts (*Sky & Telescope*, August, 1970, pp. 72–73). It is worth trying to photograph the red layer on conventional film, especially in view of the improvements in color film that have taken place since the early 1970s.

But the corona is not the only thing to take pictures of. At the beginning of totality, the thin sliver of photosphere that has been visible suddenly breaks up into a number of disconnected spots, called *Baily's beads*, which consist of light coming through the spaces between lunar mountains (Plate 5.5). Within a few seconds all of the spots disappear except one, and what remains is called the *diamond ring effect* (Plate 5.8), since the single gleaming bright spot together with the ringlike appearance of the inner corona look rather like a diamond ring in a jeweler's advertisement.

A moment later, the photosphere is hidden completely and the corona has come fully into view. But where there was a thin sliver of photosphere half a minute ago, there is now a thin, glowing, reddish sliver of something else – the *chromosphere*, a layer of ionized gas that lies between the photosphere and the corona. The chromosphere will likewise disappear from view within a few seconds, so the opportunity to capture it on film must be seized quickly. Finally, there are the *prominences* (Fig. 5.16, Plate 5.7(a)), great fountains of gas that glow red like the chromosphere but extend upward into the inner corona, usually high

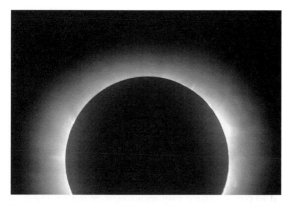

Figure 5.16 **The totally eclipsed sun, showing prominences and the inner corona. This is representative of what can be achieved at the prime focus of an amateur-sized telescope.** (Jay Pasachoff)

enough to remain visible throughout totality. At the end of totality the chromosphere, the diamond ring effect, and Baily's beads reappear in succession on the opposite edge of the moon.

The tables in Appendix A give suggested exposures for prominences; these should do equally well for the chromosphere. Exposures for Baily's beads and the diamond ring effect are hard to estimate in advance; use a slightly shorter exposure than for prominences, and hope for the best. Remember that the time to photograph Baily's beads and the diamond ring effect is at the *beginning* of totality, while you can safely continue looking into the eyepiece; when you see the first spot of photosphere reappear at the end, take your eye away from the viewfinder and put the sun filters back on quickly.

5.14 Shadow bands and other phenomena

There are also interesting things to see on the ground. Beginning about a minute before totality, and continuing until totality actually begins, the ground is covered with fast-moving parallel *shadow bands* a few inches wide, which reappear for an equal length of time at the end of totality. Shadow bands apparently result from irregular refraction in the earth's atmosphere.

Shadow bands are exceptionally hard to photograph because of their rapid motion and low contrast (there may be only a 1% difference in brightness between the bright and dark bands) and because the overall light level is constantly changing.

They are most easily seen and photographed on a bright white surface – ideally, a slide projector screen – which the sun's rays are striking as directly as possible. Use a fast film with good exposure latitude, such as one of the newer color negative films or chromogenic black-and-white films (Kodak or Fuji 400-speed print film for color, Kodak T400 CN or Ilford XP2 for black-and-white). Make the prints on high-contrast paper or increase the contrast digitally. Do not use a high-contrast film for the original exposure; it would not give enough exposure latitude.

The correct exposure for shadow bands is hard to predict; a rough guess is 1/250 second at $f/4$ (or 1/500 at $f/2$) on 400-speed film. An automatic exposure camera that measures the light level throughout the exposure, such as the Olympus OM-4T, can prove very helpful since it follows the changing light levels automatically; set the lens wide open and hope for the best. The scientific value of pictures taken with an automatic-exposure camera is increased if there is some way of determining what shutter speed the automatic mechanism has given you; one way to do so is to include in the picture an object moving at a known speed, such as a rotating disk, and measure how much of a blur it leaves on the film. The shadow bands themselves move too fast to be visible in exposures of more than 1/125 second, and much shorter exposures, on the order of 1/1000 second, are preferable.

There are interesting effects visible in the sky and on the horizon during totality. A fixed-tripod exposure of a large area of the sky (as in Chapter 2) will record the outer corona, a few bright stars, and any planets or comets that may be visible. (It is quite possible for a bright comet to be discovered during an eclipse, having been too close to the sun to be visible under ordinary conditions.) The horizon may appear orange or maroon in color, and the rapid motion of the zone of totality – which you can see coming at you out of the distance – is awe-inspiring.

5.15 BASIC TECHNIQUE 10:
Photographing a total solar eclipse

Equipment: SLR camera with long telephoto lens (200 to 1500 mm) or mounted at the prime focus of a telescope. A steady tripod and cable release are mandatory. Afocal setups that work well for photographing the moon (as in Chapter 4) are also suitable if used with care.

If you will be using a telescope on an equatorial mount, be sure you can set it up in the daytime – preferably by aligning on the stars the previous night, then reproducing its exact position by sighting on land objects. Compasses don't point directly north in all parts of the world. In a pinch, you can do drift-method alignment on the partially eclipsed sun prior to totality.

Film: Medium-speed or fast color film with wide exposure latitude. Kodak or Fuji 400-speed color print film is a good choice. Avoid excessively grainy films.

Procedure: Keep the front of the telescope or lens covered (or filtered) until totality begins. Then take pictures carefully but quickly. At the first sign of Baily's Beads or bright light on the western horizon, put the cover or filter back in place.

The entire setup can be tested on the full moon two weeks before the eclipse.

Exposure: See tables in Appendix A, and if possible, bracket widely.

5.16 Session planning

Totality is, of course, short; you are fortunate to have three or four minutes in which to take all your photographs. This means that things have to be

planned carefully and practiced in advance; make several "dry runs," without film, of the whole sequence of activities you plan to carry out during totality. It is best to plan on using only about 70% of the time you will actually have, since things will inevitably go wrong and slow you down. You may spend half of your three minutes looking for a dropped filter or something.

Wearing sunglasses for the last half hour before totality will help get your eyes dark-adapted. A tape recorder, playing a tape you have prepared in advance, can be useful for timing; you can prepare a verbal countdown so that you don't have to look at your watch to find out how many seconds of totality are left. This can be supplemented with another tape recorder to record your comments so that no time is lost writing things down. A camera with motorized film advance can save some time in making the exposures.

But don't get so busy taking pictures that you neglect the visual aspects of the eclipse. The pictures you take will probably look very much like the pictures hundreds of other people are taking at the same time, but neither your pictures nor theirs will capture the visual glory of the delicate coronal streamers or the feel of the sudden onrush of the moon's shadow. You can look at photographs any time; you may only see totality "live" for two or three minutes in your whole life.

5.17 Videotaping solar eclipses

Solar eclipses lend themselves very well to videotaping. During totality, the auto-exposure capability of the camcorder is a real boon. Most camcorders will zoom out to a long enough focal length to give a reasonably sized image.

For a partial eclipse, you can do a time-lapse videotape much as I did for a lunar eclipse (p. 50). Like the human eye, the CCD chip in the video camera needs careful protection against excessive amounts of infrared radiation, so photographic filters and crossed

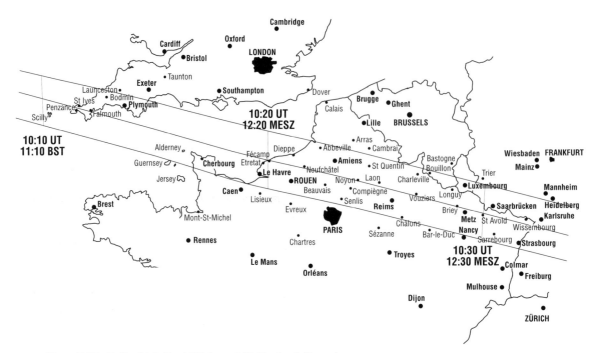

Figure 5.17 **Path of totality, 1999 August 11 (England, France).**

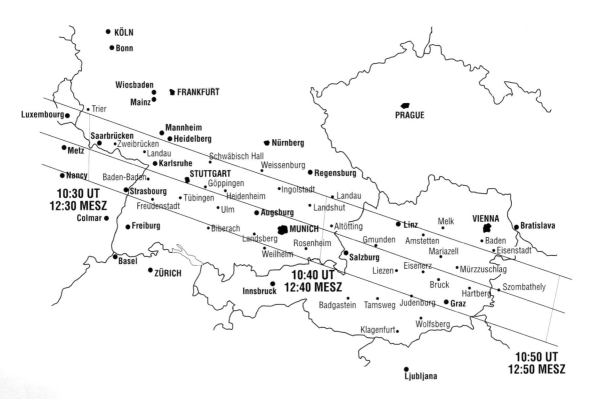

Figure 5.18 **Path of totality, 1999 August 11 (Germany, Austria).**

polarizers are not sufficient; use a proper sun filter or two layers of fully exposed and developed black-and-white film.

5.18 The 1999 total eclipse in Europe

On August 11, 1999, an unprecedented number of people in Europe, the Middle East, and India will see a total solar eclipse. The path of totality sweeps across Cornwall, barely misses Paris, and scores a direct hit on Stuttgart, Munich, and Bucharest. Figures 5.17 and 5.18 show the path of the eclipse in western Europe; weather prospects are better farther east, in Romania and Turkey. See Pasachoff and Covington, *The Cambridge Eclipse Photography Guide*, and NASA's guide (Espenak and Anderson 1997) for more information about this eclipse. Espenak and Anderson also give detailed maps of its path through the Middle East.

Never before has a total solar eclipse been within reach of so many serious amateur astronomers, and this should be the most widely observed and photographed eclipse that has ever occurred.

Advanced techniques

Part II

Coupling cameras to telescopes 6

How do you take a picture through a telescope? This chapter answers that question in detail, with optical diagrams and formulae for calculating effective focal length, image size, and f-ratio, as well as information about focusing techniques.

Most likely, not everything in this chapter applies to your equipment, so feel free to skim. If you're daunted by formulae, see p. 12.

6.1 Prime-focus astrophotography

The simplest way to take pictures through a telescope is to use the telescope objective as a camera lens. That is, remove the lens from the camera, remove the eyepiece from the telescope, and put the camera body on the telescope in place of the eyepiece (Fig. 6.1, top). The camera has to be an SLR or otherwise provide ground-glass focusing.

In this case the focal length F and f-ratio f are simply those of the telescope:

F = focal length of telescope objective

$f = F \div$ telescope aperture

That is, a 15-cm telescope of focal length 1200 mm (120 cm) has an f-ratio of 8 (abbreviated $f/8$).

Quite often you know the aperture and the f-ratio and you need to find the focal length. Use this formula:

$F = f \times$ telescope aperture

For example, the popular 20-cm (8-inch, 200-mm) $f/10$ Schmidt–Cassegrain has a focal length of $200 \times 10 = 2000$ mm.

In order for prime focus photography to work, the telescope has to provide adequate *back focus* (Fig. 6.3); that is, you have to be able to place the image plane at least 5 cm behind the end of the eyepiece tube. Whether you can do this depends on the type of telescope (Fig. 6.4). With refractors, Schmidt–Cassegrains, and Maksutov–Cassegrains, it's easy; with classical Cassegrains it's generally possible, but with

Newtonians there may not be enough back focus. The symptom is that you can focus on nearby objects, such as trees, but not on the sky.

To overcome the problem, you can modify a Newtonian telescope by moving the mirror mount a few centimeters forward from its original position in the tube. When this is done, it will then be necessary to insert a small extension tube when using eyepieces, to get them out to the new position of the image plane; a suitable extension tube can be made of $1\frac{1}{4}$-inch (35-mm) sink trap plumbing parts, available at any hardware store. It may also be necessary to enlarge the diagonal mirror to get full edge-of-field illumination with low-power eyepieces. You can also replace the focusing mount (eyepiece holder) with a special low-profile focuser that takes up less space, thus giving more back focus. On the whole, though, it may be more practical to leave the telescope unmodified and use one of the optical configurations that do not require much back focus, such as afocal or positive projection.

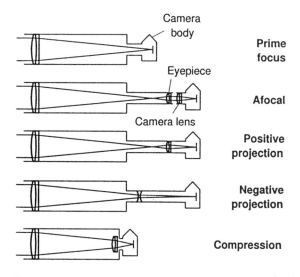

Figure 6.1 **The five basic ways to take a picture through a telescope.**

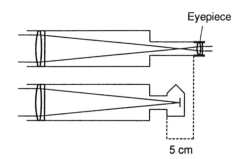

Figure 6.3 **A camera needs about 5 cm more back focus than an eyepiece.**

Figure 6.2 **No, this isn't the moon setting – it's Venus, photographed at the prime focus of a 32-cm (12.5-inch) telescope in exceptionally steady air. (Jim Baumgardt)**

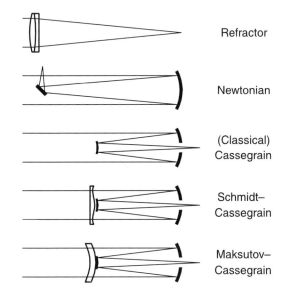

Figure 6.4 **Types of telescopes. Almost everything in this book applies to all five types, although the diagrams show the telescope as a refractor for clarity. The curvature of the Schmidt–Cassegrain corrector plate is greatly exaggerated here.**

Commercial prime-focus adapters are available for most telescopes; Fig. 6.6 shows how they fit together. If you have enough back focus and can tolerate a bit more vignetting, you can also use an eyepiece projection adapter with no eyepiece in it (Fig. 6.13).

The inside diameter of the eyepiece tube puts a limit on the size of the fully illuminated image on the film; it's obviously unreasonable to expect the image to be larger than the smallest tube it has to pass through, unless some trick is involved. Thus, prime focus photography with a standard $1\frac{1}{4}$-inch eyepiece tube produces a circular image that does not reach the corners of the 35-mm frame. To fill the frame, a telescope needs a 2-inch (5-cm) eyepiece tube, together with suitably large glare stops and other components. Schmidt–Cassegrains and Maksutov–Cassegrains use a coupling tube about 4 cm in diameter, and there is some vignetting at the corners of the field.

Vignetting is not a fatal drawback; it's often worst on the telescopes that have the best glare stops, evidence of the most careful optical design. Most telescopes are not designed to cover 35-mm film; they're designed to work with eyepieces whose lenses are seldom more than 2 cm in diameter. A vignetted image is simply an indication that the glare stops are doing their job.

6.2 Telescope types and optical limitations

Why are there so many kinds of telescopes? Because there are many different solutions to the fundamental

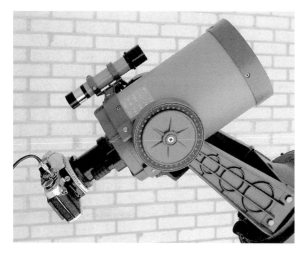

Figure 6.5 **Prime-focus astrophotography is the simplest kind – the telescope substitutes for the camera lens.**

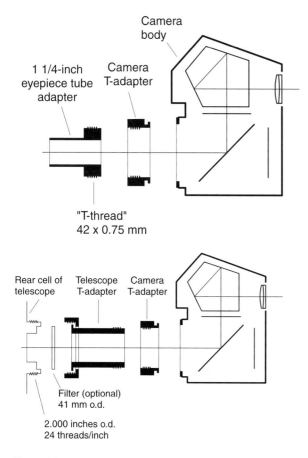

Figure 6.6 **Prime-focus adapters for a conventional eyepiece tube (top) and a Schmidt–Cassegrain telescope (bottom).**

optical problem of how to form good images, and – to paraphrase Kipling – "every single one of them is wrong," or at least imperfect. This is a good point at which to consider the challenges of optical design.

Because of the geometrical properties of light, no optical system, no matter how well manufactured, can form a perfect image of an extended object. There are six basic optical limitations on performance, or *aberrations*, that the telescope designer has to try to minimize:

astigmatism, a lack of circular symmetry that makes out-of-focus star images elliptical rather than round;

distortion ("pincushion" or "barrel"), which means that the magnification is not uniform across the field;

curvature of field, which means the image focuses on a curved surface rather than a flat one;

spherical aberration, which means the outer part of the lens has a different focal length than the center (Fig. 6.7);

coma, an off-axis aberration that makes stars look like teardrops or tiny comets rather than round spots; and

chromatic aberration, which means that the focal length is different for different wavelengths of light – causing stars to be surrounded by blue haloes (Fig. 6.8).

Figure 6.7 **Spherical aberration means the outer part of the lens does not have the same focal length as the center.**

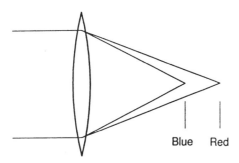

Blue Red

Figure 6.8 **Chromatic aberration means the focusing of light is affected by wavelength (color).**

In practice, astigmatism at the center of the field never occurs in well-manufactured telescopes; if you detect signs of it, check for poor collimation, misaligned optical elements, uneven temperatures within the telescope, a defective eyepiece, or uncorrected astigmatism in your eye. All telescopes show some astigmatism off-axis because, of course, a circle viewed obliquely is no longer a circle. *Most Schmidt– Cassegrains in use by amateurs are substantially out of collimation most of the time*; learn to make this simple adjustment and you can greatly improve your telescope.

Distortion and curvature of field are seldom serious in astronomical telescopes because of the narrow field of view. In Schmidt–Cassegrains, however, curvature of field is noticeable when you do photography at the prime focus.

The remaining aberrations – spherical aberration, coma, and chromatic aberration – are dealt with differently in each of the five major telescope designs.

Chromatic aberration is caused by *dispersion*. That is, the refractive index of glass – its ability to bend light – depends on wavelength. This is a problem only with refractors, which use glass to bend light; reflectors are immune to it.

To reduce chromatic aberration, a refractor uses a two- or three-element lens made of different kinds of glass whose dispersions roughly cancel out. If the total dispersion is exactly zero at two wavelengths, the lens is called an *achromat*; if at three, an *apochromat*. The curvature of the lenses is chosen to correct for coma and spherical aberration as well, and the newest refractors, using ED (extra-low-dispersion) glass, outperform all other types of telescopes.

Achromats for visual use are not necessarily ideal for photography. Visual achromats are designed for zero chromatic aberration at 486 nanometers (deep blue)

and 687 nanometers (deep red), at opposite ends of the visual spectrum, so that the image as seen by the eye is practically perfect.

Below 486 nm, in the violet and ultraviolet regions, chromatic aberration is still present in full force – and it is in this range that photographic films are most sensitive. The remedy is to add a yellow filter, such as a Wratten #8, #12, or #15, to eliminate deep blue, violet, and ultraviolet light; the problem then disappears, and the images look as good to the film as to the eye, though some light is lost. Older "photographically corrected" achromats are not the solution; they were corrected for 405–486 nm, ideal for the old blue-sensitive plates but not for modern panchromatic or color films. Best of all, use a modern apochromat if you can afford it.

The Newtonian reflector is immune to chromatic aberration, since the light never passes through glass, and is corrected for spherical aberration by making the main mirror a paraboloid. Its main problem is coma, which can be severe at short f-ratios. The size of the coma-free central area is given by this formula:

$$\text{Diameter of coma-free area (mm)} = f^2/2$$

This assumes a minimum resolution of about 40 lines per millimeter, the usual criterion for 35-mm photography; more coma is tolerable on larger-format film. If you're working with a CCD, you can make do with a smaller coma-free area, but you can also tolerate less coma.

As Table 6.1 shows, an $f/10$ or slower Newtonian is practically coma-free over the entire 35-mm field; an $f/8$ is coma-free over as much of the image as can get through a standard-size eyepiece tube; but $f/6$ and faster telescopes are coma-free only over small areas. This explains why ultra-fast Newtonians are suitable only for low-power observing or deep-sky photography in which maximum resolution of fine detail is not necessary. It also underscores the need for

Table 6.1 *Size of coma-free image in Newtonian or classical Cassegrain*

f-ratio	Diameter of sharp image (mm)
f/3.3	5.4
f/4	8
f/5	12.5
f/6	18
f/8	32
f/10	50

precise collimation: if what looks like the center of the field of an $f/4$ telescope is actually off axis by just a centimeter, coma will be severe.

Coma in fast Newtonians can be eliminated by adding a corrector lens near the film; Lumicon and Tele Vue offer these corrector lenses as commercial products. Large observatories use correctors routinely. That's how the 508-cm (200-inch) $f/3.3$ telescope on Palomar Mountain manages to produce sharp images on 4×5-inch plates; without the corrector, its coma-free image area would cover only a few millimeters.

Classical Cassegrains work very much like Newtonians, and Table 6.1 applies to them, but the f-ratio is generally so high that coma is not a concern. In fact, the appeal of the Cassegrain is its compactness; an $f/15$ telescope has a tube only four times as long as its aperture. The optical system consists of a paraboloidal primary mirror plus a hyperboloidal secondary that multiplies the effective focal length by four or five. The classical Cassegrain is ideal for lunar and planetary work. Some telescopes can be used as both Cassegrains and Newtonians (at very different f-ratios, of course) by changing the secondary mirror.

The Schmidt–Cassegrain is even more compact than the classical Cassegrain and cheaper to manufacture because both mirrors are spherical. It eliminates spherical aberration by means of a glass corrector plate with an unusual shape, shown greatly exaggerated in Fig. 6.4 – in reality, it's almost flat. This plate can be made by deforming a flat plate with a vacuum, polishing it flat again, and removing the vacuum. Thus, Schmidt–Cassegrain telescopes are well suited to mass production. Because commercial Schmidt–Cassegrains focus by moving the primary

mirror forward and backward, and this movement is magnified by the secondary, these telescopes provide an enormous range of back focus, making prime focus photography easy.

At the center of the field, the Schmidt–Cassegrain is essentially aberration-free, but coma and curvature of field are severe – in fact, the sharp image area of an $f/10$ Schmidt–Cassegrain is comparable to that of an $f/5$ Newtonian or classical Casssegrain. Although the image formed by a commercial Schmidt–Cassegrain fills a 35-mm frame, it is critically sharp only in the central area. Still, Schmidt–Cassegrains are unusually versatile and portable telescopes.

The Maksutov–Cassegrain gets rid of spherical aberration in a different way, by using a thick corrector with two spherical surfaces, and in addition, some commercial models aspherize one or both mirrors; for example, the Meade 7-inch (18-cm) uses an aspherical primary. Optical performance is excellent, reportedly much better than that of comparable Schmidt–Cassegrains, and for mechanical reasons, the telescope holds its collimation well, going for years without adjustment. The famous Questar, the Celestron C90, and the Meade ETX are also Maksutov–Cassegrains.

For detailed information on telescope design and optical performance, see Rutten and van Venrooij, *Telescope Optics* (1988). Their book includes a detailed analysis of a typical commercial 20-cm $f/10$ Schmidt–Cassegrain telescope, together with a number of Maksutov–Cassegrain designs of varying quality, none of which appears to match a commercial product exactly. They also cover Newtonians, Cassegrains, other types of telescopes, eyepieces, and corrector lenses.

6.3 Image size and field of view

Because the sky appears to be an infinite distance away, the apparent sizes of celestial objects are expressed as angles rather than linear distances; the

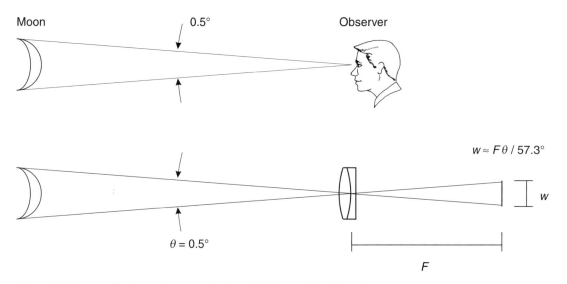

Figure 6.9 **Image size depends on angular size of object and focal length.**

observer's eye, or the center of the telescope objective, is the vertex of the angle, as shown in Fig. 6.9. The units used for measuring angles are the following:

1 degree (1°) = 60 arc-minutes (60′)

1 arc-minute (1′) = 60 arc-seconds (60″)

1 *radian* = 57.3 *degrees*
= 3438 *arc-minutes*
= 206 265 *arc-seconds*

The lower part of Fig. 6.9 shows what is involved in calculating the width, w, of the image that an object whose apparent diameter is θ will form on the film when the effective focal length is F. (We say *effective* focal length because if you're not photographing at the prime focus, the effective focal length of the optical system is not the focal length of the telescope.)

The precise formula, derived from basic trigonometry, is:

$$w = 2F \tan(\theta/2)$$

But the formula can be simplified by noting that, with the small angles involved in astrophotography, the tangent of any angle θ is very close to the value of θ itself in radians; the difference is less than 1% for angles as large as 19°. The simpler formulae are as follows:

$w = F \times \theta$	(θ in radians)
$w = (F \times \theta)/57.3$	(θ in degrees)
$w = (F \times \theta)/3438$	(θ in arc-minutes)
$w = (F \times \theta)/206\,265$	(θ in arc-seconds)

(F and w are always in the same units, usually millimeters.) The apparent diameter of the moon is just over 30′, and that of Jupiter averages about 40″, giving two easy-to-remember rules of thumb:

Moon image size $= F/110$
Jupiter image size $= F/5000$

where, again, F and the image size are expressed in the same units. It is not hard to remember the size of other objects by comparing them to the moon or Jupiter.

But what do you do if you know the image scale and you want to know the focal length? There are two situations in which such a question can come up: deciding what focal length to use to photograph a particular object, or calculating the effective focal length of your telescope from the size of the image of an object of known angular dimensions. (The second situation is common with projection setups where the lens positions are not known precisely.) The exact formula in such a case is:

$$F = w/2 \tan[(\theta/2)]$$

and, just as before, it can be simplified:

Table 6.2 *Field of view, moon image size, and Jupiter image size as a function of focal length*

Focal length (mm)	Field of view (35-mm film)	Moon image size on film (mm)	Jupiter image size (mm) on film	on ×15 enlargement
400	3.4° × 5.2°	3.6	–	–
500	2.7° × 4.1°	4.5	–	–
600	2.3° × 3.4°	5.4	–	–
800	1.7° × 2.6°	7.3	–	–
1000	1.4° × 2.1°	9.1	0.2	3.0
1250	1.1° × 1.7°	11	0.25	3.8
1500	0.9° × 1.4°	14	0.3	4.5
2000	41′ × 62′	18	0.4	6.0
2500	33′ × 50′	23	0.5	7.5
3000	28′ × 41′	27	0.6	9.0
4000	21′ × 31′	36	0.8	12
5000	17′ × 25′	45	1.0	15
6000	14′ × 21′	55	1.2	18
8000	10′ × 15′	73	1.6	24
10 000	8.3′ × 12′	91	2.0	30
15 000	5.5′ × 8.3′	136	3.0	45
20 000	4.1′ × 6.2′	182	4.0	60

$F = w/\theta$ (θ in radians)
$F = 57.3 \times (w/\theta)$ (θ in degrees)
$F = 3438 \times (w/\theta)$ (θ in arc-minutes)
$F = 206\,265 \times (w/\theta)$ (θ in arc-seconds)

The exact angular sizes of the moon and planets on a given date can be obtained from the *Astronomical Almanac*. Brief exposures of bright double stars of known separation are also useful for measuring focal length; for data on particular stars, see Burnham's *Celestial Handbook*.

Last, consider how wide an angular field the picture will cover (assuming the eyepiece tube leaves the film fully illuminated). This is equivalent to asking how big an object has to be – in angular terms – in order for its image to stretch from one edge of the film to the other; we therefore set w equal to the width of the picture area on the film and solve for θ. The precise formula is:

$$\theta = 2\arctan[w/(2F)]$$

The simplified versions, which are accurate to within 1% when F is at least 1000mm, are:

Field of view $= w/F$ radians
$\qquad = 57.3 \times (w/F)$ degrees
$\qquad = 3438 \times (w/F)$ arc-minutes
$\qquad = 206\,265 \times (w/F)$ arc-seconds

Here w is the width of the film, 24 mm for the short side of a 35-mm frame and 36 mm for the long side.

Table 6.2 summarizes the field of view and image sizes for the moon and Jupiter, the latter both on the film and on a ×15 enlargement, for a variety of effective focal lengths ranging from those of telephoto lenses to those used in high-resolution planetary photography. The same values apply to any given effective focal length whether it is obtained at the prime focus or by positive projection, negative projection, or any other method.

6.4 Afocal coupling

Unlike prime-focus photography, afocal coupling works with any telescope and almost any camera. The camera need not be an SLR, and the telescope need not have

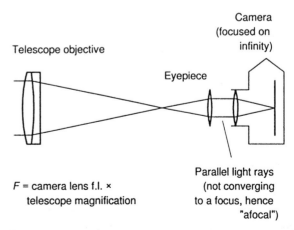

F = camera lens f.l. × telescope magnification

Telescope objective

Eyepiece

Camera (focused on infinity)

Parallel light rays (not converging to a focus, hence "afocal")

Figure 6.10 Afocal coupling. The camera, with its lens in place, is aimed into the telescope with its eyepiece in place.

Figure 6.11 **The exit pupil is the bright spot you see when you look at the eyepiece from some distance away. For afocal coupling, the exit pupil must fit within the camera lens opening.**

any more back focus than is needed for visual observing. We introduced afocal coupling in Chapter 4; this section will work out the theory of it in detail. Optics enthusiasts will note that afocal coupling is actually a special case of positive projection, where the eyepiece and camera lens together serve as the projection lens.

When coupled afocally, the eyepiece and camera lens are working at the optical image distances for which they were designed to give best performance. Moreover, the camera and telescope can stand on separate tripods, completely eliminating any transfer of vibration from the camera shutter to the telescope. Alternatively, the camera can be mounted on the telescope with a suitable bracket; a number of designs for homebuilt camera mounts are given in Sam Brown's *All About Telescopes*, pp. 60–61. A custom-

built camera mount can also solve the vexing problem of how to get the camera lens centered relative to the eyepiece.

The basic formulae for afocal photography are as follows. The overall effective focal length, F, is:

$$F = \text{focal length of camera lens} \\ \times \text{magnification of telescope}$$

Alternatively, you can use a formula also applicable to positive and negative projection systems,

$$F = F_1 \times M$$

where F_1 is the focal length of the telescope objective by itself and M is the projection magnification, which you get from this formula:

$$M = \text{camera lens focal length} \\ \div \text{eyepiece focal length}$$

As you might guess, there are other formulae for M with different projection setups.

The f-ratio is still F divided by the telescope aperture, and there are two ways to calculate it:

$$f = F \div \text{diameter of telescope objective} \\ = f_1 \times M$$

where f_1 is the f-ratio of the telescope by itself. That is, M multiplies not only the focal length but also the f-ratio. This holds true for all projection setups.

You can do afocal photography with any kind of eyepiece, but eyepieces that give ample eye relief are best. (Eye relief is the distance between your eye and the eyepiece.) Orthoscopic, symmetrical, and Plössl eyepieces work well; the new long-eye-relief eyepieces from Vixen and others are especially useful. Ideally, the diaphragm of the camera lens should be located at the exit pupil, but in practice the construction of the lens almost always makes this impossible, and the lens therefore only sees the middle of the field.

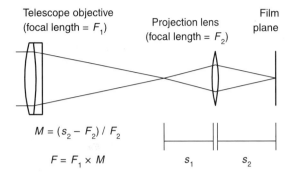

Figure 6.12 **Positive projection. If the projection lens is an eyepiece, measure s_2 from the middle of eyepiece lens group to the film.**

A few eyepieces give so much eye relief that you can put the camera too close and lose part of the field of view; experiment by photographing trees or distant mountains to find out what camera position gives the least vignetting.

The camera normally has a normal or medium telephoto lens; nothing is gained by using a wide-angle lens, since the eyepiece limits the field of view, and even if you're using a wide-angle eyepiece, you can't get close enough to take advantage of its wide field. The camera lens should always be wide open to allow for errors of centering.

Note that M can be less than 1; that is, you can use the afocal method to decrease rather than increase the system focal length. An afocal system with $M = 0.17$ has been used with the 82-inch $f/12$ Cassegrain at McDonald Observatory to yield effective $f/2$; it consists of an ordinary Leitz Summicron camera lens fed by a specially constructed giant eyepiece (Meinel 1956). This is rarely the best way to reduce the f-ratio of an amateur telescope, but it's worth keeping in mind. The objective lenses from a pair of junked 7×35 binoculars, placed with their more curved sides together, make an 80-mm symmetrical eyepiece. Together with a 50-mm camera lens, this gives you $M = 0.63$. Giant eyepieces can give prodigious amounts of eye relief; experiment to find the best camera position.

6.5 Positive projection

Positive projection is what happens when you use positive (convex) lens to form an enlarged image of an image. The telescope forms an image at its prime focus, and that image is reproduced, larger, by the projection lens. Figure 6.12 shows how the optical system works.

The positive projection lens is almost always an eyepiece, and positive projection is then known as *eyepiece projection*. Commercially made adapters for eyepiece projection are popular; Fig. 6.13 shows how they work.

Theoretically, the projection magnification M is equal to the ratio of the two distances s_1 (image to projection lens) and s_2 (projection lens to film):

$$M = s_2/s_1$$

In practice you usually don't know s_1; the known parameters are s_2 and the focal length of the eyepiece or other projection lens, F_2. In this case the formula is:

$$M = (s_2 - F_2)/F_2$$

or, if you want to find the appropriate lens-to-film distance to get a particular magnification,

$$s_2 = F_2 \times (M + 1)$$

Given M, the effective focal length and f-ratio of the whole system can then be calculated from the same formulae as with the afocal method:

$$F = F_1 \times M$$
$$f = F/D = f_1 \times M$$

Finally, s_1, should you ever need it, is given by:

$$s_1 = s_2/M$$

Notice the relationship between s_2 and F_2:

$$2F_2 < s_2 \qquad M > 1$$
$$F_2 < s_2 < 2F_2 \quad M < 1$$
$$s_2 < F_2 \qquad \text{No image is formed}$$

Note also that s_1 has to be greater than F_2; it would be equal to F_2 if the positive lens were being used as an eyepiece rather than a projection lens. That means that when you use an eyepiece for projection, you rack it

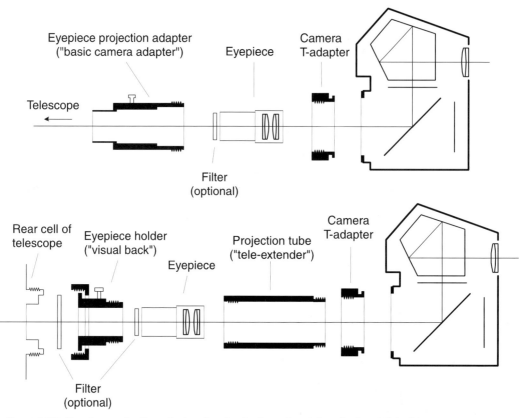

Figure 6.13 **Eyepiece projection adapters for standard eyepiece tubes (top) and Schmidt–Cassegrain telescopes (bottom).**

outward from its usual position. Back focus is therefore not a problem, and positive projection works well even with Newtonians.

Let's work out a concrete example. Suppose you're using a 15-cm (6-inch) $f/8$ reflector (aperture 150 mm, focal length 1200 mm), and the projection lens is an 18-mm eyepiece placed 75 mm (three inches) from the film. Here's how to compute M:

$$M = (s_2 - F_2)/F_2 = (75 - 18)/18$$
$$= 57/18 = 3.167$$

That is, the projected image is a bit more than three times the size of the image at the prime focus. Now that you know M, find the overall effective focal length and f-ratio as follows:

$$F = F_1 \times M = 1200 \times 3.167 = 3800 \text{ mm}$$

$$f = f_1 \times M = 8 \times 3.167 = 25.3$$

That is, the overall system has an effective focal length of 3800 mm and operates at $f/25.3$.

What kind of eyepiece is best for positive projection? Obviously, one that fits in the adapter – eyepieces with large-diameter barrels won't. Beyond that, the eyepiece should be one that works well with the same telescope visually. Plössl eyepieces work well, as do orthoscopics. Wide-angle eyepieces are not needed (which is fortunate, because they don't fit in the adapter). Instead, choose one that gives a flat field and crisp images. Field flatness is particularly important because positive projection generally increases curvature of field – unlike negative projection, which reduces it. But some eyepieces cancel out the field curvature of Schmidt–Cassegrain telescopes.

At low values of M, the eyepiece may display aberrations that are not evident in visual work. The higher the value of M, the closer s_1 gets to the image distance for which the eyepiece was designed, so that

Figure 6.14 **Positive projection is usually the best way to get high magnification for lunar and planetary work. A 20-cm (8-inch) $f/10$ Schmidt–Cassegrain telescope, ×11 projection with a 9-mm orthoscopic eyepiece giving $f/110$. A two-second "hat trick" exposure on Kodak Ektachrome Elite II 100 pushed 1 stop. (By the author)**

short side is whichever side originally worked at a shorter distance from the object or image. For example, a microscope objective is designed to be placed much closer to the specimen than to the microscope eyepiece. That means the specimen side of it is the short side. Similarly, the short side of a movie camera lens is the side that originally faced the film.

The projection lens should be large enough in diameter to catch all the incoming light rays; specifically,

$$f\text{-ratio of projection lens} < f_1[M/(M+1)]$$

where f_1 is the f-ratio of the telescope objective. With a microscope objective,

$$\text{minimum N.A.} > 0.5/f_1$$

where N.A. stands for "numerical aperture." Microscope objectives have good resolution at the center of the field, but the cheaper ones are not corrected for chromatic aberration or field curvature. To get an objective with both of these corrections, look for a "plan-achromat."

the visual performance of an eyepiece is a good indication of how it will perform as a projection lens at high M.

The projection lens need not be an eyepiece at all. Some astronomers have gotten good results with microscope objectives, movie camera lenses, or even short-focal-length enlarger lenses. Lenses salvaged from subminiature cameras or movie cameras are well worth trying since they cover a small field with high resolution. Be wary of video camera lenses and lenses from projectors; they generally are not sharp.

Any positive lens that has high resolution and works well at appropriate values of s_1 and s_2 is worth trying. Because $s_1 < s_2$, the "short side" of the projection lens should face the telescope objective. The

6.6 PRACTICAL NOTE:
Measuring s_2 for eyepiece projection

The most common question about eyepiece projection is, "What do I measure? How do I get the distance s_2?"

Theoretically this is the distance from the film plane to the nearer principal plane of the eyepiece. In practice you can measure from the film plane (marked ⦵ on the camera body) to the middle of the group of lenses in the eyepiece. You don't need sub-millimeter precision, since other parameters – especially the eyepiece focal length – are accurate only to within a few percent.

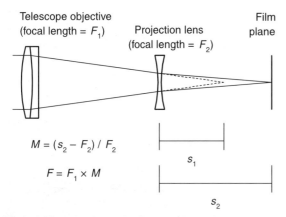

$$M = (s_2 - F_2) / F_2$$

$$F = F_1 \times M$$

Figure 6.15 **Negative projection.**

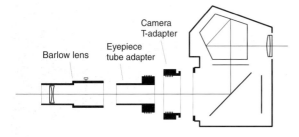

Figure 6.16 **Negative projection with a Barlow lens.**

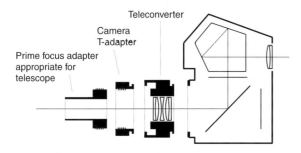

Figure 6.17 **Negative projection with a teleconverter.**

6.7 Negative projection

Another popular setup involves placing a negative (concave) lens in the path of the light coming from the telescope; it makes the image larger and the effective focal length longer (Fig. 6.15).

The negative lens is usually either a Barlow lens, the same as you'd use visually with an eyepiece (Fig. 6.16), or a teleconverter designed for use with telephoto lenses (Fig. 6.17). The back focus

requirements are about the same as for prime focus photography, except that with a Barlow lens pushed deep into the eyepiece tube, you can sometimes use an unmodified Newtonian.

The formulae for negative projection are the same as those for positive projection (repeated here for convenience) as long as you remember that *the focal length of a negative lens is a negative number.*

$$M = s_2/s_1 = (s_2 - F_2)/F_2$$

$$F = F_1 \times M$$

$$f = F/d = F_1 \times M$$

$$s_1 = s_2/M$$

In practice, teleconverters are rated to give specific values of M when mounted on the camera. For example, a ×2 teleconverter gives $M = 2$. With Barlow lenses, M is somewhat greater than what it would be with an eyepiece; for example, a ×2 Barlow will probably give $M = 3$ to 4.

Here is a concrete example. Suppose that the telescope is a 15-cm (6-inch) $f/8$ reflector of 1200 mm focal length (as in the previous example), and the projection lens, of −45 mm focal length, is located 75 mm from the film. Then:

$$M = [75 - (-45)]/(-45) = 120/(-45) = -2.67$$

M comes out negative because the magnified image is on the same side of the lens as the original image; its negative sign should be ignored in the subsequent formulae, giving $F = 1200 \times 2.67 = 3200$ mm and $f = 8 \times 2.67 = 21.4$.

Not surprisingly, s_1 also comes out negative − again, because it is measured on the same side of the lens as s_2, rather than on the opposite side − and in the present example it is:

$$s_1 = s_2/M = 75/(-2.67) = -28.1 \text{ mm}$$

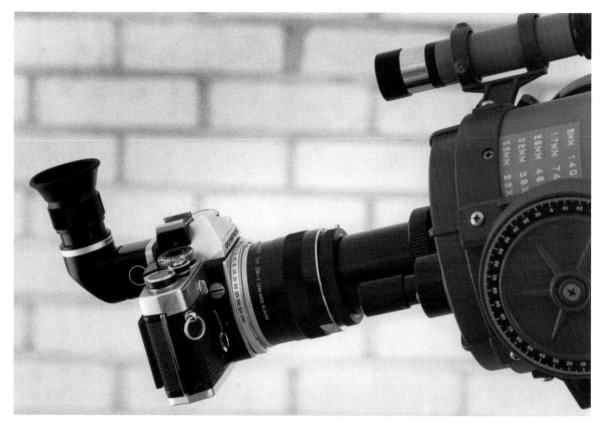

Figure 6.18 **Negative projection setup is almost as simple as prime focus – just add a teleconverter. Note the Olympus Varimagni Finder on the camera.**

With negative projection setups, the value of s_1 is always between zero and F_2 and magnifications of less than 1 are not possible. Ignoring the negative sign, s_1 of course represents the amount of back focus required by the setup – never zero, but often small enough to make it practical to use an unmodified Newtonian telescope, particularly if the projection lens can be placed inside the eyepiece tube.

Negative projection tends to reduce curvature of field. This gives it an advantage with Schmidt–Cassegrain telescopes. My experience has been that teleconverters are better than Barlow lenses, at least for small values of M; after all, they're designed to cover the whole 35-mm frame. (However, some of the cheaper ones have annoying internal reflections.) You can increase M by putting an extension tube between the teleconverter and the camera.

There are several ways to find the focal length of a negative projection lens. To begin with, if you know the rated magnification and the lens-to-film distance s_2 (or, in the case of a Barlow designed for visual work, the distance from the lens to the field stop of the eyepiece), you can use the formula

$$F_2 = s_2/(M + 1)$$

(remembering that M is negative). Alternatively, you can determine the focal length of any negative lens using only a ruler and a magnifying glass, using the following procedure:

1 Find the focal length of the magnifying glass by using it to form an image of the sun (or some other distant object) on a piece of paper and measuring the distance from the lens to the paper. Call this distance F_P.

2 Place the negative lens and the magnifying glass in contact with each other to find out which of the two is stronger. If the combination acts as a magnifying glass, go to step 3; if it acts as a reducing glass, go to step 4.

Telescope objective
(focal length = F_1) Compressor lens
(focal length = F_2)

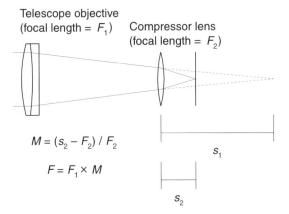

3 Determine the focal length of the combination
using the same technique as in step 1; call it F_C
(a positive number). Then apply the formula

Focal length of negative lens $= (F_P \times F_C)/(F_P - F_C)$

Here $F_P - F_C$ is negative.

$$M = (s_2 - F_2) / F_2$$

$$F = F_1 \times M$$

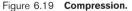

Figure 6.19 **Compression.**

4 Use the negative lens and the magnifying glass to
make a Galilean telescope. That is, hold the
negative lens to your eye, hold the positive lens
next to it, and slowly move the positive lens away
until you get a clear, magnified view of distant
objects. Measure the separation of the two lenses
when the image is in focus; call it s. Then:

Focal length of negative lens $= s - F_P$

Here s is always less than F_P, so $s - F_P$ is
negative.

A negative achromat to be used as a projection lens
should be placed with the flatter side away from the film
to minimize aberrations.

6.8 Compression (focal reducers)

Compression (Fig. 6.19) is the opposite of negative
projection; it's what happens when you insert a positive
rather than a negative lens into the converging cone of
light from the objective. Compression makes the image
smaller and brighter, so it's widely used in deep-sky
photography. Commercially made compressor lenses
(focal reducers) also flatten the curved field of Schmidt–
Cassegrain telescopes. Plate 6.1 shows what can be
achieved.

Figure 6.20 shows exactly what compression does
– it takes the same image and makes it smaller. That's
why some vignetting at the edge of the field is inevitable
(except perhaps with Lumicon's oversize compressors
on large telescopes). The goal of compression is to put a

Figure 6.20 **A compressor lens takes the same image and
makes it smaller; vignetting is almost inevitable since the
true field of the telescope does not increase. These
example pictures were taken with a Celestron 5 and a ×0.63
compressor lens.**



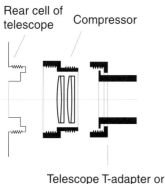

Figure 6.21 **Using a commercial focal reducer (compressor lens).**

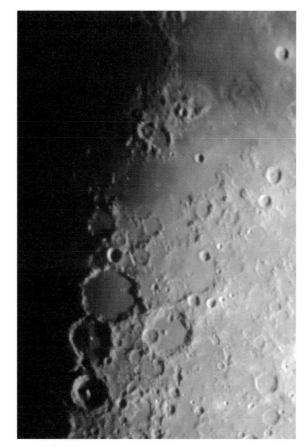

Figure 6.22 **Lunar photography with cascaded ×2 and ×3 teleconverters on a 20-cm (8-inch) f/10 telescope, giving f/60. Fuji Sensia 100 film, auto exposed with Olympus OM-4T camera. A glare spot is faintly visible in the center.**

small, bright image in the middle of the film; never mind what happens at the corners. Unfortunately, severe aberrations at the very edge of the field make it hard to use an off-axis guider.

The formulae for compression are exactly the same as for negative compression, except, of course, that F_2 is positive. (M and s_1 are still negative because the compressor lens does not form its own image.)

But in practice you seldom need to do any calculations. Meade and Celestron market commercial focal reducers (compressor lenses) with $M = 0.63$ (Fig. 6.21). Thus they turn $f/10$ telescopes into $f/6.3$ systems, suitable for wide-field viewing and photography, and they turn $f/6.3$ telescopes into fast $f/4$ systems. The Meade and Celestron products are four-element systems and were designed specifically to match Schmidt–Cassegrain telescopes; Di Cicco (1991) gave them a glowing review, and my own experience bears this out. Lumicon and other companies also offer commercial focal reducers, occasionally called "telecompressors."

The goal of compression is to shorten the exposures for deep-sky objects, or to capture fainter objects in the same exposure time, or, sometimes, to fit a large celestial object onto the small field of a CCD. Because exposure time is proportional to the square of the f-ratio, a ×0.63 compressor shortens exposures by a factor of $0.63^2 = 0.4$, reducing the exposure time to 40% of what it would have been without compression. With most films, because of reciprocity failure, the actual benefit is even greater.

Compression requires more back focus than any other setup; for this reason, it's usable only with Schmidt–Cassegrains, Maksutov–Cassegrains, and

some refractors. The back focus required is always greater than what would be needed for prime focus photography, by a factor of $1/M$.

Rutten and van Venrooij (1988: 152–154) analyze compressor lenses in detail. If you want to make your own, try a salvaged binocular objective.

6.9 Combinations of projection setups

It's sometimes advantageous to use two or more of these optical configurations in cascade. For example, one of my favorite setups is what I call "double negative projection," with a ×2 teleconverter feeding a ×3 teleconverter for a total $M = 6$. (With bright moonscapes, this setup has some internal reflections, but it's fine for planetary work.) Another possibility is to

put a Barlow lens ahead of a teleconverter or an eyepiece projection adapter. Yet another good combination is a Barlow lens with a relatively long-focal-length eyepiece (say 32 mm) for afocal photography. Experiment, and find out what works.

To do the calculations for a combined projection setup, first compute the effect of the first projection lens, positive or negative; then use the resulting effective focal length instead of F_1 in the calculations for the next step in the system.

6.10 Diffraction-limited resolution

If light always traveled in straight lines, as the idealizations that underlie geometrical optics assume that it does, the resolving power of a telescope would be limited only by uncorrected aberrations and manufacturing tolerances. In reality, however, light – like waves in a pond – shows a detectable tendency to bend around corners. This bending is called *diffraction* and is noticeable only with very narrow apertures or very high magnifications. The larger the telescope, the less diffraction affects the quality of the image; this is why larger telescopes show more fine detail, at a given magnification, that do smaller telescopes.

The resolving power of a telescope is traditionally equated with the *Rayleigh limit*, i.e., the angular separation of two stars whose images are seen as just touching, given by the formula:

Rayleigh limit (in arc-seconds) = 0.0252
 × (wavelength in nm ÷ aperture in cm)

The human eye is most sensitive to light at a wavelength of 550 nanometers; most photographic films are most sensitive at about 400 nm (allowing for the ultraviolet-absorbing properties of glass). Plugging these values into the formula, we get:

Rayleigh limit (visual, in arc-seconds) =14
 ÷ aperture in cm

Rayleigh limit (photographic) = 10 ÷ aperture in cm

That is, a 10-cm (4-inch) telescope should in theory be able to resolve a 1.4″ double star visually and a 1.0″ double star photographically, under ideal conditions. (The *Dawes limit*, determined empirically from visual double star work, is 11.5 divided by the aperture in centimeters; it is equivalent to the visual Rayleigh limit for a wavelength of 455 nm.)

The Rayleigh limit can be expressed in terms of resolution of a certain number of lines per millimeter on the film; as such, it becomes a function of the f-ratio rather than the diameter *per se*. The formula is:

Rayleigh limit (in lines/mm) = 820 000
 ÷ (wavelength in nm × f)

or, at 400 nanometers,

Rayleigh limit (in lines/mm) = 2000/f

The trouble with the Rayleigh limit is that it is defined in terms of star images *just touching* and therefore applies only to extremely high-contrast objects, where the images are easy to separate from the background. Low-contrast lunar and planetary detail is generally not visible unless the images of the points in question are *cleanly separated*, and the practical limit is therefore much lower:

Practical limit (in lines/mm) = 1000/f

Table 6.3 summarizes the results of applying these two formulae.

As Suiter (1994) has shown by detailed analysis, the central obstruction of a reflector or catadioptric telescope has a detectable effect on diffraction – but not a large effect, despite what is sometimes claimed. What's more, the effect cuts both ways. It makes the central part of a star image smaller and spreads more light into the rings that surround it. Thus, the extra

Table 6.3 *Theoretical and practical resolution limits for various f-ratios at 400 nm*

f-ratio	Rayleigh limit (lines/mm)	Practical limit (lines/mm)
f/4	500	250
f/8	250	125
f/16	125	63
f/32	63	31
f/64	31	16
f/100	20	10
f/150	13	7
f/200	10	5

Note: Lenses rarely resolve better than 60 to 80 lines/mm because of residual aberrations and manufacturing tolerances.

diffraction from the central obstruction may raise or lower the Rayleigh limit slightly, depending on the kind of object you're photographing.

The practical question is, how much projection magnification (*M*) is enough? That is, at what f-ratio should a telescope system be used in order to take full advantage of its ability to record fine detail? The following considerations apply:

1 The higher the f-ratio, the fainter the image and the longer the exposure time; hence *f* should be no higher than necessary.

2 A 35-mm slide looks sharp when it resolves 40 lines per millimeter; a negative that resolves 40 lines per millimeter will produce sharp-looking ×8 enlargements. In practice, slides or negatives that resolve only 20 lines per millimeter look only slightly fuzzy.

3 To bring out all the detail in a photograph, enlarge it until it ceases to look sharp – but no further. When a picture looks sharp, the amount of detail visible is limited (almost by definition) by the viewer's eye; when the picture ceases to look sharp, the viewer's eye is no longer the limiting factor.

If the f-ratio of the telescope system produces a resolution of about 10 lines per millimeter on the film, then all the detail captured by the telescope will be visible on ordinary enlargements. Moreover, the resolving power of the film will not be a limiting factor, since the low-contrast resolving power of most 400-speed films is about 50 lines/mm.

An f-ratio of about 100 gives this amount of resolution. Hence lunar and planetary photographers are quite correct in working at f/100 or thereabouts. With films of exceptional resolving power, such as Kodak Technical Pan 2415, the optimal f-ratio is more like 50. On matching f-ratios to CCDs, see page 248.

Why not simply match the resolving power of the telescope to that of the film? For two reasons: film grain would be objectionable, and maximum resolution would not be achieved. As a rule of thumb, the resolving powers of the telescope and film add as the sum of reciprocals:

$$\frac{1}{\text{resolving power of system}} = \frac{1}{\text{resolving power of telescope}} + \frac{1}{\text{resolving power of film}}$$

This is only an approximation; the actual relationship depends on the shape of the MTF curves. But it is enough to show that if the film and telescope have equal resolving powers, the resolving power of the complete system will be only half as good.

6.11 The subtle art of focusing

One of the simplest ways to get better astronomical photographs is to improve the accuracy of your focusing. Indeed, focusing is a more important – and more difficult – endeavor than many hobbyists realize.

One reason accurate focusing is hard is that, because of air turbulence and diffraction, you're almost always trying to focus an image that is inherently blurry and will not be crystal-clear no matter what you do – hence the temptation not to strive for precision. (Note however that *bad focusing is not the only cause of blurry pictures* – don't knock yourself out trying to improve your focusing when you are actually fighting atmospheric turbulence or diffraction limits.)

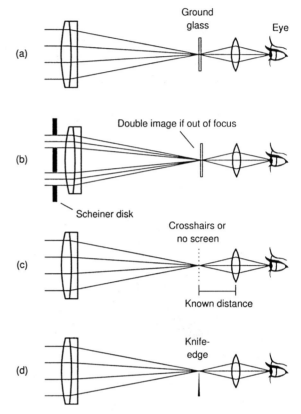

Figure 6.23 **Focusing methods.**

Another reason is that when you focus either an ordinary camera lens or a visual telescope, you have an advantage that is lacking in an astrophotographic setup. With a visual telescope, the focusing mechanism of your eye automatically corrects slight errors. With an SLR camera, you focus at a wide aperture (say $f/1.8$) and the lens stops down to take the picture at a smaller aperture, increasing the depth of field and reducing the effect of focusing errors (Fig. 6.27). Thus, what you record on film is often sharper than what you saw in the viewfinder. With telescopes, this doesn't happen; you focus at the f-ratio at which the picture will be taken.

Your focusing will improve with practice. You may want to start each session by focusing your setup several times for practice before making any exposures. When you start taking pictures, remember to focus each exposure individually, and take care to focus all of them with equal care. (I once noticed that the first exposure from each of my sessions was invariably the sharpest; it turned out that the first exposure was the only one I was really doing a good job of focusing.) Many people find it best to move through the focusing range quickly because slight changes in sharpness are easier to see if they happen fast.

Focus on low-contrast detail and faint stars, not just the most prominent stars or features. Look for detail that disappears when the focus is not perfect. If a range of positions all look equally good, the most accurate focus will be at the middle of that range.

With ground-glass or matte focusing screens, it's much easier to focus on a star than on a planet; observers of Jupiter are fortunate to have the four Galilean satellites for the purpose. You can also focus on any convenient star, then aim the telescope at the object of interest – but don't move the telescope more than a few degrees, or its optics may shift and throw off the focus. It goes without saying that focusing must be done with all filters and other optical elements in place.

6.12 Camera viewfinders

The most obvious way to focus a camera is to put a ground-glass screen at the film plane and view it with a magnifier (Fig. 6.23a). This is essentially what goes on in an SLR camera (p. 151), but it's not always easy. Astronomical images are dim, and at high f-ratios they do not snap crisply into focus, tempting you not to try to be precise. Besides, terrestrial photographers usually focus with the lens wide open and then stop it down for the exposure, increasing the depth of field; we generally expose with the lens wide open.

The right kind of ground glass (actually plastic) helps a lot. The microprism and split-image devices in most cameras are useless at f-ratios higher than 4; even with fast lenses, they're designed for speed, not precision. Use the fine matte portion of the screen instead. All-matte screens are available from some camera makers; a grid printed on the screen makes it easier to adjust focusing magnifiers when you use them.

Figure 6.24 **Focusing aids for the Olympus OM line of cameras. Plastic boxes contain focusing screens and the tools for inserting them. At their left is the Varimagni Finder, a right-angle focusing magnifier. To the left of the camera body are correcting lenses (for those who remove their eyeglasses when focusing) and a glare-reducing eyecup. (Olympus America)**

The Beattie Intenscreen is a special extra-bright, extra-fine matte screen that is available for numerous cameras (see p. 314); another company, Brightscreen, makes a similar product. Many newer cameras, such as the Nikon N70 (F70), include a bright "acute-matte" screen as standard equipment. I find these screens very useful; they give a bright image and permit precise focusing at all f-ratios, at least from $f/1.4$ to $f/120$. It has been shown, however, that if the screen is too fine, it begins to act as if it were transparent, and precision suffers (Ray 1994, p. 426).

Extra magnification improves focusing accuracy. Unfortunately, the magnification of camera viewfinders is specified in a number of different ways. Sometimes the eyepiece is treated as a magnifying glass. On this analysis, the eyepiece focal length and the eyepiece magnification M are related as follows:

$$M = 250 \text{ mm}/F_E$$

$$F_E = 250 \text{ mm}/M$$

Thus Nikon's "×6" right-angle finder has a 42-mm eyepiece.

But sometimes viewfinders are specified by the apparent size of the image with a 50-mm lens on the camera. For example, the "×0.86" viewfinder of the Nikon FM2 has an eyepiece focal length of 50 mm/0.86 mm = 58 mm, not so different from "×6" after all. Olympus OM SLRs have 60-mm eyepieces.

You can add extra magnification by means of a clip-on device such as the Nikon DG-2 (×2) or Olympus Varimagni Finder (×1, ×2.5). Figure 6.25 shows how these devices work. They are essentially tiny Galilean telescopes and must be focused so that you can see the screen clearly. (Chapter 9 describes them further.)

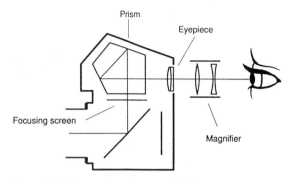

Figure 6.25 **How a focusing magnifier works.**

Figure 6.26 **B&K Astrofocuser uses your eyepiece and star diagonal to make a highly customizable, bright, powerful focusing magnifier.**

You can get even more magnification by peering into the camera eyepiece through a handheld ×8 monocular. Adding extra magnification is equivalent to shortening the eyepiece focal length.

A particularly interesting accessory for the Olympus OM series is the Astrofocuser marketed by B&K Products (p. 313). Figure 6.26 shows how it works. You supply your own eyepiece, usually in the 15- to 20-mm range. Together with the lens in the Astrofocuser, it forms a small Keplerian telescope with a magnification of about 4 (= 80 mm ÷ 20 mm) and a bright image, much brighter than that of the Olympus Varimagni Finder due to the larger entrance pupil. You focus the Astrofocuser by moving the eyepiece in and out, then focus the camera. Because the eyepiece is your own, eye relief is not a problem.

The Astrofocuser fits only the Olympus OM-1, OM-2, OM-3, and OM-4, (including OM-2S, OM-4Ti, etc., but not OM-10 or OM-2000). You can make homemade devices along the same lines to fit other cameras. Note that the Astrofocuser occupies the tripod socket and is therefore usable only when the camera is supported by the telescope or a long lens. It shows only the central area of the focusing screen, magnified, not the whole frame.

Figure 6.23b shows another handy trick: in front of the telescope, place a *Scheiner disk* with two holes in it – a device invented by Christoph Scheiner in 1619. Out-of-focus images will then appear double because the light rays arrive in two distinct bundles. This makes it much easier to distinguish defocusing from the blurring effects of diffraction and air turbulence. Scheiner disks and the holes in them need not be round; they can be made out of cardboard or paper in any convenient shape. For a camera lens, you can drill two holes in a lenscap. Commercial Scheiner disks are marketed under

the name Kwik Focus. I have found Scheiner disks helpful with camera lenses, but not so helpful with my Schmidt–Cassegrain telescope, where the central obstruction already gives a Scheiner-disk-like effect.

6.13 PRACTICAL NOTE:
Does your SLR focus accurately?

It's possible for the focusing screen in an SLR to be out of adjustment so that it does not match the focal plane of the film. This is not a common problem, but it can occur when the camera has been dropped, the mirror has been damaged, or an Olympus-type focusing screen has been inserted incorrectly.

If the problem exists, you'll notice it most when using a fast lens wide open. It will be much less of a problem when the camera is coupled to a telescope at a higher f-ratio (Table 6.4, p. 91).

To test your camera, photograph a brick wall head-on with an $f/1.8$ or $f/1.4$ lens wide open. Focus carefully, then make additional exposures with the focus thrown off slightly in each direction. If the picture that looked sharpest in the viewfinder is not the sharpest on the film, get the camera repaired.

6.14 Aerial-image and crosshair focusing

All ground-glass screens dim the image by scattering light. Can you do without the screen and focus on the aerial image (Fig. 6.23c)? Maybe; that's how the Taurus astrocamera does it (p. 161). The image is then as bright as it can possibly be. If you try aerial-image focusing with an SLR, don't just remove the screen; it's part of the optical system. Instead, substitute a clear screen such as the Olympus 1-9 or 1-12 or Nikon Type C.

 The trouble with aerial-image focusing is that the focusing action of your eye can throw off the results. To determine the potential error, consider an eye that can focus from infinity down to some minimum distance s_1, typically 250 mm. The possible focusing error Δs_2 is then:

$$\Delta s_2 = \frac{s_1 F_E}{s_1 - F_E} - F_E$$

where F_E is again the eyepiece focal length. For example:

$F_E = 50$ mm (Olympus camera viewfinder)
 $s_1 = 250$ mm $\Delta s_2 = 12.5$ mm
$F_E = 20$ mm (Olympus with Varimagni \times 2.5)
 $s_1 = 250$ mm $\Delta s_2 = 1.7$ mm
$F_E = 6$ mm (telescope eyepiece)
 $s_1 = 250$ mm $\Delta s_2 = 0.15$ mm

Only the last of these is satisfactory. Shorter eyepieces help a lot; so do aging eyes whose s_1 is 500 mm or more.

 Fortunately, there's an easy way to make aerial-image focusing much more accurate: give the eye a pair of crosshairs to focus on. This is a time-honored technique in photomicrography; Olympus, Nikon, and others make clear-crosshairs screens for the purpose. It is extremely important to focus your eye on the crosshairs and not ignore them when focusing the image. When this is done, it's equivalent to having $s_1 \geq 2000$ mm in the formula, and the expected accuracy becomes:

$F_E = 50$ mm(Olympus camera viewfinder)
 $\Delta s_2 = 1.3$ mm, acceptable at $f/60$
$F_E = 20$ mm(Olympus with Varimagni \times 2.5)
 $\Delta s_2 = 0.2$ mm, acceptable at $f/10$

Again, a little magnification helps a lot. Technique is also important; for best results, move your head slightly and check that the image stays fixed relative to the crosshairs. This is my standard technique for lunar and planetary work at $f/60$ and higher.

6.15 Knife-edge focusing

There is one last focusing technique worth knowing about because you can use it in situations where nothing else works – *knife-edge focusing*. To use this technique, you do not need a viewfinder or even a piece of ground glass – only access to the film plane before the film is loaded. The results are more precise than those of any other method. The catch is that you can only focus on a star, not a planet or other extended object.

 What you do is this: with the telescope aimed at a bright star, open the back of the camera and look in. You should see the star image as a large, bright disk (with a hole in the middle if the telescope is a reflector or catadioptric). Center the disk in the field of view. Then take a knife or similar object that you can use to interrupt the light beam precisely at the plane of focus, and pass it across the field, through the blur circle. Use the sharp edge of the knife so that the obstruction does not have any appreciable thickness at the point that matters. Instead of a knife edge, you can use a Ronchi grating, whose multiple stripes act like multiple knife edges.

 Knife-edge focusing relies on the fact that all the light rays from a star pass through a single point (Fig. 6.23d). If the blurred star image disappears all at once, you've found this point, and hence the camera is perfectly focused. If the shadow of the knife moves

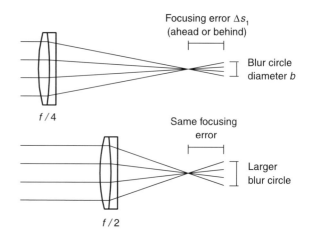

Figure 6.27 Focusing error expands points into blur circles. Lower f-ratio increases the effect of the error.

across the image in the same direction as the knife itself, rack the camera outward; if it moves in the opposite direction, rack the camera inward.

You can also use the knife-edge test as a way of checking optical quality (the *Foucault test*). If you can't get the whole blurred disk to fade out uniformly, something is wrong. The most common fault in homemade Newtonians is for an area near the edge of the mirror (and hence near the edge of the blur circle) to behave differently from the rest. In a more complex system, center-versus-edge discrepancies often indicate spherical aberration, and discrepancies between one side and the other (remaining constant as you try bringing the knife in from different directions) indicate misalignment. You can also view, in minute detail, the effects of air turbulence.

The practical problem with knife-edge focusing is how to get the knife-edge at the film plane. One way is to use a second camera body, or focus before loading the film; another is to use a commercial device that attaches in place of the camera body. Several such devices were reviewed in *Sky & Telescope* by Di Cicco (1992); they include the SureSharp, PointSource, and Celestron Multi Function Focal Tester.

Either way, knife-edge focusing takes time and requires you to attach and detach equipment, possibly altering the focus. But the accuracy of knife-edge focusing is unassailable; one of its main uses is to validate other focusing techniques.

6.16 How accurately must we focus?

All this begs the question: how accurate can focusing be, and how accurate must it be?

Because most astronomical pictures look blurry, it's tempting to assume that focusing is the problem, and to strive for infinite accuracy. Good focusing is important, but as we've already seen, diffraction and atmospheric steadiness also limit sharpness, so it's a good idea to calculate how much focusing error can actually be tolerated.

The necessary focusing accuracy depends on how large a *blur circle* you are willing to tolerate (Fig. 6.27). A blur circle diameter of 0.020 mm is generally considered acceptable in 35-mm photography; you may want to adopt a tolerance of 0.010 mm for the sharpest pictures and 0.040 mm for pictures whose sharpness is limited by diffraction or atmospheric turbulence.

The diameter of the blur circle, b, depends, in turn, on the amount of focusing error, Δs_2, and the f-ratio of the incoming cone of light:

$$b = \Delta s_2 / f$$

$$\Delta s_2 = bf$$

Here f is the f-ratio at the film, i.e., at the output of any projection or compression system, not the f-ratio of the telescope. Table 6.4 shows values for common setups.

Tolerances are looser when aberrations are present; spherical aberration blurs the image, but it also keeps the cone of light from expanding as rapidly as you move away from perfect focus. In fact, some point-and-shoot cameras deliberately use spherical aberration to make focusing less critical. With our telephoto lenses, longitudinal color has a similar effect. Nikon makes a lens, the 135-mm *f*/2 DC-Nikkor, with adjustable spherical aberration for manipulating apparent depth of field.

Table 6.4 *Required focusing accuracy at various f-ratios*

	Blur circle size		
	0.010 mm (unusually sharp)	0.020 mm (normal tolerance)	0.040 mm (slight blur)
f/1.4	± 0.014 mm	± 0.028 mm	± 0.056 mm
f/2.8	± 0.028 mm	± 0.056 mm	± 0.11 mm
f/6.3	± 0.063 mm	± 0.13 mm	± 0.25 mm
f/8	± 0.08 mm	± 0.16 mm	± 0.32 mm
f/10	± 0.10 mm	± 0.20 mm	± 0.40 mm
f/50	± 0.5 mm	± 1.0 mm	± 2.0 mm
f/100	± 1.0 mm	± 2.0 mm	± 4.0 mm
f/200	± 2.0 mm	± 4.0 mm	± 8.0 mm

The focal plane of a typical f/10 Schmidt–Cassegrain telescope moves 20 mm for each turn of the focusing knob. Thus, at f/10, the focusing tolerance is ±1/100 turn, or ±3.6° of rotation. A mark on the focusing knob will tell you whether you are focusing with this degree of reproducibility. (Remember that focusing is affected by thermal expansion and contraction; don't expect the same setting to work all the time.) When you use projection or compression, this 3.6° tolerance becomes smaller by a factor of M, but if M is large, the resolution is usually limited by diffraction or the atmosphere rather than focusing technique.[1]

There is no need to focus more precisely than the accuracy with which the film is positioned. Film flatness is a constant bugbear of camera designers; in fact, one reason for the demise of 126 (Instamatic) film was the difficulty of holding the film flat. Kämmerer (1979) reports that 35-mm film can sometimes deviate 0.08 mm from the intended focal plane; that's one reason lenses faster than f/1.4 have not become common. The worst situation arises when the camera has been sitting unused for a while and the photographer advances the film one frame. The frame now ready to be exposed has been sitting there, partly in the cartridge and partly out of it, half wound and half flat, and tends to bend in an S curve. Polyester-base film, such as Kodak Technical Pan, lies flatter than acetate-base film.

Purists working with very fast lenses may prefer to expose alternate frames, advancing two frames at a time so that each frame goes from completely wound to completely flat. Wealthy purists may prefer to use the Contax RTS III, an expensive and heavy SLR that uses a vacuum to hold the film flat, even though Crawley (1992) found the improvement in image quality minimal, and the vacuum does not operate during time exposures.

6.17 Focusing Schmidt–Cassegrains and Maksutovs

When you focus a Schmidt–Cassegrain or Maksutov telescope, the image is likely to move sideways in a random direction. This *lateral image shift* occurs because focusing is done by moving the main mirror forward and backward, and as the mirror is moved, it wobbles slightly. When you're photographing a planet at a high magnification, lateral image shift can move the planet entirely off the best area of the focusing screen.

Excessive lateral image shift means the focusing mechanism needs to be relubricated at the factory. (Newer lubricants can considerably improve the performance of old telescopes.) But some lateral image shift will remain, and one way to combat it is to do the final focusing with a separate mechanism that moves the camera forward or backward without moving the mirror. The JMI Motofocus (p. 313) does this, and because it is motorized, you don't even have to touch the telescope.

The focus of a Schmidt–Cassegrain or Maksutov can shift slowly as the mirror settles. To reduce this effect, always turn the focusing knob clockwise first, then do the final focusing by turning it counterclockwise. That way, at the final step, you are pushing the mirror away from you, working against gravity, and any slack in the mechanism or the lubricants is already taken up. If

[1] In detail: The f-ratio of the telescope, and therefore the tolerance for finding the image plane, is multiplied by M, but the movement of the image when you turn the knob is multiplied by M^2. Thus the precision with which you must position the knob is multiplied by $M^2/M = M$.

you focus the other way, you're working with gravity, and gravity may continue to pull the mirror in the same direction. Some larger Schmidt–Cassegrains contain a spring to take up slack, and they are said to work best if focused clockwise. (See also the section on mirror flop, p. 143.) Remember that when all mechanical problems are eliminated, thermal expansion or contraction can still shift the focus.

Because the field of a Schmidt–Cassegrain telescope is curved, the best overall focus is obtained if you focus on a star slightly off center, rather than one in the exact center of the field. Some camera lenses have the same quirk; it's no accident that the fine matte area of the focusing screen is usually a ring rather than a central spot.

The solar system

Amateur high-resolution photography of the sun, moon, and planets is a neglected field. I must confess to having neglected it myself, favoring wide-field deep-sky work like so many other amateurs. But high-resolution solar-system photography has several attractions. You can do it in town or even in a large city; you don't have to go elsewhere in search of dark skies. You don't have to wait for the moon to get out of the way; in fact, the moon is one of the targets. Perhaps more importantly, the appearance of the sun and many of the planets is constantly changing, so it's worthwhile to keep photographing the same object; the pictures stand a good chance of having scientific value.

With the advent of digital image enhancement – which often improves planetary pictures dramatically – and the publication of excellent handbooks by Dobbins, Parker, and Capen (1988) and Dragesco (1995), interest in the solar system may be reviving. This chapter will tell you how to get started with this rewarding kind of work.

7.1 Film or CCD?

The advent of CCD imaging has made it easier than ever for amateurs to obtain excellent images of the sun, moon, and planets. My first CCD image of Jupiter, taken with an 8-inch telescope, surpassed all my earlier photographs. There are several reasons for this. Unlike a conventional camera, a CCD does not produce any shutter vibration. There is no film grain; the CCD's response to light is relatively uniform, especially after you use it to measure and cancel out its own irregularities. That makes digital enhancement easy. CCD exposures tend to be shorter than those with conventional film, making it easier to isolate a brief moment of steady air. But the biggest advantage of CCDs is that they make it easy to take hundreds of images in a session, saving only a few of the best.

Is film dead? Not at all. Some films, such as Kodak Technical Pan, still have higher resolution than any CCD, and only film can (at present) obtain a good color image in a single exposure. This chapter will continue to concentrate on conventional film photography and on the techniques that film and CCD work have in common. CCD imaging is covered more fully in Chapter 13.

7.2 The challenge of high resolution

Ideally, a high-resolution photograph is one that shows as much detail as could have been seen visually with the same telescope. Even the best astrophotographers rarely achieve this, but it is a worthy goal to pursue. To get maximum resolution, you need:

- excellent optics;
- very fine-grained film;
- accurate focusing;
- perfect tracking (or an exposure short enough that a clock drive is not necessary);
- freedom from vibration; and
- steady air, both inside and outside the telescope.

Modern commercially built telescopes generally have good optics; see page 171 to learn how to test yours. Beware of cheap eyepieces in projection systems. We dealt with the resolving power of the film briefly in Chapter 6; the solution is to magnify the image enough that the resolution of the film is no longer the limiting factor, which means working at f-ratios higher than $f/100$ (with most films) or $f/50$ (with Kodak Technical Pan). Chapter 6 also dealt with focusing techniques. That leaves perfect tracking, freedom from vibration, and steady air to be dealt with.

Figure 7.1 **A near-occultation of Saturn by the moon on 11 November 1997. A 25-cm (10-inch)**
$f/6$ telescope stopped down to 5 cm aperture, giving $f/30$. A 110-millisecond exposure with an
SBIG ST-7 camera. (Gregory Terrance)

7.3 Tracking

It used to be widely thought that tracking was not as
critical in lunar and planetary work as it is in deep-sky
photography because lunar and planetary exposures are
shorter. To be sure, it is not usually necessary (or even
possible) to make guiding corrections during the
exposure, nor does polar alignment have to be more
accurate than to within a degree or two. You can even

get by without a clock drive at all if you keep the
exposures short enough.

 If the total tracking error during the exposure is
less than 0.5 arc-second, it will usually have no visible
effect on your photographs regardless of the size of
your telescope – no telescope can reliably show detail
finer than 0.5″ through the earth's turbulent atmosphere.
This means that if the exposure is 1/30 second or
shorter, a clock drive is unnecessary. (Relative to a fixed

Figure 7.2 **Perfect tracking is necessary for photographs like these. Venus gradually disappeared behind the moon on 26 December 1978. These are $1\frac{1}{2}$- to 2-second exposures on Kodachrome 64 with a 20-cm (8-inch) $f/5$ Newtonian using eyepiece projection to give $f/32$. (Dale Lightfoot)**

telescope, the sky moves at the rate of 15″ in one second of time, or 0.5″ in 1/30 second.) But don't push the limit. There are moments when the atmosphere calms down and enables telescopes to resolve better than 0.5″, and you'll want to make the most of them.

Your clock drive must be *smooth*. Most drives have considerable *periodic error*; that is, they run a bit too fast and a bit too slow at different points in the four- or eight-minute rotation period of the worm gear. If you set the telescope to track a star, the star will swing back and forth to either side of its original position, and during parts of this four- or eight-minute cycle, the image may shift quite rapidly. If you try to take a high-resolution photograph while the worm gear is hitting a rough spot, it will come out smeared.

It pays, therefore, to study the performance of your clock drive (see also the next chapter), and to try to improve it. Most drives benefit from simply being allowed to run for a long time; many telescopes never

get enough use for the gears to "wear in" properly. Even after several years of occasional observing sessions, the main gear may have made only a couple of complete revolutions. There's something to be said for setting up your telescope inside the house and running it for a week or two.

Good polar alignment is essential, because if the telescope is misaligned, the image will drift north or south during the exposure. Chapter 8 will cover polar alignment more fully.

Balance is also important. The fork mounts on portable catadioptric telescopes continue to function even when badly out of balance; that doesn't mean they work *well*. Use counterweights to reduce the load on the gears, and you'll get better performance. Many mounts rely on *some* imbalance to take up slack in the gears, so don't try to balance the telescope perfectly.

After pointing the telescope, let the drive run for a few seconds to take up slack in its gears before you make the exposure. Small corrections can be made with

a drive corrector and declination motor so that the gears aren't affected. This is particularly important with CCD imaging, where the field of view is extremely small and one bump can make you lose the object altogether.

The ordinary solar drive rate (one revolution in exactly 24 hours) is satisfactory for planetary work; there is no single "planetary rate," since planets deviate from the solar rate by different amounts at different points in their orbits, and the deviations would normally be noticeable only in an exposure of several minutes. Naturally, if your drive is not tracking the planet properly, you should adjust it until it does. The moon does move at a rate of its own, and the problem of tracking it will be dealt with below.

7.4 Vibration

The telescope must not vibrate during the exposure. Many telescopes, especially small refractors, come from the factory with seriously inadequate tripods, which can be improved by bracing. If there is play in any of the joints at the top of the tripod, tighten or shim them somehow, and if the three legs are not connected at the bottom, join them with chains or rigid braces as close to the ground as possible. The idea is to make a structure consisting entirely of triangles, since a triangle is unbendable as long as the lengths of its sides remain fixed. If the tripod is made of wood, so much the better: although wood may be more flexible than metal, the crucial difference is that metal responds to a blow by "ringing" and vibrating for some time, whereas vibrations in wood damp out quickly. (See Brooks 1976.) Figure 7.3 shows the author's tripod, which is unusually sturdy. If you're stuck with a metal tripod, you can reduce ringing by putting rubber discs under its feet; these vibration-reducing pads are available commercially from Celestron and others.

Any telescope mounting that is light enough to be portable, and many that are not, will be vulnerable to vibration caused by the camera shutter. To determine

Figure 7.3 **A sturdy wooden tripod that outperforms much heavier metal tripods and piers. Built for the author by Elmo Mauldin.**

how serious this problem is with your equipment, train the telescope on a star or distant terrestrial object and look through the viewfinder while tripping the shutter. (If the camera is not an SLR, clamp it to the telescope near its usual position but look through the telescope eyepiece.) If the image shakes at all, you have a vibration problem, but perhaps not an insuperable one.

To minimize camera-shutter vibration in an SLR, lock up the camera's mirror, if possible, before tripping the shutter. It goes without saying that you should use a cable release, preferably the air-bulb type, to keep from shaking the camera; better yet, use the self-timer to trip the shutter after all vibration caused by your touching the equipment has died away.

You can eliminate shutter-induced vibration completely by controlling the exposure, not with the shutter, but with a black card held in front of the telescope (not touching it). Open the camera shutter, wait a couple of seconds for the vibration to die down, and then remove the card; bring the card back into

position before closing the camera shutter. The shortest exposure you can get by this method is about 1/4 second. A large, dark hat is sometimes used instead of a card; hence the technique is sometimes referred to as the "hat trick." With apertures smaller than 20 cm you can also use the hardback edition of this book. (See, we think of everything!)

You can even put the camera and telescope on separate tripods if they are coupled afocally. This completely prevents the camera from shaking the telescope. If you want to get good pictures at minimum cost – with some clumsiness – the afocal method is well worth trying.

The only solution to vibration problems caused by wind is to surround the telescope with a low wall or even a domed observatory. If you require portability, some ingenuity may be needed to devise a movable enclosure. Fortunately, strong winds in the middle of the night are uncommon; when they do occur, the air is usually so turbulent that you would get poor results even with a perfectly steady telescope.

7.5 Unsteady air

Even when the air does not seem to be moving, it is not optically steady; irregularities in the air, analogous to the "heat waves" you see in the air above a hot iron, are in fact the main obstacle to high-resolution photography. Distortion amounting to only half an arc-second – less than 1/100 of the smallest amount the unaided eye can see – can keep a 5-inch telescope from reaching full resolving power.

Ordinarily, in fact, the blur or wobble is more like two or three arc-seconds; if it gets down to one arc-second, conditions are distinctly better than average. You can estimate the amount of atmospheric blurring by observing a close double star of known separation. There are actually two different effects to contend with: a continuous blurring that makes the image look out of focus and clears up only for brief moments, and a slow

unsteadiness that makes the whole image move around a bit. Both of these interfere with photography, though the first one is the only one a visual observer is likely to notice (if the whole image shifts, your eye follows it automatically). In any case, a visual observer can make use of fleeting moments of steadiness in a way that a camera can't, which is why you can never photograph as much detail with any telescope as a trained observer can see with the same instrument.

The battle against unsteady air is in some respects a hopeless one; you just have to wait for exceptional conditions if you want exceptional photographs. Don't waste film trying to photograph planets through air that is worse than average; but when the air is steady, take several exposures of each object – from four to a dozen – in the hope of catching a particularly steady moment. You might think that extra-short exposures would be best for capturing fleeting moments of steadiness, but the opposite is the case in practice; many observers find that the integrating effect of an exposure of a couple of seconds can smooth out moment-by-moment variations in the air, provided of course that the clock drive is tracking well.

The air is usually steadiest in the late night and early morning hours (before dawn) – times when the temperature is not changing very rapidly. It is worst during daylight (the sun heats the ground and causes thermal currents) and shortly after sunset. Good steadiness is often associated with a high pressure area (anticyclone) that has been in the same place for several days, and with a relatively small difference between the day's high and low temperatures. A slight haze (one that dims the stars and stops them from twinkling but does not blur them the way high clouds do) is often, oddly enough, a good sign, whereas a brilliantly clear sky – exactly what you'd need if you were observing faint deep-sky objects – often signals very turbulent air; the more the stars twinkle, the worse it is. It goes without saying that the view is best when the object you're observing is high in the sky, since the

amount of air you have to look through is much smaller than for objects near the horizon.

Professional observatory sites are chosen for a high percentage of clear nights – not for steady air – and good conditions sometimes occur in unexpected places. Traditionally, astronomers have observed from mountaintops in order to "get above the seeing," but in the 1980s, Donald Parker discovered that very steady air occurs in the swamps of eastern Florida, right at sea level. The moral is that any site *may* give unexpectedly good results under some conditions.

In recent years observers have begun to recognize the importance of the air inside and immediately surrounding the telescope – air whose steadiness is at least partly under your control. To begin with, the telescope should be at the same temperature as the surrounding air; allow 30 minutes for "cool-down" after bringing it out from the warm indoors. (A three- or four-hour cool-down, if possible, is even better.) Turbulence within the tube usually takes the form of currents that spiral along the inside walls; thus it helps to make the tube oversized and/or square. There is some controversy as to whether the tube should be made of a material that conducts heat; it is generally agreed that heat-conducting (e.g., metal) tubes cool down faster, but wooden or phenolic tubes perform better while the cool-down is still going on.

If at all possible, place the telescope on grass or sand rather than a paved surface, and avoid looking through the air immediately above a roof, since paved areas and roofs heat up during the day and produce thermal currents at night. Observing over a cliff is said to give especially good results.

Truly exceptional steadiness does occur occasionally at any site, and when it happens, you should photograph like mad, taking hundreds of pictures. Even on an average evening, there are likely to be a few of what Percival Lowell called "revelation peeps" – brief instants of exceptional steadiness. That's why dedicated planetary photographers such as Jean Dragesco take dozens or hundreds of exposures every evening. One or two of the images are generally much better than the rest. CCD cameras make it especially easy to acquire dozens of images and save only the best ones; the selection process could even be automated. The day may be coming when you simply tell your CCD camera to photograph Jupiter, and it goes to work for two hours, taking a thousand images and saving the five or ten best.

7.6 Dew

Finally, there is dew, an ever-present problem for astronomers in humid climates. Telescope objectives have an almost magical ability to collect dew even when the air is well above the dew point and no dew is falling on anything else.

Why this happens is worth a moment's explanation. When the air temperature is falling and there's a clear dark sky above, the telescope cools down in two ways: by conducting heat to the surrounding air and by radiating heat into space. The second of these is crucial. Because of their smooth, shiny surfaces, telescopes radiate heat very efficiently and quickly become cooler than the air around them. Because glass conducts heat very poorly, the outer surface of a glass lens is particularly vulnerable; the warmer air inside the telescope doesn't keep it warm. Dew will form on telescopes when the relative humidity is as low as 70%.

One way to keep dew from forming on the front lens of a refractor or catadioptric is to install a *dew cap* as shown in Fig. 7.4; this impedes radiation of heat into space, as well as reducing the rate at which moisture-laden air can reach the surface of the lens.

When the humidity is not too high, my usual dew cap is a piece of black artist's paper wrapped around the tube and held in place by a large rubber band, a piece of elastic, or a bungee cord. The paper itself absorbs moisture, and you can replace it with a fresh

Dew cap

Figure 7.4 **Dew caps can be made of black paper, foam plastic, or other materials.**

one if it becomes damp. (In an emergency, you can make a dew cap out of a brown paper bag.) Best of all, the weight of a paper dew cap is negligible.

Another way to make a dew cap is to cut a big piece from one of the plastic foam pads that campers put under their sleeping bags, bend it into a cylinder that just fits around the telescope, and hot-glue the edges together. Then line the inside with black felt. The assembled dewcap is slightly stretchable and holds itself in place. Because of its thermal insulating properties, it is very effective, even in high humidity. Rigid dew caps made of wood, PVC pipe, and similar materials are usually too heavy to be convenient.

An observatory dome works like a gigantic dew cap – I have never seen dew inside an observatory – but a dome generally has a deleterious effect on atmospheric steadiness; air flows in and out through the slot, so that all the turbulence is right in front of the telescope.

Some observers use electrically heated dew caps – that is, they place a ring of nichrome wire or carbon resistors around the objective to keep it slightly warmer than it would otherwise be, thereby preventing dew. Contrary to what you might think, this doesn't create air turbulence. In fact, seeing can improve when you warm

the lens *to* the air temperature, since it would otherwise have been cooler due to radiation.

Commercial anti-dew heaters are available, some of which even include heaters for the eyepiece. To design your own, use only the minimum amount of heating necessary to prevent dew formation – typically about 2 watts – and, for safety's sake, use a low voltage isolated from the AC line by a transformer or battery.

Here's how to design a resistor string. Start with the wattage you want (e.g., 2 watts) and the voltage from which you want to power it (e.g., 12 volts). The total resistance needed is given by the formula:

$$\text{Resistance (in ohms)} = (\text{volts})^2 \div \text{watts}$$

or, in this case,

$$\text{resistance} = 12^2 \div 2$$
$$= 144 \div 2$$
$$= 72 \text{ ohms}$$

Since you want the heat distributed uniformly around the edge of the lens, use a string of six 12-ohm resistors in series. The power output is divided equally among the six resistors; each puts out about 1/3 watt, and readily available 1/2-watt resistors are satisfactory. (The wattage rating of a resistor represents the maximum it can handle; the actual amount of heat dissipated depends on the voltage and the resistance.)

Finally, when choosing a power source, you need to know how many amperes a 72-ohm resistance will consume at 12 volts. The relevant formula, known as Ohm's Law, is:

$$\text{Current (in amperes)} = \text{volts} \div \text{ohms}$$

or in this case

$$12 \div 72 = 0.167 \text{ ampere} = 167 \text{ milliamperes}$$

This is a relatively small amount of current and could be supplied by an automobile's electrical system, a lantern battery, or a small transformer. It doesn't matter whether AC or DC power is used, but if you use AC, you can

cut the total power in half by putting a silicon rectifier in series with the circuit – a convenient way to get switch-selectable "high" and "low" settings without having to change the voltage.

A deceptively simple way to get rid of dew that has already formed is to blow warm air onto the affected lens with a hair dryer. For portable operation, you can use a 12-volt hot-air blower designed for melting ice on automobile windshields. Unfortunately, the air steadiness is usually ruined; the telescope needs a long time to cool down again, by which time it is again covered with dew! Hot-air blowers are fine for deep-sky work but not for high-resolution photography. A more subtle approach is to throw a dry towel over the telescope and let it absorb moisture. Do not wipe dew-laden surfaces; it will get them dirty without removing the dew.

Above all, do not store a telescope with dew on it. Leave it in the open air, indoors, until the dew has evaporated. Don't put lenscaps on dewy lenses, and don't close an eyepiece box when there is dew on the eyepieces.

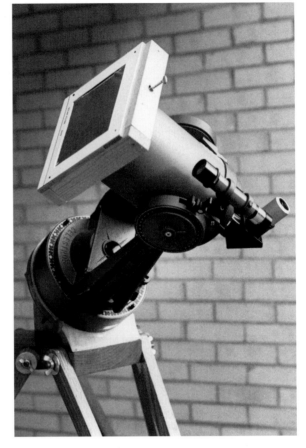

Figure 7.5 **An aluminized Mylar sun filter in a homemade wooden cell on the author's 12.5-cm (5-inch) f/10 Schmidt–Cassegrain telescope.**

7.7 The sun

The sun is fundamentally important for astronomical science because it is the only star we can see at close range. The basics of solar photography have already been covered in Chapter 5, in connection with eclipses – but there is a lot to see even on the uneclipsed sun. There are almost always a few sunspots; their number varies cyclically, with a minimum in 1997, a maximum expected around 2001, and another minimum around 2008. On a good day you can also see *faculae* (bright hydrogen patches visible near the edge of the disk), and the surface of the photosphere shows a low-contrast granular pattern. A telescope of 10 or 15 cm aperture, with a glass or Mylar filter in front, is the ideal instrument; because the daytime air is inherently unsteady, larger apertures cannot be used except on

mountaintops – which means, at least, that the amateur's modest telescope is likely to be as good as any.

The main challenge is to keep the sun from heating the telescope and objects around it, causing severe air turbulence. Be sure to keep the telescope aimed straight at the sun as much of the time as possible, to keep sunlight from falling on the outside of the tube and causing irregular heating. A white tube is, of course, less vulnerable than a dark-colored one.

It is hard to predict at what time of day the air will be steadiest. Some observers prefer to work in the early morning and, surprisingly, just before sunset; although the light has to pass through a greater thickness of air then than at midday, there is less turbulence due to heating than in the middle of the afternoon. However, this generalization does not hold up for all observing

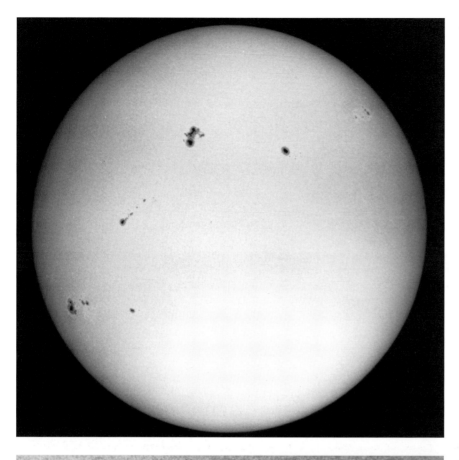

Figure 7.6 **The sun, showing sunspots and faculae near the sunspot maximum in 1992. A 1/250-second exposure at the prime focus of an Astro-Physics 13-cm $f/8$ apochromatic refractor with negative projection giving $f/17.7$. A full-aperture Solar-Skreen was used together with additional neutral density and green filters. Kodak Technical Pan Film developed 5 minutes in HC-110 (B) at 20 °C. (Gordon Garcia)**

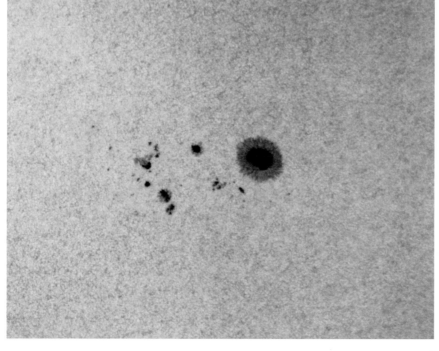

Figure 7.7 **An exceptionally sharp photograph of a sunspot group and solar granulation. An Astro-Physics 13-cm $f/8$ apochromatic refractor with eyepiece projection giving $f/58$, a 1/1000-second exposure on Kodak Technical Pan Film developed in D-19. Instead of a conventional sun filter, Gordon Garcia used a Herschel wedge (partial reflector) together with neutral density and red filters.**

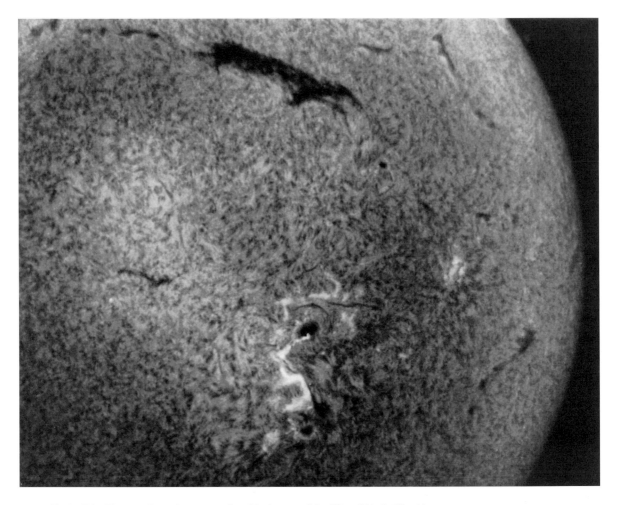

Figure 7.8 **The sun through a narrow-band hydrogen-alpha filter. (Edwin Hirsch)**

sites; a lot depends on what is within a few hundred yards of the telescope in the relevant direction. Around Los Angeles, heavy smog seems to help steady the air (surely its only known benefit). Any amount of cirrus cloud, however, blurs the sun considerably.

The film should be very fine-grained so that if you succeed in recording the granulation of the photosphere, you will not confuse it with film grain; contrast should be somewhat higher than in pictorial photography, though not extremely high. Kodak Technical Pan 2415 is the film of choice. There is little point in using color film, since the filter usually alters the color dramatically. Digital image processing can reduce limb darkening (darkness at the edges), which is otherwise a serious problem with high-contrast photographs of the sun.

Monochromatic filters that make it possible to photograph flares and prominences are now within the reach of at least some amateurs, and amateur photographs of this type can rival the work of observatories. The idea is to use a filter that transmits only light of the wavelength produced by a particular electron transition in a particular chemical element – usually the "Hydrogen-alpha" (Hα) wavelength of 656.281 nanometers – so that you can see the activity of that element while greatly attenuating everything else.

The special filters use multiple thin coatings in order to create interference between wavefronts of light and "tune in" specific wavelengths. The cheaper wide-band filters only allow photography of prominences at the edge of the solar disk, but narrower-band filters reveal hydrogen regions all over the sun. The telescope

works at $f/30$ to $f/60$ and need not be achromatic; a few observers have had success mating a $1000 filter with a $5 plano-convex lens, though most use a regular telescope stopped down to about 7 cm aperture. The film of choice is Kodak Technical Pan 2415; the 656-nm wavelength is too far off the red end of the spectrum for other black-and-white films, though color films respond to it well. For more information about Hα solar photography, see Dragesco (1995, pp. 75–85) or write to Edwin Hirsch and/or Lumicon (p. 315).

For general information about solar observing see also Taylor (1991) and Martinez (1994, vol. 1).

7.8 The moon

Not only do amateur lunar photographs look impressive, they can also be of scientific interest. There are occasional reports of anomalous glows on the moon, perhaps due to meteor impacts or volcanism, and a good photograph of one of these *lunar transient phenomena* would be most welcome. On a more mundane level, the angle of illumination on the moon's surface is constantly changing in a complex way (due to the interaction of the earth's and moon's orbits), and even if the lunar surface is perfectly static, you can spend a lifetime getting views you've never seen or photographed before. Colorimetry is also interesting; some parts of the moon are slightly warmer-colored than others, and if you take two photographs at opposite ends of the spectrum, and then subtract the images digitally or by darkroom manipulation, you can make the color differences visible. Amateur lunar observing efforts are spearheaded by the British Astronomical Association (http://www.ast.cam.ac.uk/~baa). Serious lunar photographers will find Rükl's *Atlas of the Moon* almost indispensable; indeed, for me, this was the book that made lunar observing interesting by making it easy to identify small craters and other features.

Lunar photography has already been covered in some detail in Chapter 4, and the main technical point that remains to be covered is tracking. Most clock drives are built to make one revolution in exactly 24 hours. This allows the use of standard electric clock parts, and it gives exactly the tracking rate you need for the sun; it is off by only $1°$ per day for the stars, and usually by somewhat less for the planets. The moon, however, orbits the earth so rapidly that its apparent motion in right ascension differs from the solar rate by some $10°$ to $15°$ per day, or 0.5 arc-second per second of time, and special procedures are necessary for tracking it.

If you can keep the total tracking error under $0.5''$, you can usually ignore it – it will be negligible relative to the blurring introduced by the earth's atmosphere, regardless of the size of the telescope. This means that, with a solar rate drive, your lunar exposures should be less than one second long. This is not a very serious restriction; the moon is bright enough that exposures of less than one second are almost always feasible.

For longer exposures, you can track at the moon's own rate by making your drive run at only 97% to 98% of its usual speed. Some drives are inherently adjustable; with older fixed-speed AC motors, you can use a *drive corrector* to vary the frequency of the alternating current, and hence the motor speed (see Chapter 8 and Appendix C). Aim your telescope at the moon, view through a high-power eyepiece or one with crosshairs, and adjust the drive corrector until there is no noticeable error even over a period of several minutes. There is no point in trying to isolate a single, precise "lunar rate," since the moon's daily motion in right ascension varies widely depending on its position in its orbit. There is also motion in declination – as much as $5°$ per day, or $0.2''$ per second – which the drive can't help you with.

Don't be surprised if you find that even the most finely adjusted drive corrector doesn't give you perfect lunar tracking. Once you get down to the arc-

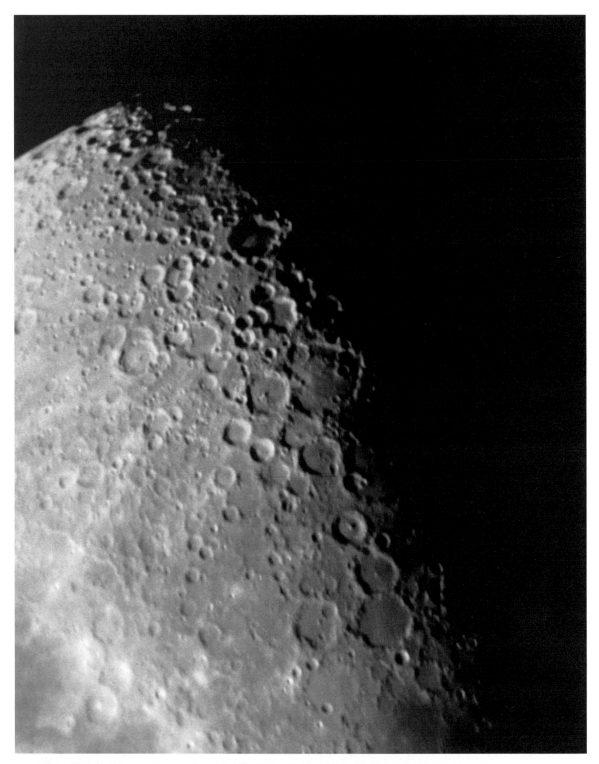

Figure 7.9 **Craters near the south pole of the Moon. A 20-cm (8-inch) *f*/10 Schmidt–Cassegrain telescope with teleconverter giving *f*/20; a brief "hat trick" exposure on Kodak T-Max 100 film. (By the author)**

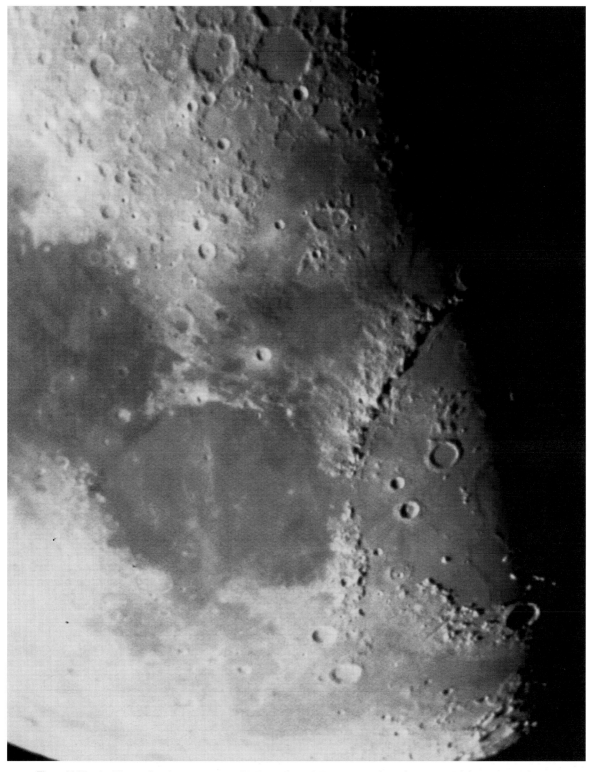

Figure 7.10 **As Fig. 9, showing a more northerly portion of the lunar surface. (By the author)**

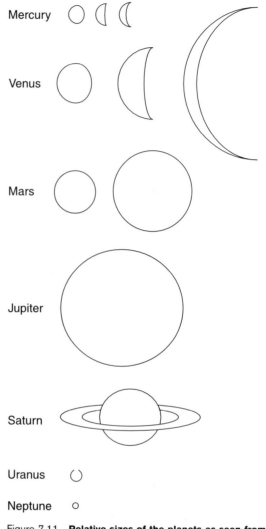

second level, even the best-built clock drives are full of inaccuracies and periodic errors (again, see Chapter 8). The moral is that, for the highest resolution, you shouldn't trust your drive for more than a few seconds.

7.9 Planetary photography

It is in planetary photography that you really need magnification. Figure 7.11 shows the relative apparent sizes of the planets as seen from earth. The size of the image on the film w depends on the angular diameter of the planet in arc-seconds (θ) and the effective focal length of the telescope (F):

$$w = \frac{(F \times \theta)}{206\,265}$$

Here w and F are in the same units, either inches or millimeters, and 206 265 is the number of arc-seconds in a radian.

For example, a 20-cm (8-inch) telescope operating at $f/64$ has an effective focal length of 12 800 millimeters; photographing Jupiter (apparent diameter, about 40″) with such a telescope, you get a 2.5-mm image on the film. This can comfortably be enlarged ×10 to make the image 2.5 cm (1 inch) in diameter on the print, big enough to show all the detail an 8-inch telescope will normally capture.

If you had been photographing Mars at 20″ apparent diameter, you would have needed a ×20 enlargement to give the same image size – more enlargement than an ordinary enlarger will give. One solution to the problem is to turn the enlarger backward on its support and project onto the floor. Another is to use a short-focal-length enlarging lens designed for subminiature film; you do not have to cover the entire 35-mm frame, of course, but make sure your enlarger will let you get the extra-short lens close enough to the film to focus it.

Figure 7.11 **Relative sizes of the planets as seen from earth. Some of them vary appreciably.**

And when you make ×20 enlargements, film grain becomes a significant problem. The ideal solution is to use a film such as Technical Pan 2415, which can withstand ×20 enlargement without difficulty. With hydrogen hypersensitization, you can push the speed of this film as high as 400 to 800; even without it, you can easily achieve 160, which is usually enough. Push-processing gives increased contrast, which is beneficial; the planets are low-contrast objects.

With grainy film, you might be tempted to put the enlarger slightly out of focus, but that doesn't work as well as you might expect; a defocused image of a random pattern is still a random pattern. Rather than

going away, the grain just gets bigger. A much more subtle solution is to combine several negatives into one print, by sandwiching, multiple exposure, or digital addition. Details common to all the negatives – representing actual features on the planet – will reinforce, while variations from one image to another, comprising atmospheric distortion and film grain, will cancel out.

Applying this technique in practice can be rather tricky. One way of doing it is to have a piece of ordinary paper which you can substitute for the photographic paper in the enlarging easel, and on which you can make pencil marks. After making the first exposure, put the photographic paper away in a light-tight place, put the plain paper in the easel, and pencil in the outline of the planet. Now take the first negative out of the enlarger, put in the second one, position it to match the penciled outline, and refocus. Then put the photographic paper back in the easel and make the second exposure. These steps can be repeated for as many exposures as necessary. Naturally, the exposure time should be reduced in proportion to the number of negatives being combined, so that if, for example, you are combining five negatives, each of them will receive only one fifth the exposure time that would be correct for a single negative by itself.

You can also combine exposures by making multiple exposures in a slide duplicator, or – perhaps best of all – by summing the images digitally.

Planetary photography often involves the use of filters, and Appendix E lists all the filters you are ever likely to come across, including a good many that are not particularly useful. The purpose of a filter is to block light of certain wavelengths while transmitting others; in general, the effect on the picture is to lighten features whose colors fall within the transmitted range while darkening those whose colors are blocked. For example, a yellow filter lightens yellow and red but darkens blue and violet.

Filters that screw into eyepieces and Barlow lenses are readily available, and some catadioptric telescopes take readily available filters of standard sizes. Also, the old Series 5 drop-in filters, sometimes available very cheaply from camera stores that accumulated large stocks of them in the 1950s, are just the right size to fit inside a $1\frac{1}{4}$-inch eyepiece tube if you can improvise a retaining ring to hold them in place.

Since the filter affects the total amount of light available, the exposure has to be corrected to allow for it. The best way to do this is to divide the film speed by the filter factor (from Appendix E), then use the corrected film speed when consulting the exposure tables:

Corrected speed = original speed ÷ filter factor

Remember that filter factors are only approximate, and bracket exposures widely.

7.10 The individual planets

Now for the planets themselves. Mercury is rather hard to photograph for two reasons: it's small ($4.8''$ to $13.3''$ in apparent diameter), and it's very close to the sun. If you want to observe Mercury when the sun is not in the sky, you have to look very close to the horizon right after sunset or before sunrise – which means you're looking through a thick layer of turbulent air, and the prospects of seeing any surface detail are poor. Since much of the blurring introduced by the air near the horizon consists of chromatic aberration, anything that restricts the range of wavelengths you use, such as a red, green, or blue filter, will help. Alternatively, you may choose to observe in the daytime, using a deep red filter to suppress the blueness of the sky.

Venus is a much easier target. It has the highest surface brightness of any planet and, at times, the largest apparent diameter ($64''$). Recording the phases of Venus photographically is an excellent project for the beginner.

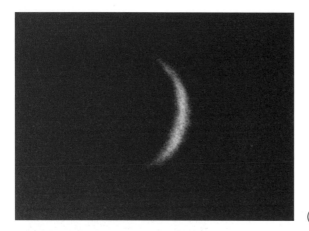

Figure 7.12 **The phases of Venus are an easy target for the beginning amateur. A 12.5-cm (5-inch) telescope at ×70 coupled afocally to a camera with a 100-mm lens and a Wratten 15 yellow filter. A 1/60-second exposure on push-processed Plus-X Pan film. (By the author)**

Photographing detail on Venus is more of a challenge – it requires the use of an ultraviolet filter (the Wratten 18A) that transmits no visible light, so that you can't see to focus. The solution is to focus through a different-colored filter made of the same type and thickness of glass, then swap filters before making the exposure. (By the way, the term "ultraviolet filter" is ambiguous – you want the almost-black 18A, not the clear 0 or 1A.) Using an ultraviolet filter of this type, amateur astrophotographer Charles Boyer discovered the 4-day rotation period of Venus' atmosphere in 1957.

Ordinary film responds well to ultraviolet wavelengths, but not all telescopes are suitable for ultraviolet work; most refractors suffer severe chromatic aberration in the ultraviolet. For the same reason, complicated afocal or projection systems are a bad idea – the lenses in them won't really be achromatic at the wavelengths you're using. In fact, the amount of glass in the system should be held to a minimum, since all glass absorbs ultraviolet to some extent; it is best to work at the prime focus of a reflector.

Mars is, in my opinion, somewhat neglected as an astrophotographic target; it is in fact the easiest planet on which to photograph detail because of the relatively high contrast of the surface features. A red filter helps bring out surface detail; a green filter is useful for highlighting the polar caps by darkening everything else. Good color photographs (with no filter, of course) are not hard to obtain.

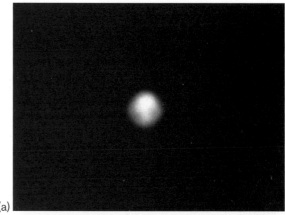

(a)

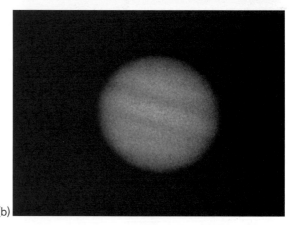

(b)

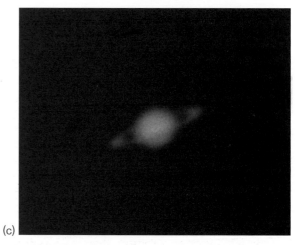

(c)

Figure 7.13 **A beginner's first planet photographs with a small telescope. Taken with a 12.5-cm (5-inch) Schmidt–Cassegrain with an 18-mm eyepiece coupled afocally to a 100-mm telephoto lens for an effective focal length of 7000 mm at *f*/56. All on Kodak SO-115 film (now known as Technical Pan), greatly enlarged. (a) Mars, 1 second, no filter (polar cap at top); (b) Jupiter, #15 yellow filter, 3 seconds; (c) Saturn, no filter, 7 seconds. (By the author)**

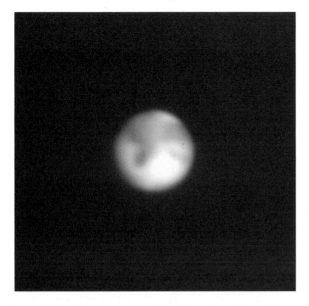

Figure 7.14 **Mars, photographed with a 25-cm (10-inch) Schmidt–Cassegrain telescope with positive projection giving $f/200$. Two 2-second exposures on were taken on Kodak Technical Pan Film. Then they were copied in a slide duplicator (using Technical Pan Film again) yielding enlarged positives. Finally they were stacked and rephotographed on Fujichrome 100. (Klaus Brasch)**

Figure 7.16 **Even a small telescope and a simple technique can produce a rewarding image of Jupiter. A 12.5-cm (5-inch) telescope at $\times 140$ coupled afocally to a camera with a 90-mm lens; a 2-second exposure on pushed Ektachrome Elite II 100. This is the best of 17 images. (By the author)**

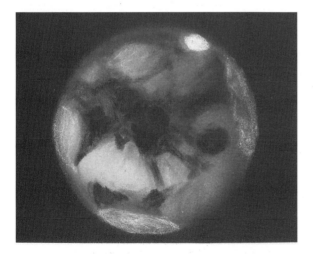

Figure 7.15 **"Photodrawing" of Mars: a photograph taken with 35-cm (14-inch) telescope was combined with visual drawing, yielding the resolution of a visual observation combined with the positional accuracy of a photograph. (Klaus Brasch)**

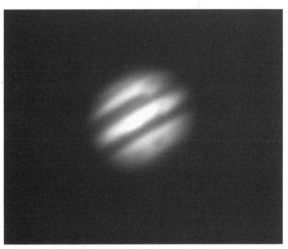

Figure 7.17 **Jupiter with the Great Red Spot. A 25-cm (10-inch) telescope working at $f/135$; the technique is the same as in Fig. 7.14. (Klaus Brasch)**

Table 7.1 *Oppositions of the bright outer planets, 1998–2005*

Mars

Date	Declination	Apparent diameter
1999 Apr. 16	$-12°$	$18''$
2001 June 13	$-26°$	$21''$
2003 Aug. 28	$-16°$	$25''$
2005 Nov. 7	$+15°$	$20''$

Jupiter

Date	Declination	Apparent diameter
1998 Sept. 16	$-4°$	$50''$
1999 Oct. 23	$+10°$	$50''$
2000 Nov. 28	$+20°$	$49''$
2002 Jan. 1	$+23°$	$47''$
2003 Feb. 2	$+17°$	$46''$
2004 Mar. 4	$+7°$	$45''$
2005 Apr. 3	$-4°$	$44''$

Saturn

Date	Declination	Apparent diameter	Inclination of rings
1998 Oct. 23	$+9°$	$20''$	$-15°$
1999 Nov. 6	$+13°$	$20''$	$-20°$
2000 Nov. 19	$+21°$	$20''$	$-24°$
2001 Dec. 3	$+20°$	$21''$	$-26°$
2002 Dec. 17	$+22°$	$21''$	$-27°$
2003 Dec. 31	$+22°$	$21''$	$-26°$
2005 Jan. 13	$+21°$	$21''$	$-23°$

Notes: Near the date of its opposition, each planet is highest in the sky at midnight and has maximum apparent diameter. The planet remains visible in the evening sky for several months afterward, but the apparent diameter decreases substantially, especially in the case of Mars. Positive (northern) declinations place the planet higher in the sky for observers in the Northern Hemisphere. Data from Espenak (1994).

The apparent diameter of Mars does vary quite a bit with its position in its orbit; not all oppositions of Mars are equally good. The 1995 opposition was especially bad; Mars had an angular diameter of only $13.9''$. Conditions are now improving, and the angular diameter will peak at $25''$ in 2003. But Mars will be south of the celestial equator and therefore rather low in the sky for Northern Hemisphere observers; the opposition of 2005, with Mars north of the equator, will probably yield better views even though the angular diameter is not quite as large.

Jupiter ($31''$ to $51''$) and Saturn ($15''$ to $21''$, plus rings) are classic targets for the amateur astrophotographer; surface detail, though low in contrast, is abundant, and even a 4-inch telescope will show a couple of bands on Jupiter. A yellow or green filter is generally helpful, as is high-contrast film (Kodak Technical Pan developed in HC-110 dilution D or the

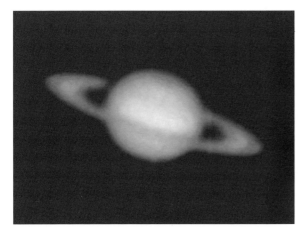

Figure 7.18 **Saturn, a relatively faint planet, requires fast film. A 2-second exposure on Fuji Super G 800 color print film with a 25-cm (10-inch) telescope operating at $f/144$; the image was digitally processed to reduce grain. (Gil Shillcutt)**

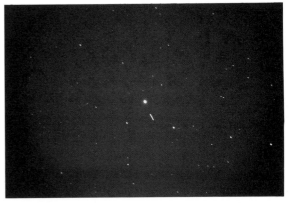

Figure 7.19 **This long exposure shows the trail of the asteroid Eros moving relative to the stars. Exposed for 30 minutes on Fujichrome 100 at the prime focus of a 12.5-cm (5-inch) telescope. (George East)**

like). A green filter darkens the Great Red Spot, which has been quite pale in recent years. Take advantage of exceptional atmospheric conditions when they occur, and try color film, especially when the Great Red Spot is prominent.

Uranus (4″), Neptune (2.5″), and Pluto (0.1″) have little to offer the amateur observer. You can, however, treat them as stars (of sixth, eighth, and fifteenth magnitude, respectively) and include them in star-field pictures. Asteroids can be handled similarly; they often move fast enough to leave a trail (Fig. 7.19).

More recently, some dedicated amateurs have started *discovering* asteroids, a relatively easy feat for anyone who can reach can reach 16th magnitude, photographically or by CCD imaging. Advances in computer technology have made it much easier to identify objects and compute orbits. See Di Cicco (1996) and Liller (1992). The best hunting is in fields that are near the ecliptic but well away from the Milky Way, to keep down the number of stars.

7.11 BASIC TECHNIQUE 11:
Photographing a planet (afocal method)

Caution: It is not easy to take satisfying pictures of the planets. Much perseverance is needed to take pictures that show more than a small amount of detail.

Telescope: Any telescope that gives a good view of the planet. Typically, the magnification will be between ×100 and ×300. A long-eye-relief eyepiece is desirable. A sturdy mount and good clock drive are necessary.

Camera: SLR camera with normal or moderate telephoto lens (up to 135mm); cable release; tripod for camera.

If the camera is not an SLR, you can focus with the aid of a small handheld telescope as described on p. 43. With an SLR, a clear-crosshairs or fine matte focusing screen is strongly desirable (see pp. 86–89).

Film: Medium-speed color slide film or slow, fine-grained black-and-white film. Kodak Technical Pan Film, developed to 100 or 200 speed, works well. Slide film should have good color saturation; Kodak Elite Chrome 100 and Fuji Velvia are good choices.

Sky conditions: Clear or slightly hazy night with steady air, as judged by the telescopic view of the planet.

Procedure: Place the camera on a separate tripod and aim it into the eyepiece. Since the telescope has a clock drive and the camera does not, frequent repositioning will be necessary. This is not as hard as it sounds.

Focus very carefully. Then take the picture using the cable release to avoid vibrating the camera or telescope. Take several pictures (as many as two dozen), focusing each afresh if

possible. Because of fluctuations in the air, some of the pictures will be considerably sharper than others.

Exposure: The camera lens must always be wide open; you cannot adjust it to change the exposure.

See p. 43 to calculate system f-ratio and focal length; then determine exposure from the tables in Appendix A. If the sky is hazy or the planet is near the horizon, increase the exposure ×2 or more.

7.12 BASIC TECHNIQUE 12:
Photographing a planet (by projection)

Caution: It is not easy to take satisfying pictures of the planets. Much perseverance is needed to take pictures that show more than a small amount of detail.

Equipment: Telescope and camera coupled by positive or negative projection (Chapter 6), typically with $M = 5$ to 20. A sturdy mount and good clock drive are necessary. The camera should be an SLR with a clear-crosshairs or very fine matte focusing screen (Beattie Intenscreen or equivalent).

Film: Medium-speed color slide film or slow, fine-grained black-and-white film. Kodak Technical Pan Film, developed to 100 or 200 speed, works well. Slide film should have good color saturation; Kodak Elite Chrome 100 and Fuji Velvia are good choices.

Sky conditions: Clear or slightly hazy night with steady air, as judged by the telescopic view of the planet.

Procedure: A carefully aligned finderscope will help you aim the telescope. Center the planet in the field, focus very carefully. Then take the picture using the cable release to avoid vibrating the camera or telescope any more than necessary.

The best way to prevent vibration is to hold a card in front of but not touching the telescope, open the shutter, wait for the vibration to die down, move the card aside for the appropriate time, then put it back and close the shutter. This is known as a "hat trick" (p. 97).

Second best is to use mirror lock. Focus, lock up the mirror of the camera, and then release the shutter.

Bear in mind that Schmidt–Cassegrain telescopes have a curved field, so if the planet drifts away from the center it will no longer be in focus. A drive corrector is helpful for recentering it.

Take several pictures (as many as two dozen), focusing each afresh if possible. Because of fluctuations in the air, some of the pictures will be considerably sharper than others.

Exposure: See tables in Appendix A. If the sky is hazy or the planet is near the horizon, increase the exposure ×2 or more.

Deep-sky photography

8

The "deep sky" is the sky beyond the solar system – comprising stars, clusters, nebulae, and other galaxies. Many deep-sky objects are extraordinarily beautiful, and the camera can "see" them much better than the eye can because of its ability to collect faint light during long exposures. Professional observatories do almost all their deep-sky work photographically or with CCDs, a tradition that goes back to E. E. Barnard's discovery of the Loop Nebula, a supernova remnant in Orion, with an inexpensive plate camera in 1894.

Table 8.1 lists a few deep-sky objects suitable for photography with modest equipment. Many more are easily located in books such as Burnham's *Celestial Handbook*, Tirion's *Sky Atlas 2000.0*, Mallas and Kreimer's *Messier Album*, and Vehrenberg's classic *Atlas of Deep-Sky Splendors*. The latter two books are especially useful because they depict many different objects photographed with the same equipment and film.

Deep-sky work is probably the most popular kind of astrophotography, and amateurs have developed

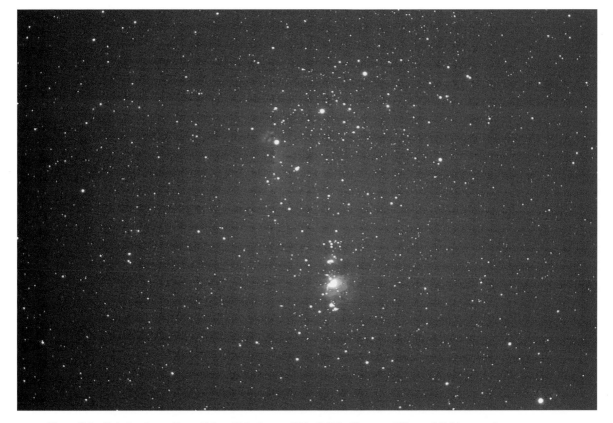

Figure 8.1 **Nebulae in southern Orion. Ektachrome Elite II 100, Olympus 135-mm *f*/2.8 lens and Meade broadband nebula filter. The camera was piggy-backed on the telescope for an 18-minute guided exposure. Compare to Fig. 8.2. (By the author)**

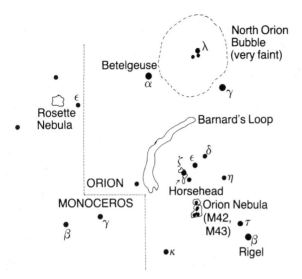

Figure 8.2 Nebulae to look for in your photographs of the Orion region. All are fluorescent gas; Barnard's Loop and the North Orion Bubble are probably supernova remnants.

quite sophisticated techniques; this chapter can't cover them all. The dedicated deep-sky photographer will want to read Wallis and Provin's *A Manual of Advanced Celestial Photography* and Clark's *Visual Astronomy of the Deep Sky*. The latter book is addressed to visual observers but contains much useful information about the brightness, size, and visibility of deep-sky objects. A book on wide-field deep-sky astrophotography is presently being written by Robert Reeves.

Finally, anyone who enjoys deep-sky astronomy will enjoy reading David Malin's *A View of the Universe*, which contains some of the finest deep-sky photographs in existence, as well as describing the scientific discoveries Malin was able to make by means of special astrophotographic techniques. Malin is a professional astrophotographer at the Anglo-Australian Observatory, but many of his techniques are accessible to amateurs, and his book is addressed to nonspecialists.

8.1 Piggy-backing

The simplest way to do deep-sky photography is to mount your camera "piggy-back" on a telescope that has an equatorial mount and clock drive. The telescope is used for guiding, but its optical system is not involved in the photography, which is done through the camera lens alone. You can use a wide-angle lens for wide

panoramas of sky, a normal lens for single constellations, or a telephoto lens for smaller areas such as M31, the Orion Nebula, or the Pleiades.

Figure 8.4 shows how an equatorial mount works. The mount has an axis, called the *polar axis*, which is aligned parallel to the axis of the earth. As the earth turns, a motor turns the telescope the opposite way. Note that in the Northern Hemisphere, you can find the earth's axis by sighting on the star Polaris. In the Southern Hemisphere, alignment is more difficult; you have to find and identify the rather faint star Sigma Octantis.

There are many ways to mount a camera on a telescope; Fig. 8.5 shows three. It's best to keep the camera close to the telescope's center of gravity in order to minimize the extra load on the drive. With fork-mounted catadioptric telescopes, counterweights help but are not essential unless the camera is unusually heavy. German-style equatorial mounts generally require careful rebalancing whenever a camera is added. The camera need not point in the same direction as the telescope; you can use a ball-and-socket tripod head to aim the camera in any direction. You can also use an angle bracket to stand the camera on end; the brackets made for tripod-mounting Celestron binoculars are good for this.

8.2 BASIC TECHNIQUE 13:
Piggy-back deep-sky photography

Equipment: Telescope with equatorial mount and clock drive; camera with normal or telephoto lens; cable release; piggy-back camera mount; drive corrector and eyepiece with crosshairs for guiding. If camera lens focal length is 135 mm or less, guiding corrections may not be necessary. A light yellow filter improves performance of telephoto lenses.

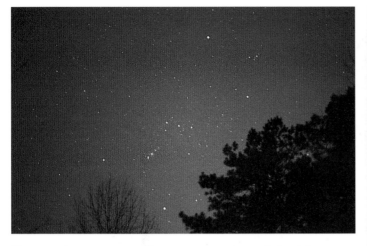

Plate 1.1 **Orion, photographed with just a camera and tripod. A 20-second exposure on Ektachrome P1600 film, with a 50-mm $f/1.8$ lens wide open. (By the author)**

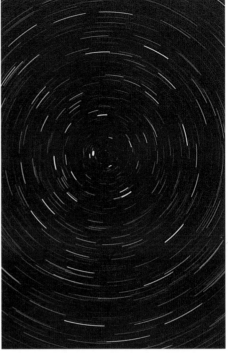

Plate 2.1 **This 1-hour fixed-camera exposure, centered on Polaris, shows how the earth's rotation makes the stars appear to circle the north celestial pole. Taken by George East with a 55-mm lens at $f/4$ on Fujichrome 100.**

Plate 2.2 **The glory of the summer Milky Way is fully evident in this 30-second fixed-tripod exposure with a 50-mm $f/1.7$ lens on Konica 3200 color print film, from a dark country site. Pink objects are emission nebulae M17, M20, and M8. (Maurice Snook)**

Plate 3.1 **If a comet is bright enough, you can photograph it on fast color print film with a camera on a fixed tripod, as in this picture of Comet Hale–Bopp. (Michelle Bass)**

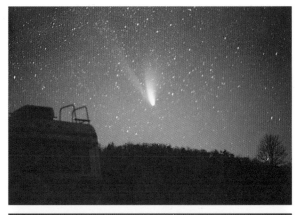

Plate 3.2 **Comet Hyakutake (1996). A six-minute exposure on Fuji Sensia 100 film with an Olympus OM-4T camera and an Olympus 180-mm $f/2.8$ lens piggy-backed on a clock-driven telescope. (By the author)**

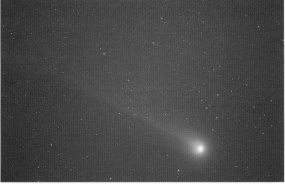

Plate 3.3 **Comet Hale–Bopp (1997) against the dark sky of Mount Tamalpais in California. A 10-minute exposure on Fuji Super G Plus 800 color print film with a Nikon F3 camera and a Nikon 300-mm $f/2.8$ lens piggy-backed on a telescope. Because the telescope was guided to track the comet nucleus rather than the stars, the stars appear as short trails. (Copyright 1997 Phil Lau)**

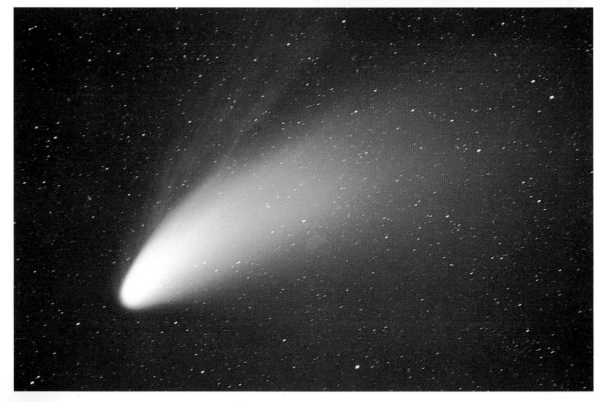

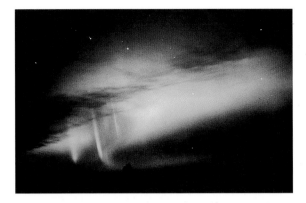

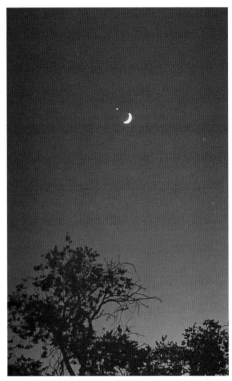

Plate 3.4 (above) **The aurora borealis with the Big Dipper in the background. A 20-second fixed-tripod exposure with a 50-mm $f/1.8$ lens on High Speed Ektachrome (ASA 160) taken more than twenty years ago. (Sherman Schultz)**

Plate 4.1 (right) **The moon and Jupiter over New Mexico, just before the occultation on 15 July 1980. A half-second exposure on Kodachrome 64 through a 100-mm lens at $f/4$. A few minutes later the planet disappeared from view as the moon moved in front of it. (By the author)**

Plate 4.2 (bottom left) **Unusually close conjunction of the moon and Venus on 19 April 1988, photographed at the prime focus of a 12.5-cm (5-inch) $f/10$ Schmidt–Cassegrain telescope. Kodachrome 64 film, auto-exposed with an Olympus OM-2S camera. (By the author)**

Plate 4.3 (bottom center) **The dark side of the crescent moon is often visible because the earth reflects light onto it. A 5-second exposure on Fujichrome 400 at the prime focus of a 25-cm (10-inch) $f/6$ Newtonian. (Kerry Hurd)**

Plate 5.1 (bottom right) **The deep partial lunar eclipse of 23 March 1997. A 16-second exposure on Fuji Super G 400 color print film with a Nikon F3 camera body at the prime focus of a 20-cm (8-inch) $f/10$ Schmidt–Cassegrain telescope. (Copyright 1997 Phil Lau)**

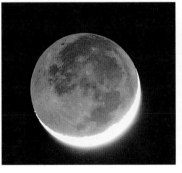

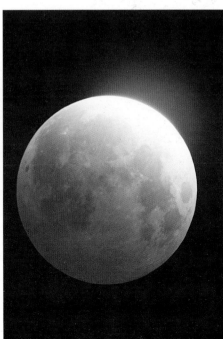

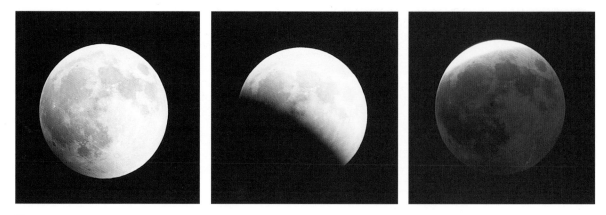

Plate 5.2 The same eclipse as Plate 5.1; the same optical configuration, but a different site and observer. Auto-exposed on Kodak Ektapress Multispeed (PJM) film with an Olympus OM-4T camera body. Exposures ranged from 1/60 to 1 second. (By the author and Cathy Covington)

Plate 5.3 A total lunar eclipse is the only time you can photograph the moon among the stars – in this case, the Hyades and Pleiades. The eclipse of 28 November 1993; a 1-minute exposure on Ektachrome Elite 200 with 100-mm $f/2.8$ lens wide open, piggy-backed on a clock-driven telescope. (By the author)

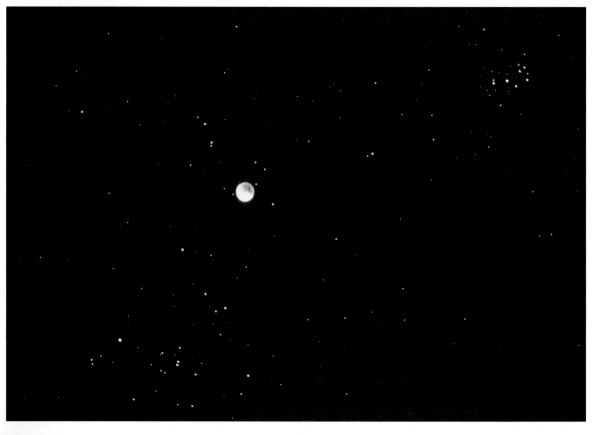

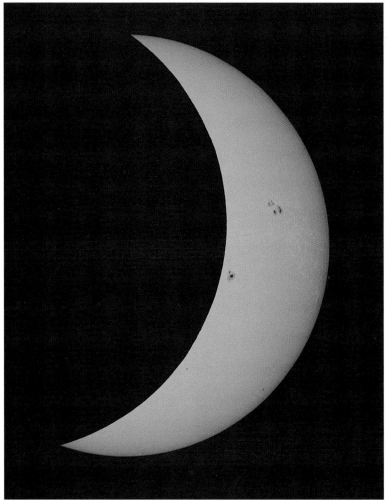

Plate 5.4 **An unusually sharp photograph of the partially eclipsed sun on 11 July 1991. A 12.5-cm (5-inch) Astro-Physics apochromatic refractor working at $f/16$ with a full-aperture Celestron solar filter, exposed for 1/30 second on Kodak Ektar 125 film. (John Volk)**

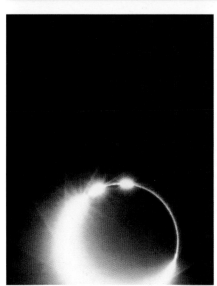

Plate 5.5 **The pink chromosphere and Baily's Beads were visible during the deep annular eclipse of 30 May 1984. A 400-mm lens at $f/32$, 1/1000-second exposures on Ektachrome 200. Because no filter was used, it was not possible to look through the viewfinder, and an attempt to aim the lens by its shadow was not wholly successful – the sun drifted out of the field. (Melody Covington)**

Plate 5.6 **Observers take aim at the totally eclipsed sun at the 1995 eclipse in India. (Jay Pasachoff)**

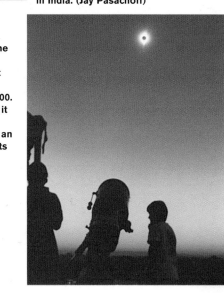

Plate 5.7 **Different exposures show different amounts of corona; the shortest exposure shows prominences. Top to bottom: 1/125, 1/30, 1/4 second. Taken in 1991 in Baja California with an Astro-Physics 18-cm (7-inch) apochromatic refractor with a compressor giving *f*/6 (*F* = 1067). (Chuck Vaughn)**

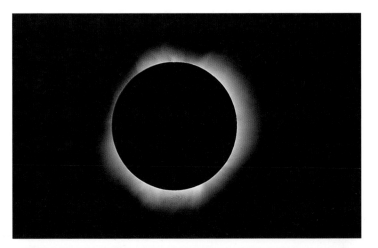

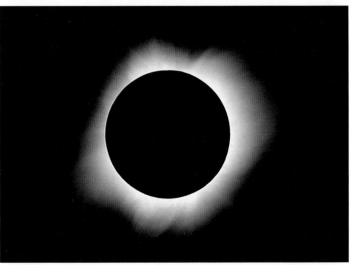

Plate 5.8 **The diamond ring effect, photographed in Papua New Guinea in 1984. (Jay Pasachoff)**

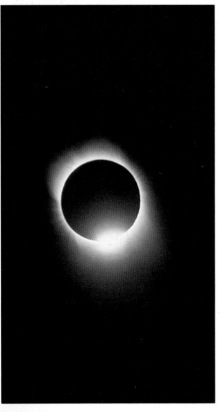

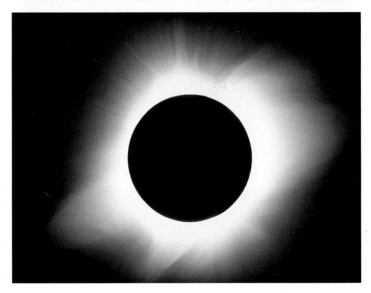

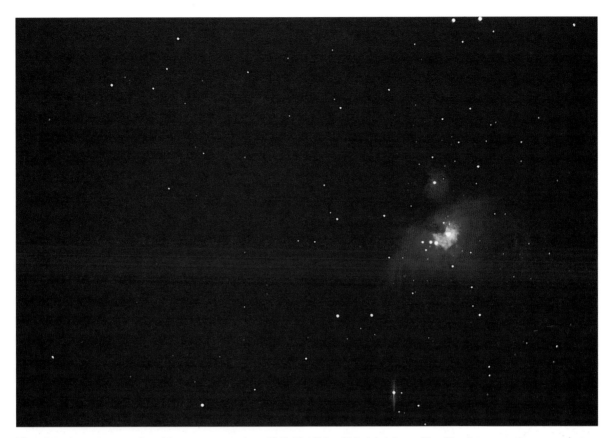

Plate 6.1 **Astrophotography with a compressor lens. M42 (the Orion Nebula), taken with a Meade 20-cm (8-inch) $f/10$ Schmidt–Cassegrain telescope with a Celestron ×0.63 compressor, giving $f/6.3$. A 4-minute exposure on Ektachrome Elite II 100 pushed 2 stops. Note the sharp star images nearly to the edge of the field. Compare to Plate 8.10 (By the author)**

Plate 7.1 (left) **Jupiter's Great Red Spot is prominent in this image. Two exposures taken through a 35-cm (14-inch) telescope at $f/200$ on Fujichrome 100 were stacked and copied in a slide duplicator. (Klaus Brasch)**

Plate 8.1 (right) **A rich star field in Cygnus photographed with a barn-door tracker. A 3-minute exposure with a 50-mm lens at $f/2.8$ on pushed Ektachrome Elite II 100 film. The North America Nebula is faintly visible at the top. (By the author)**

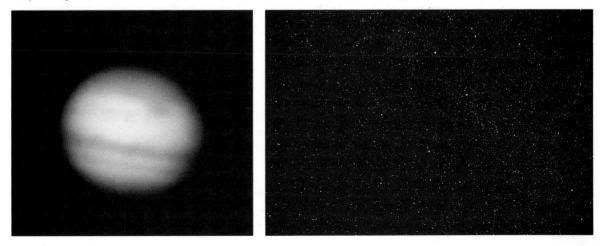

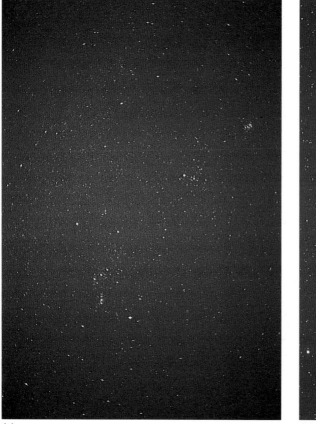
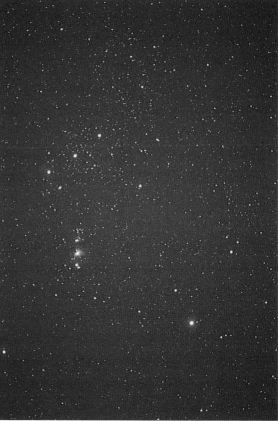

(a) (b)

Plate 8.2 **Lens focal length determines field of view. (a) A wide-field view of Orion and Taurus taken with a 24-mm $f/2.8$ lens; a 10-minute exposure on Fujichrome 400. (By the author) (b) "Zooming in" on southern Orion with a 100-mm lens, also $f/2.8$. Same film, same exposure time as (a).**

Plate 8.3 **A hand-guided exposure of the summer Milky Way; the camera was piggy-backed on a telescope with an equatorial mount but no drive motor. A 7-minute exposure on Fujichrome 100 with a 50-mm lens at $f/1.9$. The Lagoon Nebula (M8) is prominent at lower right. (Taken in 1975 by Douglas Downing)**

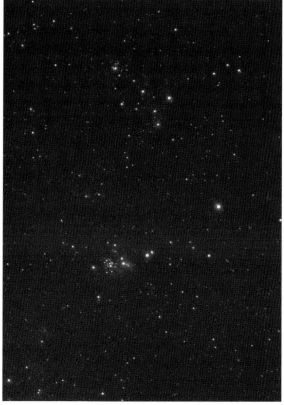

(a)

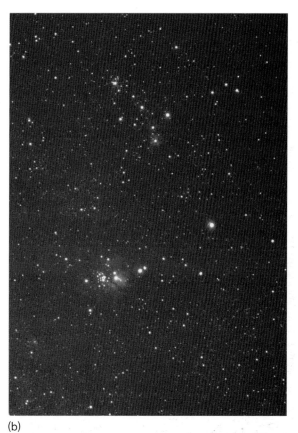

(b)

Plate 8.4 **The overall appearance of a deep-sky photograph depends on the film. Two 5-minute exposures of the Lagoon and Trifid nebulae with a 180-mm $f/2.8$ lens. (a) Fuji Provia 100; (b) Kodak Ektachrome Elite II 100. (By the author)**

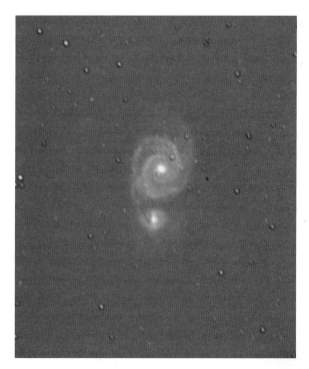

Plate 8.5 **The galaxy M51 (10 million light-years away). A 50-minute exposure at the prime focus of a 30.5-cm (12-inch) $f/5$ reflector, using Fujichrome 100 chilled with dry ice in a cold camera to prevent reciprocity failure. (Taken around 1980 by Akira Fujii)**

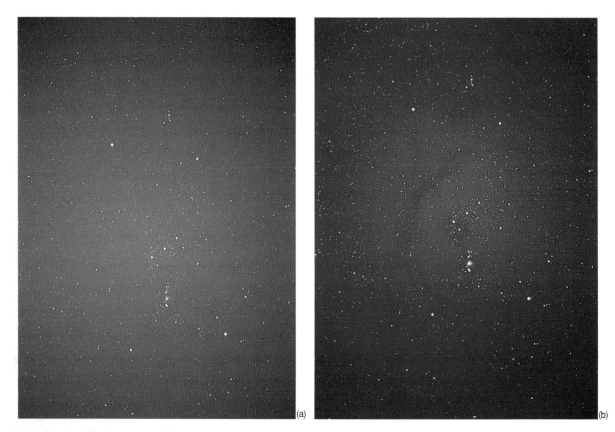
(a)
(b)

Plate 8.6 **Nebula filters selectively transmit light from emission nebulae. (a) A 2-minute exposure of Orion with a 50-mm $f/1.8$ lens on Ektachrome Elite II 100 at a rather light-polluted site. (b) A 20-minute exposure with a Meade broadband nebula filter added. Note that the filter is effective only in the center of the field; at the corners it transmits the wrong wavelengths due to the oblique angle. With longer lenses this is not a problem. (By the author)**

Plate 8.7 **The Rosette Nebula in Monoceros. A 25-minute exposure on Ektachrome Elite II 100 pushed 2 stops with a 90-mm $f/2.8$ lens and a Meade broadband nebula filter. (By the author)**

Plate 8.8 **The North America Nebula and other nebulae in Cygnus. A 20-minute exposure on Ektachrome Elite II 100 pushed 2 stops, using a 90-mm $f/2.8$ lens and a broadband nebula filter. (By the author)**

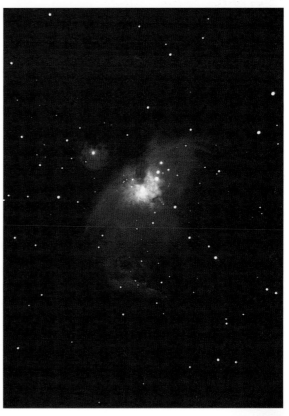

Plate 8.9 **Demonstrating the "poor man's nebula filter" – a red filter was placed over the camera lens for the first 8 minutes, then removed for the last minute of the exposure in order to give white star images. A 100-mm $f/2.8$ lens, Ektachrome Elite II 100 pushed 2 stops. (By the author)**

Plate 8.10 **The Orion Nebula at the prime focus of a 20-cm (8-inch) $f/10$ Schmidt–Cassegrain, guided with an off-axis guider. A 10-minute exposure on Ektachrome Elite II 100 pushed 2 stops. Compare to Plate 6.1. (By the author)**

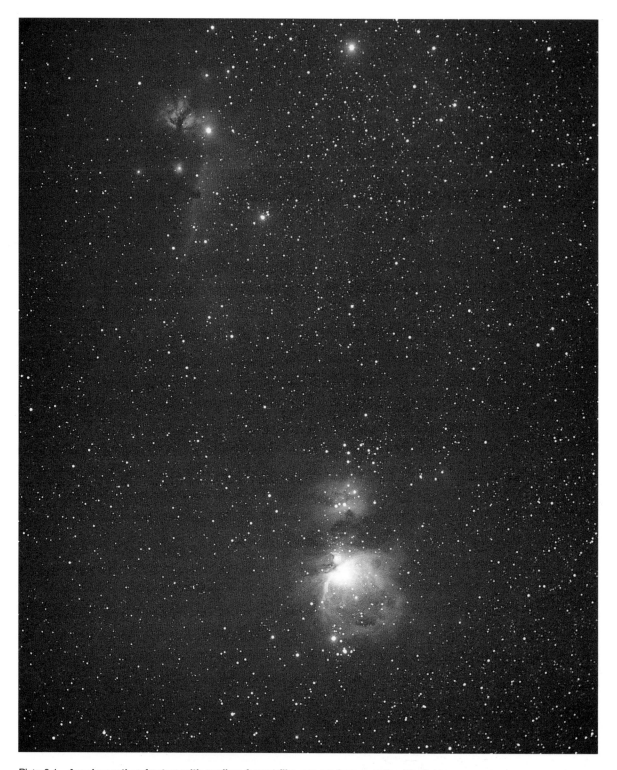

Plate 9.1 **Apochromatic refractors with medium-format film can produce superb wide-field photographs. Nebulae in Orion photographed on Kodak PMZ 1000-speed color print film with a Pentax 6×7-cm camera at the prime focus of a 10-cm (4-inch) *f*/6 Astro-Physics refractor. A 12-minute exposure at a dark-sky site in the Mojave Desert. (John Volk)**

(a)

(b)

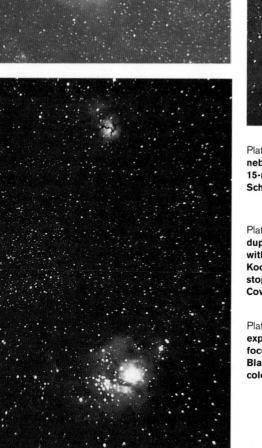

Plate 10.1 (top left) **Dramatic color contrast between emission nebulae (red) and a reflection nebula (blue). Field of M8 and M20, a 15-minute exposure on Fujichrome 100 with a 20-cm (8-inch) _f_/1.5 Schmidt camera. (Taken around 1980 by George East.)**

Plate 11.1 (top right) **A dramatic demonstration of what a slide duplicator can do. (a) The field of M8, 15 minutes on Ektachrome 200 with a 100-mm _f_/2.8 lens. (b) A slightly enlarged duplicate onto Kodachrome 25, illuminated with a blue photoflood and exposed two stops more than the meter indicated. (Michael and Melody Covington)**

Plate 11.2 **A color picture of M8 and M20 made by combining three exposures made through red, green, and blue filters at the prime focus of a 15-cm (6-inch) _f_/4 Newtonian on hypered Technical Pan. Black-and-white prints were rephotographed through appropriately colored filters in a triple exposure on color film. (Jim Baumgardt)**

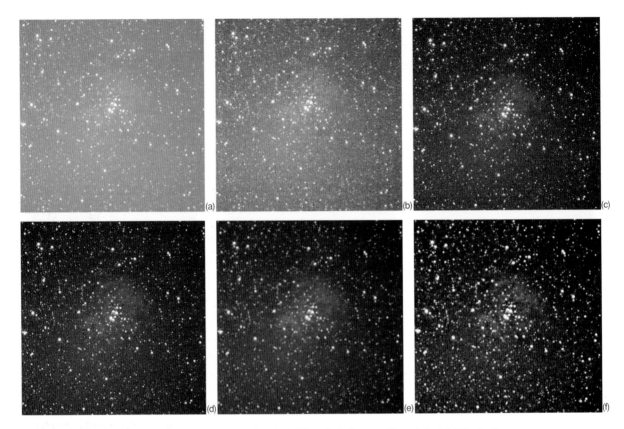

Plate 12.1 **Digital manipulation brings out an almost invisible nebula image. The original is 20-minute exposure on Ektachrome 100 HC with a 180-mm $f/2.8$ lens. See text p. 231 for details of processing. (By the author)**

Plate 12.2 **Digital color manipulation. (a) The original image of the moon, taken at prime focus of a 12.5-cm $f/10$ Schmidt–Cassegrain telescope, auto exposed on Fuji Sensia 100 film. (By the author) (b) Color saturation greatly increased, showing the bluish tint of Mare Tranquillitatis. (c) The image converted to monochrome, then back into false color as described in Fig. 12.16, p. 230, so that subtle shades of gray become visible as differences of hue.**

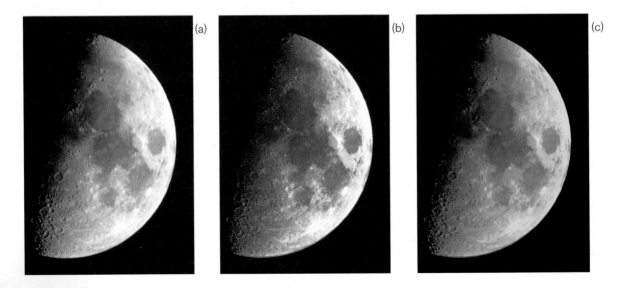

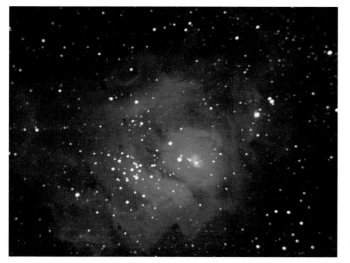

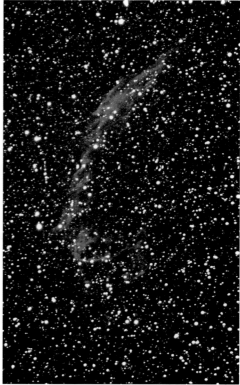

Plate 12.3 **A digitally processed image of M8, the Lagoon Nebula, a region of active star formation. A one-hour exposure on Kodak PPF (400 speed) color negative film at the prime focus of 20-cm (8-inch) $f/6.3$ Schmidt–Cassegrain telescope. Scanned with a Nikon Coolscan and enhanced with Paint Shop Pro. (Emery Hildebrand)**

Plate 12.4 **The Veil Nebula in Cygnus. A one-hour exposure on Ektachrome Elite II 100 using a Nikon N90s camera body at the prime focus of a Tele Vue Genesis 10-cm (4-inch) $f/5$ apochromatic refractor using an SBIG ST-4 CCD autoguider. Digitally processed. (Wil Milan)**

Plate 12.5 **Nebulosity around Gamma Cygni. A digital combination of two 30-minute exposures on Kodak PJM film with a Nikon 500-mm ED lens at $f/4$ and a Lumicon Deep-Sky nebula filter. (Copyright 1997 Jerry Lodriguss)**

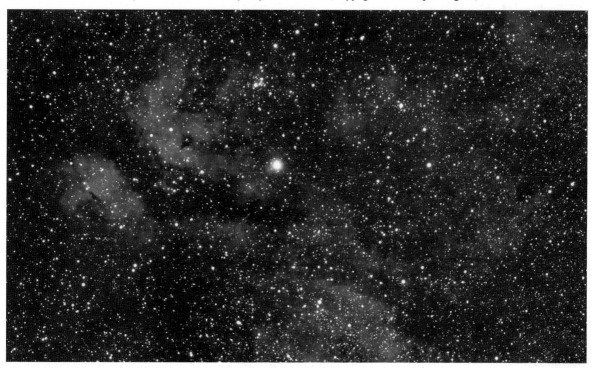

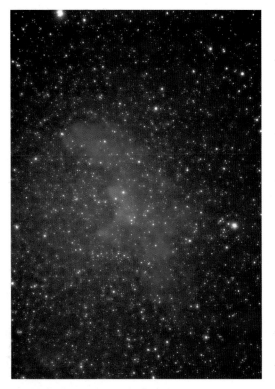

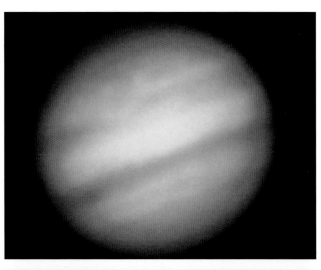

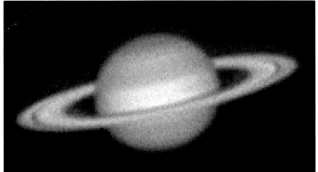

Plate 12.6 **The Witch's Head Nebula (IC 2118), a reflection nebula near Rigel. As Plate 12.5, but a composite of two 10-minute unfiltered exposures. (Copyright 1997 Jerry Lodriguss)**

Plate 13.1 **Jupiter, imaged with a Kodak DCS 420 digital camera and an 11-inch (27-cm) $f/10$ Schmidt–Cassegrain telescope using eyepiece projection. The image was processed with Adobe Photoshop to remove dust specks, enhance local contrast, and adjust overall contrast and color. (Michael Eskin)**

Plate 13.2 **A tricolor image of Saturn made by combining three exposures taken through red, green, and blue filters. Taken with a 40-cm (16-inch) $f/5$ Newtonian telescope and a Celestron PixCel 255 CCD camera. Sharpness and color saturation have been enhanced by image processing. (Gregory Terrance)**

Plate 13.3 **Mars, imaged with same setup as Plate 13.2. Image processing to bring out fine detail has resulted in a slight ripple pattern. (Gregory Terrance)**

Plate 13.4 **A tricolor CCD image of the Trifid Nebula (M20). Taken with a 40-cm (16-inch) $f/5$ reflector and an SBIG ST-6 CCD camera. (Gregory Terrance)**

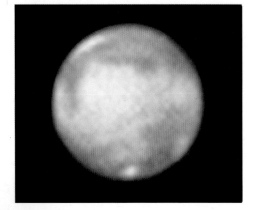

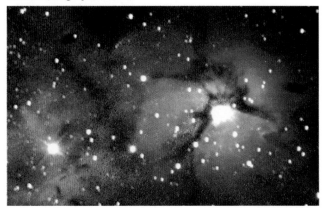

Table 8.1 *Some interesting objects for piggy-back astrophotography. This is just a selection – there are many others that are no more difficult*

Name	Type of object	Constellation	RA	Decl.	Size	Bright-ness[1]	Suggested lens	When best seen[2]	Visible from UK	USA	Australia
Pleiades	Large open cluster with faint nebula	Taurus	03:47	+24°	2°	Bright	Telephoto	December	Yes	Yes	Yes
Coma star cluster	Loose cluster	Coma Berenices	12:25	+26°	10°	Bright	Normal or telephoto	April	Yes	Yes	Yes
Double Cluster	2 open clusters	Perseus	02:20	+57°	1°	Bright	Telephoto	November	Yes	Yes	No
Omega Centauri	Globular cluster	Centaurus	13:27	−47°	1.5°	Bright	Telephoto	May	No	No	Yes
Rosette Nebula	Cluster with nebula	Monoceros	06:32	+5°	1.2°	Faint	Telephoto	January	Yes	Yes	Yes
M42	Bright nebula	Orion	05:36	−5°	2°	Bright	Telephoto	January	Yes	Yes	Yes
Barnard's Loop	Nebula	Orion	05:55	+2°	12°	Faint	Normal	January	Yes	Yes	Yes
North America Nebula	Nebula	Cygnus	20:59	+44°	3°	Medium	Normal or telephoto	September	Yes	Yes	Poorly
Small Magellanic Cloud	Galaxy	Tucana	00:53	−73°	5°	Bright	Any	October	No	No	Yes
Large Magellanic Cloud	Galaxy	Dorado, Mensa	05:25	−68°	9°	Bright	Any	January	No	No	Yes
M31	Galaxy	Andromeda	00:43	+41°	3°	Bright	Telephoto	October	Yes	Yes	Poorly
M33	Galaxy	Triangulum	01:34	+31°	1°	Medium	Telephoto	November	Yes	Yes	Yes
Galactic center	Dense Milky Way area with many clusters and nebulae	Sagittarius	17:46	−29°	20°	Bright	Normal or wide-angle	July	Poorly	Yes	Yes
Great Rift	Dark lane in Milky Way	Cygnus, Aquila	19:30	+20°	40°	Bright	Wide-angle	August	Yes	Yes	Yes

[1] Bright = easily visible to naked eye; medium = easy to photograph under good conditions; faint = somewhat difficult to photograph.
[2] At 10 pm local mean time.

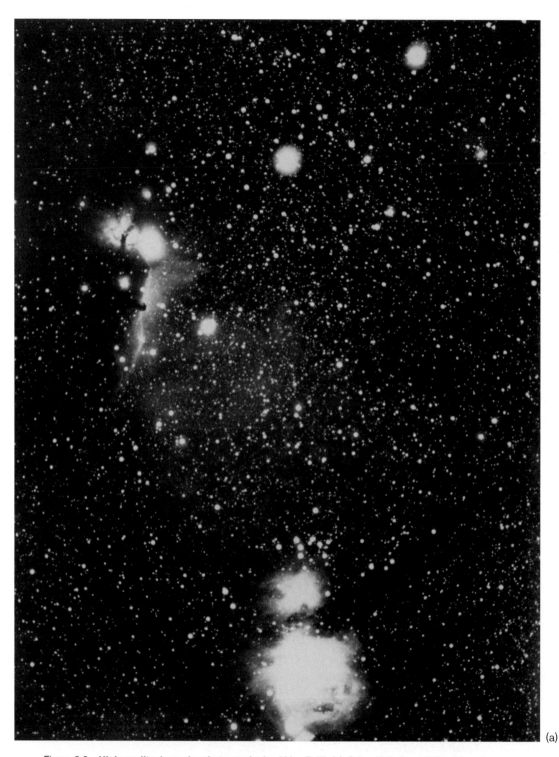

(a)

Figure 8.3 **High-quality deep-sky photographs by Akira Fujii. (a) Orion Nebula and Horsehead Nebula; (b) the North America Nebula in Cygnus. Both are 30-minute exposures on gas-hypersensitized Kodak Technical Pan Film with a Canon 300-mm $f/2.8$ telephoto lens piggy-backed on a telescope.**

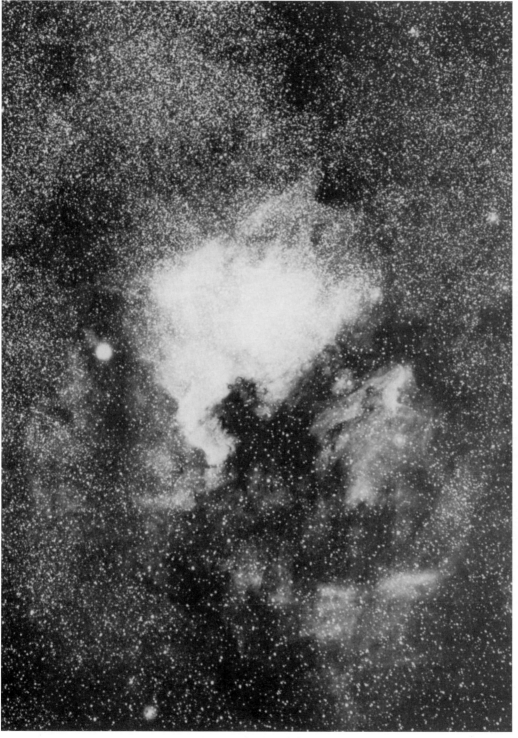

(b)

Figure 8..3 (*cont.*)

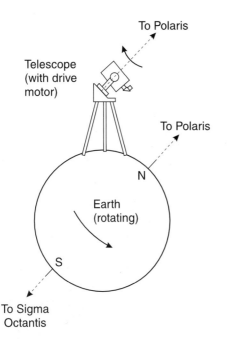

Figure 8.4 Principle of an equatorial mount.

Film: Medium-speed or fast color slide film (Kodak Elite Chrome 200 is an excellent choice). If you can obtain custom prints, Kodak Ektapress PJ400 and other new-technology color print films work very well. In black-and-white, use hypered Kodak Technical Pan if available, or Kodak T-Max 100 if hydrogen emission nebulosity is not important in your photograph.

Sky conditions: Moonless night, as clear as possible. Some nearby lights may be tolerable if they do not shine directly into the camera lens; lights can often be blocked with a lens shade.

Procedure: First align the polar axis of the telescope and familiarize yourself with the guiding controls. Determine the guiding tolerance (Table 8.4) and determine what this distance looks like in your telescope. If the camera lens is 135 mm or shorter, it will probably be sufficient to keep the guide star near the center of the eyepiece field.

Aim the telescope and camera, choosing a guide star that you can see easily. Make sure the telescope is tracking it.

Focus the camera carefully using the plain matte portion of the focusing screen. (Don't trust the infinity mark on your lens.) If you are using

a filter, focus with the filter in place; lenses that have longitudinal chromatic aberration will shift focus noticeably depending on the color of the filter.

Open the shutter and make the exposure, making guiding corrections during the exposure as necessary. Stay alert for dew and other difficulties. Dew that forms during a deep-sky session can be removed with a hair dryer; unlike planetary work, wide-field deep-sky work is not disturbed by the resulting air turbulence.

8.3 BASIC TECHNIQUE 14:
Polar alignment procedure

Sighting on Polaris is the usual way to line up a telescope mount parallel to the earth's axis. However, Polaris is not exactly on the north celestial pole. The method given here will get you within about a quarter of a degree of the true pole.

1 Make sure the declination circles really read 90° when the telescope is aimed parallel to its polar axis. Inaccuracy here is a major source of error. If the telescope and axis are truly parallel, then rotating the telescope about the polar axis will make stars seem to whirl around the center of the field rather than moving out of it.

2 Align roughly on Polaris. Then aim the telescope at a convenient star such as Capella (RA 5:16) or Mizar (13:24) and set the right ascension circle to show the star's right ascension. In effect, you are using the star as a sidereal clock.

3 Aim the telescope, by setting circles, to the coordinates of Polaris (2:32, +89.3°, epoch 2000). Then adjust the mount to get Polaris centered in the field.

(a) (b)

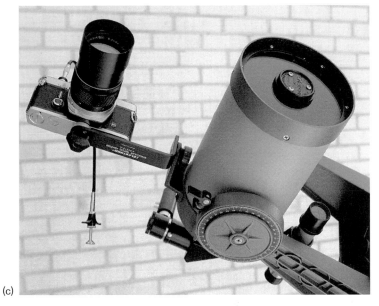

(c)

Figure 8.5 **Three ways of piggy-backing a camera on a telescope. (a) The camera is usually mounted on top. (b) Some telescopes allow you to mount the camera underneath for better balance. (c) This right-angle bracket, sold as a tripod adapter for Celestron binoculars, lets you take vertical shots, but beware of flexure with long exposures and/or heavy cameras.**

You can then refine the alignment by the *drift method* as follows:

1 Choose a star near the celestial equator, just south of the zenith, and track it for a few minutes.
 - If the star seems to drift *southward*, the polar axis is too far *east*;
 - if the star seems to drift *northward*, the polar axis is too far *west*.

 Adjust the polar axis to minimize the error.

2 Then choose a star that is about 20° above the eastern horizon, and track it.
 - If the star drifts *northward*, the polar axis is aimed too *high*;
 - if the star drifts *southward*, the polar axis is aimed too *low*.

3 Repeat steps 1 and 2 as needed, until the telescope is tracking well enough for your purposes; each adjustment may affect the other slightly.

For more on the art of polar alignment, see Wallis and Provin (1988).

8.4 Barn-door trackers

If you don't have a telescope with an equatorial mount and clock drive, don't despair – you can use a *barn-door tracker*. Despite its name, this is not a device for pursuing renegade barn doors across the prairie. Instead, it is a primitive equatorial mount made of two wooden panels hinged together.

Barn-door trackers are also known as *Haig mounts or Scotch mounts* because they were invented by a frugal Scotsman, G. Y. Haig (1975a, 1975b), and can be built very inexpensively. Although mine incorporates a ball-and-socket joint and stands on a tripod, both of these features are optional; in place of a tripod, you can use a block of wood cut at the correct

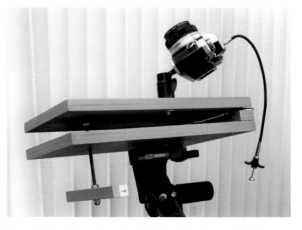

Figure 8.6 **A barn-door tracker is a simple equatorial mount made of two panels hinged together. The hinge is the polar axis. The operator turns handle one revolution per minute to track the stars.**

angle, and in place of the ball and socket, you can mount the camera on a simpler bracket or hinged wooden arm.

Jim Ballard has written a whole book about barn-door trackers and their kin (*Handbook for Star Trackers, 1988*), so I'll cover only the essentials here. The key idea is that by turning the screw at exactly one revolution per minute, you gradually open the hinges at exactly the rate of the earth's rotation. Naturally, you can only keep this up for a few minutes, but a few minutes are enough. It's reasonable to expect to be able to make 5-minute exposures with lenses up to 135 mm focal length. After that, the drive rate becomes perceptibly incorrect because the tip of the screw is no longer hitting the movable panel in the proper place.

Figure 8.7 shows a barn-door tracker in cross section. Choose the hinges for tight, smooth operation, and mount them precisely in line with each other; a continuous piece of piano hinge works well. Only one dimension is critical, the distance between the drive screw and the axis of the hinges; it depends on the thread pitch of the screw. To run the screw through the wood, you can use a brass threaded insert as I did, or you can simply drill a hole, apply a bit of oil or wax, and drive the screw through it carefully by twisting it so that it cuts its own threads.

To use the barn-door tracker, you align the axis of the hinges with Polaris. This is easily done by sighting along the hinges while illuminating them faintly with a red flashlight. *Align very carefully because, with no*

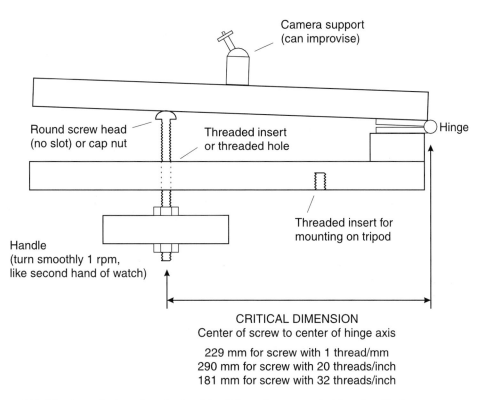

Camera support
(can improvise)

Round screw head
(no slot) or cap nut

Threaded insert
or threaded hole

Hinge

Handle
(turn smoothly 1 rpm,
like second hand of watch)

Threaded insert for
mounting on tripod

CRITICAL DIMENSION
Center of screw to center of hinge axis

229 mm for screw with 1 thread/mm
290 mm for screw with 20 threads/inch
181 mm for screw with 32 threads/inch

Figure 8.7 **Structure of a barn-door tracker. The distance from screw to hinge is critical; everything else can be improvised.**

guidescope, you won't know whether you got it right until you develop the film.

Then think for a minute about which way the stars are moving; make sure you're turning the screw in the right direction. Finally open the shutter and turn the screw at exactly 1 r.p.m.; you can do this easily by keeping it in step with the second hand of a watch. It's easier to turn it in 5- or 10-second steps than to sustain a continuous motion. Plate 8.1 and Fig. 8.8 show what you can achieve; see also Fig. 3.3 on p. 23.

Can you motorize a barn-door tracker? Yes; 1-r.p.m. motors are a standard item in the appliance repair business. However, coupling the motor to the shaft is a challenge because the shaft gets shorter as the screw turns. One solution is to make the motor turn a crank which turns the shaft; another is to mount the motor separately from the tracker and use a flexible drive shaft, perhaps a speedometer cable or a piece of aquarium tubing. See Ballard's book for other ideas. But don't try to build a perfect barn-door tracker; instead, graduate to a clock-driven telescope that lets you verify the tracking and make corrections during the exposure.

8.5 Lenses for deep-sky work

Naturally, a lens for star-field photography should be sharp, in order to produce bright, crisp star images, and free from internal reflections, in order not to introduce any unnecessary background fog. Apart from these, the two lens characteristics that matter most are light-gathering ability and focal length.

When you photograph extended objects – nebulae, galaxies, the Milky Way, or objects on earth – the brightness of the image naturally depends on the f-ratio of the lens; the lower the better. But when you photograph stars, things work differently. Regardless of the focal length, the image of a star is a tiny point. (If you wanted to magnify a star into anything more than a point, you'd need a lens system bigger than the largest telescopes on earth.) Accordingly, when you're photographing stars, what matters is not the f-ratio but the diameter of the lens.

If two lenses of the same diameter but different focal lengths are aimed at the same place in the sky for exposures of equal length on the same kind of film, they

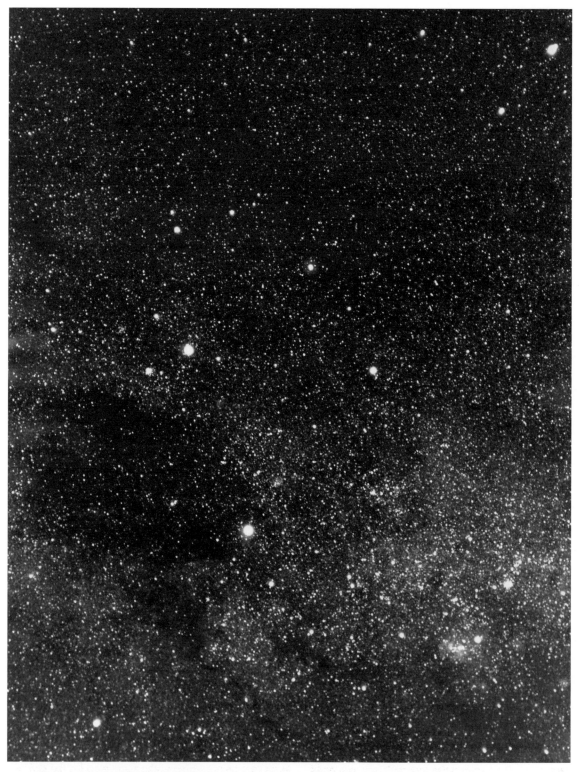

Figure 8.8 **An outstanding barn-door-tracker photograph showing the Southern Cross and Coal Sack. A 5-minute exposure with 50-mm *f*/1.9 lens on hypersensitized Technical Pan Film, taken during a trip to Chile. (Maurice Snook)**

(a)

(b)

Figure 8.9 **Two 3-minute exposures of M8 (the Lagoon Nebula) on pushed Ektachrome Elite II 100, with lenses of the same diameter but different focal length. (a) 180-mm *f*/2.8 lens; (b) 400-mm *f*/6.3 lens. The lenses are both 64 mm in diameter and record stars equally well, but their response to nebulosity and sky fog is dramatically different. (By the author)**

will photograph equal numbers of stars (within a given area of sky), but the shorter lens, having a lower f-ratio, will be more sensitive to nebulae, the Milky Way, and sky fog (Fig. 8.9). It will also yield a richer-looking picture, since the same number of stars will be compressed into a smaller area in the image. But two lenses operating at the same f-ratio but with different focal lengths, and hence different diameters, will record different numbers of stars while responding to extended objects identically.

The effective diameter of a lens is not necessarily the same as the size of the front element and should always be computed from the f-ratio:

$$D = F/f$$

where, as in Chapter 6, D is diameter, F is focal length, and f is f-ratio.

Figure 8.10 compares the suitability of various lenses for photographing stars and extended objects. Remember that most of the really interesting deep-sky

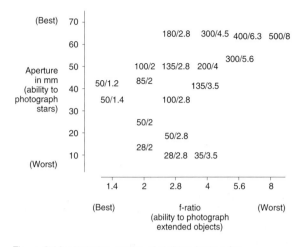

Figure 8.10 **Relative merits of various lenses for photograping stars and extended objects. "500/8" means "500-mm, $f/8$" (etc.). Different lenses are good for different things.**

Table 8.2 *Focal length, field of view, and edge-of-field effects for various focal lengths (on 35-mm film)*

Focal length (mm)	Field of view (degrees)	Relative scale enlargement at corners (center=1.00)	Illumination at corners of field (\cos^4 law), assuming lens does not compensate
18	67.4 × 90.0	2.36	20%
24	53.1 × 73.7	1.77	35%
28	46.4 × 65.5	1.56	44%
35	37.8 × 54.4	1.36	57%
50	27.0 × 39.6	1.18	74%
75	18.2 × 27.0	1.08	87%
90	15.2 × 22.6	1.05	91%
100	13.7 × 20.4	1.04	92%
135	10.2 × 15.2	1.02	96%
150	9.15 × 13.7	1.02	97%
200	6.87 × 10.3	1.01	98%
300	4.58 × 6.87	1.00	99%
400	3.44 × 5.15	1.00	100%
500	2.75 × 4.12	1.00	100%

objects are extended: nebulae, galaxies, the Milky Way, globular clusters, and so forth. Hence f-ratio is usually more important than diameter. The ability to photograph the stars themselves becomes an issue if you are interested in open clusters, novae, variable stars, or asteroids.

The types of object you will want to photograph will depend on the field of view, which depends on the focal length and film size. The formulae for computing field of view were given in Chapter 6; Table 8.2 summarizes the results for commonly used focal lengths and 35-mm film. (For focal lengths over 500 mm, see Table 6.2 on p. 75.) You may want to make an overlay for your star atlas that shows the coverage of each of your lenses, as an aid in planning exposures and comparing the resulting pictures to the charts. See also Plate 8.2 for a practical comparison of two lenses.

You may not want to use your lens wide open. Most lenses faster than $f/2.8$ have noticeable aberrations when used at maximum aperture, so that the star images at the corners of the field are blurred or distorted. This is a result of the compromises inherent in any lens design. A perfect $f/1.4$ lens would be hard if not impossible to make. So the manufacturer takes an excellent $f/2.8$ design and builds it oversize so that you can open it up to $f/2$ and $f/1.4$ when you want to. For ordinary earthbound photography, the results are quite satisfactory, but stars are more demanding subjects, and

the lens is noticeably imperfect at its widest apertures. Don't despair if even the best lens doesn't perform perfectly at apertures wider than $f/2.8$.

Most telephoto lenses have some chromatic aberration and become much sharper if you add a light yellow filter to block the extreme violet end of the spectrum. Without the filter, you get blue haloes around stars in color, blurry stars in black-and-white. Suitable filters include the Lumicon Minus Violet and Wratten #2E, #3, #6, and #8. Be sure to focus the camera with the filter in place.

8.6 Scale enlargement and edge-of-field fall-off

Table 8.2 also accounts for two things that may seem to be lens defects, but are not. First, as Fig. 8.11 shows, the angular scale will be larger at the edges than in the center. This phenomenon isn't distortion; the lens has no trouble correctly reproducing a flat target on flat film. In fact, the scale enlargement occurs *because* the film is flat. It can be computed as follows:

Figure 8.11 **Why even a distortion-free lens has a larger scale at the edges than at the center.**

$$\text{Relative scale} = \frac{1}{(\cos\theta)^2}$$

where θ is the distance off axis, expressed as an angle. The term $\cos\theta$ is squared because there are two effects to take into account: the film is farther from the lens at the corners, making the effective focal length longer, and the light is striking the film obliquely, spreading the image over a larger area. This formula is equivalent to

$$\text{Relative scale} = \frac{1}{[\cos\arctan(w/F)]^2} = 1 + \frac{w^2}{F^2}$$

where w is the linear distance from the center of the film and F is the focal length, expressed in the same units.

The third column of Table 8.2, then, gives the relative scale for a point 20 mm off-axis, in the corner of a 35-mm frame, and as you can see, the effect is

appreciable only for wide-angle lenses. Even then, it does not necessarily detract from the visual appeal of the pictures, though it is important if you want to measure positions on photographs.

The number in the rightmost column of Table 8.2 relates to the fall-off of light at the edge of the field – again, not necessarily a lens defect, but always to some extent an inevitable geometrical phenomenon.

Just as they tolerate some edge-of-field blurring, most lens makers tolerate some vignetting at the lens's widest aperture. Vignetting results from lens elements or stops that are not quite large enough to let all the light through; making the stops slightly too small is an excellent way to reduce reflections and lens flare. But true vignetting should disappear when you stop the lens down. Any light fall-off that remains is the result of what is known as the \cos^4 law or cosine-four law:

$$\text{Relative brightness} = \frac{1}{(\cos\theta)^4}$$

where, as before, θ is the angular distance off axis.

This comprises the same two cosine factors as in the previous formula, but one of them is squared because brightness depends on area rather than linear scale. That makes three cosine factors. The fourth one reflects the fact that the back opening (exit pupil) of the lens does not face the edge of the film squarely and hence has a smaller effective area when seen from an angle.

The \cos^4 law is not absolute. Most modern wide-angle lenses compensate for it by making the entrance pupil larger off-axis. You can see this for yourself by looking straight into the front of the lens from various angles. Even so, this compensation is not perfect. A spherically symmetrical lens and camera would be the only complete cure. A few experimental ultra-wide-angle lenses for terrestrial photography have been made with absorbing filters that darken the center of the field to match the edges – hardly an approach that an astrophotographer would like. Fisheye lenses combat

Figure 8.12 **This 5-minute exposure of the Coathanger Cluster reaches magnitude 13. Pushed Ektachrome Elite II 100 film, Olympus 300-mm _f_/4.5 lens wide open (67 mm clear aperture). The faintest stars may not be visible in the reproduced image. (By the author)**

Table 8.3 _Expected magnitude limit in a 5-minute exposure on 100-speed film (assuming a 50-mm f/2 lens reaches magnitude 10.0)_

Lens		Approximate diameter (mm)	Magnitude limit
400-mm	_f_/5.6		
300-mm	_f_/4	70	12.2
200-mm	_f_/2.8		
300-mm	_f_/5.6		
200-mm	_f_/4	50	11.5
135-mm	_f_/2.8		
100-mm	_f_/2		
200-mm	_f_/5.6		
135-mm	_f_/4	35	10.7
100-mm	_f_/2.8		
75-mm	_f_/2		
100-mm	_f_/4		
75-mm	_f_/2.8	25	10.0
50-mm	_f_/2		
75-mm	_f_/4		
50-mm	_f_/2.8	18	9.3
35-mm	_f_/2		
50-mm	_f_/4		
35-mm	_f_/2.8	13	8.6
28-mm	_f_/2		
35-mm	_f_/4		
28-mm	_f_/2.8	9	7.8
24-mm	_f_/2.8		
28-mm	_f_/4		
24-mm	_f_/4	6.5	7.0
18-mm	_f_/2.8		

the problem in a different way, by introducing distortion to make the scale contract, rather than enlarge, at the edges.

8.7 Magnitude limits and surface brightness

If you increase the magnitude limit of a photograph by 1, you roughly triple the number of stars in the picture. If stars were uniformly distributed in space and there were no interstellar dust, each additional magnitude would increase the number of stars by a factor of 3.98. You can study the distribution of stars and interstellar dust by photographing various areas of the sky, making both 5- and 15-minute exposures, and comparing the number of stars in each picture. "Star gauges" of this type, conducted visually, enabled Sir William Herschel to discover the pancake-like shape of our galaxy more than two hundred years ago.

Recall that magnitudes form a logarithmic scale; each magnitude unit is equivalent to a factor-of-2.512 brightness ratio. It follows that if you want to increase the magnitude limit of a photograph by 1, you have to pick up 2.512 times more light. You can do this by approximately tripling the exposure (allowing for

reciprocity failure, which is why a factor-of-2.512 increase isn't enough) or by making the lens 60% larger in diameter. You can compare the magnitude limits of two lenses, using the same film and the same exposure time, with this formula:

$$\text{Magnitude difference} = 2.5\log_{10}(D_2/D_1)^2$$

where D_1 and D_2 are the diameters of the lenses. The computed difference should be added to the magnitude limit of lens 1 to get that of lens 2. Table 8.3 gives some estimated magnitude limits based on this formula.

But the actual magnitude limit of a star-field photograph also depends on two more things: sky fog,

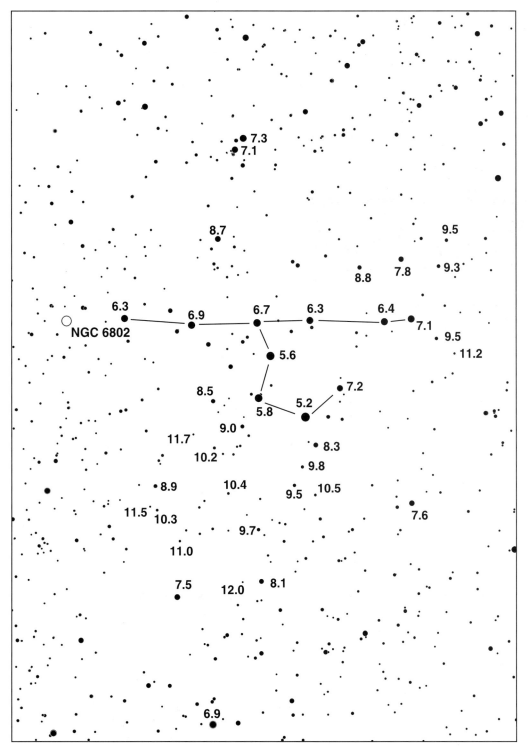

Figure 8.13 **The Coathanger (Brocchi's Cluster, Collinder 399), an open cluster in Vulpecula (right ascension 19:25, declination +20°). Field 2° × 3°; stars to magnitude 12.0. Data from Hubble Guide Star Catalogue; chart generated by Meade** *Epoch 2000sk* **software. NGC 6802 is a small cluster of 13th-magnitude and fainter stars.**

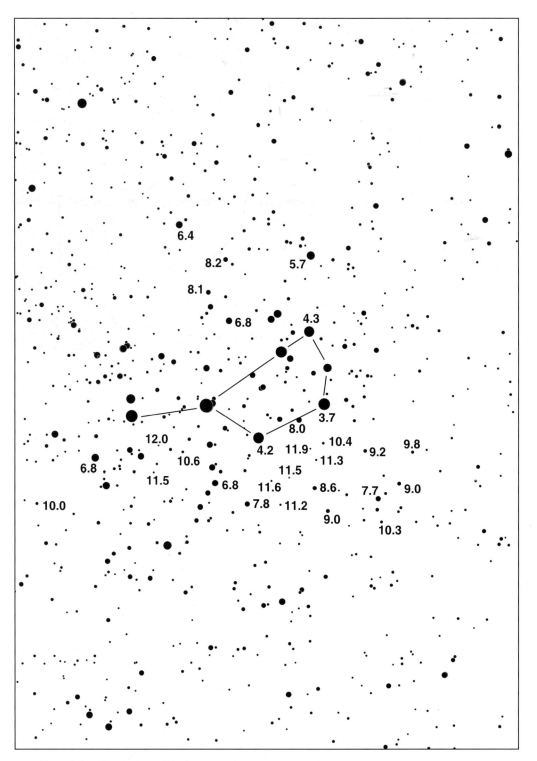

Figure 8.14 **The Pleiades (M45), an open cluster in Taurus (right ascension 3:47, declination +24°). Field 2° × 3°; stars to magnitude 12.0. Data from Hubble Guide Star Catalogue; chart generated by Meade *Epoch 2000sk* software.**

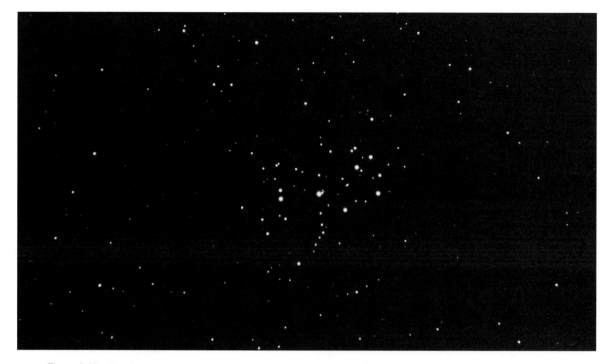

Figure 8.15 **The Pleiades, to magnitude 9.5 or so. A 5-minute exposure on Fuji Sensia 100 film with a 180-mm lens at $f/8$, giving 22 mm clear aperture. Contrast was enhanced by duplicating the slide. (By the author)**

which can obscure stars, and lens sharpness. If the lens doesn't focus the stars to sharp points, the film will not record them efficiently. Your 50-mm lens at $f/4$ will give pinpoint star images that hardly any telescope can rival. For this reason, the magnitude limits of telescopic photographs are often worse than predicted (or, to put it another way, ordinary camera lenses perform unexpectedly well). If a star image is spread out appreciably on the film, it isn't as bright as it could be.

You can use Figs. 8.13 and 8.14 to check the magnitude limits of your own photographic techniques. These charts show two bright star clusters, the Coathanger and the Pleiades, with star magnitudes indicated. Charts of this type have been published in a number of other places. One of the most useful is the American Association of Variable Star Observers' *North Polar Sequence*, a series of charts of the area around Polaris showing stars down to 18th magnitude, with precise photometric magnitudes. It is reprinted by Martinez (1994, v. 2, pp. 941–943).

Charts of star magnitudes around numerous deep-sky objects are given by Luginbuhl and Skiff (*Observing Handbook and Catalogue of Deep-Sky Objects*). Edgar Everhart's charts of two small regions of the sky with stars labeled down to magnitude 20 (*Sky & Telescope*, January, 1984) are reprinted by Wallis and Provin (1988, pp. 96–97). Of course, any variable-star chart can be useful, and nowadays, you can use a computerized star atlas to retrieve magnitude data on any star in the picture. Be forewarned that Hubble Guide Star Catalogue data are not always accurate; that catalogue was made for the purpose of identifying stars, not astrophysical study. The newer Hipparcos catalogue is better.

If you can photograph tenth-magnitude stars, that doesn't necessarily mean you can photograph tenth-magnitude galaxies. A tenth-magnitude galaxy delivers as much light as a tenth-magnitude star, but its light isn't concentrated into a point. What we need to know, therefore, is not its magnitude but rather its *surface brightness*.

Astronomers measure surface brightness in terms of *magnitude per square arc-second*, abbreviated m''. An object has a surface brightness of 1 m'' if a first-magnitude star, spread out into a 1×1-arc-second square area of sky, would match the surface brightness

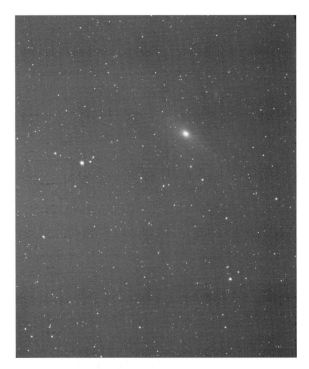

Figure 8.16 **At about 20 m'', the outer parts of the Andromeda Galaxy are hard to separate from sky glow. A 9-minute exposure on Kodak Ektachrome Professional E200 film with a 300-mm $f/4.5$ lens. (By the author)**

of the object. Appendix A goes into this in more detail. Suffice it to say that 1 m'' would be a very bright object, brighter than the full moon; nebulae and galaxies are more like 16 m'' to 22 m''. The Milky Way is about 21m''; so are other galaxies no matter how close you get to them. Thus, the popular image of a spaceship cruising among bright spiral galaxies is entirely off the mark!

Given that skyglow is typically 19 m'' at a good observing site, how does anybody ever photograph a 21-m'' galaxy? Mainly by deliberately underexposing the galaxy, so that it is visible but not in the middle of the film's response range. One effective technique is to expose for the sky fog limit, then increase the contrast of the picture. When the sky is two magnitudes brighter than the galaxy, the combined light of sky plus galaxy will still be about 20% brighter than the sky alone.

Fortunately, emission nebulae are much brighter in hydrogen-alpha light (at 656.3 nm) than in the

wavelengths visible to the dark-adapted human eye. Nebula photography depends crucially on capturing the hydrogen-alpha wavelength.

8.8 Guiding

If you use lenses shorter than about 135 mm and align carefully on the pole, you can do quite a bit of piggy-backing without making any guiding corrections. But with focal lengths longer than 200 mm, even if you have an excellent equatorial mount and clock drive, you still have to make guiding corrections by hand, for several reasons:

1 Imperfect polar alignment (the equatorial mount is not perfectly parallel with the earth's axis).
2 Periodic errors in the gear train of the clock drive. (Most gear systems run alternately a bit fast, a bit slow, a bit fast again, and so on.)
3 Fluctuations in the frequency of the AC power supplied to the motor. (The power company doesn't give you 60 Hz all the time;[1] although the long-term average frequency is very accurate, the short-term tolerance is only 1%.)
4 Discrepancies between your drive's tracking rate (usually solar rate, one revolution per 24 hours) and the sidereal rate at which the stars appear to move.
5 Flexure of the telescope tube and mounting as the load shifts.
6 Atmospheric refraction (a change in the amount of air you are looking through, slightly altering the apparent position of the object).

Those at the beginning of the list are most under your control. In practice, a well-built telescope should track well enough to allow five- or ten-minute exposures through a 50-mm lens without any guiding corrections;

[1] 50 Hz in the UK, of course.

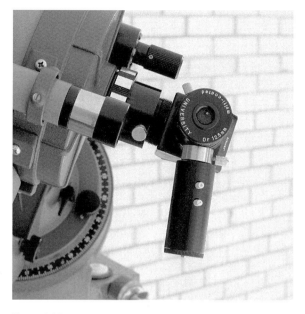

Figure 8.17 **This guiding eyepiece has a battery-powered illuminator.**

try it and see. If you get unsatisfactory results, first verify that the clock drive is indeed driving the telescope: is everything balanced? If the clock drive has an adjustable clutch, try tightening it (but not by much; the telescope should still be able to move freely, with no risk of stripping gears).

The way to deal with the other sources of inaccuracy, especially the ever-present periodic gear error, is to make guiding corrections by hand. When photographing through lenses of up to about 300 mm focal length, you can often get away with checking the tracking every minute or two; with longer focal lengths, and especially when you are photographing through the telescope as described later in this chapter, guiding has to be continuous.

To guide, you need an eyepiece with crosshairs. The old way of doing things is to use a single pair of crosshairs and center an out-of-focus star image on them. You can make this kind of guiding eyepiece yourself by gluing thin threads of spiderweb or hair across the field stop of one of your less-favorite 6-mm eyepieces. Most human hair is too thick, but a contribution from a baby or a person with thin blond hair will generally do. Thin hair-like filaments can be made out of some kinds of glue; reticles can also be made out of photographic film by photographing a suitable target.

Modern guiding eyepieces, though, have illuminated reticles, and the crosshairs are generally double, so that they form a small box at the center of the field. That box is useful; if you know its angular size, you can use it to gauge guiding tolerances.

There is some debate whether the illumination should be red or green; I've tried both, and I prefer dim green to bright red. The advantage of green is that I can be sure that my eye is focusing it in the same plane as the star image. The advantage of red is that even if quite bright, it doesn't harm night vision. I use a "PulsGuide" flashing illuminator made by Rigel Systems (p. 314). The flashing light source saves battery power and also enables you to see fainter guide stars (between the flashes, if not during them).

Naturally, you need to know how accurately you must guide. Assuming that you consider a blur of 1/40 mm (i.e., plus or minus 1/80 mm) on the film to be acceptable, the formula is:

$$\text{Guiding tolerance} = 2 \arctan \frac{1}{80F}$$

where F is the system focal length in millimeters. (The arctan function of your calculator probably gives its result in degrees; multiply by 3600 to get arc-seconds.) Table 8.4 shows the tolerances for a range of focal lengths.

Tolerances less than 5″ are not to be taken too seriously. Atmospheric turbulence introduces 3″ to 5″ of random variation into any long exposure, and star images smaller than 5″ are unlikely no matter how well you guide.

You'll need to know what the specified number of arc-seconds looks like through your telescope. There are two ways to determine this. For relatively large tolerances, you can turn off the drive and watch the rate at which the stars drift; at the celestial equator, they move 15 arc-seconds per second of time. So if you want to see what a distance of 150″ looks like, simply center the telescope on a suitable star, turn off the drive, and wait ten seconds. (Again, see the table for equivalent drift times.) For smaller tolerances, you can

Table 8.4 *Guiding tolerances for various focal lengths*

Focal length (mm)	Guiding tolerance	Drift time in seconds (at equator)
18	290″ (=4.8′)	20
24	215″ (=3.6′)	14
28	185″ (=3.1′)	12
35	145″ (=2.4′)	10
50	105″ (=1.8′)	7
100	50″	3.4
135	40″	2.5
200	25″	1.7
300	17″	1.1
500	10″	0.7
800	6.5″	0.4
1000	5.2″	–
1250	4.1″	–
1500	3.4″	–
2000	2.6″	–
2500	2.1″	–

judge distances by observing double stars of known separation. Then record, for future reference, what your guiding tolerance looks like, compared to, say, the width of the crosshairs (e.g., "Guiding tolerance for 300-mm lens = 4 crosshair widths"). If you have double crosshairs forming a small box, so much the better; determine the angular size of the box.

You must normally guide both in declination and in right ascension, although guiding on just one axis is certainly better than nothing. Guiding in declination is done with a mechanical slow motion or a small electric motor. Right ascension guiding done by varying the speed of the clock drive. Typically, you have a "fast" button that increases the speed about 15%, a "slow" button that decreases it by the same amount, and a control to adjust the speed at which the drive runs when neither of the buttons is being pressed. Most drive correctors operate off of a 12-volt DC supply (e.g., a car battery); a power consumption of 0.8 ampere is typical if you're running an older AC motor, considerably less with a newer stepping-motor drive.

Appendix C gives plans for an electronic drive corrector that operates conventional 120- or 240-volt AC motors drives from 12 V DC. Besides making guiding corrections, this device also makes you independent of

the local line voltage and frequency; you can use it to operate an American motor in Europe, or vice versa. But if you want to operate a telescope in the Southern Hemisphere that was designed for use north of the equator, you'll have to replace the motor with one that rotates in the opposite direction (which may not be difficult; clock drive motors are the same type as those used on appliance timers, and replacements are easy to obtain).

What if you have no motor at all? You can drive the telescope by hand, at least in non-critical piggy-backing work (see Plate 8.3). You'll need some means of moving the telescope smoothly (a slow-motion knob or the like) and plenty of patience. Hand-guiding is much easier if you do it in periodic spurts rather than trying to achieve continuous motion. The trick is to determine your guiding tolerance and then aim the telescope so that the star you are guiding on is just ahead of the center of the field – ahead by half of the tolerance, in fact. Let it drift until it is behind by an equal amount, and then, with a motion that need not be particularly quick, put it back in its original position. Do this over and over until the exposure is complete.

8.9 PRACTICAL NOTE:
What do you mean by 12 volts?

Most drive correctors are designed to run from a 12-volt DC supply so the telescope can be powered from a car battery. So are other accessories such as dew removers, autoguiders, and CCD cameras.

But the meaning of "12 volts" is sometimes unclear. A fully charged car battery delivers 12.6 volts, decreasing to about 11.8 volts as it discharges. When the engine is running, the electrical system of an automobile supposedly delivers 13.8 volts – at least that's the nominal

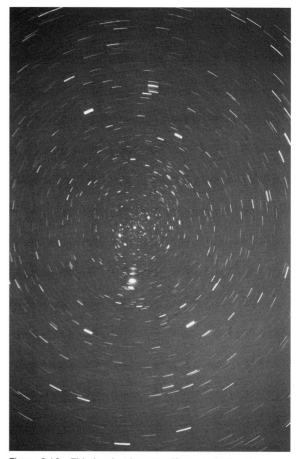

design voltage for automotive electronics. The real voltage can go as high as 17 V, with brief spikes of even higher voltages.

Line-powered "12-volt" power supplies often deliver 13.8 V. Some of them deliver as much as 18 V under a light load. Most drive correctors are more efficient at 12.6 or even 12.0 V; any higher voltage results in wasted energy. You can sometimes alter the voltage of a regulated line-powered supply by replacing a Zener diode.

8.10 Polar alignment accuracy

What happens if the polar axis isn't aligned on the pole? Three things: the star seems to drift in right ascension, it seems to drift in declination, and the image rotates. Right-ascension drift is generally absorbed into guiding corrections that you must make for other purposes. Declination drift and field rotation are what you'll notice. Field rotation can't be removed by making guiding corrections, so it's the biggest potential problem. It's all the more insidious because you won't know about it until the pictures are developed.

Consider first the extreme case: suppose that instead of aligning the polar axis on the pole, you point it straight up. Some computer-controlled telescopes, such as the Meade LX200 series, will track the stars in this configuration.

Figure 8.18 shows what you'll get if you try to take photographs this way. To see why the image rotates, suppose you are photographing Orion using an alt-azimuth mount, guiding on the center star of Orion's belt. It is a crisp November evening, and Orion has just risen; his northwestern (upper right) shoulder is at the top of the picture. With incredible patience, you guide all night, until Orion is ready to set. At that point you notice that his other shoulder (the upper left one) is now highest and sets last. Since you have an alt-azimuth

Figure 8.18 This is what happens if you make heroic guiding corrections with a mount that is not aligned on the pole, or with an alt-azimuth mount whose "pole" is straight overhead. (Akira Fujii)

mount, your camera's "up" and "down" have remained the same as yours, and the guide star has remained in the middle, but the rest of Orion has rotated something like sixty degrees. As a result, everything except the guide star has left a curved trail.

Note that the reason the stars rotated around ϵ Orionis in the example is that it was the guide star; that is, it's the star that the photographer held in a fixed position relative to the telescope. If the guide star were at the edge of the field, or outside it, the other stars would still seem to whirl around it (Fig. B4, p. 281).

A full mathematical analysis of the effects of polar axis misalignment is given in Appendix B. For those who don't want to slog through pages of formulae, here are some useful generalizations:

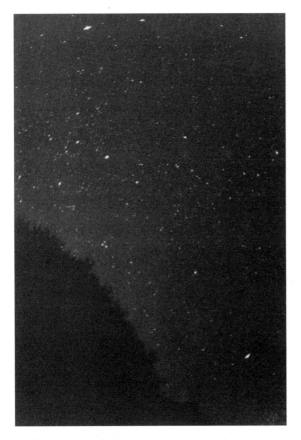

Figure 8.19 **This isn't field rotation – it's a lens aberration that disappears when the lens is stopped down. A 20-second fixed-tripod exposure of the southern sky from Sirius to Canopus, taken at Wailea Point, Hawaii, with an Olympus 40-mm *f*/2 lens wide open and Fuji 400 color print film, then printed on black-and-white paper.**

- Aligning to within 1/4° of the pole is good enough for most purposes.
- Field rotation and declination drift are proportional to the amount of alignment error, as long as it is small.
- The maximum possible declination drift during an exposure is:

Declination drift = 15.7″ × exposure time (minutes)
× alignment error (degrees)

Under some conditions it is *much* less.

- The maximum possible field rotation, for objects between declination −60° and +60°, is:

Field rotation = 0.01° × exposure time (minutes)
× alignment error (degrees)

Under some conditions it is *much* less. Near the poles, it can be greater.

- Field rotation generally will not be visible in the photograph if it is less than 0.1°, regardless of the focal length.

Declination drift and field rotation are not affected by the observer's latitude, nor by the type of equatorial mount, nor by whether the tripod is level. All that matters is whether the polar axis actually points toward the pole.

Many lenses and telescopes have an aberration that looks a lot like field rotation (Fig. 8.19). This aberration disappears if the lens is stopped down, and it is always centered around the center of the field, not the guide star. Note that if you use an off-axis guider, the guide star is necessarily outside the picture, and any apparent rotation about the center of the picture must be something else.

8.11 Periodic gear error, PEC, and autoguiding

The Holy Grail of clock drives is a drive that tracks with perfect smoothness. No real clock drive achieves this; they all have some *periodic error* caused by unevenness in the gears. Periodic error means that the drive runs first fast, then slow, over and over as one of the gears rotates. Actually, *every* gear in the system introduces its own periodic error, but most of the observed error usually comes from a worm gear with a period of either 4 or 8 minutes.

You can measure periodic error by deliberately misaligning the telescope several degrees from the pole, then taking a time exposure of some stars at the prime focus, making no guiding corrections. The exact amount of misalignment doesn't matter. You'll get a picture like Fig. 8.20, from which you can determine the period and amplitude of the periodic error. An amplitude of 15 arc-seconds is good; if it's less than 5 arc-seconds, you

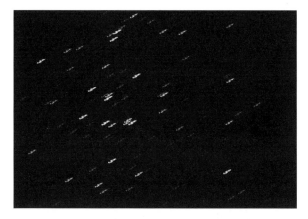

Figure 8.20 **A test for periodic gear error. The telescope is deliberately misaligned, and without the error, star trails would be smooth curves. This 12-minute prime-focus exposure shows three cycles of a 4-minute period.**

have an exceptional drive. Periodic error can generally be reduced by letting the drive run for a long time (days or weeks) so that the gears have time to "wear in."

Some drive controllers incorporate *periodic error correction* (*PEC*). The idea is that you guide carefully for four or eight minutes, and the computer records the corrections and plays them back, perhaps with some smoothing, every time the gears return to the same position. The position of the gears depends on the number of cycles of AC that have been supplied to the motor; if the AC power is generated by computer, corrections can be incorporated at the appropriate places, and the computer can also make sure the overall average drive rate is correct.

Even better than PEC is the newest electronic convenience, *CCD autoguiding*. You can attach a CCD camera in place of the eyepiece and have it automatically make corrections in right ascension and declination. Not only is the autoguider more accurate than a human being, it is also a great deal more patient, and it can see fainter stars than you can.

Thanks to autoguiders, 2- and 3-hour exposures are becoming common. You can start the autoguider going and let your exposure proceed automatically while you observe with another telescope or even take a nap. Amateurs have experimented with photoelectric autoguiders for years, but CCD technology has made autoguiding practical. The new-found feasibility of very long exposures has, naturally enough, led some amateurs to discover flexure (p. 142) and field rotation the hard way.

8.12 Choice of film

When you choose film for deep-sky work, you face several challenges:

- The objects are faint, so the pictures are likely to be underexposed, and fast film is needed. This is the most obvious challenge, and it is usually overestimated.
- Most films suffer severe *reciprocity failure* – they lose speed in long exposures.
- You need high contrast, but when you raise contrast by any method (overdevelopment, copying, or even digital enhancement), the film often becomes intolerably grainy.
- Most black-and-white films do not respond to the 656.3-nm hydrogen-alpha light emitted by emission nebulae.

Consider film speed first. Do you really need the fastest film available? Probably not. With an $f/4$ lens and a ten-minute exposure, you can photograph numerous deep-sky objects even on fine-grained 100-speed film. Faster film is not necessarily better, for several reasons.

One of the reasons is reciprocity failure. All films lose some speed in long exposures. Suppose you've made a 10-minute exposure and you want to make another exposure that captures twice as much light. If the film had no reciprocity failure, you could do this by exposing 20 minutes. In real life, though, you'll need to expose 25 to 30 minutes to double the effect of a 10-minute exposure. As the exposures get longer, the reciprocity failure gets worse.

Faster films are worse afflicted than slower films. My tests in 1996 showed that Ektachrome Elite II 100 was faster than Ektachrome Elite II 400 in exposures of more than a few minutes, because it suffered less reciprocity failure. It was finer-grained, too.

Chapter 10 will deal with reciprocity failure in detail, but in the meantime, you can estimate its effect as follows. In long exposures, older fast films, such as Kodak Tri-X Pan, follow a "three-for-two rule" – to

double the effective exposure, you have to triple the time. Newer medium-speed films, such as Kodak T-Max 100, follow a "five-for-four rule," which is not as bad. Some of the newest films are even better.

Astrophotographers have done a lot of research on ways of reducing reciprocity failure. The good news is that nowadays, the film manufacturers are doing our work for us; many of the newest films have surprisingly little reciprocity failure. For example, with Kodak T400 CN film, I was unable to detect *any* reciprocity failure in a two-minute test. Kodak Ektachrome Professional E100S, E100SW, E200, and Elite Chrome 200 slide films and Kodak PJ400 color print film are also very good performers. Fuji color slide films have a long-standing reputation for good performance in long exposures, but Elite Chrome 200 currently seems to outperform the competing Fuji products.

One classic way to eliminate reciprocity failure is to chill the emulsion in a *cold camera*, a special telescope-mounted device that holds the back of the film against a chamber full of dry ice. Cold cameras give better picture quality than other ways of dealing with reciprocity failure, since cooling the emulsion does not introduce fog or shift the color balance. But they are technically demanding; not only do you have to deal with dry ice makers and vacuum pumps, but you usually have to cut the film into small pieces and expose it one frame at a time. For this reason, they have fallen into disuse. For technical information and beautiful examples of cold-camera photography, see Newton and Teece, *The Cambridge Deep-Sky Album.*

A newer and much more effective way to reduce recprocity failure is to bake the film in hydrogen gas, or in "forming gas," a non-flammable mixture of hydrogen and nitrogen. This is known as *gas hypersensitization* or *hypering* and is described more fully in Chapter 10. Gas-hypersensitized film is available commercially from Lumicon and other suppliers.

The effect of hypering depends on the film. Kodak Technical Pan Film benefits spectacularly; it shows a large speed increase, a great reduction in reciprocity failure, and only a moderate amount of fog. What's more, it can be kept for months in a freezer after treatment.

Most other films do not benefit as much. In general, hypering produces a bothersome amount of fog on color slide films. With negative films, the fog is less troublesome because it can be counteracted in printing. Color films do *not* keep well after hypering; they should be kept in the freezer no more than a few days, used, and then developed on the following day if possible.

At one time Kodak made a line of "Spectroscopic" films that were specially treated to reduce reciprocity failure. The advent of gas-hypered Technical Pan has made them obsolete. In fact, even without hypering, many newer films equal or surpass the old Spectroscopic series.

There are several other good reasons for using Kodak Technical Pan. It is remarkably fine-grained, perhaps four times finer than any other film on the market. Thus, grain will not be a problem no matter how you post-process the images. Kodak Technical Pan gives rather high contrast when developed in D-19 or Dektol; you don't have to do much to raise the contrast further. Its effective speed with such development is about 200 without hypering, perhaps 600 hypered.

Finally, Technical Pan responds extremely well to the deep red hydrogen-alpha emission from nebulae, a wavelength that most black-and-white films miss. If you photograph Orion or the North America Nebula on T-Max 100 and Technical Pan and compare the pictures, you'll find that they pick up comparable numbers of stars, but only Technical Pan records the fainter nebulosities.

Most color films respond well to hydrogen-alpha. Kodak Elite Chrome 200 works especially well; nebulae come out bright ruby-red. Competing Fuji films, at least at present, don't perform quite as well.

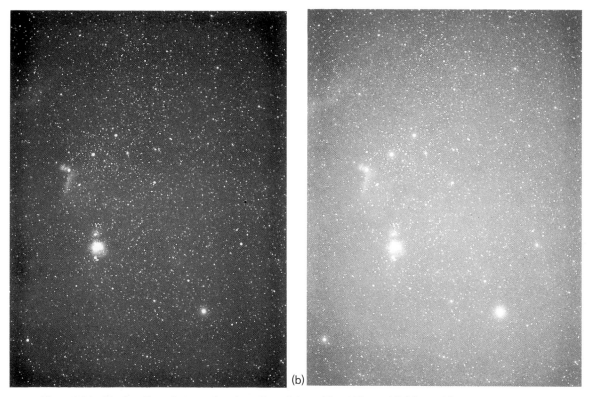

(a) (b)

Figure 8.21 **Sky fog. Two photographs of southern Orion with a 100-mm _f_/2.8 lens wide open, on Fujichrome 400: (a) 10 minutes; (b) 24 minutes. The shorter exposure shows more stars. (By the author)**

8.13 Light pollution and nebula filters

Once you get rid of reciprocity failure, you quickly run into _sky fog_ – that is, you find that even in a relatively short exposure, the film records enough sky glow to cover up some star images (Fig. 8.21). Sky fog sets an absolute limit to the magnitude of the faintest stars you can photograph with a given lens, regardless of exposure time.

Sky fog consists mostly of reflected city lights. It is strongest on hazy nights, on holidays (when more people are out driving around), and in the early evening (when the most lights are on). Sky fog is reduced when the air is unusually clear, such as right after the passage of a cold front; after midnight, when there is less traffic; and in very cold weather, when people are not out and about. But snow reflects city lights into the air. At very remote sites, it becomes evident that in addition to man-made sky fog, there is also a faint natural skyglow, related to the aurora borealis but present throughout the atmosphere.

One reason color negative films are coming into vogue for astrophotography is that you can compensate for the fog when you make a print. A fogged slide is fogged for good; digital enhancement can subtract the fog, and slide copying can reduce it to some extent, but neither of these is as easy as making a darker print of a negative, subtracting out the fog in the enlarger. It has been argued that negative films record faint details best when there is some fog present, pushing the response of the film up into the middle of its range; nearly-clear film is inefficient film.

The only way to eliminate sky fog, apart from moving to a remote mountaintop, is to photograph through a filter that blocks out the parts of the spectrum in which the sky fog is worst. A yellow filter usually helps, but a better technique is to photograph in the extreme red, using a #25, #29, or even #92 deep red filter and a film that responds well to deep red light. The Lumicon Hydrogen Alpha filter is very similar to Wratten #92.

This technique was pioneered by Joseph A. Cocozza (1977), who used Kodak Spectroscopic Film

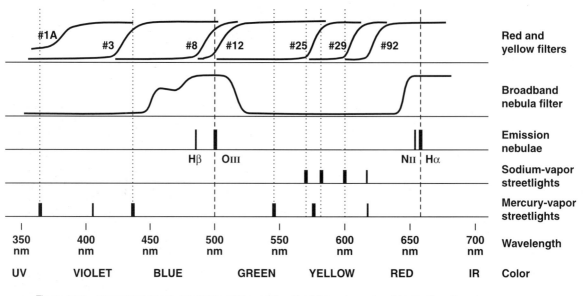

Figure 8.22 **How filters block city lights while passing light from deep-sky objects. Broadband nebula filters are best for photography. Deep red filters work well with Technical Pan Film and CCDs, not with most other black-and-white films.**

103a-F, a very coarse-grained material that is now unavailable and not much missed. Hypered Technical Pan is *much* better. The fog-penetrating ability of such a combination is impressive, and it is worth trying even in environments that you would normally consider too urban for deep-sky work. Emission nebulae record best because they emit most of their light in just the part of the spectrum that the #29 filter passes. (The #92 is a bit too dark, but it can cut through city lights when nothing else will.) If you don't have hypered Technical Pan handy, try a color film with a #25 filter, realizing that you'll get a deep red image. Red filters also work well with CCD cameras.

To get white star images in a red-filtered color photograph, remove the filter for the last 10 or 15 percent of the exposure. I call this technique the "poor man's nebula filter" (Plate 8.9). The filter cannot be screwed into the lens, or you'll disturb the camera when you remove it. Instead, use an oversize filter and lay it down gently on the front of the lens, using its retaining ring to keep it from slipping aside.

Even better, use a *nebula filter* – that is, an interference filter that passes the major emissions from nebulae while blocking city lights (Fig. 8.22). It's called an *interference filter* because it relies on wavefront interference in multiple, very thin coatings to select

particular wavelengths of light. Broadband nebula filters are best for photography; narrower-band versions are made for visual observing and do not transmit hydrogen-alpha light.

These filters work because the emissions of nebulae are confined to a few wavelengths; the emissions from most streetlights are confined to a few other wavelengths; and these wavelengths are not the same. Plates 8.6 and 8.8 show what a nebula filter can do. The improvement in picture quality can be dramatic. Plate 8.6 also shows a quirk of nebula filters – they work correctly only when light hits them straight-on. At the edges of a wide-angle picture, the light rays are hitting the interference layers at an angle, changing their effective thickness, and the wrong wavelengths start to get through. For tests and measured transmission curves of commercial nebula filters, see Harrington (1995).

Nebula filters are considerably less useful when you are photographing stars, reflection nebulae (like that around Merope in the Pleiades), or galaxies, all of which emit light throughout the visible spectrum. And, of course, contrary to what some published pictures might suggest, *a filter never makes anything brighter*. The filter merely darkens the background so you can expose longer. Heavily filtered exposures are often surprisingly long – but rewarding.

(a)

Figure 8.23 **Three excellent deep-sky photographs on hypered Technical Pan film, using Olympus lenses and a Lumicon hydrogen-alpha (deep red) filter. (a) The Pipe Nebula, a dark nebula in Ophiuchus. A 45-minute exposure with 180-mm $f/2.8$ lens. (b) Barnard's Loop in Orion. A 60-minute exposure with 350-mm $f/2.8$ lens. (c) The California Nebula in Perseus. A 110-minute exposure with 350-mm $f/2.8$ lens and Olympus $\times1.4$ teleconverter, giving 500 mm at $f/4$. (Chuck Vaughn)**

8.14 PRACTICAL NOTE:
The campaign against light pollution

As cities expand, the stars become ever harder to see. Mount Wilson Observatory had to stop doing deep-sky work long ago, and even Palomar Mountain is threatened by the encroaching lights of San Diego.

Non-astronomers generally don't care about preserving the visibility of the stars – but if you talk to them about saving money and protecting the environment, they'll listen. Here are some points to make:

- Light that goes into the sky is wasted energy and wasted money. Somebody is paying for it and not getting any benefit.
- Power companies are eager to sell electricity, especially at night, when most people aren't using much – so they'll always tell you you need more outdoor lights.
- Some lights can be turned off without being missed. Do you have to light an empty parking lot all night, or can you cut back the illumination after the customers have gone home?

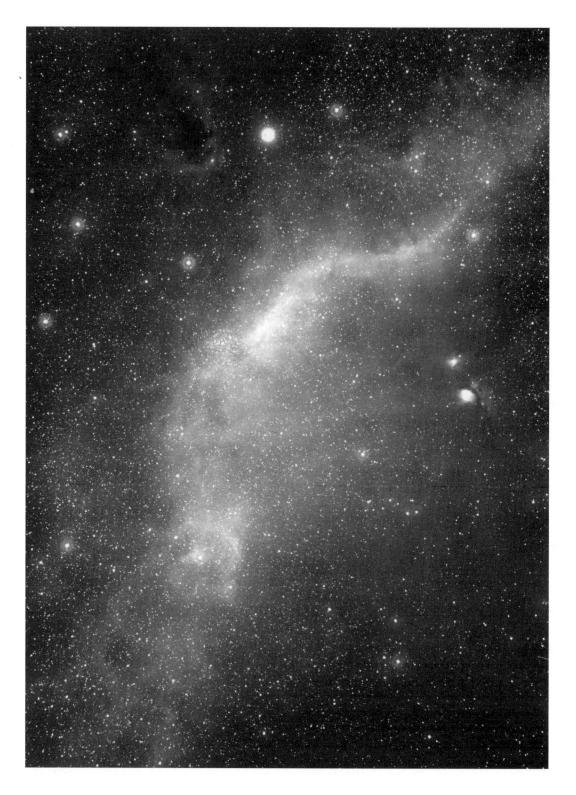

(b) Figure 8.23 (cont.)

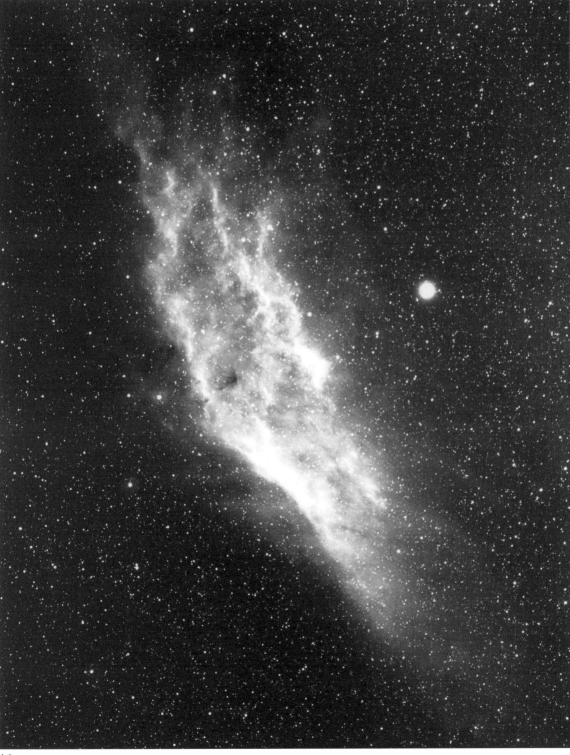

(c)

Figure 8.24 **Wasteful versus efficient outdoor illumination.**

- Continuous outdoor lighting does not necessarily prevent crime. It may just make it easier for the burglar to find his way in. If you want to scare burglars, install lights that are triggered by motion detectors.
- Lights that shine in people's eyes can easily do more harm than good. They create "blind spots" in which burglars can hide, and they can even cause automobile crashes by blinding drivers.

Some outdoor light fixtures are very inefficient. The University of Georgia is presently decorated with lollipop-style lampposts that send more than half of their light skyward while casting a shadow on the footpath they are supposed to illuminate (Fig. 8.24, left). Changing to lamps that are aimed downward would improve people's safety and comfort while saving energy.

A number of municipalities have adopted laws against wasteful outdoor lighting. Campaigns to do this are led by the International Dark-Sky Association and the British Astronomical Association (addresses in Appendix F).

In the ideal case, town leaders may even realize that the starry sky is part of the beauty of nature. Many towns are bird sanctuaries; why shouldn't there also be star sanctuaries?

8.15 Deep-sky photography through the telescope

The advent of cold cameras and hypersensitized film has made it possible for amateurs to take impressive photographs of spiral galaxies, globular clusters and similar objects, often rivaling the work of large observatories only a few decades ago. The required optical configurations, prime focus and compression, were discussed in Chapter 6. The main challenge is guiding – how do you guide if the main telescope is occupied with taking a picture?

One obvious solution is to use a *guidescope* – a second telescope, similar in focal length to the main one, mounted piggy-back on the instrument with which you are taking the picture. The guidescope should have a long enough focal length, and operate at a high enough magnification, to make it easy to stay within the guiding tolerance of the main instrument. It does not have to be large or have particularly good optics; a 6 cm refractor with a strong Barlow lens is typical, and folded refractors or other unusual configurations can be used for compactness.

Nor does the guidescope have to be aimed at precisely the same object as the main telescope; you can aim it at a bright star while photographing something fainter.

The main thing that can go wrong with a guidescope is *flexure*. During a long exposure, the weight of the telescope shifts. If, as this happens, the guidescope bends as much as 1/500 of a degree relative to the main telescope, you can go outside of the guiding tolerance without knowing it. Flexure is seldom a big problem with relatively short exposures (10 minutes or less); if you have flexure problems, don't overlook the possibility of a shifting optical component, such as a diagonal mirror or Schmidt–Cassegrain primary. Wallis and Provin (1988) discuss flexure in detail.

Flexure is much less of a challenge if you use an *off-axis guider* (Fig. 8.25). This device intercepts a small, outlying area of the image formed by the main

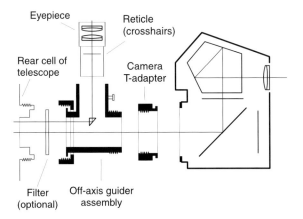

Figure 8.25 **An off-axis guider for a Schmidt–Cassegrain telescope.**

telescope and allows you to view it through a guiding eyepiece. The only problem is that you almost always have to guide on a rather faint star, since you cannot see the main object being photographed. Indeed, it seems that whenever the main object is interesting, the only available guide stars are twelfth magnitude! Off-axis guiders are available for Newtonians and refractors as well as Schmidt–Cassegrains; they are sometimes combined with compressor lenses (focal reducers).

Another problem specific to catadioptrics is *mirror flop*. Schmidt–Cassegrains and Maksutovs focus by moving the main mirror. The mirror is therefore always a bit loose in its mount, and as the weight of the telescope shifts during an exposure, the mirror will move, gradually or suddenly. If the movement is gradual, the off-axis guider takes care of it; by guiding, you compensate for all image motion, regardless of its source.

But if the flop is sudden, there's nothing you can do about it. Some telescopes have holes for screws that hold the mirror firmly in place when the telescope is shipped; inserting such a screw carefully after focusing can prevent mirror flop. The best policy, though, is to identify the conditions that cause flop and avoid them. Generally, flop occurs when the telescope crosses the meridian, so that the mirror shifts from west of the axis to east of the axis. Clock drives with slack in their gears can "flop," too, as the center of gravity crosses the meridian.

Much deep-sky photography is done with compressor lenses (focal reducers) to reduce the focal length and f-ratio. These are discussed in detail in Chapter 6 on pp. 82–84. A crucial point is that the compressor does not make the telescope into a wider-angle instrument. It takes the existing image and makes it smaller. As a result, you can fit more of the sky onto the film – and especially onto a small CCD – but the field of view is still limited by the design of the instrument. There are still aberrations at the edges of the field; these aberrations are often mistaken for field rotation.

It is important not to be naive about the optical performance of telescopes in deep-sky photography. No telescope designed for visual use will produce crisp star images all the way across a 35-mm frame. For wide-field photography, telephoto lenses almost always beat telescopes of comparable focal length and f-ratio. (Telescopes are far sharper at the center of the field, but they are not uniformly sharp across the film.) Some newer apochromatic refractors are an exception; they're designed to cover a wide, flat field on film, and they work well with compressors because the unvignetted image area inside the tube is quite large. Chapters 6 and 9 deal with telescope performance in detail.

Apart from a large telescope, the ultimate instrument for deep-sky photography is probably the *Schmidt camera*, an instrument built rather like a Schmidt–Cassegrain telescope except that the corrector plate is farther from the mirror (making the instrument twice as long) and the film itself is mounted in place of the secondary. The result is a very low f-ratio with excellent sharpness over a wide field. Celestron has manufactured 5.5-inch $f/1.65$ and 8-inch $f/1.5$ Schmidt cameras designed to be piggy-backed on larger telescopes. Because of their cost, these instruments are outside the scope of this book. The need for Schmidt cameras has declined now that hypered films make it possible to photograph faint objects at $f/4$.

8.16 BASIC TECHNIQUE 15:
Deep-sky photography with an off-axis guider

Caution: This type of photography is difficult. Before attempting it, you need considerable experience doing piggy-back astrophotography and observing deep-sky objects visually.

Equipment: Telescope with camera at prime focus; compressor lens is optional. Off-axis guider, guiding eyepiece with crosshairs, and electronic drive corrector. The camera should be an SLR, preferably with a fine matte focusing screen (Beattie Intenscreen or equivalent).

Film: Fast color slide or negative film; in the latter case you will need custom prints. Kodak Elite Chrome 200 pushed 1 stop (to 320 speed) and Kodak PJ400 color print film are good choices. Hypered Technical Pan Film also works very well. For objects other than emission nebulae, Kodak T-Max 100, pushed to 400 or 800, is a good choice.

Sky conditions: Clear night with steady air. You need the best of both worlds – good transparency and reasonably good steadiness.

Procedure: Polar alignment is critical. After aligning on the pole, use the telescope visually to examine the area you will be photographing. If the object is faint, note the brightest stars near it; they may be all you will be able see in the camera.

Then attach the off-axis guider, focus the camera on the brightest star in the field, and attempt to find a suitable guide star.

Finding a guide star will probably be difficult, especially if you are photographing a galaxy in a star-poor field. The more ways you can move the off-axis guider, the better; besides rotating the off-axis guider around the tube, you may be able to shift the prism forward, backward, or sideways. Persevere; this step may take you half an hour.

When you've found a guide star and you're sure the object is in the field of the camera, check focusing once more and get ready to begin the exposure. Center the guide star in the crosshairs and *quickly* place a black card in front of the telescope, open the shutter, and remove the black card. Now check the position of the guide star relative to the crosshairs. You must hold it *exactly there* until the exposure is over. You can end the exposure by closing the shutter, without using the black card.

Exposure: Generally, as long as possible – 5 minutes on your first try, 15 to 60 minutes for more sophisticated work. Appendix A gives some very rough exposures for various kinds of deep-sky objects. There is no single "correct" exposure; how much light you want to collect is up to you.

Variations: Most CCD autoguiders will work with an off-axis guider and can guide on fainter stars than you can. Some CCD cameras have a second CCD built in for autoguiding.

For advanced deep-sky work, a useful accessory is a *flip mirror*, a manually actuated mirror ahead of the camera that lets you view and center the object through an ordinary eyepiece, then flip the mirror out of the way in order to take the picture.

8.17 Keeping warm while observing

Astrophotography is one of the few human activities that involve standing perfectly still outdoors at night in the middle of the winter. (Visual astronomers, with no continuous guiding to do, at least get to walk around.)

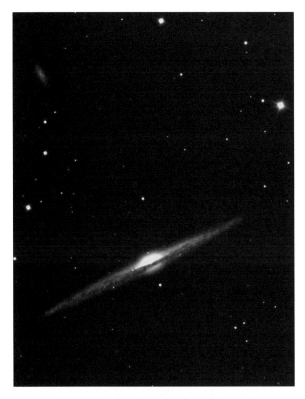

Figure 8.26 **A painstakingly guided two-hour exposure of NGC 4565 and two other galaxies at the prime focus of a 37-cm (14.5-inch) $f/8$ telescope, using hypered Technical Pan film. (Kim Zussman)**

As a result, the astrophotographer is exposed to colder weather than anyone else living in the same part of the world. The necessary clothing and the knowledge of how to wear it are seldom available locally, especially in warm climates. Growing up on the Georgia–Florida border, I had to learn the art of dressing for cold weather the hard way; what follow are a few practical observations.

A big overcoat is surprisingly little help. Overcoats are meant to keep out rain and snow, not cold air. They leave your head, neck, and lower legs uncovered, they impede your movements, and they are often heavy enough to be uncomfortable after a couple of hours.

Instead, dress in layers in order to trap warm air close to your body. Wear a sweater under your jacket. Consider using two or three layers in place of what is ordinarily just a shirt. Keep your legs warm with long underwear, possibly two pairs at once. (Loose-fitting long underwear is better than tight elastic mesh.) You can even wear a complete set of flannel pajamas under

your clothes for extra warmth. Best of all, wear a snowsuit, a zippered garment that covers your entire body, with or without a full set of clothes under it.

If your feet are cold, consider whether your legs are also cold; if so, warm up your legs with long underwear and your feet will have a much easier time. Thick wool socks, possibly with thin cotton socks inside them, are a great help. Shoes should have thick rubber soles to reduce heat conduction between your feet and the cold, damp ground; putting down a rubber mat or a scrap of carpet where you are standing can help considerably.

A knitted wool hat is obligatory below about 45 °F (7 °C); at much lower temperatures a Russian fur hat is better. (A hat with a brim would bump into the telescope.) Fill the gap between collar and hat with a thick wool scarf. Gloves are helpful but should be fairly thin if you are to manipulate controls. Catalytic (fuel-burning) hand warmers can be useful not only for keeping your fingers limber but also for getting dew off lenses.

The best suppliers of cold-weather clothing are camping and hunting outfitters; if the pickings are slim in your area, write to L. L. Bean and Company, Freeport, Maine 04033, U.S.A., which sells a full line of high-quality products by mail. If the price seems high, consider it part of your equipment budget; anything that doubles the number of nights a year that you can photograph is effectively doubling the value of your telescope and camera.

8.18 Safety and etiquette at the observing site

For the modern amateur, deep-sky photography often means going on the road in search of dark skies and observing from a campground or other remote site.

At group observing sessions, it is important not to use flashlights unless they are red-filtered, and even then, to keep the red light out of observers' eyes. Red is used because it preserves night vision; contrary to what

some people think, it is definitely not "safe for film" and certainly not innocuous to CCDs, which are very sensitive to red light.

It is even more important not to shine automobile headlights on the observers. If your car has automatic daytime running lights (obligatory in Canada and common in the United States) and you have to move your car at night, complying with this requirement may require some ingenuity. You may have to remove fuses to disable all the lights. With older cars, it's easier; only the brake lights are apt to come on unexpectedly. My wife and I once drove out of Lockwood Valley, California, in an old Toyota that was completely light-less, finding our way by shining a flashlight out the window and braking with the parking brake to keep from actuating the brake lights.

When you observe on your own at a remote site, some form of radio contact with the outside world is highly desirable. (You could fall ill, have an accident, get bitten by a snake, or be robbed or threatened by the local riff-raff. In the desert near the Mexican border, there is some risk of encountering smugglers.) Your communication device can be a cellular phone or CB or ham radio transceiver. Remember that CB will do little good if you're not near a major truck route; remember also that you'll need to be able to give exact directions to your location.

8.19 Mosquitoes and other vermin

Astronomers in the eastern United States and many other parts of the world are all too familiar with mosquitoes. These blood-sucking insects are attracted by carbon dioxide (in your breath), perspiration, dry skin, and water; they are repelled by garlic, thiamine (vitamin B1), most moisturizing skin creams (at least to a limited extent), citronella, eucalyptus, other plants with spicy scents, mothballs, and numerous chemicals.

Commercial mosquito repellents usually contain DEET (N,N-diethyl-meta-toluamide), which is not necessarily the most potent mosquito repellent, just the most odorless. *DEET attacks plastics, paint, and synthetic fabrics*; be very careful not to get it on your fingers before handling equipment. Some questions have been raised about possible toxicity of DEET to humans, and I am reluctant to apply it to skin, especially broken skin. It is safe enough on natural-fiber fabrics and leather shoes. Not all kinds of mosquitoes are sensitive to DEET; other repellents are well worth trying. Long sleeves also offer some protection against mosquitoes.

Mosquitoes are most active around dusk; by midnight, most have retired for the evening. Because mosquitoes don't fly very high, rooftop observatories are not much bothered by them, and you can get some protection by putting up walls made of wire mesh or mosquito netting around your observing site. Mosquitoes' natural enemies include bats, dragonflies, some birds, some lizards, and any fish that can get to the larvae.

You can reduce the mosquito population by getting rid of any standing water that does not have fish in it. Mosquitoes like to breed in marshes, puddles, gutters, and even jars and flowerpots. However, because they can quickly migrate for miles, it is not practical to keep an observing site completely mosquito-free. Instead, my usual tactic is to eliminate mosquitoes by spraying the site with insecticide a few hours before an observing session. I use permethrin, which repels mosquitoes as well as killing them and is not very toxic to mammals. Spray a fine mist of insecticide into grass and shrubbery where mosquitoes hide. Propane-powered insect foggers are said to be especially effective. There is something to be said for switching insecticides or repellents periodically to keep from developing a resistant population of mosquitoes.

"Yard Guard" and similar sprays are effective and fast-acting; you can spray the observing site just before setting up the telescope. (Don't spray anything

while optics are exposed to the air.) Worries about the environmental effect of the insecticides should be balanced against the fact that the mosquitoes themselves are not benign; they carry malaria, encephalitis, and other blood-borne infections.

In western North America, larger animals are more likely to present hazards. Amateur astronomers have told me of encounters with deer, bears, armadillos, rattlesnakes, skunks, coyotes, cattle, and even herds of wild horses. Fortunately, none of these beasts actually prey on humans, and in general, they will gladly stay away if you give them adequate warning of your presence. Play music, talk to yourself, and use smelly insect repellents such as mothballs or garlic.

Raccoons have unusual manual dexterity; they have been known to unclip battery cables and unpack the contents of small boxes, all in search of food. They can sometimes be intimidated by shining a flashlight at them; even then, they will often wait on the periphery of your observing site, confident that you will eventually unpack your picnic basket.

Don't forget ants. Inspect the observing site for anthills before setting up, especially if you're in fire-ant country.

And finally, remember aircraft, the vermin of the skies (at least from an astrophotographer's point of view). No matter how remote your observing site may be, sooner or later some air traffic controller will send a parade of jetliners over you. I recently took two consecutive ten-minute exposures of M31 and got an airplane trail in each one. If you hear an airplane approaching, locate it visually and hold a black card in front of the camera or telescope while it passes by.

Photographic technology

Part III

Cameras, lenses, and telescopes **9**

The purpose of this chapter is to help you choose equipment for astrophotography. Many of the technical requirements have already been covered in earlier chapters. Readers of earlier editions asked for especially detailed advice about choosing cameras, so here it is. Please remember that you don't have to buy one of the cameras recommended here – if you already have a camera that is even partly suitable, go as far as you can with it before looking for another. Now is a good time to dig up the fully-mechanical 35-mm camera that you or a relative bought 20 years ago – many families have very suitable cameras languishing in closets.

9.1 The 35-mm SLR

The 35-mm single-lens reflex (SLR) is the most useful type of camera for amateur astrophotography. It is small and light enough to be attached to a telescope without overloading it; it lets you view and focus through any kind of lens system; and its film format is about the same size as the eyepiece tubes of amateur telescopes, so that vignetting does not result in much wasted film. Moreover, a wider variety of emulsions is available on 35-mm film than in any other format.

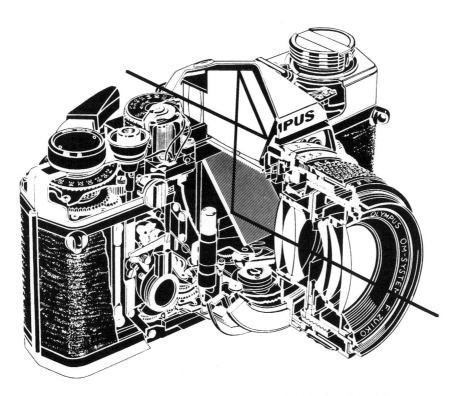

Figure 9.1 **Cross section of a 35-mm SLR. The mirror intercepts light for focusing on the screen. (Olympus)**

A single-lens reflex is a camera in which viewing, focusing, and picture taking are done through the same lens (Fig. 9.1). This made possible by a mirror that intercepts the light coming in from the lens and directs it onto a ground glass screen which you view through a prism and magnifying eyepiece. When you take a picture, the mirror flips up, out of the way; the shutter, located behind the mirror, opens and closes, and then the mirror returns to its original position.

9.2 Choosing an SLR

Modern, highly automated SLRs are not as useful for astrophotography as their counterparts of 20 years ago. The problem is that in their efforts to make ordinary photography easier, the manufacturers have made the cameras less versatile. Some of the newest SLRs, such as the Olympus IS series, do not even have removable lenses. Others work only with their own lenses and do not accept T-mounts or telescope adapters; examples of the latter are the Minolta Maxxum 2xi, 3xi, and SPxi.

Another drawback of many newer cameras is that they consume battery power throughout a time exposure. That is no problem for the ordinary photographer who takes an occasional 10-second exposure of a city skyline at dusk. It may not even be an obstacle for lunar and planetary work. But a long deep-sky observing session, with several hours of time exposures, can completely exhaust a pair of MS76 button cells, especially at low temperatures. Even fresh batteries do not work well when cold.

Not all electronically controlled cameras have this problem. Some of them, such as the Olympus OM-2 and OM-4 series, have a mechanical "B" or "T" mode that does not require battery power. (To verify this in the showroom, actuate the shutter on "B" or "T" with no batteries in the camera.) Others, such as the Nikon N90 (F90), reduce the battery current to a trickle when the exposure exceeds 30 seconds or so.

Table 9.1 *Camera features needed for astrophotography*

Feature	Deep-sky work	Lunar and planetary
Interchangeable lenses (able to use T-mounts and telescope adapters)	Important	Necessary
Autofocus	Unnecessary	Unnecessary
Automatic exposure	Useless	Limited use
Long exposures without using battery power	Almost a necessity	Unimportant
Mirror lock or prefire	Unimportant	Desirable
Interchangeable focusing screens	Useful	Very desirable

Some cameras can be tricked into making a batteryless time exposure by starting the exposure in the usual way, then removing or disconnecting the batteries. If you're lucky, the shutter will stay open. You can then reconnect the batteries to terminate the exposure. If that trick doesn't work, you can at least use an external power supply. Some camera makers supply external battery packs, or you may be able to connect external batteries by making a wooden or plastic plug that fits into the battery compartment. Last, if a camera is otherwise satisfactory, buying a new set of batteries for every deep-sky session may not be prohibitive.

To get around all these problems, the serious astrophotographer is forced to become a connoisseur of older, or at least old-fashioned, cameras. Table 9.1 summarizes the camera features that are important. Autofocus is almost useless because it doesn't work at f-ratios higher than about 5.6, and even when it works, it's not always as accurate as manual focusing. (But some of the best autofocus systems, such as those in the Nikon F4 and N90/F90, can provide focus confirmation at the prime focus of an $f/6$ telescope.) Automatic exposure has some use in lunar work and eclipse photography, but is otherwise unnecessary.

Vibration is a major problem with SLRs because so much of the mechanism has to move when taking a picture. The shutter consists of two large curtains near the film plane. The mirror also has to flip up. To eliminate some of the vibration, some cameras let you

Table 9.2 *Features of recommended SLRs*

Camera	Exposure meter	Mirror lock or prefire	Inter-changeable screens	Removable prism	Lens mount	Last manufactured
Olympus OM-1, 1N	Manual	Lock	Yes	No	OM	1987
Olympus OM-2, 2N	Auto	No	Yes	No	OM	1984
Olympus OM-3, 3T(i)	Manual	No	Yes	No	OM	Current
Olympus OM-2S(P)	Auto	Prefire	Yes	No	OM	1988
Olympus OM-4, 4T(i)	Auto	Prefire	Yes	No	OM	Current
Olympus OM-2000	Manual	Prefire	No	No	OM	Current
Nikon FM2, FM2N	Manual	Prefire	Yes	No	AI	Current
Nikon FM	Manual	Prefire	No	No	AI	1984
Nikon FM10	Manual	Prefire	No	No	AI	Current
Nikon FE2	Auto	Prefire	Yes	No	AI	1989
Nikon FE	Auto	Prefire	Yes	No	AI	1984
Nikon F3, F3T, F3HP	Auto	Lock	Yes	Yes	AI	Current
Nikon F2A, F2AS	Manual	Lock	Yes	Yes	AI	1980
Nikon F2, F2S	Manual	Lock	Yes	Yes	Pre-AI	1977
Nikkormat FTN	Manual	Lock	No	No	Pre-AI	1975
Pentax LX	Auto	Lock	Yes	Yes	K	1995
Pentax K-1000	Manual	No	No	No	K	1997

Notes: All of these cameras take time exposures without consuming battery power. On the Nikon F3, the battery is required to open and close the shutter on "T," but not to hold it open.

The Olympus OM-2, 2N, 2S, 4, and 4T(i) require battery power for mirror prefire; the OM-2000 and the Nikons with mirror prefire do not.

bring the mirror up in advance of the exposure. This feature is called *mirror lock* or *mirror prefire*. The latter term means that when you use the self-timer, the mirror goes up at the beginning of the self-timer cycle, several seconds before the shutter opens. Prefire may actually be better than mirror lock because it discharges more of the mechanism.

Mirror lock is important mainly for exposures between 1/60 and 1/2 second. With shorter exposures (rare in astronomy), the shutter is fast enough to "stop" the vibration, and with longer ones, you can use a "hat trick" (p. 97). Even with mirror lock, you still have vibration from the shutter. That is why I do not consider mirror lock indispensable. Vibration *after* the exposure is often substantial; don't let it mislead you into thinking you have a problem. To check, clamp your camera to your telescope near the eyepiece, but keep the visual eyepiece in place. While looking through the telescope, open the shutter on "B" and see how much the telescope shakes.

Interchangeable focusing screens are desirable because when focusing an astronomical photograph, you need all the help you can get (see p. 111). For deep-sky work you will generally want to use a fine matte screen and, if available, a magnifier; for lunar and planetary work, a clear central spot with crosshairs is more helpful. If your camera has interchangeable screens, you can use the special fine-matte screens made by Beattie or Brightscreen (p. 87). Even on cameras that don't have interchangeable screens, a special screen can sometimes be installed by a repair shop.

Table 9.2 lists the features of several cameras that are good for astrophotography. It's no accident that Olympus and Nikon dominate the list. These companies also make microscopes and medical imaging instruments. Astrophotography may be the hobby of the select few, but photomicrography takes place in every hospital and requires much the same kind of camera. Thus, good astrocameras generally begin life as good medical cameras.

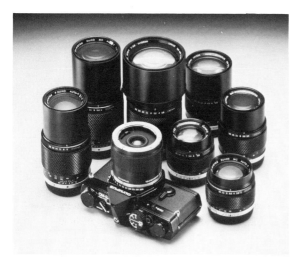

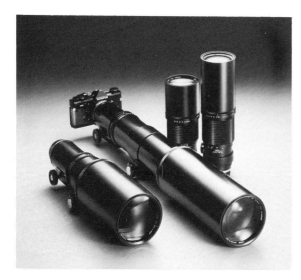

Figure 9.2 **Olympus OM camera, teleconverter, and lenses.**
(Olympus)

9.3 Olympus SLRs

For many years the most popular camera for astrophotography has been the Olympus OM-1. I still recommend it except for one problem: Olympus stopped making OM-1's in 1987. Fortunately, Olympus still makes three OM-series cameras, the OM-3Ti, OM-4Ti, and OM-2000, all of which take the same lenses as the original OM-1. Olympus OM-series cameras and their accessories are abundant on the

secondhand market, and there are even repair shops that specialize in them (see p. 317).

Olympus Zuiko lenses created something of a sensation in the 1970s; they were small, lightweight, and sharp, often surpassing all competitors. Unfortunately, the Olympus lens line has changed little since then, while Nikon, Pentax, and others have continued introducing new designs and using newer technology. Olympus has introduced a few new-technology lenses, such as the 90-mm $f/2$, but they are expensive, and third parties such as Sigma no longer offer all their lenses in Olympus mount. Still, even today, Olympus lens designs from the 1970s are better than most moderately priced alternatives, and some Olympus lenses are truly outstanding. The light weight of Olympus equipment is an advantage when cameras are to be mounted on telescopes.

The OM-1 is small and light (510 grams) and has exactly the features needed for astrophotography: mirror lock, an add-on Varimagni Finder, and interchangeable focusing screens, including a fine matte screen (Olympus 1-8) and a matte screen with a clear-crosshairs central area (1-11). The shutter is fully mechanical, and battery power is required only for the exposure meter. The original mercury battery is no longer available, but the camera can be modified to take silver oxide or alkaline cells.

Olympus makes a newer, extra-bright fine-matte focusing screen for the OM-2S, OM-3, and OM-4; it's called the 2-4 and can apparently be fitted to the OM-1 with a bit of filing, although the OM-1 light meter is not necessarily accurate when it is installed. Beattie Intenscreens are also available for all OM-1, 2, 3, and 4 models.

The Olympus Varimagni Finder (visible in Fig. 6.18 on p. 81) attaches to the camera's eyepiece and allows right-angle viewing with magnifications of ×1.2 and ×2.5 (on top of the ×5 eyepiece already in the camera, giving total magnifications of ×6 and ×12.5 respectively). Focus it so you can see the focusing screen clearly, then focus the camera. You can get

higher magnifications by unscrewing the eyepiece of the Varimagni Finder and substituting a 15-mm or shorter eyepiece of your own.

A drawback of the Varimagni Finder is that it has a relatively small entrance pupil, and as a result, the image is not as bright as it could be. Nor is the eye relief always adequate for eyeglass wearers. To remedy these problems, B&K Products makes an "Astrofocuser" for the OM series; it contains one lens element but uses a star diagonal and eyepiece supplied by the user. As a result, you are assured of comfortable eye relief, and you can get high magnifications. For more on the Astrofocuser see p. 88.

The OM-3Ti is essentially a more rugged OM-1 with a better light meter and a much higher price tag. It lacks mirror lock, which according to Olympus is not needed (I have my doubts).

The OM-2, OM-2S, OM-4, and OM-4T(i) are electronic cameras whose shutters also work on B and 1/60 without batteries. In auto exposure mode, the exposure meter reads the light actually reflected from the film during the exposure. Thus it can deal with light levels that change during the exposure. The meter is sensitive enough to make automatic exposures as long as a couple of minutes.

I've done a lot of astrophotography with an OM-4T and have found the auto exposure mode useful for lunar work, eclipses, and comet photography at twilight. It is also a superb camera for general photography. Some early OM-4's and OM-2S's have electrical problems that deplete the batteries prematurely, but later versions are reliable.

The Olympus letter models (OM-F, OM-G) and double-digit models (OM-10, OM-20, etc.) are not as suitable for astrophotography because they lack interchangeable focusing screens and cannot make time exposures without batteries. They are also noticeably less rugged than the single-digit OMs. The OM-2000 is a low-cost camera introduced in 1997 and made for Olympus by Cosina. It lacks interchangeable screens, but its shutter is fully mechanical, it uses battery power only for the light meter, and it can make multiple exposures without moving the film even slightly – a feature missing on all the other OMs.

9.4 Nikon SLRs

The astrophotographer who is starting a camera system today may prefer to go with Nikon, whose newest autofocus and digital cameras take the same lenses as its manual-focus 35-mm SLRs; thus the future of the product line seems secure. More importantly, a vast army of professional photographers have built Nikon systems over the past 30 years, creating an abundant supply of secondhand equipment, accessories, repairs, and information. Nikon has continued introducing new state-of-the-art lens designs, so if telephoto lenses are important to you, Nikon has an advantage over Olympus, most of whose lenses were designed in the 1970s. None of the Nikon cameras suits me quite as well as the Olympus OM series, but several are very good.

The classic Nikon F2(S), F2A(S), and F3 are excellent for astrophotography except for their heavy weight (about 760 g). (The S suffix indicates an improved light meter.) All of them take a wide variety of interchangeable focusing screens, including matte, clear-crosshairs, Beattie Intenscreen, and Brightscreen. What's more, the viewfinder prism itself is removable; instead of the usual ×3.75 eyepiece, you can use Nikon's ×6 right-angle finder (which gives a brighter image than the Olympus Varimagni Finder) or simply examine the focusing screen with a strong magnifying glass.[1]

[1] The magnification of the eyepiece itself, reckoned as a magnifying glass, is 5× the magnification of the complete viewfinder with a 50-mm lens in place, reckoned as a telescope. See page 87.

Figure 9.3 **Pre-Al Nikon lenses use an external prong instead of a concealed aperture-indexing slot.**

Of the classic Nikons, only the F2A, F2AS, and F3 take current Nikon Al lenses with full functionality, and only the F3 is in current production. On the original Nikon F, mirror lock requires you to waste a frame of film. The F2 and F3 are magnificent cameras, built like army tanks, and the F3 has a long-eye-relief ("high eyepoint") viewfinder that is convenient for eyeglass wearers. For an unusually detailed review of the F3, see Crawley (1980). The F4 and F5 are autofocus cameras; they have similar features to the F3 but are heavier and more expensive.

Nikon lens mounts have been the same since 1959 except for the mechanism that couples the aperture setting to the exposure meter. The "pre-Al" mount of the Nikon F, F2, and their kin uses a prong on the outside of the lens mount (Fig. 9.3). The newer "Al" (aperture-indexing) mount uses a small pin concealed in the lens mount. Most Nikon Al lenses have both the internal pin socket and the external prong.

If the Nikon F line is too expensive for you, consider the Nikon FM2, a less expensive but very reliable camera. It is about the same size and weight as the Olympus OM-1 and has similar features. The shutter of the FM2 is completely mechanical; only the light meter requires batteries. The FM2's interchangeable focusing screens include type B2 (fine matte), E2 (fine matte with grid), Beattie, and Brightscreen. The FM-2 takes Nikon's ×2 viewing magnifier (DG-2), which combines with the built-in ×4.3 eyepiece to give a total magnification of ×8.6. Unlike Olympus's product, the DG-2 does not provide right-angle viewing.

The FM2 does not take old pre-Al Nikon lenses, important to the bargain hunter. Its predecessor, the FM, is compatible with the oldest lenses, but its focusing screen is not interchangeable. A better choice among discontinued Nikons is the FE, an auto-exposure version of the FM with interchangeable focusing screens. The FE's shutter operates on B without battery power, and it takes pre-Al as well as Al lenses.

The Nikon F, F2, F3, FM, FM2, and some others can make multiple exposures with no film movement, a feature that comes in handy for preflashing and related techniques.

If you do not need meter coupling, you can put any Nikon lens, old or new, on pre-Al Nikon cameras. (The converse is not true; Al cameras take pre-Al lenses only if the Al pin is retractable, which it is, for example, on the F3 but not on the FM2.) An especially inexpensive way to start a Nikon system is to get a secondhand Nikkormat FTN, a pre-Al camera that has mirror lock, though it lacks interchangeable screens and does not take multiple exposures.

There are many good books about Nikons. See especially Herbert Keppler, *The Nikon Way* (1982), and B. Moose Peterson, *Nikon System Handbook* (1996).

9.5 Other SLR makers

Olympus and Nikon are not the only makers of suitable cameras. Another camera that stands out is the Pentax LX, recently discontinued but still widely available. It has all the requisite features, including interchangeable viewfinders and screens. One of the finders is a ×6 right-angle unit like Nikon's. For details of the LX see Crawley (1981). The Canon F-1 is another good choice, but the entire Canon manual-focus product line has been discontinued, and newer autofocus lenses do not fit manual-focus cameras.

If you can do without interchangeable screens and mirror lock, a much less expensive camera will suffice. The Pentax K-1000 is a 1960s-style SLR that is

Figure 9.4 **An unusually bad case of "foam rot." I repaired this one myself!**

popular with students and easy to find secondhand – the Volkswagen Beetle of photography, so to speak. Other "student" cameras with mechanical shutters include the Nikon FM10 (initially marketed only outside the United States, but available from New York discounters), the Yashica FX-3, and various models of Ricoh KR-5. The Ricoh takes Pentax lenses; the Yashica gives you access to excellent (but expensive) Contax lenses made by Zeiss. Vixen markets a camera for astrophotographers; it takes Pentax K-mount lenses and has a special, bright focusing screen, but it reportedly lacks mirror lock.

Many of the newest cameras have an "acute-matte" or "fine-matte" focusing screen similar to the Beattie Intenscreen. In that case, the screen need not be interchangeable because you already have a screen that is nearly ideal for all types of astronomical work.

Finally, almost any SLR from the 1960s or 1970s is at least partly suitable for astrophotography. The Pentax Spotmatic and Minolta SRT series resemble the present Pentax K-1000, but the Minoltas have an especially nice focusing screen, and some of the earliest units have mirror lock. Be wary of obscure cameras that never had a wide selection of good lenses.

9.6 Buying used cameras

Astrophotographers aren't the only people who still find older SLRs useful; in recent years the used-camera market has grown into a major industry. Appendix F lists some reputable used-camera dealers; *Shutterbug* magazine has ads for dozens more, as well as a calendar of camera swap meets across the United States. Cameras are traded on the Internet in the newsgroup *rec.photo.marketplace* There are also a few used cameras in every pawn shop, but because dealers use standard price guides, it won't cost any more to buy from an established camera dealer who offers a warranty. Better yet, buy from, or through, a repair shop, and see if you can get a camera that has recently been overhauled.

The price of cameras, new and used, varies greatly from country to country. If you're in Great Britain or Australia, it may be greatly to your advantage to buy from an American dealer and have the camera exported, even though you have to pay duty when it enters your country.

The best secondhand cameras are those that have been used, at least a little, every year. A camera that goes completely unused for several years is likely to need relubricating. On the other hand, an excessively battle-weary camera is not a good buy; Nikons, in particular, are often used very heavily by photojournalists and traded in when they are nearly worn out.

Worn-off paint at the corners of a black camera body ("brassing") is not serious. My OM-4T acquired this symptom right after I took it out of the box, due to using the wrong kind of camera strap! Black bodies that show no wear at the corners have probably never been used at all.

To test a secondhand camera, first make sure it feels right and sounds right. Next, look for "foam rot" (Fig. 9.4). In some climates (notably the southeastern United States), the black foam in the camera crumbles or becomes gooey after 10 or 20 years. If the foam pads get sticky, the mirror can stick in the raised position during a long time exposure. There is also foam where the back of the camera seals shut; if it crumbles, there will be light leaks.

Then test the shutter by choosing a suitable (terrestrial) subject and taking a series of exposures that should be equivalent, such as 1/60 at $f/16$, 1/125 at $f/11$, 1/250 at $f/8$, and so on. Repeat each exposure

several times to check for variation; the first exposure on each speed will probably be the least accurate. Make sure the exposure is uniform across the frame; if it isn't, the two shutter curtains are not moving at the same speed. Use slide film or examine the negatives, not just the prints. If the shutter is erratic, have the camera cleaned and lubricated. Don't use a camera heavily if its lubricants are drying out (as they do after 10 or 15 years of disuse); get it lubricated before any parts are damaged from lack of lubrication.

Verify that the focusing screen is accurately aligned with the film plane. To do this, take some pictures of a flat target, such as a brick wall that you are facing square-on, with your fastest lens wide open ($f/2$ or wider). Focus carefully and check that the resulting pictures are sharp. Focusing at $f/2$ is much more critical than at higher f-ratios, so this is a stiff test. Misalignment of the focusing screen is not a common problem, but there's no substitute for peace of mind.

If the focusing screens are interchangeable, make sure you can really change them; my OM-1 once had its screen pinioned in place by an inept foam replacement job. Likewise, try removing everything else that is supposed to be removable.

Finally, test the self-timer, the mirror lock button, and the light meter. At this point you may hit a snag: the light meters in many earlier cameras require 1.35-volt mercury batteries, which are no longer available. You can use 1.4-volt zinc–air cells, but they don't last long. A better alternative is to use an adapter that holds a silver oxide cell together with a voltage-dropping diode, or have the camera modified by a repair shop. For astrophotography you won't need the light meter anyhow.

For a real bargain, buy a camera that has defects you can live with, such as a dead light meter or some inaccurate shutter speeds. For example, I once paid $20 for an old Mamiya/Sekor that had a broken wire in the battery compartment but was still perfectly usable for astrophotography. Many dealers unload defective cameras at the lowest possible price, since most

photographers don't want them at all. The extreme case is an electronic-shutter camera such as an OM-2 or Nikon FE whose electronics are completely dead; the camera still works on "B" and is fine for time exposures, though useless for everything else.

But beware of shutters that jam; in the showroom, trip the shutter of the camera 10 or 20 times to make sure it's going to work reliably, even if the speeds aren't accurate. Try tripping the shutter with the film advance only partly cocked – the condition under which jamming is most likely.

9.7 Camera maintenance and repair

To anyone who uses older cameras, maintenance is important. In heavy use, a camera may need cleaning, lubrication, and adjustment ("CLA") as often as once every three years. For the average astrophotographer, 10- or 15-year intervals are probably sufficient.

There are many repair shops, and the repair industry seems to be growing as photographers realize that their classic cameras need maintenance. Service by the manufacturer is best, but if a camera is more than 10 years old, the manufacturer probably no longer services it, and, sadly, not everyone who claims to repair cameras is entirely up to the task. The foam rot in Fig. 9.4 occurred when a technician used a strong solvent to clean the mirror (which didn't need cleaning). Once, a shop returned a Minolta to me with a yellow wire protruding from under a cover; apart from that, it was in tip-top condition.

Good shops do exist, and professionals rely on them. Appendix F lists some shops that get consistently good recommendations. Professional photographers in your area can give further recommendations. Be aware that there are two kinds of repairs: a complete overhaul, with a guarantee that the camera will continue to work perfectly for six months, and a simple repair of one problem with no guarantee of anything else. Most photographers want

the first kind, which costs $100 or more; you can often make do with the second kind, which is cheaper. Besides fixing cameras, a repair shop can also tell you where to buy used cameras in your area, and can help you find cheap junked cameras that are still usable for your purposes.

Can you fix a camera yourself? Maybe. Don't try unless the camera is otherwise beyond economic repair; there's a real risk that you'll have an accident and make it unrepairable. On the other hand, those of us who make 1/10-wave mirrors and assemble telescopes can certainly do at least the simpler kinds of camera repairs.

Tomosy's *Camera Maintenance and Repair* is a good introductory guide, as are the manuals available from Ed Romney (p. 317). Here are some guidelines:

1 Use tools carefully. If a screwdriver doesn't fit, find one that does, or make one by re-grinding. The wrong screwdriver can quickly destroy a screw, and then you'll *never* get it out.

2 Never force anything; parts are easy to break. If something looks like it should unscrew, but you can't unscrew it, it's probably left-hand threaded.

3 Never spray lubricants, cleaning solutions, or compressed gas into a camera. Use liquids only when you can completely control where they are going. Compressed gas or air can blow delicate mechanisms apart or push dirt deeper, where it can do more harm. Apply lubricants with a toothpick.

4 If a mechanism is sticking, don't lubricate it – clean it. Denatured alcohol is a good cleaning solvent. Do not use alcohol that contains more than 1% water.

5 To unjam a camera, first look for obvious problems such as a dead battery or film at the end of the roll. Try pressing the rewind button. Some cameras can be unjammed by pulling upward very gently on the mirror, by setting off the self-timer, or by bumping the bottom of the camera gently onto the palm of your hand.

If all else fails, remove the bottom plate of the camera and see if you can trip the shutter or unlock the film advance. Don't force anything; you're looking for a latch that is just on the verge of tripping. Unfortunately, jamming is usually a recurrent problem.

6 Damage from a corroded battery is often confined to the battery compartment; if so, all you'll have to do is clean contacts. Do this very carefully with an ink eraser, a glass fiber brush, and/or a cotton swab dipped in alcohol. Do *not* let liquids or dust get into unknown parts of the camera.

7 Complete foam replacement is a tedious job best left to a professional, but you can do piecemeal repairs yourself. I made a nice mirror pad for the camera in Fig. 9.4 out of some brown foam furniture padding from a hardware store. Since it's not in the image-forming light path, the brown color does not matter.

9.8 Some miscellaneous SLR hints

1 Clean the outside of a camera with a brush, not with compressed air, which can blow dust into the camera through narrow cracks.

2 Do not apply excessive force to the tripod socket of any camera. Use enough force to hold the camera firmly, of course, but no more. Some tripods and piggy-back mounts will let you apply enough force to tear the camera apart.

3 The Olympus Varimagni Finder fits not only Olympus OMs, but also the Minolta SRT series, the Pentax K-1000, and perhaps some other cameras with rectangular eyepiece frames. Pentax makes a $\times 2$ flip-up magnifier that may fit other cameras.

4 Instruction books for secondhand cameras are often available free of charge from the manufacturer.

5 Many camera makers specify Japanese SR44 batteries. The SR44 has several North American equivalents of which the MS76 is the most popular but not necessarily the best. I have had better results with #357 watch-calculator batteries, which are electrically equivalent but last longer. This substitution has the blessing of Olympus and Eveready.

6 Remove batteries from electronic-shutter cameras that are not going to be used for a while. The reason? Battery drain does not drop to zero when the camera is switched off. The OM-2 and OM-4 continue to draw 7 to 30 microamperes, enough to run down a battery in a few months.

7 Store the OM-2 and OM-4 with the shutter set to B or red (manual) 1/60 so that pressure on the shutter release button will not turn on the meter. (Even so, the previous hint still applies.)

8 On many cameras, you can make double exposures in the following way: Make the first exposure normally. Then turn the rewind crank to take up slack in the film. While holding the rewind crank tightly in position, press the rewind button. You can now actuate the film advance and cock the shutter without actually moving the film. On Olympus OMs, you must make a third exposure to complete this process and re-engage the film advance.

9 An old trick for making a bright spot on a matte focusing screen is to apply a tiny, tiny dab of grease with a toothpick. If you do this to a plastic screen, use silicone grease and remember that you're doing it at your own risk. Use an expendable screen. Olympus screens are said to be unable to survive immersion in alcohol; soapy water should be safe, but the screens are very easy to scratch.

9.9 Other types of cameras

Not all cameras are 35-mm SLRs, of course, but that doesn't mean they're useless. Cameras that lack interchangeable lenses can be used only for piggy-back and afocal work, but some of them are very good for those purposes. Some of my early work was done with a Voigtländer Vito B (vintage 1955) coupled afocally to a telescope focused by the hand-telescope method. Its leaf shutter produced very little vibration. I still use this camera with my barn-door tracker because it is so small and light. Its four-element $f/3.5$ lens is surprisingly sharp.

Some modern "point and shoot" cameras have a "T" setting for time exposures, will accept a cable release, and can be used the same way. If you have "T" but no cable release socket (as on the Konica Hexar), simply hold a black card in front of the camera while you press the button, then remove it after the vibration dies away.

What about larger formats? The next step up from 35-mm is *medium format* or *6-cm* photography on 120 or 220 film. (Not "120-mm" – the film isn't nearly that wide. The pictures are usually 55 mm square or 45×55 mm. "120" is the last survivor from a series of film format numbers nearly a century old.)

For photography through a small telescope, medium format has no advantage because the image has to come through a 32-mm eyepiece tube, and the outer part of the film goes unused. You could expand the image by projection, but it would be better to leave it smaller and brighter and use finer-grained 35-mm film.

For piggy-backing, though, and for prime focus work with larger telescopes and apochromatic refractors, medium format has some advantages. The most obvious is the improvement in the speed-grain ratio. Because the negatives are enlarged only half as much to yield the same size picture, twice as much grain is tolerable, and full-page enlargements from 400 speed film look almost grainless. You can use films that are too grainy for 35-mm work and still get grainless

prints (Plate 9.1). Alternatively, 120-size Kodak Technical Pan Film produces pictures that are absolutely grainless and look like observatory plates from a few decades ago.

Hasselblad, Bronica, Pentax, Mamiya, and other medium-format SLRs are expensive, but the price gap between 35-mm and medium format has narrowed. These cameras are the workhorses of professional photographers. Because of this, they are durably built, many useful accessories are available, customer support is excellent, and the designs change little from year to year.

Some astrophotographers recommend Pentax medium-format SLRs as giving the best film flatness. Hasselblads are reputed to have the best lenses, but all major brands are good; a bad lens would not survive in the professional market. Few lenses faster than $f/2.8$ are available, but medium format lenses are generally quite sharp wide open. There is also less vignetting than with 35-mm cameras. *The Hasselblad Manual* (Wildi, 1995) is full of useful information even if your camera is not a Hasselblad.

Twin-lens reflexes (TLRs) cannot be coupled directly to the telescope, but in afocal work, you can focus through the viewing lens and then shift the camera so that the taking lens is at the eyepiece. Many TLRs have rather undistinguished lenses. Most TLRs are rather heavy; one of them, the Russian-made Lubitel, is very light because of its plastic body, but I have found it optically unimpressive (to say the least). Still, an attempt at afocal work with a Lubitel was quite successful (Fig. 4.11, p. 42).

Going to a larger format has an interesting effect on the picture. Suppose you photograph the same star field with a 35-mm camera with its normal lens, 50-mm $f/1.8$, and a medium-format camera with its normal lens, 80-mm $f/2.8$. Because of its lower f-ratio, the smaller camera picks up more nebulosity and sky fog, but because both lenses are the same diameter (28 mm), they pick up equal numbers of stars. If both lenses were set to $f/2.8$, they would record the same amount of nebulosity, but the larger one would record more stars. Thus, larger-format photographs show richer star fields. They are also likely to be sharper.

A few determined astrophotographers, pushing this principle to the limit, use 4×5-inch sheet-film cameras. The normal lens in that case is typically 150 mm at $f/4.5$. Before World War II, that is how astrophotography was commonly done – by the few who did it at all.

9.10 Special astrocameras

So far I've been assuming that you want to do your astrophotography with a general-purpose camera. Cameras designed just for astrophotography also exist. One of the most elaborate is the Taurus Astrophotography System, from Taurus Technologies (p. 314). Designed for prime-focus deep-sky photography, it has an off-axis guider built in, as well as a viewing eyepiece for centering objects in the field. A third eyepiece attaches in place of the film chamber for aerial-image focusing.

The big advantage of the Taurus camera is that you can view and focus on the object you are photographing, no matter how faint. With conventional SLRs, a faint galaxy is often invisible on the ground glass, and you must locate it by means of the surrounding stars. The mirror and shutter produce little vibration because they are worked by hand, with no springs or timing mechanisms.

At one time, Praktica and Miranda made special astrophotographic models of their SLRs. Both of them provided the ability to raise the mirror slowly with a second cable release – something that can also be done with the Visoflex attachment on a Leica camera body. See Dragesco (1995, especially p. 36) for more about customized cameras.

You can even build your own camera – all it has to do is hold a piece of film in place at the focal plane. Simple homebuilt astrocameras are described in *Sky &*

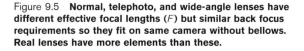

Telescope (December, 1980, pp. 530–533, and December, 1985, pp. 612–613). They take round images on cut pieces of 35-mm film. And there are of course many ways to modify an old or cheap 35-mm camera for astrophotography.

9.11 Lenses

Now for lenses – which are at least as important as cameras if you do piggy-backing or afocal work. The next few sections will define the basic types of camera lenses, explain how they work, and give some practical advice. For the whole story about how lenses work, see Kingslake (1978, 1989) and Ray (1994).

A *normal lens* is one for which the focal length, film size (corner to corner), and lens-to-film distance are all about the same. For 35-mm film, which measures 43 mm corner to corner, normal lenses are in the 40–55-mm range.

Whether normal lenses "match the human eye" is a matter of dispute; artists' sketches usually cover a narrower field, corresponding to an 80- or 100-mm lens, but taking pictures of people indoors with an 80-mm lens is difficult because you often can't get far enough away from the subject. Camera makers have settled on 50 mm as the best compromise, and this is generally their sharpest lens, as well as fastest.

A *telephoto* lens produces a larger image of a narrower field of view. But "telephoto" means more than "long-focal-length." As Fig. 9.5 shows, the focal length of a telephoto lens is usually greater than the physical length of the lens barrel. This is accomplished by negative projection – there is a negative element, similar to a Barlow lens, near the film. Some especially compact telephotos are *mirror lenses*, miniature Maksutov–Cassegrain telescopes, often with extra glass elements and even a refracting layer of glass in front of the mirror.

Conversely, a *wide-angle* lens is usually farther from the film than its focal length would suggest; it has

Figure 9.5 **Normal, telephoto, and wide-angle lenses have different effective focal lengths (*F*) but similar back focus requirements so they fit on same camera without bellows. Real lenses have more elements than these.**

to be in order to fit on the camera. Wide-angle lenses generally have a negative element in front, like a telephoto lens turned backward. Besides increasing the angle of view, this negative element enables the lens to defy the \cos^4 law (pp. 124–125) and give better illumination at the edge of the field.

A *teleconverter* is a negative projection element that mounts between the lens and the camera, to turn a normal lens into a telephoto or to make a telephoto lens longer. Confusingly, teleconverters are sometimes called *tele-extenders*, a word that is also Celestron and Meade's name for a positive projection attachment.

Teleconverters aren't as useful as you might expect. They spread the same amount of light over a wider area, making the image dimmer, and they do not gain detail; you can't magnify what isn't there. Even the humblest 100- or 135-mm telephoto lens will generally outperform a good 50-mm lens with a good teleconverter. But teleconverters have improved over the years; some of the latest ones have more than seven

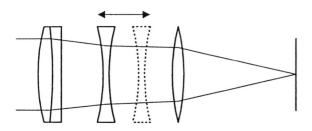

Figure 9.6 **A zoom lens contains a negative projection system with variable magnification, followed by a compressor.**

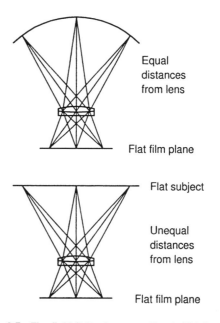

Equal distances from lens

Flat film plane

Flat subject

Unequal distances from lens

Flat film plane

Figure 9.7 **The field-flattening correction built into enlarging, projection, and copy lenses (bottom) usually makes them unsuitable for astrophotography (top).**

elements and are designed to correct the residual aberrations of specific lenses. I find ×2 and ×3 teleconverters useful with a prime focus telescope adapter; it's a simple way to build a negative projection system for lunar and planetary work (pp. 83–84).

A *zoom* lens is one whose focal length can be varied, ostensibly without throwing the image out of focus (but for best results, you should always check). Zoom lenses were originally developed for special effects in movies. Figure 9.6 shows how they work. Recall from Chapter 6 that you can change the magnification of a negative projection system by moving the projection lens forward or backward. That's what goes on deep inside the zoom lens. The negative element or group is normally followed by a positive element that acts as a compressor, enabling the negative part to work over a wider range, including positions in which it would not otherwise form an image at all. Elaborate mechanisms move the elements to keep the image in focus as the focal length changes. Some zooms use variable compression instead of variable negative projection.

Zoom lenses are usually slow (*f*/3.5 to *f*/5.6) and not as sharp as fixed-focal-length lenses. But zoom lenses have improved since the 1970s, and current zooms are sharper than many of the fixed-focal-length lenses of yesteryear. Some of the newest zooms have more than a dozen elements and rely on multi-coating to keep down internal reflections.

A *macro lens* is a lens whose aberrations are corrected for focusing on nearby objects rather than infinity. Most macro lenses are corrected for a reproduction ratio of 1:10, for photographing things about 10 times the size of the film. Some of the best macro lenses use *floating elements* (variable separations) to correct for more than one focal distance;

for example, my Sigma 90-mm *f*/2.8 macro lens performs well all the way from 1:2 up to infinity, and in this case, photographing a galaxy with a macro lens isn't as crazy as it sounds. (On some zoom lenses, "macro" merely means "close focusing" and does not imply that the lens is corrected for macro work.)

Like macro lenses, enlarging and copying lenses are corrected for low reproduction ratios. Figure 9.7 shows why such a lens will not focus the stars sharply. The stars are all at the same apparent distance, but the lens is designed to focus farther away at the edges of the field than at the center. Other aberrations, especially spherical aberration, also depend on the reproduction ratio. Thus, the lens from a copying machine probably won't be very good for astrophotography despite its large size and low f-ratio. (But try it and see – you may be lucky.) Projector lenses are even worse because they are not very sharp even in their intended application.

Other important parameters of a lens are the size of film it covers, the position of the lens relative to the film, and the resolution. For example, a 150-mm normal lens for a view camera must cover 4×5-inch film but need only resolve 20 lines per mm in order to be considered sharp. It will be mounted about 150 mm from the film. But a 150-mm telephoto lens for a 35-mm camera is subject to quite different requirements. It need

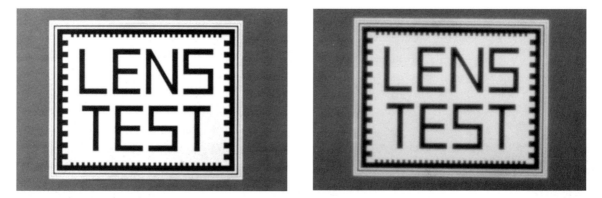

Figure 9.8 **Why resolving power does not tell the whole story. The picture on the right has higher resolving power but the picture on the left looks sharper.**

only cover a 24×36-mm image, but it should resolve at least 50 lines per mm, and its rear element should be about 50 mm from the film.

9.12 Lens quality and performance

The quality of lenses for 35-mm SLRs has risen considerably in the past few decades. Thirty years ago, only a few companies, such as Zeiss and Nikon, could be trusted to produce consistently good lenses. By the 1970s all reputable camera makers were making reasonably good lenses, and since 1985 or so, the independent lens companies, such as Tamron and Vivitar, have raised their standards dramatically.

The most common way to rate lenses is to measure their resolving power in lines per millimeter (l/mm or lpm). This is determined by photographing a special test target on extremely fine-grained film in a completely vibration-free environment. A resolving power of 40 lines per millimeter is supposedly adequate for 35-mm photography, but good lenses resolve at least 60 l/mm in the center of the field, and really excellent ones reach 90.

Lenses are always sharpest in the middle of their f-stop range. When a lens is operated wide open, uncorrected aberrations and manufacturing tolerances take their toll; at the smallest apertures, resolution is limited by diffraction (at $f/16$, the practical diffraction limit is about 60 l/mm). Also, naturally enough, lens designers plan their aberration corrections to work best at the apertures they think will be used most frequently, around $f/5.6$ to $f/11$. In astronomy, what matters is the

performance of the lens wide open. There is often a big difference between the widest stop and the second-widest (e.g., $f/1.4$ versus $f/2$).

Resolving power is not the only thing that determines how sharp a picture looks. A lens with uncorrected aberrations produces a sharp image superimposed on a blurry one. Conventional resolving-power tests pick up only the sharp image, ignoring the blurry part, but if the blurred component is removed, the picture looks much sharper (Fig. 9.8). Reflections and scattered light within the lens will also affect apparent sharpness. For this reason, test reports often evaluate contrast as well as resolving power. The best way to evaluate a lens is to measure its *modulation transfer function* (MTF), the relation of contrast to fineness of detail (see also p. 187). Lens tests based on MTF are published in *Popular Photography* magazine.

Internal reflections and vignetting are also important, perhaps more so for conventional photographers than for us. Uncoated glass reflects 5% of the light reaching it. Since the 1950s, lenses have had coatings that reduce this reflection to about 1%. Around 1980, a new generation of multicoating became available that reduces reflections to 0.2% or even less. The difference is dramatic in pictures like Fig. 9.9, and many photographers now insist on multicoated (MC or SMC) lenses.

Is multicoating necessary for astrophotography? I'm not sure. Astronomical pictures are not like beach scenes at sunset; they are seldom dominated by one excessively bright object. Multicoated lenses do transmit more light, but the difference is seldom

Figure 9.9 **Sunset at the seashore – and multiple images of the sun caused by internal reflections. Pictures like this are why photographers care so much about multicoating. (By the author)**

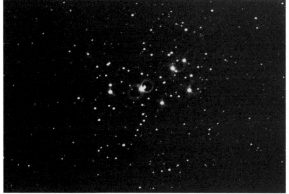

Figure 9.10 **Internal reflections in a 300-mm $f/5.6$ mirror lens. A 12-minute exposure of the Pleiades on hypered Technical Pan. (By the author)**

Most long lenses have some residual chromatic aberration that can be reduced with a UV-blocking, skylight (1A), or pale yellow filter. I keep a skylight filter on most of my lenses all of the time; it protects the front element from dust and scratches. The current advice among fine-art photographers is, "Whenever you put an extra optical element on a lens, you reduce the quality," to which I can only reply, "Show me!" My star fields are sharper with the skylight filter than without it, due to reduction of chromatic aberration.

One word of caution: many cheaper filters have no anti-reflection coating. Coating the skylight filter is especially important because it is nearly clear and won't absorb reflected light. Hoya makes good multicoated filters.

noticeable. In fact, it can work the other way. I once photographed a star field with the multicoated and non-multicoated versions of the Olympus 50-mm $f/1.8$ Zuiko. To my surprise the multicoated lens picked up less light. To reduce reflections, the manufacturer had made the clear aperture slightly smaller and apparently increased the vignetting. But I do have one lens that is troubled by internal reflections, a 300-mm $f/5.6$ mirror lens (Fig. 9.10); multicoating there would be welcome.

Some lenses shift annoyingly during a long exposure as the telescope moves to follow the stars. Zooms can shift in focal length, and mirror lenses that focus by moving the mirror (like a catadioptric telescope) can change focus spontaneously. Autofocus lenses are often a bit loose, even when used on manual-focus cameras, and can "flop" during an exposure.

9.13 Lens mounts

Why don't all SLRs use the same lens mount? There was a time when many of them did. The so-called "universal screw mount" was a 42×1-mm metric thread with a flange-to-film distance of 45.5 mm, and was used on Pentax, Praktica, Mamiya/Sekor, Yashica, and many other brands of cameras in the early 1960s. But even then, Minolta and Nikon insisted that screw mounts were too slow for the busy photojournalist; they used bayonet (push-and-twist) mounts like the ones popular today.

Another universal mount, the T-mount, was introduced by Spiratone, a lens importer in New York. The T-mount uses a 42 × 0.75-mm thread with an unusually large flange-to-film distance, 55 mm. The idea was that you would buy T-mount lenses together with T-adapters for all your cameras. T-adapters are still used for coupling cameras to telescopes, but not for much else.

The universal screw mount and T-mount died out as lens mounts became more complicated. The lens mount on a modern SLR has to do three things:

1 Hold the lens in place at the correct distance from the film.
2 Stop down the lens diaphragm to the specified aperture when taking a picture, leaving it wide open the rest of the time for focusing ("auto diaphragm").
3 Tell the camera the aperture setting, so the light meter can take it into account while you view with the lens wide open ("open metering," "aperture indexing").

Of these, T-mounts do only 1; old T-mount lenses have "preset diaphragms," which means there is a ring that quickly switches the lens from wide-open to the preselected aperture. The universal screw mount performs function 2 by means of a pin at the bottom. When aperture indexing (3) became important, the universal screw mount died out, although several camera makers tried to add this function to it – unfortunately in incompatible ways.

Can you get an adapter to use one brand of lens on another brand of camera? Maybe, but you may not want to. Auto diaphragms and aperture indexing generally don't work through adapters. More importantly, the adapter takes up space, placing the lens too far from the film. To preserve infinity focus, the adapter generally has to contain a weak negative projection lens, potentially affecting optical quality. Adapters are available from Adorama, B&H Photo, and other large suppliers (p. 316).

Figure 9.11 **Misshapen star images from a lens with a decentered element. This looks like a guiding problem but isn't.**

9.14 Buying lenses

There is noticeable unit-to-unit variation among lenses of the same manufacturer and type. Manufacturing tolerances are very tight, and if the curvature or placement of an element is even slightly in error, performance can suffer. With modern lenses from reputable manufacturers, unit-to-unit variation is not a big problem, but you should be aware of the possibility and test every new lens promptly.

Occasionally a "lemon" does sneak through. Figure 9.11 shows star images, greatly magnified, from a 1975-vintage telephoto lens that I bought at a clearance sale. Apparently, a lens element is decentered – that is, the optical center is not in the middle of the disk of glass. Alternatively, an element may have slipped out of position; one day I may take the lens apart and investigate.

You can save money by buying used lenses, but you do take a risk; the previous owner may have gotten rid of the lens because it wasn't sharp. The best bargains are lenses for out-of-date cameras, such as pre-AI Nikkors; they're cheap because of declining demand, and they're on the market because the owner traded them for newer equipment rather than because of any problems with the lenses themselves.

Fixed-focus telephoto lenses are less expensive now that everyone wants zooms. Very specialized lenses, such as extra-long telephotos, are also good secondhand buys; professionals buy them for special projects or brief periods of experimentation and later trade them in.

Figure 9.12 **You can find the best infinity focus setting for a lens by making multiple exposures of the moon on fine-grained film, noting the exact position of the lens barrel for each. These were taken with a 300-mm *f*/4.5 lens wide open and Ilford Pan F film. (By the author)**

A lens in pristine condition, hardly used, is not necessarily a good buy; it may not have been sharp enough to satisfy the owner, and a lens that has served someone well is a better buy. On the other hand, battle-weary lenses owned by photojournalists and travel photographers may have been dropped.

For a real bargain, look for lenses with diaphragm problems. In astrophotography, lenses are used wide open and the condition of the diaphragm is unimportant. For conventional photography, though, a lens with sticky blades is almost unsalable and can be picked up for just a few dollars. Scratches may also be tolerable; a small scratch on a lens often has no detectable effect in star-field photographs, especially if you fill the scratch with black ink. I'd rather have a great lens with a scratch than a mediocre lens in pristine condition.

Buy your lenses, new or used, from a dealer who will let you return them if you're not satisfied, and who understands that you need to wait for a clear moonless night in order to perform a complete test.

9.15 BASIC TECHNIQUE 16:
Testing lenses

To test a lens, first look at its overall mechanical condition. Does the diaphragm stop down and open up easily when you work the appropriate lever or pin on the mount? Is focusing smooth? Is anything loose?

Next, take some terrestrial pictures at various apertures. To test for distortion, photograph a brick wall. Test sharpness by photographing distant buildings or a newspaper hanging on the wall. For best results, test the lens against another one that should be comparable. Use a tripod to eliminate camera motion.

Then find the true infinity focus position, which is usually slightly short of the infinity mark on the lens barrel. You can usually do this by focusing carefully on the moon or a bright star; in difficult cases you can even make multiple exposures of the moon (Fig. 9.12) or the stars on fine-grained film, recording how the focus was set for each. Don't focus in the exact center of the field; instead, focus about halfway from center to edge in order to minimize the effect of curvature of field.

With the lens properly focused at infinity, test it on the stars using fine-grained 100-speed color slide film, such as Kodak Elite Chrome 100. Color film will reveal chromatic aberration as blue haloes around stars. Fine grain is necessary to test sharpness, and slide film is preferable so that the print-making process will not confound the results.

Well-guided piggy-back exposures are good tests, but you should also make some fixed-tripod exposures so that guiding will not be a factor in the results. (For a while I thought the problem in Fig. 9.11 was a guiding problem.) One convenient tactic is to aim the camera high in the southern sky, expose for about three minutes, cap the lens, turn the camera 90° (from horizontal to vertical format) while keeping it aimed in the same direction, and expose another three minutes. You will get star trails in two perpendicular directions (Fig. 9.14).

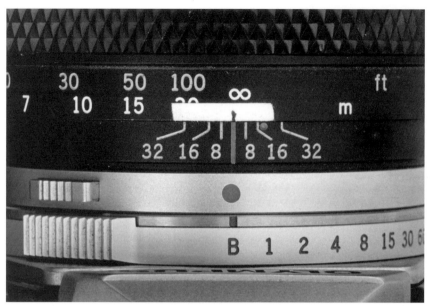

Figure 9.13 **Once you find true infinity focus, mark it with a small paper label. Temperature changes can still shift it somewhat, so you should still focus carefully on a star whenever possible.**

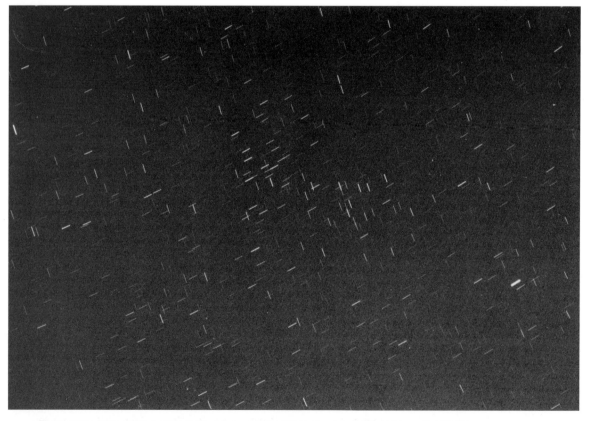

Figure 9.14 **Perpendicular star trails are a good lens test; they're obtained by reorienting the camera halfway through the exposure.**

Table 9.3 *Major types of telescopes and their suitability for astrophotography*

Feature	Newtonian	Classical Cassegrain	Schmidt– Cassegrain	Maksutov– Cassegrain	Conventional Refractor	Apochromatic Refractor
Usual f-ratio	4–8	10–20	6.3, 10	15	10–20	5–10
Tube length	Moderate	Short	Very short	Very short	Long	Moderate
Back focus	Restricted	Ample	Very ample	Very ample	Ample	Ample
Weight	Moderate	Moderate	Light	Heavy	Heavy	Heavy
Optical performance	Very good	Very good	Good	Very good	Good	Excellent
Cost	Low	High	Low	Moderate	Moderate	High
Portability	Moderate	Moderate	Very good	Good	Moderate	Good

9.16 Lens repair

Looseness in the focusing mechanism of a lens, and even inaccuracy of the infinity stop, can often be fixed from the outside with nothing more than a jeweler's screwdriver.

When necessary, many lenses are fairly easy to take apart, repair, and reassemble. To remove retaining rings, use a *spanner wrench (optical spanner)*, a wrench with two prongs an adjustable distance apart. Tomosy (1993) discusses repair techniques in detail. The main problem is dust: a lens that has been opened in an ordinary environment will never be quite free of internal dust afterward. Fortunately, small amounts of dust have no photographic effect. Keep the can of compressed air handy and hope for the best.

Diaphragm problems are usually caused by oil on the blades. You can often clean it off by applying a drop or two of alcohol, opening and closing the diaphragm several times, and soaking up the alcohol that remains, if any, with tissue paper. Do this repeatedly.

Another problem is "fungus," damage to the antireflection coating that may or may not be caused by a real fungus. This is often surprisingly easy to clean off with alcohol. To kill any fungus that may still be alive, expose lens elements to sunlight for half an hour. One of my best lenses is a 135-mm $f/2.8$ Olympus Zuiko that cost me only $15 because it had "fungus." I think the fungus was actually a fine spray pattern of oil or some other contaminant; it came right off and has not grown back. Indeed, it was hardly noticeable and the lens would have been quite usable without repair.

Zoom lenses are excessively hard to repair because of the mechanisms that move the elements;

even professional technicians balk at fixing them. That's another good reason to stick with fixed-focus lenses.

9.17 Choosing a telescope

Choosing a telescope for astrophotography is much easier than choosing a camera because you're using the instrument for its intended purpose. Cameras are not designed for astrophotography, and finding a good one often seems like a battle of wits against designers who had something entirely different in mind. Many telescopes, on the other hand, are designed and promoted as astrophotographic instruments.

Any telescope you can actually afford will be a compromise between performance, cost, and portability. Do not neglect the last of these. A generation ago, amateur astronomers observed from their homes, and heavy Newtonians and refractors were their usual instruments. Nowadays, many amateurs do all their observing from campgrounds and other remote sites, using portable Schmidt–Cassegrains, the lightest and most compact type of astronomical telescope.

The best telescope is the one you can actually use most effectively. A limited budget can be a blessing because it will force you to buy a small, convenient instrument. Well-heeled amateurs often buy a telescope that is too large to use conveniently, then wish, later on, for something smaller. Equipment that is too hard to transport and set up is useless no matter how fine its optics. On a more mundane level, do you want to commit yourself to hefting a 25-kg instrument if you have back trouble? On the other hand, someone else's

misjudgement can be your gain; a remarkable number of people buy big, complex telescopes, never learn how to use them, and unload them at much lower prices later.

The telescope features that you need depend on the kind of work you want to do. For prime-focus deep-sky photography, and even for wide-field pictures of the moon, you need a wide aberration-free image, but for planetary work, only the center of the field matters. The central obstruction of a reflector or catadioptric increases diffraction and reduces the contrast of planetary detail but is no obstacle to deep-sky photography, except, of course, that it causes some loss of light.

You'll notice that I've rated the optical performance of Schmidt–Cassegrains and conventional refractors lower than that of other types of telescopes. There are two reasons for this. As noted in Chapter 6, a Schmidt–Cassegrain has a rather small aberration-free image area, outside of which the off-axis aberrations are severe. However, at the center of the field the image is as good as in any other telescope. With conventional refractors, the problem is variation of quality; some are excellent, but some of the least expensive ones have inferior lenses. Also, in larger refractors, conventional two-element lenses cannot correct chromatic aberration completely. New-technology apochromatic refractors, however, are superb instruments.

A sturdy equatorial mount and clock drive are practically essential. In fact, the mount is arguably more important than the telescope; if you can't hold the telescope steady, you can't see or photograph anything. Many advanced astrophotographers use premium-quality Losmandy and Byers mounts and drives. I often use an old Celestron 5 whose mount is essentially that of the Celestron 8, but because the telescope is much lighter, the mount is much steadier. Beware of *Dobsonian* telescopes, which are Newtonians on alt-azimuth mounts; they're a bargain for visual observing, but you can't use them for photography.

The best telescope for a beginner is whatever helps you learn how to observe. If you do start with a

bare-minimum telescope, save up and get a good 20-mm or 25-mm eyepiece; it often makes a dramatic difference.

9.18 PRACTICAL NOTE:
Does a lower f-ratio give a brighter image?

With camera lenses, a lower f-ratio gives a brighter image. Is the same true of telescopes?

When you're photographing nebulae at the prime focus, yes. Under other circumstances, not necessarily.

Consider stars, for example. The brightness of star images depends only on aperture, not f-ratio or magnification, because star images are always points. Thus, the limiting stellar magnitude of a telescope is independent of its f-ratio.

With extended objects, such as galaxies and nebulae, the image brightness on the film depends on the f-ratio. But the visual brightness as seen through an eyepiece depends only on the aperture and magnification. Point two 20-cm telescopes at the same object, both of them working at ×100 with equally good eyepieces, and no one will be able to tell which one is the $f/6.3$ telescope and which one is $f/10$.

If you put identical eyepieces into both telescopes, the $f/6.3$ telescope will give a smaller and brighter image, but that's because of its lower magnification, not its lower f-ratio. You could get the same effect by changing eyepieces on the $f/10$ telescope.

Low-f-ratio telescopes are harder to manufacture well, and even when perfectly made, they have more serious off-axis aberrations. Choose a higher f-ratio for better image quality unless you plan to do deep-sky photography at the prime focus. Even then, consider using a compressor lens (focal reducer) rather than a fast

telescope. Di Cicco (1991) found that the Celestron and Meade ×0.63 compressor lenses greatly improve flatness of field.

9.19 Telescope quality and performance

Like lenses, telescopes suffer considerable unit-to-unit variation. This is especially the case with mass-produced Schmidt–Cassegrains, where no two sets of optics are quite alike and the maker must decide whether each set is good enough. Anecdotal evidence suggests that standards were high in the early days of Schmidt–Cassegrain manufacture, slipped during the excitement about Comet Halley in 1986, and have risen since the famous "showdown" published in *Sky & Telescope* (Di Cicco 1989; see also Dragesco 1976).

Neither Meade nor Celestron is consistently better than the other; there is apparently some risk of getting an unsatisfactory telescope from either company. Thus, it is important to test every telescope carefully during the warranty period. Meade used to give a lifetime warranty, and one of my telescopes had its optics replaced under warranty nine years after the purchase, when I finally got around to doing a critical test. Nowadays, the warranty is one year, and one should act more promptly. As Ceravolo (1989) points out, "Only your satisfaction is guaranteed," which means the final testing is left to you. (Not to keep you in suspense, I have one Celestron telescope and one Meade telescope, both of which have good optics.)

Concerns about optical quality should be kept in perspective. Nobody gets around the laws of physics; a reasonably good 20-cm telescope outperforms the best 10-cm for every purpose except wide-field imaging. In fact, the resolution of most telescopes larger than 20 cm is limited by the atmosphere, not by diffraction or aberrations. More importantly, *most Schmidt–*

Cassegrains in actual use are seriously out of collimation; a simple adjustment can greatly improve performance. And despite its optical limitations, the Schmidt–Cassegrain is unusually portable, versatile, and inexpensive.

Newtonians and all other kinds of telescopes are also subject to unit-to-unit variation and should be tested. Mirror defects in a Newtonian are especially easy to detect using the Foucault test (p. 90). For those who don't want to take their chances, premium-quality, hand-figured telescopes are available from Takahashi, Astro-Physics, Ceravolo, Optical Guidance Systems, Zeiss, and others. Because the cost of making a telescope largely reflects the optician's time, and time is proportional to precision, these telescopes are not cheap. One of the axioms of amateur astronomy is that any telescope you can actually afford is imperfect.

9.20 BASIC TECHNIQUE 17:
Star-testing a telescope

Telescopes are among the few human artifacts that can easily be tested to nanometer precision. The only instrument needed besides the telescope is a star viewed through steady air. Lacking a star, you can make do with a distant ball bearing illuminated by a spotlight or slide projector (Fig. 9.15).

Give the telescope a long time for its temperature to equalize with that of the surrounding air. If the air is not steady, you won't be able to perform a precise test, and you'll have to wait until another night.

Then look at a moderately bright star – not an extremely bright one – using a high-power eyepiece. If your telescope is a reflector or Schmidt–Cassegrain, adjust the collimation according to the manufacturer's instructions.

Figure 9.15 **Indoor star-test setup. Expect spherical aberration because the telescope is not focused at infinity.**

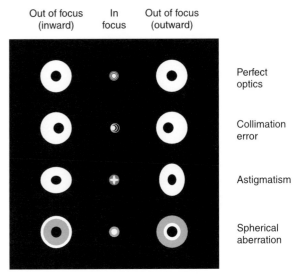

Figure 9.16 **Star images at high power (simplified; see Suiter 1994 for the full story).**

Always collimate for the best possible star images; centering the shadow of the secondary is only an approximation.

Finally, examine the star images carefully both in and out of focus. At perfect focus, each star image should be a tiny disk surrounded by concentric diffraction rings. If the rings aren't concentric, the collimation isn't quite right; adjust it further. Figure 9.16 shows *roughly* what the star images look like under various conditions; what you actually see will always reflect small irregularities in your eye and in the atmosphere.

If the in-focus star image isn't round, and especially if it changes shape considerably when you change the focus, you have a problem. Astigmatism in your eye may be the culprit, so try your other eye. If that doesn't help, try replacing or rotating the eyepiece and the diagonal. Also make sure the telescope is in thermal equilibrium; air currents within the tube can cause strange symptoms, such as moving defects, pie-slice effects, and circles that seem to have one side bashed in. If a mirror is being pinched by its three mounting clips, star images will be triangular.

Repeat the test on several nights in steady air. Check the collimation again and again. If the problem remains, compare your telescope with others and, if possible, consult a more experienced astronomer. Then contact the telescope manufacturer. Be cautious and polite;

no one knowingly sells defective telescopes, but any manufacturer can have bad luck occasionally, and reputable manufacturers will work with you to correct the problem. Remember that, as Suiter (1994) demonstrates, rigorous star testing can detect flaws that are too small to have any real effect on image quality.

9.21 How to clean optics

Except for eyepieces, telescope and camera lenses do not get dirty in normal use and seldom need cleaning. Dew should be left to evaporate; it consists of distilled water and will dry clean. A camera lens used in dirty environments should have a removable skylight or UV filter that can be cleaned separately.

Apart from blowing dust off with a can of compressed air, I *rarely* clean lenses. How rarely? Well, the corrector plate of one of my Schmidt-Cassegrains was cleaned in 1982 and again in 1996; I regretted having to do it that often. Most of my camera lenses get cleaned about once per decade; some have been 20 years without a cleaning.

Small amounts of dust do not harm image quality. Suiter (1994, p. 167) argues that dust is not noticeable until it covers about 1/1000 of the surface area of the

lens – and on a 20-cm-diameter lens, that's a quantity of dust which, if gathered into one pile, would be 6 mm in diameter. In any case, you can remove the dust with compressed air without touching the lens.

Do not evaluate the cleanliness of a lens or mirror by shining a flashlight on it in the dark. No lens or mirror will pass that test, except perhaps one that has never been used; you'll see bright reflections from dust specks and flaws that are truly microscopic.

Cleaning, on the other hand, is a risky and vexing process. One grain of sand trapped under your cloth can scratch the lens permanently. More commonly, when you clean a lens, a tiny drop of grease, previously self-contained and doing little harm, will spread all over the lens so that you spend half an hour getting rid of it.

When you do clean a lens, start by removing as much dust as possible with a brush and then with compressed gas ("Dust-Off"). If further cleaning is necessary, wipe the lens very, very gently with a well-laundered handkerchief moistened with Windex or isopropyl alcohol. Better yet, use a microfiber cloth specially made for cleaning optics. Wipe from the center to the edge; your goal is to *remove* dirt particles, not take them around and around on a carousel ride. Change handkerchiefs frequently, or use lab-grade, oil-free, grit-free tissue paper (Kimwipes or equivalent). Ordinary facial tissues often leave oil and lint on the lens.

Do not spray a liquid onto a mounted lens; some of it will get under the edges and can cause rust. Unmounted lens elements, however, can be washed with dishwashing detergent and running water; the water carries gritty particles away before they can do any harm.

Never wipe a mirror at all; the coating may come right off. Instead, remove it from its mount, wash it with water and dishwashing liquid, and let it air-dry.

Film

To a great extent, astrophotography is the art of getting film to perform as well as possible under difficult conditions. Astrophotography therefore revolves around film the way automobile racing revolves around engines. This chapter surveys film technology from an astronomical perspective.

10.1 How film works

All present-day photographic films contain crystals of a silver halide (silver chloride, bromide, or iodide). When treated with a developer, these crystals precipitate a dark deposit of metallic silver in proportion to the amount of light to which they have been exposed. The film remembers its exposure to light even if weeks or months elapse between exposure and development.

Black-and-white film consists of an emulsion of silver compounds and other sensitizing agents suspended in gelatin and coated on a base of cellulose acetate or, sometimes, polyester (Kodak ESTAR). After exposure, the film is processed with a developer and then with a fixer, which washes away the undeveloped silver compounds. The result is a negative that is black

Figure 10.1 **Clumps of silver halide grains are visible in this enlargement of a small area of a picture of M21 taken on Tri-X Pan Film.**

with silver where light has struck it (corresponding to bright areas in the subject of the photograph) and clear elsewhere. When the negative is copied onto another piece of film or paper that works the same way, light and dark are reversed again, and a positive image results.

The new *chromogenic* black-and-white films (Kodak T400 CN and Ilford XP2) use a more elaborate process. In addition to silver halide, their emulsions contain *dye couplers* that react with a special developer and form a tiny colored patch around every grain of precipitated silver. The silver can then be bleached out, leaving only the dye. The obvious advantage of this process is that the expensive silver can be recovered and reused. More importantly, the image looks less grainy because dye spots are less sharp-edged than silver grains. The film can tolerate larger amounts of overexposure than conventional film because the dye can be piled up more heavily than silver without becoming totally opaque.

More importantly, dye couplers make color photography possible. A color negative film has three layers, each of which is sensitive to part of the spectrum (red, green, or blue) and forms an image in a dye of the complementary color (cyan, magenta, or yellow, respectively). The resulting image renders light objects as dark, just like a black-and-white negative, and renders each color as its complement. Copying or printing onto a similar material reverses brightness and color a second time, giving a realistic positive image. (Actual color negative films also incorporate a bright orange masking layer, and the response of color enlarging paper is adjusted to compensate for it; hence the colors involved are not exact complements.) The processing of color negative film is hardly any more complex than for black and white: develop, rinse, bleach, and fix. In fact, chromogenic black-and-white films can be, and often are, developed in chemicals designed for color negative film.

If you want slides (i.e., a positive image on film), development is more complicated. The first step is to develop the film normally, so that the silver halide

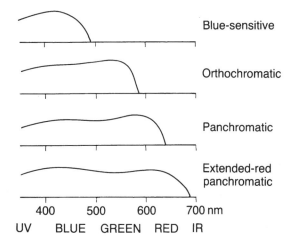

Figure 10.2 **The spectral sensitivity of several kinds of black-and-white film.**

molecules that have been exposed to light are reduced to metallic silver. Then, instead of removing the undeveloped silver halides, a bleach solution removes the precipitated silver itself. Next, the remaining silver halide crystals are fogged, either chemically or by exposing them to light, and developed; the dark areas on the film at this stage are those on which no light fell originally, and the image is a positive, rendering dark as dark and light as light. After fixing to remove unused sliver halides and other chemicals from the emulsion, the image is ready for viewing.

This is known as *reversal* processing, and in black and white, it is used for movie film but not, nowadays, for much else. (Kodak makes a kit for reversal processing of T-Max 100, and Agfa makes a black-and-white slide film called Scala.) A color reversal process, however, is the normal way of making color slides.

Color slide film, like color negative film, consists of three layers that are sensitive to different parts of the spectrum (red, green, and blue) and form images in the complementary colors (cyan, magenta, and yellow). Since the final image is a positive, the resulting colors are realistic, in spite of (or rather because of) the fact that complementary dyes are used. For example, photographing a yellow object triggers a response from the red- and green-sensitive layers, causing them to become transparent and leaving the blue-sensitive, yellow-forming layer dark, i.e., yellow.

Most color slide films (Agfachrome, Fujichrome, Kodak Ektachrome) use dye couplers to color the images, resulting in relatively simple, non-critical development processes that you can carry out at home. (In fact, nowadays all of these films use the same process, Kodak Process E-6.) Kodachrome film is different; it contains no dye couplers, and each of the three layers is developed and dyed separately. Since the processing of the three layers can be adjusted individually, much finer quality control is possible, but because of the equipment required, Kodachrome can only be processed by large laboratories. Because

Kodachrome dyes are more stable, Kodachrome slides can be expected to last 100 years in storage without fading; Ektachrome and Fujichrome, just 50 years. This is less of a difference than in the old days of Process E-4 or E-3, when Ektachrome was noticeably fade-prone.

10.2 Spectral sensitivity

If a photographic emulsion contains only silver halides, it responds only to blue, violet, and ultraviolet light. Emulsions of this type are called *unsensitized* or *blue-sensitive* (Fig. 10.2) and are used, nowadays, only in black-and-white photographic paper and some graphic arts materials. Their big advantage is that they are unaffected by a red or orange safelight. In the past, blue-sensitive emulsions were used extensively by observatories, mostly in the form of Kodak 103a-O and similar photographic plates; the B magnitudes in star catalogues indicate the brightness of stars as photographed on blue-sensitive film. No blue-sensitive films useful in amateur astrophotography are currently being manufactured.

In the early 1900s, blue-sensitive films and plates were replaced by *orthochromatic* materials – emulsions that respond to all visible wavelengths except red. The results were a gain in speed – if you cover more of the spectrum, you catch more light – and, more importantly, an improvement in photographic realism; there was

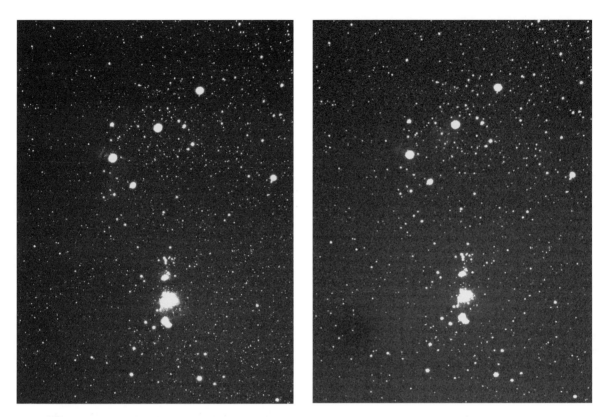

Figure 10.3 **Southern Orion on hypered Kodak Technical Pan film (left) and Kodak Tri-X Pan film (right). Both are two-minute piggy-backed exposures with a 90-mm *f*/2.8 lens wide open and a 1B (UV-blocking) filter. Technical Pan film is finer-grained; it picks up more nebulosity due to its greater red sensitivity.**

much less of a tendency for people's lips and cheeks to come out too dark. Because the film did not respond to red light, it was still possible to use a safelight when developing it.

By the 1960s, orthochromatic film was also obsolete, and the only orthochromatic materials now available are high-contrast graphic-arts films (Kodalith Ortho, Kodak Ektagraphic Slide Film, Agfaortho 25). Today's films are *panchromatic*, which means they respond to the entire visible spectrum – or at least, almost all of it.

The human eye can see light of wavelengths up to about 670 nanometers, but the response of most panchromatic films extends only to 630 or 640 nm so that reddish objects, especially people's lips, won't photograph too light (the opposite of the orthochromatic problem). Some films designed for scientific photography, such as Kodak Technical Pan 2415 and Kodak Recording Film 2475, are sensitized to wavelengths as long as 700 nm or a bit beyond, both in

order to gain speed by catching more light, and in order to record scientific light sources such as helium–neon lasers (633 nm) and red light-emitting diodes (640 nm).

As Fig. 10.5 shows, the three layers of color film respond to different parts of the spectrum, overlapping somewhat (especially in the faster films), and the red-sensitive layer extends farther into the red than that of most black-and-white films. Color films are further classified as *daylight type*, balanced for natural illumination, and *tungsten type*, with color shifted toward blue to compensate for the relative redness of artificial light. Daylight type film is almost always preferable for astrophotography, but tungsten film is sometimes useful to bring out the blue ion tail of a comet.

Anything that alters the sensitivity of color film – aging, reciprocity failure, or hypersensitization – distorts the color balance insofar as it affects the three layers unequally. Fortunately, astronomers seldom require the degree of realism that is necessary in, say, portrait photography, and most inaccuracies of color can be

ignored. The usefulness of color in astrophotography is not that it reproduces the colors seen by the eye – a hopeless endeavor, since even visual astronomers cannot agree on them – but rather that, besides enhancing the esthetic value of the picture, it makes important detail easier to see.

The most dramatic way in which color astronomical photographs are unrealistic is in the way that they render nebulae. Emission nebulae, such as the Orion Nebula, almost always photograph as red, though they look white or pale blue-green to the eye. The reason for this is that such nebulae shine by fluorescence, and their light is confined almost entirely to two narrowly defined wavelengths, 500.7 nanometers (from ionized oxygen) and 656.3 nm (from hydrogen). The 500.7-nm wavelength is near the maximum sensitivity of the human eye and dominates the visual appearance of the nebula, but it falls between the peaks of the blue- and green-sensitive layers of film, so that color film does not record it well (Fig. 10.4). The 656.3-nm wavelength, on the other hand, records well on the red-sensitive layer even though the human eye has trouble seeing it. By contrast, reflection nebulae, which shine by reflecting starlight, photograph as white or blue-white. A photograph of an object containing some of each, such as M20 in Sagittarius, can display a dramatic juxtaposition of colors (see for example Plate 10.1).

10.3 The characteristic curve

The way a film responds to light is best summarized in its *characteristic curve*, a graph of density versus exposure (Fig. 10.5). The horizontal scale gives the logarithm of the exposure, in meter-candle-seconds; each unit represents ten times as much exposure as the next lower unit, and a one-stop exposure change (multiplying or dividing the exposure by 2) is equivalent to moving 0.3 of a logarithmic unit to the right or left.

The vertical scale is the logarithmic density of the negative, calculated the same way as for sun filters (Chapter 5).

The curve consists of three portions: the toe, where it tapers off to a minimum; the straight-line portion; and the shoulder, where it tapers off to a maximum. In practice, photographs are taken on the toe and the lower part of the straight-line portion; if you go up to the shoulder, you get a very dense, grainy negative, as well as a loss of effective speed since more light is required.

The steeper the curve, the higher the contrast, since a steep curve renders a small difference in exposure as a large difference in density. The slope of the straight-line portion is called *gamma* (γ) and is one way to measure contrast. Gamma is about 0.7 for normal pictorial photography, though much higher values are desirable in astrophotography – about 1.0 to 2.5 for planetary work and as high as 4.0 for star fields. Gamma of course varies with development time, but for any given combination of film and developer, there is a maximum, known as *gamma infinity* (γ_∞), beyond which further development does not increase contrast. (Note that the infinity symbol is a subscript; "gamma infinity" means "gamma with infinite development" and does not mean that the value of gamma is itself infinite. Note also that gamma means something different in electronic imaging; see p. 225.)

Gamma describes only the straight-line portion of the curve, but most actual photographs use the toe. As an alternative, most Kodak publications use a measure called the *contrast index*, which is the average contrast for the parts of the curve likely to be used in a typical photograph. The ideal contrast index for pictorial photographs is considered to be 0.56.

The shape of the curve is different for different films. "Short-toed" films have a curve that straightens out only a short distance above the minimum; "long-toed" films have a curve that sags in the middle. In ordinary photography, the choice between the two is mostly esthetic: short-toed films produce a more faithful

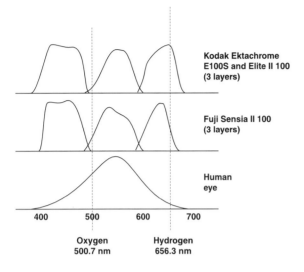

Kodak Ektachrome
E100S and Elite II 100
(3 layers)

Fuji Sensia II 100
(3 layers)

Human
eye

Oxygen
500.7 nm

Hydrogen
656.3 nm

Figure 10.4 **Why emission nebulae look bluish but photograph as red – and why they are redder on some films than on others. The eye responds to the 500.7-nm line of oxygen, but the film responds to hydrogen-alpha at 656.3 nm. (The curves were scaled from the manufacturers' literature and are intended for illustrative purposes only. See also Plate 8.4.)**

copy of the tones in the subject, while long-toed films produce pictures in which the contrast varies with the illumination, not unlike the way the human eye sees. In astronomy, the main considerations are that short-toed films are more resistant to sky fog and lens flare, while long-toed films are more likely to pick up faint detail that can be brought out by overdevelopment, intensification, or high-contrast copying.

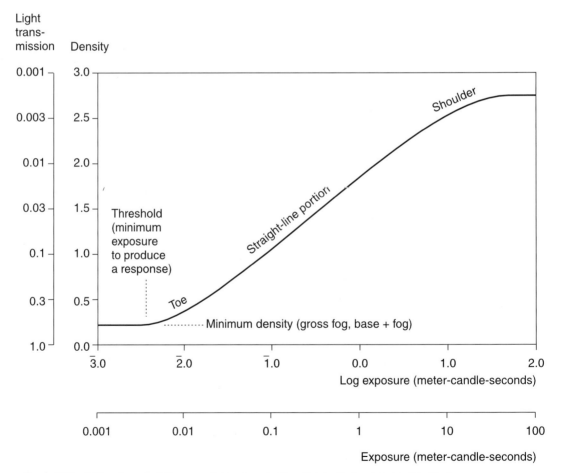

Figure 10.5 **A film characteristic curve plots response (density) against exposure. Density is measured logarithmically the same way as for sun filters. Exposure scale is also logarithmic; bars over digits indicate negative logarithms.**

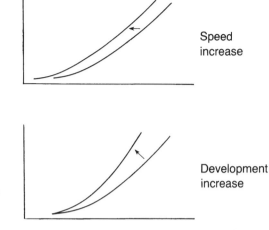

Figure 10.6 **A true speed increase shifts the entire characteristic curve to the left, including the threshold. Push-processing (overdevelopment) merely makes the curve steeper. Either way, the film's response to light increases.**

The shortest-toed general-purpose films available today are the Agfapan Professional series, followed closely by Kodak's Plus-X Pan and Recording Film 2475. Kodak Tri-X Pan and Verichrome Pan are medium-toed. The T-Max films and Kodak Technical Pan Film are medium- to long-toed depending on development.

10.4 Film speed

The speed of a film is its sensitivity to light (and hence the rapidity with which a time exposure can be completed). Under the ISO system, film speed is reported as two numbers, the first equivalent to the older ASA speed rating, and the second, identified by a degree sign, equivalent to the older DIN rating. Thus Tri-X Pan, formerly ASA 400 and DIN 27°, is now ISO 400/27°. The second of the two numbers is often omitted.[1] The two numbers are related as follows:

$$\text{DIN number} = 1 + 10\log_{10}(\text{ASA number})$$

The Russian GOST system is essentially equivalent to the ASA system, although the actual numbers differ by a few percent.

Until recently, official ISO speeds presupposed a specific type of processing; for black and white films, this entailed development to a specific contrast index in a specified developer formula similar to Kodak's D-76. Although ISO testing requirements have recently been liberalized, many film manufacturers prefer not to use the official speed-testing method; instead, they tell you the speed rating that *they* think will give you the best pictures. For this reason, many film speeds are not prefixed with "ISO." An unofficial film speed is called an Exposure Index (EI). In this book, I simply say "400 speed" or "640 speed," or whatever, using ASA-type ISO speed units, whether or not the speed numbers are official.

A simple way to measure the approximate speed of a film is to photograph a Kodak gray scale in bright sunlight at $f/16$, and find the shortest shutter speed at which the two darkest patches are distinguishable on the negative. If the minimum exposure is 1/500 second, then the film is approximately 500 speed; if 1/250, then 250 speed, and so forth. A suitable gray scale is provided in the *Kodak Black-and-White Darkroom Dataguide* and is also available from Kodak as a separate item.

The true speed of a film varies a bit with the chemicals in which it is developed; as explained in the next chapter, developers that contain Phenidone, such as Ilford Microphen and Kodak Xtol, produce a slight speed increase, and some developers give a a slight speed reduction. Also, the speed of color slide film can be increased by increasing the time in the first developer, thereby developing out more of the silver halide crystals that would otherwise be fogged and darkened by the second developer.

However, the usual practice of "pushing" black-and-white or color negative film by increasing the development time increases the effective speed mostly by raising the contrast (Fig. 10.6). Photographs on pushed film are, technically speaking, underexposed, since they lack some shadow detail that would be

[1] Following French practice, Dragesco (1995) puts a degree sign after ASA (not DIN) numbers. Don't let that confuse you.

present on pictures exposed and developed normally. However, the underexposure is made up for by a contrast increase, which increases the density of faint details not actually lost, and the photographer can get reasonably normal-looking negatives while giving the film only half or a quarter of the rated exposure.

Medium- and long-toed films are more pushable than short-toed films, since the effect of increased development on their characteristic curves is more like that of a true speed increase. Kodak T-Max films, Kodak Tri-X Pan, and Ilford HP5 Plus are often pushed in pictorial photography. Astronomical photographs in which only the faintest detail is of real interest (e.g., star fields with nebulosity) should of course be pushed generously.

10.5 Reciprocity failure: theory

The photochemical law of reciprocity is honored more in the breach than in the observance. It states that the same amount of light should have the same effect whether it is delivered slowly or quickly. That is, if a particular exposure gives a properly exposed negative, then twice the light for half the time, or half the light for twice the time, should give the same result.

Real photographic films do not obey the law of reciprocity. General-purpose films are most sensitive to light when the exposure time is about 1/100 second, and less sensitive in exposures that are a great deal shorter or longer.

In long exposures, what happens is called *low-intensity reciprocity failure* (LIRF). It has to do with the way silver halide crystals respond to photons of light. Each photon adds some energy to the crystal, and eventually the crystal switches into an energized state. If there is too long a time lag between arriving photons, the crystal may "forget" a photon, losing all the energy it got from it before the next photon arrives. Because the least-exposed areas of the picture are most affected, LIRF increases contrast.

At the other end of the scale, with exposures less than 1/10 000 second or so, there is *high-intensity reciprocity failure* (HIRF). The problem is that too many photons are arriving at once, and the crystals don't catch all of them. It apparently takes a crystal some time to undergo its energy-level transition, and if there are too many photons per microsecond, some of the photons will have no effect. Here the brightest areas of the image suffer the most reciprocity failure, so HIRF reduces contrast.

Reciprocity failure does serve one useful purpose: it makes the film insensitive to very weak light leaks, low-level ionizing radiation, fogging due to heat, and the like; you can safely assume that a light leak that does not fog the film within a few hours will not fog it at all.

Low-intensity reciprocity failure is approximately logarithmic. Schwarzschild (1900) published a formula that still describes it very well:

$$\text{Actual speed} = \text{rated speed} \times t^{p-1}$$

where t is the exposure time in seconds and p is a constant, the *Schwarzschild exponent*, which differs from film to film – about 0.65 for older 400-speed films, 0.75 to 0.8 for older slow films, 0.8 to 0.95 for newer films of all types, and 1.0 for a theoretically perfect film with no reciprocity failure.

As Fig. 10.7 shows, the Schwarzschild formula is reasonably accurate only for relatively long exposures. A much better description of the film's behavior is given by modifying the formula slightly:

$$\text{Actual speed} = \text{rated speed} \times (t+1)^{p-1}$$

This makes the curve level off as exposure times approach the optimal range, just as the real curve does. It does not show the drop-off that occurs with very short exposures (HIRF).

Here is the same formula rearranged for adjusting exposure times rather than film speeds:

$$\text{Corrected exposure time} = (t+1)^{1/p} - 1$$

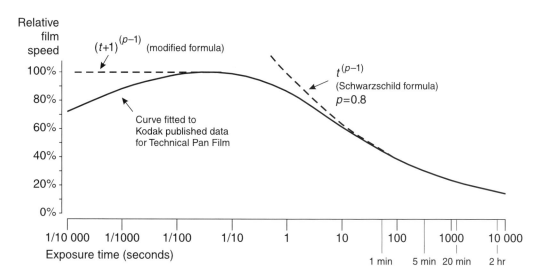

Figure 10.7 **Reciprocity failure. The modified formula given in the text fits the film's behavior more accurately than the original Schwarzschild formula.**

where t is what the exposure time would be if the film suffered no reciprocity failure.

Bear in mind that any value of p that you may be working with is quite approximate. The difference between $p = 0.75$ and $p = 0.80$ is equivalent to a 30% difference in film speed in a one-hour exposure – and you can never pin p down even as precisely as that. Calculations of reciprocity failure are often hardly more than rough guesses.

With color film, speed loss is not the only problem; there is color shift as well. A shift toward red or yellow will usually reduce sky fog, while a shift toward blue can be expected to increase it, though if the sky fog comes mainly from sodium-vapor streetlights, the opposite may be the case. Table 10.1, p. 183, summarizes the color shift of various popular films. On the theory of reciprocity failure, see also Hamilton (1977).

10.6 Reciprocity failure: measurement

Film manufacturers do not publish much information about the reciprocity characteristics of their films, and when they do, the information often takes a form that is not very useful to us. Manufacturers' reciprocity tables usually cover exposures no longer than a minute or two, and they often specify filters or changes in development that affect the apparent film speed. Further, film makers err on the side of caution, often suggesting a good bit more compensation for reciprocity failure than is actually necessary.

The only sure way to quantify reciprocity failure, then, is to measure it oneself. Even testing films on the sky isn't adequate because sky transparency can vary from session to session; so can temperature and humidity, which affect LIRF.

I therefore make my tests indoors with the aid of a ×1000 neutral density filter (mine is a Wratten #96 ND 3.0 in a homemade cell, but a B+W 110 would be more convenient).[2] First I photograph a set of gray scales and color charts with a 1/8-second exposure, adjusting the f-stop and the light source so that this is a correct exposure at the rated film speed. Then I put the filter on the camera and expose for about 1000 times as long (actually 128 seconds, for reasons to be explained shortly). I make 128-second exposures first at the original f-stop, and then with the lens opened 1, 2, and 3 stops wider.

Last, by comparing pictures, I judge how much speed loss the film suffered in the 128-second exposure. It isn't hard to estimate this to an accuracy of

[2] As Robert Reeves learned from personal experience, there is some risk of getting a filter whose density is not what was specified. Before testing films, test the filter and satisfy yourself that its density is at least roughly correct.

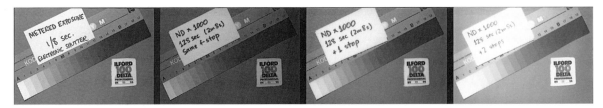

Figure 10.8 **Reciprocity tests: 1/8-second unfiltered exposure versus 128-second exposures with ×1000 ND filter.**

1/3 stop, particularly when negatives are contact printed (Fig. 10.8). Naturally, in order to be usable, any print should be a contact print of all the negatives together; separate prints are no good because the exposure of each would be adjusted to conceal the difference.

Then I obtain *p* by the formulae:

$$s = 1/2^n$$
$$p = 1 - (\log s / \log t)$$

where *n* is the number of stops of speed loss and *t* is the exposure time in seconds. The logarithms can be taken to any base.

Now for a trick. If the exposure time *t* is rounded to 128 ($= 2^7$) seconds and the logarithms are taken to base 2, the formula becomes a lot simpler:

$$p = 1 - (n/7)$$

That is why I used exposures of 128 rather than 125 seconds; the resulting 2.4% error is insignificant (less than 0.04 stop).

I follow this up with a "simulated nebula test" to determine how well the film records faint objects in a 10-minute exposure. The simulated nebula consists of two LEDs shining very obliquely, through paper tape, onto a grid (Fig. 10.9). The red LED was chosen for peak emission at 660 nm rather than the usual 640; I selected it from a group of surplus LEDs by looking at it through a #92 filter, but you can select suitable LEDs by their catalogue descriptions. The blue LED is a silicon carbide unit with peak emission around 470 nm, not too far from the 500-nm oxygen line.

Table 10.1 shows the results of some tests done this way. The values of *p* given there are not definitive; don't try to do elaborate calculations based on them. But these tests are a very good way to make a preliminary assessment of a new film and see how it compares to its rivals.

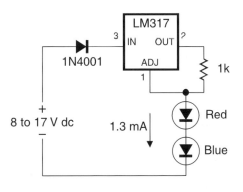

Figure 10.9 **A "nebula simulator," a faint light source that can be photographed in a darkroom. LEDs shine obliquely onto a grid through a layer of paper tape.**

Figure 10.10 **A current regulator holds the LEDs at a constant, low brightness. The supply voltage, nominally 12 V, can vary.**

Some of the newest films had so little reciprocity failure that none was evident in a 2-minute exposure. The obvious question is whether a 2-minute exposure is long enough to be a valid test. I think it is; it certainly demonstrates dramatic differences between films. At the same time, the possibility remains that instead of a high

Table 10.1 *Results of some of the author's reciprocity tests. Currently available films are in boldface*

Film	Date tested	Measured p (higher is better)	Response to simulated nebula		Color shift
			Red	Blue	
Color slide films					
Fuji Astia 100 (RAP)	1997	0.93	2	1	Yellow (slight)
Fuji Provia 100 (RDP)	1996	0.93	2	1	Yellow
Fuji Sensia 100 (RD)	1996	> 0.95	2	1	Yellow-green
Fujichrome 100 (RD)	1992	> 0.95	–	–	Yellow-green
Fujichrome 100 (RD)	1990	0.90	–	–	Green
Fuji Sensia 400 (RH)	1996	0.85	2	1	Green (strong)
Fujichrome 400 (RH)	1990	0.80	–	–	Yellow-green
Kodak Ektachrome Elite II 100 (EB)	1996	> 0.95	3	1	Yellow
Kodak Ektachrome Elite 100 (EB)	1994	> 0.95	–	–	Yellow
Kodak Ektachrome 100 HC	1990	0.80	–	–	Almost none
Kodak Ektachrome Professional E200	1997	> 0.95	4	1	Yellow
same, pushed to 640	1997	> 0.95	5	1	Yellow
Kodak Ektachrome Elite II 200 (ED)	1996	0.85	2	1	Cyan (strong)
Kodak Ektachrome Elite 200 (ED)	1995	0.90	2	1	Yellow
Kodak Ektachrome 200 (ED)	1990	0.85	–	–	Almost none
Kodachrome 200	1990	0.70	–	–	Red-magenta
Kodak Ektachrome P1600 (EPH)	1996	0.80	5	2	Yellow (slight)
Color negative films					
Kodak Ultra Gold 400 (GC)	1997	0.85	5	2	Not significant
Kodak Ektapress Multispeed (640) (PJM)	1997	0.85	4	2	Not significant
Kodacolor Gold 1600	1990	0.78	–	–	Blue
Black-and-white films					
Kodak Technical Pan (not hypered)	1990	0.80	–	–	
Kodak T-Max 100	1990	0.88	–	–	
Kodak Tri-X Pan	1990	0.70	–	–	
Kodak T-Max 400	1990	0.80	–	–	
Kodak T-Max T400 CN	1997	> 0.95	1	2	
Ilford 100 Delta	1996	0.85	–	–	
Ilford SFX 200 (infrared)	1996	< 0.70	2	0	

Caution: These are not high-precision tests. Small differences between films are not necessarily significant. *There can be significant roll-to-roll variation with any particular film.*

Figure 10.11 **Test photo taken with nebula simulator. Kodak Ektachrome P1600 film, 10 minutes at *f*/22 in totally dark room. Strong response to red, weak response to blue is typical of color films.**

value of *p*, what these films actually have is a curve whose flat portion extends farther to the right than the example in Fig. 10.7, and then bends down with an unknown slope. In that case, reciprocity failure might set in after 10 or 20 minutes even if it is not evident after just two. That's one reason for my 10-minute simulated nebula test. I encourage others to perform more thorough tests with a variety of exposure times.

10.7 PRACTICAL NOTE:
Does film "give up" after a certain amount of time?

Does reciprocity failure make the film completely stop responding to light after the exposure exceeds a certain length? It almost seems so. Anybody who has tried a 3-hour exposure has probably found it almost indistinguishable from a 1-hour exposure.

Consider, however, what's really happening. Recall that the eye perceives brightness logarithmically, and that a one-stop increase in exposure is a factor-of-2 increase. If your film had no reciprocity failure and you took exposures of 5, 10, 20, 40, 80, and 160 minutes, they'd appear to be evenly spaced, each of them brighter than the preceding one by the same amount. Going from 5 to 10 minutes is a one-stop increase; going from 80 to 160 minutes is also a one-stop increase. That's not reciprocity failure; it's just the logarithmic nature of exposure.

Reciprocity failure makes matters worse. With Tri-X Pan (an old-technology film that's rather badly afflicted), your exposures would have to be 5, 15, 45, 135, 405, and 1215 minutes respectively. (That last one would require several nights of multiple exposures – something astrophotographers actually had to do in the old days!)

In fact, an infinite exposure would not record infinitely faint light. For any film, there will be some light level so low that it never has any effect on the film at all. That's why film is not fogged by occasional photons that leak through the packaging, nor by low levels of background radiation. However, few if any astronomical photographs bump into this kind of limit.

Most amateurs limit exposures to about 30 minutes or an hour in order to avoid flexure problems and impossible guiding marathons. For exposures longer than that, it's usually better to take separate negatives and stack them or combine them digitally. If nothing else, you only lose 30 minutes' work if a negative gets damaged or an airplane flies into the field.

10.8 Hypersensitization

Hypersensitization (hypering) is chemical or physical treatment of the film by the user to increase speed and/or reduce reciprocity failure. The effects of hypering are twofold:

1 To prefog the film, putting the silver halide crystals into a partly energized state so they will be more responsive to faint light;

2 To rid the film of water, oxygen, and other
 substances that reduce sensitivity or increase
 LIRF.
Unlike push-processing, hypering does not increase
grain.

Preflashing the film with light will accomplish step
1; it is a time-honored hypering technique known to
reduce reciprocity failure (Hamilton 1977; Wallis and
Provin 1988, pp. 223–226). Storing the film in a
vacuum is a time-honored way to accomplish step 2.
Baking the film in air will do both things, to some extent
(try 12 hours at 60 °C).

In 1974, Kodak researchers announced a much
better way to hypersensitize film: soak or bake it in
hydrogen (Babcock *et al.* 1974). Hydrogen apparently
adheres to molecules in the emulsion, displacing water
and oxygen and keeping them away. It also prefogs the
film to a useful extent.

The gas must be hydrogen; helium does not
work, but non-flammable "forming gas" (92% N_2 + 8%
H_2) works very well. Forming gas is used in the
semiconductor industry to protect silicon wafers from air
by coating them with hydrogen; what happens to film
emulsions is apparently quite similar. Lyding (1997) has
discovered that deuterium (heavy hydrogen) is better
than ordinary hydrogen for coating silicon; it may also
be better for hypering film, although I know of no one
who has tried it. Unlike tritium, deuterium is not
radioactive and is not prohibitively expensive.

Hydrogen has a dramatic effect on Kodak
Technical Pan Film. Martinez (1994, vol. 2, pp. 890–
895) describes a simple procedure: bake the film in
forming gas for 24 hours at 60 °C at normal
atmospheric pressure, changing the gas every 6 hours
to carry away the water vapor, oxygen, and other
gases emitted by the film. This produces a ×10 speed
increase in 40-minute exposures, and afterward, the
film can be stored at room temperature for two
months with only a modest speed loss. *Properly
hypered Technical Pan looks quite dark when
developed*; it has a fog density of about 0.2 to 0.3, so

that the clear areas of the film are as dark as a ×2
neutral density filter. Wallis and Provin advocate
hypering this film even more forcefully, to a total
density of about 0.7, which takes 96 hours at 50 °C
in forming gas, preceded by 24 to 72 hours in a
vacuum.

Hypered Technical Pan should be developed in
Dektol (undiluted, 3 to 5 minutes at 20 °C), D-19 (10
minutes at 20 °C), or HC-110 developer (dilution B, 12
minutes, at 20 °C). Of these, Dektol gives the highest
contrast; HC-110 gives somewhat more fog than the
others. Be sure to agitate very carefully and uniformly to
prevent streaking. Most developers other than these
produce inadequate contrast, and some produce
excessive fog. Diluting Dektol is an experiment well
worth trying. (See also Zussman 1989 and Conrad *et
al.* 1985.)

With other films, the benefits of hypering are less
dramatic. The results tend to be lots of fog, only a
modest speed increase (typically ×2), and rapid
deterioration if the film is not used and processed
within a day or two. Typical hypering times for color
films are 5 to 12 hours at 50 °C in forming gas,
preceded by at least 24 hours in a vacuum.

For hypering, the film is pulled out of its cartridge
and loaded onto a developing reel so that the gas can
reach it easily. Then, for best results, the film is kept in
a vacuum for several hours or days – the higher the
vacuum, the better – in order to remove moisture and
oxygen. Finally the forming gas is introduced and the
film is baked for a while. Last, for best results, the film
is stored in a canister of dry nitrogen, or at least very
dry air.

With Technical Pan, the process is simpler in a
couple of ways: you can leave the film in its 35-mm
canister during hypering (at least, most of the people
who have tried this report success), and you can do
without the vacuum if you change the forming gas once
or twice during the procedure. Whatever method you
adopt, standardize it so it will be reproducible.

Complete instructions for hydrogen hypering are beyond the scope of this book; Wallis and Provin (1988) and Smith (1989) cover the subject in detail. See also the web sites of Wallis and Provin (http://voltaire.csun.edu/wallis_provin.html) and Jerry Lodriguss (http://www.astropix.com). You can buy hypering apparatus from Lumicon (p. 315); forming gas is usually available locally.

> CAUTION: *Hydrogen gas is flammable and explosive. It burns with a dim blue flame that is invisible in daylight. Even non-flammable gases can be dangerous because apparatus can burst under pressure.*

The hydrogen or forming gas must of course be clean and dry; you cannot obtain your hydrogen from an acid–metal reaction unless you can remove the acid fumes and moisture before using it.

Anyone wanting to sell hypered film commercially should be aware that John B. Marling, of Lumicon, holds a currently valid patent on some techniques involving the use of forming gas (U.S. Patent 4,473,636, 1984). Hydrogen hypering itself was patented by Kodak in 1976 (U.S. Patent 3,984,249), but that patent has expired. Both patents are available online at http://patent.womplex.ibm.com and contain interesting technical information. The patent holders have never objected to individuals experimenting with hypered film and publishing the resulting pictures; in fact, they encourage it.

Astrophotographers fall into two camps: those who hyper nearly all their film, and those like me, who occasionally purchase hypered Technical Pan from Lumicon or other suppliers, but otherwise rely on modern films that perform well without hypering. If the film has little reciprocity failure in the first place, there's little to get rid of.

10.9 Graininess and resolution

When you see grain in a ×10 or ×20 enlargement from a black-and-white film such as Tri-X Pan, you are not looking at the developed silver grains themselves, but at a mottled pattern resulting from their irregular distribution (measured as *RMS granularity* in manufacturers' data sheets).[3] To see the grains themselves, you would need a microscope. Nonetheless, it remains true that if the grains were smaller or the emulsion thinner, or both, there would be less visible mottle.

High-speed films have coarser grain than slow films, since a faster film requires larger silver halide crystals and a thicker emulsion in order to capture more light. The graininess of any particular kind of film is affected by development; one of the most effective ways to reduce grain is to underdevelop the film slightly. High-energy developers such as D-19 or DK-50 produce grainier pictures than do normal developers such as D-76 (which was classed as a fine-grain developer when it first came out); for the finest grain, you can use a developer such as Kodak Microdol-X or Ilford Perceptol, which however results in a slight speed loss.

Although the finest-grained films do have the highest resolving powers, grain is not the only thing that limits film resolution. Chromogenic and color films have unusually little grain in proportion to their speed because dye clouds don't look as grainy as silver crystals. You can view this as an advantage – dye doesn't look grainy – or a disadvantage – the film has less resolution than a comparably fine-grained black-and-white film.

You can increase the resolution of a picture by increasing the contrast even though this also increases graininess. To see how this is possible, consider what happens as you approach the resolution limit of a film.

[3] RMS granularity is affected by contrast; it is always lower for negatives than for slides, regardless of the graininess of the resulting print.

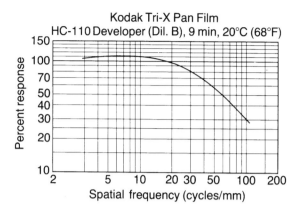

Figure 10.12 **Modulation-transfer function (MTF) curve for Kodak Tri-X Pan Film. The edge effect pushes the response above 100% between 2 and 15 lines per mm. (Eastman Kodak Company)**

If a particular film resolves 100 lines per millimeter (lpm or l/mm), this does not, of course, mean that a 99-l/mm test target will be reproduced perfectly while a 101-l/mm target will show no detail at all. No; what happens is that as details become finer, they blur together and are reproduced at reduced contrast. The 100-l/mm rating means that, at 100 lines per millimeter, the contrast reduction is considered sufficient to impair greatly the usefulness of the image.

Figure 10.12 shows how contrast varies with the size of image details. It's known as an *MTF curve* (modulation-transfer function curve). It implies that increasing the contrast of a picture (by overdevelopment) can increase resolution even if it also increases grain. Also, the same film under the same conditions picks up more detail in a high-contrast subject than in one of lower contrast; hence manufacturers publish both low-contrast and high-contrast resolving-power figures for their films.

Figure 10.12 shows another peculiarity: the relative contrast actually goes *higher* than 100% at certain spatial frequencies. That is, detail with a certain degree of fineness is actually reproduced at higher contrast than coarser detail.

This results from the *edge effect*. Consider what happens when you develop a piece of film that contains a large light area next to a large dark area. Over the dark area, the developer is consumed rapidly and becomes weak; over the light area, the developer has little work to do and remains strong. In between, near the edge, the developer is stronger than over most of

the dark area, but weaker than over most of the light area; hence the light area is lighter, and the dark area is darker, near the border than elsewhere. Agitation reduces the edge effect, of course, as does a strong developer. Lunar photographers sometimes to try to enhance the edge effect by using a very dilute developer with little agitation, since increased edge contrast helps bring out lunar detail.

10.10 Some specific films

Films are getting better and better. Today you can buy film at the nearest supermarket whose reciprocity characteristics surpass the special Kodak Spectroscopic films used by observatories in years past. With the appearance of new films and the proliferation of minilabs, astrophotography on color negative film has become practical even if you don't have your own darkroom.

The following recommendations of specific films are based partly on manufacturers' literature, partly on the literature of amateur astronomy, and partly on my own experience. These are not, of course, the only suitable films on the market; film technology is advancing rapidly, and one or two promising new products become available every year. Take these recommendations only as starting points, and do your own comparison tests of films you are curious about. For some classic astronomical film tests, see Keene and Sewell (1975) and Brown, Keene, and Millikan (1980); the films they tested are mostly obsolete, but the methods and results are nonetheless interesting.

Kodak Elite Chrome 100 (EB) is a versatile color slide film with relatively high contrast, strong color saturation, and a very strong response to hydrogen-alpha light. Its immediate predecessor, Ektachrome Elite II 100 (1996–1998), had outstanding reciprocity characteristics ($p > 0.95$ in my tests); Elite Chrome

100, introduced in 1998, is not quite as good, but still quite useful.

For deep-sky photography I usually give this film a standard E-6 two-stop push, which does not actually increase its speed two stops; the effective speed is then about 320, not 400. Push-processing increases contrast and helps bring out faint detail, but it also increases grain. Pushing does not affect reciprocity failure. Star fields tend to have a bluish background, and emission nebulae come out ruby-red. This film is, however, not as sensitive to blue reflection nebulae as the competing Fuji films.

Elite Chrome 100 is good for planetary work (at $f/100$ or higher) and is also good for duplicating slides to increase contrast and color saturation.

Two Kodak Professional films, Ektachrome E100S and E100SW, are (as this is written, in 1998) essentially the same emulsion as the former Elite II 100. The second of these is said to have warmer color balance, though I have not been able to see much of a difference in practice. The current E100 films have outstanding reciprocity performance, but there is every reason to expect that they will shortly be reformulated to make them more like Elite Chrome 100.

Fujichrome 100 (RD) has a long and well-earned reputation as a good film for deep-sky work; for many years it had less reciprocity failure than any competitor, though Ektachrome E100S, E100SW, and E200 now surpass it.

Fujichrome 100 is actually a family of films that have undergone a number of changes. Before 1988, Fujichrome 100 star fields had a generally reddish look with vivid star colors. At the time, no other film gave comparable results, and many astrophotographers standardized on Fujichrome. Post-1988 versions of Fujichrome 100 show a strong green color shift in long exposures, producing greenish or blue-green star fields; nonetheless, there is comparatively little reciprocity failure and deep-sky objects record well.

In the mid-1990s, Fujichrome 100 was renamed Sensia 100, and as of 1997, RD is apparently no longer on the market, although its professional counterparts, Provia 100 (RDP) and Provia II 100 (RDP II), are still available. Recent batches of Provia 100 show substantially improved reciprocity characteristics, with a yellow color shift instead of green; so does the latest version of the film, Provia II 100.

Fuji Sensia II 100 (RA) and its professional counterpart, Fuji Astia 100 (RAP), were introduced in 1997 to replace earlier 100-speed Fuji slide films. The change of letter designation, from RD to RA, indicates a substantial change, and indeed, the color saturation and contrast of the film have been reduced in order to make it more suitable for portraits. Lower contrast translates into greater pushability, since pushing raises contrast.

More importantly, RA has very good reciprocity characteristics. Compared with the competing Kodak products, it picks up less red (emission) nebulosity but more of bluish features such as reflection nebulae and the ion tails of comets. Overall color balance is neutral, the color shift in long exposures is very slight, and grain is minimal.

Kodak Elite Chrome 200 (ED) and **Kodak Ektachrome Professional E200** are "professional" and "amateur" versions of the same film; I have more experience with E200, but the two should be indistinguishable in practice.

Compared to Elite Chrome 100, E200 has higher speed, lower contrast, and only slightly coarser grain. E200's reciprocity characteristics are the best I have seen in a color slide film ($p > 0.95$ in 2- and 9-minute tests). Like other Kodak films, E200 responds strongly to red nebulae and produces cherry-red images of them. Normally processed E200 has finer grain than E100S pushed to 200.

Compared with other slide films, the lower contrast of E200 manifests itself mainly as increased shadow detail and increased tolerance for

underexposure. The contrast in the midtones and highlights is comparable to other slide films and is certainly not inadequate.

E200 does not need hypering, nor does it benefit from it. It can be given a standard E-6 two-stop push, but this raises its speed only to 640, not 800 as you might expect. When the film is pushed, the contrast is higher and the grain is noticeably coarser. After experimenting with pushing E200, I reverted to normal processing; pushing increases the gain without bringing out much more image detail. In fact, the main effect of pushing is to remove the underexposure latitude; the shadows become harsher but the midtones continue to have roughly normal contrast.

There have been several earlier 200-speed Ektachrome films. In the early 1990s, Ektachrome 200 had remarkably little color shift in long exposures and was highly favored for both planetary and deep-sky work. Ektachrome Elite II 200 was a step down; in my tests in 1996, it had a strong cyan color shift in long exposures and was inferior to Ektachrome Elite II 100 on all counts. The current E200 is, of course, much better, but there is no way to predict when Kodak will change it again.

Fujichrome 400 (RH, now Fuji Sensia II 400) has a varied history. Prior to 1985 it was many astrophotographers' favorite film for star fields, with a somewhat reddish color shift in long exposures (good for eluding sky fog) and good, dense blacks even when hypersensitized. In 1985, it was reformulated and became less suitable for gas hypersensitizing. It may have been modified again around 1989, and there have certainly been some minor changes since. Testing Sensia 400 in 1996, I found moderate reciprocity failure with a strong color shift in long exposures; Fuji's literature indicates that the latest version, Sensia II 400, may have substantially better reciprocity characteristics.

Kodak Ektachrome P1600 is an unusually fast color slide film with moderate reciprocity failure and relatively coarse grain. To achieve 1600 speed, it requires a modified E-6 process corresponding to a 2-stop push; with ordinary E-6 processing its speed would be about 400. This film responds well to hydrogen nebulae and is popular for prime-focus deep-sky work, where maximum speed is needed and coarse grain is tolerable. Pushed E200, however, is a viable alternative, considerably finer-grained.

Kodak Ektapress PJ400 Film is one of many new color negative films that perform well in astrophotography. I have settled on this one because it has unusually fine grain for its speed and because it closely resembles two successful predecessors, Kodak Ektapress Multispeed Film (PJM) and an earlier Ektapress 400 film designated PJB.

Like its predecessors, PJ400 performs very well in deep-sky work, with a strong response to red nebulae. It usually gives me brownish sky backgrounds. See Lodriguss (1997) for a detailed review of PJM, to which PJ400 is almost identical. This film does not need hypering, nor does it benefit from it.

PJ400 is marketed to photojournalists in bulk packs and may be hard to find at your local camera store. Some other color negative films that perform well in deep-sky work are Kodak Pro 400 Professional Film (PPF) and Kodak Ultra Gold 400 (GC). All of these have somewhat more reciprocity failure than the best slide films, but that is balanced by their high speed and the ability to adjust color and bring out faint detail when making prints. Films faster than 400 speed are not necessarily superior; they have more grain and greater reciprocity failure. This is particularly the case with PJ800, which is inferior to PJ400 for astronomical work.

Kodak T-Max 100 is a good general-purpose black-and-white film with extremely fine grain (comparable to the older Panatomic-X, enlargeable $\times 20$ or more) and low reciprocity failure ($p \approx 0.88$). Indeed, the T-Max

100 emulsion, on glass plates, is now being used by observatories in place of older Kodak Spectroscopic materials. Its characteristic curve is medium- to long-toed depending on the developer. Ilford 100 Delta is a similar product.

For lunar and planetary work, T-Max 100 should be developed according to Kodak's recommendations (see Appendix D), perhaps with push-processing to EI 400 to increase contrast. For maximum speed and contrast in deep-sky work, it can be developed for 12 minutes in HC-110 (dilution B) at 20 °C (68 °F). This increases grain but brings out faint detail.

The main drawback of T-Max 100 is that, like nearly all black-and-white films, it has virtually no response to the 656-nm emission from ionized hydrogen, and hence does not photograph emission nebulae very well.

Kodak T-Max 400 and T-Max P3200 are faster black-and-white films with moderately good reciprocity characteristics ($p \approx 0.80$ in both cases). T-Max 400 is somewhat finer-grained than the old standard, Tri-X Pan; T-Max P3200 is grainier than Tri-X, but nowhere near as grainy as Kodak 2475 Recording Film. Their characteristic curves are long-toed (at least with some developers) and both films are quite pushable. T-Max 400 and P3200 are useful for long exposures of deep-sky objects when grain is tolerable, maximum speed is necessary, and hypersensitized film is not available.

Kodak Tri-X Pan and Ilford HP5 Plus represent the older generation of ISO 400 black-and-white films, with medium-toed characteristic curves (quite unlike T-Max 400) and severe reciprocity failure ($p \approx 0.65$ to 0.70). Precisely because of the reciprocity failure, these films are good for meteor photography. Also, they are relatively tolerant of incorrect exposure and incorrect development time. Neither is very sensitive to hydrogen-alpha light, but Wallis and Provin (1988, p. 212) found that HP5 had slightly more sensitivity at that wavelength than Tri-X.

I tested Tri-X for reciprocity in 1990, and Robert Reeves, replicating my tests in 1997, found a somewhat higher value of p (less reciprocity failure). Maybe Tri-X has been improved; it has certainly undergone unannounced improvements in the past. Reeves found Ilford HP5 Plus to perform at least as well as Kodak Tri-X Pan.

Kodak T-Max T400 CN (not to be confused with T-Max 400) is an interesting new product that I have just begun to test. Introduced in 1997, it is a chromogenic black-and-white film and is developed just like Kodak color negative films. (I've found it hard to get minilab operators to believe this, even though "Process C-41" is written on the box.) Because the image is composed of dye rather than silver granules, pictures are surprisingly free of grain, even though the resolving power is no greater than with other fast films.

What is remarkable about T400 CN is its lack of reciprocity failure; indeed, I could not measure any speed loss at all in a 2-minute exposure, so I cautiously labeled it "$p > 0.95$" in Table 1. This makes T400 CN dramatically different from its older competitor, Ilford XP2 ($p \approx 0.7$). Both films give relatively low contrast, requiring high-contrast printing, and neither of them responds well to hydrogen-alpha light. Sanford (1982) demonstrated that because of the lack of distracting grain, chromogenic film can give quite pleasing deep-sky images. Because of their wide exposure latitude, these films are also good for lunar work and solar eclipses.

Kodak Technical Pan Film (TP, 2415, 4415, and 6415) is Kodak's all-purpose, ultra-fine-grained black-and-white film for scientific photography. Originally designated SO-115, it was introduced to replace, among other things, Kodak High Contrast Copy Film, which in turn replaced an even older material called Microfile.

Technical Pan far surpasses numerous other films in numerous ways. It is so fine-grained that grain is rarely visible in a picture; $\times 25$ enlargements are quite

feasible if the image is sharp enough. Processed in different developers, Technical Pan can take the place of several different films; it acts as an ultra-fine-grain pictorial film when developed in Technidol or POTA (p. 197), a high-contrast scientific film when developed in HC-110, or a very-high-contrast graphic-arts-type copying film when developed in a print developer such as Dektol. The effective speed varies from 25 to 200 depending on development.

Technical Pan is supplied on a polyester (ESTAR) base, rather than the usual cellulose acetate, and is not easy to tear. If you are accustomed to tearing the film loose after pulling it out of the cartridge for development, bring along a pair of scissors; trying to rip the film with your fingers will do no more than stretch it slightly. Also, the film base is thinner than that of most films and may require padding in some cameras. Because it is so thin and flexible, I have had trouble getting it onto plastic developing reels.

This film benefits from gas hypersensitization more than any other; it undergoes a dramatic speed increase, then retains its speed and remains relatively free from fog even if kept out of refrigeration for several days. Even without hypersensitization, Technical Pan can yield pleasing results in deep-sky exposures of 30 minutes or so, with a fast lens; the high resolution and freedom from grain give the picture a large-format look that more than makes up for the lack of faint detail.

With its extended red sensitivity, Technical Pan responds very well to the 656-nm emission from hydrogen nebulae. This is one reason deep-sky photographs taken on this film look so dramatic. Further, the exposures can be made through deep red filters (Wratten #25, #29) to eliminate sky fog even in urban settings.

Like T-Max 100, Technical Pan is now supplied to observatories on glass plates.

Kodak Spectroscopic Films are now of only historical interest. These special black-and-white products were manufactured by Kodak for scientific research. The ones of interest to astrophotographers have the suffix 'a' (103a-O, IIa-O, IIIa-J, and the like, as opposed to 103-O or III-J), indicating that were specially treated to reduce reciprocity failure. They had $p \approx 0.8$, which is not impressive by today's standards.

In their time, the Spectroscopic films and plates were a great advance and resulted in many scientific discoveries. With the advent of gas-hypersensitized Technical Pan, however, they are essentially obsolete, and only a couple of them are still in production (at very high prices). Even without hypersensitization, Technical Pan, T-Max 100, T400 CN, and many newer color emulsions outperform most of the Spectroscopic emulsions in speed, grain, or both.

Infrared films generally suffer severe reciprocity failure but nonetheless have their uses. Kodak High Speed Infrared Film (HIE) and Ilford SFX 200 are both rather grainy black-and-white films; the Ilford product is easier to work with because its sensitivity does not extend as far into the infrared. Suspecting that it would work well for photographing nebulae at 656 nm, I tried it only to find that the reciprocity failure was prohibitive ($p < 0.7$).

The most versatile infrared film is Kodak Ektachrome Professional Infrared Film (EIR), a Process E-6 slide film introduced in 1997. It replaced an older film that required E-4 processing − a process for which the chemicals had been discontinued even though the film hadn't. As a result, in the early 1990s people didn't do much color infrared photography. (Processing it wasn't quite impossible; a few labs still had E-4 chemistry, and there was a workaround that involved using E-6 chemicals at lower-than-normal temperatures.)

Now that the new film is available, I encourage astrophotographers to try it out. Ektachrome Infrared renders green as blue, red as green, and infrared as red. All three layers are sensitive to blue light, so a #12 yellow filter is mandatory. The film is meant to be stored in a freezer, but it can be kept at room temperature for a few days, especially if different rolls do not need to match each other precisely.

Most minilabs cannot process Ektachrome Infrared because they use infrared photoelectric sensors inside the machinery. (If fogged by these sensors, the film comes out red.) Check with the lab before having the film processed, or process it yourself in a tank.

Some amateur astronomical photographs taken with the original Infrared Ektachrome were published by Norton (1973) and Piini (1973). They include a bright blue-green totally eclipsed moon, a sky-blue Orion Nebula, and a comet with a prominent dust tail.

10.11 PRACTICAL NOTE:
 Film: What's in a name?

Sometimes, not much. Films with similar names do not necessarily have similar performance, at least in astronomical situations. For example Kodak Elite Chrome 200 and 400 behave quite differently in long exposures. T-Max 100 and 400 have appreciably different curve shapes.

Sometimes the product changes and the name remains the same. In the 1970s and 1980s, there were several versions of Fujichrome 100. Kodak Tri-X Pan has undergone numerous unannounced improvements over the years. Conversely, sometimes the name changes with no change in the product; Kodak Elite Chrome 400 equals Ektachrome Elite II 400.

Most films also have letter designations (EB, PJM, RD, etc.), which are more stable than the names; in particular, the letter designations are the same all over the world, while the names vary from country to country. But the letters do not necessarily change when a product changes; all the "amateur" 200-speed Ektachromes within living memory have been designated ED.

10.12 PRACTICAL NOTE:
 Is "professional" film better?

Many Kodak and Fuji color films come in two versions, amateur and professional. For example, Kodak Elite Chrome 200 film, marketed to amateurs, corresponds to Kodak Professional Ektachrome E200 film. The professional film costs more; is it better?

Not necessarily. If you're photographing weddings or doing studio portraiture, you need precise color matching between different rolls of the same film. That's what the extra cost of "professional" film buys you, and it's something astrophotographers don't need.

The difference has to do with aging. After film is made, it has to age for a few months in order for the emulsion to stabilize. "Professional" films are held at the factory until they've aged to perfection and are then refrigerated by the dealer. "Amateur" films are released a few weeks before optimum, to allow for more aging during storage and use. Roll-to-roll color matching is less precise but the film remains usable for a year or more.

Even the professional film doesn't actually have to be refrigerated if perfect color matching isn't needed. It's physically the same as the corresponding amateur emulsion, just a few months older, and it will hold up just as well.

Some films are designated "professional" just to encourage professional photographers to use them, or perhaps to indicate that they are less than ideal for casual snapshooting. For example, the word "professional" has just started appearing on boxes containing Kodak Tri-X Pan, a product dating from the 1960s. No change in the product is implied. Confusingly, Tri-X Pan Professional is a different product, made only in sizes larger than 35-mm.

10.13 Bulk loading

A good way to save money on any kind of 35-mm film is to purchase it in 50- or 100-foot rolls and load it into individual cartridges yourself. With the aid of a gadget called a *bulk loader*, you can do this in full room light; total darkness is required only when you place the long roll into the bulk loader at the start.

The cheapest kind of bulk loader passes the film through a plush felt-lined light trap. Unfortunately, a grain of sand or similar particle trapped in the felt can scratch 100 feet of film before you realize that anything was wrong. Fortunately, newer bulk loaders use plastic light traps that open up and allow the film to pass freely when the outer enclosure is closed.

The other problem you have to face is that of light leaks, which are usually the fault of the cartridge. I have had excellent results with Kodak Snap-Cap Film Cartridges, which are fairly expensive, but not with the cheap off-brand cartridges that are sometimes provided free with the bulk loader. It is important not to use a cartridge more than two or three times, and never to use a cartridge that is in any way suspect.

Secure the film to the takeup spool with masking tape or drafting tape, not strong plastic tape. If someone tries too hard to advance the film past the end of the roll, you'd much rather break the tape than break the camera.

A roll of 35-mm film requires about 38 mm (1.5 inches) of film for each frame, plus about 230 mm (9 inches or 6 frames) for leader and trailer. A 100-foot (30.5-meter) roll makes nineteen 36-exposure rolls, thirty 20-exposure rolls, or forty-four 12-exposure rolls.

Standard bulk loaders accommodate 100-foot rolls of acetate-base film or 150-foot (45-meter) rolls of polyester-base film, which are the same diameter. These long rolls are designed to fit 35-mm movie cameras and industrial cameras that must take thousands of pictures on a roll, so they exist in many varieties.

Fortunately, you seldom need to do more than ask for film in a format suitable for bulk loading. If you do have to specify a format exactly, make sure the film is wound on a core, not a spool (the difference is that a spool has sides) and that it is perforated. There are two kinds of perforations, KS and BH, and either kind will do.

The main disadvantage of bulk loading is the increased risk of scratching the film. Even if the bulk loader itself is entirely innocent, particles of grit can become trapped in the felt light trap of a reusable cartridge. It may be prudent to use a fresh cartridge for any roll that will contain important work.

Another disadvantage is that unless they know you personally, lab technicians are often unwilling to process bulk-loaded film. They can't be sure that the film in the cartridge is what you say it is, and putting the wrong film into a processing machine can contaminate the chemicals.

There is also "poor man's bulk loading." You can purchase a roll of 36 exposures, cut it apart in total

Figure 10.13 **The author's trusty Alden bulk loader.**

darkness, and load part of it into another cartridge. Or you can expose part of the roll, open the camera in the dark, cut off the exposed film, and develop it, cutting a new leader for the rest of the roll so that you can load it back into the camera.

The bulk film comes in a can with a label identifying the emulsion. I usually remove this label (by heating it with a hair dryer to soften the glue) and affix it to the bulk loader for positive identification of its contents, as shown in Fig. 10.13.

Developing, printing, and photographic enhancement **11**

Doing your own darkroom work gives you complete control over the appearance of your pictures, gives you opportunities to experiment, and, at least with black-and-white materials, saves you money. Even without a darkroom, you can improve your astronomical photographs by copying slides and prints. This chapter covers darkroom work and photographic enhancement methods.

11.1 The darkroom

There are many good books on how to outfit and use a darkroom, so I won't try to cover the whole subject here. Instead, let me outline what darkroom work is like in case you're completely unacquainted with it, and then give some specific practical hints.

A darkroom for developing 35-mm film is actually dark only for the few minutes that it takes to load the film into a light-tight developing tank (which you can do in a closet or a changing bag, not necessarily the room where the developing will be done). Once the film is in the tank, the lights are turned on, and then the chemicals can be poured in and out of the tank in full room light. The chemicals are a developer, stop bath (or water rinse), fixer, and an optional washing aid. The whole process takes perhaps 20 or 30 minutes, after which the tank is opened and the film is washed for perhaps half an hour, then hung up to dry.

Printing is done under an orange safelight that does not affect the photographic paper. Although a negative can be placed directly against the paper and *contact printed* to produce a print the same size, usual practice is to use an *enlarger* to project an image of the negative (in white light) onto a larger piece of paper.[1] The exposure is controlled by adjusting the enlarger's f-stop and varying the exposure time, which is on the

order of 10 seconds; correct exposure is usually determined by trial and error on small scraps of paper. The exposed paper is processed in trays of developer, stop bath, and fixer, in succession; modern resin-coated paper then requires only four minutes of washing before being hung up to dry.

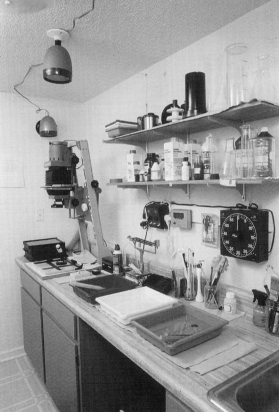

Figure 11.1 **The author's darkroom.**

[1] Originally, "prints" were contact prints and "enlargements" were everything larger. Nowadays, with smaller film formats, contact prints are not usable, and "prints" (or, in Britain, "en-prints") are small enlargements.

That is the basic outline; for more information, see *Basic Developing and Printing in Black-and-White* (published by Saunders for Kodak and revised frequently) or, for greater detail, Ansel Adams' *The Negative* and *The Print* and the *Kodak Black-and-White Darkroom Dataguide*. Now for some practical hints based on my own experience.

If you are having trouble finding a suitable location for a darkroom, remember the option of working only at night – not having daylight to deal with can make light-proofing a great deal easier. You can also do without running water, since you can wash film and prints elsewhere. You can even do without a darkroom of your own – a local camera club may have one you can use, and in large cities there are darkrooms you can rent by the hour.

Test the light-tightness of a darkroom for film developing by going into it and letting your eyes adapt to the darkness. If after ten minutes you still can't see your hand in front of you, all is well; any faint glimmers that may remain will probably have no photographic effect. (But a digital wristwatch that lights up when a button is pushed can be a hidden peril.) Somewhat more stray light is tolerable in printing than in film developing, especially if each individual piece of paper is not out in the open for very long.

I greatly prefer chemicals in liquid concentrate form rather than powders. Most powdered chemicals are difficult to mix and require large amounts of storage space once prepared; also, chemical dust, especially fixer, can easily damage photographic materials. With liquid concentrates, you can mix up just what you need for one session, so that you never use anything that isn't fresh; what's more, you don't have to filter the solution to remove undissolved powder. I use Kodak HC-110 film developer (see the next section), Ilford Multigrade print developer, plain water or a citric acid solution for a stop bath, and Ilford Universal Fixer.

Air dissolved in the water can shorten the life of developer, so I use water that has been standing in a jug for a day or more. Prepared developer can be protected from air with a chemically inactive gas (such as "Dust-Off") or by blowing some carbon dioxide (from your lungs) through a tube into the airspace at the top of the bottle. (This latter technique is also used in France to preserve wine.) When a developer starts to deteriorate, it may get stronger before it gets weaker, because the preservative (sodium sulfite) is also a restrainer. Its job is to gather oxygen (by changing into sodium sulfate) to keep the developer from oxidizing, and as it does so its restraining action diminishes.

11.2 Developing black-and-white film

Most of the characteristics of a film, including its speed and graininess and the shape of its characteristic curve, are affected by the way it is developed. The important variables are the choice of developer and the amount of development time given.

Ordinary black-and-white film developers contain one or more developing agents, plus an alkali such as sodium carbonate (the "accelerator"), a preservative such as sodium sulfite, and a restrainer such as potassium bromide to keep the developer from fogging the unexposed areas of the film.

The characteristics of a developer depend largely on the developing agent or agents that it uses. The three most popular are hydroquinone, Metol (para-methylaminophenol, also known as Elon), and Phenidone (1-phenyl-3-pyrazolidinone).

By itself, hydroquinone produces high contrast and high film speed; it is the sole developing agent in graphic arts developers such as Kodak's D-8. For greater speed without excessive contrast, hydroquinone is usually used in combination with another developing agent. An example is D-19, Kodak's standard developer for scientific photography, which uses hydroquinone with some Metol added; it gives relatively high contrast, high speed, and good freedom from fog. Kodak Dektol print developer is very similar to D-19, but with more accelerator.

A more balanced mixture of hydroquinone and Metol makes a good general-purpose developer such as Kodak's D-76 and Ilford's ID-11. With all Metol and no hydroquinone, you get a fine-grain developer such as Kodak's D-23 and Microdol-X or Ilford's Perceptol; contrast and film speed are slightly lower than normal, graininess is markedly reduced, and exposure latitude is increased.

Phenidone gives high speed and low contrast, an unusual combination. Kodak Technidol LC developer, now discontinued, used Phenidone as its only developing agent; so does POTA, which exists only as a published formula (Wallis and Provin 1988, p. 138; Adams, *The Negative*, 1981 edition, p. 254). These are super-low-contrast developers. They produce very low contrast on ordinary films. With Technical Pan, which is inherently a high-contrast film, they produce normal pictorial contrast, suitable for terrestrial photography or lunar work.

If you don't want to mix up your own POTA, there are some other ways to get normal pictorial contrast with Technical Pan. Kodak recommends Technidol Liquid, which contains phenidone and hydroquinone together. You can try developing Technical Pan in highly diluted Xtol, HC-110, or Rodinal, but people tell me their results have not been satisfying. One technique that *does* get good reviews, even though Kodak doesn't recommend it, is to use Kodak Flexicolor C-41 developer for 8 minutes at 20 °C. The color couplers in the developer don't affect the black-and-white film. Just be sure to use ordinary fixer, not C-41 bleach or blix, or the film will come out blank!

Phenidone and hydroquinone in combination generally produce normal contrast with maximum film speed. The classic developer of this type is Ilford Microphen, which is good for push-processing but tends to produce excessive fog on gas-hypersensitized film. I suspect that Acufine is also a developer of this type, although its formula has not been made public.

The effect of any developer on film speed depends not only on the developing agents, but also on the restrainer (anti-fog agent). The more restrainer, the lower the speed. The higher level of fog with Microphen, Edwal FG7, and their kin is doubtless due to the reduced amount of restrainer in these developers rather than the developing agents.

A promising new developer, Kodak Xtol, uses a combination of Phenidone and ascorbic acid (vitamin C). It is supplied as a powder that is relatively easy to dissolve in water and keeps for months in solution. Xtol gives unusually fine grain combined with high emulsion speed. My experience has been that with the recommended development times, the contrast is a bit on the low side, and the film speed is noticeably higher than with D-76 or HC-110.

Perhaps the most versatile developer is Kodak HC-110; it gives results similar to D-76 or, in higher concentrations, D-19, with somewhat finer grain. The formula of HC-110 is a closely guarded secret, and the only developing agent listed in the Material Safety Data Sheet (MSDS) is hydroquinone, but HC-110 definitely produces full emulsion speed, strongly suggesting that Phenidone or a similar agent is present in small quantities. Ilford Ilfotec HC is a similar product, though not an exact equivalent.

HC-110 is supplied as a syrupy liquid, and Kodak recommends that you dilute the whole bottle of concentrate 1:3 to make a stock solution, from which you then make up the working solution as needed. The rationale is that the liquid is too syrupy to measure accurately, but I have no trouble measuring it with an oral medicine syringe (Fig. 11.2). I divide the 16-ounce bottle into eight 2-ounce portions only one of which is exposed to the air at a time; handled that way, a bottle of HC-110 can last three years with no noticeable deterioration.

HC-110 works well with gas-hypersensitized film and, indeed, with all films for which D-19 is recommended. Development for 12 minutes in HC-110 (dilution B) produces more speed but less contrast than 4 or 5 minutes in D-19 (but developing for 10 minutes in D-19 produces more speed yet). HC-110 produces little developer fog, but D-19 produces even less. Table

Figure 11.2 **Syrupy liquid concentrate developers can be decanted into small containers to protect them from air, then measured with an oral medicine syringe. The photos show two techniques. (Cathy Covington)**

11.1 gives instructions for preparing the most commonly used dilutions of HC-110, both Kodak's way and my way, and Table 11.2 lists development times for a number of films, from various sources.

Kodak T-Max developer is apparently similar in composition to HC-110, but with the proportions of ingredients changed to make it more active. It is used at much lower dilutions (1:4 instead of 1:31). Kodak

Table 11.1 *Preparation of HC-110 developer*

Dilution	Kodak's method			Author's method		
	Dilute stock solution	Amount of stock solution to make 240 ml	Amount of stock solution to make 300 ml	Dilute concentrate[1]	Amount of concentrate to make 250 ml	Amount of concentrate to make 300 ml
A	1:3	60 ml	75 ml	1:15	15 ml	19 ml
B	1:7	30 ml	38 ml	1:31	7.5 ml	9.3 ml
D	1:9	24 ml	30 ml	1:39	6.0 ml	7.5 ml
F	1:19	12 ml	15 ml	1:79	3.0 ml	3.8 ml

[1]In Europe, HC-110 is also sold as a liquid less concentrated than the full-strength syrup. Check the label carefully.

Table 11.2 *Development times for various films in Kodak HC-110, T-Max, and Xtol developers, based on published data and the author's experience*

Film	Effective speed (ISO)	Development time (minutes)		
		Kodak HC-110 (B) 20 °C (68 °F)	Kodak T-Max (1:4) 24 °C (75 °F)	Kodak Xtol (1:2) 20 °C (68 °F)
Kodak Technical Pan	100	4	–	–
	160	8	–	–
	250	12	–	–
Kodak T-Max 100	100	7	$6\frac{1}{2}$	$12\frac{1}{2}$
	400	$9\frac{1}{2}$	9	16
Kodak T-Max 400	400	6	6	$10\frac{1}{2}$
	1600	8	$8\frac{1}{2}$	14
Kodak T-Max P3200	800	8	$6\frac{1}{2}$	$16\frac{1}{2}$
	3200	$11\frac{1}{2}$	$9\frac{1}{2}$	22
Kodak Plus-X Pan	125	5	5	$8\frac{1}{2}$
Kodak Tri-X Pan	400	$7\frac{1}{2}$	$5\frac{1}{2}$	$10\frac{1}{2}$
	1600	10	10	15
Kodak Recording Film 2475	3200	12	–	–
Ilford 100 Delta	100	6	5	13
Ilford 400 Delta	400	$7\frac{1}{2}$	–	14
	1600	14	8	20
Ilford Pan F Plus	50	4	–	9
	200	10	8	12
Ilford FP4 Plus	125	5	–	$11\frac{1}{2}$
Ilford HP5 Plus	400	5	$4\frac{1}{2}$	16
Fuji Neopan 400	400	5	$4\frac{1}{2}$	$12\frac{1}{2}$
	1600	12	8	17
Fuji Neopan 1600	1600	7	–	10
	3200	–	$7\frac{1}{2}$	12
Agfapan 400	400	8	–	16

Notes: Developing film to higher speeds produces greater contrast and graininess. Development times shorter than 5 minutes are not recommended because of the risk of uneven development.

Dilution "1:4" means 1 part concentrate to 4 parts water, by volume; likewise for other dilution numbers.

When diluting Xtol, use at least 100 ml of concentrate per 36-exposure roll of film. With the 1:2 dilution in a 300-ml tank, this happens automatically, but you will need to overfill a 240-ml tank or use rolls shorter than 36 exposures.

recommends it for push-processing; I don't use it much because it tends to build up excessive density in overexposed portions of the picture. Xtol gives equal or higher speed without excessive density.

A few other developing agents are in use. An example is Agfa Rodinal, which goes back to the early days of photography; it uses para-aminophenol in a strongly alkaline solution and is supplied as a liquid concentrate that can be diluted as much as 1:100 to yield normal contrast, slightly lower than normal speed, coarse grain, and enhanced edge effects.

Besides increasing the edge effect, highly diluted developers such as Rodinal change the shape of the film's characteristic curve, reducing contrast in strongly

exposed areas. This is known as *compensating action*; like the edge effect, it results from exhaustion of the developer over large dense regions. Compensating development is helpful in photographs whose highlights tend to be too light and void of detail, such as pictures of the moon (especially near quarter phase) and of nebulae with overexposed central regions. It is important not to agitate too much, and to use a large volume of developer (e.g., developing one reel in a full two-reel tank) so that an adequate amount of developing agent is available. For fuller information, see Ansel Adams, *The Negative*.

Judge and Holm (1990) studied the effect of several different developers on Kodak Technical Pan and T-Max 100 films (see also Covington 1991 for analysis of the data). Their tests made it obvious that Kodak T-Max developer is speed-increasing, Agfa Rodinal is speed-reducing, and D-19 yields normal or below-normal speed. HC-110 came out surprisingly well, yielding high speed with moderate contrast on Technical Pan.

Since then Kim Zussman has shared with me the results of his tests of hypered Technical Pan in HC-110 versus D-19 and Dektol print developer. He found that HC-110 produces more fog on hypered film than D-19, but Dektol (5 minutes, undiluted, at 20 °C) is a very good substitute for D-19 and is more readily available. With most films, Dektol produces intolerable grain, but Technical Pan remains practically grainless.

The amount of development that takes place depends, of course, on both the duration and the temperature of development. To some extent, changes in temperature can be made up for by changes in time; Fig. 11.3 is a classic conversion chart from Ilford.[2] To do the conversion on your calculator, multiply the specified development time by $\exp(-0.084\,T)$, where T is the difference between the specified and the actual temperature in degrees C, positive if warmer than

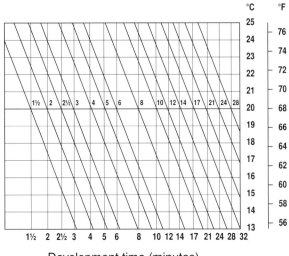

Development time (minutes)

Figure 11.3 **Time and temperature chart. Follow any diagonal line to get to equivalent combinations of time and temperature. Adapted from a chart published by Ilford Photo; reproduced by permission.**

specified and negative if lower. The equivalences are not exact, however, and it is better to standardize developing temperature at 20 °C (68 °F).

Development times are not necessarily the same for the same film in different formats (e.g., 35-mm versus sheet film) for two reasons. First, agitation takes place differently in different kinds of tanks. Second, and more importantly, the "glue" that holds the emulsion on the film is different depending on the size and flexibility of the support medium. A third confounding factor is that similar names sometimes denote different films in different sizes (e.g., 35-mm Tri-X Pan, ISO 400, versus medium-format Tri-X Pan Professional, ISO 320).

After development, the film goes into a stop bath, which can be plain water or a solution of not more than 2% acetic or citric acid, and then into a fixer. The fixing time depends on the type of fixer used (sodium thiosulfate, used in powders, or ammonium thiosulfate, used in liquid concentrates) and on the thickness of the film's emulsion, so one must consult the instructions for each type of film used. Washing takes about 30 minutes, or only five minutes if you use a washing aid first.

[2] The chemists among us will note that the slope of the lines is slightly greater than that demanded by Arrhenius' Law; the rate of development doubles for every 8 °C increase, not 10 °C as you might expect. This apparently happens because heat softens the emulsion as well as speeding up the reactions.

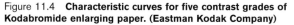

Figure 11.4 **Characteristic curves for five contrast grades of Kodabromide enlarging paper. (Eastman Kodak Company)**

11.3 Black-and-white printing

Enlarging paper comes in contrast grades numbered from 0 or 1 to 5 (see Fig. 11.4), with grade 2 or 3 considered "normal." These grade numbers are arbitrary. In pictorial photography, the gamma (curve slope) of the paper is about 1.4 and the gamma of the negative is about 0.7; together, they yield an overall contrast of $1.4 \times 0.7 \approx 1.0$, so that the print has the same tonal range as the subject.

Astronomical photographs, particularly of planets and star fields, benefit from printing on grade 4 or 5, or, better yet, on variable-contrast paper with a filter that makes it use the high-contrast layer of its emulsion. High-contrast paper is relatively intolerant of enlarging exposure errors and tends to bring out film grain. Still, you get less grain by printing a normally developed negative on high-contrast paper than you would if you tried to achieve the same contrast increase by overdevelopment. (Kodak Technical Pan Film is an exception; nothing that you can do will make it grainy!)

Variable-contrast paper (Ilford Multigrade, Kodak Polycontrast and Polymax) gives you a choice of contrast grades by using filters (Fig. 11.5). The Ilford paper has three emulsion layers, all of them sensitive to blue light, but two of them rather less sensitive to green. Thus, when you expose a picture through a blue filter (or magenta, which passes blue plus safelight red), you expose all three layers equally and get high contrast. When you expose through a green filter (or yellow,

which passes green plus red), you expose one layer fully and the other two only partially, and they add up to give a lower-contrast image. Intermediate filters give you the contrast grades in between.

There are now two types of variable-contrast papers. The new-style papers are Ilford Multigrade IV and Kodak Polymax II; they give higher contrast in the dark areas of the picture than in the highlights (Fig. 11.6). This makes it easier for pictorial photographers to get good blacks without making the midtones too dark. It also helps bring out faint stars and nebulosity without blocking up the lighter areas of a deep-sky photograph. The older-style papers, Multigrade III and Kodak Polycontrast III, have a straighter characteristic curve.

The new-style papers also give a wider contrast range. To accompany the new paper, Kodak introduced two new filters, 5+ and −1, but Ilford added only one, 00. You can use either manufacturer's filters with either brand of paper, and you can continue to use older Polycontrast and Multigrade filter sets. The maximum contrast obtainable with the new papers is *remarkably* high, so high that I seldom use the 5 or 5+ filters.

A good print uses the entire density range of the paper from white to black. As Figs. 11.4 and 11.6 show, paper is contrastier than film, and since its entire characteristic curve is being used, there is no room for exposure error. In fact, pictorial photographers routinely "dodge" or "burn in" areas of the print, controlling their exposure selectively to get them within range. I find that lunar photographs (other than full moon) and pictures of nebulae with overexposed central regions benefit from burning-in; most other astronomical photographs do not.

Some papers have the developing agent incorporated into the emulsion to facilitate machine processing. These include Kodak Polycontrast III and Ilford Multigrade III Rapid. They develop very fast, and you have no choice but to develop them to saturation. With other papers, such as Ilford Multigrade IV Deluxe and Kodak Polymax II, you can adjust the contrast and density of the print by varying the developing time; just

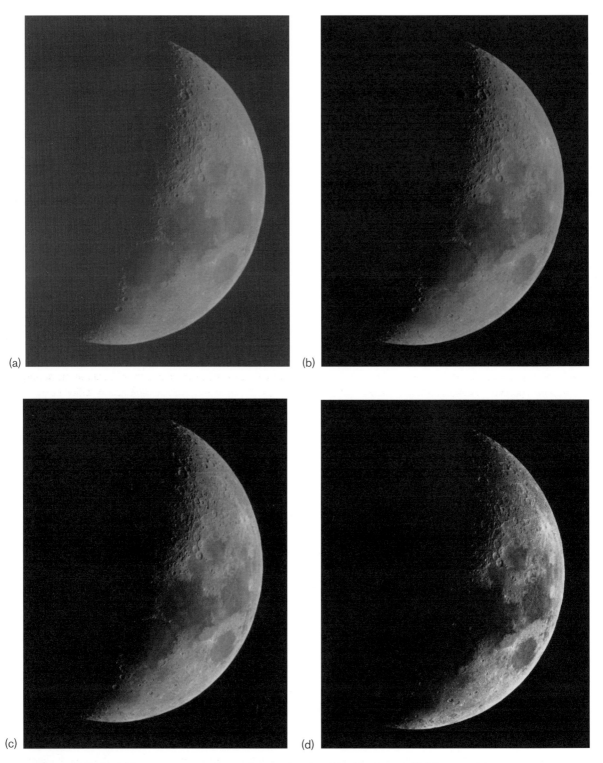

Figure 11.5 **Variable-contrast paper. Same picture printed on Ilford Multigrade IV RC paper: (a) with Ilford #0 filter; (b) with no filter (equivalent to #2 or #2$\frac{1}{2}$); (c) with Ilford #3$\frac{1}{2}$ filter; (d) with Kodak #5+ filter.**

Figure 11.6 New-style enlarging papers give higher contrast in dark areas of the picture – just what we need for star fields and nebulae.

leave the print in the developer until it looks right, then transfer it to the stop bath. Unfortunately, prints that "look right" in the dim environment of the darkroom are usually too light; you find yourself wanting to remove the print from the developer too soon, resulting in weak, mottled blacks.

It used to be thought that controlling development in this way was a bad idea because a print given less than maximum development would would never have maximum blacks. In a very useful book, Henry (1986) demonstrated that this is not true; after about one minute of development, properly exposed prints have a full tonal range, and after that, prolonging development increases the effective paper speed (and hence the effective exposure) rather than the curve shape.

There is no longer any reason not to use resin-coated (RC) paper and get the benefit of rapid processing. Conventional fiber-base paper is still in vogue among fine-art photographers, who suspect that prints made on it will last longer; in reality, there is little difference between the two if the prints are well taken care of. In my opinion, RC paper gives better print quality due to the ease of obtaining a perfectly glossy surface, but some artists feel that fiber-base paper looks better.

The main difference between paper developers and film developers is that paper developers contain large amounts of alkaline accelerator to make them work quickly. If you develop film in a paper developer, you get unacceptably coarse grain – unless, of course, the film is an extremely fine-grained one such as Technical Pan, in which case you get very quick development and high contrast.

I use Ilford Multigrade print developer because of its convenience; it comes in 16-ounce bottles of a liquid concentrate that is diluted 1:9 for use. Ilford and Kodak

make several other liquid concentrate print developers, and I can't tell any difference between them. As a rule, print developers are much more interchangeable than film developers; you can develop practically any paper in practically any print developer without noticing more than a slight change in contrast or speed.

Safelights aren't safe unless proven to be so. To test a safelight, expose a piece of paper so that it will develop as mid-gray, then lay it down, face up, on the countertop and place a coin on it. Wait three minutes, then develop it. If you can see the shadow of the coin, the safelight isn't safe. You can improve an unsafe safelight by using a smaller bulb or adding one or two layers of "Amberlith," a graphic arts masking material made by Ulano Corporation and available at art supply stores. You can even make a cheap but efficient safelight filter out of eight or ten layers of Amberlith alone. Test safelights whenever you switch to a new kind of paper, and test them annually (because of possible fading) even if your paper hasn't changed.

11.4 PRACTICAL NOTE:
Color negatives on black-and-white paper?

You can print color negatives on ordinary black-and-white paper. When you do, objects that are blue on the negative (red or orange in real life) come out dark because the paper sees blue light as white. That means red nebulae don't show up well, but stars and galaxies do. Printing on black-and-white paper is a good way to make high-contrast prints of color negatives as long as the objects of interest are not reddish in color. It tends to bring out a surprising amount of film grain.

Special panchromatic papers exist for printing color negatives in black-and-white without losing the reds. One of them is Kodak Panalure. These papers are used almost exclusively for portraiture and are not available in high contrast grades.

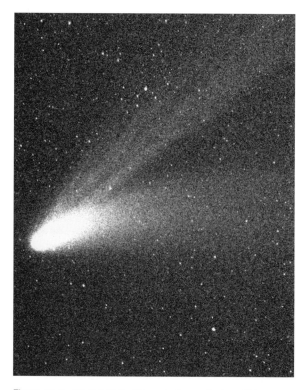

Figure 11.7 **Comet Hale-Bopp photographed on Ektapress Multispeed (PJM) color negative film and printed on black-and-white paper with #4 contrast filter. Note bright ion tail (top), which was originally blue. (By the author)**

11.5 Making high-contrast prints

Prints of star fields need to be perfectly smooth and free of mottle; making them so requires more than the usual amount of care.

To begin with, the negatives must be developed uniformly. Because they are printed on high-contrast paper, astronomical negatives are especially sensitive to streaking that results from improper agitation. In general, too little agitation causes streaks that seem to flow from bright or dark objects in the picture, while streaks coming from 35-mm film perforations result from excessively vigorous or monotonous agitation. Fogging around the sprocket holes can also result from light leaks or from rewinding the film too tightly in the cartridge.

I get more uniform development with Paterson plastic tanks than with metal tanks. Tanks that are partly full are advantageous (e.g., two rolls in a 3-roll tank). During development, I agitate the tank every 30 seconds by inverting it several times with rapid motion.

When it's time to make the print, paper and chemicals must be fresh. Kodak Polymax II and Ilford Multigrade IV papers with filters 5 or 5+ give as much contrast as you are likely to want, considerably more than you would normally get with #5 graded paper.

Each print must be developed for at least 1 minute with good agitation and then rinsed for at least 20 seconds in an acid stop bath (1.5% acetic acid, or, to avoid the odor, 1% citric acid). Without the acid stop bath, the action of the fixer would be impaired.

White lights must not be turned on until the print is fully fixed. This is not as bad as it sounds; Ilford Universal Fixer will fix all resin-coated papers in less than 1 minute. So will Kodak Rapid Fixer if the hardener (Part B) is left out.

High-contrast printing brings out the worst in any enlarger. It can be very instructive to make a maximum-contrast print with no negative in the film carrier; expose for mid-gray with the lens at $f/16$ or $f/22$, and you'll see vignetting and images of dust in the condenser system. Clean and adjust the condensers, and then, to eliminate the dust images, work with the lens fairly wide open ($f/8$ or wider). To reduce vignetting, adjust the condensers if you can, and use a longer-focal-length enlarging lens (75 mm rather than 50 mm for 35-mm film). As a last resort, put a piece of white plastic in the enlarger just above the film. By doing so, you are converting your condenser enlarger into a diffusion enlarger, and although the apparent contrast will be slightly reduced, the illumination will be more even and scratches will not show up as readily.

Some enlargers are so bright that the exposure times for star-field prints are impossibly short. To remedy this problem in my Beseler 23C, I went to a local glass shop and got a piece of 25%-transmission gray glass which I keep in the filter tray above the lens (Fig. 11.8).

Combination printing of multiple negatives came up in Chapter 7. To eliminate grain and reduce the effect of atmospheric turbulence, you can combine

Figure 11.8 **If your enlarger is too bright, add a piece of gray glass. (Cathy Covington)**

several exposures of a lunar or planetary photograph by making multiple exposures in the enlarger or slide copier.

There's another way to combine two images – stack the negatives. Like combination printing, this greatly reduces the effect of grain. The difference is that when you stack negatives, you can bring out details that were too faint to see on any negative individually. Malin (1993) has put combination printing and stacking to good use.

As you might guess, stacking negatives isn't easy. To get them precisely registered, you have to match up at least two points (such as star images) near opposite corners. Jerry Lodriguss (http://www.astropix.com) has developed a technique that involves cellophane-taping the negatives to pieces of flat optical glass, aligning them precisely, and then cementing the glass (not all over, but just at the corners) to hold the negatives

precisely in registration. He uses epoxy cement, which hardens gradually in a useful way; you can make finer and finer adjustments as it gets stiffer, and if you've used a small enough glob, you can cut it loose with a razor knife after you're finished. To prevent Newton's rings and related interference phenomena where the negatives contact the glass, you can use small amounts of anti-Newton powder, a photographic product made of particles so small that they don't show up as dust on the film.

Bear in mind that stacking can result in a total density too great to print. Like combination printing, stacking can also be done digitally (see p. 231).

11.6 Unsharp masking

A powerful technique for improving picture quality is *unsharp masking*, a process that amounts to "automatic dodging" since it lightens and darkens parts of the picture to keep them within the response range of the paper. Although it is now the name of a digital process, unsharp masking was originally a purely photographic technique, and you can still do it the old way.

To understand unsharp masking, imagine what would happen if you took a negative, made a low-contrast contact print of it on film, and sandwiched the two. You'd get a contrast reduction, of course; the contact print would partly cancel out the original negative. This is a practical technique and is used in some color copying processes.

If the contact print is blurred so that it does not pick up fine detail, an interesting thing happens. The densities of large areas are brought toward the average, but the contrast of the fine detail is not reduced. The effect is the same as if the print had been made by someone with great, indeed superhuman, dodging skill, and the detail that shows up in nebulae and similar objects is remarkable (Fig. 11.9).

(a) 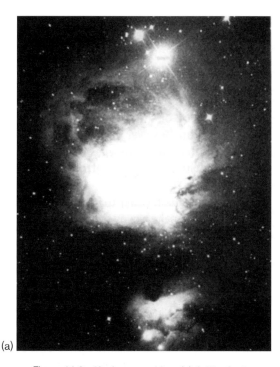 (b)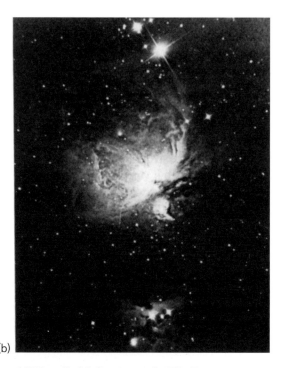

Figure 11.9 **Unsharp masking. (a) A 25-minute exposure of M42 on Kodak Spectroscopic 103a-F film at the prime focus of a 20-cm (8-inch) $f/5$ Newtonian. (b) The result of photographic unsharp masking. (Dale Lightfoot)**

A good way to make an unsharp mask is to interpose a thin piece of glass, not more than a couple of millimeters thick, between the negative and the film, then make the exposure using a light source, such as an enlarger, that is several feet away. You can use conventional black-and-white film if you are willing to work in total darkness; an alternative is to use Kodak Fine Grain Positive Film 7302 (in 4×5 sheets) and Eastman Fine Grain Positive Film 5302 (in long 35-mm rolls), which consist of a paper-type emulsion on a film base. It's not practical to make an unsharp mask by putting an enlarger or slide duplicator out of focus because defocusing changes the size of the image.

For more on unsharp masking, see Lightfoot (1982), Malin (1977), and Malin and Zealey (1979). Malin's technique is very sophisticated and involves density and contrast measurements.

11.7 Processing color film

Many amateurs develop their own color film for two reasons: to check results immediately (perhaps before the night of observing is over) and to experiment with push-processing. You can "push" any color film by prolonging the time in the developer (the first developer if it's slide film).

The main difference between black-and-white and color processing is that with color, the temperature is higher and has to be controlled carefully. This is done by placing the containers of chemicals and rinse water and the developing tank in a large tray or basin of warm water whose temperature is carefully monitored. When everything reaches the specified temperature (38 °C, 100 °F), processing can begin. Not counting rinses, Kodak process C-41, for color negatives, involves four chemicals, and process E-6, for color slides, involves six. However, three-step versions of these processes are marketed by other companies. Fuji and Agfa films are now fully compatible with Kodak chemistry.

Kodak has not published formulae for the E-6 chemicals, but they have been reverse-engineered and the formulae published by Gehret (1980, 1981) and Watkins (1995). Few people will want to mix their own chemicals, but the published formulae are helpful for understanding how the process works. In particular, the first developer is essentially a black-and-white developer. Presumably, you could substitute D-19 or another high-

energy developer in order to get maximum speed and contrast, then proceed with the rest of the E-6 process. I'd like to hear from anyone who pursues this idea and works out a practical technique.

Another way to get the most out of slide film is to cross-process it in C-41 chemistry. You get negatives, of course, but they lack the orange mask layer of normal color negative film, so they require heavy orange filtration when prints are made. Cross-processing yields a speed increase, and extreme push-processing is less risky; fog on negatives is much less objectionable than fog on slides because you can compensate for it in printing.

Relatively few amateurs make their own color prints because the materials are much more expensive than for black and white, and the process is difficult. (Besides exposure, color balance has to be adjusted.) It's usually cheaper and easier to work with a custom lab and teach the technicians to make good astronomical prints.

11.8 PRACTICAL NOTE:
Help! The film is scratched!

The bad news: astronomical photographs, especially pictures of star fields, are much more vulnerable to scratches than ordinary slides or negatives. Smooth sky backgrounds and high-contrast prints bring out the smallest scratches and imperfections.

The good news: not all scratches are significant, and those that are can often be temporarily removed. If you hold a slide or negative up to the light and view it with a magnifier, you may see scratches on the back (base) side of the film. But in a well-designed slide projector or enlarger, the same scratches will often be invisible. Projectors and enlargers use condenser lenses to illuminate the film in such a way that scratches on the back do not cast shadows.

To hide a scratch temporarily so you can make a print or duplicate, fill the scratches with a liquid or gel. Edwal No-Scratch works well and makes your darkroom smell like turpentine. Petroleum jelly does the same job without the odor. When you're finished, use Kodak Film Cleaner or a similar product to clean the film.

Scratches on 35-mm film are usually caused by grit inside the camera which lodges in the light trap of the cartridge when the film is rewound. Remedy: keep the camera clean and do not reuse cartridges whose light traps are suspect. Scratching can also occur when you pull the film tight trying to advance past the end of the roll.

Some minilabs handle film very roughly; watch them at work and avoid them. And some photographers distrust roller-transport processing machines, preferring labs with "dip-and-dunk" machinery. When processing film by hand, never wipe it with a chamois or sponge.

Why are the scratches usually on the back? Presumably because the softer emulsion side is more likely to absorb a grit particle, leading to a mysterious opaque spot.

11.9 Slide duplication

After the camera and the telescope, the third most important basic tool for astrophotography may well be a slide duplicator. With it you can alter the contrast, magnification, and color balance of images, often bringing out hidden detail dramatically (as in Plate 11.1), without having to do any developing or printing yourself.

There are many kinds of slide duplicators. One way to duplicate slides is to photograph the slide on a light box, using a macro lens, extension tubes, or bellows that will let you focus down to 1:1. Naturally, the light box must be masked off so that only the slide

Figure 11.10 **The inexpensive kind of slide duplicator works well when used carefully. The image in the viewfinder is very dim.**

is illuminated. Watkins (1997) tells how to build a homemade slide duplicator of the light-box type.

Other slide duplicators attach to the camera, either directly or in front of the 50-mm lens. Figure 11.10 shows a popular model; it contains a small lens that works at about $f/22$. The image in the viewfinder is

quite dim, but apart from that, the high f-ratio isn't as much of a drawback as you might think; even the best lenses often have to work at $f/16$ to get enough depth of field to overcome the curvature of the slide. I have done good work with a duplicator of this type. The only trick is that my duplicator (from Spiratone, now out of business) supposedly did not require focusing; in reality, I had to focus it by adding plastic shims. Because of the high f-ratio, these slide duplicators give a rather dim image, and you'll need a bright focusing screen and perhaps a magnifier, just as in planetary photography.

Figure 11.11 shows my present setup, built over the years at what may well have been excessive expense. It consists of an Olympus bellows, an Olympus

Figure 11.11 **A professional-quality slide duplicator with bellows, 1:1 macro lens, and TTL autoflash.**

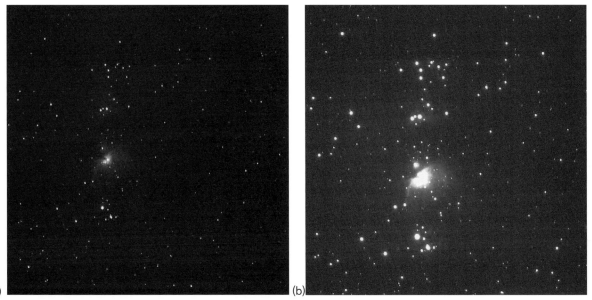

(a) (b)

Figure 11.12 **The effect of duplicating a slide. (a) A 10-minute exposure of M42 on Fuji Sensia 100 film with a 400-mm f/6.3 lens. (b) A duplicate on Ektachrome Elite II 100 film, exposed with TTL autoflash, deliberately overexposing 1 stop. (By the author)**

slide duplicator, and an Olympus 80-mm flat-field lens (specially designed for 1:1 duplication), together with an electronic flash on a bracket I made out of acrylic. The flash is coupled to the in-camera, off-the-film photocells in my Olympus OM-4T.

Most lenses, even macro lenses, do not work well for slide duplication unless stopped down to f/16 or smaller. This is not just because of slide curvature; another problem is that normal lenses and even 1:2 macro lenses usually have appreciable aberrations at a 1:1 reproduction ratio. (Optically, there's as much difference between 1:1 and 1:2 as between 1:2 and 1:∞.) Floating-element macro lenses, such as the Olympus 50/3.5 and Sigma 90/2.8, should always be used with the barrel fully extended, as if to focus as close as possible. If you are enlarging a portion of the slide, mount the lens backward, with the film side toward the slide and the subject side toward the camera, if your bellows allows this.

When you copy a slide onto ordinary color slide film, it undergoes a contrast increase. If you want an exact copy of the original, you must prevent the contrast increase, either by prefogging the film slightly or by using a special slide duplicating film. With astronomical photographs, however, the contrast increase is almost always beneficial; it helps to bring out faint stars and make planetary detail more visible. The film onto which you duplicate should, of course, be fine-grained; I usually use Kodak Elite Chrome 100. But there is such a thing as too much contrast; for a more moderate contrast increase I've used Fuji Astia 100 or Sensia II 100. At the other end of the range, Kodak makes a special high-contrast Ektachrome for electronic output devices.

Usually, the exposure indicated by the meter in your camera will give you a duplicate that's about as light or dark as the original, although, because of the contrast increase, the darkest parts of the picture are black and the lightest parts are washed out. (Surprisingly, this holds true even with pictures of celestial objects on a black background, where you'd expect an averaging meter to give incorrect results.) With a planetary photograph, where all the detail is in the middle of the density range, this may be just what you need.

Much of the detail of interest in a star field photograph is present on the slide but too dense to see unless you view the slide by a very strong light. It is in such cases that the slide duplicator proves its worth: you can lighten such a slide by exposing about two stops more than the meter indicates. In either case, bracket exposures widely.

Naturally, the color balance of a duplicate slide depends on the light source used. Electronic flash produces realistic copies; the color balance can be adjusted with CC or CP filters. Ordinary tungsten light (from a slide projector, enlarger, or ordinary light bulb) produces a color shift toward coppery-red that is sometimes helpful in eliminating blue or blue-green fog and bringing out reddish nebulosity.

Color balance also depends strongly on the kind of film you're copying. All recent Ektachromes and Fujichromes use essentially the same dyes, but Kodachrome and the older Ektachromes are distinctly different. It would be a mistake to try to get neutral gray when there is no slide in the duplicator; instead, adjust your filter pack to give accurate reproductions of the slides you are interested in.

Electronic flash is the best light source for slide duplication, but through-the-lens autoflash is not necessary; after some experimenting, you can use fixed exposures. The obvious drawback of flash is that you need some other light source, probably a very bright one, to focus by; your slide projector can be pressed into service for this purpose.

At one time I used blue photofloods as the light source for slide duplication. With my Olympus OM-1, this setup worked fine, but when I switched to an OM-2S, I started getting severe underexposures. I recalibrated my exposure procedures and carried on. Then, after a while, I switched to using a slide projector as a light source and got – guess what? – severe *over*exposures.

It turned out that infrared light from the photofloods was fooling the silicon light meter in the OM-2S. The problem was worst when I was duplicating very dark slides in order to lighten them. The reason? The dyes in color film are almost transparent to infrared light. With an ordinary slide, this doesn't create a large problem because there's also plenty of visible light passing through. An underexposed slide, however, is dark in visible light but bright in the infrared, and the OM-2S meters it incorrectly. The OM-1, with its

cadmium sulfide meter, wasn't affected, and the slide projector contained infrared-blocking glass that reduced the effect. With electronic flash illumination I have not had problems.

Professional slide duplicators such as the Bowens Illumitran also use flash for another purpose – they preflash the film to reduce contrast so you can make duplicates that look like the original slides. That, of course, is what pictorial photographers want to do, and doing it is very difficult. Both Kodak and Fuji make special low-contrast slide-duplicating films, but, paradoxically, it is much easier to improve a slide by duplication than to make a copy that looks like the original. If you want copies of existing slides, you're much better off sending them to Kodak. The usefulness of a slide duplicator lies in the changes that the image undergoes when it is duplicated.

A slide duplicator can also substitute for an enlarger; you can put a negative in a slide mount and use the slide duplicator to make positives from it. You need, of course, a film that has the contrast of enlarging paper. In black and white, Technical Pan Film, exposed at ISO 200 and developed for 12 minutes in HC-110 (dilution B), or developed to saturation (about 5 minutes) in a paper developer, should make a good starting point for experimentation. To make positives from color negatives, you can use Kodak Vericolor Slide Film 5072, which is designed especially for this purpose.

11.10 Rephotography

Rephotography is like slide duplication except that you copy, not a slide, but a print – usually a carefully made glossy 8 × 10. For copying prints, a copy stand is helpful but not necessary; a table with a couple of flexible-arm lamps for shadow-free illumination will suffice. To bring out faint detail on a picture using this technique, make a slightly lighter-than-normal print (you

don't want anything to disappear into the shadows) and photograph it on Technical Pan or a similar high-contrast film.

Rephotography also includes copying of negatives, plates, and the like. Malin (1981, 1993) has discovered unusual features of galaxies simply by making high-contrast copies of existing observatory plates, retrieving information that was in the picture but invisible to human eyes. One way to increase the contrast of a negative is to copy it in a slide duplicator on high-contrast film; then copy the resulting positive to make another negative with even higher contrast.

Rephotography is the key to a system of tricolor photography developed by Jim Baumgardt (1983). The tricolor process is a way of making color pictures, not with conventional three-layer color film, but with three separate black-and-white negatives exposed through different colored filters. For instance, a typical star-field photograph might consist of a 24-minute exposure through a #25 red filter, a 22-minute exposure through a #44A blue filter, and a 32-minute exposure through a #11 green filter, all on gas-hypersensitized Technical Pan. The times are calculated to produce equal densities.

A good 8 × 10 enlargement is then made from each negative, and the enlargements are retouched to eliminate dust spots. Then a precisely registered multiple exposure combining the three is made on color film. Each print is photographed through a filter of the

same color as the one it was taken through, although the filters are now #25 (red), #38A (blue), and #58 (green), respectively, chosen to pick out the layers of the color film. A suggested exposure ratio is 1 for red, 5.3 for blue, and 2.3 for green; that is, the blue exposure should be 5.3 times as long as the red one, and so forth, though considerable variation is possible. Plate 11.2 shows the result of combining images this way. This is obviously a technique that requires much experimentation and careful record-keeping. An alternative is to combine the separate images digitally as is done with tricolor CCD images.

David Malin (1993) pioneered the use of tricolor photography in scientific research. One of its striking advantages is that you can choose your color filters so the film doesn't miss the green line of oxygen in emission nebulae (cf. Fig. 10.4, p. 178). The colors are thus "truer," or at least more informative, than those recorded by color film, and you get all the advantages of hypersensitized high-contrast black-and-white emulsions. Malin was delighted to discover that the colors in his pictures showed features that would otherwise be discoverable, if at all, only through tedious spectroscopy, and he could record the colors of objects that were too faint for their light to be analyzed any other way. For example, he found that a portion of the Merope nebula in the Pleiades is whitish, apparently consisting of thicker dust than the surrounding blue nebulosity.

Digital imaging

Part IV

Computer image enhancement **12**

Both amateur and professional astronomers are now making extensive use of digital image enhancement. The extent to which a photograph can be improved is often little short of amazing. Besides adjusting the brightness, contrast, and color balance of a digitized picture, the computer can alter the shape of the characteristic curve and even increase sharpness of the image. Computer processing can even correct guiding errors.

Digital image processing is not synonymous with CCD imaging. In fact, at present, the best way to get digital images is to take pictures on film and then scan the negatives into the computer. CCDs are important, and the next chapter will cover them, but digital image processing is even more important and needs to be covered first.

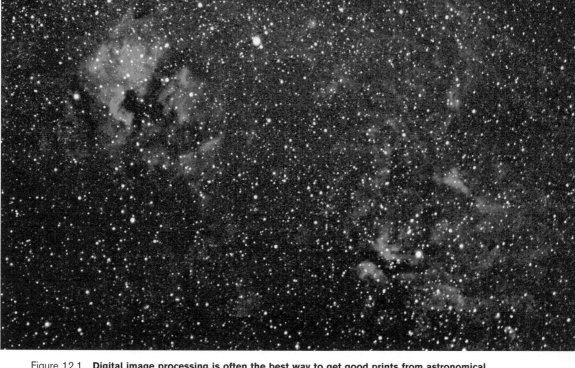

Figure 12.1 **Digital image processing is often the best way to get good prints from astronomical slides and negatives. This monochrome image was made by digitizing the slide in Plate 8.8.**

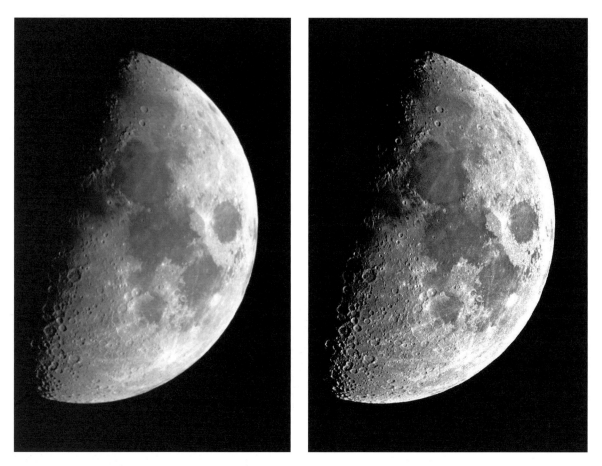

Figure 12.2 **Digital image enhancement at work.** *Left*: **Original image, prime focus of a 12.5-cm f/10 Schmidt–Cassegrain telescope, auto exposed on Fuji Sensia 100 by the author, then scanned and converted to monochrome.** *Right*: **The same image after unsharp masking and Gaussian sharpening.**

I have resisted the temptation to digitize all the pictures in this book, although nearly all of them could have been improved by digital enhancement. (Fig. 12.2 shows a simple example.) Except where noted, none of the images in previous chapters has been processed digitally.

Because the technology is advancing so fast, this chapter will have to concentrate on underlying principles rather than the use of specific software and hardware. That is not a serious limitation; the basic building blocks of computer graphics have long been the same no matter what software you use, although the nomenclature tends to vary. The most important technological advance happened in the mid-1990s when desktop computers became powerful enough to process high-resolution images. Although more computer power is always useful, the most important obstacle has already been overcome.

12.1 How computers represent images

A computer can represent a graphical image in either of two ways:

- *Vector graphics*, a series of commands to draw lines, circles, shaded areas, etc., in particular places; or
- *Bitmap graphics*, a large array of numbers indicating the brightness or color of every *pixel* (picture cell) in the image.

Figure 12.3 **A small part of Fig. 12.2 showing individual pixels.**

Figure 12.4 **Bitmap image shown as a picture (left) and as an array of numbers (right).**

Vector representations are used for line drawings (including the drawings in this book) because vector images can be printed at the full resolution of any printer. Lines are lines and curves are curves; higher-resolution printers draw them more smoothly.

Digitized photographs and CCD images, however, are invariably bitmaps. The picture is scanned by breaking it into discrete cells (squares) and recording the brightness or color of each. The computer has no idea whether the image contains lines, circles, or other geometric shapes; all it knows is what color to put where. Figure 12.4 shows how bitmaps work.

Vector and bitmap editing programs are also called "draw" and "paint" programs respectively. Draw programs such as Corel Draw and Adobe Illustrator produce vector images, which may have bitmaps embedded in them. Paint programs such as Windows Paint, Corel Photo-Paint, and Adobe Photoshop are used to create and edit bitmap images. Many of them are useful in astronomical image processing, although specialized astronomical software is needed for the more advanced kinds of image enhancement.

Not all bitmaps store the same amount of information per pixel, of course. In the simplest bitmaps (used for type fonts and the like), each pixel is either 0 or 1 (black or white) and there are no other values. Lacking shades of gray, this representation is almost useless for astronomical imaging. Satisfactory black-and-white pictures require 256 shades of gray, which can be stored as one-byte integers ranging from 0 to 255. (One byte equals 8 bits, and $2^8 = 256$.)

But 256 shades of gray are not always enough. Many images use only part of the available brightness scale, sometimes as little as a tenth or twentieth of it. Consider a low-contrast image that uses only 12 shades of gray on a scale of 256. It can, of course, be processed to use all 256, but it won't use them smoothly and evenly; distinctions that were lost cannot be regained. Better CCD cameras and scanners have a *bit depth* of 10, 12, or 16 bits per pixel rather than just eight.

An image that can distinguish 65 536 ($= 256 \times 256$) shades of gray will remain satisfactory even if only 1/256 of the scale is actually used. Here's the formula:

$$\text{Number of brightness levels} = 2^{(\text{bits per pixel})}$$

That's for monochrome (black-and-white) images. Good color images require three times as much space because they must store brightness levels for each of the three primary colors, red, green, and blue. Good color images therefore require 24 bits (3 bytes) per pixel.

Many video cards and some graphics programs store color images more compactly by using *indexed color*. Instead of storing red, green, and blue levels for each pixel, the software gives each pixel an arbitrary color number from 0 to 255 or 0 to 65 535. The color numbers point to sets of red, green, and blue levels stored in a table. Thus, with eight bits per pixel, you can have only 256 colors, but they can be *any* 256 chosen from a gigantic range. This often results in pleasing rendition of pictures, but indexed color is very hard to process computationally. Squeezing all the colors into a set of 256 causes loss of information, and when a new color arises as a result of processing or editing, the computer has to go through an elaborate juggling act to find a place for it in the color table without discarding something more important.

Table 12.1 *Types of bitmap images*

Image type	Bits per pixel	Number of colors	Suitability for image processing
1-bit monochrome	1	Black and white only	Poor
8-bit monochrome	8	256 shades of gray	Good
16-bit monochrome*	16	65 536 shades of gray	Excellent
8-bit indexed color	8	Any 256 chosen from a much larger range	Poor
16-bit indexed color	16	Any 65 536 chosen from a much larger range	Poor
24-bit (8-bit) true color	8 each red, green, and blue	16 777 216	Good
48-bit (16-bit) true color*	16 each red, green, and blue	$>10^{14}$	Excellent

*16-bit monochrome and 48-bit true color are seldom used in the graphic arts but are common as the output of scientific imaging systems.

Going in the other direction, the best scientific imaging equipment distinguishes 65 536 levels of each color, requiring a total of 48 bits per pixel, but 48-bit color is not widely used in the graphic arts.

12.2 Resolution and image size

A bitmap image must, of course, contain enough pixels to look sharp. Most file formats allow you to store an expected display size for the image, so that the software can continue print it out at the correct size when you change printers. The question is, how many pixels do you need to make a decently sharp image of a particular size?

Equally important, how many would be *more* than enough? Digitized images result in big computer files. A 1.4-megabyte diskette is not big enough for an uncomprepssed high-resolution scan of one 35-mm negative. Thus, for economic reasons it is important not to use a higher resolution than is actually necessary.

Table 12.2 gives some rules of thumb. A computer screen typically displays about 70 to 100 pixels per inch (dots per inch, abbreviated dpi). Sharp photographic prints resolve 300 dpi, although most continuous-tone pictures look acceptable at 150 dpi. An unenlarged 35-mm negative resolves about 2500 dpi.

These numbers should be approached with some caution. First, *the positioning accuracy of a printer is not the same as the resoluton it will produce in a continuous-tone picture* because colors or shades of gray are generally made out of smaller dots. For example, a 1200-dpi laser printer that constructs shades of gray out of halftone dots will typically render gray-scale pictures at 150 dpi. Inkjet printers claiming 1440 dpi for any single color of ink generally achieve less than 300 dpi for a complete color picture. Dye-sublimation printers that apply three colors of dye to each pixel in the image do achieve their full rated resolution, which is typically 300 dpi.

Second, *the dot pitch of a monitor is not the pixel size*, although it should be roughly comparable in order to prevent blurring. The tiny red, green, and blue

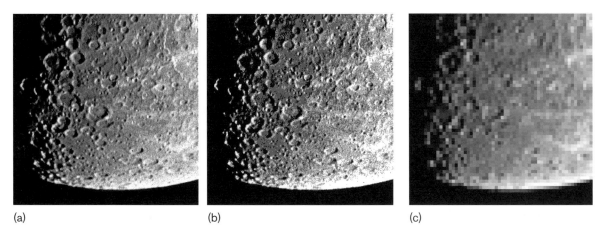

(a) (b) (c)

Figure 12.5 **The same image at different resolutions and bit depths. (a) 300×300 pixels × 8 bits (256 shades of gray); (b) 300×300 pixels × 2 bits (only 4 shades of gray, inadequate bit depth); (c) 60×60 pixels × 8 bits (inadequate resolution; note individual pixels rendered as square boxes).**

Table 12.2 *Approximate resolution of imaging media*

Imaging medium	Resolution	
	Dots per inch (dpi)	Pixels per mm
Television screen	25–75	1–3
Computer video screen	70–100	3–4
Acceptable photographic print	150	6
Sharp photographic print	300	12
Sharp 35-mm negative or slide	2500	100
Crisp line diagram on paper	1200–2400	50–100

phosphor dots on the screen do not correspond to pixels in any systematic way, but they do set a limit on pixel size. For example, a monitor with a dot pitch of 0.33 mm will not be able to display more than 3 pixels per millimeter with acceptable sharpness.

Third, as is probably obvious, *film grains are not pixels either.* Unlike digital images, film does not use a rectangular array of pixels; the grains are distributed randomly, and in fact the grains that we see are actually clumps of smaller, microscopically tiny crystals.

Scanning a negative at a resolution of 2400 dpi will generally capture all the detail in the image, as well as some of the grain if the film is coarse-grained.

Fourth, *lines per millimeter are not the same as pixels per millimeter.* To resolve a line, you need a pixel for the line and a pixel for the space between lines, so

$$\text{Pixels per millimeter} = 2 \times \text{lines per millimeter}$$

and because there are 25.4 millimeters to the inch:

$$\text{Dots per inch} = 2 \times 25.4 \times \text{lines per millimeter}$$

With all this information we can start calculating how big images actually need to be. Table 12.3 gives some examples. The formula is:

The divisor is 8 because there are eight bits per byte on all modern computers. The size of a large image is normally given in kilobytes (KB) and megabytes (MB), where "kilo-" and "mega-" mean 1024 and 1 048 576 (= 1024^2) rather than 1000 and 1 000 000 respectively.[1]

[1] That's also why the binary "kilo-" is abbreviated K rather than k. The meaning of "megabyte" is not always clear; some disk drive vendors define a megabyte as 1 000 000 or even 1 024 000 bytes.

Table 12.3 *Image quality versus file size*

Image type	Size (pixels)	File size, uncompressed		
		8-bit monochrome (256 shades of gray)	16-bit monochrome (65 536 shades of gray)	24-bit true color (16 777 216 colors)
TV screen, very small snapshot, or planet image	200 × 320	63 KB	125 KB	188 KB
Computer screen or small snapshot	480 × 640	300 KB	600 KB	900 KB
Sharp photograph, 4 × 6 in (10 × 15 cm)	1200 × 1800	2.1 MB	4.1 MB	6.2 MB
Full resolution of 35-mm slide or negative (100 pixels/mm)	2400 × 3600	8.2 MB	16.5 MB	25 MB

12.3 PRACTICAL NOTE: How images get resized

In general, when you change the size of a bitmap image, information is lost. Resizing (*resampling*) is therefore something you'll usually want to avoid, or save until the last step, after all processing is complete.

Shrinking an image is easy – just get rid of some of the pixels at regular intervals. While this could be done by just skipping the unwanted pixels, usual practice is to arrange the pixels into groups and average the groups (Fig. 12.6).

Enlarging an image is harder because you need pixels that aren't there. Computers use sophisticated algorithms to produce reasonable-looking images from inadequate information. Consider the left-hand image in Fig. 12.7. One way to double its size would be to expand each pixel into a group of four – but that would greatly increase the stairstep appearance of the diagonal line.

Instead, usual practice is to expand the image, then *interpolate* the values of the missing pixels by averaging the pixels around them. The resulting image looks a bit blurry, but it has smooth transitions rather than stairstep effects.

Beware of scanners that make claims of "interpolated" resolution. A genuine 2400-dpi scanner is twice as sharp as one that scans at 1200 dpi and then interpolates to double the size of the image.

12.4 File compression

The numbers in Table 12.3 are *uncompressed* image sizes. Most bitmap images can be stored much more compactly through some form of *file compression*, of which there are two kinds, *lossless* and *lossy*.

Consider lossless compression first. Suppose a bitmap contains the row:

17 17 17 17 17 30 30 30 17 17 17 17 17

Repetitions of this kind are common in bitmap images. This example can be described more concisely as "five 17's, three 30's, and five 17's," or:

5 17 3 30 5 17

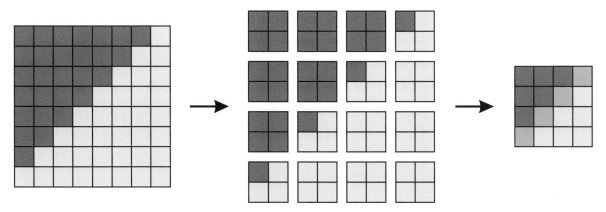

Figure 12.6 **How to shrink a bitmap. By averaging each group of pixels that are to be combined, the resampling algorithm preserves some information about features too small to show clearly.**

Figure 12.7 **How a bitmap is enlarged. First the pixel array is expanded, then the missing pixel values are filled in by averaging their neighbors. This reduces the stairstep appearance of diagonal lines.**

This is known as *run-length encoding*, and the original image can be reconstructed from the compressed image with no loss of information. TIFF (Tagged Image File Format) and other file formats provide for various compression algorithms based on run-length encoding and other techniques for detecting regular patterns and describing them concisely.

Often, lossless compression doesn't make an image small enough for its intended use (such as rapid transmission across the Internet), and there is no choice but to discard some of its information content, so that the decoded image will be similar, but not entirely identical, to the original. The most widely used lossy compression scheme is that of JPEG (Joint Photographic Experts Group). JPEG compression analyzes the image by means of a discrete cosine

transform in order to find, and selectively discard, low-contrast fine detail that is superimposed on higher-contrast features. Since that kind of fine detail is usually hard to see anyhow, JPEG compression can make an image file much smaller without noticeably degrading its visible appearance.

To give you a concrete example, the image in Fig. 12.1 is 900×1200 pixels, with one byte per pixel. Accordingly, it should occupy 1055 KB on disk, and that is precisely its size when saved as an uncompressed TIFF file. To my surprise, TIFF compression didn't help at all – when stored as a compressed TIFF file the image actually came out bigger, at 1160 KB. (Presumably those tiny star images didn't lend themselves to run-length encoding.)[2] Saved as an ASCII EPS file – which is a bulky way to store a

[2] An important theorem in computer science is that, for any lossless compression algorithm, there will be *some* files that cannot be made smaller. If this were not so, you could compress a file to nothing by running the same algorithm on it repeatedly.

bitmap, but necessary for the typesetting of this book – the same image occupied 2178 KB. But JPEG compression, specifying "medium" image quality, reduced it to a mere 358 KB.

The trouble with lossy compression is, of course, that it loses information. Lossy compression should never be performed on images that are going to undergo further digital image enhancement, since the low-contrast detail discarded by JPEG and similar algorithms is often exactly what the astronomer wants to bring out by further processing.

12.5 File formats

Regardless of the type of computer you use, there are several standard formats for bitmap images. The three most common are TIFF, promoted by Aldus (now Adobe); FITS (Flexible Image Transport System), from the International Astronomical Union; and BMP (Windows Bitmap, essentially a dump of the internal representation used by Microsoft Windows and OS/2). Of these, TIFF is by far the most popular. It provides for several different lossless compression schemes, of which the most popular is Lempel–Ziv–Welch (LZW), and it accommodates images with a variety of bit depths. The one fault of TIFF is that it's too versatile; some software doesn't actually accept all possible kinds of TIFF files. For instance, 16-bit monochrome TIFFs are common in astronomy but uncommon in the graphic arts, and not all software accepts them. Full specifications for TIFF can be downloaded from http://www.adobe.com. There are TIFF subformats for the differing byte orders of the PC and the Macintosh, but most software will accept both kinds of files.

FITS format is used only in scientific work; software not designed for astronomy generally doesn't accept FITS files. Unlike other graphics file formats, FITS files are readable as ASCII text; they even fit onto 80-column punched cards. The brightness levels can be floating-point numbers, enabling FITS files to record

extremely subtle distinctions. A real convenience for astronomers is the fact that FITS files provide space for information about the object being photographed, observer, exposure time, equipment, and calibration. FITS file specifications can be obtained from NASA at ftp://nssdc.gsfc.nasa.gov/pub/fits and from the newsgroup sci.astro.fits.

GIF, PCX, and BMP file formats are essentially more primitive forms of TIFF. As already noted, JPEG format, popular on the World Wide Web, involves lossy compression and is therefore not suitable for images that are to be processed further. (It's fine for displaying the end product of your labors.) PostScript (.PS, .EPS, .AI) is a vector graphics language, although PostScript files can contain bitmap images, and Adobe Photoshop can even store and reload bitmaps in PostScript form.

For more information about graphics file formats, including details of all those mentioned here, see Kay and Levine, *Graphics File Formats* (1995).

12.6 Getting images into the computer

The usual way to get a 35-mm film image into the computer is to use a slide and negative scanner. Technology is advancing rapidly, so I won't recommend any specific products, but the resolution should be at least 2400 dpi (real, not interpolated); almost all scanners meet this requirement. With coarse-grained film, you will often use a *scan pitch* of 2 or 3, combining pixels in 2×2 or 3×3 squares, to reduce the file size and conceal grain.

What is more important is the *bit depth* (number of bits per pixel) or *dynamic range* of the scanner, the range of brightnesses that it can digitize properly. The first scanners had a bit depth of 8 bits per pixel per color. That's fine for scanning normal-looking pictures, but in astronomical work, it leads to two problems. First, a low-contrast negative often uses only a small part of the scale, and as already noted, 256 shades of gray are

sufficient only when you're using all of them. If a negative uses only a tenth of the 256-step scale, then in effect you're scanning it with 26 shades of gray, which aren't enough.

Second, a dense slide or overexposed negative is likely to have areas that are more than 256 times as dark as other areas in the same picture. In that case, a 256-step, 8-bit scanner will not be able to record, in a single scan, all the detail in the picture. To some extent you can overcome this by making two scans with different exposures, then adding them mathematically, but it's better to have adequate dynamic range in the first place.

For these reasons, newer scanners have a bit depth of 10 or 12, giving 1024 or 4096 brightness levels for each color. The idea is to allow you some maneuvering room. Although the scanning software still produces 8-bit monochrome or 24-bit color images, you can adjust density, contrast, and curve shape before the image is output in 8-bit form, thus taking advantage of additional bit depth.

Even so, underexposed pictures do not scan well; they use too little of the available density range. With a dark, black slide or a nearly clear negative, you can often get a better scan by turning off auto exposure and setting the scanner exposure yourself.

Always scan color negatives and slides in color; if you want to convert them to monochrome, do that in software, afterward. When you scan a black-and-white negative, the scanner uses only green light, for maximum sharpness; that's usually not what you want to do with a color slide or negative, even if the end product is to be a black-and-white picture. In particular, when scanning with green light, the scanner does not see red nebulosity that records as green on color negatives.

Another way to get a picture into the computer is to scan a print. Color flatbed scanners normally resolve 300 dpi (adequate for any normal-sized print, though not for scanning negatives) with a bit depth of 8, producing 24-bit color images. The prints that scan best are those with slightly lower-than-normal contrast; the background of a star field should not be black.

Of course, you don't have to do the scanning yourself. Many camera stores and photo processing labs will do it for you, returning your images to you on CD-ROM. Kodak Photo CDs use a proprietary file format, but other labs (called "service bureaus" in the graphics industry) will deliver your pictures in TIFF or other standard formats.

Beware of excessively low-resolution scans. A good scan of a 35-mm slide or negative does not fit onto a 1.4-MB PC diskette. Casual snapshot photographers are often satisfied with 640×480-pixel images, but you'll need much higher resolution, more like 2000×3000, or at least 1000×1500 for a scan of the entire negative.

12.7 Scanner artifacts

Scanners aren't perfect. A scanner uses a linear array of CCD sensors to detect light, and particularly at low brightness levels, the sensors aren't all equal. If you raise the contrast of the dark areas of a color slide, you're likely to get visible streaks or tartan-like patterns in the picture.

Raising the threshold for maximum black will reduce the problem. So will using a pitch of 2 or higher, i.e., telling the scanner to combine adjacent pixels. That's one reason for using a high-resolution scanner; the resolution should still be adequate for some purposes even with pitch greater than one.

Proper maintenance helps keep a scanner performing well. Many scanners have a calibration procedure to compensate for aging of the CCD sensors or light sources; read the instruction book and don't hesitate to send the scanner to the repair shop every couple of years.

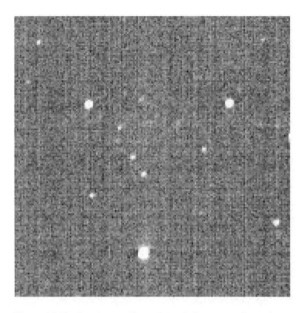

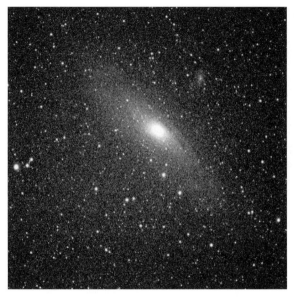

Figure 12.8 **Scanner artifacts (streaks) are prominent in this portion of a scanned image from a severely underexposed slide. Remedies: adjust scanner exposure, set a high threshold for minimum black, or copy the slide on film in a slide duplicator.**

Figure 12.9 **Raising contrast digitally can bring out faint outer parts of galaxies, as well as lots of film grain. M31, 6-minute exposure with 300-mm *f*/4.5 lens on Kodak Ektapress Multispeed (PJM) from a light-polluted site. (By the author)**

If you can't eliminate irregularities in your scanner, you can measure them and counteract them. Put a gelatin neutral density filter or a uniformly exposed piece of film in a slide mount, scan it, and use the result exactly like a flat-field calibration frame from a CCD camera (p. 250).

Better yet, take pictures that fall into the density range that your scanner handles well, and use a slide duplicator as a first step in dealing with really underexposed slides.

preflashing the film before making deep-sky exposures. You can easily remove the fog by raising the contrast later.

Third, use fine-grained film. Digital processing often involves enormous increases in contrast, and today's scanners are definitely sharp enough to see grain. For the same reason, be especially wary of scratching the film; the same techniques that bring out faint stars will bring out scratches, as happened in one place in Fig. 12.2.

12.8 PRACTICAL NOTE:
Taking pictures that scan well

How do you take pictures that will scan well? First, use 35-mm film. Scanners for larger formats are uncommon, and the resulting files can be gigantic.

Second, don't underexpose. In this situation, note that sky fog can be your friend. It helps bring the important parts of the picture into the middle of the density range, where the scanner responds best. You might even consider

12.9 The ethics of retouching

It's important to make a clear distinction between *processing* an image and *retouching*. By "processing" I mean applying some algorithm uniformly to the whole picture to enhance the visibility of the features that were already there. "Retouching" means altering particular pixels by deliberate action – taking out a dust speck here, "drawing in" a feature there, and so forth.

Figure 12.10 **A picture that has been retouched. Such a picture can have some value as a drawing that records a visual observation, but it is no longer a photograph.**

Clearly, retouching can raise ethical questions. Is it legitimate to take a photograph of Jupiter and "draw in" features that you saw through the telescope even though they did not show on the film? Yes, if you explain what you did; otherwise, definitely not.

Even removing dust specks and airplane trails can be problematic. What if the dust speck was hiding a nova? You end up with a picture that tells a lie – it says the nova wasn't visible at a time when it actually was.

In my opinion, removing dust and airplane trails can be a legitimate way to improve the esthetics of a star-field picture, but when you do it, you should clearly note that it has been done. Also, it's better to tone down blemishes rather than remove them completely; that way, a careful observer can tell that, indeed, there is a flaw in the image, although you've made it much less distracting.

A related question that arises is whether it is legitimate to use enhancement algorithms that result in an unnatural-looking picture. "Unnatural" is in the eye of the beholder; almost all astronomical photographs are "unnatural" insofar as they show celestial objects much brighter and larger than they would appear to the unaided eye.

My answer is that the purpose of astrophotography is to make things visible. If an unusual kind of processing helps to bring out the features of a celestial object, do it, even if the result is not like anything you would ever see by viewing the object directly. Of course, if an image is unrealistic in a misleading way (such as a false-color image of a planet), it should be clearly labeled as such.

12.10 Manipulating the characteristic curve

Computers make it possible to adjust the contrast and brightness of an image far beyond what could be done in the darkroom or slide duplicator. This is done by altering the characteristic curve that maps the original brightness of the image to the brightness of the display.

Figures 12.11–12.13 show the basic manipulations. A *straight scan* (a) uses the entire dynamic range of the scanner. This is more than most pictures need, so it is usual practice to *scale* the characteristic curve to fit the brightness range actually used (b). A related technique is *raising the threshold* (c), discarding all pixels below a certain minimum brightness; this helps get rid of sky fog and irregularities in the scanner itself.

A steeper curve results in higher contrast (d); a flatter curve lowers the contrast (e). If the curve slants the wrong way, you get a negative image (f), useful for making star maps.

Changes in the shape of the curve are especially useful. Most pictures, astronomical and terrestrial, benefit from lightening the midtones (g). Darkening the midtones (h) can reduce sky fog in severe cases.

In electronic imaging, the term *gamma* (γ) refers to the shape of the curve rather than its slope (cf. p. 177), and alterations in curve shape are known as *gamma correction*. Positive gamma correction means raising the middle of the curve, and negative gamma correction means lowering it.

Expanding the midtones (i) is a way of raising contrast selectively without discarding the ends of the scale; it is particularly good for planetary work. The opposite transformation, compressing the midtones (j), is useful with pictures whose important details are all at the two ends of the scale (underexposed and overexposed), as sometimes happens with deep-sky images.

The curve need not be smooth. By changing it into a stairstep, you can posterize a picture (k). You can even turn a picture into a contour map (l). These

(a) Straight scan (unmanipulated)

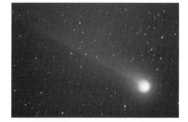

(b) Straight, scaled to the brightness range of the picture

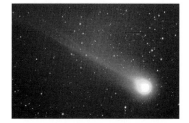

(c) Straight, raised threshold

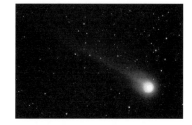

(d) Straight, increased contrast

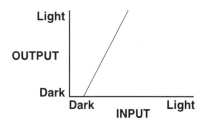
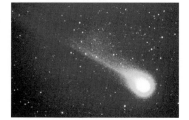

Figure 12.11 **Curve shape manipulations.**

(e) Straight, reduced contrast

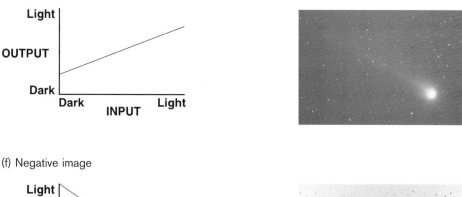

(f) Negative image

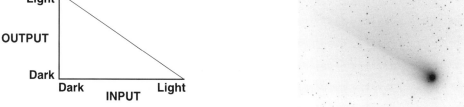

(g) Lightened midtones (positive gamma correction, logarithmic scaling)

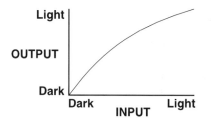
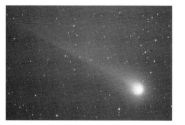

(h) Darkened midtones (negative gamma correction, exponential scaling)

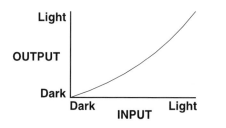
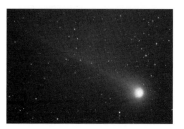

Figure 12.12 **Curve shape manipulations (continued).**

(i) Expanded (stretched) midtones

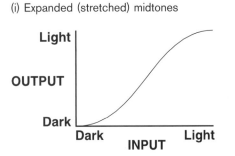

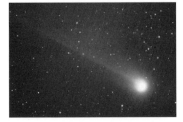

(j) Compressed midtones

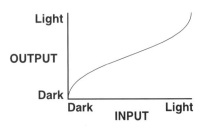

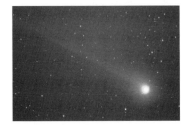

(k) Posterized (4 levels)

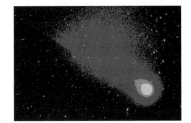

(l) Contour map

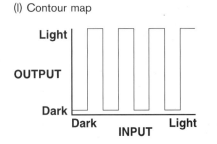

Figure 12.13 **Curve shape manipulations (continued).**

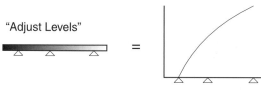

"Adjust Levels"

Figure 12.14 **The user interface for curve shape adjustment sometimes consists of three triangles on a scale from black to white. The left and right triangles set the ends of the curve; the middle triangle sets the point at which the curve passes through 50%. Move the middle triangle to the left to lighten the midtones.**

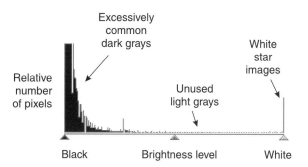

Figure 12.15 **Histogram of a typical deep-sky photograph that needs its midtones lightened. Note the three triangles as in Fig. 12.14.**

transformations make it possible to see *isophotes*, contours of equal brightness useful for tracing out the shape of a comet or nebula. The resulting pictures are quite unrealistic but have scientific value. Bear in mind that the isophotes contain jagged errors due to film grain.

If at all possible, curve manipulations should be done while scanning, while you have the full bit depth of the scanner available. Many scanners scan at 10 to 12 bits per pixel but save only 8 bits per pixel on disk. By adjusting the curve while scanning, you can use these 8 bits as effectively as possible.

Even if your software doesn't allow you to edit the curve, you can do some curve shape manipulation while adjusting the white and black levels. Typically you are allowed to adjust three points: the left-hand and right-hand ends of the curve and the place where the curve is halfway up the scale (Fig. 12.14).

12.11 Working with histograms

A histogram is a graph of how frequently things occur. Specifically, in computer graphics, a histogram shows how many pixels there are at each brightness level. For example, Figure 12.15 shows a histogram of a typical deep-sky photograph that needs its midtones lightened – easily done by moving the middle triangle leftward, closer to the bunch of dark grays, which will spread out when you do so.

In general, the histogram tells you what parts of the characteristic curve need expanding. The horizontal scale at the bottom of the histogram is the same as that of the characteristic curves. Peaks in the histogram correspond to areas where the curve needs to be steeper.

Many software packages perform *histogram equalization* automatically; that is, they will automatically expand and compress various parts of the

characteristic curve to make the histogram more even. This is a boon for ordinary photography, but with astronomical images it tends to be thrown off by the solid black background. Use automatic histogram equalization with caution.

12.12 Manipulating color

Most graphics editing programs make it easy to perform the same color manipulations that you could do with filters in the slide duplicator – that is, shift the overall color balance toward red, green, or blue. But there's more. The computer can do things to color that could never be done with filters.

Instead of one characteristic curve, a color image actually has three. You can manipulate the red, green, and blue curves independently. For example, you can set different curves for blue and green (the color of sky fog) than for red (the color of nebulosity). In deep-sky photographs, I find it useful to lighten midtones in red while darkening midtones in blue and green.

You can also increase color saturation – that is, you can make all the colors more vivid. To increase saturation, the computer takes the levels of red, green, and blue, averages them, and then makes each of them farther from the average. The results range from beautiful to garish. Many of us have seen space-probe pictures of Jupiter and Saturn with artificially saturated color.

Plate 12.2b shows the result of artificially increasing the color saturation in a picture of the moon; the film has an overall reddish cast, but Mare Tranquillitatis stands out as bluer than its surroundings, a subtle difference of hue that has been confirmed photometrically (Morris, 1996).

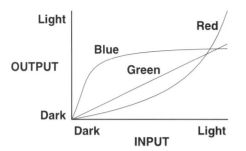

Figure 12.16 **Unusual characteristic curves used in Plate 12.2c to translate brightness into hue. Highlights come out red, shadows blue.**

You can even use false color to make low-contrast details more visible. Plate 12.2c shows the same picture of the moon, converted to monochrome and then processed with the three curves in Fig. 12.16. Darker features are blue; midtones include some green; but only the highlights contain substantial amounts of red. As a result, subtle shades of gray are transformed into dramatic variations in hue.

12.13 Enhancing detail

Manipulating the brightness of pixels is not the only thing you can do with a computer. You can also sharpen pictures to bring out fine detail.

One way to enhance detail is to increase differences between adjacent pixels, thereby raising the contrast at boundaries. How this is done is fairly complicated and is explained on pp. 237–238. The basic idea is that if a pixel is like its neighbors, it should be left alone, but if it is different from its neighbors, either brighter or darker, the difference should be increased. In graphic arts software, this type of

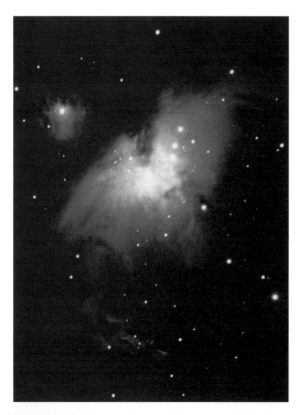 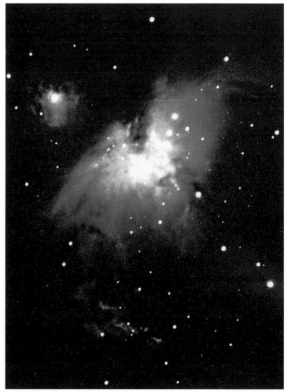

Figure 12.17 **Unsharp masking selectively increases contrast of fine details. Image from Plate 8.10.**

Figure 12.18 **Too much unsharp masking produces dark rings around stars, especially if you increase the contrast afterward.**

enhancement is called *sharpening* and can often correct blurring due to inaccurate focus, diffraction, or atmospheric turbulence. It works best with images that are already rather sharp and need just a bit of help.

Another technique is *unsharp masking*, i.e., making a blurred copy of a picture and subtracting it from the original. This is much easier to do electronically than on film, and the results are shown in Fig. 12.17.

Unsharp masking is especially good for bringing out detail in nebulae and in blurry planet images. Taken too far, though, it produces ripply images and dark haloes around stars (Fig. 12.18). For best results, adjust contrast and brightness before unsharp masking, not afterward.

12.14 PRACTICAL NOTE:
An example of digital enhancement

Plate 12.1a–f shows how a mediocre, sky-fogged picture of the Rosette Nebula was enhanced by computer. The original picture was a 20-minute exposure on Ektachrome 100 HC with a 180-mm $f/2.8$ lens at a rather light-polluted site. It was scanned in with a Minolta QuickScan scanner at pitch 2, giving 1200 dpi. The six frames in Plate 12.1 show how it was processed step by step:

(a) Straight scan.
(b) Scanner adjusted for higher overall contrast.
(c) Increased contrast in red; darkened midtones in blue and green.
(d) Raised threshold in blue and green to get rid of star haloes caused by chromatic aberration in the telephoto lens.
(e) Applied Gaussian blur (1.0-pixel radius) to remove grain and remove scanner artifacts.
(f) Unsharp masked (radius = 20 pixels) to enhance detail in nebula.

All that is from a picture that looked quite bad to begin with. Consider what digital processing can do to *good* pictures!

12.15 Combining images

It is much easier to combine images digitally than on film. Adobe Photoshop and other software packages let you scan images separately, then combine them under software control.

In lunar and planetary work, combining images gives you a way to smooth out the effects of atmospheric turbulence while eliminating film grain. The grain is, of course, different on each slide or negative.

There's another reason to combine deep-sky images – to build up faint details that are only barely visible in each individual negative. Here the ability to reduce film grain is especially valuable. Plates 12.5 and 12.6 show what can be achieved.

Do not hesitate to combine images that were taken with the same lens on different films or under different conditions. Tricolor images (p. 211) can easily be combined by software.

12.16 Printing out the results

Once you've created a digital image, what do you do with it? If you want to post it on your web page, you'll probably want to reduce it (making it perhaps 400 pixels wide) and apply JPEG compression.

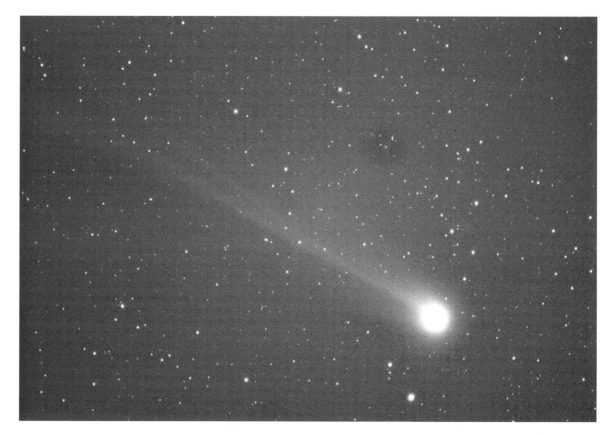

Figure 12.19 **The final product from the image in Figs. 12.11–12.13. Comet Hyakutake, 6-minute exposure on Fuji Sensia 100 with a 180-mm lens at $f/2.8$. Digitized, scaled to increase contrast, midtones slightly expanded, unsharp-masked, retouched to remove a dust spot.**

More commonly, though, you want a print or slide. Although the price of good color printers is coming down, most computer artists still prefer to use a service bureau (digital photo lab) to get images printed out. For a few dollars, you get a full-page (A4 or 9×12-inch) dye-sublimation or wax-transfer print, almost indistinguishable from a real photograph.

Digital images can also be recorded on film. Service bureaus can use film recorders to produce perfect 35-mm or 4×5 transparencies of your images.

Or you can photograph the computer screen. To do this, darken the room, put the camera on a tripod, and, if possible, use a medium telephoto lens (80 to 135 mm). Expose for at least 1/8 second so that the electron beam scans the screen several times during the picture. If the image consists of stars on a black background, take an exposure meter reading of a mid-gray screen display rather than the star field itself.

12.17 Image enhancement theory: spatial frequency

You're probably familiar with the idea of breaking up a sound wave into low- and high-frequency components (bass and treble) and adjusting the levels of high and low frequencies separately.

Images can also be broken up into low and high frequencies. Figure 12.20 shows what this means. Small details in the image correspond to high frequencies; large features correspond to low frequencies.

In fact, an image can be separated into as many different frequency bands as you like by a process called a *Fourier transform*. Some of the most sophisticated image processing techniques – which we won't go into here – actually perform the Fourier transform, converting the image into a frequency spectrum and then back into an image.

The concept of *spatial frequency* gives us a way to describe exactly what is done by smoothing and

Complete waveform

Low-frequency components

High-frequency components

Figure 12.20 Sound waves can be broken into low- and high-frequency components. So can images.

sharpening operations. Smoothing is like turning down the treble; it reduces the high-frequency component of the image. That is, smoothing operations are *low-pass filters.*

Sharpening is the opposite; sharpening an image emphasizes its high frequencies and cuts the low frequencies, like turning down the bass. Sharpening operations are therefore *high-pass filters.*

What is really needed, in general, is a *band-pass filter* that will pass a range of frequencies while eliminating everything outside it. We want to reject the very highest frequencies, which consist of film grain and CCD noise, and the lowest frequencies, which represent uneven illumination and vignetting. The interesting parts of the picture lie in the middle frequencies.

That's why it's common to process an image with a (low-pass) smoothing filter to get rid of grain, followed by unsharp masking or a (high-pass) sharpening filter to bring out detail. The two operations together form a band-pass filter.

Frequencies of sounds are measured in cycles per second (= Hertz); spatial frequencies are measured in cycles per pixel, invariably a number less than 1 because nothing in the image can be smaller than a pixel. For example, a pattern that recurs every 3 pixels has a spatial frequency of 1/3 pixel. The frequencies of interest in most digitized images range from about 1/2 to 1/100 pixel.

One thing image filters have in common with audio filters is the ability to "ring" or echo. The dark circles that surround stars in a sharpened picture are an example of ringing – they indicate that a high-frequency

component of the image has been amplified far beyond what was originally present. The narrower the frequency band that a filter picks out, the more likely it is to "ring" at that frequency, producing spurious stripes or wavy effects.

Indeed, bandpass filtering can confuse astronomers. Do the patches on a picture of Jupiter reflect real features on the planet, or are they the effect of random noise from film grain, carefully filtered so that it *looks* like planetary detail? Sometimes the only way to find out is to examine another picture.

12.18 PRACTICAL NOTE:
Signal and noise

Astronomical images have at least two kinds of inaccuracy built in: random noise (from irregularities in the CCD, film grain, and the like), and *quantization error* resulting from force-fitting everything into discrete pixels with discrete integer brightness values.

Just as with audio signals, these inaccuracies are called *noise,* and our task is to separate the noise from the signal. Thus we use smoothing filters to remove grain, sharpening filters to remove optical aberrations, and maximum-entropy deconvolution to reduce the effects of quantization error.

12.19 Convolutions, 1: smoothing

Now let's look at how smoothing and sharpening are actually done. Consider smoothing (blurring) first. Intuitively, if you want to smooth or blur an image, you can do it by averaging each pixel with its neighbors. To describe this process precisely, imagine a 3 × 3 square window that you can place anywhere on the picture:

$$\begin{bmatrix} a & b & c \\ d & e & f \\ g & h & i \end{bmatrix}$$

To smooth an image, you place e successively on each pixel in the original image. For each pixel, compute the corresponding pixel in the new image as follows:

New pixel corresponding to e
$$= \frac{a+b+c+d+e+f+g+h+i}{9}$$

That's simply the average of the pixels in the window. It turns out to be better to compute a weighted average, giving the original e a bit more weight than its neighbors:

New pixel corresponding to e
$$= \frac{a+b+c+d+2e+f+g+h+i}{10}$$

The new image is kept separate from the old one, of course, so that it won't disturb computations that still need to see the old pixels. Information is lost at the edges of the picture; you can't put e on an edge pixel unless you assume (as is standard practice) that the picture is surrounded by an infinite array of zeroes. We can summarize these two formulae in matrix form as

$$\begin{bmatrix} 1 & 1 & 1 \\ 1 & 1 & 1 \\ 1 & 1 & 1 \end{bmatrix}$$ **3 × 3 uniform box smoothing filter**

and

$$\begin{bmatrix} 1 & 1 & 1 \\ 1 & 2 & 1 \\ 1 & 1 & 1 \end{bmatrix}$$ **3 × 3 Gaussian box smoothing filter**

respectively. The matrix gives the coefficients by which a, b, c, etc., are to be multiplied; the result is then divided by the sum of the numbers in the matrix. Note that the filters have names; we'll define "Gaussian" shortly.

Applying a matrix to an image in this way is called *convolving* it or performing a *convolution*, and the convolution matrix is sometimes called a *kernel*. Many software packages let you specify your own convolution matrix, since convolution is extremely versatile. Figures 12.21–12.23 show some of the things convolution can do.

Mathematically, convolution is equivalent to multiplying the frequency spectrum of the image with that of the filter matrix, so convolutions can change frequency response in almost any way imaginable. For example, the uniform box filter contains no features smaller than than 3 pixels wide; that means it has no frequencies higher than 1/3 pixel. When convolved with an image, it gets rid of spatial frequencies of 1/3 pixel and lower.

Box filters have one obvious fault – they are not *isotropic*; that is, they don't have the same effect in all directions. Being square, they blur diagonal lines more than horizontal or vertical ones. To reduce this problem, you can use a cross-shaped filter such as this:

$$\begin{bmatrix} 0 & 1 & 0 \\ 1 & 2 & 1 \\ 0 & 1 & 0 \end{bmatrix}$$ **3 × 3 Gaussian cross smoothing filter**

Even better, you can use this filter, which is almost perfectly isotropic because the numbers in the corners are reduced by just the right factor:

$$\begin{bmatrix} 1 & 2 & 1 \\ 2 & 4 & 2 \\ 1 & 2 & 1 \end{bmatrix}$$ **3 × 3 Gaussian isotropic smoothing filter**

Recall that the last step in the convolution is to divide by the sum of the numbers in the matrix, so the fact that the numbers are somewhat larger here – with 4 instead of 2 in the middle – is not a problem.

Gaussian filters attenuate high frequencies more smoothly than uniform filters do. Consider, again, the 3 × 3 uniform filter. Obviously, that filter is good at eliminating the component of the signal whose frequency is 1/3 pixel. A signal at that frequency can't

(a) Original image

(b) 3 × 3 uniform box smoothing

$$\begin{bmatrix} 1 & 1 & 1 \\ 1 & 1 & 1 \\ 1 & 1 & 1 \end{bmatrix}$$

(c) 3 × 3 Gaussian isotropic smoothing

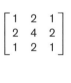

$$\begin{bmatrix} 1 & 2 & 1 \\ 2 & 4 & 2 \\ 1 & 2 & 1 \end{bmatrix}$$

(d) 5 × 5 Gaussian isotropic smoothing

$$\begin{bmatrix} 1 & 4 & 6 & 4 & 1 \\ 4 & 16 & 24 & 16 & 4 \\ 6 & 24 & 36 & 24 & 6 \\ 4 & 16 & 24 & 16 & 4 \\ 1 & 4 & 6 & 4 & 1 \end{bmatrix}$$

Figure 12.21 **Convolutions: smoothing filters.**

(e) 3 × 3 cross sharpening

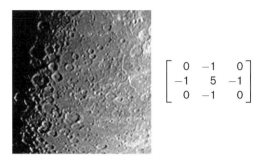

$$\begin{bmatrix} 0 & -1 & 0 \\ -1 & 5 & -1 \\ 0 & -1 & 0 \end{bmatrix}$$

(f) 3 × 3 Gaussian sharpening

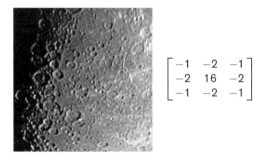

$$\begin{bmatrix} -1 & -2 & -1 \\ -2 & 16 & -2 \\ -1 & -2 & -1 \end{bmatrix}$$

(g) 5 × 5 Gaussian sharpening

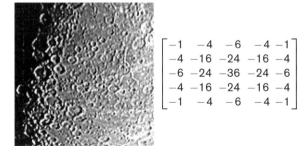

$$\begin{bmatrix} -1 & -4 & -6 & -4 & -1 \\ -4 & -16 & -24 & -16 & -4 \\ -6 & -24 & -36 & -24 & -6 \\ -4 & -16 & -24 & -16 & -4 \\ -1 & -4 & -6 & -4 & -1 \end{bmatrix}$$

(h) 3 × 1 horizontal sharpening

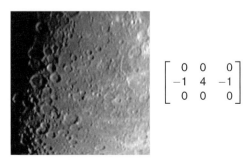

$$\begin{bmatrix} 0 & 0 & 0 \\ -1 & 4 & -1 \\ 0 & 0 & 0 \end{bmatrix}$$

Figure 12.22 **Convolutions (continued): sharpening filters.**

(i) 3 × 3 discrete Laplacian operator

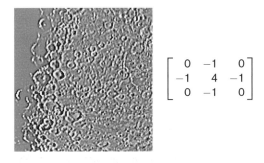

$$\begin{bmatrix} 0 & -1 & 0 \\ -1 & 4 & -1 \\ 0 & -1 & 0 \end{bmatrix}$$

(j) Diagonal first derivative (embossing)

$$\begin{bmatrix} -1 & 0 & 0 \\ 0 & 1 & 0 \\ 0 & 0 & 0 \end{bmatrix}$$

Figure 12.23 Convolutions (continued): edge-finding filters. To keep the brightness in the middle of the range, a constant was added to every pixel after convolution.

$$\begin{bmatrix} 1 & 4 & 6 & 4 & 1 \\ 4 & 16 & 24 & 16 & 4 \\ 6 & 24 & 36 & 24 & 6 \\ 4 & 16 & 24 & 16 & 4 \\ 1 & 4 & 6 & 4 & 1 \end{bmatrix}$$

$$\begin{bmatrix} 1 & 6 & 15 & 20 & 15 & 6 & 1 \\ 6 & 36 & 90 & 120 & 90 & 36 & 6 \\ 15 & 90 & 225 & 300 & 225 & 90 & 15 \\ 20 & 120 & 300 & 400 & 300 & 120 & 20 \\ 15 & 90 & 225 & 300 & 225 & 90 & 15 \\ 6 & 36 & 90 & 120 & 90 & 36 & 6 \\ 1 & 6 & 15 & 20 & 15 & 6 & 1 \end{bmatrix}$$

But even Gaussian filters aren't necessarily the best. An even better way to cut off higher frequencies while preserving lower ones is to use a higher-order low-pass filter. These are discussed by Jähne (1995, p. 148); here is one of them:

$$\begin{bmatrix} -1 & -4 & -6 & -4 & -1 \\ -4 & 16 & 40 & 16 & -4 \\ -6 & 40 & 92 & 40 & -6 \\ -4 & 16 & 40 & 16 & -4 \\ -1 & -4 & -6 & -4 & -1 \end{bmatrix}$$ **5 × 5 second-order smoothing filter**

The negative numbers around the edge give sharper rejection of high frequencies.

get through it at all. However, some *higher* frequencies can sneak through, at least partially. For example, a frequency of 1/2 pixel will not be completely wiped out because a 2×2 feature will never be perfectly centered on the 3×3 filter.

Giving some extra weight to the central pixel, as in the Gaussian filter, helps overcome this problem. You can think of the 3×3 Gaussian filter as a combination of 3×3, 2×2, and 1×1 uniform filters.

These filters are called Gaussian because the numbers diminish, from center to edge, according to what statisticians call a *normal, bell-curve,* or *Gaussian* function (discovered by Karl Friedrich Gauss, 1777–1855). Jähne (1995, pp. 122–124) shows how to construct integer Gaussian filters by cross-multiplying the rows in Pascal's Triangle. (He calls them *binomial* filters – the integer special case of the Gaussian function.) Here are some larger Gaussian isotropic smoothing filters:

12.20 PRACTICAL NOTE:
Median filters

Sometimes the best way to smooth an image is to take the median of adjacent pixels rather than the average. This is the case if you have a basically normal image peppered with occasional pixels that are wildly deviant, such as "hot pixels" in a CCD camera.

If you took the average, every deviant pixel would have some effect. When you take the median, you simply throw out the numbers at the ends of the range. For example, the median of

10, 20, and 255 is 20, but the average is 95. If the 255 value is a "hot pixel," it should be ignored (by taking the median) rather than averaged in.

For this reason, many software packages include a median filter or "dust and scratches" filter to reject pixels whose values are too far from those of their neighbors.

12.21 Convolutions, 2: sharpening

Now consider how you might *sharpen* an image. Intuitively, what you want to do in this case is *increase* the difference between each pixel and its neighbors. We've already seen that this can be done by unsharp masking, i.e., by making a blurred copy of the image and subtracting it from the original.

Can you do all of this in a single convolution? Yes. As you might expect, the key idea is to average the surrounding pixels and subtract them from the original pixel, which has to be multiplied by a constant first so that it doesn't come out negative. Clearly, this can be done by matrices something like these:

$$\begin{bmatrix} -1 & -1 & -1 \\ -1 & 9 & -1 \\ -1 & -1 & -1 \end{bmatrix} \quad \textbf{3} \times \textbf{3 box sharpening filter}$$

$$\begin{bmatrix} 0 & -1 & 0 \\ -1 & 5 & -1 \\ 0 & -1 & 0 \end{bmatrix} \quad \textbf{3} \times \textbf{3 cross sharpening filter}$$

Notice that the number in the middle is chosen to be 1 + the sum of the other numbers; that way, any expanse of uniform brightness will remain unchanged. These filters work well, and plenty of people use them.

We can do better. What's really needed is a filter that will perform a Gaussian blur and then subtract the blur rather than adding it. Such a filter is easy to construct by the following recipe (following Jähne 1995, p. 140):

- Start with a Gaussian filter of the appropriate size.
- Sum the numbers in the matrix; call the sum *s*.
- Reverse the sign of all the numbers (make them negative).
- Finally, put *s* (which is positive) in place of the central element.

For example, from

$$\begin{bmatrix} 1 & 2 & 1 \\ 2 & 4 & 2 \\ 1 & 2 & 1 \end{bmatrix}$$

we get

$$s = (1 + 2 + 1) + (2 + 4 + 2) + (1 + 2 + 1)$$
$$= 16$$

and construct:

$$\begin{bmatrix} -1 & -2 & -1 \\ -2 & 16 & -2 \\ -1 & -2 & -1 \end{bmatrix} \quad \textbf{3} \times \textbf{3 Gaussian isotropic sharpening filter}$$

Filters of this kind come surprisingly close to being the exact inverse of the corresponding Gaussian smoothing filter. That is fortunate, because Gaussian blur is a good model of the degradation that images suffer due to atmospheric turbulence, focusing errors, optical defects, and diffraction. Here are larger Gaussian sharpening filters:

$$\begin{bmatrix} -1 & -4 & -6 & -4 & -1 \\ -4 & -16 & -24 & -16 & -4 \\ -6 & -24 & 256 & -24 & -6 \\ -4 & -16 & -24 & -16 & -4 \\ -1 & -4 & -6 & -4 & -1 \end{bmatrix}$$

$$\begin{bmatrix} -1 & -6 & -15 & -20 & -15 & -6 & -1 \\ -6 & -36 & -90 & -120 & -90 & -36 & -6 \\ -15 & -90 & -225 & -300 & -225 & -90 & -15 \\ -20 & -120 & -300 & 4096 & -300 & -120 & -20 \\ -15 & -90 & -225 & -300 & -225 & -90 & -15 \\ -6 & -36 & -90 & -120 & -90 & -36 & -6 \\ -1 & -6 & -15 & -20 & -15 & -6 & -1 \end{bmatrix}$$

In practice, sharpening filters larger than 5×5 are seldom used; unsharp masking is used instead.

If, instead of using s, you choose the central number so that the matrix sums to 0, you get an *edge finder* (edge detector) – that is, you get a convolution that picks out areas where the brightness undergoes a sudden change. Here's an example:

$$\begin{bmatrix} -1 & -2 & -1 \\ -2 & 12 & -2 \\ -1 & -2 & -1 \end{bmatrix}$$ **3 × 3 Gaussian edge finder**

Edge finders are very important in computer vision and automated analysis of images. In fact, there is good reason to believe the human brain uses an edge finder to process visual images. This is shown by the fact that people find it natural to make and use outline drawings, which look like the output of an edge finder applied to the images produced by our eyes.

None of these convolutions is equivalent to unsharp masking the way we normally do it – that would require an enormous matrix to produce a sufficient amount of blur. That's why unsharp masking and sharpening of fine detail are generally best handled as two separate steps. The filters are, however, equivalent to unsharp masking with a small radius of blur.

12.22 The Laplacian operator

Collectively, sharpening filters are called *Laplacian filters* because they compute an approximation of the Laplacian operator, i.e., the second derivative in two directions (studied by Pierre Simon de Laplace, 1749–1827). The mathematics behind this is worth trying to grasp, at least intuitively.

Think of the image as a function $f(x, y)$ that maps x and y onto brightness. Now consider the derivative of f – that is, the rate of change of brightness with respect to position. If you want to find fine detail in the image, the derivative helps you because it tells you where the brightness is non-uniform. But the first derivative doesn't do the whole job; it is nonzero on gradients of all sizes, not just fine detail.

The second derivative of f – that is, the rate of change of the rate of change – is more useful because it is zero not only in areas of uniform brightness, but also along smooth gradients. It swings positive and negative only at sharp boundaries.

This special kind of second derivative, taken in two directions x and y at once, is called a *Laplacian operator*:

$$\nabla^2 f = \partial^2 f / \partial x^2 + \partial^2 f / \partial y^2$$

(Don't worry if you don't understand this formula.) The discrete Laplacian operator corresponds to the convolution

$$\begin{bmatrix} 0 & -1 & 0 \\ -1 & 4 & -1 \\ 0 & -1 & 0 \end{bmatrix}$$ **3 × 3 discrete Laplacian operator**

which, by itself, operates as an edge finder; add 1 to the central element, and you get the sum of the original image with its Laplacian, as in the cross-shaped sharpening filter at the beginning of this section.

If you take the first derivative rather than the second, you get an embossed effect. To fully appreciate this, you have to add a constant to every pixel after convolution, to bring the brightness up to mid-gray level. Here is a convolution that approximates the first derivative:

$$\begin{bmatrix} -1 & 0 & 0 \\ 0 & 1 & 0 \\ 0 & 0 & 0 \end{bmatrix}$$ **Diagonal embossing filter**

Notice that the embossing filter is directional. So is a filter like the following, which sharpens the image in only one direction:

$$\begin{bmatrix} 0 & 0 & 0 \\ -1 & 4 & -1 \\ 0 & 0 & 0 \end{bmatrix}$$ **3-pixel Gaussian horizontal sharpening filter**

This is derived from the one-dimensional Gaussian filter [121] by Jähne's recipe. It is useful in dealing with images that have been blurred slightly in one direction by imperfect guiding. A more sophisticated algorithm to correct motion blur is given by Gonzalez and Woods (1993, p. 278, formula 5.4-36).

12.23 PRACTICAL NOTE:
Convolution or deconvolution?

Convolution and deconvolution are supposed to be opposites, but often the same operation is called by both names. How can this be?

The answer is that any convolution can (in theory) be undone by another convolution. In practice, results are not perfect because information is lost; when you convolve an image, you squeeze it into the finite set of available pixel positions and color values, and anything falling in between pixels or colors is changed or lost.

Images are convolved not only by computers, but also by atmospheric turbulence and lens defects, both of which are low-pass filters. Restoring a blurred image is, of course, deconvolution, even if the original convolution wasn't performed arithmetically.

12.24 Maximum-entropy deconvolution

If you know what the image is supposed to look like, you can devise an intelligent filtering algorithm that puts that knowledge to use. Intelligent filtering is risky; if the computer or the observer "knows" too much, it or he will "see" things that aren't there. A century ago, telescopic astronomers "knew" Mars was criscrossed by straight lines (the "canals"), so the image processors in their brains happily connected all sorts of small irregular features to make straight lines. When space probes demonstrated that the canals did not exist, the news came as something of a shock. See Sheehan (1996) for the whole story.

Nonetheless, intelligent or guided filtering has its uses. The most common problem in astronomy is *deblurring* (undoing blur), where the nature of the blur is at least partly known. The technology to do this became very important in 1990 when it was discovered that the Hubble Space Telescope had defective optics. Computer programs were developed to correct the optical defects after the images were transmitted to earth.

Any convolution can be undone by another convolution. Accordingly, if you know the *point spread function* (the effect of the blur on each point in the image), you can, in theory, compute an inverse convolution that has exactly the opposite effect, and apply it. This is called *algebraic deconvolution.*

In astronomy we very often *do* know the point spread function because we photograph stars, which are point sources. Accordingly, deblurring ought to be easy. In practice, however, the results of algebraic deconvolution are easily thrown off by small errors from film grain or CCD noise, quantization error, and the like.

Accordingly, instead of *computing* the inverse convolution, we want the computer to *approximate* it, correcting small errors by following some criterion of what is reasonable. One of the best criteria is the fact that good images are simple; speckles and small haphazard fluctuations are likely to be errors. Information

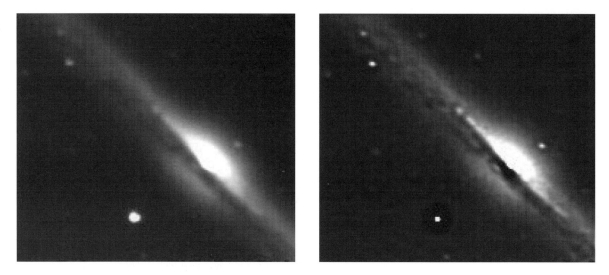

Figure 12.24 **Maximum-entropy deconvolution uses a star image to determine the nature of the blur, then corrects it across the entire picture. This CCD image of NGC 4565 was processed with MaxIm DL software from Cyanogen Productions. (Reproduced by permission of Cyanogen Productions, Inc.)**

theorists call this criterion *maximum entropy*, where entropy means, roughly, smoothness or simplicity. *Maximum-entropy deconvolution* can indeed fix minor blurring or trailing, using a star image as a guide. Another, similar technique is the *Richardson–Lucy algorithm*. Both of these are based on probability theory and on the assumption that random noise has a Gaussian distribution.

Deconvolutions of this type require lots of computer time – minutes to hours on a Pentium, days on the mainframe computers of yore – but the results are often distinctly better than what can be achieved with ordinary sharpening filters. They work best with CCD images because CCDs respond to light linearly. Because film is nonlinear, film images tend to have a different point-spread function in bright areas of the picture than in dark areas.

What if the point-spread function isn't known? It turns out that by using the maximum-entropy or Richardson–Lucy criteria, the computer can recover *both* the point-spread function and the deconvolved image. This is known as *blind deconvolution* because the computer doesn't know, in advance, what to do. The usual practice is to assume that the point-spread function is a Gaussian blur, then refine the guess as the computation proceeds. Blind deconvolution techniques are still being developed. Fortunately, because of the Internet and the abundance of good computers in amateur hands, amateurs need not lag behind the professional state of the art.

The literature on these subjects is very technical, but see Gull and Daniell (1978), Hanisch, White, and Gilliland (1997), and Jefferies and Christou (1993) for the basic techniques, and Meinel (1986) for a useful summary of algorithms.

CCD imaging

Astrophotography need not involve film. The newest method, used at most observatories and on the Hubble Space Telescope, uses a *charge-coupled device* (CCD) as an electronic image sensor. The images are downloaded directly into a computer in digital form.[1] CCDs are now within reach of amateurs, too. A typical astronomical CCD camera:

- Is at least as sensitive to light as 1600-speed film but has no reciprocity failure;
- Covers a greater brightness range than film;
- Has a perfectly linear characteristic curve, making it easy to subtract sky fog from the image;
- Responds to the entire visible spectrum, plus deep red and infrared, making it easy to penetrate sky fog with deep red filters;

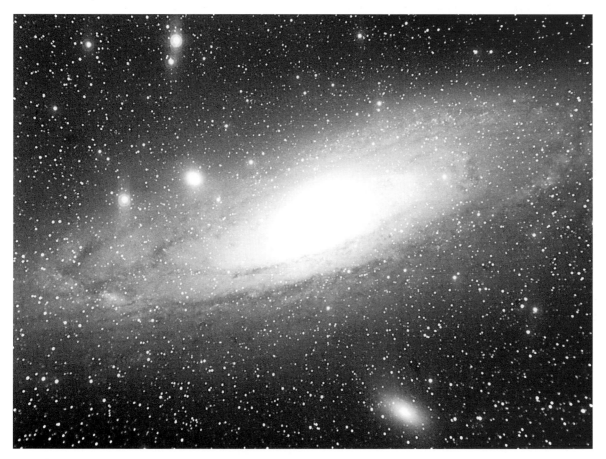

Figure 13.1 **Fifteen-minute exposure of the Andromeda Galaxy, M31, taken with a 10-cm (4-inch) refractor and a 1280×1024-pixel camera built by Finger Lakes Instrumentation. (Gregory Terrance)**

[1] I want to thank Dennis Di Cicco and Gregory Terrance for help with this chapter, and Meade Instruments for the loan of a Pictor 216XT CCD camera.

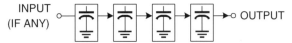
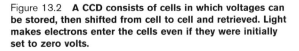

Figure 13.2 **A CCD consists of cells in which voltages can be stored, then shifted from cell to cell and retrieved. Light makes electrons enter the cells even if they were initially set to zero volts.**

- Resolves 50 lines per millimeter, comparable to high-speed films;
- Can measure and compensate for its own defects, yielding a much smoother image than film would produce;
- Lets you see your images almost immediately on a computer screen, so you can adjust exposure and focus.

In addition, many CCD cameras fit on any telescope in place of an eyepiece, requiring no additional back focus, and most are completely solid-state and therefore vibration-free. (A few have cooling fans.)

The main disadvantage of CCDs is that affordable ones are small, ranging from 200×300 to 500×700 pixels (2×3 to 5×7 mm). Large CCDs are always going to be relatively expensive because they require large, flawless silicon wafers. (Contrast this with microprocessors and memory chips, which have dropped in price as the industry has figured out how to get more and more transistors onto a wafer of constant size.) Nonetheless, even a 2×3-mm CCD can yield excellent planetary images and rewarding deep-sky pictures.

This chapter cannot pretend to cover CCD imaging completely; it would be presumptuous to try to write the definitive work on something that is still in the process of being invented. Anyone serious about CCD imaging will want to read books such as Buil, *CCD Astronomy*; Berry, *Choosing and Using a CCD Camera*; Martinez and Klotz, *A Practical Guide to CCD Astronomy*; and Ratledge, *The Art and Science of CCD Astronomy*. Also keep a close eye on magazines such as *Sky & Telescope* for information about the current state of the art.

13.1 How CCDs work

Charge-coupled devices were originally invented as a type of analog memory – a computer memory that can store any voltage within its range, not just 0 and 1.

CCDs are still used to store sound waveforms and other analog data. The discovery that CCDs can record images came as something of a surprise.

A CCD consists of an array of cells in which electrons are stored (Fig. 13.2). The cells are called "charge wells," and they are actually tiny capacitors embedded within a semiconductor device. They are arranged so that the electrons in each cell can be transferred to the next one. In this manner, voltages can be fed in at one end of the array, stored in the cells, and retrieved in sequence at the other end.

To detect images, the cells are first cleared, i.e., set to zero volts. Light falling on the cells allows some electrons to enter them from the surrounding material. The number of electrons in each cell is exactly proportional to the amount of light that has reached it. The resulting voltages can be shifted out, in sequence, to give electronic rendition of the image.

Figure 13.2 shows a *linear* CCD array, one that has its cells in a straight line. Linear CCDs are used in scanners, and because they are very cheap, a few people have experimented with using them astronomically, letting the image drift across the array with the clock drive turned off.

However, almost all electronic cameras use *rectangular* CCD arrays (Fig. 13.3). The charge wells are arranged into rows and columns, and the charges can be shifted downward and to the right to read out each row in succession.

Some rectangular CCDs include a *frame-transfer area* (storage area) that is not exposed to light. This makes a shutter unnecessary, at least for exposures of more than a few milliseconds. Instead, the CCD is cleared, the exposure is made, and then the entire image is rapidly shifted into the frame-transfer area

Figure 13.3 **A rectangular CCD array for imaging.**

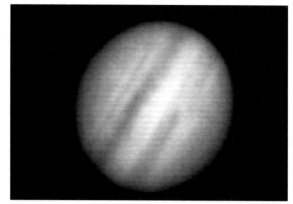

Figure 13.4 **A captured video image of Jupiter. Taken with a Sony camcorder coupled afocally to a 28-cm (11-inch) Schmidt–Cassegrain telescope; the image was digitized with a Minolta Snappy frame grabber, then processed to bring out detail. (Copyright 1997 David Kodama)**

where further light will not affect it. Then it can be read out as quickly or as slowly as the attached equipment requires.

The output of a CCD is analog, not digital. That is, the output from each cell is a voltage proportional to the number of electrons in it. Video cameras treat this voltage as an analog signal; digital cameras digitize it with a *analog-to-digital converter* (ADC).

To appreciate the amazing performance of CCDs, consider this: a typical CCD used in amateur astronomy responds to over 80% of the photons reaching it, at least at certain wavelengths. The cells hold 70 000 or 80 000 electrons, and the voltages are digitized by a 16-bit ADC, distinguishing 65 536 levels. That means almost every photon gives rise to an electron, and almost every electron is represented in the digitized signal. There's not much more to wish for.

13.2 Video and digital cameras

One way to get into CCD astronomy is to attempt astronomical imaging with a CCD camera designed for something else. In a few situations, this tactic works well. CCDs have almost completely displaced the vidicon tubes that used to be used in television cameras. Accordingly, ordinary camcorders and digital cameras are CCD devices.

Camcorders are especially handy for eclipse photography, where the action is fast and the objects being photographed are reasonably bright. Some amateur astronomers have obtained good results by coupling a camcorder or other video camera to a telescope for lunar and planetary work (Fig. 13.4). A striking advantage of this technique is that you can watch the image continuously, wait for a moment of especially good seeing, and then "freeze" the image by photographing the screen or digitizing the image with a frame grabber.

If you experiment with video astronomy, don't rely on the camcorder's viewfinder; instead, connect an external monitor so that you can judge sharpness critically. With most camcorders, afocal coupling is your only option; you can photograph eclipses with the zoom lens at maximum focal length, without a telescope. Better video cameras have interchangeable C-mount lenses; C-mount is a standard screw mount used on movie cameras, and T-to-C adapters are available for coupling cameras to telescopes.

What about "digital cameras," i.e., still-picture cameras that produce a digital image? Most of the inexpensive ones are not manually adjustable and are therefore almost useless in astronomy, but you can try holding the camera up to the eyepiece of a telescope aimed at the moon, and see what you get. Better digital cameras, such as the Kodak DCS 420, are fully adjustable and take interchangeable lenses (the Kodak camera is a modified Nikon). Although these cameras

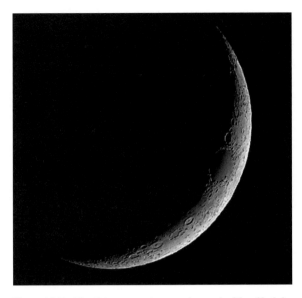

Figure 13.5 **The thin crescent moon, imaged with a Kodak DCS 420 digital camera at the prime focus of an 11-inch (27-cm) *f*/10 Schmidt–Cassegrain telescope. This image is about 1085×1150 pixels. (Michael Eskin)**

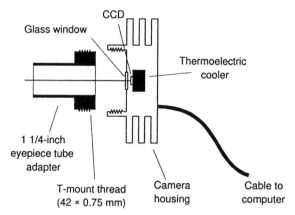

Figure 13.6 **An astronomical CCD camera fits into the eyepiece tube or onto a telescope T-adapter.**

are very expensive, they can give good results in lunar and planetary work (Fig. 13.5, Plate 13.1).

Camcorders and ordinary digital cameras can't do time exposures. With a any kind of video camera, the exposure time is obviously limited by the scan rate; the camera has to deliver a new image every 1/30 second.

With digital still cameras, the limitation comes from *dark currents*. During the exposure, electrons gradually creep into the charge wells even if no light is falling on them, and they do this in a very uneven manner, so that some pixels come out a lot brighter than others (Fig. 13.18, p. 252). This effect limits practical exposures to a few seconds at the most. Astronomical CCD cameras get around it by cooling the CCD.

13.3 Astronomical CCD cameras

Figure 13.6 shows an astronomical CCD camera, which fits into the telescope in place of an eyepiece. You can also mount it on the telescope more sturdily with a telescope T-adapter, but then you can't swap an eyepiece for it for finding and focusing. A more elaborate setup would consist of a sturdily mounted CCD with a *flip mirror* ahead of it so that the light can be diverted to an eyepiece.

In operation, the CCD chip is cooled to about −10 °C (+14 °F) to minimize dark currents. This is done by Peltier-effect thermoelectric devices – devices that, when fed with electricity, become cold on one side and hot on the other side. Since it is consuming energy, the Peltier device can't cool down all over; the energy has to be dissipated as heat somewhere. Accordingly, the back side of the camera is usually a large heat sink with cooling fins. Some CCDs have multiple Peltier devices and reach temperatures as low as −50 °C.

The camera is powered by 12 volts DC, at about one ampere, and is connected to a computer by a serial or SCSI cable. Laptop computers are very convenient for CCD work. To avoid pulling too hard on the telescope, cables should be secured to it in convenient places with plastic cable ties or the like.

Imaging takes place entirely under computer control, and you get to see your images as soon as the camera can transmit them to the computer. A SCSI or fast serial connection is advantageous, because if it takes more than about half a minute to download each image, you will never get the camera aimed and focused!

13.4 Field of view

The field of view of a CCD camera is often annoyingly small. It's nice to have Jupiter fill the field until you realize that you have to aim the telescope very precisely in order to get Jupiter into the picture at all. An irregular clock drive or misaligned mount can be a constant

Figure 13.7 **A CCD image of a small area of the moon before and after image processing to adjust contrast and bring out detail. Taken with a Meade Pictor 216XT camera at the prime focus of 20-cm (8-inch)** $f/10$ **telescope with a Wratten G yellow filter. The streak at the top is apparently a frame-transfer artifact. (Sharon Covington, assisted by the author)**

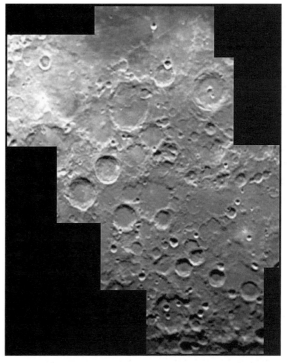

Figure 13.8 **This partial CCD image corresponds to a** 2×2-**mm area at the prime focus; the same telescope fits the whole moon onto a frame of 35-mm film. Taken with the same setup as Fig. 13.7. (By the author)**

Figure 13.9 **One way to cover a substantial field with a CCD is to combine several images into a mosaic like this. Taken with a 20-cm (8-inch)** $f/9$ **Newtonian telescope and a Lynxx PC CCD camera. (Gregory Terrance)**

source of vexation; in fact, when I started CCD imaging, one of the first things I had to do was fine-tune the polar alignment of my pier, to keep the planets from crawling southward out of the picture during the time it took to focus.

The field of view of a CCD is given by this formula:

$$\begin{array}{c}\text{Field of view}\\ \text{(in arc-seconds)}\end{array} = \frac{206\,265'' \times \text{CCD size}}{\text{focal length}}$$

where the focal length and CCD size are given in the same units. For example, a Texas Instruments TC-255 CCD is 2.4×3.3 mm. At the prime focus of a 20-cm $f/10$ telescope ($F = 2000$ mm), the field of view is therefore $247'' \times 340''$, so small that Jupiter ($40''$) fills a substantial part of the picture. With $\times 3$ negative projection, Jupiter fills half the frame.

Most deep-sky objects are much too large to fit on the CCD unless you use compression. Some astrophotographers use two $\times 0.63$ compressors, in succession, to reduce an $f/10$ telescope to $f/4$. Shortening the focal length widens the field as well as making the image brighter. Off-axis aberrations are not a problem because the CCD is so small. Celestron even makes a modified Schmidt–Cassegrain, the "Fastar," in which you can remove the secondary mirror and put the CCD at the prime focus of the $f/1.95$ primary.

You can, of course, deal with larger objects by making *mosaics* – images composed of separate pictures joined together. CCD images of the whole moon are almost invariably produced this way (Figs. 13.9 and 13.10). Some computer-controlled telescopes, such as the Meade LX200, will automatically take mosaic images under the control of the CCD camera.

13.5 Aiming and focusing

Aiming a telescope for CCD imaging can be a real challenge because the field of view is so small. It's not enough to aim the telescope using an eyepiece, then

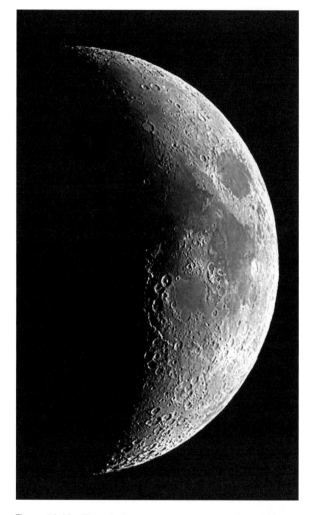

Figure 13.10 **The whole crescent moon: a mosaic of 25 images carefully combined. Taken at the prime focus of a 12.5-cm (5-inch) $f/10$ telescope with a Lynxx PC CCD camera. (Gregory Terrance)**

substitute the camera; the weight of the camera will usually make the telescope flex enough to throw the object outside the field. With practice, you can compensate for this by pressing down on the eyepiece while you look through it, but a flip mirror ahead of the camera is much more convenient.

A good finderscope, preferably high-powered, is a virtual necessity. At the very least, make sure your 6×30 or 8×50 finder is accurately aligned; better yet, install a $\times 30$ guidescope (old 60-mm refractors are good for this). Otherwise you will have a hard time finding objects accurately enough to get them into the small area

Figure 13.11 **"Blooming" makes star images look like this as electrons spill into adjacent wells. Maximum blooming occurs at the sharpest focus.**

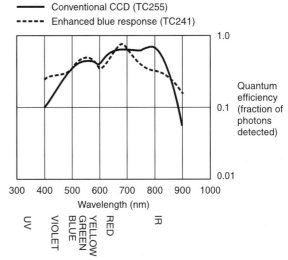

Figure 13.12 **The spectral response of CCDs extends deep into the infrared, where refractors and camera lenses are not achromatic.**

covered by the CCD. A guiding eyepiece is also helpful, especially if you can adjust the position of the crosshairs.

Focusing is also a challenge because it takes time for the computer to download each image, and the sharpness of an image on a computer screen is often hard to judge. Fortunately, you can make good use of a CCD artifact called *blooming*. When too many electrons are placed in a charge well, they tend to spill over into adjacent wells, especially in one direction (Fig. 13.11).

To focus the CCD camera precisely, turn off its anti-blooming circuit, if any, and aim it at a star of medium brightness near the object you want to photograph. Put your software in "focus mode" so that it will take images over and over and display them immediately. Then focus to make the blooming streaks as long as possible. Finally, aim the telescope back at the object you actually want to image. Avoid swinging through large distances, since flexure can throw off the focus of a catadioptric telescope.

Another way to focus is to make a reasonable exposure, not enough to cause blooming, and read out the light intensity registered by the pixel on which the star fell. To keep random noise from throwing you off, take several readings at each focus setting and average them. For rough focusing, a Scheiner disk (lenscap with two holes in it) is helpful.

You can save a lot of time by parfocalizing an eyepiece so that it focuses in exactly the same plane as

the camera. This is done by putting a ring of metal or plastic tape around the eyepiece barrel. (Dymo label-maker tape is good for this.) First focus the CCD camera precisely on a star. Then put the eyepiece in place of the camera, and, without adjusting the focus of the telescope, pull the eyepiece out until it gives a sharp image. Then put a ring around it to hold it at that position. You can then swap the eyepiece for the camera to focus before taking CCD images. I have found that a parfocalized 9-mm eyepiece often enables me to focus the CCD camera well enough that no further adjustment is required.

13.6 Exposure

Instead of a film speed number, CCDs are rated in *quantum efficiency*, the proportion of photons that cause electrons to enter the charge wells. As Fig. 13.12 shows, in deep red and near infrared light the quantum efficiency is 0.7 or better. This deep red response can be a drawback – the CCD responds to wavelengths at which refractors and camera lenses are not achromatic. Newer CCDs have "enhanced blue response," or perhaps we should call it reduced infrared response.

To determine the exposure for a CCD image, you first have to decide how much of the well capacity you want to use. If you want to fill the charge wells at least

Table 13.1 *Suggested CCD exposures based on the author's experience with a TC255 chip at $-10\,°C$*

Object	f/2	f/4	f/6.3	f/8	f/10	f/20	f/30	f/60
Bright objects – using full dynamic range of CCD								
Moon (full)	–	–	–	4 ms	6 ms	25 ms	50 ms	200 ms
Moon (bright areas)	–	4 ms	10 ms	15 ms	25 ms	100 ms	225 ms	900 ms
Moon (dim areas)	–	8 ms	20 ms	30 ms	50 ms	190 ms	430 ms	1.7 s
Mercury	–	–	6 ms	9 ms	14 ms	60 ms	130 ms	520 ms
Venus	–	–	–	–	–	4 ms	9 ms	36 ms
Mars	–	–	4 ms	6 ms	10 ms	40 ms	90 ms	360 ms
Jupiter	–	5 ms	13 ms	21 ms	33 ms	130 ms	300 ms	1.2 s
Saturn	5 ms	20 ms	50 ms	75 ms	120 ms	480 ms	1.1 s	4.3 s
Uranus	28 ms	110 ms	275 ms	440 ms	700 ms	2.8 s	6.2 s	25 s
Neptune	50 ms	200 ms	525 ms	850 ms	1.3 s	5.3 s	12 s	48 s
Faint objects – using bottom 12 of 16 bits or bottom 4 of 8 bits								
Comets, bright nebulae	2.5 s	10 s	25 s	40 s	1 min	4 min	–	–
Faint nebulae and galaxies	3 min	10 min	30 min	45 min	1 h	–	–	–

half full for midtones and highlights, then most CCDs are about comparable to 100-speed film.

In deep-sky imaging, however, you probably won't use the full capacity of the wells. If you use only the bottom 12 bits of a 16-bit DAC – that is, only values 1 to 4096 on a scale of 65 536 – you'll get a pleasing picture that requires only 1/16 as much light. In that case the CCD is comparable to 1600-speed film, but without reciprocity failure.

In practice, exposures are easy to adjust because you can view the image as soon as you've taken it. More importantly, you can and should view a histogram (p. 229) to see how much of the brightness range is being used.

Table 13.1 gives suggested exposures for various kinds of celestial objects. They are computed exactly like the exposures in Appendix A, using film speeds of 100 (lunar and planetary) and 1600 (deep-sky) and assuming no reciprocity failure. Notice that you can photograph bright nebulae with quite short exposures; the lack of reciprocity failure in the CCD really pays off, as does the CCD's high sensitivity to hydrogen-alpha light. You can get a decent image of the Ring Nebula in four minutes at the prime focus of an $f/10$ telescope. In fact, as Fig. 13.16 shows, you can sometimes get good images with much shorter exposures than the table indicates.

Because CCDs are so sensitive to red and infrared light, filter factors for red filters are quite low, often 2.0 or less. Stories are told of accidentally leaving a deep red filter on the CCD camera and forgetting about its presence, except that it helped cut through sky fog (Luc Vanhoeck, in Ratledge 1997, p. 87). On the other hand, filter factors for green and blue filters are higher than with film, and the infrared transmission of a blue filter can have a significant effect on the picture.

13.7 Optimal focal length

The CCD camera should have just enough resolving power to do justice to the telescope's diffraction-limited and atmosphere-limited image. It is a mistake to suppose that the resolving power of the CCD and of the telescope should be the *same*, because if they are, the overall resolution will be only half as good as that of either component. (As explained on p. 85, resolving powers add as the sum of reciprocals.) Results are better if the the resolution of the CCD is about twice that of the telescope.

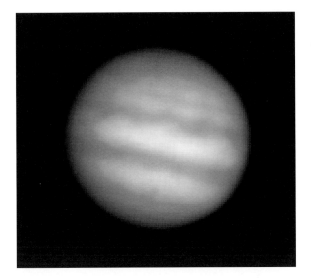

Figure 13.14 **CCD cameras are well matched to the resolution of amateur-size telescopes. Saturn, taken with a 25-cm (10-inch) $f/6$ reflector with eyepiece projection giving $f/20$ and a Celestron PixCel 255 camera. (Gregory Terrance)**

Figure 13.13 **Jupiter. A Meade Pictor 216XT camera on a 20-cm (8-inch) $f/10$ Schmidt–Cassegrain telescope using a Barlow lens for negative projection ($f/20$). A 200-millisecond exposure through Wratten G yellow filter. Atmospheric conditions were mediocre, but the image still shows a respectable amount of detail. (By the author)**

Ordinarily, the atmosphere limits the resolution of amateur telescopes to about $1''$; that is also the Rayleigh limit of a 20-cm telescope at 800 nm, the wavelength at which CCDs have maximum sensitivity. Accordingly, the CCD should resolve details at least as fine as $1''$, and preferably finer. To resolve $1''$, the CCD needs to have at least two pixels per arc-second in the image. Here's the formula:

$$\text{Pixels per arc-second} = \frac{\text{focal length}}{206\,265'' \times \text{pixel size}}$$

where focal length and pixel size are expressed in the same units.

The TC 255 and comparable CCDs have a pixel size of 0.01 mm (10 micrometers, 10 microns). Accordingly, a resolution of 2 pixels per arc-second requires a focal length of about 4000 mm. That happens to be what you get with $\times 2$ negative projection using a Barlow lens on a 20-cm $f/10$ Schmidt–Cassegrain. To ensure that the CCD is not the limiting factor, use a higher projection magnification, such as 3 or 4. It is fortunate that astronomical CCD cameras are so well matched to the resolution of amateur telescopes.

13.8 BASIC TECHNIQUE 18:
Imaging the moon or a planet

Equipment: Telescope (with clock drive running), CCD camera, computer. Set up all equipment at least 10 minutes and preferably an hour before exposure, to allow temperatures to stabilize. Turn on the CCD camera and set the desired working temperature (usually $-10\,°\text{C}$).

Sky conditions: Air must be steady. This is one reason for letting the telescope stabilize for a long time before taking pictures.

Procedure:

1 Check all equipment. The telescope (if a Schmidt–Cassegrain, classical Cassegrain, or Newtonian) must be accurately collimated. The finderscope must be accurately aligned. A high-power finder is helpful. The CCD must be at working temperature. Cables must be secured so they will not pull the telescope in random directions during the session.

2 Polar-align very carefully; otherwise the object will drift out of the field repeatedly during the session.

3 Aim and focus. A parfocalized eyepiece is a great help; otherwise, you may have to focus on a nearby star and then aim at the object you want to photograph.

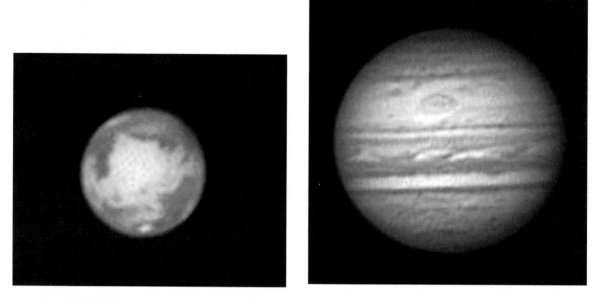

Figure 13.15 **Mars and Jupiter. With a 40-cm (16-inch) telescope and skillful image processing, CCDs yield observatory-quality images. (Gregory Terrance)**

4 Take a series of exposures, possibly as many as a hundred. Check the resulting pixel values; aim for 70% of maximum. Images that are disappointing need not be saved to disk. If you get several good images, you can combine them digitally to smooth out atmospheric ripples and CCD irregularities.

5 Also take several flat-field images if you plan to do flat-field correction (recommended, especially for lunar work).

6 Follow the recommended warm-up procedure when turning off the CCD; do not power it off before it reaches ambient temperature.

7 After the session, process the best images by contrast scaling, unsharp masking, and other applicable techniques.

Exposure: As in Table 13.1. As soon as you have an image, look at its histogram and adjust the exposure to use the entire brightness range, or at least the central part of it.

Variations: When photographing the moon or Venus, you may need a filter to keep the exposure from being too short. Green filters improve sharpness by narrowing the range of wavelengths used, thus counteracting atmospheric dispersion. Moving to a shorter wavelength (blue or green instead of red) also improves diffraction-limited resolution. Filter factors can be found by experimentation; for blue and green filters they will be higher, and for red filters they will be lower, than with film.

13.9 Flat-fielding

The response of a CCD is not entirely even across the entire field; sources of unevenness include irregularities in the CCD itself, uneven heating, vignetting in the telescope, and even dust specks on the glass window. Fortunately, it is easy to measure the unevenness and correct it.

Doing so is known as flat-fielding. Figure 13.16 shows what it accomplishes. A flat-field image is simply an image of an overcast sky or a uniform white object, taken with an exposure time comparable to that of the pictures that are to be corrected. Dividing the pixel values of a CCD image by those of a flat-field image gives a corrected image, which can then be further processed to produce the finished product.

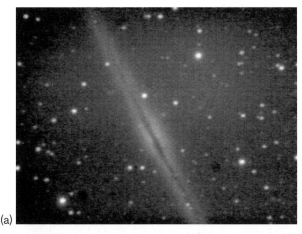

(a)

(b)

(c)

Figure 13.16 **Flat-fielding corrects irregularities in CCD response and can even remove the effect of dust specks in the camera. One-minute exposure of NGC 891 at the prime focus of a 20-cm (8-inch) *f*/10 Schmidt–Cassegrain telescope and a Cookbook 245 camera. (a) Unprocessed image; (b) flat-field image (contrast exaggerated here); (c) the result of flat-field correction. (Mike McCammant)**

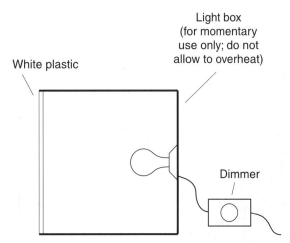

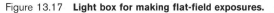

Figure 13.17 **Light box for making flat-field exposures.**

I produced my first flat-field image by putting two layers of wax paper across the front of the telescope and aiming it at a floodlight. A better way to do flat-fielding is to make a light box as shown in Fig. 13.17, containing a light whose brightness is adjustable. Ideally, the light box should be some distance away from the telescope – at least a few feet – so it doesn't bring out internal reflections that would not occur in actual astrophotography. Adjust it so you can use the same exposure time for the flat field and the picture that you want to correct.

It goes without saying that flat fields must be taken with exactly the same equipment configuration as the astronomical images with which they will be used, even down to the position of the camera on the telescope. If you rotate the camera even slightly, the effects of vignetting and internal reflections are likely to be different. All CCD cameras come with software for flat-field correction.

13.10 Calibration frames

Flat-fielding is not a complete cure for measurable CCD defects. Any CCD image will have five types of errors:

1. *Sensitivity errors*, comprising variations in sensitivity from pixel to pixel, as well as uneven illumination caused by vignetting and specks of dust;

2. *Thermal noise*, the tendency of pixels to accumulate some electrons due to heat and electrical leakage, even in the absence of light;

Figure 13.18 **This is not a star field; it's a 1-minute exposure of total darkness with a TC255 chip at 15 °C. The "stars" are caused by electrons leaking into wells of "hot pixels." They also appear superimposed on deep-sky images until removed by subtracting calibration frames.**

3 *Bias errors*, the failure of pixels to read out as exactly 0 volts even when they are completely empty, due to unavoidable voltage offsets in the pixels themselves and the amplification and ADC circuits;

4 *Quantization error*, a lack of precision caused by distinguishing only 256 or 65 536 output levels (with 8-bit and 16-bit ADCs, respectively); and

5 *Random noise*, resulting from atmospheric fluctuations and from the uneven flow of discrete photons and electrons. (Neither light nor electricity is a smooth fluid, and at CCD signal levels, the individual photons and electrons are noticeable.)

Flat-fielding by itself doesn't distinguish these errors, but in order to undo them completely, they must be separated because bias errors and thermal noise are *added* to the pixel values whereas sensitivity errors are *multiplied*.

The only way to get rid of random errors is to take several images and average them. Quantization error is a serious problem with 8-bit ADCs; to minimize it, use a 12- or 16-bit camera and don't underexpose. The remaining errors can be measured and corrected by taking appropriate *calibration frames*, of which flat fields are just one kind. Besides flat fields, you'll need to take *dark frames*, which contain bias errors and thermal noise, and, if possible, *bias frames*, which contain bias errors alone.

A dark frame is an exposure taken with no light entering the camera. (Putting the front cap on the telescope is an easy way to achieve this.) In all other respects – exposure time, CCD temperature, and position of the camera on the telescope – the dark frame should match the images you want to correct. To distinguish thermal noise from random noise, take several dark frames and average them; the same pixels will be "hot" each time. You will probably find that the thermal noise in your CCD increases over the years,

especially if it has been heated up and cooled down abruptly a number of times. Newer types of CCD chips have less thermal noise than older ones.

Patterns in the dark frame – stripes, waves, or herringbones – indicate electrical or magnetic interference from ripple in the power supply or RF emissions from nearby radio or computer equipment.

A bias frame is a zero time exposure; it, too, should be taken at the same temperature as the images you will be correcting, and for best results, several bias frames should be averaged. By subtracting a bias frame from a dark frame, you can make a *thermal frame*, which contains thermal noise only. The reason for separating bias errors from thermal noise is that once you have done so, you can perform some corrections even if your calibration frames do not entirely match the original exposure. The bias frame is theoretically the same all the time (although in practice it can be slightly affected by temperature), and thermal frames can be scaled to match different exposure times and temperatures, at least approximately.

You can also make a *sensitivity frame* by subtracting bias errors and thermal noise from the original flat-field image. This gives you a map of sensitivity errors alone, separated from other effects. (The term *sensitivity frame* is my own; in other literature, it is confusingly called a "flat field" whether or not the thermal and bias errors have been subtracted out.)

A *raw image* is what you download from the CCD camera immediately after imaging a celestial object. It consists of the actual image multiplied by sensitivity errors, plus bias errors and thermal noise:

Raw image = bias errors + thermal noise
+ (true image × sensitivity errors)

It follows that you can recover the true image by processing it with the calibration frames as follows:

$$\text{True image} = \frac{\frac{\text{raw}}{\text{image}} - \frac{\text{bias}}{\text{frame}} - \frac{\text{thermal}}{\text{frame}}}{\text{sensitivity frame}}$$

or, if you haven't separated the dark frame into bias and thermal components:

$$\text{True image} = \frac{\text{raw image} - \text{dark frame}}{\text{sensitivity frame}}$$

Berry (1992) explains this whole process in greater detail; CCD cameras come with software that leads you through it step by step.

13.11 Deep-sky work

Now let's take a deep-sky image with a CCD camera. Because there is no reciprocity failure, this should be easy. Even light pollution is not a serious problem; Dennis Di Cicco takes excellent deep-sky images from a mediocre site in suburban Boston. The reason for this is twofold: CCDs work very well with deep red filters, and even without filters, the response of the CCD is quite linear over a very wide range of brightnesses, so that the light pollution can simply be subtracted out. If film were equally sensitive to light, the light pollution would overexpose it.

The hard part of deep-sky imaging is aiming and guiding. Indeed, the field of view is so small that many deep-sky objects simply don't fit; globular clusters and planetary nebulae are good targets for your first attempts. Compressor lenses help widen the field; you

may even want to put the CCD on a short-focal-length telescope and piggy-back it on the main instrument. Most CCD cameras have T-threads, but in order to focus an image with a T-mount camera lens, they require an extension tube, possibly custom-made. Remember that $f/5.6$ is plenty fast enough; inexpensive telephoto lenses can work well if you can find a way to mount them on the camera.

Guiding is done with a guidescope or off-axis guider, just as with film imaging. Although CCDs are used in autoguiders, a single CCD cannot be used for both imaging and autoguiding at the same time. The reason is of course that the CCD chip doesn't deliver any output until the exposure is over.

There are two ways around this limitation. Some of the better CCD cameras include a built-in off-axis guider with a second CCD chip. (One promising tactic would be to use a beamsplitter, diverting about 5% of the light to the guider and enabling it to guide on the object being photographed, eliminating the search for a suitably placed guide star.) Other cameras alternately expose and guide, making many short exposures with guiding corrections in between; the exposures are then summed digitally.

13.12 Choosing a CCD camera

One of the most important things about a CCD camera is, of course, the CCD image sensor inside it. Table 13.2 give the specifications of a number of widely used CCDs, but it does not tell the whole story. Over the years, specifications for thermal noise and pixel uniformity have gradually improved, and prices have fallen. The earliest amateur CCD cameras were built with chips that had "cosmetic defects" (bad pixels) because these were the only CCDs amateurs could afford. Today, there is no reason not to get a CCD that is free of noticeable flaws. Inferior CCDs can be used in autoguiders.

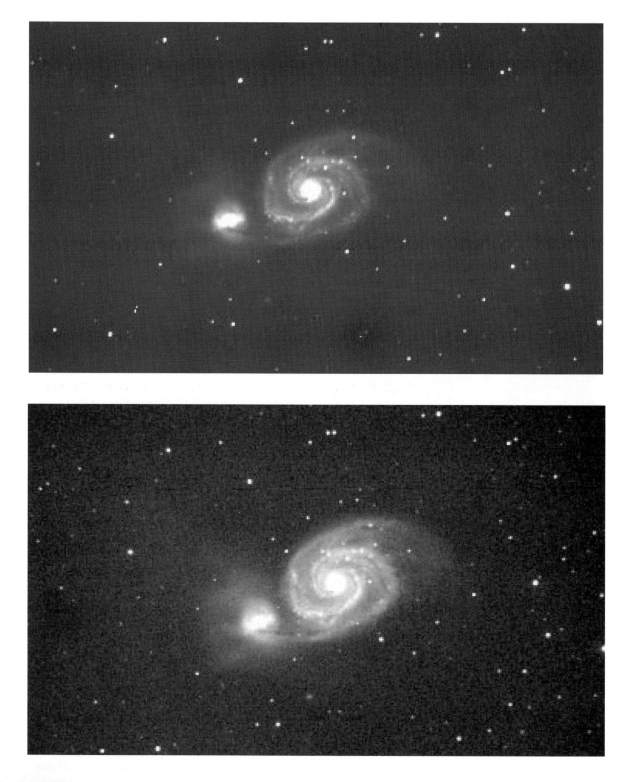

Figure 13.19 **Images of the galaxy M51 before and after processing to bring out faint detail. An SBIG ST-6 camera at the prime focus of a 20-cm (8-inch)** *f*/5 **reflector. (Gregory Terrance)**

Table 13.2 *Some representative CCD chips*

Manufacturer	Chip	Number of pixels	Pixel size (μm)	Array size (mm)	Frame transfer?
Texas	TC211	192 × 165	13.75 × 16	2.6 × 2.6	No
Instru-	TC241	780 × 488	11.5 × 13.5	8.6 × 6.5	No
ments	TC255P	336 × 243	10 × 10	3.3 × 2.4	Yes
	TC281	1036 × 1010	8 × 8	8 × 8	Yes
Kodak	KAF-0400	768 × 512	9 × 9	6.9 × 4.6	No
	KAF-1300	1280 × 1024	16 × 16	20.5 × 16.4	No
	KAF-1600	1536 × 1024	9 × 9	13.8 × 9.2	No

Note: The TC241 also has a "binned" mode in which pixels are twice as large and response is smoother. Many other CCD chips accomplish binning under software control.

Figure 13.20 **The spiral galaxy M33, imaged with a 20-cm (8-inch) *f*/5 reflector and an SBIG ST-6 CCD camera. (Gregory Terrance)**

The cost of a CCD sensor rises disproportionately with size; although sensors exist that are as big as a 35-mm film frame, or bigger, they are not yet affordable for most amateurs. Square pixels are desirable; that is, the pixels should be the same size horizontally and vertically. Otherwise the image will have to be resampled before being printed out or displayed in final form.

The camera housing, support circuitry, and software are equally important. Two of the most prominent manufacturers of amateur CCD cameras are Meade (catering to beginners) and SBIG (with more sophisticated cameras for advanced users). Meade has worked hard to push prices down, and their CCD cameras are now only slightly more expensive than 35-mm SLRs. Lynxx cameras from SpectraSource are also inexpensive and well respected. Higher-priced

SBIG cameras include a second CCD for autoguiding during the exposure. The SBIG control commands are documented so that if you want to, you can write your own software in addition to using theirs. Several other companies make advanced CCDs for serious amateur and professional use; addresses are on pp. 314–315. Like telescopes, high-end CCD cameras are built carefully, one at a time; some of the best CCD makers are one-person companies that sell only a few dozen cameras a year.

You can even build your own CCD camera; for plans, see *The CCD Camera Cookbook* (Berry, Kanto, and Munger 1994). Parts and kits are available from University Optics (p. 315).

One of the most important camera specifications is the bit depth of the ADC, which is not part of the CCD chip itself. Early amateur CCDs used 8-bit ADCs, which give satisfactory images only if the exposure is just right; underexpose even slightly and you get a posterization effect. If your interest in CCDs extends beyond casual experimentation and autoguiding, you need a 16-bit ADC, which will produce images that stand up to contrast enhancement and other forms of digital processing. One advantage of 8-bit CCD cameras is that they can be purchased secondhand from amateurs who have outgrown them, and they work well as autoguiders even if you are not satisfied with their imaging performance.

Astronomical CCDs are inherently monochrome devices (unlike the CCDs in video cameras, which have a tiny filter matrix on the imaging surface). Color CCD imaging requires successive exposures through red,

green, and blue filters (Plates 13.2, 13.3, and 13.4), and filter wheels for this purpose are marketed with CCD cameras. Platt (1995) has explored astronomical uses of CCDs that have filter matrices built in.

CCDs are good for measuring the position and brightness of asteroids and other celestial objects. Each pixel's output voltage is linearly proportional to brightness, and the CCD array does not stretch or shrink the way film does. Also, because they cover such a wide brightness range, CCDs are ideal for detecting supernovae in distant galaxies.

One of the latest developments is *adaptive optics*, the use of a CCD autoguider to smooth out the effects of atmospheric turbulence, not just errors in the drive system. Atmospheric turbulence has a time scale measured in milliseconds; slower than an audio waveform, it is easy to track electronically. The adaptive optics system contains a mirror or lens that moves rapidly under electronic control to counteract fluctuations. SBIG has introduced an adaptive optics system for use with their CCD cameras; in long exposures, it yields star images as small as $1''$ instead of the usual $5''$. Major observatories have been using adaptive optics for some time; this technology may be the next big revolution in amateur imaging.

Appendices

Exposure tables

Appendix A

I present these exposure tables with an important warning: *they are only approximate* and may differ from your results for many reasons (see p. 000). Sometimes the main function of the table is to tell you whether a photograph is practical at all. All of these tables, however, have been checked against numerous actual photographs, and the exposures in them should work well under almost all conditions.

These tables are different from those in the first edition in several ways. The software that generates them has been rewritten. Shutter speeds now go up to 1/8000 second, film speeds go up to 3200, and the correction for reciprocity failure reflects newer film technology. When reciprocity failure has a substantial effect on the exposure, a range of exposures is given. In response to popular demand I have added tables for deep-sky objects, but the information in them is very approximate.

Excessively short and excessively long exposures are denoted by << and >> respectively. "Excessively long" doesn't necessarily mean the exposure is impossible; it only means that it can't be calculated accurately.

A.1 How exposures are calculated

The ISO (ASA) system of film speeds is based on this formula for calculating exposures:

$$t \text{ (seconds)} = \frac{f^2}{SB}$$

where t is the exposure time, f is the f-ratio, S is the film speed, and B is the brightness of the object being photographed, in candelas per square foot (Kingslake, *Optical System Design*, p. 126). In practice B is somewhat arbitrary, since any photographic subject spans a range of brightnesses.

If you are using a filter, B has to be adjusted thus:

$$B \text{ (adjusted)} = B \div \text{filter factor}$$

If there is no filter, the filter factor is 1 and you can skip this step.

For example, a brightly sunlit landscape has $B \approx 256$ (with no filter). So the exposure at $f/16$ on 400-speed film is:

$$t = \frac{f^2}{SB} = \frac{16^2}{400 \times 256} = \frac{1}{400} \text{ second}$$

Photographers know this as the "sunny $f/16$ rule" – the exposure for a sunlit landscape at $f/16$ happens to be $1/S$. But it's a bit of a fudge; actual landscapes in temperate climates are closer to $B = 180$. So is the surface of the full moon, which is brilliantly sunlit but is made of rather dark material.

If the exposure is more than 1 second, it should be corrected for reciprocity failure as follows:

$$t \text{ (corrected)} = (t+1)^{(1/p)} - 1$$

where p is the Schwarzschild exponent (p. 180), typically 0.9 for newer slow films, 0.8 for older slow films or newer fast films, and 0.7 for older-technology fast films.

A.2 Obtaining B from photometric brightness

Astronomers measure the surface brightness of celestial objects in terms of *magnitude per square arc-second* (abbreviated m''), the magnitude of the star that would produce the same surface brightness if its light were spread out to cover one square arc-second of sky. Here are approximate formulae to interconvert B and m'':

$$B \approx 2.512^{(9.0 - m'')}$$
$$m'' \approx 9.0 - 1.086 \ln B$$

Values of m'' for the planets are published in the *Astronomical Almanac*. For any round celestial object of uniform brightness, m'' can be obtained from its total magnitude m with the formula:

$$m'' = m + 2.5 \log_{10} \left(\frac{\pi}{4} d^2 \right)$$

where d is the apparent diameter in arc-seconds. For example, the full moon has $m = -12.5$ and an apparent diameter of $30' = 1800''$. From this we find:

$$m'' = (-12.5) + 2.5 \log_{10}(0.78 \times 1800^2)$$
$$= (-12.5) + 2.5 \times 6.40 = 3.5$$

This agrees well with the measured value of 3.4.

Because galaxies are so faint, galaxy observers often use magnitude per square arc-*minute* (m'), related to m'' by the formula:

$$m' = m'' - 8.9$$

For more on the photometry of galaxies see *Sky Catalogue 2000.0*, vol. 2, p. xxxii, and Clark, *Visual Astronomy of the Deep Sky* (which is a whole book about the brightness of faint objects).

A.3 Other systems for calculating exposure

Robert Burnham (1981) and Richard Berry (1992, p. 45) give values of B derived from their own photographic and CCD experiments. They are generally comparable to the values in my tables, though not entirely the same.

Barry Gordon's *fx* system (1985) uses logarithmic units for brightness – in fact, brightness is measured in f-stops:

$$fx = 18 - \log_2 B$$
$$B = 2^{(18-fx)}$$

This makes the calculations simpler; you can add and subtract instead of multiplying and dividing. Gordon's book is well worth consulting if you are interested in exposure calculation; he tackles sky fog and limiting magnitude in some detail.

The *fx* system does not include an explicit correction for reciprocity failure. Instead, the average effect of reciprocity failure is already factored into Gordon's values of *fx* for faint objects.

A.4 PRACTICAL NOTE:
Why don't my results agree with the tables?

Anybody who publishes astrophotographic exposure tables quickly becomes a target for criticism. Plenty of great photographs use exposures other than what the tables recommend. Here are several reasons why your best exposure might be different from what is in the tables.

The difference may not be significant. "The table said 5 seconds, but I exposed 3 seconds and got a great picture." That's not a significant difference. A ×2 difference in exposure is well within the film's exposure latitude. A ×1.4 difference is usually unnoticeable. Some films tolerate exposure variations of ×8 or more.

The film speed may not be what you think. Remember that push-processing increases film speed; so does gas hypersensitization. For example, when T-Max 100 is developed in D-19, its effective speed can be as high as 800. A good way to find out the effective speed of specially processed film is to take ordinary terrestrial photographs with it.

The object you're photographing may not be uniformly bright. When you photograph a comet or the Orion Nebula, for instance, you can expose for the bright central region or the faint periphery. These differ in brightness by a factor of more than 100. That means an enormous range of exposures will be correct for *some* part of the object.

Filters affect different objects differently. Mars, which is red, will look brighter through a red filter than Uranus, which is blue. More to the point, a #25 red filter has a filter factor of about

8 for most objects on most films, but only 1.5 or so when you are photographing hydrogen-alpha nebulosity on a film with good deep-red response.

Reciprocity failure takes its toll. Any exposure longer than 1 second will be affected to some extent by reciprocity failure, which differs greatly from film to film and is affected by temperature and humidity.

Even the atmosphere is fickle. The transparency of the air can vary by a factor of 2 or more. (The exposure table for Mercury includes a $\times 2.5$ correction for atmospheric dimming.) On a hazy night, everything will need 2 to 4 times more exposure than on a perfectly clear night.

A.5 Moon and lunar eclipses

MOON (thin crescent)
$m'' = 6.7$ $B = 8$

| $f/$ | Film speed (ISO) | | | | | | | |
	25	50	100	200	400	800	1600	3200
2	1/60 s	1/125 s	1/125 s	1/250 s	1/500 s	1/1000 s	1/2000 s	1/4000 s
2.8	1/30 s	1/60 s	1/125 s	1/125 s	1/250 s	1/500 s	1/1000 s	1/2000 s
4	1/15 s	1/30 s	1/60 s	1/60 s	1/125 s	1/250 s	1/500 s	1/1000 s
4.5	1/8 s	1/15 s	1/30 s	1/60 s	1/125 s	1/250 s	1/500 s	1/1000 s
5.6	1/8 s	1/15 s	1/30 s	1/60 s	1/60 s	1/125 s	1/250 s	1/500 s
6.3	1/4 s	1/8 s	1/15 s	1/30 s	1/60 s	1/125 s	1/250 s	1/500 s
8	1/4 s	1/4 s	1/8 s	1/15 s	1/30 s	1/60 s	1/125 s	1/250 s
10	1/2 s	1/4 s	1/8 s	1/15 s	1/30 s	1/60 s	1/125 s	1/250 s
11	1/2 s	1/2 s	1/4 s	1/8 s	1/15 s	1/30 s	1/60 s	1/125 s
16	1 s	1 s	1/2 s	1/4 s	1/8 s	1/15 s	1/30 s	1/60 s
22	3 s	1 s	1 s	1/2 s	1/4 s	1/8 s	1/15 s	1/30 s
32	6 s	3 s	2 s	1 s	1/2 s	1/4 s	1/8 s	1/15 s
45	14 s	7 s	3 s	2 s	1 s	1/2 s	1/4 s	1/8 s
64	30 s	15 s	8 s	4 s	2 s	1 s	1/2 s	1/4 s
100	1 m	40 s	20 s	10 s	5 s	2 s	1 s	1/2 s
200	6 m	3 m	2 m	55 s	25 s	13 s	6 s	3 s

MOON (wide crescent, or dimly-lit features on terminator)

$m'' = 5.9$ $B = 16$

f/	Film speed (ISO)							
	25	50	100	200	400	800	1600	3200
2	1/125 s	1/250 s	1/500 s	1/500 s	1/1000 s	1/2000 s	1/4000 s	1/8000 s
2.8	1/60 s	1/125 s	1/250 s	1/500 s	1/500 s	1/1000 s	1/2000 s	1/4000 s
4	1/30 s	1/60 s	1/125 s	1/125 s	1/250 s	1/500 s	1/1000 s	1/2000 s
4.5	1/15 s	1/30 s	1/60 s	1/125 s	1/250 s	1/500 s	1/1000 s	1/2000 s
5.6	1/15 s	1/30 s	1/60 s	1/125 s	1/125 s	1/250 s	1/500 s	1/1000 s
6.3	1/8 s	1/15 s	1/30 s	1/60 s	1/125 s	1/250 s	1/500 s	1/1000 s
8	1/8 s	1/15 s	1/30 s	1/60 s	1/60 s	1/125 s	1/250 s	1/500 s
10	1/4 s	1/8 s	1/15 s	1/30 s	1/60 s	1/125 s	1/250 s	1/500 s
11	1/4 s	1/8 s	1/15 s	1/30 s	1/30 s	1/60 s	1/125 s	1/250 s
16	1/2 s	1/4 s	1/4 s	1/8 s	1/15 s	1/30 s	1/60 s	1/125 s
22	1 s	1/2 s	1/4 s	1/8 s	1/8 s	1/30 s	1/30 s	1/60 s
32	3 s	1 s	1 s	1/2 s	1/4 s	1/8 s	1/15 s	1/30 s
45	6 s	3 s	2 s	1 s	1/2 s	1/4 s	1/8 s	1/15 s
64	13 s	7 s	3 s	2 s	1 s	1/2 s	1/4 s	1/8 s
100	35 s	20 s	9 s	4 s	2 s	1 s	1/2 s	1/4 s
200	3 m	1 m	45 s	20 s	11 s	5 s	2 s	1 s

MOON (quarter phase, or well-lit features on terminator)

$m'' = 5.2$ $B = 32$

f/	Film speed (ISO)							
	25	50	100	200	400	800	1600	3200
2	1/250 s	1/500 s	1/500 s	1/1000 s	1/2000 s	1/4000 s	1/8000 s	<<
2.8	1/125 s	1/250 s	1/250 s	1/500 s	1/1000 s	1/2000 s	1/4000 s	1/8000 s
4	1/60 s	1/125 s	1/125 s	1/250 s	1/500 s	1/1000 s	1/2000 s	1/4000 s
4.5	1/30 s	1/60 s	1/125 s	1/250 s	1/500 s	1/1000 s	1/2000 s	1/4000 s
5.6	1/30 s	1/60 s	1/125 s	1/125 s	1/250 s	1/500 s	1/1000 s	1/2000 s
6.3	1/15 s	1/30 s	1/60 s	1/125 s	1/250 s	1/500 s	1/1000 s	1/2000 s
8	1/15 s	1/30 s	1/60 s	1/60 s	1/125 s	1/250 s	1/500 s	1/1000 s
10	1/8 s	1/15 s	1/30 s	1/60 s	1/125 s	1/250 s	1/500 s	1/1000 s
11	1/4 s	1/8 s	1/15 s	1/30 s	1/60 s	1/125 s	1/250 s	1/500 s
16	1/2 s	1/4 s	1/8 s	1/15 s	1/30 s	1/60 s	1/125 s	1/250 s
22	1/2 s	1/2 s	1/4 s	1/8 s	1/15 s	1/30 s	1/60 s	1/125 s
32	1 s	1 s	1/2 s	1/4 s	1/8 s	1/15 s	1/30 s	1/60 s
45	3 s	2 s	1 s	1/2 s	1/4 s	1/8 s	1/15 s	1/30 s
64	6 s	3 s	2 s	1 s	1/2 s	1/4 s	1/8 s	1/15 s
100	15 s	9 s	4 s	2 s	1 s	1/2 s	1/4 s	1/8 s
200	1 m	40 s	20 s	10 s	5 s	2 s	1 s	1/2 s

MOON (gibbous)

$m'' = 4.4$ $B = 70$

f/	Film speed (ISO)							
	25	50	100	200	400	800	1600	3200
2	1/500 s	1/1000 s	1/2000 s	1/2000 s	1/4000 s	1/8000 s	<<	<<
2.8	1/250 s	1/500 s	1/1000 s	1/2000 s	1/2000 s	1/4000 s	1/8000 s	<<
4	1/125 s	1/250 s	1/500 s	1/500 s	1/1000 s	1/2000 s	1/4000 s	1/8000 s
4.5	1/60 s	1/125 s	1/250 s	1/500 s	1/1000 s	1/2000 s	1/4000 s	1/8000 s
5.6	1/60 s	1/125 s	1/250 s	1/500 s	1/500 s	1/1000 s	1/2000 s	1/4000 s
6.3	1/30 s	1/60 s	1/125 s	1/250 s	1/500 s	1/1000 s	1/2000 s	1/4000 s
8	1/30 s	1/60 s	1/125 s	1/125 s	1/250 s	1/500 s	1/1000 s	1/2000 s
10	1/15 s	1/30 s	1/60 s	1/125 s	1/250 s	1/500 s	1/1000 s	1/2000 s
11	1/15 s	1/30 s	1/60 s	1/125 s	1/125 s	1/250 s	1/500 s	1/1000 s
16	1/8 s	1/15 s	1/30 s	1/60 s	1/60 s	1/125 s	1/250 s	1/500 s
22	1/4 s	1/8 s	1/15 s	1/30 s	1/30 s	1/60 s	1/125 s	1/250 s
32	1/2 s	1/4 s	1/4 s	1/8 s	1/15 s	1/30 s	1/60 s	1/125 s
45	1 s	1/2 s	1/2 s	1/4 s	1/8 s	1/15 s	1/30 s	1/60 s
64	3 s	1 s	1 s	1/2 s	1/4 s	1/8 s	1/15 s	1/30 s
100	8 s	4 s	2 s	1 s	1/2 s	1/4 s	1/8 s	1/15 s
200	35 s	20 s	9 s	4 s	2 s	1 s	1/2 s	1/4 s

MOON (full)

$m'' = 3.4$ $B = 180$

f/	Film speed (ISO)							
	25	50	100	200	400	800	1600	3200
2	1/1000 s	1/2000 s	1/4000 s	1/8000 s	1/8000 s	<<	<<	<<
2.8	1/500 s	1/1000 s	1/2000 s	1/4000 s	1/8000 s	1/8000 s	<<	<<
4	1/250 s	1/500 s	1/1000 s	1/2000 s	1/4000 s	1/8000 s	1/8000 s	<<
4.5	1/250 s	1/500 s	1/1000 s	1/1000 s	1/2000 s	1/4000 s	1/8000 s	<<
5.6	1/125 s	1/250 s	1/500 s	1/1000 s	1/2000 s	1/4000 s	1/8000 s	1/8000 s
6.3	1/125 s	1/250 s	1/500 s	1/500 s	1/1000 s	1/2000 s	1/4000 s	1/8000 s
8	1/60 s	1/125 s	1/250 s	1/500 s	1/1000 s	1/2000 s	1/4000 s	1/8000 s
10	1/30 s	1/60 s	1/125 s	1/250 s	1/500 s	1/1000 s	1/2000 s	1/4000 s
11	1/30 s	1/60 s	1/125 s	1/250 s	1/500 s	1/1000 s	1/2000 s	1/4000 s
16	1/15 s	1/30 s	1/60 s	1/125 s	1/250 s	1/500 s	1/1000 s	1/2000 s
22	1/8 s	1/15 s	1/30 s	1/60 s	1/125 s	1/250 s	1/500 s	1/1000 s
32	1/4 s	1/8 s	1/15 s	1/30 s	1/60 s	1/125 s	1/250 s	1/500 s
45	1/2 s	1/4 s	1/8 s	1/15 s	1/30 s	1/60 s	1/125 s	1/250 s
64	1 s	1/2 s	1/4 s	1/8 s	1/15 s	1/30 s	1/60 s	1/125 s
100	3 s	1 s	1 s	1/2 s	1/4 s	1/8 s	1/15 s	1/30 s
200	13 s	6 s	3 s	2 s	1 s	1/2 s	1/4 s	1/8 s

MOON (earthshine on unilluminated portion)

$m'' = 13.5$ $B = 0.016$

f/	Film speed (ISO)							
	25	50	100	200	400	800	1600	3200
2	14 s	7 s	4 s	2 s	1 s	1/2 s	1/4 s	1/8 s
2.8	30 s	15 s	8 s	4 s	2 s	1 s	1/2 s	1/4 s
4	1 m	35 s	15 s	8 s	4 s	2 s	1 s	1/2 s
4.5	1 m	45 s	25 s	11 s	5 s	3 s	1 s	1/2 s
5.6	2 m	1 m	40 s	20 s	9 s	4 s	2 s	1 s
6.3	3 m	2 m	50 s	25 s	12 s	6 s	3 s	1 s
8	5 m	3 m	1 m	45 s	20 s	10 s	5 s	2 s
10	9 m	5 m	2 – 4 m	55 s – 2 m	35 s	20 s	8 s	4 s
11	11 m	4 – 9 m	2 – 5 m	1 – 2 m	35 s – 1 m	20 s	10 s	5 s
16	15 – 35 m	9 – 20 m	5 – 12 m	3 – 7 m	1 – 3 m	40 s – 2 m	20 – 45 s	9 – 20 s
22	35 m – 1 h	20 – 50 m	10 – 30 m	5 – 15 m	3 – 8 m	1 – 4 m	40 s – 2 m	20 – 50 s
32	1 – 3 h	45 m – 2 h	25 m – 1 h	13 – 45 m	7 – 25 m	3 – 12 m	2 – 6 m	45 s – 3 m
45	>>	>>	50 m – 3 h	30 m – 2 h	15 m – 1 h	8 – 35 m	4 – 20 m	2 – 8 m
64	>>	>>	>>	>>	35 m – 3 h	20 m – 2 h	9 – 55 m	4 – 25 m
100	>>	>>	>>	>>	>>	>>	25 m – 4 h	14 m – 2 h
200	>>	>>	>>	>>	>>	>>	>>	>>

MOON (partially eclipsed, exposing for bright portion)

$m'' = 4.7$ $B = 50$

f/	Film speed (ISO)							
	25	50	100	200	400	800	1600	3200
2	1/250 s	1/500 s	1/1000 s	1/2000 s	1/4000 s	1/8000 s	1/8000 s	<<
2.8	1/125 s	1/250 s	1/500 s	1/1000 s	1/2000 s	1/4000 s	1/8000 s	1/8000 s
4	1/60 s	1/125 s	1/250 s	1/500 s	1/1000 s	1/2000 s	1/4000 s	1/8000 s
4.5	1/60 s	1/125 s	1/250 s	1/500 s	1/1000 s	1/2000 s	1/4000 s	1/8000 s
5.6	1/30 s	1/60 s	1/125 s	1/250 s	1/500 s	1/1000 s	1/2000 s	1/4000 s
6.3	1/30 s	1/60 s	1/125 s	1/250 s	1/500 s	1/1000 s	1/2000 s	1/4000 s
8	1/15 s	1/30 s	1/60 s	1/125 s	1/250 s	1/500 s	1/1000 s	1/2000 s
10	1/15 s	1/30 s	1/60 s	1/60 s	1/125 s	1/250 s	1/500 s	1/1000 s
11	1/8 s	1/15 s	1/30 s	1/60 s	1/125 s	1/250 s	1/500 s	1/1000 s
16	1/4 s	1/8 s	1/15 s	1/30 s	1/60 s	1/125 s	1/250 s	1/500 s
22	1/2 s	1/4 s	1/8 s	1/15 s	1/30 s	1/60 s	1/125 s	1/250 s
32	1 s	1/2 s	1/4 s	1/8 s	1/15 s	1/30 s	1/60 s	1/125 s
45	2 s	1 s	1/2 s	1/4 s	1/8 s	1/15 s	1/30 s	1/60 s
64	4 s	2 s	1 s	1/2 s	1/4 s	1/8 s	1/15 s	1/30 s
100	10 s	5 s	3 s	1 s	1/2 s	1/4 s	1/8 s	1/15 s
200	50 s	25 s	12 s	6 s	3 s	1 s	1 s	1/2 s

MOON (partially eclipsed, umbra and penumbra together)
$m'' = 10.5$ $B = 0.25$

$f/$	Film speed (ISO)							
	25	50	100	200	400	800	1600	3200
2	1 s	1/2 s	1/4 s	1/8 s	1/15 s	1/30 s	1/60 s	1/125 s
2.8	1 s	1 s	1/2 s	1/4 s	1/8 s	1/15 s	1/30 s	1/60 s
4	3 s	2 s	1 s	1/2 s	1/4 s	1/8 s	1/15 s	1/30 s
4.5	4 s	2 s	1 s	1/2 s	1/4 s	1/8 s	1/15 s	1/30 s
5.6	7 s	3 s	2 s	1 s	1/2 s	1/4 s	1/8 s	1/15 s
6.3	8 s	4 s	2 s	1 s	1/2 s	1/4 s	1/8 s	1/15 s
8	14 s	7 s	4 s	2 s	1 s	1/2 s	1/4 s	1/8 s
10	25 s	12 s	6 s	3 s	1 s	1 s	1/2 s	1/4 s
11	30 s	15 s	7 s	4 s	2 s	1 s	1/2 s	1/4 s
16	1 m	35 s	15 s	8 s	4 s	2 s	1 s	1/2 s
22	2 m	1 m	35 s	20 s	9 s	4 s	2 s	1 s
32	5 m	3 m	1 m	45 s	20 s	10 s	5 s	2 s
45	11 m	4 – 9 m	2 – 5 m	1 – 3 m	35 s – 1 m	15 – 35 s	11 s	5 s
64	15 – 40 m	9 – 20 m	5 – 13 m	3 – 7 m	1 – 3 m	40 s – 2 m	20 – 45 s	9 – 20 s
100	45 m – 2 h	25 m – 1 h	14 – 40 m	7 – 20 m	4 – 12 m	2 – 6 m	55 s – 3 m	25 s – 1 m
200	>>	>>	>>	35 m – 2 h	20 m – 1 h	10 – 50 m	5 – 25 m	2 – 12 m

MOON (relatively light total eclipse)
$m'' = 12.2$ $B = 0.05$

$f/$	Film speed (ISO)							
	25	50	100	200	400	800	1600	3200
2	4 s	2 s	1 s	1/2 s	1/4 s	1/8 s	1/15 s	1/30 s
2.8	8 s	4 s	2 s	1 s	1/2 s	1/4 s	1/8 s	1/15 s
4	15 s	9 s	4 s	2 s	1 s	1/2 s	1/4 s	1/8 s
4.5	25 s	11 s	6 s	3 s	1 s	1/2 s	1/4 s	1/4 s
5.6	35 s	20 s	9 s	5 s	2 s	1 s	1/2 s	1/4 s
6.3	50 s	25 s	12 s	6 s	3 s	1 s	1 s	1/2 s
8	1 m	40 s	20 s	10 s	5 s	2 s	1 s	1/2 s
10	2 m	1 m	35 s	20 s	9 s	4 s	2 s	1 s
11	3 m	1 m	45 s	20 s	11 s	5 s	2 s	1 s
16	6 m	3 m	2 m	55 s	25 s	13 s	6 s	3 s
22	13 m	5 – 11 m	3 – 6 m	1 – 3 m	40 s – 2 m	20 – 45 s	13 s	6 s
32	20 – 45 m	12 – 30 m	6 – 15 m	3 – 9 m	2 – 4 m	50 s – 2 m	25 – 60 s	11 – 25 s
45	45 m – 2 h	25 m – 1 h	13 – 40 m	7 – 20 m	4 – 12 m	2 – 6 m	55 s – 3 m	25 s – 1 m
64	>>	55 m – 3 h	30 m – 2 h	15 – 55 m	8 – 30 m	4 – 15 m	2 – 8 m	60 s – 4 m
100	>>	>>	>>	45 m – 3 h	25 m – 2 h	12 m – 1 h	6 – 35 m	3 – 15 m
200	>>	>>	>>	>>	>>	>>	>>	15 m – 3 h

MOON (relatively dark total eclipse)

$m'' = 14.8$ $B = 0.005$

f/	Film speed (ISO)							
	25	50	100	200	400	800	1600	3200
2	55 s	25 s	14 s	7 s	3 s	2 s	1 s	1/2 s
2.8	2 m	60 s	30 s	15 s	7 s	3 s	2 s	1 s
4	4 m	2 m	1 m	35 s	15 s	8 s	4 s	2 s
4.5	5 m	3 m	2 m	45 s	25 s	11 s	5 s	2 s
5.6	9 m	5 m	2 – 4 m	55 s – 2 m	40 s	20 s	9 s	4 s
6.3	12 m	5 – 10 m	2 – 5 m	1 – 3 m	35 s – 1 m	20 – 40 s	12 s	5 s
8	14 – 30 m	8 – 15 m	4 – 10 m	2 – 5 m	1 – 3 m	30 s – 1 m	15 – 35 s	10 s
10	25 – 50 m	12 – 30 m	7 – 15 m	3 – 9 m	2 – 5 m	50 s – 2 m	25 s – 1 m	12 – 30 s
11	30 m – 1 h	15 – 40 m	8 – 20 m	4 – 12 m	2 – 6 m	1 – 3 m	30 s – 1 m	15 – 40 s
16	1 – 3 h	35 m – 2 h	20 – 60 m	10 – 35 m	5 – 20 m	3 – 9 m	1 – 5 m	35 s – 2 m
22	>>	1 – 4 h	40 m – 2 h	20 m – 1 h	11 – 45 m	6 – 25 m	3 – 12 m	1 – 6 m
32	>>	>>	>>	50 m – 4 h	25 m – 2 h	14 m – 1 h	7 – 40 m	4 – 20 m
45	>>	>>	>>	>>	>>	30 m – 3 h	15 m – 2 h	8 m – 1 h
64	>>	>>	>>	>>	>>	>>	>>	20 m – 3 h
100	>>	>>	>>	>>	>>	>>	>>	>>
200	>>	>>	>>	>>	>>	>>	>>	>>

A.6 Sun and solar eclipses

SUN (full disk or partial eclipse)

$m'' = -10.8$ $B = 80\,000\,000$ Filter factor $= 1\,000\,000$

Filter density 6.0, Solar-Skreen or equivalent

f/	Film speed (ISO)							
	25	50	100	200	400	800	1600	3200
2	1/500 s	1/1000 s	1/2000 s	1/4000 s	1/8000 s	1/8000 s	<<	<<
2.8	1/250 s	1/500 s	1/1000 s	1/2000 s	1/4000 s	1/8000 s	1/8000 s	<<
4	1/125 s	1/250 s	1/500 s	1/1000 s	1/2000 s	1/4000 s	1/8000 s	1/8000 s
4.5	1/125 s	1/125 s	1/250 s	1/500 s	1/1000 s	1/2000 s	1/4000 s	1/8000 s
5.6	1/60 s	1/125 s	1/250 s	1/500 s	1/1000 s	1/2000 s	1/4000 s	1/8000 s
6.3	1/60 s	1/125 s	1/125 s	1/250 s	1/500 s	1/1000 s	1/2000 s	1/4000 s
8	1/30 s	1/60 s	1/125 s	1/250 s	1/500 s	1/1000 s	1/2000 s	1/4000 s
10	1/15 s	1/30 s	1/60 s	1/125 s	1/250 s	1/500 s	1/1000 s	1/2000 s
11	1/15 s	1/30 s	1/60 s	1/125 s	1/250 s	1/500 s	1/1000 s	1/2000 s
16	1/8 s	1/15 s	1/30 s	1/60 s	1/125 s	1/250 s	1/500 s	1/1000 s
22	1/4 s	1/8 s	1/15 s	1/30 s	1/60 s	1/125 s	1/250 s	1/500 s
32	1/2 s	1/4 s	1/8 s	1/15 s	1/30 s	1/60 s	1/125 s	1/250 s
45	1 s	1/2 s	1/4 s	1/8 s	1/15 s	1/30 s	1/60 s	1/125 s
64	2 s	1 s	1/2 s	1/4 s	1/8 s	1/15 s	1/30 s	1/60 s
100	6 s	3 s	2 s	1 s	1/2 s	1/4 s	1/8 s	1/15 s
200	30 s	15 s	7 s	4 s	2 s	1 s	1/2 s	1/4 s

SUN (full disk or partial eclipse)

$m'' = -10.8$ $\quad B = 80\,000\,000$ \quad Filter factor $= 100\,000$

Filter density 5.0, Thousand Oaks Type 2

$f/$	Film speed (ISO)							
	25	50	100	200	400	800	1600	3200
2	1/4000 s	1/8000 s	1/8000 s	<<	<<	<<	<<	<<
2.8	1/2000 s	1/4000 s	1/8000 s	1/8000 s	<<	<<	<<	<<
4	1/1000 s	1/2000 s	1/4000 s	1/8000 s	1/8000 s	<<	<<	<<
4.5	1/1000 s	1/2000 s	1/4000 s	1/8000 s	1/8000 s	<<	<<	<<
5.6	1/500 s	1/1000 s	1/2000 s	1/4000 s	1/8000 s	1/8000 s	<<	<<
6.3	1/500 s	1/1000 s	1/2000 s	1/4000 s	1/8000 s	1/8000 s	<<	<<
8	1/250 s	1/500 s	1/1000 s	1/2000 s	1/4000 s	1/8000 s	1/8000 s	<<
10	1/250 s	1/500 s	1/500 s	1/1000 s	1/2000 s	1/4000 s	1/8000 s	<<
11	1/125 s	1/250 s	1/500 s	1/1000 s	1/2000 s	1/4000 s	1/8000 s	1/8000 s
16	1/60 s	1/125 s	1/250 s	1/500 s	1/1000 s	1/2000 s	1/4000 s	1/8000 s
22	1/30 s	1/60 s	1/125 s	1/250 s	1/500 s	1/1000 s	1/2000 s	1/4000 s
32	1/15 s	1/30 s	1/60 s	1/125 s	1/250 s	1/500 s	1/1000 s	1/2000 s
45	1/8 s	1/15 s	1/30 s	1/60 s	1/125 s	1/250 s	1/500 s	1/1000 s
64	1/4 s	1/8 s	1/15 s	1/30 s	1/60 s	1/125 s	1/250 s	1/500 s
100	1/2 s	1/4 s	1/8 s	1/15 s	1/30 s	1/60 s	1/125 s	1/250 s
200	2 s	1 s	1/2 s	1/4 s	1/8 s	1/15 s	1/30 s	1/60 s

SUN (full disk or partial eclipse)

$m'' = -10.8$ $\quad B = 80\,000\,000$ \quad Filter factor $= 10\,000$

Filter density 4.0, Thousand Oaks Type 3

$f/$	Film speed (ISO)							
	25	50	100	200	400	800	1600	3200
2	<<	<<	<<	<<	<<	<<	<<	<<
2.8	<<	<<	<<	<<	<<	<<	<<	<<
4	1/8000 s	<<	<<	<<	<<	<<	<<	<<
4.5	1/8000 s	1/8000 s	<<	<<	<<	<<	<<	<<
5.6	1/8000 s	1/8000 s	<<	<<	<<	<<	<<	<<
6.3	1/4000 s	1/8000 s	1/8000 s	<<	<<	<<	<<	<<
8	1/4000 s	1/4000 s	1/8000 s	<<	<<	<<	<<	<<
10	1/2000 s	1/4000 s	1/8000 s	1/8000 s	<<	<<	<<	<<
11	1/2000 s	1/2000 s	1/4000 s	1/8000 s	<<	<<	<<	<<
16	1/1000 s	1/1000 s	1/2000 s	1/4000 s	1/8000 s	<<	<<	<<
22	1/500 s	1/500 s	1/1000 s	1/2000 s	1/4000 s	1/8000 s	<<	<<
32	1/250 s	1/250 s	1/500 s	1/1000 s	1/2000 s	1/4000 s	1/8000 s	<<
45	1/125 s	1/125 s	1/250 s	1/500 s	1/1000 s	1/2000 s	1/4000 s	1/8000 s
64	1/60 s	1/125 s	1/125 s	1/250 s	1/500 s	1/1000 s	1/2000 s	1/4000 s
100	1/15 s	1/30 s	1/60 s	1/125 s	1/250 s	1/500 s	1/1000 s	1/2000 s
200	1/4 s	1/8 s	1/15 s	1/30 s	1/60 s	1/125 s	1/250 s	1/500 s

SUN, total eclipse, prominences and innermost corona

$m'' = 4.8$ $B = 48$

No filter

$f/$	Film speed (ISO)							
	25	50	100	200	400	800	1600	3200
2	1/250 s	1/500 s	1/1000 s	1/2000 s	1/4000 s	1/8000 s	1/8000 s	<<
2.8	1/125 s	1/250 s	1/500 s	1/1000 s	1/2000 s	1/4000 s	1/8000 s	1/8000 s
4	1/60 s	1/125 s	1/250 s	1/500 s	1/1000 s	1/2000 s	1/4000 s	1/8000 s
4.5	1/60 s	1/125 s	1/250 s	1/500 s	1/1000 s	1/1000 s	1/2000 s	1/4000 s
5.6	1/30 s	1/60 s	1/125 s	1/250 s	1/500 s	1/1000 s	1/2000 s	1/4000 s
6.3	1/30 s	1/60 s	1/125 s	1/250 s	1/500 s	1/1000 s	1/1000 s	1/2000 s
8	1/15 s	1/30 s	1/60 s	1/125 s	1/250 s	1/500 s	1/1000 s	1/2000 s
10	1/8 s	1/15 s	1/30 s	1/60 s	1/125 s	1/250 s	1/500 s	1/1000 s
11	1/8 s	1/15 s	1/30 s	1/60 s	1/125 s	1/250 s	1/500 s	1/1000 s
16	1/4 s	1/8 s	1/15 s	1/30 s	1/60 s	1/125 s	1/250 s	1/500 s
22	1/2 s	1/4 s	1/8 s	1/15 s	1/30 s	1/60 s	1/125 s	1/250 s
32	1 s	1/2 s	1/4 s	1/8 s	1/15 s	1/30 s	1/60 s	1/125 s
45	2 s	1 s	1/2 s	1/4 s	1/8 s	1/15 s	1/30 s	1/60 s
64	4 s	2 s	1 s	1/2 s	1/4 s	1/8 s	1/15 s	1/30 s
100	11 s	6 s	3 s	1 s	1 s	1/2 s	1/4 s	1/8 s
200	55 s	25 s	14 s	7 s	3 s	2 s	1 s	1/2 s

SUN, total eclipse, inner corona (3° field)

$m'' = 7.5$ $B = 4$

No filter

$f/$	Film speed (ISO)							
	25	50	100	200	400	800	1600	3200
2	1/30 s	1/60 s	1/60 s	1/125 s	1/250 s	1/500 s	1/1000 s	1/2000 s
2.8	1/15 s	1/30 s	1/30 s	1/60 s	1/125 s	1/250 s	1/500 s	1/1000 s
4	1/4 s	1/8 s	1/15 s	1/30 s	1/60 s	1/125 s	1/250 s	1/500 s
4.5	1/4 s	1/8 s	1/15 s	1/30 s	1/60 s	1/125 s	1/250 s	1/500 s
5.6	1/2 s	1/4 s	1/8 s	1/15 s	1/30 s	1/60 s	1/125 s	1/250 s
6.3	1/2 s	1/4 s	1/8 s	1/15 s	1/30 s	1/60 s	1/125 s	1/250 s
8	1 s	1/2 s	1/4 s	1/8 s	1/15 s	1/30 s	1/60 s	1/125 s
10	1 s	1/2 s	1/4 s	1/8 s	1/15 s	1/30 s	1/60 s	1/125 s
11	1 s	1 s	1/2 s	1/4 s	1/8 s	1/15 s	1/30 s	1/60 s
16	3 s	2 s	1 s	1/2 s	1/4 s	1/8 s	1/15 s	1/30 s
22	6 s	3 s	2 s	1 s	1/2 s	1/4 s	1/8 s	1/15 s
32	14 s	7 s	4 s	2 s	1 s	1/2 s	1/4 s	1/8 s
45	30 s	15 s	8 s	4 s	2 s	1 s	1/2 s	1/4 s
64	1 m	35 s	15 s	9 s	4 s	2 s	1 s	1/2 s
100	3 m	2 m	50 s	25 s	12 s	6 s	3 s	1 s
200	14 m	6–12 m	3–7 m	2–4 m	45 s–2 m	20–50 s	15 s	7 s

SUN, total eclipse, outer corona (10° field)

$m'' = 9.0$ $B = 1$
No filter

f/	Film speed (ISO)							
	25	50	100	200	400	800	1600	3200
2	1/4 s	1/8 s	1/15 s	1/30 s	1/60 s	1/125 s	1/250 s	1/500 s
2.8	1/2 s	1/4 s	1/8 s	1/15 s	1/30 s	1/60 s	1/125 s	1/250 s
4	1 s	1/2 s	1/4 s	1/8 s	1/15 s	1/30 s	1/60 s	1/125 s
4.5	1 s	1/2 s	1/4 s	1/8 s	1/15 s	1/30 s	1/60 s	1/125 s
5.6	2 s	1 s	1/2 s	1/4 s	1/8 s	1/15 s	1/30 s	1/60 s
6.3	2 s	1 s	1/2 s	1/4 s	1/8 s	1/15 s	1/30 s	1/60 s
8	3 s	2 s	1 s	1/2 s	1/4 s	1/8 s	1/15 s	1/30 s
10	5 s	3 s	1 s	1/2 s	1/4 s	1/8 s	1/15 s	1/30 s
11	6 s	3 s	2 s	1 s	1/2 s	1/4 s	1/8 s	1/15 s
16	14 s	7 s	4 s	2 s	1 s	1/2 s	1/4 s	1/8 s
22	30 s	15 s	7 s	4 s	2 s	1 s	1/2 s	1/4 s
32	1 m	35 s	15 s	9 s	4 s	2 s	1 s	1/2 s
45	2 m	1 m	40 s	20 s	9 s	4 s	2 s	1 s
64	5 m	3 m	1 m	45 s	20 s	10 s	5 s	2 s
100	14 m	6 – 12 m	3 – 7 m	2 – 3 m	45 s – 2 m	20 – 50 s	15 s	7 s
200	45 m – 2 h	25 m – 1 h	14 – 40 m	7 – 25 m	4 – 12 m	2 – 6 m	55 s – 3 m	25 s – 1 m

A.7 Planets

MERCURY

$m'' = 4.4$ $B = 70$
Allowing for 1 magnitude of atmospheric extinction

f/	Film speed (ISO)							
	25	50	100	200	400	800	1600	3200
2	1/500 s	1/1000 s	1/2000 s	1/2000 s	1/4000 s	1/8000 s	<<	<<
2.8	1/250 s	1/500 s	1/1000 s	1/2000 s	1/2000 s	1/4000 s	1/8000 s	<<
4	1/125 s	1/250 s	1/500 s	1/500 s	1/1000 s	1/2000 s	1/4000 s	1/8000 s
4.5	1/60 s	1/125 s	1/250 s	1/500 s	1/1000 s	1/2000 s	1/4000 s	1/8000 s
5.6	1/60 s	1/125 s	1/250 s	1/500 s	1/500 s	1/1000 s	1/2000 s	1/4000 s
6.3	1/30 s	1/60 s	1/125 s	1/250 s	1/500 s	1/1000 s	1/2000 s	1/4000 s
8	1/30 s	1/60 s	1/125 s	1/125 s	1/250 s	1/500 s	1/1000 s	1/2000 s
10	1/15 s	1/30 s	1/60 s	1/125 s	1/250 s	1/500 s	1/1000 s	1/2000 s
11	1/15 s	1/30 s	1/60 s	1/125 s	1/125 s	1/250 s	1/500 s	1/1000 s
16	1/8 s	1/15 s	1/30 s	1/60 s	1/60 s	1/125 s	1/250 s	1/500 s
22	1/4 s	1/8 s	1/15 s	1/30 s	1/30 s	1/60 s	1/125 s	1/250 s
32	1/2 s	1/4 s	1/4 s	1/8 s	1/15 s	1/30 s	1/60 s	1/125 s
45	1 s	1 s	1/2 s	1/4 s	1/8 s	1/15 s	1/30 s	1/60 s
64	3 s	1 s	1 s	1/2 s	1/4 s	1/8 s	1/15 s	1/30 s
100	8 s	4 s	2 s	1 s	1/2 s	1/4 s	1/8 s	1/15 s
200	35 s	20 s	9 s	4 s	2 s	1 s	1/2 s	1/4 s

VENUS
$m'' = 1.5$ $B = 1000$

f/	Film speed (ISO)							
	25	50	100	200	400	800	1600	3200
2	1/4000 s	1/8000 s	<<	<<	<<	<<	<<	<<
2.8	1/2000 s	1/4000 s	1/8000 s	<<	<<	<<	<<	<<
4	1/1000 s	1/2000 s	1/4000 s	1/8000 s	<<	<<	<<	<<
4.5	1/1000 s	1/2000 s	1/4000 s	1/8000 s	1/8000 s	<<	<<	<<
5.6	1/500 s	1/1000 s	1/2000 s	1/4000 s	1/8000 s	<<	<<	<<
6.3	1/500 s	1/1000 s	1/2000 s	1/4000 s	1/8000 s	1/8000 s	<<	<<
8	1/250 s	1/500 s	1/1000 s	1/2000 s	1/4000 s	1/8000 s	<<	<<
10	1/250 s	1/500 s	1/1000 s	1/2000 s	1/4000 s	1/8000 s	1/8000 s	<<
11	1/125 s	1/250 s	1/500 s	1/1000 s	1/2000 s	1/4000 s	1/8000 s	<<
16	1/60 s	1/125 s	1/250 s	1/500 s	1/1000 s	1/2000 s	1/4000 s	1/8000 s
22	1/60 s	1/60 s	1/125 s	1/250 s	1/500 s	1/1000 s	1/2000 s	1/4000 s
32	1/30 s	1/30 s	1/60 s	1/125 s	1/250 s	1/500 s	1/1000 s	1/2000 s
45	1/8 s	1/15 s	1/30 s	1/60 s	1/125 s	1/250 s	1/500 s	1/1000 s
64	1/4 s	1/8 s	1/15 s	1/30 s	1/60 s	1/125 s	1/250 s	1/500 s
100	1/2 s	1/4 s	1/8 s	1/15 s	1/30 s	1/60 s	1/125 s	1/250 s
200	2 s	1 s	1/2 s	1/4 s	1/8 s	1/15 s	1/30 s	1/60 s

MARS
$m'' = 4.0$ $B = 100$

f/	Film speed (ISO)							
	25	50	100	200	400	800	1600	3200
2	1/500 s	1/1000 s	1/2000 s	1/4000 s	1/8000 s	1/8000 s	<<	<<
2.8	1/250 s	1/500 s	1/1000 s	1/2000 s	1/4000 s	1/8000 s	1/8000 s	<<
4	1/125 s	1/250 s	1/500 s	1/1000 s	1/2000 s	1/4000 s	1/8000 s	1/8000 s
4.5	1/125 s	1/250 s	1/500 s	1/1000 s	1/2000 s	1/4000 s	1/8000 s	1/8000 s
5.6	1/60 s	1/125 s	1/250 s	1/500 s	1/1000 s	1/2000 s	1/4000 s	1/8000 s
6.3	1/60 s	1/125 s	1/250 s	1/500 s	1/1000 s	1/2000 s	1/4000 s	1/4000 s
8	1/30 s	1/60 s	1/125 s	1/250 s	1/500 s	1/1000 s	1/2000 s	1/4000 s
10	1/30 s	1/60 s	1/60 s	1/125 s	1/250 s	1/500 s	1/1000 s	1/2000 s
11	1/15 s	1/30 s	1/60 s	1/125 s	1/250 s	1/500 s	1/1000 s	1/2000 s
16	1/8 s	1/15 s	1/30 s	1/60 s	1/125 s	1/250 s	1/500 s	1/1000 s
22	1/4 s	1/8 s	1/15 s	1/30 s	1/60 s	1/125 s	1/250 s	1/500 s
32	1/2 s	1/4 s	1/8 s	1/15 s	1/30 s	1/60 s	1/125 s	1/250 s
45	1 s	1/2 s	1/4 s	1/8 s	1/15 s	1/30 s	1/60 s	1/125 s
64	2 s	1 s	1/2 s	1/4 s	1/8 s	1/15 s	1/30 s	1/60 s
100	5 s	3 s	1 s	1/2 s	1/4 s	1/8 s	1/15 s	1/30 s
200	25 s	12 s	6 s	3 s	1 s	1 s	1/2 s	1/4 s

JUPITER

$m'' = 5.3$ $B = 30$

f/	Film speed (ISO)							
	25	50	100	200	400	800	1600	3200
2	1/125 s	1/250 s	1/500 s	1/1000 s	1/2000 s	1/4000 s	1/8000 s	1/8000 s
2.8	1/60 s	1/125 s	1/250 s	1/500 s	1/1000 s	1/2000 s	1/4000 s	1/8000 s
4	1/30 s	1/60 s	1/125 s	1/250 s	1/500 s	1/1000 s	1/2000 s	1/4000 s
4.5	1/30 s	1/60 s	1/125 s	1/250 s	1/500 s	1/1000 s	1/2000 s	1/4000 s
5.6	1/30 s	1/30 s	1/60 s	1/125 s	1/250 s	1/500 s	1/1000 s	1/2000 s
6.3	1/15 s	1/30 s	1/60 s	1/125 s	1/250 s	1/500 s	1/1000 s	1/2000 s
8	1/8 s	1/15 s	1/30 s	1/60 s	1/125 s	1/250 s	1/500 s	1/1000 s
10	1/8 s	1/15 s	1/30 s	1/60 s	1/125 s	1/250 s	1/250 s	1/500 s
11	1/4 s	1/8 s	1/15 s	1/30 s	1/60 s	1/125 s	1/250 s	1/500 s
16	1/2 s	1/4 s	1/8 s	1/15 s	1/30 s	1/60 s	1/125 s	1/250 s
22	1 s	1/2 s	1/4 s	1/8 s	1/15 s	1/30 s	1/60 s	1/125 s
32	2 s	1 s	1/2 s	1/4 s	1/8 s	1/15 s	1/30 s	1/60 s
45	3 m	2 s	1 s	1/2 s	1/4 s	1/8 s	1/15 s	1/30 s
64	7 m	4 s	2 s	1 s	1/2 s	1/4 s	1/8 s	1/15 s
100	20 m	10 s	5 s	2 s	1 s	1/2 s	1/4 s	1/8 s
200	1 m	45 s	25 s	12 s	6 s	3 s	1 s	1/2 s

SATURN

$m'' = 6.7$ $B = 8$

f/	Film speed (ISO)							
	25	50	100	200	400	800	1600	3200
2	1/60 s	1/125 s	1/125 s	1/250 s	1/500 s	1/1000 s	1/2000 s	1/4000 s
2.8	1/30 s	1/60 s	1/125 s	1/125 s	1/250 s	1/500 s	1/1000 s	1/2000 s
4	1/15 s	1/30 s	1/60 s	1/60 s	1/125 s	1/250 s	1/500 s	1/1000 s
4.5	1/8 s	1/15 s	1/30 s	1/60 s	1/125 s	1/250 s	1/500 s	1/1000 s
5.6	1/8 s	1/15 s	1/30 s	1/60 s	1/60 s	1/125 s	1/250 s	1/500 s
6.3	1/4 s	1/8 s	1/15 s	1/30 s	1/60 s	1/125 s	1/250 s	1/500 s
8	1/4 s	1/4 s	1/8 s	1/15 s	1/30 s	1/60 s	1/125 s	1/250 s
10	1/2 s	1/4 s	1/8 s	1/15 s	1/30 s	1/60 s	1/125 s	1/250 s
11	1/2 s	1/2 s	1/4 s	1/8 s	1/30 s	1/30 s	1/60 s	1/125 s
16	1 s	1 s	1/2 s	1/4 s	1/8 s	1/15 s	1/30 s	1/60 s
22	3 s	1 s	1 s	1/2 s	1/4 s	1/8 s	1/15 s	1/30 s
32	6 s	3 s	2 s	1 s	1/2 s	1/4 s	1/8 s	1/15 s
45	14 s	7 s	3 s	2 s	1 s	1/2 s	1/4 s	1/8 s
64	30 s	15 s	8 s	4 s	2 s	1 s	1/2 s	1/4 s
100	1 m	40 s	20 s	10 s	5 s	2 s	1 s	1/2 s
200	6 m	3 m	2 m	55 s	25 s	13 s	6 s	3 s

URANUS
$m'' = 8.6$ $B = 1.4$

f/	Film speed (ISO)							
	25	50	100	200	400	800	1600	3200
2	1/8 s	1/15 s	1/30 s	1/60 s	1/125 s	1/250 s	1/500 s	1/1000 s
2.8	1/4 s	1/8 s	1/15 s	1/30 s	1/60 s	1/125 s	1/250 s	1/500 s
4	1/2 s	1/4 s	1/8 s	1/15 s	1/30 s	1/60 s	1/125 s	1/250 s
4.5	1/2 s	1/4 s	1/8 s	1/15 s	1/30 s	1/60 s	1/60 s	1/125 s
5.6	1 s	1/2 s	1/4 s	1/8 s	1/15 s	1/30 s	1/60 s	1/125 s
6.3	1 s	1/2 s	1/4 s	1/8 s	1/15 s	1/30 s	1/30 s	1/60 s
8	2 s	1 s	1/2 s	1/4 s	1/8 s	1/15 s	1/30 s	1/60 s
10	3 s	2 s	1 s	1/2 s	1/4 s	1/8 s	1/15 s	1/30 s
11	4 s	2 s	1 s	1/2 s	1/4 s	1/8 s	1/15 s	1/30 s
16	10 s	5 s	2 s	1 s	1/2 s	1/4 s	1/8 s	1/15 s
22	20 s	10 s	5 s	2 s	1 s	1/2 s	1/4 s	1/8 s
32	45 s	25 s	11 s	6 s	3 s	1 s	1/2 s	1/4 s
45	2 m	50 s	25 s	12 s	6 s	3 s	1 s	1/2 s
64	3 m	2 m	55 s	30 s	14 s	7 s	3 s	1 s
100	10 m	5 m	2 – 4 m	60 s – 2 m	30 s – 1 m	20 s	9 s	4 s
200	30 m – 1 h	15 – 45 m	9 – 25 m	5 – 14 m	2 – 7 m	1 – 4 m	35 s – 2 m	15 – 45 s

NEPTUNE
$m'' = 9.3$ $B = 0.75$

f/	Film speed (ISO)							
	25	50	100	200	400	800	1600	3200
2	1/4 s	1/8 s	1/15 s	1/30 s	1/60 s	1/125 s	1/250 s	1/500 s
2.8	1/2 s	1/4 s	1/8 s	1/15 s	1/30 s	1/60 s	1/125 s	1/250 s
4	1 s	1/2 s	1/4 s	1/8 s	1/15 s	1/30 s	1/60 s	1/125 s
4.5	1 s	1/2 s	1/4 s	1/8 s	1/15 s	1/30 s	1/60 s	1/60 s
5.6	2 s	1 s	1/2 s	1/4 s	1/8 s	1/15 s	1/30 s	1/60 s
6.3	3 s	1 s	1/2 s	1/4 s	1/8 s	1/15 s	1/30 s	1/30 s
8	4 s	2 s	1 s	1/2 s	1/4 s	1/8 s	1/15 s	1/30 s
10	7 s	3 s	2 s	1 s	1/2 s	1/4 s	1/8 s	1/15 s
11	9 s	4 s	2 s	1 s	1/2 s	1/4 s	1/8 s	1/15 s
16	20 s	10 s	5 s	2 s	1 s	1/2 s	1/4 s	1/8 s
22	40 s	20 s	10 s	5 s	2 s	1 s	1/2 s	1/4 s
32	2 m	45 s	25 s	12 s	6 s	3 s	1 s	1/2 s
45	3 m	2 m	55 s	25 s	13 s	6 s	3 s	1 s
64	7 m	4 m	2 m	1 m	30 s	14 s	7 s	3 s
100	14 – 30 m	8 – 15 m	4 – 10 m	2 – 5 m	1 – 3 m	30 s – 1 m	15 – 35 s	10 s
200	1 – 3 h	35 m – 2 h	20 – 55 m	10 – 35 m	5 – 20 m	3 – 9 m	1 – 4 m	35 s – 2 m

A.8 Faint objects

COMETS (typical; they vary widely)

$m'' = 17.0 \qquad B = 0.0006$

Exposing for coma and tail; nucleus is much brighter.

$f/$	Film speed (ISO)							
	25	50	100	200	400	800	1600	3200
2	9 m	5 m	2 – 4 m	55 s – 2 m	35 s	20 s	8 s	4 s
2.8	13 – 25 m	7 – 15 m	4 – 9 m	2 – 5 m	60 s – 2 m	30 s – 1 m	14 – 30 s	9 s
4	30 m – 1 h	15 – 40 m	8 – 20 m	4 – 12 m	2 – 6 m	1 – 3 m	30 s – 1 m	15 – 40 s
4.5	35 m – 1 h	20 – 50 m	11 – 30 m	6 – 15 m	3 – 9 m	1 – 4 m	40 s – 2 m	20 – 55 s
5.6	55 m – 2 h	30 m – 1 h	20 – 55 m	9 – 30 m	5 – 15 m	2 – 8 m	1 – 4 m	35 s – 2 m
6.3	1 – 3 h	40 m – 2 h	25 m – 1 h	12 – 40 m	6 – 25 m	3 – 12 m	2 – 6 m	45 s – 3 m
8	>>	1 – 4 h	40 m – 2 h	20 m – 1 h	11 – 45 m	6 – 25 m	3 – 12 m	1 – 6 m
10	>>	>>	1 – 4 h	35 m – 2 h	20 m – 1 h	10 – 45 m	5 – 25 m	2 – 12 m
11	>>	>>	>>	45 m – 3 h	25 m – 2 h	12 m – 1 h	6 – 35 m	3 – 15 m
16	>>	>>	>>	>>	>>	30 m – 3 h	15 m – 2 h	8 m – 1 h

NEBULAE, bright (M42, M27, M57)

$m'' = 16.5 \qquad B = 0.001$

Using film with good sensitivity at 656 nm. Visually, these objects are about 21 m''.

$f/$	Film speed (ISO)							
	25	50	100	200	400	800	1600	3200
2	5 m	3 m	1 m	45 s	20 s	10 s	5 s	2 s
2.8	11 m	4 – 9 m	2 – 5 m	1 – 3 m	35 s – 1 m	25 s	11 s	5 s
4	15 – 35 m	9 – 20 m	5 – 12 m	3 – 7 m	1 – 3 m	40 s – 2 m	20 – 45 s	9 – 20 s
4.5	20 – 50 m	12 – 30 m	6 – 15 m	3 – 9 m	2 – 5 m	50 s – 2 m	25 s – 1 m	12 – 25 s
5.6	35 m – 1 h	20 – 50 m	11 – 30 m	6 – 15 m	3 – 9 m	1 – 4 m	40 s – 2 m	20 – 55 s
6.3	45 m – 2 h	25 m – 1 h	14 – 40 m	7 – 20 m	4 – 12 m	2 – 6 m	55 s – 3 m	25 s – 1 m
8	1 – 3 h	40 m – 2 h	25 m – 1 h	13 – 45 m	7 – 25 m	3 – 12 m	2 – 6 m	45 s – 3 m
10	>>	1 – 4 h	40 m – 2 h	20 m – 1 h	11 – 45 m	6 – 25 m	3 – 12 m	1 – 6 m
11	>>	>>	50 m – 3 h	25 m – 2 h	14 – 60 m	7 – 30 m	4 – 15 m	2 – 8 m
16	>>	>>	>>	>>	35 m – 3 h	20 m – 2 h	9 – 50 m	4 – 25 m

NEBULAE, faint (California, Horsehead), deliberate underexposure

$m'' = 21.0$ $\quad B = 0.000\,016$ \quad Underexposure factor $= 0.25$

Using film with good sensitivity at 656 nm. Visually, these objects are about 24 m''.

$f/$	Film speed (ISO)							
	25	50	100	200	400	800	1600	3200
2	1–3 h	40 m–2 h	25 m–1 h	12–40 m	6–25 m	3–12 m	2–6 m	45 s–3 m
2.8	>>	>>	50 m–3 h	25 m–2 h	14 m–1 h	7–35 m	4–15 m	2–8 m
4	>>	>>	>>	>>	35 m–3 h	15 m–2 h	9–50 m	4–25 m
4.5	>>	>>	>>	>>	45 m–4 h	25 m–2 h	12 m–1 h	6–40 m
5.6	>>	>>	>>	>>	>>	>>	20 m–2 h	10 m–1 h
6.3	>>	>>	>>	>>	>>	>>	25 m–4 h	14 m–2 h
8	>>	>>	>>	>>	>>	>>	>>	>>

GALAXIES, bright cores

$m'' = 18.0$ $\quad B = 0.000\,25$

$f/$	Film speed (ISO)							
	25	50	100	200	400	800	1600	3200
2	15–35 m	9–20 m	5–12 m	3–7 m	1–3 m	40 s–2 m	20–45 s	9–20 s
2.8	35 m–1 h	20–50 m	10–30 m	6–15 m	3–9 m	1–4 m	40 s–2 m	20–55 s
4	1–3 h	40 m–2 h	25 m–1 h	12–45 m	7–25 m	3–12 m	2–6 m	45 s–3 m
4.5	>>	55 m–3 h	30 m–2 h	15–60 m	9–35 m	4–15 m	2–9 m	1–4 m
5.6	>>	>>	50 m–3 h	25 m–2 h	14 m–1 h	7–35 m	4–15 m	2–8 m
6.3	>>	>>	1–4 h	35 m–2 h	20 m–1 h	10–45 m	5–25 m	2–12 m
8	>>	>>	>>	>>	35 m–3 h	15 m–2 h	9–50 m	4–25 m
10	>>	>>	>>	>>	>>	30 m–3 h	15 m–2 h	8–55 m
11	>>	>>	>>	>>	>>	>>	20 m–2 h	10 m–1 h
16	>>	>>	>>	>>	>>	>>	>>	>>

GALAXIES, outer regions, deliberate underexposure

$m'' = 21.0$ $\quad B = 0.000\,016$ \quad Underexposure factor $= 0.25$

$f/$	Film speed (ISO)							
	25	50	100	200	400	800	1600	3200
2	1–3 h	40 m–2 h	25 m–1 h	12–40 m	6–25 m	3–12 m	2–6 m	45 s–3 m
2.8	>>	>>	50 m–3 h	25 m–2 h	14 m–1 h	7–35 m	4–15 m	2–8 m
4	>>	>>	>>	>>	35 m–3 h	15 m–2 h	9–50 m	4–25 m
4.5	>>	>>	>>	>>	45 m–4 h	25 m–2 h	12 m–1 h	6–40 m
5.6	>>	>>	>>	>>	>>	>>	20 m–2 h	10 m–1 h
6.3	>>	>>	>>	>>	>>	>>	25 m–4 h	14 m–2 h
8	>>	>>	>>	>>	>>	>>	>>	>>

SKY FOG LIMIT, typical town sky

$m'' = 18.0 \qquad B = 0.00025$

For slide film at sites where 5.5-mag. stars can be seen.

Negative film and/or dark country skies allow much longer exposures.

$f/$	Film speed (ISO)							
	25	50	100	200	400	800	1600	3200
2	15 – 35 m	9 – 20 m	5 – 12 m	3 – 7 m	1 – 3 m	40 s – 2 m	20 – 45 s	9 – 20 s
2.8	35 m – 1 h	20 – 50 m	10 – 30 m	6 – 15 m	3 – 9 m	1 – 4 m	40 s – 2 m	20 – 55 s
4	1 – 3 h	40 m – 2 h	25 m – 1 h	12 – 45 m	7 – 25 m	3 – 12 m	2 – 6 m	45 s – 3 m
4.5	>>	55 m – 3 h	30 m – 2 h	15 – 60 m	9 – 35 m	4 – 15 m	2 – 9 m	1 – 4 m
5.6	>>	>>	50 m – 3 h	25 m – 2 h	14 m – 1 h	7 – 35 m	4 – 15 m	2 – 8 m
6.3	>>	>>	1 – 4 h	35 m – 2 h	20 m – 1 h	10 – 45 m	5 – 25 m	2 – 12 m
8	>>	>>	>>	>>	35 m – 3 h	15 m – 2 h	9 – 50 m	4 – 25 m
10	>>	>>	>>	>>	>>	30 m – 3 h	15 m – 2 h	8 – 55 m
11	>>	>>	>>	>>	>>	>>	20 m – 2 h	10 m – 1 h
16	>>	>>	>>	>>	>>	>>	>>	>>

SKY FOG LIMIT, typical city sky

$m'' = 16.0 \qquad B = 0.0016$

For slide film at sites where 4.5-mag. stars can be seen.

Negative film allows appreciably longer exposures.

$f/$	Film speed (ISO)							
	25	50	100	200	400	800	1600	3200
2	3 m	2 m	50 s	25 s	12 s	6 s	3 s	1 s
2.8	7 m	4 m	2 m	55 s	25 s	13 s	6 s	3 s
4	15 m	6 – 12 m	3 – 7 m	2 – 4 m	45 s – 2 m	20 – 50 s	15 s	7 s
4.5	13 – 30 m	7 – 15 m	4 – 9 m	2 – 5 m	60 s – 2 m	30 s – 1 m	14 – 30 s	9 s
5.6	20 – 50 m	12 – 30 m	6 – 15 m	3 – 9 m	2 – 4 m	50 s – 2 m	25 – 60 s	11 – 25 s
6.3	25 m – 1 h	15 – 40 m	8 – 20 m	4 – 12 m	2 – 6 m	1 – 3 m	30 s – 1 m	15 – 40 s
8	45 m – 2 h	25 m – 1 h	14 – 40 m	7 – 25 m	4 – 12 m	2 – 6 m	55 s – 3 m	25 s – 1 m
10	1 – 3 h	40 m – 2 h	25 m – 1 h	12 – 40 m	6 – 25 m	3 – 12 m	2 – 6 m	45 s – 3 m
11	2 – 4 h	50 m – 3 h	30 m – 2 h	15 – 55 m	8 – 30 m	4 – 15 m	2 – 8 m	60 s – 4 m
16	>>	>>	>>	35 m – 3 h	20 m – 1 h	10 – 50 m	5 – 25 m	2 – 12 m

Mathematical analysis of polar-axis misalignment **Appendix B**

If the polar axis of an equatorial mount is misaligned, three kinds of errors result:

- *Hour angle error* (the object appears to drift in right ascension, or putting it another way, the drive rate appears to be wrong);
- *Declination error* (the object appears to drift in declination);
- *Field rotation* (the object appears to rotate).

The hour angle error is entirely absorbed into guiding corrections that are needed for other reasons. In this appendix I shall analyze the remaining two. As far as I can determine, no one in the twentieth century has published a full analysis of this matter, although it is discussed by Chauvenet (1876, vol. 2, pp. 367–390) and Pickering (1886, pp. 195–201). Their equipment was quite different from that now in use, and their aim was to build perfect equatorial mounts rather than to analyze the effect of making guiding corrections with portable equipment whose alignment is never perfect. On the related problem of tracking the stars with an altazimuth mount and field-de-rotator, see Trueblood and Genet (1985, p. 109 ff.) and Pouplier (1992).

Precaution for calculators Many of the calculations described here require a large number of significant digits in order to yield useful results. For example, in Example 1, a number is multiplied by 0.999 990 480 7, and if this were rounded to 1.0 the entire significance of the number would be lost.

Ordinary 8-digit pocket calculators are not always accurate enough for these computations. If possible, use a computer with double precision arithmetic (`double` in C and its descendants, `DEFDBL` in Microsoft BASIC). Java functions for these computations are given in Section B.4, p. 281.

B.1 Summary of the most important results

- When the object, the true pole, and the false pole form a right angle, declination drift is greatest and field rotation is zero.
- When the object, the true pole, and the false pole are in a straight line, declination drift is zero and field rotation is greatest.
- Declination drift is largely independent of declination up to $\pm 80°$ or so; it diminishes sharply near the poles.
- Field rotation increases with increasing declination. At $\pm 60°$ it is twice what it would be at the celestial equator, and it increases sharply at the celestial poles.
- The maximum possible declination drift during an exposure is:
 Declination drift = 15.7$''\times$ exposure time (minutes) \times alignment error (degrees)
 Under some conditions it is *much* less.
- The maximum possible field rotation, for objects between declination $-60°$ and $+60°$, is:
 Field rotation = $0.01°\times$ exposure time (minutes) \times alignment error (degrees)
 Under some conditions it is *much* less. Near the poles, it is greater.

B.2 Declination drift

B.2.1 Total drift during an exposure

Define variables as follows (Figs. B.1, B.2):

δ is the declination of the star being tracked;

$d = 90° - \delta$ is the distance of the star from the true pole, and is constant;

D is the distance of the star from the false (instrumental) pole, constantly changing due to declination drift as shown in Fig. B.2;

e is the amount of polar alignment error (i.e., the distance between the true and false poles);

Figure B.1 **A star moves in a circle around the true pole; the telescope moves around the false (instrumental) pole.**

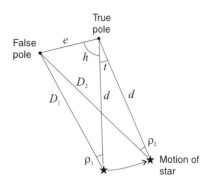

Figure B.2 **Declination drift is $D_2 - D_1$; field rotation is $\rho_2 - \rho_1$. Time elapsed is t.**

t is the length of the exposure, usually expressed in angular units (the earth's rotation during the exposure, $15°$ per hour of time);

h is the difference in right ascension between the false pole and the star at the beginning of the exposure. Because the false pole does not move with the stars, its right ascension is constantly changing, and at the end of the exposure, in place of h we have $h + t$.

The rate of change of D is what we are ultimately investigating.

Note that e, d, and D form a spherical triangle. D is unknown, but the angle opposite D is h. These quantities are related by a familiar formula from spherical trigonometry,

$$\cos D = \cos h \sin d \sin e + \cos d \cos e$$

which we can solve for D:

$$D = \arccos(\cos h \sin d \sin e + \cos d \cos e)$$

Recalling that $d = 90° - \delta$, we can substitute $\cos \delta$ for $\sin d$ and $\sin \delta$ for $\cos d$ so that the formula uses the declination of the star rather than its polar distance:

$$D = \arccos(\cos h \cos \delta \sin e + \sin \delta \cos e)$$

But D is not what we want. We have no trouble aiming the telescope at the star; what we want to know is how much it will drift. What we need to know is the *change* in D over a period of time, given by this formula:

$$\Delta D = D_2 - D_1$$
$$= \arccos (\cos (h + t) \ \cos \ \delta \ \sin \ e + \sin \delta \cos e$$
$$- \arccos(\cos \ h \cos \delta \sin e + \sin \delta \cos e)$$

where t is elapsed time (rotation of the earth expressed as an angle). This formula gives the total declination drift during an exposure.

Example 1: Innocuous $1°$ misalignment Suppose the polar axis is aimed one degree too high and we are tracking a star that on the celestial equator ($\delta = 0°$) and is initially on the meridian. Then $e = 1°$ and $h = 0°$ (because the false pole and the star are both on the meridian).

This is the special case in which polar misalignment causes the smallest amount of declination drift, and we should expect a one-minute exposure ($t = 0.25°$ of earth rotation) to have practically none. Does it? We compute

$$\Delta D = \arccos(\cos(h + t) \cos \delta \sin e + \sin \delta \cos e)$$
$$- \arccos(\cos h \cos \delta \sin e + \sin \delta \cos e)$$
$$= \arccos(\cos 0.25° \cos 0° \sin 1° + \sin 0° \cos 1°)$$
$$- \arccos(\cos 0° \cos 0° \sin 1° + \sin 0° \cos 1°)$$
$$= \arccos(0.999\,990\,480\,7 \times 0.017\,452\,406\,44)$$
$$- \arccos(0.017\,452\,406\,44)$$
$$= 89.000\,009\,52° - 89.000\,000\,00°$$
$$= 0.000\,009\,52°$$
$$= 0.03 \text{ arc-second}$$

which is indeed negligible. (But there is appreciable field rotation in longer exposures, as shown in Example 7 below.)

Example 2: Worst-case 1° misalignment Suppose the situation is as before except that the alignment error is entirely in azimuth rather than altitude, and the polar axis is east of the true pole, i.e., its right ascension is 90° greater than that of the meridian. Then $e = 1°$, $\delta = 0$, $t = 0.25°$, but $h = 90°$, and we compute:

$$\Delta D = \arccos(\cos(h + t) \cos \delta \sin e + \sin \delta \cos e)$$
$$- \arccos(\cos h \cos \delta \sin e + \sin \delta \cos e)$$
$$= \arccos(\cos 90.25° \cos 0° \sin 1° + \sin 0° \cos 1°)$$
$$- \arccos(\cos 90° \cos 0° \sin 1° + \sin 0° \cos 1°)$$
$$= \arccos(-0.004\,363 \times 0.017\,452) - \arccos 0$$
$$= 90.004\,363° - 90.000\,000°$$
$$= 0.004\,363° = 15.7 \text{ arc-seconds}$$

Here D is increasing; the object appears to be drifting away from the pole. Compare this with the values tabulated by Martinez (1994, vol. 2, p. 853), noting that his column titled "Alignment error (arcsec)" is actually in arc-*minutes*.

Example 3: Drift reverses direction during exposure
There is one special case in which ΔD is deceptive. Suppose h starts out negative and goes through zero to the opposite of its initial value. That is, at mid-exposure, the object and the false pole have the same right ascension. This can easily happen when the alignment error is purely in altitude (like Example 1) and we are photographing a star that crosses the meridian during the exposure. Suppose h is initially $-5°$ and $t = 10°$ ($= 40$ minutes of time). Calculate:

$$\Delta D = \arccos(\cos(h + t) \cos \delta \sin e + \sin \delta \cos e)$$
$$- \arccos(\cos h \cos \delta \sin e + \sin \delta \cos e)$$
$$= \arccos(\cos(-5° + 10°) \cos 0° \sin 1° + \sin 0° \cos 1°)$$
$$- \arccos(\cos -5° \cos 0° \sin 1° + \sin 0° \cos 1°)$$
$$= \arccos(0.996\,194\,7 \times 1 \times 0.017\,452\,4)$$
$$- \arccos(0.996\,194\,7 \times 1 \times 0.017\,452\,4)$$
$$= 0$$

What happened? Was there no drift? Of course not. The star drifted in one direction until it crossed the meridian, then backtracked along its path, returning to its initial apparent position. This shows that ΔD is not always a truthful indicator of declination drift. That is, computing the total drift during the exposure does not necessarily tell you all you need to know. You also need to know the rate of drift at the beginning of the exposure.

B.2.2 Rate of declination drift at any particular time

The rate of declination drift at any particular time is the derivative of D with respect to h (taking h to be constantly changing with t as the earth rotates):

$$\frac{dD}{dh} = \frac{\sin h \cos \delta \sin e}{\sqrt{1 - (\cos h \cos \delta \sin e + \sin \delta \cos e)^2}}$$

Here D and h are given in the same units; "degrees per degree of earth rotation" as it were. To get degrees per minute of time, divide by 4.

Example 4. Rate of drift from Example 2 Recall that the total drift over this 1-minute exposure was 15.7 arc-seconds. What was the rate of drift at the beginning of the exposure?

$$\frac{dD}{dh} = \frac{\sin h \cos \delta \sin e}{\sqrt{1 - (\cos h \cos \delta \sin e + \sin \delta \cos e)^2}}$$
$$= \frac{\sin 90° \cos 0° \sin 1°}{\sqrt{1 - (\cos 90° \cos 0° \sin 1° + \sin 0° \cos 1°)^2}}$$
$$= \frac{0.017\,452\,406}{1}$$
$$= 0.017\,452\,406 \text{ degrees of drift per degree}$$
of earth rotation
$$= 0.004\,363\,1 \text{ degrees of drift per minute of time}$$
$$= 15.7 \text{ arc-seconds of drift per minute of time}$$

That's not at all surprising; the initial drift rate per minute is essentially the same as the total drift over a one-minute exposure.

Example 5. Rate of drift from Example 3 Now consider Example 3, the one where the total drift over the length of the exposure was zero because the stars drifted first one way and then the other. Unlike the formula for ΔD, the formula for dD dh won't fool you.

In this example, $e = 1°$, $\delta = 0°$, $h = -5°$, and t doesn't matter because we are now computing the instantaneous rate of drift rather than the total over some period of time. We calculate:

$$\frac{dD}{dh} = \frac{\sin h \cos \delta \sin e}{\sqrt{1 - (\cos h \cos \delta \sin e + \sin \delta \cos e)^2}}$$

$$= \frac{\sin -5° \cos 0° \sin 1°}{\sqrt{1 - (\cos -5° \cos 0° \sin 1° + \sin 0° \cos 1°)^2}}$$

$$= \frac{-0.087\,156 \times 1 \times 0.017\,452}{\sqrt{1 - (0.996\,194\,7 \times 1 \times 0.017\,452)^2}}$$

$$= 0.001\,521 \text{ degrees of drift per degree of earth rotation}$$

$$= 1.37 \text{ arc-seconds of drift per minute of time}$$

This shows that despite the zero total drift, there is drift going on at the beginning of the exposure. Admittedly, it's not a lot of drift.

Example 6. Case where dD/dh is misleading Note *that dD/dh by itself can sometimes mislead you, because there are instants when dD/dh is zero even though there is drift during the exposure as a whole.*

Looking at the formula, you can see that whenever $\sin h = 0$, dD/dh must also be zero. This happens when h passes through $0°$, i.e., the false pole and the object being photographed happen to have the same right ascension. This is the case only for an instant and does not mean there is no drift during the entire exposure.

B.3 Field rotation

B.3.1 Total field rotation during an exposure

Now consider field rotation, which is more troublesome than declination drift because most telescopes do not provide a way to correct it.

Field rotation consists of a change in the angle ρ in Fig. B.2. We can determine ρ by solving the spherical triangle of which it is a corner. By the law of sines,

$$\frac{\sin \rho}{\sin e} = \frac{\sin h}{\sin D}$$

and therefore:

$$\rho = \arcsin\left(\frac{\sin e \sin h}{\sin D}\right)$$

But we already have a formula for D. Therefore:

$$\rho = \arcsin\left(\frac{\sin e \sin h}{\sin \arccos(\cos h \cos \delta \sin e + \sin \delta \cos e)}\right)$$

Because $\sin \arccos x \equiv \sqrt{1 - x^2}$, we can simplify a bit:

$$\rho = \arcsin\left(\frac{\sin e \sin h}{\sqrt{1 - (\cos h \cos \delta \sin e + \sin \delta \cos e)^2}}\right)$$

This resembles the formula for dD/dh, as well it should, since the greater the angle ρ, the faster the object drifts in declination.

But what we actually wanted was not the value of ρ (always small), but the *change* in ρ when h is replaced by $h + t$. Accordingly:

$$\Delta\rho = \arcsin\left(\frac{\sin e \sin(h + t)}{\sqrt{1 - (\cos(h + t) \cos \delta \sin e + \sin \delta \cos e)^2}}\right)$$

$$- \arcsin\left(\frac{\sin e \sin h}{\sqrt{1 - (\cos h \cos \delta \sin e + \sin \delta \cos e)^2}}\right)$$

This is a considerably more complicated function than ΔD. In general, the field rotates fastest when $h = 0°$ (just when declination drift is slowest), and the field rotation slows down and reverses direction when h passes through $90°$.

Example 7. Field rotation in "innocuous" $1°$ misalignment As in Example 1, the polar axis is aimed $1°$ too high ($e = 1°$) and the object is on the celestial equator ($\delta = 0°$) and initially on the meridian. We have $h = 0°$. This is the situation in which declination drift is minimized. Instead of exposing for one minute, we expose for one hour ($t = 15°$).

$$\Delta\rho = \arcsin\left(\frac{\sin e \sin(h + t)}{\sqrt{1 - (\cos(h + t)\cos\delta\sin e + \sin\delta\cos e)^2}}\right)$$

$$- \arcsin\left(\frac{\sin e \sin h}{\sqrt{1 - (\cos h\cos\delta\sin e + \sin\delta\cos e)^2}}\right)$$

$$= \arcsin\left(\frac{\sin 1° \sin(0° + 15°)}{\sqrt{1 - (\cos(0° + 15°)\cos 0°\sin 1° + \sin 0°\cos 1°)^2}}\right)$$

$$- \arcsin\left(\frac{\sin 1° \sin 0°}{\sqrt{1 - (\cos 0°\cos 0°\sin 1° + \sin 0°\cos 1°)^2}}\right)$$

$$= \arcsin\left(\frac{0.004\,517\,0}{\sqrt{1 - 0.168\,577^2}}\right)$$

$$- \arcsin\left(\frac{0}{\sqrt{1 - 0.017\,452^2}}\right)$$

$$= \arcsin 0.004\,517\,66 - \arcsin 0$$

$$= 0.26° \text{ of field rotation}$$

which is definitely noticeable in photographs; as far as field rotation goes, the 1-degree alignment error is certainly not innocuous.

Example 8. Same situation, but the error is in azimuth In this case, the polar axis is aimed $1°$ to the east of the true pole. As before, we have $e = 1°$, $\delta = 0°$, $t = 15°$, but this time $h = 90°$.

$$\Delta\rho = \arcsin\left(\frac{\sin e \sin(h + t)}{\sqrt{1 - (\cos(h + t)\cos\delta\sin e + \sin\delta\cos e)^2}}\right)$$

$$- \arcsin\left(\frac{\sin e \sin h}{\sqrt{1 - (\cos h\cos\delta\sin e + \sin\delta\cos e)^2}}\right)$$

$$= \arcsin\left(\frac{\sin 1° \sin(90° + 15°)}{\sqrt{1 - (\cos(90° + 15°)\cos 0°\sin 1° + \sin 0°\cos 1°)^2}}\right)$$

$$- \arcsin\left(\frac{\sin 1° \sin 90°}{\sqrt{1 - (\cos 90°\cos 0°\sin 1° + \sin 0°\cos 1°)^2}}\right)$$

$$= \arcsin\left(\frac{0.016\,858}{\sqrt{1 - (-0.004\,517)^2}}\right) - \arcsin\left(\frac{0.017\,452}{\sqrt{1 - 0^2}}\right)$$

$$= \arcsin\left(\frac{0.016\,858}{0.999\,990}\right) - \arcsin\left(\frac{0.017\,452}{1}\right)$$

$$= 0.966° - 1.000°$$

$$= -0.034° \text{ of field rotation}$$

which is definitely tolerable. This shows that $\Delta\rho$ depends greatly on the *direction* of the misalignment, not just its extent.

B.3.2 Instantaneous rate of field rotation

The instantaneous rate of rotation, $d\rho/dh$, is even more complicated to compute than $\Delta\rho$. It can, however, be approximated for all practical purposes by computing $\Delta\rho$ for a short exposure (such as one minute).

Figure B.3 **Field rotation is always centered on the guide star, and all star images rotate through the same angle. The rotation shown is 3°.**

Figure B.4 **Even when the guide star is outside the field, star images describe arcs around it.**

B.3.3 How much field rotation is tolerable?

All this begs the question of how much field rotation is tolerable in a photograph. Surprisingly, the answer does not involve the lens focal length, nor the film size, as long as the guide star is in the center of the picture. All we care about is the size of the largest print that should not show visible elongation of the star images in its corners.

As Figs. B.3 and B.4 show, field rotation makes the star images describe arcs around the guide star, i.e., the star which the telescope tracks perfectly as a result of guiding corrections.

Consider an 8×10-inch (20×25-cm) print with the guide star in the center. The corners of the print are about 150 mm from the center, and the star images there should not be visibly elongated.

The human eye resolves details as small as 0.2 mm when viewing a print. Accordingly, solving the segments of circles in Fig. B.3, the maximum acceptable $\Delta\rho$ is 0.2 mm/150 mm = 1/750 radian, or about 0.08°. Because images at the corners of the print are seldom perfectly sharp in the first place, a tolerance of 0.1° or even 0.2° is more appropriate in practice, as long as the guide star is near the center of the picture.

Changing the lens focal length does not alter this because all the star images in Fig. B.3 rotate through the same angle. It does not matter whether you use the whole field or magnify a small region of the center; the amount of twisting is the same.

If, however, the guide star is outside the field (Fig. B.4), the tolerance for $\Delta\rho$ becomes much tighter.

As a rule of thumb, if the guide star is more than 2 or 3 field-widths from the center of the field, the maximum tolerable $\Delta\rho$ becomes impractically small.

One last note: Lens aberrations are often mistaken for field rotation. Many wide-angle lenses have an aberration that makes pictures look much like Fig. B.3. However, the "rotation" is always centered exactly on the center of the picture, not the guide star, and it increases more than linearly toward the corners (that is, if you enlarge the center of the picture, the "rotation" is absent). To distinguish this aberration from true rotation of the field, try very short unguided exposures, or try guiding on a star at the corner of the field.

B.4 Computer algorithms

These functions are written in Java but are designed to be translated easily into other programming languages (which means they are not the in finest Java style). Note that this is not a complete computer program.

Throughout, `double` means "double-precision" (64-bit floating-point numbers). If a result is between −0.000 01 and +0.000 01, it is set to zero because its nonzero value almost certainly consists mainly of accumulated inaccuracies.

Functions to compute instantaneous rates of change are not given here; it is generally sufficient to compute the total change over a short period, such as one minute.

```
// Library functions and constants

double cos(double x)    { return Math.cos(x); }
double sin(double x)    { return Math.sin(x); }
double acos(double x)   { return Math.acos(x); }
double asin(double x)   { return Math.asin(x); }
double square(double x) { return x*x; }
double sqrt(double x)   { return Math.sqrt(x); }
double abs(double x)    { return Math.abs(x); }

double DR = 180/Math.PI;    // degrees-to-radians factor, approx. 57.3

double decshift(  // Declination shift, in arc-seconds, computed from:
  double e,         // Polar misalignment, in degrees
  double h,         // Hour angle of star - that of false pole, degrees
  double delta,     // Declination of star, in degrees
  double t)         // Duration of exposure, in minutes of time
{
  double x, y, z;                 // local variables

  e = e/DR;                       // convert to radians
  h = h/DR;
  delta = delta/DR;
  t = (t/4)/DR;

  x = sin(delta)*cos(e);          // core of computation
  y = cos(delta)*sin(e);
  z = acos(cos(h+t)*y+x) - acos(cos(h)*y+x);

  z = z*DR*3600;                  // convert to arc-seconds
  if (abs(z) < 0.00001) z = 0.0;  // discard if too small (imprecise)
  return z;
}

double rotation(   // Field rotation, in degrees
  double e,         // Polar misalignment, in degrees
  double h,         // Hour angle of star - that of false pole, degrees
  double delta,     // Declination of star, in degrees
  double t)         // Duration of exposure, in minutes of time
{
  double w, x, y, z;              // local variables

  e = e/DR;                       // convert to radians
  h = h/DR;
  delta = delta/DR;
  t = (t/4)/DR;

  w = sin(e);                     // core of computation
  x = sin(delta)*cos(e);
  y = cos(delta)*w;
  z = asin(w*sin(h+t) / sqrt(1 - square(cos(h+t)*y+x)))
      - asin(w*sin(h) / sqrt(1 - square(cos(h)*y+x)));

  z = z*DR;                       // convert to degrees
  if (abs(z) < 0.00001) z = 0.0;  // discard if too small (imprecise)
  return z;
}
```

Plans for an electronic drive corrector

Appendix C

Many telescope drives still use 120- or 240-volt synchronous AC motors. The drive corrector described here enables you to run such a motor from any source of 12-volt DC (such as a car battery), adjust the drive rate, and make guiding corrections by pressing the "fast" and "slow" buttons.

The speed of a synchronous motor is proportional to the frequency of the AC power. Accordingly, the U.S. version of the drive corrector normally produces 60-Hz power. Press the "fast" or "slow" button, and the frequency changes to 75 or 45 Hz respectively, so that the telescope slews forward or backward at a rate of 4 arc-seconds per second of time. (The U.K. version produces 50 Hz with appropriate changes for slewing.)

You can adjust the basic 60-Hz frequency to get a more exact solar, sidereal, planetary, or lunar rate. The quartz frequency standard (optional) tells you how close you are to 60 Hz by means of a blinking LED. For example, to get sidereal rate (60.164 Hz), first "zero in" on 60 Hz by adjusting the control knob until the LED stops blinking. Then raise the frequency slightly until the LED blinks once every six seconds. That tells you you're 1/6 Hz above 60 Hz.

There is also a "lock" switch to hold the drive corrector at exactly 60 Hz by synchronizing it with the quartz oscillator. (It has to be set reasonably close to 60 Hz for this to work, of course.) Lock mode should be switched off when you want to make guiding corrections.

Figure C.1 **The drive corrector accepts 12-volt DC power, runs a 120- or 240-volt AC motor, and allows guiding corrections.**

C.1 How it works

This circuit is a considerable improvement over the one in the first edition of this book. Figure C.2 shows what's different. Ideally, the motor should be driven by a sine wave (center), but sine waves are not easy to generate with efficient switching circuits. Most drive correctors, including my own earlier model, therefore generate a square wave (top). But this one generates the staircase wave shown at the bottom – a considerably closer approximation to the ideal.[1]

The staircase wave has two advantages. First, it consists of shorter pulses. As a result, the transformer and motor do not undergo magnetic saturation, which would waste energy. Because saturation is avoided, this drive corrector requires only 0.8 ampere to drive an old-model Celestron with two 4-watt motors. That's 9.6 watts in and 8 watts out, about as efficient as you could wish.

[1] I want to thank Brian Rhodefer of Tektronix for suggesting the use of the staircase wave.

Figure C.2 **Waveforms (top to bottom): square wave, sine wave, and the staircase wave produced by this drive corrector.**

Figure C.3 **The pulse width is constant; only the pulse spacing varies with frequency. Thus the RMS voltage is proportional to frequency, as required by an AC motor.**

Second, as shown in Fig. C.3, the pulses remain the same width as the frequency changes. As a result, the motor gets more power when running faster, exactly as it should; to be precise, the RMS voltage is proportional to the frequency. Because of this, response to the "fast" button is never sluggish.

Figure C.4 shows a block diagram of the complete drive corrector. The heart of it is a variable-frequency oscillator (VFO) that generates a square wave. The square wave is fed into two pulse-shortening circuits that produce pulses synchronized with its rising and falling edges. These pulses are amplified to energize the two sides of the transformer. In the block diagram, the center tap is shown grounded, but because it is part of the amplifier circuit, the tap actually goes to +12V in the finished circuit.

A nice side effect of the pulse shorteners is that if the oscillator stops working, neither side of the transformer will be energized, and no harm will result – in effect, when the oscillator goes away, the whole drive corrector shuts down. That makes it practical to build

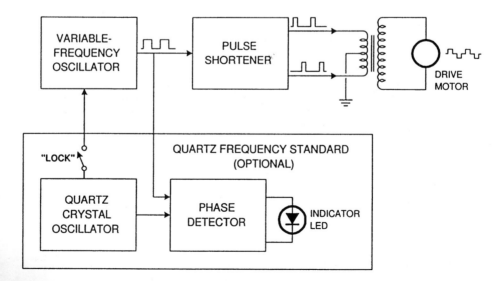

Figure C.4 **How it works: block diagram of the complete drive corrector.**

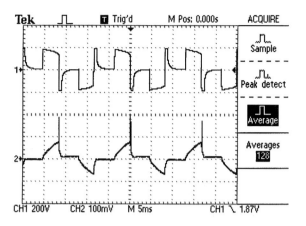

Figure C.5 **Voltage and current waveforms driving an actual motor. Note the inductive spikes.**

the oscillator in a separate, detachable unit (although I did not do so), and to substitute other kinds of oscillators, such as microprocessors that correct for periodic gear error.

As Fig. C.5 shows, the actual waveform delivered to the motor includes some inductive spikes. These are not harmful; in fact, the IRF510 MOSFETs in the output stage contain built-in 100-volt Zener diodes to absorb

spikes without damage. In use, the transistors do not get hot, but I included heat sinks as a precaution.

The drive corrector thrives on low voltage, and it will run most drive motors well on as little as 10.5 volts input. If ample voltage is available, you may want to put additional diodes in series with D1 (Fig. C.6), thereby lowering the voltage supplied to the motor and reducing its power consumption. Beware of excessively high voltages; some "12-volt" power supplies deliver as much as 15 V, causing some risk of saturation and overheating.

The quartz frequency standard is optional. If present, it produces a fixed-frequency 50- or 60-Hz oscillation to which the VFO signal can be compared. The difference between the two frequencies is displayed on a flashing LED. The output of the quartz

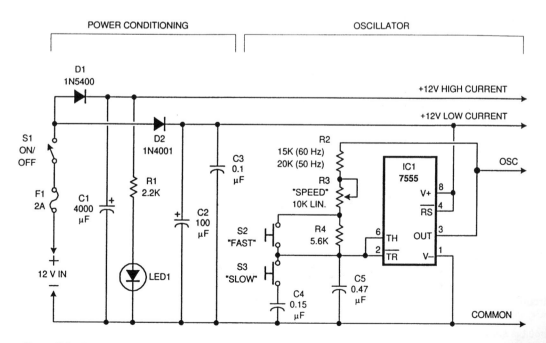

Figure C.6 **Power conditioning and oscillator circuits.**

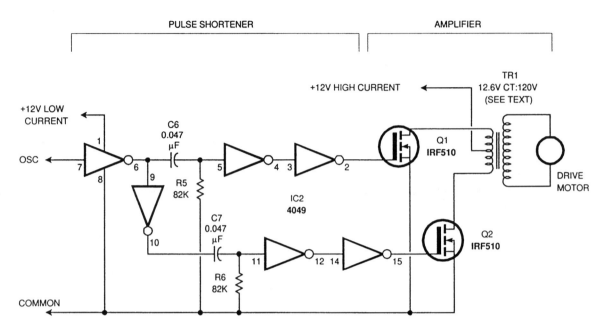

Figure C.7 **Pulse shortener and output amplifier circuits.**

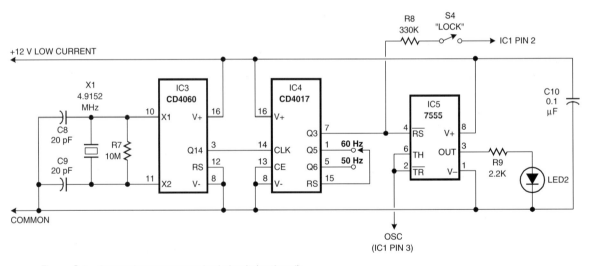

Figure C.8 **Quartz-frequency-standard circuit (optional).**

oscillator can also be fed into the VFO to lock it in synchronism.

C.2 Circuits and parts list

The circuit is shown in Figs. C.6, C.7, and C.8. All the parts are relatively easy to find; most are not critical.

C.2.1 Resistors

All are 1/10-watt, 5% tolerance; higher wattages can be substituted.

R1, R9 – 2200 ohms.

R2 – 15 000 ohms. May require adjustment so that 60 Hz is in the middle of the scale on R3.

R3 – 10 000-ohm, linear-taper potentiometer.

R4 – 5600 ohms.

R5, R6 – 82 000 ohms. Pulse width is proportional to resistance. You may want to experiment with lower values, giving narrower pulses and saving battery power.

R7 – 10 megohms.

R8 – 330 000 ohms. This resistor determines the strength of the locking effect; lower values make it stronger.

C.2.2 Capacitors

All are rated at 35 volts or higher.

C1 – 4 000 µF electrolytic (OK to substitute higher values).

C2 – 100 µF electrolytic (OK to substitute higher values).

C3, C10 – 0.1 µF ceramic disc, Mylar, or polyester.

C4 – 0.15 µF. Determines frequency of "slow" button. Do not substitute.

C5 – 0.47 µF, Mylar or polyester (for stability), preferably 5% or better tolerance. Determines frequency of VFO. Do not substitute.

C6, C7 – 0.047 µF, preferably 5% or better tolerance. Do not substitute. Pulse width is proportional to capacitance.

C8, C9 – 18 to 22 pF, ceramic disc.

C.2.3 Semiconductors

D1 – Type 1N5400 or any silicon rectifier rated at 2 or more amperes, 50 or more volts.

D2 – Type 1N4001 or any silicon rectifier rated at 1 or more amperes, 50 or more volts.

LED1, LED2 – Red light-emitting diodes. (Other colors will work, but red is less disturbing to night vision.)

IC1, IC4 – 7555, LMC555, or TLC555 CMOS timer IC. Do not use non-CMOS version (NE555).

IC2 – 4049 (CD4049, MC14049) CMOS inverting buffer IC. (Not 74HC4049.)

IC3 – 4060 (CD4060, MC14060) CMOS oscillator-divider IC. (Not 74HC(T)4060.)

IC4 – 4017 (CD4017, MC 14017) CMOS decade counter IC. (Not 74HC(T)4017.)

Q1, Q2 – IRF510 N-channel enhancement-mode power MOS field-effect transistors. Acceptable substitutes include IRF511, IRF512, IRF530. Heat sinks should not be necessary, but I included them as a precaution.

C.2.4 Other components

F1 – 2-ampere, slow-blow fuse.

S1, S4 – SPST toggle switches.

S2, S3 – Momentary-contact normally open SPST pushbutton switches. (I used the plug-in control paddle from a slide projector.)

TR1 – 120-volt to 12.6-volt (6.3-0-6.3) center-tapped, 1-ampere power transformer. Higher ampere ratings can be substituted. A 12-volt (6-0-6) transformer can be substituted and will produce slightly higher voltage at the motor.

X1 – 4.9152-MHz microprocessor crystal, preferably parallel-resonant, 20-pF load.

C.3 Adaptation to 240 V, 50 Hz

To get 240 volts for a European motor, use a 240-to-12.6-volt transformer for TR1, still rated at 1 ampere on the low-voltage side.

To get 50 Hz from the VFO, change R2 to 20 000 ohms (or two 10 000-ohm resistors in series). The exact value may require adjustment to put 50 Hz in the middle of R3's scale.

The quartz frequency standard gives either 50 or 60 Hz depending on whether pin 15 of IC4 is tied to pin 5 or pin 1 respectively.

C.4 Drive rates

Assuming the quartz frequency standard delivers exactly 50 or 60 Hz, as the case may be, Table C.1 shows how to use it to achieve correct solar, lunar, sidereal, and King rates. The King rate is a sidereal rate corrected for the average effect of atmospheric refraction (King, 1931). Recall that the lunar rate varies with the moon's position in its orbit.

Table C.2 tells more of the story; it gives the exact drive frequencies needed, along with the crystal frequencies that will produce them in the quartz frequency standard circuit. Note that the same crystal is needed whether 50 or 60 Hz is selected. Custom-ground crystals are available from many suppliers, among them International Crystal, 10 N. Lee Ave, Oklahoma City, OK 73102, U.S.A., phone 405-236-3741, http://www.icmfg.com, and JAN Crystals, 2341 Crystal Dr., Fort Myers, FL 33907, U.S.A. The cheapest microprocessor-grade crystals are adequate; they cost only a few dollars each.

You may prefer to equip your quartz frequency standard with a crystal that will produce the sidereal or King rate as its reference point. Then, to get solar rate, you would "zero in" on sidereal rate and reduce the frequency until you got a blink every six seconds.

Table C.1 *How to set the drive corrector for specific rates (assuming the quartz frequency standard is exactly 50 or 60 Hz)*

Solar rate	No blinking
Lunar rate (average)	Lower, 2 blinks per second
Sidereal rate	Higher, 1 blink per 6 seconds
King rate	Higher, 1 blink per 7 seconds

C.5 Line power supply

If a car battery or rechargeable battery pack isn't handy, you'll need a line power supply, which must be quite free of ripple, because if there is any ripple, the VFO will lock onto it.

The circuit in Fig. C.9 fills the bill. It delivers a maximum of 1 ampere at 12.0 volts and includes automatic overload protection – if the 7812 regulator overheats, it shuts down. In this circuit, the 7812 needs a heat sink. The parts list for the line power supply is as follows:

F1 – 0.5-ampere slow-blow fuse.
TR1 – 24-volt (12-0-12) or 25.2-volt (12.6-0-12.6), 1-ampere center-tapped power transformer. Higher ampere ratings can be substituted.

Table C.2. *Drive rates and the frequencies that produce them*

		Drive frequency (Hz)		Crystal
Drive rate	Fraction of solar rate	60-HZ motor	50-Hz motor	frequency (MHz)
Solar	1.000 000	60.000	50.000	4.915 200
Lunar (avg.)	0.978	58.69	48.91	4.807
Sidereal	1.002 738	60.164	50.137	4.928 657
King	1.002 456	60.148	50.123	4.927 288

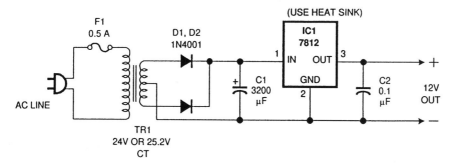

Figure C.9 **Line power supply.**

D1, D2 – Type 1N4001 or any silicon rectifier rated at 1 ampere, 50 volts, or higher.

C1 – 3200-μF, 35-volt electrolytic capacitor. Higher capacitances and voltages can be substituted.

C2 – 0.1-μF capacitor, 35 volts or higher.

IC1 – 7812 voltage regulator, mounted on a heat sink.

C.6 Other designs

Many circuits have been published that are similar to this one except that they generate a square wave; one of the simplest designs is that of Koolish (1978). West and Bradford (1975) generate the square wave with a digital circuit that lets you dial in the oscillator frequency, or rather period, on a set of thumbwheel switches.

Going one better, Horowitz and Hill (1989, pp. 249 and 549) input the frequency from thumbwheel switches and generate a true sine wave, delivered to the telescope through a power amplifier; their circuit is used on Harvard's 61-inch telescope.

The truly modern solution, of course, is to generate a staircase waveform – with as many steps as you care to – using a microprocessor. The microprocessor can also correct for periodic error by recording your guiding corrections and playing them back, somewhat smoothed, on every successive revolution of the worm gear. But if you're going this far, you'll probably want to replace the synchronous motors with stepper motors that consume far less power.

Film data

Appendix D

The following pages are excerpts from film data booklets, reproduced by permission of Eastman Kodak Company. The films covered are:

- Kodak Technical Pan Film (black-and-white)
- Kodak Professional Ektachrome Film E200 (color slides)
- Kodak Professional Ektapress Films (color negatives)

To save space, some information not relevant to astrophotography has been left out. Complete, up-to-date data booklets are available from Kodak and other film manufacturers.

Because products change frequently, you should always use the most current information. These data sheets will remain useful as a basis of comparison for evaluating newer products.

D.1 Kodak Technical Pan Film (TP)

From Kodak Publication P-255, June, 1996. Copyright © 1996 Eastman Kodak Company

DESCRIPTION

KODAK Technical Pan Film is Kodak's slowest and finest-grained black-and-white film for pictorial photography (when developed in KODAK TECHNIDOL Liquid Developer). It is a variable-contrast panchromatic film with extended red sensitivity; because of its extended red sensitivity, it yields prints with a gray-tone rendering slightly different from that produced by other panchromatic films. (This is most noticeable in portraits, in which it suppresses blemishes.)

Use this film for pictorial, scientific, technical, and reversal-processing applications. It is an excellent choice for making big enlargements or murals.

APPLICATIONS

You can vary the contrast of KODAK Technical Pan Film by modifying development. The wide range of contrast levels, along with the spectral sensitization and combination of speed and image-structure properties, makes this film unusually versatile and suitable for many applications:

- Pictorial photography
- Photomicrography
- Microphotography (Microfilming)
- Solar photography
- Photographing electrophoretic gels
- Laser recording
- Other applications such as slide making, copying, and microfilming that require high or moderately high contrast combined with fine grain and high resolving power

SIZES AVAILABLE

Sizes and CAT numbers may differ from country to country. See your dealer who supplies KODAK Professional Products.

KODAK Technical Pan Film 2415

Size mm x ft	Film Code	Base	Sp No.	Letter Code	CAT No.
35 x 150	2415	ESTAR-AH	442	TP	129 9916

Size	Film Code	Base	Letter Code	CAT No.
135-36	2415	ESTAR-AH	TP	129 7563

KODAK Technical Pan 4415

Sheets Per Package	Sizes (inches)	Film Code/Notch	Base	CAT No.
25	4 x 5	4415	ESTAR Thick	800 4640
25	8 x 10			818 2826

KODAK Technical Pan Film 6415

Size	Film Code	Base	Letter Code	CAT No.
120	6415	3.6-mil acetate	TP	151 1054

Because 2415 Film has a thinner base than conventional 35 mm picture-taking films, 150-foot rolls finished to Sp 442 will fit in bulk-film loaders designed to accept 100-foot rolls.

Other sizes are available on a special-order basis, subject to manufacturing limitations and current minimum-order requirements. Minimum-order quantities for special-order sizes are generally 750 square feet (70 square metres) of film.

SPECTRAL SENSITIVITY

Technical Pan Film has reasonably uniform spectral sensitivity at all visible wavelengths out to 690 nanometres (nm). Because of this extended red sensitivity, red areas and flesh tones may appear lighter than they would with conventional black-and-white films. This is often an advantage. For example, it helps conceal some skin blemishes and often adds a pleasing luminous quality to skin tones. (This effect is less evident in portraits made in the shade outdoors, because there is less red light present.)

To approximate the response of conventional pan-chromatic films more closely, make exposures through a color-compensating filter such as a KODAK Color Compensating Filter CC40C or CC50C (cyan). With this filter, increase the exposure by one stop with tungsten light or two stops with daylight or electronic flash.

STORAGE AND HANDLING

Load and unload your camera in total darkness. Do not use a safelight.

High temperatures or high humidity may produce unwanted quality changes. Store unexposed film at 75°F (24°C) or lower in the original package. Always store film (exposed or unexposed) in a cool, dry place. For best results, process film as soon as possible after exposure.

Protect processed film from strong light, and store it in a cool dry place. For more information on storing negatives, see KODAK Publication No. E-30, *Storage and Care of Photographic Materials—Before and After Processing.*

EXPOSURE

The speed of this film depends on the application, the type and degree of development, and the level of contrast required. Therefore, no single speed value applies for all situations. (Speed ratings may range from a low of EI 16 for pictorial photography to a high EI 320 for microfilming. Use the exposure indexes in the following table with meters marked for ISO, ASA, or DIN speeds or exposure indexes. They are intended for trial exposures.

You can expose this film with daylight or tungsten light. Exposure to tungsten illumination produces a 10-percent increase in speed and a 5-percent increase in contrast.

Exposure- and Contrast-Index Values for Various Development Conditions

Contrast Index		KODAK Developer	Development Time (minutes at 68°F [20°C])	Exposure Index
High	2.50	DEKTOL	3	200
	2.40 to 2.70	D-19 (1:2)	4 to 7	100 to 160
	2.25 to 2.55	D-19	2 to 8	100 to 200
	1.20 to 2.10	HC-110 (Dil B)	4 to 12	100 to 250
	1.25 to 1.75	HC-110 (Dil D)	4 to 8	80 to 125
	1.10 to 2.10	D-76	6 to 12	64 to 125
	1.00 to 1.50	MICRODOL-X	8 to 12	32 to 50
	0.80 to 0.95	HC-110 (Dil F)	6 to 12	32 to 64
Low	0.50 to 0.70	TECHNIDOL Liquid	5 to 11	16 to 25

For *pictorial applications,* use EI 25/15° and process the film in KODAK TECHNIDOL Liquid Developer.

For *high-contrast reversal-processing applications,* use EI 64/19° to produce slides from high-contrast subjects such as line art. Process the film with the KODAK T-MAX 100 Direct Positive Film Developing Outfit.

Filter Factors

Multiply the normal exposure by the filter factor indicated below. If you use a through-the-lens meter, take the meter reading without the filter over the lens, and then calculate your exposure by using the filter factor. Where no filter factor is listed in the table, no test was made with that filter.

KODAK WRATTEN Gelatin Filter	Tungsten Filter Factor*	Daylight Filter Factor†
No.8 (yellow)	1.2	1.5
No. 11 (yellowish green)	5	—
No. 12 (deep yellow)	1.2	—
No. 15 (deep yellow)	1.2	2
No. 25 (red)	2	3
No. 47 (blue)	25	12
No. 58 (green)	12	—

* Based on a 1-second exposure and development in KODAK HC-110 Developer (Dilution D) for 8 minutes at 68°F (20°C).
† Based on a 1/25-second exposure and development in KODAK TECHNIDOL Liquid Developer for 9 minutes at 68°F (20°C).

Adjustments for Long and Short Exposures

Compensate for the reciprocity characteristics of this film by increasing exposure and adjusting the development as shown.

If Indicated Exposure Time Is (seconds)	Use This Lens-Aperture Adjustment	OR	This Adjusted Exposure Time (seconds)	AND Use This Development Adjustment
1/10,000	None		None	+30%
1/1,000	None		None	+20%
1/100	None		None	None
1/10	None		None	None
1	None		None	−10%
10	+½ stop		15	−10%
100	+1½ stops		Adjust aperture	None

Changes in Speed and Contrast
Due to Long- and Short-Exposure Adjustments

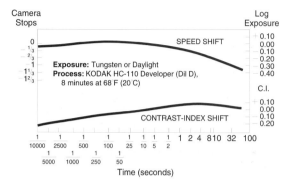

DARKROOM RECOMMENDATIONS

Handle unprocessed film in total darkness. After development is half completed, you can use a KODAK 3 Safelight Filter (dark green) in a suitable safelight lamp with a 15-watt bulb. Keep the safelight at least 4 feet (1.2 metres) from the film.

For information on safelight testing, see KODAK Publication K-4, *How Safe Is Your Safelight?*

QUICK REFERENCE GUIDE TO DEVELOPERS

KODAK Technical Pan Film (sizes)	KODAK Developer to Use for—									
	Pictorial	Reverse-Text Slides	Copying Printed Material	Copying Continuous-Tone Photos	Micro-photography	Electro-phoretic Gels	Photo-micrography	Electron Micrography	Astro-nomical	Laser
2415 (135 and long rolls)	TECHNIDOL Liquid	DEKTOL	D-19	HC-110 (Dil B), TECHNIDOL Liquid	HC-110 (Dil D)	HC-110 (Dil B), TECHNIDOL Liquid	HC-110 (Dil B), D-19, or HC-110 (Dil D)	D-19, D-19 (1:2), or HC-110 (Dil B)	D-19	HC-110 (Dil B)
4415 (4 x 5- and 8 x 10-inch)			HC-110 (Dil B) or TECHNIDOL Liquid		HC-110 (Dil D) or TECHNIDOL Liquid					
6415 (120)										

PROCESSING

Handle unprocessed film in total darkness. After development is half complete, you can use a suitable a safelight lamp equipped with a KODAK 3 Safelight Filter (dark green) and a 15-watt bulb for *a few seconds*. Keep the safelight at least 4 feet (1.2 metres) from the film.

When you use these films for pictorial applications, you must select a film-and-developer combination carefully. With 35 mm Technical Pan Film, use TECHNIDOL Liquid Developer. With Technical Pan Film / 4415 and 6415 (sheets and 120 size), use *only* TECHNIDOL Liquid Developer. Observe the precautionary information on the developer packaging.

KODAK TECHNIDOL Liquid Developer

Small-Tank Processing (rolls)

You can process roll film in small 8- or 16-ounce stainless-steel or 10- or 20-ounce plastic tanks with spiral reels using the following instructions. With some spiral reels, the 35 mm film may be susceptible to nonuniform processing effects if agitation is not carefully controlled. Pouring the developer on dry film through the light trap in the tank top can also produce nonuniformity. To avoid processing problems, pour the developer into the tank before you insert the loaded reel, and follow the agitation recommendations below.

Preparing a Working Solution: Mix your liquid developer according to the instructions packaged with the developer. Use water at 68 to 86°F (20 to 30°C).

To process one roll of 135-36 film, make 8 fl oz (237 mL) of developer solution. Stir until the solution is completely mixed. To process one 120-size roll or two 135-36 rolls of film in the same process, prepare one pint (16 fl oz [473 mL]) of developer.

You can reuse the developer if you increase the development time of the second process by 1 minute. Store the developer in an air-tight bottle, and use it within a week.

Processing with TECHNIDOL Liquid Developer in a Small Tank: The following procedure may vary from the instructions provided with your tank, but you must follow it to obtain good results.

Develop roll film for the amount of time in the table below, according to the developer temperature you choose.

**Development Times for
KODAK TECHNIDOL Liquid Developer
in Stainless-Steel 8- or 16- oz
or Plastic 10- or 20-oz Tanks**

Temperature	68°F (20°C)	77°F (25°C)	86°F (30°C)
Time	9 minutes	7½ minutes	6½ minutes

*With 35 mm film only

1. Fill the tank with developer adjusted to one of the temperatures in the table.

2. In total darkness, drop the loaded reels into the tank of solution and attach the top to the tank.

3. Firmly tap the bottom of the tank on the top of the work surface to dislodge any air bubbles. (You can then turn on the room lights.)

4. Provide immediate agitation by shaking the tank **vigorously** up and down 10 to 12 times for 2 seconds. *Do not rotate the tank.*

Liquid Developer Agitation Technique

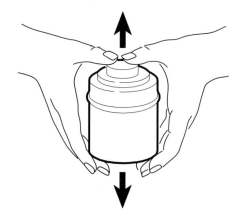

5. Let the tank sit for 30 seconds, and then start the next 2-second agitation.

6. Repeat steps 4 and 5 every 30 seconds for the remainder of the development time.

Final Steps in Tank Processing—
68 to 86 °F (20 to 30°C)

Step/Solution	Time (min:sec)
Rinse — with agitation:	
KODAK Indicator Stop Bath	0:15 to 0:30
KODAK EKTAFLO Stop Bath	0:15 to 0:30
Fix — with frequent agitation:	
KODAK Fixer	2:00 to 4:00
KODAK Rapid Fixer	1:30 to 3:00
KODAFIX Solution	2:00 to 4:00
Wash:	
Running water	5:00 to 15:00
—OR—	
Rinse with water	0:15
KODAK Hypo Clearing Agent	1:30
Running water	5:00
Final rinse:	
KODAK PHOTO-FLO Solution	0:30
Dry — in a dust-free place	

Note: Keep the rinse and fix temperatures within 3 °F (1.7°C) of the developer temperature, and the wash temperature within 5°F (3°C) of the developer temperature.

Rinse the film in KODAK Indicator Stop Bath or KODAK EKTAFLO Stop Bath for 15 to 30 seconds. Use running water for 30 seconds if you don't use a stop bath.

Fix the film with frequent agitation in KODAK Rapid Fixer for 1½ to 3 minutes. Or use KODAK Fixer or KODAFIX Solution for 2 to 4 minutes.

Wash the film in clean running water for 5 to 15 minutes.

To save time and conserve water, use KODAK Hypo Clearing Agent. Rinse the fixed film in running water for 15 seconds. Bathe the film in KODAK Hypo Clearing Agent for 1 to 2 minutes with agitation. Then wash the film for 5 minutes in running water, providing at least one change of water during the 5 minutes.

Dry the film in a dust-free place. To minimize drying marks, treat the film with KODAK PHOTO-FLO Solution after washing, or wipe the surface carefully with a KODAK Photo Chamois or soft viscose sponge.

You can use heated forced air at 10 °F (38°C) to reduce drying time.

NOTICE: The sensitometric curves and data in this publication represent product tested under the conditions of exposure and processing specified. They are representative of production coatings, and therefore do not apply directly to a particular box or roll of photographic material. They do not represent standards or specifications that must be met by Eastman Kodak Company. The company reserves the right to change and improve product at any time.

IMAGE-STRUCTURE CHARACTERISTICS

The data in this section are based on development at 68°F (20°C) in KODAK HC-110 Developer (Dilution D) for 8 minutes or KODAK TECHNIDOL Liquid Developer for 9 minutes.

	KODAK Developer	
	HC-110 (Dilution D)	**TECHNIDOL Liquid**
Diffuse rms Granularity*	8 Extremely fine	5 Micro fine

* Read at a net diffuse density of 1.0 using a 4-micrometre aperture and 12X magnification.

Spectral-Sensitivity Curves

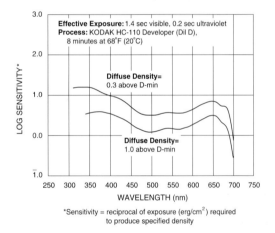

*Sensitivity = reciprocal of exposure (erg/cm^2) required to produce specified density

Modulation-Transfer Curves

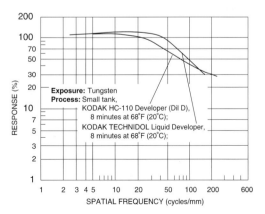

Characteristic Curves

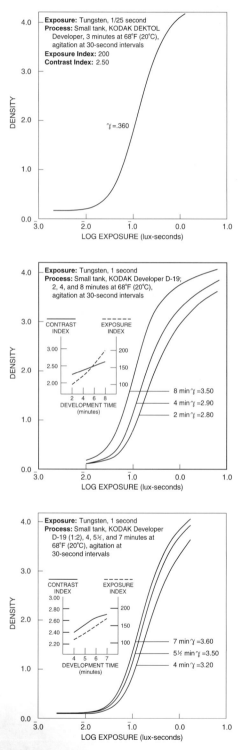
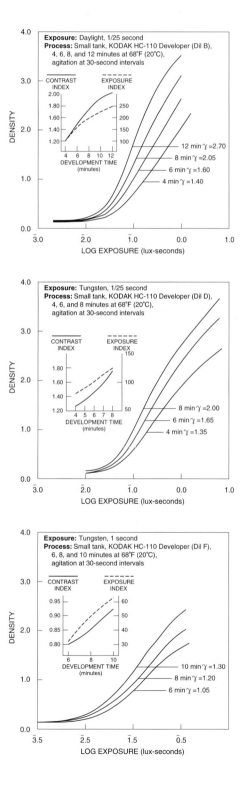

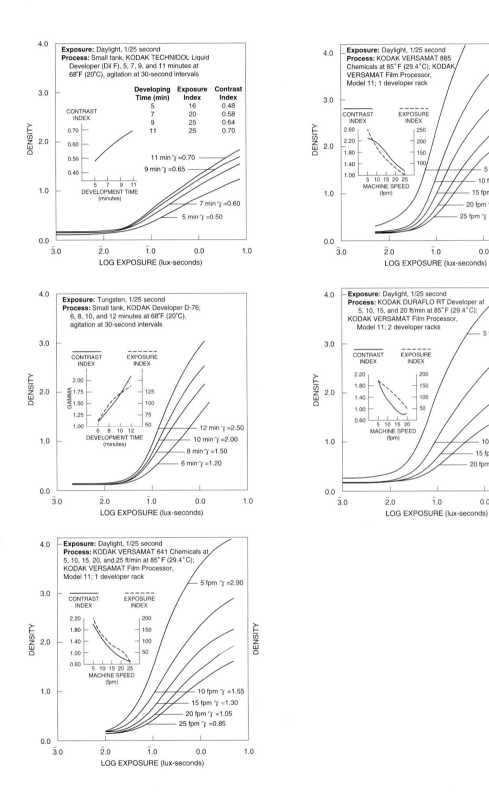

Exposure: Daylight, 1/25 second
Process: Small tank, KODAK TECHNIDOL Liquid
Developer (Dil F), 5, 7, 9, and 11 minutes at
68°F (20°C), agitation at 30-second intervals

Developing Time (min)	Exposure Index	Contrast Index
5	16	0.48
7	20	0.58
9	25	0.64
11	25	0.70

CONTRAST INDEX

0.70
0.60
0.50
0.40

5 7 9 11
DEVELOPMENT TIME (minutes)

11 min γ =0.70
9 min γ =0.65
7 min γ=0.60
5 min γ =0.50

DENSITY

4.0
3.0
2.0
1.0
0.0

3.0 2.0 1.0 0.0 1.0
LOG EXPOSURE (lux-seconds)

Exposure: Daylight, 1/25 second
Process: KODAK VERSAMAT 885
Chemicals at 85°F (29.4°C); KODAK
VERSAMAT Film Processor,
Model 11; 1 developer rack

CONTRAST INDEX EXPOSURE INDEX

2.60 250
2.20 200
1.80 150
1.40 100
1.00

5 10 15 25
MACHINE SPEED (fpm)

5 fpm γ =3.60
10 fpm γ =2.80
15 fpm γ =2.20
20 fpm γ =1.60
25 fpm γ =1.35

DENSITY

4.0
3.0
2.0
1.0
0.0

3.0 2.0 1.0 0.0 1.0
LOG EXPOSURE (lux-seconds)

Exposure: Tungsten, 1/25 second
Process: Small tank, KODAK Developer D-76;
6, 8, 10, and 12 minutes at 68°F (20°C),
agitation at 30-second intervals

CONTRAST INDEX EXPOSURE INDEX

2.00
1.75 125
1.50 100
1.25 75
1.00 50

GAMMA

6 8 10 12
DEVELOPMENT TIME (minutes)

12 min γ =2.50
10 min γ =2.00
8 min γ =1.50
6 min γ=1.20

DENSITY

4.0
3.0
2.0
1.0
0.0

3.0 2.0 1.0 0.0 1.0
LOG EXPOSURE (lux-seconds)

Exposure: Daylight, 1/25 second
Process: KODAK DURAFLO RT Developer at
5, 10, 15, and 20 ft/min at 85°F (29.4°C);
KODAK VERSAMAT Film Processor,
Model 11; 2 developer racks

CONTRAST INDEX EXPOSURE INDEX

2.20 200
1.80 150
1.40 100
1.00 50
0.60

5 10 15 20
MACHINE SPEED (fpm)

5 fpm γ =2.40
10 fpm γ =1.60
15 fpm γ =1.00
20 fpm γ =0.80

DENSITY

4.0
3.0
2.0
1.0
0.0

3.0 2.0 1.0 0.0 1.0
LOG EXPOSURE (lux-seconds)

Exposure: Daylight, 1/25 second
Process: KODAK VERSAMAT 641 Chemicals at
5, 10, 15, 20, and 25 ft/min at 85°F (29.4°C);
KODAK VERSAMAT Film Processor,
Model 11; 1 developer rack

5 fpm γ =2.90

CONTRAST INDEX EXPOSURE INDEX

2.20 200
1.80 150
1.40 100
1.00 50
0.60

5 10 15 20 25
MACHINE SPEED (fpm)

10 fpm γ =1.55
15 fpm γ =1.30
20 fpm γ =1.05
25 fpm γ =0.85

DENSITY

4.0
3.0
2.0
1.0
0.0

3.0 2.0 1.0 0.0 1.0
LOG EXPOSURE (lux-seconds)

D.2 Kodak Professional Ektachrome Film E200

From Kodak Publication E-28, September, 1997. Copyright © 1997 Eastman Kodak Company. This film is essentially identical to Kodak Elite Chrome 200.

DESCRIPTION

KODAK PROFESSIONAL EKTACHROME Film E200 is a daylight-balanced 200-speed color reversal film designed for KODAK Chemicals, Process E-6. The film offers moderate contrast, along with excellent color and image structure, making it the first high-speed color reversal film with the "look" of a lower speed film. In addition, E200 film delivers outstanding push-processing performance to an exposure index (EI) of 1000 with only minimal shifts in contrast and color balance.

E200 film also features KODAK T-GRAIN® Emulsion Technology for extremely fine grain and very high sharpness, plus improvements in reciprocity and manufacturing consistency.

The film is designed for exposure with daylight or electronic flash. You can also expose it with tungsten illumination (3200 K) or photolamps (3400 K) using filters.

Use E200 film to produce color transparencies for projection or viewing with 5000 K illumination. Duplicate transparencies can be made by direct printing. To make color prints, you can print transparencies onto color reversal paper. Or make internegatives for printing onto color negative paper. You can also scan transparencies for digital printing and for graphic arts and Photo CD applications.

FEATURES	BENEFITS
• Outstanding push-processing performance out to EI 1000.	• Maintains good contrast and color balance. • Extends shooting range under demanding existing-light conditions.
• Preferred contrast of an EI 100-speed color reversal film (lower contrast than other high-speed CR films).	• Improved reproduction of highlight and shadow details. • More tone gradation for more natural-appearing images.
• KODAK T-GRAIN Emulsion Technology in all color records.	• Finest grain structure of any daylight, high-speed color reversal film on the market. • High sharpness. • Grain and sharpness hold up well under push conditions

FEATURES	BENEFITS
• Enhanced colors while maintaining natural-looking skin tones.	• Pleasing colors for exceptional results both outdoors and in the studio. • Beautiful skin-tone reproduction for both outdoor and studio applications.
• Superb reciprocity.	• Consistent results in exposures from 10 seconds to 1/10,000 second with no exposure or filter corrections.

MANUFACTURING UNIFORMITY

Similar to KODAK PROFESSIONAL EKTACHROME Films E100S and E100SW, the E200 film takes full advantage of Kodak's new state-of-the-art manufacturing facility in Rochester, New York. The result is a film with excellent roll-to-roll consistency and accurate 200 speed.

STORAGE AND HANDLING

Load and unload film in subdued light.

Store unexposed film in a refrigerator at 55 °F (13 °C) or lower in the original sealed package. To avoid moisture condensation on film that has been refrigerated, allow the film to warm up to room temperature before opening the package. Process film as soon as possible after exposure.

Protect transparencies from strong light, and store them in a cool, dry place. For more information, see KODAK Publication No. E-30, *Storage and Care of KODAK Photographic Materials—Before and After Processing*.

SIZES AVAILABLE

KODAK PROFESSIONAL EKTACHROME Film E200

Rolls	Code	Base	CAT No.
135-36	E200	5-mil acetate	107 7114
135-36 (20-roll pack)	E200	5-mil acetate	128 8422
120 (Available early 1998)	E200	3.6-mil acetate	813 7069
120 (5-roll pack) (Available early 1998)	E200	3.6-mil acetate	137 3216

Note: Use the catalog numbers in the table above only for orders placed in the United States and Canada.

Rolls	Code/ Spec No.	Base	CAT No.
35 mm x 100 ft	E200 SP404: Perforated on both edges	5-mil acetate	183 2997

DARKROOM RECOMMENDATIONS

Do not use a safelight. Handle unprocessed film in total darkness.

EXPOSURE

Exposure Index Numbers

Use the exposure index numbers below with cameras or light meters marked for ISO or ASA speeds or exposure indexes. Do not change the film-speed setting when metering through a filter. Metering through filters may affect meter accuracy; see your meter or camera manual for specific information. For critical work, make a series of test exposures.

Light Source	KODAK WRATTEN Gelatin Filter	Exposure Index
Daylight or Electronic Flash	None	200
Photolamp (3400 K)	No. 80B	64
Tungsten (3200 K)	No. 80A	50

Adjustments for Long and Short Exposures

No filter correction or exposure compensation is required for exposures from 1/10,000 to 10 seconds.

Note: This information applies only when exposing the film to daylight. The data are based on average emulsions rounded to the nearest 1/3 stop and assume normal, recommended processing. Use the data only as a guide. For critical applications, make tests under your conditions.

PROCESSING

Chemicals

Process E200 film in KODAK Chemicals, Process E-6. For consistent processing of this and all other EKTACHROME Films, use a lab that is a member of the KODAK Q-LAB Process Monitoring Service.

Push Processing Characteristics

You can increase the effective speed (i.e., push) of E200 film by adjusting the time of the first developer. Increased film speed is useful under dim lighting conditions, or when you need high shutter speeds to stop action or small lens openings for increased depth of field. Pushing E200 film will also compensate for underexposure.

Exposing EKTACHROME E200 Film for Push Processing

Labs that provide push processing with Process E-6 usually offer the service for fixed time increases such as push 1, push 2, or push 3 in the first developer (see the following table). It is a good idea to make a series of test exposures and then work with your lab to determine optimum exposure settings for push processing.

The following exposure indexes are good starting points for daylight exposures when you intend to have E200 film push processed.

Starting-Point Exposures for Push Processing EKTACHROME E200 Film

Exposure Index	Specify This Push Condition to the Lab	Typical Time in First Developer
320	Push 1	8 minutes
640	Push 2	11 minutes
1000	Push 3	14 minutes

IMAGE STRUCTURE
Diffuse rms Granularity* 12

*Read at a gross diffuse visual density of 1.0, using a 48-micrometre aperture, 12X magnification.

Characteristic Curves

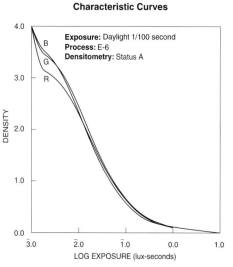

Exposure: Daylight 1/100 second
Process: E-6
Densitometry: Status A

Spectral-Sensitivity Curves

Effective Exposure: 0.1 second
Process: E-6
Densitometry: 1.0
Density: E.N.D.

Yellow-Forming Layer
Magenta-Forming Layer
Cyan-Forming Layer

*Sensitivity = reciprocal of exposure (erg/cm^2) required to produce specified density

Modulation-Transfer Curves

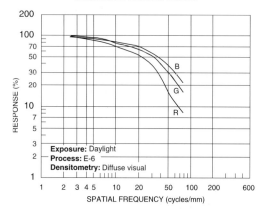

Exposure: Daylight
Process: E-6
Densitometry: Diffuse visual

Spectral-Dye-Density Curves

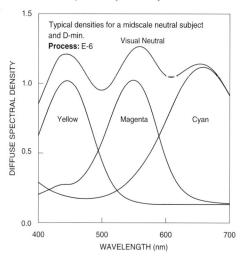

Typical densities for a midscale neutral subject and D-min.
Process: E-6

Visual Neutral

Yellow Magenta Cyan

NOTICE: The sensitometric curves and data in this publication represent product tested under the conditions of exposure and processing specified. They are representative of production coatings, and therefore do not apply directly to a particular box or roll of photographic material. They do not represent standards or specifications that must be met by Eastman Kodak Company. The company reserves the right to change and improve product characteristics at any time.

D.3 Kodak Professional Ektapress Films

DESCRIPTION

This portfolio of professional color negative films is intended for 35 mm location shooting, such as photojournalism. These films are designed for exposure with daylight or electronic flash, but they can also be exposed with other light sources. KODAK PROFESSIONAL EKTAPRESS Films are excellent choices when negatives will be electronically scanned.

KODAK PROFESSIONAL EKTAPRESS Film PJ100 features excellent sharpness and highlight detail and very fine grain; it allows a very high degree of enlargement. Suggested uses of PJ100 Film include editorial, feature, studio, and corporate and industrial photography. It is now available in a frosted can for easy film identification.

KODAK PROFESSIONAL EKTAPRESS Film PJ400 features unsurpassed sharpness and fine grain, excellent highlight and shadow detail, and good push-process performance to EI 1600. Suggested applications of PJ400 Film include editorial, feature, spot news, and corporate and industrial photography. It is available in a frosted can for easy film identification.

KODAK PROFESSIONAL EKTAPRESS Film PJ800 is Kodak Professional's first 800-speed film. It provides photographers with a high-speed color negative film with rich and accurate colors, unsurpassed sharpness, excellent shadow detail, and good push-processing performance to EI 3200. Suggested applications of PJ800 Film include sports, spot news, corporate and industrial, and runway fashion photography.

KODAK EKTAPRESS Plus 1600 Professional Film / PJC features very high to ultra-high speed (up to EI 6400 with push processing). Use this film in low-light or fast-action situations.

FEATURES	BENEFITS
• Wide exposure latitude	• Rich, accurate colors maintained with under- and overexposure
• Room-temperature storage	• Ideal when conditions prohibit refrigerated storage
• Consistent scanning performance	• Saves time, less need for scanner adjustments.

FEATURES	BENEFITS
• PJ100 Film—extremely fine grain with excellent sharpness and highlight detail	• Provides maximum image quality under relatively bright daylight or flash conditions • Excellent for making high-quality enlargements
• PJ400 Film— unsurpassed sharpness; fine grain; excellent highlight and shadow detail	• Provides a wide range of exposures for action shots and lighting conditions
• PJ800 Film— unsurpassed sharpness and excellent shadow detail	• Provides a very wide exposure latitude—EI 200 to 3200 • Excellent for stopping action and for a variety of lighting conditions
• EKTAPRESS Plus 1600 Professional Film / PJC— very high speed and medium sharpness	• Good-quality prints with a moderate degree of enlargement • Excellent when hand-holding telephoto lenses, or for subjects that require good depth of field and high shutter speeds

PJ100, PJ400, and PJ800 Films also offer the following ease-of-use features—

• ¾-inch square notes area on the film magazine	• More space to indicate subject notes or exposure/ processing conditions
• Writable magazine surface; improved texture	• Readily accepts indelible markers or pencils • Reduces glare under harsh lighting
• Translucent ("frosted") film cans for PJ100 and PJ400 Films	• Easier identification • More area for exposure/ processing notes
• 5- and 20-roll Pro-Packs	• Convenient sizes for short or long assignments • Pro-Pack 20 includes a plastic film bag for easy transport
• Improved film support	• Better quality scans and prints

STORAGE AND HANDLING

Load and unload film in subdued light.

Store unexposed film at 70 °F (21 °C) or lower in the *original sealed package.* Always store film (exposed or unexposed) in a cool, dry place. Process film as soon as possible after exposure. Protect negatives from strong light. For more information about storing negatives, see KODAK Publication No. E-30, *Storage and Care of KODAK Photographic Materials—Before and After Processing.*

Note: High-speed films, such as PJ800 Film and EKTAPRESS Plus 1600 Professional Film, are sensitive to environmental radiation. Expose and process them promptly. As exposure to radiation is cumulative, you may also want to request *visual* inspection of PJ800 and EKTAPRESS Plus 1600 Professional Film at airport and other security x-ray inspection stations.

EXPOSURE

Adjustments for Long and Short Exposures

For EKTAPRESS PJ100, PJ400, and 1600 Films, no filter corrections or exposure adjustments are required for exposure times of 1/10,000 second to 10 seconds; for EKTAPRESS PJ800 Film, no adjustments are required for exposures from 1/10,000 second to 1 second. At longer exposure times, exposure compensation is required.

PROCESSING

Process these films in KODAK FLEXICOLOR Chemicals for Process C-41 using automated or manual processing techniques.

PJ100 Film

Exposure Index	100
Development Time (minutes:seconds)	3:15

PJ400 Film

Exposure Index	400	800 to 1600
Development Time (minutes:seconds)	3:15	3:45

PJ800 Film

Exposure Index	800	1600 to 3200
Development Time (minutes:seconds)	3:15	3:45

1600 Film / PJC

Exposure Index	1600	3200	6400
Development Time (minutes:seconds)	3:15	3:45	4:15

Note: These times are starting points. Make tests to determine the best development time for your application.

PRINTING NEGATIVES

You can make color prints by direct contact printing or enlarging on KODAK EKTACOLOR ULTRA II, EKTACOLOR SUPRA II, or EKTACOLOR PORTRA III Paper or KODAK DURAFLEX® RA Print Material.

Make slides by direct exposure onto KODAK VERICOLOR Slide Film. Make display transparencies on KODAK DURATRANS® RA Display Material, DURACLEAR™ RA Display Material, or KODAK VERICOLOR Print Film.

Make black-and-white prints on KODAK PANALURE SELECT RC Paper or KODAK EKTAMAX RA Professional Paper.

IMAGE STRUCTURE

Print Grain Index

The Print Grain Index number refers to a method of defining graininess in a print made with diffuse-printing illumination. It replaces rms granularity and has a different scale which cannot be compared to rms granularity.

- This method uses a uniform perceptual scale, with a change of four units equaling a *just-noticeable difference* in graininess for 90 percent of observers.

- A Print Grain Index rating of 25 on the scale represents the approximate visual threshold for graininess. A higher number indicates an increase in the amount of graininess observed.

- The standardized inspection (print-to-viewer) distance for all print sizes is 14 inches, the typical viewing distance for a 4 x 6-inch print.

- Print Grain Index numbers may not represent graininess observed from more specular printing illuminants, such as condenser enlargers.

- In practice, larger prints will likely be viewed from distances greater than 14 inches, which reduces apparent graininess.

To determine the Print Grain Index numbers listed below, prints were made from 135-size (24 x 36 mm) negatives. In each case, the viewing distance was the standard 14 inches.

Print Size (inches)	4 x 6	8 x 10	16 x 20
Magnification	4.4X	8.8X	17.8X
EKTAPRESS Film	Print Grain Index No.		
PJ100	28	50	79
PJ400	41	62	92
PJ800	57	79	108
1600 / PJC	57	78	107

For more information, see KODAK Publication No. E-58, *Print Grain Index—An Assessment of Print Graininess from Color Negative Films.*

KODAK PROFESSIONAL
EKTAPRESS Film PJ100

Image-Structure Data

Sharpness:	Extremely High
Degree of Enlargement:	Very High

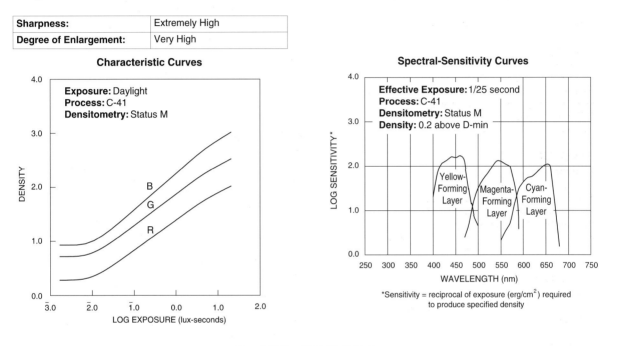

Characteristic Curves

Exposure: Daylight
Process: C-41
Densitometry: Status M

Spectral-Sensitivity Curves

Effective Exposure: 1/25 second
Process: C-41
Densitometry: Status M
Density: 0.2 above D-min

Yellow-Forming Layer
Magenta-Forming Layer
Cyan-Forming Layer

*Sensitivity = reciprocal of exposure (erg/cm^2) required to produce specified density

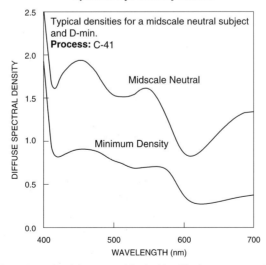

Spectral-Dye-Density Curves

Typical densities for a midscale neutral subject and D-min.
Process: C-41

Midscale Neutral

Minimum Density

Note: The sensitometric curves and data in this publication represent product tested under the conditions of exposure and processing specified. They are representative of production coatings, and therefore do not apply directly to a particular box or roll of photographic material. They do not represent standards or specifications that must be met by Eastman Kodak Company. The company reserves the right to change and improve product characteristics at any time.

KODAK PROFESSIONAL
EKTAPRESS Film PJ400

Image-Structure Data

Sharpness:	High
Degree of Enlargement:	High

Characteristic Curves

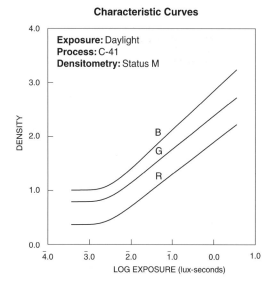

Characteristic Curves / Push 1

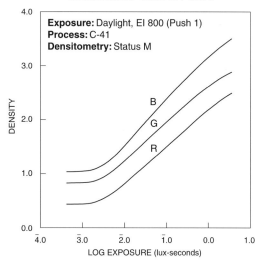

Spectral-Sensitivity Curves

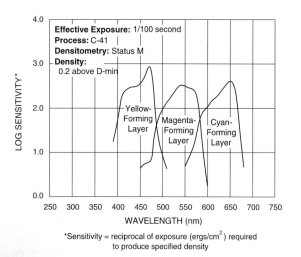

*Sensitivity = reciprocal of exposure (ergs/cm^2) required
to produce specified density

Spectral-Dye-Density Curves

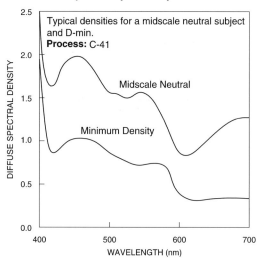

KODAK PROFESSIONAL
EKTAPRESS Film PJ800

Image-Structure Data

Sharpness:	High
Degree of Enlargement:	High

Characteristic Curves

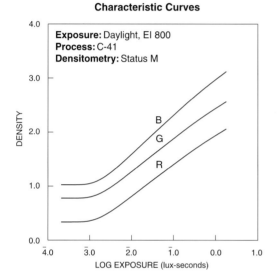

Exposure: Daylight, EI 800
Process: C-41
Densitometry: Status M

Characteristic Curves / Push 1

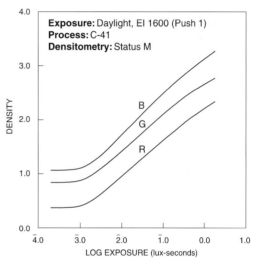

Exposure: Daylight, EI 1600 (Push 1)
Process: C-41
Densitometry: Status M

Spectral-Sensitivity Curves

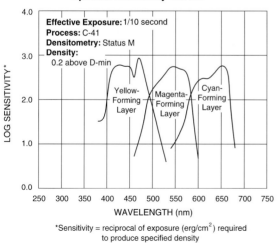

Effective Exposure: 1/10 second
Process: C-41
Densitometry: Status M
Density:
0.2 above D-min

*Sensitivity = reciprocal of exposure (erg/cm^2) required
to produce specified density

Spectral-Dye-Density Curves

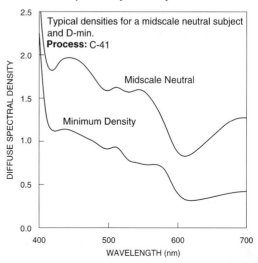

Typical densities for a midscale neutral subject
and D-min.
Process: C-41

KODAK EKTAPRESS Plus 1600
Professional Film / PJC

Image-Structure Data

Sharpness:	Medium
Degree of Enlargement:	Moderate

Characteristic Curves

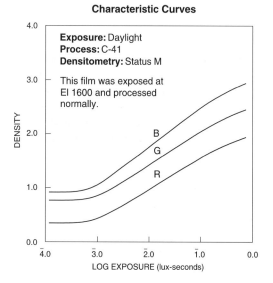

Exposure: Daylight
Process: C-41
Densitometry: Status M

This film was exposed at EI 1600 and processed normally.

Characteristic Curves / Push 2

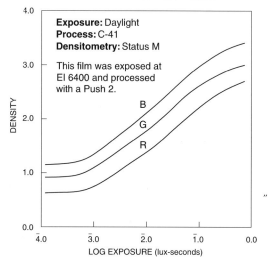

Exposure: Daylight
Process: C-41
Densitometry: Status M

This film was exposed at EI 6400 and processed with a Push 2.

Spectral-Sensitivity Curves

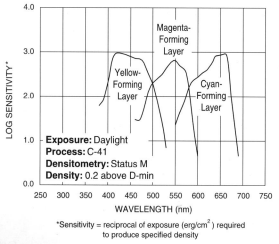

Exposure: Daylight
Process: C-41
Densitometry: Status M
Density: 0.2 above D-min

*Sensitivity = reciprocal of exposure (erg/cm^2) required to produce specified density

Spectral-Dye-Density Curves

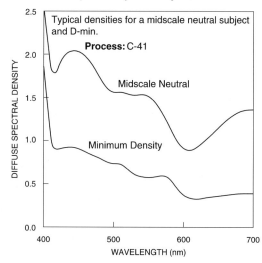

Typical densities for a midscale neutral subject and D-min.
Process: C-41

Midscale Neutral

Minimum Density

Photographic filters

Appendix E

Most photographic filters are *dye filters*; that is, they are made of colored glass or of colored gelatin coated on glass or plastic. The table lists most of the dye filters you are likely to encounter; the most useful ones are listed in boldface. Regardless of their color, *almost all dye filters transmit infrared wavelengths above 750 nm*; that's within the response range of CCDs, silicon-cell exposure meters, and infrared films. That is also why it is not safe to view the sun through ordinary photographic filters.

A filter is considered efficient if it blocks the undesired wavelengths completely while transmitting the desired wavelengths without attenuation. Red, orange, and yellow dye filters are more efficient than those of other colors. Blue dye filters are especially inefficient; they don't transmit all the blue light, nor do they block all the light of other wavelengths.

Interference filters are more efficient than dye filters, but also a great deal more expensive. They use multiple layers of very thin coatings to "tune in" specific wavelengths of light. Nebula filters are interference filters; so are the hydrogen-alpha filters used for narrow-band solar observing. These are discussed on pp. 138 and 102 respectively.

The identification of filters can be confusing. At least five systems are in use:

- Kodak Wratten numbers, always one or two digits, sometimes followed by a letter, such as 12, 15, and 47B. Dragesco (1995) and some other writers prefix these with W.
- Obsolete Kodak Wratten letters for some of the most popular filters, such as A, G, X1, and X2.
- Hoya (Japanese) letter-and-number designations, sometimes reduced to just the initial letter, such as Y48 (alias Y) and O54 (alias O).
- B+W three-digit numbers, such as 040, 092, and 461.
- Schott glass designations, such as OG 530, which are widely used in Germany.

Thus Wratten 15, Wratten G, Hoya O or O54, B+W 099, and Schott OG 530 are essentially the same filter. (Note the distinction between the letter O and the numeral 0.)

The Kodak Wratten line used to contain more than 100 filters, but many of these have been discontinued in recent years. Most other manufacturers' products are imitations of Wratten filters and use the same numbering, but the B+W line includes some German-made Schott glass filters that have no exact Wratten equivalents. In the table, closely equivalent filters from different manufacturers are listed together even if the actual specifications are not exactly the same.

If possible, use multicoated glass filters of good optical quality. The best multicoated filters come from Hoya and B+W. Cheaper filters often lack anti-reflection coating altogether. Good secondhand filters are available from KEH Camera Brokers (p. 316).

The table lists two filter factors for each filter, one for ordinary films and the other for imaging materials that have extended red response, namely CCDs and Kodak Technical Pan Film. Bear in mind that the filter factor is only approximate and depends on the kind of object being photographed. For example, a red hydrogen-alpha nebula is hardly attenuated at all by a Wratten 23A red filter, although ordinary visible light is attenuated by a factor of about 6.

E.1 High-efficiency yellows, oranges, and reds

Except where noted, these filters have over 90% transmission at wavelengths longer than a certain threshold, and less than 0.1% transmission at substantially shorter wavelengths. See also Fig. 8.22, p. 138.

Designation			Filter factor			
Wratten number	Wratten letter	Other	Most films	CCDs and Tech Pan	Color	Remarks
0	–	UV, 010	1.0	1.0	Clear	Blocks UV <360 nm
1A	–	L39, KR1.5	1.0	1.0	V. pale pink	Blocks UV <390 nm, giving slight reduction of haze and sky fog. Transmits all visible wavelengths
2E	–	Y44, 420, GG 420	1.1	1.1	Pale yellow	"Minus violet." Blocks violet and deep blue <430 nm. Available from Lumicon
3	–	–	1.5	1.2	Light yellow	Blocks violet and deep blue <465 nm
6	K1	–	1.5	1.2	Light yellow	Partly blocks <465 nm; weaker version of #3
8	K2	Y, Y48, 022	2	1.5	Yellow	Blocks violet and blue <495 nm
9	K3	–	2	1.5	Yellow	Blocks violet and blue <510 nm
12	–	Y52, 023	2	1.5	Deep yellow	Blocks violet, blue, and some green. Very sharp cutoff at 520 nm
15	G	O, O54, 040, 099, 424, OG 530	2.5	2	Deep yellow	Very similar to #12; you won't need both. Cutoff at 530 nm
21	–	O56	4	2	Orange	Blocks violet, blue, and green <555 nm
23A	–	O58, 041, 490, OG 590	6	2	Light red	Transmits only red and infrared >580 nm
25	A	R60, 090	8	3	Red	Transmits only red and infrared >600 nm
29	F	R62, 091	20	8	Deep red	Transmits only red and infrared >620 nm
92	–	RG 645	40	10	V. dark red	Transmits only red and infrared >650 nm. Used in infrared and hydrogen-alpha photography. ≈ Lumicon hydrogen-alpha-pass filter
–	–	092, RG 695	–	–	Reddish black	Transmits near infrared > 700 nm. Not same as Wratten 92
87A, 87B, 87C, 88A, 89B	–	093, RG 830	–	–	Black	Transmits only deep infrared >800 nm

E.2 Other sharp-cutoff filters

These filters are, in general, not as efficient as red, orange, and yellow dye filters; that is, their transmission of the desired wavelengths is not as high, and the cutoff from transmitted to non-transmitted wavelengths is not as sharp. Still, they are as efficient as dye technology permits.

Most blue filters are rather dark, and most black-and-white films have relatively low sensitivity in the deep blue. As an alternative to photographing through a blue filter, consider photographing on color slide film and then duplicating through a blue filter in order to extract the image recorded on the blue-sensitive layer of the film.

Magenta filters are especially useful for exaggerating the contrast between reddish and bluish colors. The traditional Wratten 34A is too dark for many purposes; the newly introduced B+W 442 (Schott RG 6) is likely to be more useful. You can also use one of the Kodak Polycontrast or Ilford Multigrade filters normally used with variable-contrast enlarging paper. The original Polycontrast PC 3 filter is an efficient light magenta, partly blocking 500–600 nm. The current Ilford Multigrade 3 filter is not much different, but newer Kodak Polymax filters transmit more orange and less blue. Finally, you can use a broadband nebula filter as an efficient magenta filter in lunar and planetary work; it transmits blue and deep red, even though it looks blue-green to the eye.

Designation			Filter factor			
Wratten number	Wratten letter	Other	Most films	CCDs and Tech Pan	Color	Remarks
11	X1	G11, 060	4	4	Yellow-green	Blocks violet and deep blue <480 nm; partly blocks orange and red >580 nm
13	X2	061	5	5	Yellow-green	Transmits green and yellow (480–580 nm). More efficient version of #11
18A	–	403, UG 1	–	–	Black	Transmits only UV (320–380 nm) and some infrared. Blocks visible light
34A	–	–	8	≈8	Purple (magenta)	Blocks 455–560 nm (yellow, green, and some blue) Transmits red and most of blue and violet
–	–	442, RG 6	3	3	Purple (magenta)	Blocks green; transmits red and blue Made by B+W and Schott
38A	–	081	2	4	Blue-green	Transmits 350–550 nm
44	–	–	8	≈12	Blue-green	Transmits blue and green (450–535 nm)
–	–	480, BG 12	5	≈10	Blue	Lighter than #47. Made by B+W and Schott
47	C5	B43	6	12	Blue-violet	Transmits violet and blue (410–480 nm)
47B	–	–	8	16	Blue-violet	Darker version of #47
49	C4	–	–	–	Blue-black	Partly transmits 430–470 nm
–	–	470, BG 18	2	2	Light green	Transmits 400-575 nm. Made by B+W and Schott
–	–	461, VG 9	4	2	Light green	Transmits less blue than 470. Made by B+W and Schott
56	–	–	6	8	Green	Transmits green (490–580 nm)
58	B	G58	8	12	Green	Transmits green (505–560 nm)
61	N	–	12	20	Dark green	Partly transmits green (500–560 nm)
301A		489, KG 3	1	1	Clear	"Heat-absorbing glass." Blocks infrared 700–950 nm. Useful with slide duplicator, to keep silicon exposure meter from being misled by high infrared transmission of film

E.3 Color balancing filters

Designation		Filter factor		Color	Remarks
Wratten number	Other	Most films	CCDs and Tech Pan		
80A, 80B	KB12, KB15	4	≈8	Pale blue	Absorbs some green, yellow, and red
80C	KB6	2	≈4	Pale blue	As #80A, weaker
82, 82A	KB1.5	1.2	1.5	Pale blue	As #80A, even weaker
81, 81A, 81B, 81C	KR3	1.2	1.0	Pale yellow	Absorbs some blue
85, 85B	KR12, KR15	1.5	1.2	Pale orange	Absorbs some blue and green
–	FL-D, 499, F-Day	2	2	Grayish magenta	For color photography under fluorescent lights. Not very useful in astronomy
–	FL-B	2	2	Pinkish magenta	Like FL-D, transmits more red
CC05R–CC50R				Pale red	Various strengths
CC05G–CC50G				Pale green	Various strengths
CC05B–CC50B				Pale blue	Various strengths
CC05Y–CC50Y				Pale yellow	Various strengths
CC05M–CC50M				Pale magenta	Various strengths
CC05C–CC50C				Pale cyan	Various strengths
CP05R, etc.					As CC05R, etc., but lower optical quality, for use in light sources rather than lens systems

These filters transmit the entire spectrum while partly attenuating part of it. Their purpose is to adjust the color rendition of color film; they are seldom used in astrophotography, but they may be useful in correcting overall color casts, especially in slide duplication.

E.4 Other filters

Neutral-density filters use carbon as the filter dye; they absorb visible light quite uniformly but do not absorb infrared wavelengths past 700 nm or so. Kodak Wratten 96 neutral density filters are made of gelatin on plastic and are available in several densities. The most complete line of neutral-density filters, however, is made by B+W and has the following specifications:

Filter number	Filter factor	Logarithmic density
B+W 101	2	0.3
B+W 102	4	0.6
B+W 103	8	0.9
B+W 106	16	1.8
B+W 110	1000	3.0
B+W 113	10 000	4.0
B+W 120	1 000 000	6.0

Filters for safe solar viewing are made of thin layers of metal coated on glass or plastic; the transmitted image is usually blue. Welder's glass consists of a heavy dye filter (usually green) sometimes assisted by a metal coating; it is safe for solar viewing (at appropriate densities) but is usually of low optical quality.

Polarizers have a filter factor slightly greater than 2 (naturally, you're throwing away half of the light when you choose a specific axis of polarization) and do not polarize infrared or deep violet light.

A *circular polarizer* is a polarizer that selects light rays with a particular polarization, just like an ordinary polarizer, and then scrambles their polarization again to keep from affecting beamsplitters or other polarization-sensitive elements in exposure meters. A consequence of this is that if you stack two circular polarizers, you don't get a variable neutral-density filter as you would if you stacked two ordinary polarizers.

Organizations and resources

Appendix F

Astrophotography is a combination of two popular hobbies and therefore attracts two kinds of people, photographers who are new to astronomy and amateur astronomers who are new to photography.

One of the best ways to get more information about astronomy is to read the major magazines – *Astronomy*, *Astronomy Now*, *Sky & Telescope*, and the journals of the main amateur societies. You can find these magazines, as well as a wide selection of books, at public or university libraries.

You can often locate other amateur astronomers through a nearby planetarium, science museum, or college or university astronomy department.

Getting information about photography is considerably easier, since any good camera shop or bookseller can supply books, and local clubs are abundant; many of them have darkrooms for members to use.

The manufacturers and dealers listed here are known to me personally or by reputation. Many others are equally good and can be located through ads in astronomy and photography magazines.

F.1 Organizations

American Association of Variable Star Observers (AAVSO), 25 Birch Street, Cambridge, Massachusetts 02138, U.S.A., http://www.aavso.org.

Association of Lunar & Planetary Observers (ALPO), c/o Mr. H. D. Jamieson, P.O. Box 171302, Memphis, TN 38187, U.S.A., http://www.lpl.arizona.edu/alpo.

Astronomical Society of New South Wales, GPO Box 1123, Sydney 1043, NSW, Australia, http://www.ozemail.com.au/~asnsw. (One of several regional societies in Australia.)

Astronomical Society of Southern Africa, PO Box 9, Observatory 7935, South Africa, http://www.saao.ac.za.

British Astronomical Association (BAA), Burlington House, Piccadilly, London W1V 9AG, U.K., http://www.ast.cam.ac.uk/~baa. (Has members all over the world; publishes useful Handbook and Journal.)

International Dark-Sky Association (IDSA), 3545 N. Stewart Avenue, Tucson, AZ 85716, U.S.A., http://www.darksky.org. (Coordinates the campaign against light pollution, especially in the U.S.A.)

Olympus Camera Club, PO Box 222, Southall, Middlesex UB2 4SB, U.K. (For serious users of Olympus cameras, whether astronomical or not.)

Orange County Astronomers, c/o Mr. Charlie Oostdyk, P. O. Box 1762, Costa Mesa, CA 92628, U.S.A., http://www.chapman.edu/oca. (Not confined to Orange County, this nationally prominent organization holds astrophotography conferences and publishes proceedings.)

Royal Astronomical Society of Canada, 136 Dupont Street, Toronto, Ontario M5R 1V2, Canada, http://www.rasc.ca. (Amateur organization with a wide range of observing programs; many members are outside Canada.)

Royal Astronomical Society of New Zealand, P.O. Box 3181, Wellington, New Zealand.

Vereinigung der Sternfreunde, Am Tonwerk 6, D-64646 Heppenheim, Germany. (For German-speaking amateurs.)

The Webb Society of Deep-Sky Observers, c/o Mr. R. W. Argyle, Lyndhurst, Ely Road, Waterbeach, Cambridge CB5 9NW, U.K., http://www.webbsociety.org.

F.2 Internet resources

http://www.ai.uga.edu/~mc, the author's permanent web address. Follow links from here to get updated information about this book and related subjects.

http://www.ast.cam.ac.uk, Institute of Astronomy, Cambridge University. Links to many other astronomical sites.

http://www.skypub.com, Sky Publishing Corp., U.S.A. Weekly news bulletins and links to other sites.

http://www.astromart.com, Astromart, an online trading post for astronomical equipment.

http://www.astronomy-mall.com, Astronomy-Mall, an online showcase containing web pages for many astronomical equipment dealers.

http://www.astronomy.net, Astronomy-Net. Indexes of, and links to, many astronomical sites.

http://www.yahoo.com/Science/Astronomy, astronomy index at Yahoo search engine (an index of indexes).

F.3 Magazines

F.3.1 Astrophotography

The Astrograph, P.O. Box 369, Dumfries, VA 22026, U.S.A., astrogph@erols.com. For amateur astrophotographers.

AAS Photo-Bulletin, for professional astronomers, was published from 1969 to 1986 by the American Astronomical Society.

CCD Astronomy was published by *Sky & Telescope* from 1994 to 1997 and then merged into the latter magazine.

F.3.2 Astronomy

Astronomy, Kalmbach Publishing Co., P.O. Box 1612, Waukesha, WI 53187, U.S.A., http://www.kalmbach.com/astro. (The most popular American magazine; circulated internationally. Wide coverage of the field; strongly amateur-oriented; many ads for equipment and materials.)

Astronomy Now, P.O. Box 175, Tonbridge, Kent TN10 4ZY, U.K., http://www.astronomynow.com. (Wide coverage; the leading British magazine for amateurs.)

Popular Astronomy, Society for Popular Astronomy, 36 Fairway, Keyworth, Nottingham NG12 5DU, U.K. (For beginners of all ages.)

Sky & Telescope, Sky Publishing Corp., P.O. Box 9111, Belmont, MA 02178, U.S.A., http://www.skypub.com. (The most distinguished of the American astronomy magazines; accessible to beginners but more oriented toward experienced observers. Widely read by professional astronomers.)

SkyNews, National Museum of Science and Technology P.O. Box 9724, Station T, Ottawa, Ontario K1G 5A3, Canada, http://www.cmpa.ca/o9.html. (For Canadian amateurs.)

The Starry Messenger, P.O. Box 6552-H, Ithaca, NY 14851, U.S.A., http://www.StarryMessenger.com. (Classified ads for secondhand telescopes, cameras, and other equipment.)

L'Astronomie, Société Astronomique de France, 3, rue Beethoven, 75016 Paris, France, http://www.iap.fr/saf. (In French.)

Sterne und Weltraum, Portiastrasse 10, D-81545 München, Germany, http://www.mpia-hd.mpg.de/suw/suw.html. (In German.)

F.3.3 General photography

Chasseur d'Images, La Petite Motte, 86100 Senillé,
France. (In French. Publishes lens tests, probably
the most reliable of various magazines that do
so.)

Darkroom User, Foto Format Publications, PO Box 4,
Machynlleth, Powys SY20 8WB, U.K. (One of the
best technically oriented photography magazines.)

Photo Techniques (formerly *Darkroom and Creative
Camera Techniques*), Preston Publications, 6600
W. Touhy, Niles, IL 60714, U.S.A. (Strong
emphasis on darkroom work.)

Photon (formerly *PHOTOpro*), Icon Publications Ltd,
Maxwell Place, Kelso TD5 7BB, U.K.,
http://www.photonpub.co.uk. (General
photography magazine with strong technical
content. Published online as well as on paper.)

Popular Photography, 1633 Broadway, New York, N.Y.
10019, U.S.A. (Largest American photography
magazine; contains ads for highly competitive
discount dealers in New York and elsewhere.)

Practical Photography, Apex House, Oundle Road,
Peterborough PE2 9NP, U.K. (Largest British
photography magazine; full of useful ads; strong
on equipment reviews and technical topics.)

Shutterbug, 5211 S. Washington Ave., Titusville, FL
32780, U.S.A., http://www.shutterbug.net. (Large-
format magazine with classified ads for used
equipment. Published online as well as on paper.)

F.4 Manufacturers

F.4.1 Telescopes and eyepieces
*These companies generally sell through dealers, but
you can contact them directly for catalogues and other
product information.*

Astro-Physics, 11250 Forest Hills Road, Rockford, IL
61115, U.S.A. (Premium-quality refractors
designed for photography.)

Celestron International, 2835 Columbia Street,
Torrance, CA 90503, U.S.A.,
http://www.celestron.com. (The original Schmidt–
Cassegrain telescope manufacturer. Now makes
telescopes and accessories of all kinds.)

Meade Instruments Corporation, 6001 Oak Canyon,
Irvine, CA 92620, U.S.A.,
http://www.meade.com. (Telescopes and
accessories of all kinds.)

Tele Vue Optics, Inc., 100 Route 59, Suffern, NY
10901, U.S.A., http://www.televue.com.
(Eyepieces and compact refractors of high
quality.)

Vixen Optical Industries Ltd., 247 Hongo, Tokorozawa,
Saitama 359, Japan. (Telescopes, eyepieces, and
accessories.)

F.4.2 Other astronomical equipment
*Unless noted, these companies sell directly to
individuals.*

B&K Products, 500 E. Arapaho Road #611,
Richardson, TX 75081, U.S.A. ("Astrofocuser" for
Olympus OM-1, a substitute for the Varimagni
Finder giving higher magnification.)

Edmund Scientific, 101 East Gloucester Pike,
Barrington, NJ 08007, U.S.A.,
http://www.edsci.com. (Telescopes, accessories,
lenses, other optical components, tools, and test
instruments.)

Edwin Hirsch* (Hydrogen-alpha filters for observing
solar prominences.)

JMI, 810 Quail St., Unit E, Lakewood, CO 80215.
(Motorized focusers, telescope accessories,
movable mounts for heavy telescopes.)

*After a long career of service to amateur astronomy, Edwin Hirsch died in November 1998. The hydrogen-alpha filters that he sold
are now available directly from the manufacturer, Daystar Filters, 3857 Schaefer Ave. Suite D, Chine, CA 91710, U.S.A.,
http://www.daystarfilters.com.

Jim Kendrick Studio, 2775 Dundas Street West, Toronto, Ont. M6P 1Y4, Canada, http://www.kendrick-studio.com. (Dew-removing heaters, large Scheiner disks to aid focusing.)

Rigel Systems, 26850 Basswood Ave, Rancho Palos Verdes, CA 90275, U.S.A., http://pw2.netcom.com/ rigelsys/Rigelsys.html. ("PulsGuide" flashing reticle illuminator, LED flashlights, and other observing aids.)

Taurus Technologies, P.O. Box 14, Woodstown, NJ 08098, U.S.A. (Maker of Taurus Astrocamera.)

F.4.3 Photographic equipment and materials
In general, these companies sell only through dealers.

Fresnel Optics, Inc., 1300 Mount Read Blvd., Rochester, NY 14606, U.S.A., phone 716-647-1140. (Maker of Beattie Intenscreen extra-bright fine-matte focusing screens, sold through camera dealers. Pronounced "Beety" and formerly made by Beattie Systems of Cleveland, Tennessee, a manufacturer of high-volume portrait cameras.)

B+W Filters, Schneider Optics, 285 Oser Ave, Hauppauge, NY 11788, U.S.A., http://www.schneideroptics.com. *In Germany*: Schneider-Kreuznach, Postfach 2463, D-55513 Bad Kreuznach, Germany. (High-quality filters; also excellent enlarging lenses. Useful filter data book. B+W was originally a separate company but has merged with Schneider.)

Brandess–Kalt–Aetna Group, 5441 N. Keeside Ave., Chicago, IL 60625, U.S.A. (Major distributor of specialized camera accessories. Your local camera store probably has the Kalt catalogue and can order from it; a browse through the catalogue is very worthwhile.)

Eastman Kodak Company, Kodak Information Center, 343 State Street, Rochester, New York 14650, U.S.A., phone (toll-free) 800-242-2424, http://www.kodak.com. *In Britain*: Kodak Ltd., Hemel Hempstead, Hertfordshire HP1 1JU, U.K., phone 01442-61122, http://www.kodak.co.uk.

Fuji Photo Film U.S.A., Inc., 555 Taxter Road, Elmsford, NY 10523, U.S.A., http://home.fujifilm.com. *In Britain*: Fuji Photo Film (U.K.) Ltd., Fuji Film House, 125 Finchley Road, Swiss Cottage, London NW3 6JH, U.K.

Ilford Ltd., Town Lane, Mobberley, Knutsford, Cheshire WA16 7JL, U.K., phone 01565-684000. *In the United States*: Ilford Photo, West 70 Century Road, Paramus, NJ 07653, U.S.A., http://www.ilford.com).

Kalt, *see* Brandess–Kalt–Aetna, above.

Nikon, Inc., 1300 Walt Whitman Rd., Melville, N.Y. 11747-3064, U.S.A., http://www.nikon.com and http://www.nikon.co.jp. *In Britain*: Nikon U.K. Ltd., 380 Richmond Road, Kingston upon Thames, Surrey KT2 5PR, U.K.

Olympus America, 2 Corporate Center Drive, Melville, NY 11747, U.S.A., http://www.olympusamerica.com and http://www.olympus.co.jp. *In Britain*: Olympus Optical Co. (UK) Ltd., 2–8 Honduras Street, London EC1Y 0TX, U.K.

Zörkendörfer Technik, Gollierstrasse 70, 80339 München, Germany. (Unusual camera accessories, lens adapters, and the like. Catalogue available in English.)

F4.4 Image processing and CCDs

Apogee Instruments, 3340 N. Country Club #103, Tucson, AZ 85716, U.S.A., http://www.apogee-ccd.com. (CCD cameras for advanced amateurs and professionals.)

Cyanogen Productions, Inc., 25 Conover St., Nepean, Ont. K2G 4C3, Canada, cyanogen@cyanogen.on.ca. (Image-processing software that performs maximum-entropy deconvolution.)

Finger Lakes Instrumentation, 8031 Parker Hill Road, Dansville, NY 14437, U.S.A., http://www.fli-cam.com. (High-quality CCD cameras built in small quantities.)

Lynxx, see SpectraSource, below.

Meade Instruments (listed in section F.4.1 above). (Low-cost CCD cameras and autoguiders.)

SBIG (Santa Barbara Instrument Group), 1482 East Valley Road #33, Santa Barbara, CA 93150, U.S.A., http://www.sbig.com. (Wide range of well-engineered CCD cameras for amateur and professional astronomy.)

SpectraSource Instruments, 31324 Via Colinas, Suite 114, Westlake Village, CA 91362, U.S.A., http://www.optics.org/spectrasource. (Lynxx, Teleris, and Orbis CCD cameras.)

Starlight Xpress, c/o FDE Ltd., Briar House, Foxley Green Farm, Ascot Road, Holyport, Maidenhead, Berkshire SL6 3LA, U.K., http://www.ibmpcug.co.uk/starlite. (Low-cost and mid-range CCD cameras.)

F.5 Dealers

F.5.1 Astronomy and astrophotography

Adirondack Video Astronomy, 35 Stephanie Lane, Queensbury, NY 12804, U.S.A. (Astronomical video and CCD cameras.)

Astrofilms, c/o Mr. N. S. Fox, 44 Ledbrook Road, Leamington Spa CV32 7LU, U.K. (Supplier of hypered film in Britain.)

Astronomics, 2401 Tee Circle, Norman, OK 73069, U.S.A. (Wide selection of telescopes and accessories; reliable service. Does not export.)

Broadhurst, Clarkson & Fuller (Fullerscopes), Telescope House, Farringdon Road, London EC1 M3JB, U.K., phone 0171-405-2156. (Telescopes, accessories, and books. Sells its own line of telescopes and imports products of Meade, Celestron, Lumicon, and others. Large showroom.)

Camera Bug Ltd., 1799 Briarcliff Road, Atlanta, GA 30306, U.S.A. (Small telescope dealer with good personal service; ships anywhere. Also processes astronomical photographs in minilab.)

Lichtenknecker Optics N.V., Kuringersteenweg 44, B-3500 Hasselt, Belgium. (Telescopes and hard-to-find accessories for astrophotography.)

Lumicon, 2111 Research Drive #5A, Livermore, CA 94550, U.S.A., http://Astronomy-Mall.com/lumicon. (Excellent selection of equipment and materials for astrophotography, including nebula filters, hypered film, and hypering kits. Free catalogue.)

Orion Optics, Unit 21, 3rd Avenue, Crewe, Cheshire CW1 6XU, U.K. (British distributor for Vixen and other products. Not to be confused with Orion Telescope Center in California.)

Orion Telescopes and Binoculars, P.O. Box 1815, Santa Cruz, CA 95061 U.S.A., http://www.oriontel.com. (Full range of telescopes and accessories; excellent service.)

Texas Nautical Repair Company, 3110 S. Shepherd, Houston, TX 77098, U.S.A., http://www.lsstnr.com. (U.S. distributor of Takahashi premium-quality telescopes and eyepieces.)

University Optics, P.O. Box 1205, Ann Arbor, MI 48106, U.S.A. (Eyepieces, accessories, and kits for the Cookbook CCD camera.)

Vehrenberg KG, Schillerstrasse 17, D-40237 Düsseldorf, Germany. (Full-range equipment dealer.)

F.5.2 General photography

Charlotte Camera, 2400 Park Road, Suite G, Charlotte, North Carolina 28203, U.S.A., http://www.charlottecamera.com. (Used cameras, competitive prices, good service.)

Freestyle Sales Co., 5124 Sunset Blvd., Los Angeles, CA 90027, U.S.A., phone 213-660-3460, http://www.freestylesalesco.com. (Film, paper, chemicals, and cameras for serious darkroom workers and photography students. Many hard-to-find materials. Discounts on outdated film that has been refrigerated and is still good.)

Grays of Westminster, 40 Churlton St., Pimlico, London SW1V 2LP, U.K., phone 0171-828-4925. (Highly respected Nikon specialist; secondhand equipment and repairs available.)

KEH Camera Brokers, 2310 Marietta Blvd., N.W., Atlanta, GA 30318, U.S.A., phone 404-892-5522, http://www.keh.com. (Largest North American used camera dealer; ships worldwide. Cameras, lenses, filters, and accessories. Reliable service.)

Photographers' Formulary, Inc., P.O. Box 950, Condon, MT 59826, U.S.A., http://www.montana.com/formulary. (Hard-to-find photographic chemicals; developers premixed from published formulae.)

Porter's Camera Store, Box 628, Cedar Falls, IA 50613, U.S.A., http://www.porters.com. (Large catalogue of hard-to-find camera accessories and darkroom supplies; ships worldwide.)

F.5.3 High-volume photographic discount dealers

These companies supply cameras, accessories, photographic materials, and some telescopes at the lowest possible prices, and they ship anywhere. Photographers around the world rely on them. Treat them like wholesalers; to maintain their low prices they must process orders quickly, and they do not have time to discuss or demonstrate products.

Some of their merchandise is labeled "direct import" or "gray market," which means it is manufactured for sale in other countries but imported by the dealer to take advantage of lower prices. These products are the same as those supplied through normal channels except for some risk that film may have been stored improperly and cameras may not have full warranty coverage in your country. Some cameras are available only on the "gray market" in the U.S.A. because their manufacturers do not sell them there.

The two companies listed here have good reputations, but other high-volume discounters come and go, and some are much less reliable than others. Make sure you're ordering exactly the item you want; beware of cheap lenses bundled with good camera bodies. As far as possible, check out the current reputation of any company before doing business.

Adorama, 42 West 18th Street, New York, NY 10011, U.S.A., phone 212-741-0052, http://www.adorama.com. (Very large selection, quick service.)

B&H Photo, 420 9th Ave., New York, NY 10001, U.S.A., phone 212-444-6615, http://www.bhphoto.com. (Even larger selection. Showroom in New York is well worth visiting.)

F.5.4 Miscellaneous

L. L. Bean and Company, Freeport, Maine 04033, U.S.A., http://www.llbean.com. (Cold-weather clothing.)

Observer's Inn, 3535 Highway 79, Julian, CA 92036, U.S.A. (Guest house at dark-sky observing site near San Diego, with observatory and telescopes. Bring your own equipment or use theirs.)

F.6 Camera repairs and modifications

Brightscreen, 1905 Beech Cove Drive, Cleveland, TN 37312, U.S.A., http://www.brightscreen.com. (Extra-bright focusing screens for a wide range of cameras. Can modify existing screens that are not interchangeable. See also Fresnel Optics, listed in section F.4.3, above.)

Camtech, 21 South Lane, Huntington, NY 11743 U.S.A., phone 516-424-2121. (Olympus specialist, highly recommended.)

C.R.I.S. Camera Services, 250 N. 54th St., Chandler, AZ 85226 U.S.A. (602-940-1103). (General camera repairs, strong on electronics. Supplies MR-9 adapter for using silver oxide cells in place of mercury.)

Essex Camera Service, 100 Amor Avenue, Carlstadt, NJ 07072, U.S.A. (Repairs all kinds of cameras, including obsolete ones. Well recommended.)

Kirk Enterprises, 4370 E. U.S. Highway 20, Angola, IN 46703, U.S.A. (Custom-made camera accessories, lens supports, etc.; some items available from stock.)

Luton Camera Repair Services, 49 Guildford St., Luton, Bedfordshire LU1 2N1, U.K., phone 01582-458323, http://www.lutcamre.demon.co.uk. (Repairs Olympus and other professional-grade cameras.)

Photosphere Camera Service, 2510 Electronic Lane #907, Dallas, TX 75220, U.S.A., phone 214-352-8448. (Olympus specialist.)

Professional Camera Repair, 37 West 47th Street, New York, NY 10036, U.S.A., phone 212-382-0550. (Repairs Nikon and other brands; custom-builds and modifies equipment; can change lens mounts. Trusted by professional photographers nationwide.)

Ed Romney, Box 487, Drayton, SC 29333, U.S.A., http://www.edromney.com. (Books about how to repair older cameras.)

Bibliography

Note: These items are not as hard to obtain as you may think. Most libraries, even small public libraries, can borrow books and obtain copies of articles through interlibrary loan. Some *Sky & Telescope* articles are online at http://www.skypub.com.

Adams, Ansel (1980) *The Camera*. With the collaboration of Robert Baker. (The new Ansel Adams photography series, vol. 1.) Boston: Little, Brown. (Standard textbook on how photography works.)

Adams, Ansel (1981) *The Negative*. With the collaboration of Robert Baker. (The new Ansel Adams photography series, vol. 2.) Boston: Little, Brown. (Standard textbook on exposure and development of black-and-white film, from the man who perfected photography as we know it. Adams developed and popularized the Zone System, a method of mapping the characteristic curve onto actual pictures.)

Adams, Ansel (1983) *The Print*. With the collaboration of Robert Baker. (The new Ansel Adams photography series, vol. 3.) Boston: Little, Brown. (Standard textbook on black-and-white enlarging, mainly for fine-art photographers but of interest to all.)

Anderson, Bill, and Sikes, Ken (1980) The plastic astrocamera. *Sky & Telescope*, December, 1980, pp. 530–533.

Astronomical Almanac for the Year 1998 (etc.). London: HM Stationery Office; Washington: U.S. Government Printing Office. (Positions of the sun, moon, and planets; details of eclipses and other phenomena. Revised annually. Many libraries shelve this book under government publications rather than astronomy.)

Babcock, T. A., Sewell, M. H., Lewis, W. C., and James, T. H. (1974) Hypersensitization of spectroscopic films and plates using hydrogen gas. *Astronomical Journal*, 79 (12), pp. 1479–1487. (Reports the discovery of hydrogen hypersensitization. With one Kodak Spectroscopic emulsion, vacuum treatment produced a ×9 speed increase and hydrogen produced a ×30 speed increase in 1-hour exposures.)

Ballard, Jim (1988) *Handbook for Star Trackers: Making and Using Star Tracking Camera Platforms*. Cambridge, Mass.: Sky Publishing Corporation.

Baumgardt, Jim (1983) Simple and inexpensive tricolor photography. *Astronomy*, November, 1983, pp. 51–54.

Berry, Richard (1992) *Choosing and Using a CCD Camera*. Richmond, Va.: Willmann-Bell.

Berry, Richard, Kanto, Veikko, and Munger, John (1994) *The CCD Camera Cookbook*. Richmond, Va.: Willmann-Bell. (How to build your own CCD camera.)

Brooks, John J. (1976) Structural considerations for telescope makers. *Sky & Telescope*, June, 1976, pp. 423-428.

Brown, G. P., Keene, G. T., and Millikan, A. G. (1980) An evaluation of films for astrophotography. *Sky & Telescope*, May, 1980, pp. 433–439.

Brown, Sam (1975) *All About Telescopes*. 2nd edn. Barrington, N.J.: Edmund Scientific.

Buil, Christian (1991) *CCD Astronomy: Construction and Use of an Astronomical CCD Camera*. Translated by E. and B. Davoust. Richmond, Va.: Willmann-Bell. Originally published by the author as as *Astronomie CCD*, Toulouse, 1987.

Burnham, Robert (1978) *Burnham's Celestial Handbook*. 3 vols. Revised and enlarged edn. New York: Dover Publications. (Indispensable handbook of deep-sky objects, with physical data and observing techniques. This author, Robert Burnham, Jr., 1931–1993, is not the same as the Robert Burnham who writes for *Astronomy*.)

Burnham, Robert (1981) Getting the Correct Exposure. *Astronomy*, June 1981, pp. 51–55.

Ceravolo, Peter (1989) Commercial telescope optics: buyer beware! *Sky & Telescope*, December, 1989, p. 564.

Chauvenet, William (1876) *A Manual of Spherical and Practical Astronomy*. 2 vols. Philadelphia: Lippincott.

Chou, B. Ralph (1981a) Safe solar filters. *Sky & Telescope*, August, 1981, pp. 119–121.

Chou, B. Ralph (1981b) Protective filters for solar observation. *Journal of the Royal Astronomical Society of Canada*, vol. 75, pp. 36–45. (More detailed than the preceding item; includes transmission curves and references to the literature.)

Chou, B. Ralph (1996) Eye safety during solar eclipses – myths and realities. In Z. Madourian and M. Stavinschi, eds., *Theoretical and Observational Problems Related to Solar Eclipses: Proceedings of a NATO Advanced Research Workshop*. Dordrecht: Kluwer.

Chou, B. Ralph (1997) Eye safety and solar eclipses. In Espenak and Anderson (1997), pp. 19–21.

Chou, B. Ralph (1998) Solar filter safety. *Sky & Telescope*, February, 1998, pp. 36–40.

Chou, B. Ralph, and Krailo, M. D. (1981) Eye injuries in Canada following the total solar eclipse of 26 February 1979. *Canadian Journal of Optometry*, 43, pp. 40–45.

Clark, Roger N. (1990) *Visual Astronomy of the Deep Sky*. Cambridge University Press.

Cocozza, Joseph A. (1977) *Astrophotography Near City Lights*. Published by the author, Westville, N.J.

Conrad, Craig M., Smith, Alex G., and McCuiston, W. B. (1985) Evaluation of nine developers for hypersensitized Kodak Technical Pan Film 2415. *AAS Photo-Bulletin*, 38, pp. 3–4. (Found that D-8, which resembles Dektol, and D-19 gave the highest speed; HC-110 was close. Others have found higher speed with HC-110.)

Covington, Michael A. (1991) Choosing a developer scientifically: an interpretation of the Judge–Holm test data. *Kodak Tech Bits*, 1991, issue 2, pp. 14–16.

Crawley, Geoffrey (1980) Nikon F3 – a review. Published in six installments. *British Journal of Photography*, 7 Nov. 1980, pp. 1100–1103; 14 Nov. 1980, pp. 1130-1131, 1134–1135; 28 Nov. 1980, pp. 1178–1181, 1183; 5 Dec. 1980, pp. 1210–1212, 1214–1215; 12 Dec. 1980, pp. 1240–1243; 19 Dec. 1980, pp. 1268–1269, 1275–1276. Republished in book form as *Camera Test: Nikon F3,* London: Henry Greenwood, 1981.

Crawley, Geoffrey (1981) Pentax LX system – a review. Published in seven installments. *British Journal of Photography*, 13 Nov. 1981, pp. 1164–1167, 1182; 20 Nov. 1981, pp. 1196–1197, 1200, 1207; 4 Dec. 1981, pp. 1240–1243; 11 Dec. 1981, pp. 1272–1275, 1280; 18 Dec. 1981, pp. 1290–1294; 1 Jan. 1982, pp. 6–9, 11; 8 Jan. 1982, pp. 34–36. Republished in book form as *Camera Test: Pentax LX System*, London: Henry Greenwood, 1982.

Crawley, Geoffrey (1992) Contax RTS III. Published in five installments. *British Journal of Photography*, 6 Feb. 1992, pp. 16–17; 13 Feb. 1992, pp. 22–23; 20 Feb. 1992, pp. 12–13; 27 Feb. 1992, pp. 10–11; 5 Mar. 1992, pp. 12–13.

Di Cicco, Dennis (1989) Celestron vs. Meade: an 8-inch showdown. *Sky & Telescope*, December, 1989, pp. 576–582, and January, 1990, pp. 33–39.

Di Cicco, Dennis (1991) An update on Schmidt–Cassegrain telescopes. *Sky & Telescope*, June, 1991, pp. 601–604.

Di Cicco, Dennis (1992) Better ways to focus your telescope. *Sky & Telescope*, June, 1992, pp. 616–618.

Di Cicco, Dennis (1996) Hunting asteroids. *CCD Astronomy*, Spring, 1996, pp. 8–13.

Dobbins, Thomas A., Parker, Donald C., and Capen, Charles F. (1988) *Introduction to Observing and Photographing the Solar System*. Richmond, Va.: Willmann-Bell.

Dragesco, Jean (1976) Essai de télescopes Schmidt–Cassegrain Celestron. *L'Astronomie*, 90, pp. 238–245.

Dragesco, Jean (1995) *High Resolution Astrophotography*. Translated by Richard McKim. Cambridge University Press.

Edberg, Stephen J., and Levy, David H. (1994) *Observing Comets, Asteroids, Meteors, and the Zodiacal Light*. Cambridge University Press.

Espenak, Fred (1987) *Fifty Year Canon of Solar Eclipses: 1986–2035*. Revised edn. NASA Reference Publication 1178. Goddard Space Flight Center, Greenbelt, MD 20771. Distributed by Sky Publishing, Cambridge, Mass.

Espenak, Fred (1989) *Fifty Year Canon of Lunar Eclipses: 1986–2035*. NASA Reference Publication 1216. Goddard Space Flight Center, Greenbelt, MD 20771. Distributed by Sky Publishing, Cambridge, Mass.

Espenak, Fred (1994) *Twelve Year Planetary Ephemeris: 1995–2006*. NASA Reference Publication 1349. Goddard Space Flight Center, Greenbelt, MD 20771.

Espenak, Fred, and Anderson, Jay (1997) *Total Solar Eclipse of 1999 August 11*. NASA Reference Publication 1398. Goddard Space Flight Center, Greenbelt, MD 20771.

Everhart, Edgar (1984) Finding your telescope's magnitude limit. *Sky & Telescope*, January, 1984, pp. 28–30. (Maps of three selected areas showing magnitudes of stars down to 20.5, with references to other sources of similar information.)

Gehret, Ernest-Charles (?) (1980) E-6 reversal process: alternative formulae. *British Journal of Photography*, 18 Apr. 1980, pp. 370–371. (How to mix your own E-6 chemicals. Article is unsigned but Gehret appears to have been the author.)

Gehret, Ernest-Charles (1981) Ektachrome E-6 process. *British Journal of Photography*, 28 Aug. 1981, pp. 888–890, and 4 Sept. 1981, pp. 910–911 and 919. (Another set of published formulae for E-6 processing. Formulae are in the second installment of the article.)

Goldberg, Norman (1992) *Camera Technology: The Dark Side of the Lens*. Boston: Academic Press.

Gonzalez, Rafael C., and Woods, Richard E. (1993) *Digital Image Processing*. Reading, Mass.: Addison-Wesley.

Gordon, Barry (1985) *Astrophotography, Featuring the fx System of Exposure Determination*. 2nd edn. Richmond, Va.: Willmann-Bell.

Gull, S. F., and Daniell, G. J. (1978) Image reconstruction from incomplete and noisy data. *Nature*, 272, pp. 686–690 (20 April 1978). (The paper that introduced maximum entropy deconvolution to the scientific community as a practical technique.)

Haig, G. Y. (1975a) A stellar spectrograph. *Journal of the British Astronomical Association*, 85.5, pp. 408–411.

Haig, G. Y. (1975b) A simple camera mounting for short exposures. *Sky & Telescope*, April, 1975, pp. 263–266.

Hamilton, J. F. (1977) Reciprocity failure and the intermittency effect. In T. H. James, ed., *The Theory of the Photographic Process*, 4th edn., pp. 133–144. New York: Macmillan.

Hanisch, Robert J., White, Richard L., and Gilliland, Ronald L. (1997) Deconvolution of Hubble Space Telescope images and spectra. In Peter A. Jansson, ed., *Deconvolution of Images and Spectra*, 2nd edn., pp. 310–360. San Diego, Calif.: Academic Press. (Explains Richardson-Lucy algorithm and describes experiences with Hubble data.)

Harrington, Philip (1995) Nebula filters for light-polluted skies. *Sky & Telescope*, July, 1995, pp. 38–42.

Henry, Richard J. (1986) *Controls in Black and White Photography*. 2nd edn. Boston: Focal Press.

Heudier, J.-L. (1992) *Photographie astronomique à grand champ*. Paris: Masson. (Written for professional astronomers, this handbook is concise but strong on photographic and astronomical science.)

Hirshfeld, Alan, Sinnott, Roger W., and Ochsenbein, Francois (1991) *Sky Catalogue 2000.0*. 2 vols. Cambridge University Press. (Catalogue to accompany *Sky Atlas 2000.0*. Vol. 1 lists stars to magnitude 8.0; vol. 2 lists double stars, variables, clusters, nebulae, and galaxies.)

Horowitz, Paul, and Hill, Winfield (1989) *The Art of Electronics*. 2nd edn. Cambridge University Press.

Istock, T. H. (1985) Solar retinopathy: a review of the literature and case report. *Journal of the American Optometric Association*, 56 (5), pp. 374–382.

Jähne, Bernd (1995) *Digital Image Processing*. 3rd edn. Berlin: Springer.

Jefferies, Stuart M., and Christou, Julian C. (1993) Restoration of astronomical images by iterative blind deconvolution. *Astrophysical Journal*, 415, pp. 862–874.

Judge, Nancianne, and Holm, Jack (1990) Sensitometric evaluation of Kodak Technical Pan Film and Kodak T-Max 100 Professional Film using a wide range of developments. *Kodak Tech Bits*, 1990, issue 2, pp. 5–9. (Available from Kodak.)

Kämmerer, Joachim (1979) When does it make sense to improve the quality of photographic lenses? *British Journal of Photography*, 16 Nov. 1979, 1104–1108.

Karttunen, H., Kröger, P., Oja, H., Poutanen, M., and Donner, K. J. (1996) *Fundamental Astronomy*. Berlin: Springer. (Somewhat more thorough than other astronomy textbooks; a good reference book on astronomical science.)

Kay, David C., and Levine, John R. (1995) *Graphics File Formats*. 2nd edn. New York: Windcrest/McGraw-Hill.

Keene, G. T., and Sewell, M. H. (1975) An evaluation of eight films for astrophotography. *Sky & Telescope*, July, 1975, pp. 61–65.

Keppler, Herbert (1982) *The Nikon Way*. 3rd edn. London: Focal Press.

King, Edward Skinner (1931) *A Manual of Celestial Photography*. Boston: Eastern Science Supply Company (ESSCO). (Based on early work at the Harvard College Observatory. Strong emphasis on clock drive performance; introduces "King rate.")

Kingslake, Rudolf (1978) *Lens Design Fundamentals*. New York: Academic Press. (Standard handbook on classic methods for designing lenses and minimizing aberrations; based on an older work by Conrady. Contrast with the newer computer-based techniques of Shannon (1997), listed below.)

Kingslake, Rudolf (1983) *Optical System Design*. New York: Academic Press. (Basic principles for designing optical instruments of any kind.)

Kingslake, Rudolf (1989) *A History of the Photographic Lens*. Boston: Academic Press.

Kodak (1973) *Kodak Plates and Films for Scientific Photography*. Rochester, N.Y.: Eastman Kodak Company.

Kodak (1987) *Scientific Imaging with Kodak Films and Plates*. Rochester, N.Y.: Eastman Kodak Company.

Kodak (1995) *Basic Developing and Printing in Black-and-White*. Rochester, N.Y.: Saunders (for Eastman Kodak Company). (Beginner's handbook of darkroom work; revised frequently.)

Kodak (1996) *Kodak Black-and-White Darkroom Dataguide*. Rochester, N.Y.: Saunders (for Eastman Kodak Company). (Covers all Kodak products; revised frequently.)

Koolish, Richard M. (1978) A drive control in an ammo box. *Sky & Telescope* December, 1978, pp. 566–567.

Kronk, Gary W. (1988) *Meteor Showers: A Descriptive Catalog.* Hillside, N.J.: Enslow.

Lightfoot, Dale (1982) Making the most of black-and-white astronegatives. *Astronomy*, January, 1982, pp. 51–55.

Liller, William (1992) *The Cambridge Guide to Astronomical Discovery.* Cambridge University Press.

Liller, William, and Mayer, Ben (1990) *The Cambridge Astronomy Guide.* Cambridge University Press. (Photographically oriented guide for beginners. Presumes that you have a camera but not a telescope.)

Lodriguss, Jerry (1997) A film for all nebulae. *Astronomy*, May, 1997, pp. 83–87. (Review of Kodak PJM and PPF films.)

Luginbuhl, Christian B., and Skiff, Brian A. (1990) *Observing Handbook and Catalogue of Deep-Sky Objects.* Cambridge University Press.

Lyding, J. W. (1997) UHV STM nanofabrication – progress, technology spin-offs, and challenges. *Proceedings of the IEEE*, 85.4 (April, 1997), pp. 589–600. (Discusses advantages of deuterium for coating silicon; deuterium may have similar advantages for hypering film.)

Malin, David (1977) Unsharp masking. *AAS Photo-Bulletin*, 16, pp. 10–13.

Malin, David (1981) Photographic enhancement of direct astronomical images. *AAS Photo-Bulletin*, 27, pp. 4–9. (High-contrast copying led to discovery of faint outer parts of galaxies.)

Malin, David (1993) *A View of the Universe.* Cambridge University Press. (Memoirs of a professional astrophotographer, with information about his techniques and the discoveries he has made.)

Malin, David, and Zealey, W. J. (1979) Astrophotography with unsharp masking. *Sky & Telescope*, April, 1979, pp. 354–359.

Mallas, John H., and Kreimer, Evered (1978) *The Messier Album: An Observer's Handbook.* Cambridge University Press.

Martinez, Patrick, ed. (1994) *The Observer's Guide to Astronomy.* 2 vols. Translated by Storm Dunlop. Cambridge University Press. (Detailed coverage of observing techniques for all kinds of celestial objects. Emphasis is on scientifically useful results.)

Martinez, Patrick, and Klotz, Alain (1997) *A Practical Guide to CCD Astronomy.* Cambridge University Press.

Meinel, A. B. (1956) An $f/2$ Cassegrain camera. *Astrophysical Journal*, 124, pp. 652–654.

Meinel, Edward S. (1986) Origins of linear and nonlinear recursive restoration algorithms. *Journal of the Optical Society of America*, series A, vol. 3, pp. 787–799.

Millennium Star Atlas = Sinnott and Perryman (1998).

Moore, Patrick (1990) *The Amateur Astronomer.* Cambridge University Press.

Morris, Steven (1996) Photographing lunar color. *Sky & Telescope*, March, 1996, p. 99.

Newton, Jack, and Teece, Philip (1983) *The Cambridge Deep-Sky Album.* Cambridge University Press. (Cold-camera photographs of deep-sky objects.)

Norton, O. Richard (1973) Color infrared photography of some astronomical objects. *Sky & Telescope*, June, 1973, pp. 401–402.

Pasachoff, Jay M., and Covington, Michael A. (1993) *The Cambridge Eclipse Photography Guide.* Cambridge University Press.

Peterson, B. Moose (1996) *Nikon System Handbook.* Rochester, N.Y.: Saunders PhotoGraphic, Inc.

Pickering, Edward C. (1886) Stellar photography. *Memoirs of the American Academy of Arts and Sciences,* Vol. XI, Part IV, No. IV, pp. 179–226.

Piini, Ernest W. (1973) A three-way camera for solar eclipse photography. *Sky & Telescope*, September, 1973, pp. 187–189.

Platt, Terry (1995) Astronomical colour imaging – notes on a new technique. *Journal of the British Astronomical Association*, 105.3, June, 1995, pp. 113–116.

Pouplier, Alphonse (1992) Field rotation in astrophotography. *Sky & Telescope*, September, 1992, pp. 318–321. (Deals with field rotation experienced by instruments on altazimuth mounts. Software available from http://www.skypub.com.)

Ratledge, David, ed. (1997) *The Art and Science of CCD Astronomy*. London: Springer.

Ray, Sidney F. (1994) *Applied Photographic Optics*. 2nd edn. Oxford: Focal Press.

Reeves, Robert (in preparation) *Wide-Field Astrophotography* (tentative title). Richmond, Va.: Willmann-Bell.

Rükl, Antonín (1996) *Atlas of the Moon*. Waukesha, Wisconsin: Kalmbach; London: Reed. (Detailed maps of the entire moon as seen from earth, suitable for use at the telescope and for interpreting photographs. Much better than the moon maps available elsewhere.)

Rutten, Harrie, and van Venrooij, Martin (1988) *Telescope Optics: Evaluation and Design*. Richmond, Va.: Willmann-Bell.

Sanford, John R. (1982) Testing a chromogenic film for astrophotography. *Journal of the British Astronomical Association*, 92.4, pp. 196–197. (Successful deep-sky photography with Ilford XP1.)

Schwarzschild, K. (1900) On the deviations from the law of reciprocity for bromide of silver gelatine. *Astrophysical Journal*, 11, pp. 89–91. (Classic paper on reciprocity failure. Schwarzschild found that his photographic plates had $p = 0.85$, similar to today's slow films.)

Shannon, R. R. (1997) *The Art and Science of Optical Design*. Cambridge University Press. (Modern computer-based approach to optical design and correction of aberrations; contrasts with the older approach expounded by Kingslake.)

Sheehan, William (1996) *The Planet Mars: A History of Observation and Discovery*. Tucson: University of Arizona Press.

Simpson, J. Wesley (1967) Lunar libration-cloud photography. In *The Zodiacal Light and the Interplanetary Medium*, ed. J. L. Weinberg, pp. 97–107. Washington, D.C.: NASA.

Sinnott, Roger W. (column editor) (1973) Some hints for photographers of total solar eclipses. *Sky & Telescope*, May, 1973, pp. 322–326.

Sinnott, Roger W. (1973) Limiting magnitudes with amateur telescopes. *Sky & Telescope*, June, 1973, pp. 401–402.

Sinnott, Roger W., and Perryman, Michael A. C. (1998) *Millennium Star Atlas*. 3 vols. Cambridge, Mass.: Sky Publishing. (Stars to 11th magnitude and deep-sky objects; the most thorough star atlas ever printed. Based on data from the Hipparcos satellite, giving unprecedented accuracy.)

Sky Atlas 2000.0 = Tirion (1981).

Sky Catalogue 2000.0 = Hirshfeld, Sinnott, and Ochsenbein (1991).

Smith, Alex G. (1989) Gas hypersensitization of 14 Kodak films and use of the films in astronomy. *Kodak Tech Bits*, 1989, issue 3, pp. 3–10. (Available from Kodak.)

Stensvold, Mike (1978) *Increasing Film Speed*. Los Angeles: Petersen. (Covers push-processing and hypersensitizing techniques, not including hydrogen.)

Suiter, Harold Richard (1994) *Star Testing Astronomical Telescopes*. Richmond, Va.: Willmann-Bell.

Taylor, Peter O. (1991) *Observing the Sun*. Cambridge University Press.

Tirion, Wil (1981) *Sky Atlas 2000.0*. Cambridge University Press. (Currently the standard star atlas for amateur observing. Maps of the entire sky, to 8th magnitude. Useful at the telescope and in interpreting photographs. Replaces an earlier atlas by Bečvář.)

Tirion, Wil, Rappaport, Barry, and Lovi, George (1987) *Uranometria 2000.0* 2 vols. Richmond, Va.: Willmann-Bell. (Detailed atlas of stars to magnitude 9 and deep-sky objects, designed for use at larger telescopes and for interpreting photographs.)

Tomosy, Thomas (1993) *Camera Maintenance and Repair.* Amherst, N.Y.: Amherst Media.

Trueblood, Mark, and Genet, Russell (1985) *Microcomputer Control of Telescopes.* Richmond, Va.: Willmann-Bell. (Includes a section on the field rotation experienced with altazimuth mounts.)

Uranometria 2000.0 = Tirion, Rappaport, and Levy (1987).

Vehrenberg, Hans (1983) *Atlas of Deep-Sky Splendors.* Cambridge University Press. Originally published as *Mein Messier-Buch*, Düsseldorf: Treugesell-Verlag, 1965.

Vranjican, Mladen (1985) A lightweight astrocamera for pennies. *Sky & Telescope*, December, 1985, pp. 612 613.

Wallis, Brad D., and Provin, Robert W. (1988) *A Manual of Advanced Celestial Photography.* Cambridge University Press.

Watkins, Bob (1997) Do-it-yourself duping. *British Journal of Photography*, 7 July 1997, pp. 20–21. (Construction of a light box for slide duplication.)

Watkins, Derek (1995) Chrome brew – making your own E-6 from raw chemicals. *Photon*, June 1995. Republished online, http://www.photonpub.co.uk/photon/june95/e6.html.

West, John B., and Bradford, Robert S. (1975) A crystal-controlled oscillator for telescope drives. (With appendix by R. W. Sinnott.) *Sky & Telescope*, August, 1975, 125–128. (Contains discussion of King rate.)

Wildi, Ernst (1995) *The Hasselblad Manual: A Comprehensive Guide to the System.* Newton, Mass.: Butterworth-Heinemann.

Wyckoff, Charles W., and Leavitt, Peter R. (1970) Eclipse photography with a new color film. *Sky & Telescope*, August, 1970, pp. 72–73. (Special extended-dynamic-range film made by EG&G confirmed existence of a reddish ring in the corona.)

Zussman, Kim (1989) Optimizing of Kodak 2415. *Proceedings, Astrophoto VIII.* Orange, California: Orange County Astronomers. (Reviews literature and reports experiments with hypersensitization procedure and choice of developer.)

Index

References to figures are in *italic* font, and reference to tables are in **bold**

aberrations, 71–3, 164, 170
 astigmatism, 71, 172
 chromatic, 37, 72, 90, 124
 reducing with filters, 124, 165
 coma, 71–3, **73**
 curvature of field, 71, 78, 82, 92,
 112, 163
 distortion, 71–2, 125–6
 vs. effect of flat field, 123–4
 mimicking field rotation, 134
 spherical, 71–2, 90, 163, 172
achromat, 72
Adams, A., 196, 197, 200
adaptive optics, 256
ADC, 243, 252, 255
afocal coupling, 40–4, 69, 75–7,
 111–12
Agfa, *see* films
aircraft, 147
Amberlith, 203
analog-to-digital converter (ADC), 243,
 252, 255
Anderson, J., 46, 65
angular size of celestial objects, 74
animals, 147
annular eclipse, *see* eclipses
apochromat, 72
arc-minutes, 74
arc-seconds, 74
artifacts, scanner, 224
ASA, 179, 259
asteroids, 19, 111
 discovering, 111
astigmatism, 71, 172
Astrofilms, 16, 315
Astrofocuser, 88, 155
atmospheric turbulence, 95, 97–8
 daytime, 100, 102
 effect on guiding tolerance, 131
 electronic correction, 256
aurora borealis, 28
autofocus, 152
autoguiders, 135, 143
automatic exposure, 152
automobiles, 146

B&K Astrofocuser, 88, 155, 313
Babcock, T. A., 185
back focus, 69–70
Baily's beads, 61, 63
baking film, 185
Ballard, J., 120

barn-door trackers, 120–1, *121*
Barlow lens, *see* lenses
Barnard, E. E., 113
Bass, M., Plate 3.1
batteries
 12-volt, for drive motor, 132–3
 camera, 152, 154, 160
 mercury, substitutes for, 154, 317
Baumgardt, J., 36, 70, 211, Plate 11.2
Bean, L. L., 145
Beattie Intenscreen, 87, 112, 153, 314
Berry, R., 242, 253, 260
bias frames, bias error, 252
binoculars, photography through, 40–3
bit depth, 217, 222, 255
bitmap graphics, 216–220
bits per pixel, 217, **218**
blind deconvolution, 240
blooming, 247
blur circle, 90
BMP files, 222
books, 5
Boyer, C., 108
Bradford, R. S., 289
Brasch, K., 109, Plate 7.1
brassing, 157
brightness, *see* magnitude
Brightscreen, 87, 153, 317
Brooks, J. J., 96
Brown, G. P., 187
Brown, S., 76
budget, 7, 169–72
Buil, C., 242
bulk loading, 193–4
Burnham, Robert (1931–1993), 5, 75,
 113
Burnham, Robert (of *Astronomy*), 260
byte, defined, 217

C-41 process, 190, 197, 206–7
C-mount, 243
calibration frames, 251–3
camcorders, 50, 63, 65
cameras
 all-sky, 33
 Bronica, 161
 CCD, *see* CCD imaging
 choosing, 3, 12–14, 151–62
 cold, 136, Plate 8.5
 Contax, 91
 digital, 243–4
 Exakta, 19

 features, **152**, **153**
 Hasselblad, 161
 homebuilt, 161–2
 Instamatic, 91
 Leica, 161
 Lubitel, 42, 161
 medium-format (120 size), 40–3,
 160–1
 Mamiya, 161
 Minolta, 152, 157
 Miranda, 161
 Nikon, 87, 89, **153**,155–6, 157
 Olympus, 62, 87–9, **153**, 154–5,
 210
 Pentax, **153**, 156–7, 161
 "point-and-shoot", 160
 Praktica, 161
 repairing, 157–8, 317
 Ricoh, 157
 Schmidt, 143, Plate 10.1
 secondhand, 157–8
 sheet-film, 161
 single-lens reflex (SLR), 40, 44,
 86–8, *151*, 151–60
 focusing accuracy, 88, 158
 shutter vibration, 40–1, 96–7,
 152–3
 Taurus, 89, 161, 314
 testing, 157–8
 twin-lens reflex, 40, 42, 43
 video, 50, 63, 65, 243
 viewfinder magnification, 87, 155
 Vixen, 157
 Voigtländer, 160
 Yashica, 157
Capen, C. F., 93
Cassegrain, *see* telescopes
CCDs, 242–3; **255**
 spectral response, *247*
CCD array, 242
CCD autoguiders, 135, 143
CCD imaging, 98, 146, 241–56
 asteroids, 111
 cameras, 244, 253–6
 color, 255–6
 deep-sky, 253
 moon, 249–50
 planets, 93, 249–50
CD-ROM, 223
central obstruction, 84–5, 88
Ceravolo, P., 171
changing films in mid-roll, 19

characteristic curve, of film, 177–9
 affected by developer, 199–200
 manipulating digitally, 225–9
charge-coupled devices, see CCDs
charge wells, 242
Chesterton, G. K., 7
Chou, B. R., 55–7
Christou, J. C., 240
chromatic aberration, see aberrations
chromosphere, solar, 61
Clark, R. N., 114, 260
cleaning
 cameras, 159
 lenses, 172–3
 internally, 169
clock drive, see tracking
clothing, warm, 144–5
Coathanger star cluster, 127
Cocozza, J. A., 137–8
cold cameras, 136, Plate 8.5
collimation, 72, 171–2
color
 indexed, 217
 lateral/longitudinal, see aberrations,
 chromatic
 manipulating digitally, 229–30
 "true", 218
coma, 71–3
combination printing, 107, 205
 digital, 231
comets, 21–3, 25
 exposure table, **273**
compression
 of computer files, 220–2
 of midtones, 225, 228
 optical, 69, 82–4, 143, 246
Conrad, C. M., 185
contour maps, 228
contact printing, 195
contrast index, 177
convolution, 233–40
cooled-emulsion photography, 136,
 Plate 8.5
corona, solar, 60–2
\cos^4 law, 124–5
Crawley, G., 91, 156
crosshairs
 for focusing, 89
 for guiding, 131
curvature of field, 71, 78, 82, 92, 112, 163

Daniell, G. J., 240
dark frames, 252
darkroom, 195–6

Dawes limit, 84
deblurring, 239
 see also image processing
declination, 10
deconvolution, 239–40
 see also convolution
deep-sky objects, 113–48, **115**
 exposure tables, 273–5
degrees
 as measure of size of object, 74
 in film speed notation, 179
density, logarithmic, **56**, 177–8
deuterium, 185
developers, 174, 179, 196–200
 Agfa Rodinal, 197, 199–200
 compensating, 199–200
 effect on film speed, 179
 Ilford
 Ilfotec HC, 197
 Microphen, 179
 Multigrade, 196
 Perceptol, 186
 Kodak
 D-8, 196
 D-19, 16, 45, 136, 185, 186,
 196, 197, 200
 D-76, 186
 Dektol, 136, 185, 196, 200
 DK-50, 186
 Flexicolor C-41, 197
 HC-110, 16, 45, 110, 185, 190,
 197–8, **198**, **199**, 200
 Microdol-X, 186
 Technidol, 45, 197
 T-Max, **199**, 198–200
 Xtol, 179, 197, **199**
 POTA, 197
 preserving, 196
developing agents, 179, 196–200
development times, **199**
 vs. temperature, 200
dew, 98–100
dew cap, 99–100
diamond ring effect, 61
Di Cicco, D., 83, 90, 111, 171, 240
diffraction, 84–5
digital images, 215–40
DIN, 179
disk space, see files
dispersion, 72
distortion, 71–2, 125–6
Dobbins, T. A., 93
dot pitch, 218
Downing, D., 49, Plate 8.3

Dragesco, J., 93, 98, 103, 161, 171
draw programs, 217
drift method (polar alignment), 120
drive correctors, electronic, 132, 283–9
drive motors, see tracking
duplication
 prints, 210–11
 slides, 15, 207–10
dust, interplanetary, 28–33
dye couplers, 174
dynamic range, 222–3

E-6 process, 175, 206–7
East, G., Plate 2.1, Plate 10.1
eclipses, 46–65
 lunar (moon), 46–52, **47**
 exposure tables, 264–6
 solar (sun), 52–65
 annular, 56–60
 exposure tables, 266–9
 filters for viewing, see filters
 partial, 56–60
 safety, 54–7
 total,
Edberg, S. J., 26
edge-finding, 236, 238–9
effective focal length, see focal length
enlargements and enlargers, 106, 195,
 204–5
 see also prints
en-prints, 195
entropy, maximum, 239–40
Ephemeris Time (ET), 47
EPS files, 221–2
equalization, histogram, 229
equatorial mounts, 114, 118, 170
 see also polar alignment; tracking
equipment, see cameras; telescopes
error, periodic, see periodic error
Eskin, M., 244, Plate 13.1
Espenak, F., 46, 47, 65
ESTAR, 174, 191
etiquette, at observing sessions, 145
Europe, total solar eclipse in, **64**, 65
Everhart, E., 129
exit pupil, 76
expanding midtones, 225, 228
exposure
 automatic, 152
 calculating, 38–9, 259–60
 CCD, 247–8, **248**
 effect of reciprocity failure, 180, 184
 latitude, 44–5
 multiple, 50, 51, 54, 160

exposure tables, 259–74
 comets, 273
 deep-sky objects, 273–5
 eclipses, 264–9
 maximum without clock drive, 12, 39
 moon, 38, 261–6
 planets, 269–72
 stars, fixed-tripod, 12
eye injuries, 54–5
eyepiece projection, *see* positive
 projection
eyepieces, 76–7, 78, 170

field flatness, *see* aberrations, curvature
 of field
field of view, 73–5, **75**, **124**
 CCD cameras, 244, 246
 limited by aberrations, 143
 limited by eyepiece tube, 70, 82, 160
field rotation, 133–4, 276, 279–82
files, computer
 formats, 220–2
 size, 218–22; **220**
film flatness, 91
film speed, 38–9, 179–80, 259
 ratios, in "stops", 39–40
 see also exposure; reciprocity failure
films, 174–94, 183
 Agfa, 206
 Agfachrome, 175
 Agfaortho 25, 176
 Agfapan 400, 25
 blue-sensitive, 175
 changing in mid-roll, 19
 choosing, 13, 44–5, 135–6, 187–92
 chromogenic, 174, 186
 color, 176–8, data sheets, 291–306,
 186; *see also specific films*
 Fuji, 136, 206
 Astia, 61, 188, 209
 Fujichrome 100, 188
 Fujichrome 400, 175, 189
 Provia, 188
 Sensia, 188, 189, 209
 Velvia, 111–12
 Ilford
 HP5 Plus, 180, 190
 SFX 200, 191
 XP2, 45, 62, 174, 190
 infrared, 191–192
 Kodak
 Ektachrome (as a group), 175
 Ektachrome Elite II 100, 135,
 179, 187–8

Ektachrome Elite II 200, 189
Ektachrome Elite II 400, 135
Ektachrome P1600, 189
Ektachrome Professional E100S
 and E100SW, 136, 179,
 188
Ektachrome Professional E200,
 13, 15, 61, 136, 188–9
 data sheets, 298–300
Ektachrome Professional Infrared,
 191–2
Ektagraphic Slide Film, 176
Ektapress
 data sheets, 301–6
 Multispeed (PJM), 189
 PJ400, 118, 136, 143, 189
 PJ800, 189
Elite Chrome 100, 45, 111–12,
 167, 187–8, 209
Elite Chrome 200, 19, 118, 136,
 143, 188–9
Fine Grain Positive, 206
High Speed Infrared, 191
Kodachrome, 175
Kodalith Ortho, 176
Panatomic-X, 45, 189
Plus-X Pan, 25, 33
Pro 400 Professional Film (PPF),
 189
Recording Film 2475, 26, 176
Spectroscopic (103a-O, IIIa-J,
 etc.), 136, 137–8, 191
SO-115, 190
Technical Pan 2415/4415/6415,
 45, 85, 91, 93, 102–3,
 106, 110–12, 118, 136,
 138, 161, 176, 185,
 190–1, 200, 210
 data sheets, 291–7
 development, 200
 see also hypersensitization
T-Max 100, 20, 45, 57, 118, 136,
 143, 180, 189–90, 200
T-Max 400, 180, 190
T-Max P3200, 26, 180, 190
T-Max T400 CN, 45, 62, 136,
 174, 190
Tri-X Pan, 13, 26, 135, 180, 190
MTF curve, 187
Tri-X Pan Professional, 192, 200
Ultra Gold 400, 189
Verichrome Pan, 57
Vericolor Slide Film 5072, 210
long-toed, 45, 177–9

orthochromatic, 175–6
panchromatic (pan), 176
"professional," 192
short-toed, 25, 177–9
spectral sensitivity, 175–7; *see also*
 hydrogen-alpha
testing, 181–4, 187
filter factors, 107
filters
 detailed tables, **307–10**
 digital, *see* image processing
 for comets, 25
 for meteors, 26
 for planets, 107–11
 for viewing sun safely, 54–7, **56**, **57**,
 266–7
 Hoya, 165
 hydrogen-alpha monochromatic,
 102–3
 hydrogen-alpha-passing, 137–8
 interference, 102, 138
 multicoated, 165
 nebula, 138
 neutral-density, 54–7, 181, 310
 polarizing, 50, 310
 skylight, 165
 to change paper contrast, 201
 to improve sharpness of telephoto
 lens, 37, 124, 165
 to reduce sky fog, 137–8, **138**
 tricolor, 211
 ultraviolet-blocking, 165
 ultraviolet-passing, 108
 with CCDs, 250
finderscopes, 246
FITS files, 222
fixer, 174, 200, 204
flat-fielding, 250–1
flatness of field, *see* curvature of field
flatness of film, 91
flexure, 142
flip mirrors, 143, 246
floating elements, 163
flop, mirror, 153
foam rot, 157, 158
focal length
 afocal setups, 43, 76
 of negative lens, 80–2
 negative projection, 80
 positive projection, 77
 prime focus, 69
 vs. image size, *see* image size
focal reducers, *see* compression

focusing, 85–92
 accuracy, 88, 90–2, **91**, 158
 aerial-image, 89
focusing (*cont.*)
 afocal systems, 40–3
 CCDs, 47
 crosshairs, 89, 111–12
 hand-telescope method (for afocal
 setups), 43
 knife-edge, 89
 magnifiers, 87–8, 154–5, 159
 screens, 86–9, 111–12, 153, 157,
 160
forming gas, 136, 185
formulae
 symbols used in, xvi
 using and understanding, 12
 see also specific subjects
Foucault test, 90, 171
Fourier transform, 232
f-ratio
 formulae, 69, 76, 77, 80
 effect on stars vs. extended objects,
 121, 123–4, 170–1
 vs. coma, 73
 vs. diffraction-limited resolution, 84–5
 vs. required focusing accuracy, 90–1
frame-transfer area, 242–3
frequency, spatial, 232–3; *see also*
 modulation transfer function
f-stops, 39–40
Fuji film, *see* films
Fujii, A., 51, 54, 116–17, Plate 8.5

galaxies
 brightness, seen from spaceship, 130
 exposure tables, **274**
gamma
 electronic imaging, 225
 film, 177
Garcia, G., 101
gas hypersensitization, *see*
 hypersensitization
Gauss, K. F., 236
gears, *see* periodic error
Gegenschein, 30–1
 position of, **31**
Gehret, E.-C., 206
Gilliland, R. L., 240
Global Positioning System (GPS), 47
Gonzalez, R. C., 239
Gordon, B., 260
GOST, 179
grain, of film, 174, 186–7, 224, 233

increased by overdevelopment, 45
less apparent with larger film, 160–1
reducing, in printing, 106–107, 233
graphics, bitmap vs. vector, 216
Greenwich Mean Time (GMT), 47–8
guiders, off-axis, 142–4
guidescopes, 142, 246
guiding, 130–5, 142–4
 automatic, 135, 143
 tolerance, 131–2, **132**
 with CCDs, 253
 see also tracking
Gull, S. F., 140

Haig, G. Y., 120
Haig mounts, 120
halation (reflection within film), 23
Hamilton, J. F., 181, 185
hand-telescope focusing, 43
Hanisch, R. J., 240
Harrington, P., 138
"hat trick", 97
heaters, to prevent dew, 99–100
Herschel wedge, 57
Hildebrand, E., Plate 12.3
Hill, W., 289
HIRF, 180
Hirsch, E., 102–3, 313
histograms, 229, 248
Holm, J., 200
Horowitz, P., 289
Hurd, K., Plate 4.3
Hyakutake, 22
hydrogen-alpha wavelength (656.281
 nm)
 film response, 135–6, 175–8
 filters, 137–8
 nebulae, 130
 sun, 102–3
hydrogen gas, 185–6
hypersensitization (hypering), 16, 136,
 184–6

Ilford, *see* films
image processing, 215–40
 convolutions, 233–40
 filters, 232–40
 band-pass, 233
 binomial, 236
 edge-finding, 236, 238–9
 embossing, 238–9
 Gaussian, 234–8
 isotropic, 234, 237
 Laplacian, 236, 238

median, 236–7
 sharpening, 230–1
 sharpening (high-pass), 233, 235,
 237–8
 smoothing (low-pass), 233–7
image size
 of digital image (file size), 218–22
 on film or CCD
 enlarged at edge of field, 123–4
 formulae, 35, 74, 106
 Jupiter, **75**
 moon, **35**, **75**
images, digital, *see* digital images
infrared light, 54–7, 191–2, 247
insect repellents, 146–7
interpolation, 220–1
ISO, 179, 259
isophotes, 229
Istock, T. H., 55

Jähne, B., 236, 238
Jefferies, S. M., 240
JMI Motofocus, 91, 313
JPEG files, 221
Judge, N., 200
Jupiter, 110–11
 exposure table, **271**
 opposition dates, **110**

Kämmerer, J., 91
Kanto, V., 255
Karttunen, H., 5
Kay, D. C., 222
Keene, G. T., 187
keeping warm, 144–5
Keppler, H., 156
kernel, convolution, 234
kilobyte, defined, 219
King, E. S., 288
King rate, 288
Kingslake, R., 259
Kipling, R., 71
Klotz, A., 242
knife-edge focusing and testing, 89–90
Kodak, *see* developers; films
Kodama, D., 243
Koolish, R. M., 289
Kordylewski, K., 31–2
Krailo, M. D., 55
Krajci, T., 32
Kreimer, E., 113
Kronk, G. W., 26
Kwik Focus, 88

Lagrange, G. L., 31
Laplacian operator, 236, 238
Lau, P., Plate 3.3, Plate 5.1
Leavitt, P. R., 61
lens mounts, 165–6
 adapters, 166
 M42 (42-mm universal), 165
 see also T-adapters
lenses
 achromatic, 72
 apochromatic, 72
 Barlow, 80, 142, 249
 choosing, 12–14, 121–30
 coated, 164–5
 compressor, *see* compression
 enlarger, 79, 106, 204
 fisheye, 125–6
 for deep-sky work, 121–30
 for medium-format cameras, 161
 macro, 163, 207–10
 microscope, 79
 mirror, 162, 165
 multicoated, 164–5
 negative (concave), 80–1
 Nikon, 90, 156, 164
 Olympus, 154, 165, 208
 normal, 162
 repairing, 169, 317
 Sigma, 163, 209
 Tamron, 164
 telephoto, 162
 for deep-sky work, 121–30
 for photographing moon, 35–7
 testing, 166–7
 Vivitar, 164
 wide-angle, 125–6, 162
 Zeiss, 157, 164
 zoom, 163, 169
Leonids, 26
Levine, J. R., 222
Levy, D. H., 26
libration points, 32
light pollution, 137–42
 combatting, 139, 142
 see also sky fog
Lightfoot, D., 95, 206
Liller, W., 5, 111
limb darkening, 102
lines per millimeter, 164
LIRF, 180
Lodriguss, J., 186, 205, Plate 12.5,
 Plate 12.6
Lowell, P., 98
lubrication

of cameras, 159
of telescope focusing mechanism, 91
Lucy–Richardson algorithm, 240
Luginbuhl, C. B., 129
Lumicon, 16, 73, 82, 103, 124, 136,
 137, 186, 315
lunar, *see* moon
lunar libration clouds, 31–3
lunar rate, 103, 106, 288
lunar transient phenomena (LTP), 103
Lynxx, 255, 315

magazines, 5
magnitude, 19, 126–30
 B (blue), 175
 limits, **126**
 of extended objects, 22, 129–30
 of stars, *127–8*
 per square arc-second, 129–30,
 259–60
 vs. number of stars, 126
Maksutov–Cassegrain, *see* telescopes
Malin, D., 20, 30, 114, 205, 206, 211
Mallas, J. H., 13
maps
 contour, 228
 solar eclipses, 53, 64
 stars, showing magnitudes, 127–8
Marling, J. B., 186
Mars, 108–110
 "canals", 239
 exposure table, **270**
 opposition dates, **110**
Martinez, P., 5, 103, 129, 242
masking, unsharp, *see* unsharp masking
matrix, *see* convolution
Mauldin, E., 96
maximum-entropy deconvolution, 239–40
Mayer, B., 5
McCammant, M., 251
McDonald Observatory, 77
megabyte, defined, 219
Meinel, A. B., 77
Meinel, E. S., 240
Mercury, 107
 exposure table, **269**
meteors, 25–8
 showers, **26**
microscope objectives, as projection
 lenses, 79
Milan, W., Plate 12.4
Milewski, R. A., 6
Milon, D., 27, 30
mirror

flop, 143
lock, 152–3
prefire, 152–3
mirrors
 flip, 144
 wide-field, 33
modulation transfer function (MTF), 164,
 187
moon, 35–45, 103–6
 color, 103, 229, Plate 12.2
 exposure tables, 38, 261–6
 tracking, 103, 106
Moore, P., 5
Morris, S., 229
mosaics, 245, 246
mosquitoes, 146–7
motors, 121
mounts, equatorial, *see* equatorial
 mounts
mounts, lens, *see* lens mounts
MTF, 164, 187
multicoating, 164–5
multiple exposures, 50, 51, 54, 160
Munger, J., 255

nebula filters, 138
nebulae, 20, 113–14, *114*, 130, 136,
 138
 CCD imaging, 248
 colors, 211
 exposure tables, **273–4**
 wavelengths emitted, 177
 see also deep-sky objects; hydrogen-
 alpha wavelength
negative projection, 69, 83–4, 112, 249
Nelson, L., 24
Neptune, 111
 exposure table, **272**
Newtonian, *see* telescopes
noise
 thermal, 251
 vs. signal, 233
Northern Lights, 28
Norton, O. R., 192

off-axis guiders, 142–3
Olympus Varimagni Finder, 154–5, 159
see also cameras, Olympus
oppositions of planets, **110**

paint programs, 217
partiality, zone of, 52
Palomar Mountain, 73
papers, photographic, 201–3

Parker, D. C., 93, 98
Pasachoff, J. M., 46, 55, 65, Plate 5.6,
 Plate 5.8
Paul, G. and A., 23
Peltier devices, 244
penumbra, 46–7
periodic error, 95, 130, 134–5
 correction (PEC), 135
 measuring, 134–5
Peterson, B. M., 156
Phenidone, 179, 196–7
Photo CD, 223
piggy-backing, 3, 5, 114, 118
Piini, E. W., 192
pitch, scanner, 222
pixels, 216
 "hot", 236–7, 252
 per inch or mm, 218, **219**
planets, 106–12
 opposition dates, **110**
 relative size, *106*
Platt, T., 256
Pleiades star cluster, 128
Pluto, 111
point spread function (PSF), 239
polar alignment, 114, 118, 120
 inaccurate, effect of, 133–4, 276
 procedure, 118, 120
polar axis, 114
polarizers, *see* filters, polarizing
positive projection, 69, 77–9, 112
posterization, 228
PostScript files, 222
preflashing, 16, 185
prime focus photography, 40, 69–71
printers, computer, 218, 231–2
prints
 black-and-white, 16, 45, 201–3
 from color negatives, 203
 color, 14
 high-contrast, 204
 multiple images superimposed, 107,
 205
 vs. slides, 14, 137
projection, *see* negative projection,
 positive projection
prominences, solar, 61–2, 102
Provin, R., 114, 120, 129, 142, 185,
 186, 190, 197
Pulstar, 131, 314
pupil, exit, 76
push-processing, 15–16, 106, 179–80

quantization error (quantization noise),
 233
quantum efficiency, 247

radians, 74
radiant, of meteor shower, 25
Ratledge, D., 242, 248
Rayleigh limit, 84–85
reciprocity failure, 13, 26, 83, 135–6,
 180–4, **183**
 formulae, 180
 methods of reducing, 136
recordkeeping, 16–18
Reeves, R., 181, 190
reflections,within lenses, 164–5
repair, *see* cameras; lenses
rephotography, 210–11
resampling (resizing), 220–1
resolution (resolving power), 84–5
 in dots (pixels) per inch or mm,
 218–9
 interpolated, 220
 limited by atmospheric turbulence,
 95, 249
 limited by diffraction, **85**, 164, 249
 of astronomical photographs, 93
 of camera lenses, 164
 of CCD, 248–9
 of film, 186–7
 vs. apparent sharpness, 164
reticles, illuminated, 131
retouching, 224–5
reversal, 175
Richardson–Lucy algorithm, 240
ringing, digital, 233
RMS granularity, 186
Romney, E., 159, 317
Ronchi gratings, 89
rotation (of image), *see* field rotation
Rükl, A., 103
Rutten, H., 73, 83

safelights, 203
safety
 at remote observing sites, 145–6
 viewing sun, 54–7
Sanford, J., 190
Saturn, 110–11
 opposition dates, **110**
SBIG, 255, 256, 315
scale, *see* image size
scan pitch, 222
scanners, 222–4
Scheiner, C., 88

Scheiner disk, 86, 88
Schmidt cameras, 143
Schmidt–Cassegrain, *see* telescopes
Schultz, S., 29, Plate 3.4
Schur, C., 33, 34
Schwarzschild, K., 180
Schwarzschild exponent, 180
Scotch mounts, 120
scratches, on film, 207
screen, computer or video,
 photographing, 232
SCT (Schmidt–Cassegrain telescope),
 see telescopes
"seeing", *see* atmospheric turbulence
sensitivity frames, 252
service bureaus, 223
Sewell, M. H., 187
shadow bands, 62
sharpening, digital, 230–1
Sheehan, W., 239
sidereal rate, 288
signal vs. noise, 233
silver halide crystals, 174
Simpson, J. W., 33
Skiff, B. A., 129
sky fog (skyglow), 9, 20, 130, 137–42
 exposure limit, **275**
slides
 duplication, 15, 207–10
 processing, 14–15, 174–5, 206–7
 vs. prints, 14, 137
SLR (single-lens reflex), *see* cameras
Smith, A. G., 186
Snook, M. 122, Plate 2.2
software
 Adobe Illustrator, 217
 Adobe Photoshop, 217
 Corel Draw, 217
 Corel Photopaint, 217
solar, *see* sun
solar activity, *see* sunspot cycle
solar rate, 288
Solar-Skreen, 57, 266
spanner wrench, 169
speed, *see* film speed; f-ratio
spherical aberration, *see* aberrations
stacking negatives, 205
 digitally, 231
star atlases, 19–20, 113
star catalogues, 20, 129
star testing, 171–2
star trails, 8–14
 as lens test, 167–8

stars
 colors of, 19–20
 fixed-camera photography, 8–20
steadiness, *see* atmospheric turbulence
Stensvold, M., 16
stop bath, 200
stops, as unit of exposure or film speed, 39–40
streaks, in scanned image, 224
Suiter, H. R., 84, 172
sun, 100–3
 exposure tables, 266–9
 filters for viewing, *see* filters
 projection, 55–6
sunspot cycle, 28, 100
symbols used in formulae, xvi

T-adapters, T-mounts, 71, 152, 243
Taurus astrocamera, 89, 161, 314
Taylor, P. O., 103
Tele Vue, 73
teleconverters, 35–7, 80–2, 83–4, 162–3
tele-extender, 78
 vs. teleconverter, 162
telephoto lenses, *see* lenses
telescopes, 169–72
 Cassegrain, 70, 73, 169
 catadioptric, *see*
 Maksutov–Cassegrain,
 Schmidt–Cassegrain
 Celestron, 73, 170, 171, 246
 choosing, 3, 169–72, **169**
 computer-controlled, 5, 133, 246
 Dobsonian, 170
 Maksutov–Cassegrain, 40, 70, 73, 83, 143, 169
 Meade, 73, 133, 171, 246
 Newtonian, 70, 72, 90, 169, 172
 Questar, 73
 refractor, 70, 72, 83, 169, 170

Schmidt–Cassegrain, 40, 70, 73, 82–3, 142–3, 169, 170, 246, 249
 focusing, 91–2, 112
 importance of collimating, 72, 171–2
 quality, 171
 testing, 90, 171–2
Terrance, G., 94, 240, 241, 245, 246, 249, 250, 254, 255, Plate 13.2, Plate 13.3, Plate 13.4
testing
 cameras, 157–8
 films, 181–4, 187
 lenses, 166–7
 safelights, 203
 telescopes, 90, 171–2
thermal noise, 251
Thousand Oaks filters, 57, 267
threshold, adjusting, 225–6
TIFF files, 221, 222
time zones, 47–8, **47**
Tirion, W., *see* star atlases
toe shape, 25, 45, 177–9, 180
Tomosy, T., 159, 169
totality, zone of, 52
trackers, barn-door, 120–1
tracking, with clock drive, 94–6
 "flop" due to loose gears, 143
 King rate, 288
 lunar rate, 103, 106, 288
 sidereal rate, 288
 solar rate, 288
 see also equatorial mounts; guiding; periodic error
transient lunar phenomena (TLP), 103
tripods, 96
turbulence, *see* atmospheric turbulence
twilight, duration of, 29–30, **29**

ultraviolet light, 108, 165
umbra, 46–47
Universal Time (UT), 47–8

unsharp masking, 205–6
 digital, 231
Uranus, 111
 exposure table, **272**
University Optics, 255, 315

van Venrooij, M., 73, 83
Vanhoeck, L., 246
Vaughn, C., 6, Plate 5.7
vector graphics, 216
Vehrenberg, H., 113
Venus, 107–8, 270
vibration, from camera shutter, 40–1, 96–7, 152–3
video imaging
 of lunar eclipses, 50–2
 of solar eclipses, 63–4
viewfinders, *see* cameras
vignetting, 70, 82, 125, 164
 see also \cos^4 law
Volk, J., Plate 5.4, Plate 9.1
voltage, battery, 132–3

Wallis, B., 114, 120, 129, 142, 185, 186, 190, 197
Watkins, B., 206
weather, 97–100
wells, charge, 242
West, J. B., 289
White, R. L., 240
Wildi, E., 161
Woods, R. E., 239
World Wide Web addresses, 186, 311–17
 comets, 22
 eclipses, 46
 graphics file formats, 222
 patents, 186
Wyckoff, C. W., 61

Zealey, W. J., 206
zodiacal light, 28–30
Zussman, K., 145, 185, 200